Walter Benjamin

SELECTED WRITINGS

Michael W. Jennings
General Editor

Marcus Bullock, Howard Eiland, Gary Smith
Editorial Board

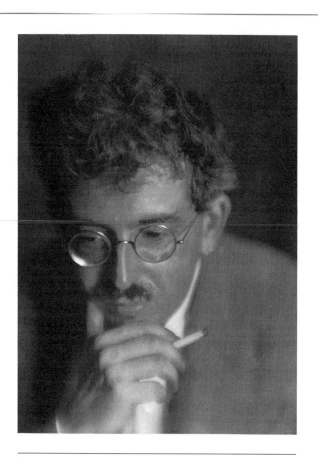

Walter Benjamin

SELECTED WRITINGS
VOLUME 1
1913–1926

Edited by Marcus Bullock
and Michael W. Jennings

WITHDRAWN

THE BELKNAP PRESS OF
HARVARD UNIVERSITY PRESS
Cambridge, Massachusetts
London, England

Third printing, 1999

This work is a translation of selections from Walter Benjamin, *Gesammelte Schriften, unter Mitwirkung von Theodor W. Adorno und Gershom Scholem, herausgegeben von Rolf Tiedemann und Hermann Schweppenhäuser,* copyright © 1972, 1974, 1977, 1982, 1985, 1989 by Suhrkamp Verlag. "The Task of the Translator" originally appeared in English in Walter Benjamin, *Illuminations,* edited by Hannah Arendt, English translation copyright © 1968 by Harcourt Brace Jovanovich, Inc. "On Language as Such and the Language of Man," "Fate and Character," "Critique of Violence," "Naples," and "One-Way Street" originally appeared in English in Walter Benjamin, *Reflections,* English translation copyright © 1978 by Harcourt Brace Jovanovich, Inc. Published by arrangement with Harcourt Brace Jovanovich, Inc. "One-Way Street" also appeared in Walter Benjamin, *"One-Way Street" and Other Writings* (London: NLB/Verso, 1979, 1985). "Socrates" and "On the Program of the Coming Philosophy" originally appeared in English in *The Philosophical Forum* 15, nos. 1–2 (1983–1984).

Publication of this book has been aided by a grant from Inter Nationes, Bonn.

Frontispiece: Walter Benjamin, Paris, 1927. Photo by Germaine Krull. Collection Gary Smith, Berlin.

Library of Congress Cataloging-in-Publication Data
Benjamin, Walter, 1892–1940.
[Selections. English. 1996]
Selected writings / Walter Benjamin; edited by Marcus Bullock and Michael W. Jennings.
 p. cm.
"This work is a translation of selections from Walter Benjamin, Gesammelte Schriften . . . copyright 1972 . . . by Suhrkamp Verlag"—T.p. verso.
Includes index.
Contents: v. 1. 1913–1926.
ISBN 0–674–94585–9 (v. 1: alk. paper)
I. Bullock, Marcus Paul, 1944– . II. Jennings, Michael William. III. Title.
PT2603.E455A26 1996
838'.91209—dc20 96–23027

Designed by Gwen Frankfeldt

Contents

ANGELUS NOVUS, 1920–1926

Metaphysics of Youth, 1913–1919

Walter Benjamin as a student, 1912. Photographer unknown.
Werkbund Archiv, Berlin.

"Experience"

In our struggle for responsibility, we fight against someone who is masked. The mask of the adult is called "experience." It is expressionless, impenetrable, and ever the same. The adult has always already experienced [*erlebt*] everything: youth, ideals, hopes, woman. It was all illusion.—Often we feel intimidated or embittered. Perhaps he is right. What can our retort be? We have not yet experienced [*erfuhren*] anything.

But let us attempt to raise the mask. What has this adult experienced? What does he wish to prove to us? This above all: he, too, was once young; he, too, wanted what we wanted; he, too, refused to believe his parents, but life has taught him that they were right. Saying this, he smiles in a superior fashion: this will also happen to us—in advance he devalues the years we will live, making them into a time of sweet youthful pranks, of childish rapture, before the long sobriety of serious life. Thus the well-meaning, the enlightened. We know other pedagogues whose bitterness will not even concede to us the brief years of youth; serious and grim, they want to push us directly into life's drudgery. Both attitudes devalue and destroy our years. More and more we are assailed by the feeling: our youth is but a brief night (fill it with rapture!); it will be followed by grand "experience," the years of compromise, impoverishment of ideas, and lack of energy. Such is life. That is what adults tell us, and that is what they experienced.

Yes, that is their experience, this one thing, never anything different: the meaninglessness of life. Its brutality. Have they ever encouraged us to anything great or new or forward-looking? Oh, no, precisely because these are things one cannot experience. All meaning—the true, the good, the beautiful—is grounded within itself. What, then, does experience signify?—

And herein lies the secret: because he never raises his eyes to the great and the meaningful, the philistine has taken experience as his gospel. It has become for him a message about life's commonness. But he has never grasped that there exists something other than experience, that there are values—inexperienceable—which we serve.

Why is life without meaning or solace for the philistine? Because he knows experience and nothing else. Because he himself is desolate and without spirit. And because he has no inner relationship to anything other than the common and the always-already-out-of-date.

We, however, know something different, which experience can neither give to us nor take away: that truth exists, even if all previous thought has been an error. Or: that fidelity shall be maintained, even if no one has done so yet. Such will cannot be taken from us by experience. Yet—are our elders, with their tired gestures and their superior hopelessness, right about *one* thing—namely, that what we experience will be sorrowful and that only in the inexperienceable can courage, hope, and meaning be given foundation? Then the spirit would be free. But again and again life would drag it down because life, the sum of experience, would be without solace.

We no longer understand such questions, however. Do we still lead the life of those unfamiliar with the spirit? Whose sluggish ego is buffeted by life like waves against the rocks? No. Each of our experiences has its content. We ourselves invest them with content by means of our own spirit—he who is thoughtless is satisfied with error. "You will never find the truth!" he exclaims to the researcher. "That is my experience." For the researcher, however, error is only an aid to truth (Spinoza). Only to the mindless [*Geistlosen*] is experience devoid of meaning and spirit. To the one who strives, experience may be painful, but it will scarcely lead him to despair.

In any event, he would never obtusely give up and allow himself to be anesthetized by the rhythm of the philistine. For the philistine, you will have noted, only rejoices in every new meaninglessness. He remains in the right. He reassures himself: spirit does not really exist. Yet no one demands harsher submission or greater "awe" before the "spirit." For if he were to become critical, then he would have to create as well. That he cannot do. Even the experience of spirit, which he undergoes against his will, becomes for him mindless [*geistlos*].

> Tell him
> That when he becomes a man
> He should revere the dreams of his youth.[1]

Nothing is so hateful to the philistine as the "dreams of his youth." And most of the time, sentimentality is the protective camouflage of his hatred. For what appeared to him in his dreams was the voice of the spirit, calling him once, as it does everyone. It is of *this* that youth always reminds him,

eternally and ominously. That is why he is antagonistic toward youth. He tells young people of that grim, overwhelming experience and teaches them to laugh at themselves. Especially since "to experience" [*Erleben*] without spirit is comfortable, if unredeeming.

Again: we know a different experience. It can be hostile to spirit and destructive to many blossoming dreams. Nevertheless, it is the most beautiful, most untouchable, most immediate because it can never be without spirit while we remain young. As Zarathustra says, the individual can experience himself only at the end of his wandering. The philistine has his own "experience"; it is the eternal one of spiritlessness. The youth will experience spirit, and the less effortlessly he attains greatness, the more he will encounter spirit everywhere in his wanderings and in every person.— When he becomes a man, the youth will be compassionate. The philistine is intolerant.

Written in 1913; published pseudonymously in *Der Anfang,* 1913–1914. Translated by Lloyd Spencer and Stefan Jost.

Notes

1. Friedrich Schiller, *Don Carlos*, IV, 21, lines 4287–4289.

The Metaphysics of Youth

The Conversation

Where are you, Youth, that always wakes me
Promptly in the morning? Where are you, Light?
—Friedrich Hölderlin, "The Blind Singer"

I

Daily we use unmeasured energies as if in our sleep. What we do and think is filled with the being of our fathers and ancestors. An uncomprehended symbolism enslaves us without ceremony.—Sometimes, on awakening, we recall a dream. In this way rare shafts of insight illuminate the ruins of our energies that time has passed by. We were accustomed to spirit [*Geist*] just as we are accustomed to the heartbeat that enables us to lift loads and digest our food.

Every conversation deals with knowledge of the past as that of our youth, and with horror at the sight of the spiritual masses of the rubble fields. We never saw the site of the silent struggle our egos waged with our fathers. Now we can see what we have unwittingly destroyed and created. Conversation laments lost greatness.

II

Conversation strives toward silence, and the listener is really the silent partner. The speaker receives meaning from him; the silent one is the unappropriated source of meaning. The conversation raises words to his lips as do vessels, jugs. The speaker immerses the memory of his strength in words and seeks forms in which the listener can reveal himself. For the speaker speaks in order to let himself be converted. He understands the listener despite the flow of his own speech; he realizes that he is addressing someone whose features are inexhaustibly earnest and good, whereas he, the speaker, blasphemes against language.

But even if he revives an empty past through orgiastic excitement, the listener hears not words but the silence of the present. For despite the flight of spirit and the emptiness of words, the speaker is present; his face is open to the listener, and the efforts made by his lips are visible. The listener holds true language in readiness; the words enter him, and at the same time he sees the speaker.

Whoever speaks enters the listener. Silence, then, is born from the conversation. Every great man has only one conversation, at whose margins a silent greatness waits. In the silence, energy was renewed; the listener led the conversation to the edge of language, and the speaker creates the silence of a new language, he, its first auditor.

III

Silence is the internal frontier of conversation. The unproductive person never reaches that frontier; he regards his conversations as monologues. He exits the conversation in order to enter the diary or the café.

Silence has long reigned in the upholstered rooms. Here he may make as much noise as he wants. He goes amongst the prostitutes and the waiters like a preacher among the faithful—he, the convert of his latest conversation. Now he has mastered two languages, question and answer. (A questioner is someone who hasn't given a thought to language in his entire life, but now wants to do it right. A questioner is affable even toward the gods.) The questions of the unproductive person break in on the silence, troubling the active, thinkers and women: he inquires about revelation. At the end *he* feels exalted, *he* remains unbowed. His eloquence escapes him; enraptured, he listens to his own voice. He hears neither speech nor silence.

But he saves himself by fleeing into the erotic. His gaze deflowers. He wishes to see and hear himself, and for that reason he wishes to gain control of those who see and hear. Therefore, he misspeaks himself and his greatness; speaking, he flees. But he always sinks down, annihilated by the humanity of the other; he always remains incomprehensible. And the gaze of the silent passes searchingly through him, toward the one who will silently draw near.—

Greatness is the eternal silence after the conversation. It is to hear the rhythm of one's own words in the empty space. The genius [*Genie*] has utterly cursed his memory in giving it shape. He is forgetful and at a loss. His past was already fate and is now beyond recall. In the genius, God speaks and listens for the contradictions of language.

The windbag thinks the genius is an evasion of greatness. Art is the best remedy for misfortune. The conversation of the true spirit [*Genius*], however, is prayer. As he speaks, the words fall from him like cloaks. The words of the true spirit strip him naked, and are covers in which the listener feels clothed. Whoever listens is the past of the great speaker, his object and his

dead strength. The speaking spirit is more silent than the listener, just as the praying man is more silent than God.

IV

The speaker is always obsessed with the present. That is his curse: he can never utter the past, which is, after all, his aim. And what he says has long since taken hold of the unspoken question of the silent, and their gaze asks him when he will stop speaking. He should, rather, entrust himself to the listener so that she may take his blasphemy by the hand and lead it to the abyss in which the speaker's soul lies, his past, the lifeless field to which he is straying. But there the prostitute has long been waiting. For every woman possesses the past, and in any case has no present. This is why she protects meaning from understanding; she wards off the misuse of words and refuses to let herself be misused.

She guards the treasures of daily life, but also of the night, the highest good. This is why the prostitute is a listener. She rescues the conversation from triviality; greatness has no claim upon her, for greatness comes to an end when confronted by her. She has seen every man's desire fail and now the stream of words drains away into her nights. The present that has been eternally will come again. The other conversation of silence is ecstasy.

V

The Genius: I've come to you for a rest.

The Prostitute: Sit down, then.

The Genius: I'd like to sit down with you—I touched you just now, and it's as if I'd already been resting for years.

The Prostitute: You make me uneasy. If I were to lie next to you, I wouldn't be able to sleep.

The Genius: Every night people come to your room. I feel as if I'd received them all, and they'd given me a joyless look and gone on their way.

The Prostitute: Give me your hand—your sleeping hand makes me feel that you've forgotten all your poems.

The Genius: I'm thinking only of my mother. May I tell you about her? She gave birth to me. Like you, she gave birth—to a hundred dead poems. Like you, she didn't know her children. Her children have gone whoring with strangers.

The Prostitute: Like mine.

The Genius: My mother always looked at me, asked me questions, wrote

to me. Through her I've learned not to know people. In my eyes, all were mothers. All women had given birth to me; no man had played a part in my conception.

The Prostitute: This is the complaint of all the men who sleep with me. When they look at their lives through my eyes, they see nothing but a thick column of ash that reaches their chin. No one engendered them, and they come to me in order not to engender.

The Genius: All the women I go to are like you. They gave birth to me and I was stillborn, and all wish to receive dead things from me.

The Prostitute: But I am the one who has least fear of death. [*They go to bed.*]

VI

Woman is the guardian of conversation. She receives the silence, and the prostitute receives the creator of what has been. But no one watches over the lament when men speak. Their talk becomes despair; it resounds in the muted space and blasphemes against greatness. Two men together are always troublemakers; they finish by resorting to torch and axe. They destroy women with their smutty jokes; the paradox violates greatness. Words of the same gender couple and inflame each other with their secret desire; a soulless double entendre arises, barely concealed by the relentless dialectic. Laughing, revelation stands before them and compels them to fall silent. The dirty joke triumphs—the world was built of words.

Now they have to rise and smash their books and make off with a woman, since otherwise they will secretly strangle their souls.

VII

How did Sappho and her women-friends talk among themselves? How did women come to speak? For language extinguishes their soul. Women receive no sounds from it and no salvation. Words waft over women who are sitting together, but the wafting is crude and toneless; they lapse into idle chatter. Yet their silence towers above their talk. Language does not bear women's souls aloft, because they do not confide in it; their past is never resolved.

The words fumble around them and some skill or other enables them to make a swift response. But only in the speaker does language appear to them; tortured, he squeezes the bodies of the words in which he has reproduced the silence of the beloved. The words are mute. The language of women has remained inchoate. Talking women are possessed by a demented language.

VIII

How did Sappho and her women-friends talk among themselves?—Language is veiled like the past; like silence it looks toward the future. The speaker summons the past in it; veiled by language, he conceives his womanly past in conversation—but the women remain silent. Listen as they may, the words remain unspoken. They bring their bodies close and caress one another. Their conversation has freed itself from the subject and from language. Despite this it marks out a terrain. For only among them, and when they are together, does the conversation come to rest as part of the past. Now, finally, it has come to itself: it has turned to greatness beneath their gaze, just as life had been greatness before the futile conversation. Silent women are the speakers of what has been spoken. They leave the circle; they alone perceive the perfection of its roundness.

None of them complain; they gaze in wonderment. The love of their bodies does not procreate, but their love is beautiful to see. And they venture to gaze at one another. It makes them catch their breath, while the words fade away in space. Silence and voluptuous delight—eternally divorced in conversation—have become one. The silence of the conversations was future delight; delight was bygone silence. Among the women, however, the conversations were perceived from the frontier of silent delight. In a great burst of light, the youth of mysterious conversations arose. Essence was radiant.

The Diary

The next place might be so near at hand
That one could hear the cocks crowing in it, the dogs barking;
But the people would grow old and die
Without ever having been there.
—Lao Tzu, trans. Arthur Waley

I

We wish to pay heed to the sources of the unnameable despair that flows in every soul. The souls listen expectantly to the melody of their youth—a youth that is guaranteed them a thousandfold. But the more they immerse themselves in the uncertain decades and broach that part of their youth which is most laden with future, the more orphaned they are in the emptiness of the present. One day they awake to despair: the first day of the diary.

With hopeless earnestness it poses the question: In what time does man live? The thinkers have always known that he does not live in any time at all. The immortality of thoughts and deeds banishes him to a timeless realm

at whose heart an inscrutable death lies in wait. Throughout his life the emptiness of time surrounds him, but not immortality. Devoured by the countless demands of the moment, time slipped away from him; the medium in which the pure melody of his youth would swell was destroyed. The fulfilled tranquillity in which his late maturity would ripen was stolen from him. It was purloined by everyday reality, which, with its events, chance occurrences, and obligations, disrupted the myriad opportunities of youthful time, immortal time, at which he did not even guess. Lurking even more menacingly behind the everyday reality was death. Now it manifests itself in little things, and kills daily so that life itself may go on. Until one day the great death falls from the clouds, like a hand that forbids life to go on. From day to day, second to second, the self preserves itself, clinging to that instrument: time, the instrument that it was supposed to play.

In despair, he thus recalls his childhood. In those days there was time without flight and an "I" without death. He gazes down and down into the current whence he had emerged and slowly, finally, he is redeemed by losing his comprehension. Amid such obliviousness, not knowing what he thinks and yet thinking himself redeemed, he begins the diary. It is the unfathomable document of a life never lived, the book of a life in whose time everything that we experienced inadequately is transformed into experience perfected.

A diary is an act of liberation, covert and unrestrained in its victory. No unfree spirit will understand this book. When the self was devoured by yearning for itself, devoured by its desire for youth, devoured by the lust for power over the years to come, devoured by the yearning to pass calmly through the days to come, darkly inflamed by the pleasures of idleness but cursed and imprisoned in calendar time, clock time, and stock-exchange time, and when no ray of immortality cast its light over the self—it began to glow of its own accord. I am myself (it knows), a ray of light. Not the murky inwardness of the self which calls me "I" and tortures me with its intimacies, but the ray of light of that other self which appears to oppress me but which is also myself: the ray of time. Trembling, an "I" that we know only from our diaries stands on the brink of an immortality into which it plunges. It is *time* after all. In this self, to which events occur and which encounters human beings—friends, enemies, and lovers—in this self courses immortal time. The time of its greatness runs out in it; it is the glow that radiates from time and nothing else.

This believer writes his diary. He writes it at intervals and will never complete it, because he will die. What is an interval in a diary? It does not occur in developmental time, for that has been abrogated. It does not occur *in* time at all, for time has vanished. Instead it is a book *of* time: a book of days. This transmits the rays of his knowledge through space. A diary does not contain a chain of experiences, for then it would exist without intervals.

Instead time is overcome, and overcome, too, is the self that acts in time: I am entirely transposed into time; it irradiates me. Nothing further can happen to this self, this creation of time. Everything else on which time exerts its effect yields to it. For in the diary our self, as time, impinges on everything else, the "I" befalls all things, they gravitate toward our self. But time no longer impinges on this self, which is now the birth of immortal time. The self experiences timelessness, all things are assembled in it. It lives all-powerful in the interval; in the interval (the diary's silence), the "I" experiences its own time, pure time. It gathers itself in the interval; no thing pushes its way into its immortal juxtaposition of events. Here it draws the strength to impinge on things, to absorb them, to misrecognize its own fate. The interval is safe and secure, and where there is silence, nothing can befall. No catastrophe finds its way into the lines of this book. That is why we do not believe in derivations and sources; we never remember what has befallen us. Time, which shines forth as the self that we are, impinges on all things around us as they become our fate. That time, our essence, is the immortality in which others die. What kills them lets us feel our essential nature in death (the final interval).

II

Inclining her head, the beloved of the landscape shines in time,
But the enemy broods darkly above the center.
His wings are poised in slumber. The black redeemer of the lands
Breathes out his crystal No, and decides our death.

On rare occasions the diary emerges hesitantly from the immortality of its intervals and writes itself. Silently it rejoices and surveys the fates that lie within it, clearly entailed by its time. Thirsting for definition, things draw near in the expectation of receiving their fate at its hands. In their impotence they approach its sovereign majesty; their amorphousness seeks definition. They give limits to humanity through their questioning existence and lend depth to time. And as time at its extremity collides with things, it quivers with a hint of insecurity, and, questioning, replies to the questions posed by those things. In the interchange of such vibrations, the self has its life. This is the content of our diaries: our destiny declares its faith in us because we have long since ceased to relate it to ourselves—we who have died and who are resurrected in what happens to us.

There is, however, a place reserved for the resurrections of the self, even when time disperses it in ever widening waves. That is the landscape. As landscape all events surround us, for we, the time of things, know no time. Nothing but the leaning of the trees, the horizon, the silhouetted mountain ridges, which suddenly awake full of meaning because they have placed us

in their midst. The landscape transports us into their midst, the trembling treetops assail us with questions, the valleys envelop us with mist, incomprehensible houses oppress us with their shapes. We, their midpoint, impinge on them. But from all the time when we stand there quivering, one question remains: Are we time? Arrogance tempts us to answer yes—and then the landscape would vanish. We would be citizens. But the spell of the book bids us be silent. The only answer is that we set out on a path. As we advance, the same surroundings sanctify us. Knowing no answers but forming the center, we define things with the movement of our bodies. By drawing nigh and distancing ourselves once again on our wanderings, we single out trees and fields from their like and flood them with the time of our existence. We give firm definition to fields and mountains in their arbitrariness: they are our past existence—that was the prophecy of childhood. We are their future. Naked in this futurity, the landscape welcomes us, the grownups. Exposed, it responds to the shudder of temporality with which we assault the landscape. Here we wake up and partake of the morning repast of youth. Things perceive us; their gaze propels us into the future, since we do not respond to them but instead step among them. Around us is the landscape where we rejected their appeal. Spirituality's thousand cries of glee storm around the landscape—so with a smile the diary sends a single thought in their direction. Permeated by time, the landscape breathes before us, deeply stirred. We are safe in each other's care, the landscape and I. We plunge from nakedness to nakedness. Gathered together, we come to ourselves.

The landscape sends us our beloved. We encounter nothing that is not in landscape, and in it we find nothing but future. It knows but one girl, and she is already a woman. She enters the diary along with the history of her future. Together we have already died once. We were once entirely identical with that story. If we impinge on it in death, it impinges on us in life, countless times. From the vantage point of death, every girl is the beloved woman who encounters us sleepers in our diary. And her awakening takes place at night—invisibly, to the diary. This is the shape of love in a diary; it meets us in the landscape, beneath a very bright sky. Passion has slept its fill between us, and the woman is a girl, since she girlishly gives us back our unused time that she has collected in her death. The plunging nakedness which overwhelms us in the landscape is counterbalanced by the naked beloved.

When our time expelled us from our isolation into the landscape and our beloved strode toward us on the protected path of thought, we could feel how time, which sent us forth, flooded back toward us. This rhythm of time, which returns home to us from all corners of the earth, lulls us to sleep. Anyone who reads a diary falls asleep over it and fulfills the fate of its writer. Again and again the diary conjures up the death of its writer, if only in the

sleep of the reader: our diary acknowledges only one reader, and he becomes the redeemer as he is mastered by the book. We ourselves are the reader, or our own enemy. He has found no entry into the kingdom that flowered around us. He is none other than the expelled, purified "I," dwelling invisibly in the unnameable center of time. He has not abandoned himself to the current of fate that washed around us. As the landscape rose up toward us, strangely invigorated by us, as our beloved flew past us, she whom we had once wooed, the enemy stands in the middle of the stream, as upright as she. But more powerful. He sends landscape and beloved toward us and is the indefatigable thinker of the thoughts that come only to us. He comes to meet us in total clarity, and while time conceals itself in the silent melody of the diary intervals, he is busily at work. He suddenly rears up in an interval like a fanfare, and sends us off on an adventure. He is no less a manifestation of time than we are, but he is also the most powerful reflector of ourselves. Dazzling us with the knowledge of love and the vision of distant lands, he returns, bursting in on us, inciting our immortality to ever more distant missions. He knows the empires of the hundred deaths that surround time, and wishes to drown them in immortality. After every sight and every flight from death, we return home to ourselves as our enemy. The diary never speaks of any other enemy, since every enemy fades away when confronted by the hostility of our illustrious knowledge; for he is an incompetent compared to us, who never catch up with our own time, who are always lagging behind it or precociously overtaking it. We are always putting our immortality at risk and losing it. Our enemy knows this; he is the courageous, indefatigable conscience which spurs us on. Our diary writes what it must, while he remains active when it breaks off at intervals. In his hand rest the scales of our time and of immortal time. When will they come to rest? We shall befall ourselves.

III

The cowardice of the living, whose manifold self is present in every adventure and constantly hides its features in the garments of its dignity—this cowardice must ultimately become unbearable. For every step we took into the kingdom of fate, we also kept looking back—to see whether we were truthful even when unobserved. So the infinitely humiliated sovereign will in us finally became weary; it turned away, full of endless contempt for the self that had been given to it. It mounted a throne in the imagination and waited. In large letters the stylus of its sleeping spirit wrote the diary.

These books, then, are concerned with the accession to the throne of an abdicating self. Abdicating from the experience for which he holds his self to be neither worthy nor capable, and from which he ultimately retreats.

Once upon a time the things fell across his path, instead of coming to meet him; they assailed him from all sides while he took flight. Never did the noble spirit taste the love of the defeated. He felt mistrust about whether he was meant by the things. "Do you mean me?" he asked of the victory that had fallen to him. "Do you mean me?" to the girl who has cuddled up to him. Thus did he tear himself away from his consummation. He had appeared as victor to his victory, as the beloved to the woman who loves him. But love had come to him and victory had fallen at his feet while he was sacrificing to the Penates of his privacy. He ran past his fate, unable ever to encounter it.

But when, in the diary, the sovereignty of the self withdrew and the raging against the way things happen fell silent, events showed themselves to be undecided. The ever more distant visibility of this self that relates nothing more to itself weaves the ever more imminent myth of things that storm on, endlessly attracted to the self, as a restless questioning, thirsting for definition.

The new storm rages in the agitated self. Dispatched in the shape of time, things storm on within it, responding to it in their humble, distancing movement toward the center of the interval, toward the womb of time, whence the self radiates outward. And fate is: this countermovement of things in the time of the self. And that time of the self in which the things befall us—that is greatness. To it all future is past. The past of things is the future of the "I"-time. But past things have futurity. They dispatch the time of the self anew when they have entered into the diary interval. With the events our diary writes the history of our future existence. And thereby prophesies our past fate. The diary writes the story of our greatness from the vantage point of our death. For once, the time of things is really overcome in the time of the self; fate is overcome in greatness; and intervals in the interval. One day the rejuvenated enemy will confront us with his boundless love, he who has gathered together all our dazzled weakness in his strength, bedded down all our nakedness in his bodilessness, and drowned out all our silence with his speechlessness. He brings all things home and puts an end to all men, since he is the great interval: death. In death we befall ourselves; our deadness releases itself from things. And the time of death is our own. Redeemed, we become aware of the fulfillment of the game; the time of death was the time of our diary; death was the last interval, the first loving enemy, death which bears us with all greatness and the manifold fate of our wide plain into the unnameable centerpoint of time. Death, which for one instant bestows immortality upon us. Simple and multifold, this is the content of our diaries. The vocation that we proudly dismissed in our youth takes us by surprise. Yet it is nothing but a call to immortality. We enter into the time that was in the diary, the symbol of yearning, the rite of purification. With us things sink toward the center, with

us they await the new radiance. For immortality can be found only in death, and time rises up at the end of time.

The Ball

For the sake of what prelude do we cheat ourselves of our dreams? With a wave of the hand we push them aside into the pillows, leave them behind, while some of them flutter silently about our heads. How do we dare carry them into the brightness of day, as we awake? Oh, into the brightness! All of us carry invisible dreams around with us; how deeply veiled the girls' faces are, their eyes are secret [*heimliche*] nests of the uncanny [*der Unheimlichen*], of dreams, quite inaccessible, luminous from sheer perfection. The music elevates us all to the level of that bright strip of light—you have all seen it—that shines from beneath the curtain when the violins tune up in the orchestra. The dance begins. Our hands slide off one another; our glances meet, laden, emptying themselves out and smiling from the ultimate heaven. Our bodies make careful contact; we do not arouse each other from our dreams, or call each other homeward into the darkness—out of the night of nights which is not day. How we love each other! How we safeguard our nakedness! We have bound everything in gay colors, masks, alternately withholding and promising naked flesh. In everything there is something monstrous that we have to keep quiet about. But we hurl ourselves into the rhythm of the violins; never was a night more ethereal, more uncanny, more chaste than this.

Where we stand alone, on a cartload of fanfares, alone in the bright night of nights which we conjured up, our fleeing soul invites a woman to come—a girl who stands at the end of a distant room.

She walks regally across the parquet floor that lies so smoothly between the dancers, as if it reflected the music; for this smooth floor to which people do not belong creates a space for Elysium, the paradise that joins the isolated into a round dance. Her stately step creates order among the dancers; she presses some to leave; they break into fragments at the tables where the din of the lonely holds sway, or where people move along corridors, as if on tightropes through the night.

When did night ever attain brightness and become radiant, if not here? When was time ever overcome? Who knows whom we will meet at this hour? Otherwise (were there an "otherwise") we would be just here, but already complete; otherwise we would perhaps just pour away the dregs of the day and start to taste the new one. But now we pour the foaming day over into the purple crystal of the night; it becomes peaceful and sparkling.

The music transports our thoughts; our eyes reflect our friends around us, how they all move, surrounded by the flowing night. We are truly in a

house without windows, a ballroom without world. Flights of stairs lead up and down, marble. Here time is captured. It sometimes resists, moves its weary breath in us, and makes us restless. But a word, uttered in the night, summons someone to us; we walk together, we did not really need the music but could lie together in the dark, even though our eyes would flash, just like a sword between people. We know that all the merciless realities that have been expelled still flutter round this house. The poets with their bitter smiles, the saints and the policemen, and the waiting cars. From time to time, music penetrates to the outside world and submerges them.

Written in 1913–1914; unpublished in Benjamin's lifetime. Translated by Rodney Livingstone.

Two Poems by Friedrich Hölderlin

"The Poet's Courage" and "Timidity"

The task of the following investigation cannot be classified under the aesthetics of poetry without further explanation.[1] This discipline, as pure aesthetics, has devoted its best energies to exploring the foundation of individual genres of poetry—among them, most frequently, tragedy. Few works outside the great works of classical literature have had a commentary bestowed on them; a commentary on a work outside classical drama tended to be philological rather than aesthetic. Here, an aesthetic commentary on two lyric poems shall be attempted, and this intention requires several preliminary remarks on method.[2] The inner form, which Goethe characterized as content [*Gehalt*], shall be demonstrated in these poems. The poetic task, as the preliminary condition of an evaluation of the poem, is to be established. The evaluation cannot be guided by the way the poet has fulfilled his task; rather, the seriousness and greatness of the task itself determine the evaluation. For the task is derived from the poem itself. The task is also to be understood as the precondition of the poem, as the intellectual-perceptual [*geistig-anschaulich*] structure of the world to which the poem bears witness. This task, this precondition, shall be understood here as the ultimate basis accessible to analysis. Nothing will be said here about the process of lyrical composition, nothing about the person or world view of the creator; rather, the particular and unique sphere in which the task and precondition of the poem lie will be addressed. This sphere is at once the product and the subject of this investigation. It itself can no longer be compared with the poem; it is, rather, the sole thing in this investigation that can be ascertained. This sphere, which for every poem has a special configuration, is characterized as the poetized [*das Gedichtete*].[3] In this

sphere that peculiar domain containing the truth of the poem shall be opened up. This "truth," which the most serious artists so insistently claim for their creations, shall be understood as the objectivity of their production, as the fulfillment of the artistic task in each case. "Every work of art has in and of itself an a priori ideal, a necessity for being in the world" (Novalis). In its general character, the poetized is the synthetic unity of the intellectual and perceptual orders. This unity gains its particular configuration as the inner form of the particular creation.

The concept of the poetized is in two respects a limit-concept. It is first of all a limit-concept with respect to the concept of the poem. As a category of aesthetic investigation, the poetized differs decisively from the form-content model by preserving within itself the fundamental aesthetic unity of form and content. Instead of separating them, it distinctively stamps in itself their immanent, necessary connection. Since what follows concerns the poetized of individual poems, this cannot be adduced theoretically but only in the individual case. Neither is this the place for a theoretical critique of the form-content concept with respect to its aesthetic significance. In the unity of form and content, therefore, the poetized shares one of its most essential characteristics with the poem itself. It, too, is built on the basic law of the artistic organism. It differs from the poem as a limit-concept, as the concept of its task, not simply through some fundamental characteristic but solely through its greater determinability; not through a quantitative lack of determinations but rather through the potential existence of those that are effectively [aktuell] present in the poem—and others. The poetized is a loosening up of the firm functional coherence that reigns in the poem itself, and it cannot arise otherwise than by disregarding certain determinations, so that the meshing, the functional unity of the other elements is made evident. For the poem is so determined through the effective existence of all its defining features, that it can be conceived in a unified manner only as such. Insight into the function, on the other hand, presupposes a variety of possibilities of connection. Thus, insight into the organization of the poem consists in grasping its ever stricter determination. In order to lead us to this highest degree of determination in the poem, the poetized must disregard certain determinations.

Through this relation to the perceptual and intellectual functional unity of the poem, the poetized emerges as a limit-determination with respect to the poem. At the same time, however, it is a limit-concept with respect to another functional unity, since a limit-concept is possible only as a limit between two concepts. This other functional unity, now, is the idea of the task, corresponding to the idea of the solution as which the poem exists. (For task and solution can be separated only in the abstract.) For the creator, this idea of the task is always life. In it lies the other extreme functional unity. Thus, the poetized emerges as the transition from the functional unity

of life to that of the poem. In the poetized, life determines itself through the poem, the task through the solution. The underlying basis is not the individual life-mood of the artist but rather a life-context determined by art. The categories in which this sphere, the transitional sphere of the two functional unities, can be grasped do not yet have adequate models and should perhaps more readily be associated with the concepts of myth. It is precisely the feeblest artistic achievements that refer to the immediate feeling of life; whereas the strongest, with respect to their truth, refer to a sphere related to the mythic: the poetized. One could say that life is, in general, the poetized of poems. Yet the more the poet tries to convert without transformation the unity of life into a unity of art, the plainer it is that he is a bungler. We are used to finding such shoddy work defended, even demanded, as "the immediate feeling of life," "warmth of heart," "sensibility." With respect to the significant example of Hölderlin, it becomes clear how the poetized creates the possibility of judging poetry according to the degree of coherence and greatness of its elements. Both characteristics are inseparable. For the more a slack extension of feeling replaces the inner greatness and structure of the elements (which we term, approximately, "mythic"), the more meager the coherence becomes and the more readily there comes into being either an endearing, artless natural product or some concoction alien to art and nature. Life, as the ultimate unity, lies at the basis of the poetized. But the more prematurely the analysis of the poem—without encountering the structuration of perception and the construction of an intellectual world—leads us to life itself as its poetized, the more the poem proves, in a strict sense, to be more material, more formless, and less significant. Whereas, to be sure, the analysis of great works of literature will encounter, as the genuine expression of life, not myth but rather a unity produced by the force of the mythic elements straining against one another.

The method by which the poetized is represented testifies to its nature as a domain set against two limits. The method cannot be concerned with demonstrating so-called ultimate elements. For within the poetized no such things exist. Rather, what is to be demonstrated is nothing other than the intensity of the coherence of the perceptual and intellectual elements, and this, of course, first with respect to individual examples. But in this demonstration it must be evident that it is not elements but relations that are at stake, since the poetized itself is, after all, a sphere of relation between the work of art and life, whose unities themselves are wholly ungraspable. In this way the poetized will come to light as the precondition of the poem, as its inner form, as artistic task. The law according to which all apparent elements of sensation and ideas come to light as the embodiments of essential, in principle infinite functions is called the Law of Identity. This term describes the synthetic unity of functions. It may be recognized in each particular configuration it takes as an a priori of the poem. The disclosure

of the pure poetized, the absolute task, must remain—after all that has been said—a purely methodological, ideal goal. The pure poetized would otherwise cease to be a limit-concept: it would be life or poem.—Until the applicability of this method to the aesthetics of the lyric as such and perhaps to other domains has been tested, further exposition is not in order. Only then can one clearly perceive the a priori of the individual poem, that of the poem in general, or even that of other literary genres or of literature in general. What will emerge more clearly, however, is that with respect to lyric poetry, a judgment, even if unprovable, can nonetheless be justified.

Two poems by Hölderlin, "The Poet's Courage" [*Dichtermut*} and "Timidity" [*Blödigkeit*], as they have come down to us from his mature and late periods, will be investigated according to this method. The method will demonstrate that the poems are comparable. A certain relationship connects them, so that one could speak of different versions. A version that belongs between the earliest and the latest ("The Poet's Courage," second version) will not be discussed here, since it is less essential.

The Poet's Courage

1. Are not all the living related to you?
Does not the Parca herself nourish you for service?
Then just wander forth defenseless
Through life, and have no care!

2. Whatever happens, let everything be a blessing for you,
Be disposed toward joy! What could then
Offend you, heart! What
Could you encounter there, whither you must go?

3. For, ever since the poem escaped from mortal lips
Breathing peace, benefiting in sorrow and happiness,
Our song brought joy to the hearts
Of men; so, too, were

4. We, the poets of the people, gladly among the living,
Where much joins together, joyful and pleasing to all,
Open to everyone; thus indeed is
Our ancestor, the sun god,

5. Who grants the joyful day to poor and rich,
Who in fleeting time holds us, the ephemeral ones,
Drawn erect on golden
Leading strings, like children.

6. His purple flood awaits him, takes him, too,
Where the hour comes—look! And the noble light
Goes, knowing of change,
With equanimity down the path.

7. Thus pass away then, too, when the time has come
And the spirit nowhere lacks its right; so dies
Once in the seriousness of life
Our joy, a beautiful death!

Timidity

1. Are not many of the living known to you?
Does not your foot stride upon what is true, as upon carpets?
Therefore, my genius, only step
Naked into life, and have no care!

2. Whatever happens, let it all be opportune for you!
Be rhymed to joy! What could then
Offend you, heart? What
Could you encounter there, whither you must go?

3. For, since the heavenly ones, like men, a lonely deer,
And leads the heavenly ones themselves toward homecoming,
The poem and the chorus of princes,
According to their kinds, so, too, were

4. We, the tongues of the people, gladly among the living,
Where much joins together, joyous and equal to everyone,
Open to everyone; thus is indeed
Our Father, the god of heaven,

5. Who grants the thinking day to poor and rich,
Who, at the turning of time, holds us, who pass away in sleep,
Drawn erect on golden
Leading strings, like children.

6. Good, too, are we and skillful for [or sent to] someone to some end,
When we come, with art, and bring one
From among the heavenly beings. Yet we ourselves
Bring suitable [or appropriate] hands.

Reflection on the first version reveals a considerable indeterminacy of the perceptual and an incoherence of detail. The myth of the poem is still rank with mythology. The mythological emerges as myth only through the extent of its coherence. The myth is recognizable from the inner unity of god and destiny. From the way *ananke* reigns. In the first version of his poem, Hölderlin's subject is a destiny—the death of the poet. Hölderlin praises in song the sources of the courage to die this death. This death is the center from which the world of poetic dying was meant to arise. Existence in that world would be the poet's courage. But here only the most vigilant intuition can have a glimmer of this structure of laws from a world of the poet. The voice rises up timidly at first to sing a cosmos, whose own decline is signified by the death of the poet. But the myth is developed from mythology. The

sun god is the poet's ancestor, and his death is the destiny through which the poet's death, at first mirrored, becomes real. A beauty whose inner source we do not know dissolves the figure of the poet—scarcely less that of the god—instead of forming it.—Still, the poet's courage is justified, curiously, on the basis of another, alien order—that of the relationship with the living. Through it he is connected with his destiny. What significance does the relationship with his people have for poetic courage? The deeper right by which the poet associates himself with and feels himself related to his people, those who are alive, cannot be felt in the poem. We know that this thought is one of the consolations of poets and that it was especially dear to Hölderlin. Yet that natural connectedness with all people cannot justifiably strike us here as the condition of poetic life. Why doesn't the poet celebrate—and with a higher right—the *odi profanum?*[4] This question may, indeed must be asked wherever the living have not yet founded any sort of spiritual order.—In the most surprising way, the poet reaches with both hands into alien world orders, grabs at people and God to raise within him his own courage—the courage of poets. But the song, the inwardness of the poet, the significant source of his virtue, appears, where it is named, weak, without power and greatness. The poem lives in the Greek world; a beauty modeled on that of Greece animates it, and it is dominated by the mythology of the Greeks. The particular principle of Greek creation, however, is not fully manifest. "For, ever since the poem escaped from mortal lips / Breathing peace, benefiting in sorrow and happiness / Our song brought joy to the hearts / Of men . . ." These words give only a feeble hint of the awe that filled Pindar—and also the late Hölderlin—before the figure of poetry. Neither do the "bards of the people," "pleasing to all," thus seen, serve to give this poem a perceptual world foundation. The figure of the dying sun god testifies most clearly to an unmastered duality in all its elements. Idyllic nature still plays its special role opposite the figure of the god. Beauty, in other words, has not yet wholly become form. Neither does the idea of death flow out of a pure, structured context. Death itself is not—as it is later understood to be—form in its deepest degree of union; it is the extinguishing of the plastic, heroic essence in the indeterminate beauty of nature. The space and time of this death have not yet arisen as a unity in the spirit of form. The same indeterminacy of the shaping principle, which contrasts so strongly with that of the conjured Hellenism, threatens the entire poem. The beauty, which connects almost by means of mood the beautiful appearance of the poem with the serenity of the god, and this isolation of the god, whose mythological destiny furnishes merely analogical significance for the poet, do not arise from the center of a structured world, whose mythological law would be death. Instead, a world that is only weakly articulated dies in beauty with the setting sun. The relation of the gods and men to the poetic world, to the spatiotemporal unity in which they live, is structured neither

intensively nor with a purely Greek character. It must be fully recognized that the basic feeling underlying this poem, one by no means free of conventionality, is the feeling of life, of life spread out and undefined; hence that this gives rise to the coherence, charged with mood, of the poem's elements isolated in beauty. Life as an undoubted basic fact—perhaps lovely, perhaps sublime—still determines (while also veiling thought) this world of Hölderlin's. In a curious way the wording of the title attests to the same thing, since a peculiar lack of clarity characterizes that virtue to which the name of its bearer has been attached, thus pointing to a clouding of its purity through its all too great proximity to life. (Compare the locution *Weibertreue* [the sort of fidelity one attributes to a woman].) An almost alien sound, the ending falls gravely into the chain of images. "And the spirit nowhere lacks its right": this powerful admonition, which arises from courage, here stands alone, and only the greatness of a single image from an earlier verse survives in it ("holds . . . us / Drawn erect on golden / Leading strings, like children"). Following rigid rhythms, the connectedness of the god with men is constrained into a great image. But in its isolation it is unable to explain the basis of those allied powers, and it loses itself. Only the power of transformation will make it clear and appropriate to declare that the poetic law has not yet fulfilled itself in this Hölderlinian world.

What is signified by the innermost context of that poetic world contained in an allusive way in the first version; and how, furthermore, an increase in profundity brings about the revolution of the structure; and how from the structured center a structuring movement necessarily forces its way from verse to verse—this is what the final version produces. A nonperceptual conception of life, an unmythic, destiny-less concept of life stemming from a spiritually exiguous sphere, proved to be the binding precondition of the early draft. Where formerly there was isolation of form and a lack of relation between events, there now appears a perceptual-intellectual order, the new cosmos of the poet. It is difficult to gain any kind of access to this fully unified, unique world. The impenetrability of relation resists every mode of comprehension other than that of feeling. The method requires from the outset that connected things be taken as a point of departure, in order to gain insight into the articulation. Beginning with the context of forms, let us compare the poetic construction of both versions, in this way striving to advance slowly toward the center of the connected elements. We have already noted that in the earlier version the affiliation linking the people and god (and the poet as well) is indeterminate. Opposed to this in the latter poem is the powerful affiliation of the individual spheres. The gods and the living are bound together in the destiny of the poet by ties of iron. The traditional and simple superiority of mythology is transcended. It is said of the poem, which leads men "toward returning, ingathering, homecoming" [*der Einkehr zu*], that it leads them "like the heavenly ones" [*Himmlischen*

gleich]—and leads the heavenly ones themselves. The actual basis of the comparison is transcended, for the continuation says that the poem leads the heavenly ones, too, and no differently from men. Here, at the center of the poem, the orders of gods and men are curiously raised up toward and against each other, the one balanced by the other. (Like two scales: they are left in their opposing positions, yet lifted off the scale beam.) From this emerges, very graphically, the fundamental formal law of the *poetized,* the origin of that order of law whose realization gives the later version its foundation. This Law of Identity states that all unities in the poem already appear in intensive interpenetration; that the elements are never purely graspable; that, rather, one can grasp only the structure of relations, whereby the identity of each individual being is a function of an infinite chain of series in which the poetized unfolds. This is the Law of Identity— the law according to which all essences in the *poetized* are revealed as the unity of what are in principle infinite functions. No element can ever be singled out, void of relation, from the intensity of the world order, which is fundamentally felt. With respect to all individual structures—to the inner form of the verses and images—this law will prove to be fulfilled, so as to bring about, finally, at the heart of all the poetic connections, the identity of the perceptual and intellectual forms among and with one another—the spatiotemporal interpenetration of all configurations in a spiritual quintes- sence, the poetized that is identical with life.—Here, however, it is necessary to identify only the present configuration of this order: the balancing of the spheres of the living ones and the heavenly ones (this is how Hölderlin most often names them), in an arrangement far removed from the mythological. And following the heavenly ones, even following the naming of poetry, there once again arises "the chorus of princes, / According to their kind." So that here, at the center of the poem, men, heavenly ones, and princes—crashing down from their old orders, as it were—are linked to one another. That this mythological order is not decisive, however, that a quite different canon of figures runs through this poem, is seen most vividly in the tripartite arrange- ment in which princes still claim a place beside the heavenly ones and men. This new order of poetic figures—of the gods and the living—is based on the significance that both have for the destiny of the poet, as well as for the sensuous order of his world. Their real origin, as Hölderlin saw it, can come to light only at the end, as the underlying foundation of all relations; and what is at first evident is only the difference in the dimensions of this world and this destiny, a difference that these dimensions assume with respect to the gods and the living, and, specifically, the complete life of these once so isolated worlds of figures in the poetic cosmos. But now the law, which appeared formally and generally to be the condition of the building of this poetic world, begins, foreign and powerful, to unfold.—In the context of poetic destiny, all figures acquire identity; for here they are sublated within

a single vision, and though they may seem governed only by their own whim, they do finally fall back into the boundedness of the poem. The growing definiteness of the intensified figures is seen most forcefully in the changes made to the first version. At every point the concentration of poetic power will make room for itself, and a rigorous comparison will make the basis of even the slightest deviation understandable as one that subserves unity. What is most important about the inner intention must thereby come to light, even where the first version only feebly pursued it. We shall pursue life in poetry, in the unwavering poetic destiny which is the law of Hölderlin's world, on the basis of its context of figures.

In orders that are momentously and sharply profiled, gods and mortals pass in contrasting rhythms through the poem. This becomes clear in the movement going forth from, and returning to, the middle verse. A most highly structured, albeit concealed, sequence of dimensions is realized. In this world of Hölderlin's, the living are always clearly the *extension* of space, the plane spread out, in which (as will become evident) destiny extends itself. Majestically, or with a vastness evoking the oriental, the appeal begins: "Are not many of the living known to you?" In the first version, what was the function of the opening verse? The relation of the poet to all the living was appealed to as the origin of courage. And nothing remained other than an acquaintance with, a knowing of, the many. The question of the origin of the multitude's determination by the genius, to whom it is "known," leads into the contexts of what follows. A great deal, a very great deal, of Hölderlin's cosmos is laid bare in the following words, which—once again foreign-sounding, as if from the world of the East, and yet much more primordial than the Parca—confer majesty upon the poet: "Does not your foot stride upon what is true, as upon carpets?" The transformation of the opening of the poem, with its significance for the kind of courage, proceeds. The association with mythology gives way to the context of a myth of one's own. For here, if one sought to see nothing more than the conversion of the mythological vision into the more sober one of walking, or to see nothing more than how dependency in the original version ("Does not the Parca herself nourish you for service?") turns, in the second version, into a positing ("Does not your foot stride upon what is true?")—all this would mean to remain only on the surface of the poem.—In an analogous way, the word "related" of the first version was intensified, changed to the more emphatic "known": a relation of dependency has become an activity.—Yet the crucial fact is that this activity is once again converted into the mythic; it was from this that the dependency in the earlier poem flowed. The mythic character of this activity is based, however, on its following the course prescribed by destiny; indeed, it already comprehends the fulfillment of destiny. The existence of the people, its proximity to the poet, testifies to the way in which the activity of the poet always reaches into orders determined by destiny

and thus is eternally preserved in these orders while sublating them. His knowledge of the living, of their existence, is based on the order that, according to the sense of the poem, may be termed the truth of the situation [*Lage*]. The possibility of the second verse, with the tremendous vigor of its image, necessarily presupposes the truth of the situation as the ordering concept of Hölderlin's world. The spatial and intellectual orders prove themselves connected through an identity of that which determines and that which is determined—an identity that befits both. In both orders, this identity is a matter not of likeness but of sameness; through it they permeate each other to the point at which they become identical. Decisive for the spatial principle, then, is that it fulfills in vision [*Anschauung*] the identity of that which determines and that which is determined. The situation is the expression of this unity; space is to be understood as the identity of situation and situated. Immanent to everything determinative in space is its own determination. Every situation is determined only in space, and is only determinative in space. Just as the image of the carpet (since a plane is here laid down as the foundation of an intellectual system) should remind one of its exemplariness [*Musterhaftigkeit*][5] and put before the mind's eye the intellectual arbitrariness of its ornament—ornament thus constituting a true determination of the situation, making the situation absolute—so the order of truth itself, on which one may stride, is occupied by the intensive activity of the gait as an inner, plastically temporal form.[6] This intellectual domain is something that one can stride upon; and, so to speak, it necessarily allows the strider his every arbitrary stride in the region of what is true. These intellectual-sensory orders in their essence constitute the living, in whom all the elements of poetic destiny are laid down in an inner and particular form. Temporal existence in infinite extension, the truth of the situation, binds the living to the poet. In the same way, too, the coherence of the elements in the relation between people and poet comes to light in the final verse: "We too are good and sent to someone to some end." According to a (perhaps general) law of lyric, the words achieve their perceptual meaning in the poem without sacrificing the figurative. Thus, two orders interpenetrate in the double meaning of the word *geschickt* [sent, skillful]. The poet appears among the living, determining and determined. As in the participle *geschickt* [sent], a temporal determination completes the spatial order in the event—namely, of being-found-fitting. This identity of orders is once more repeated in the determination of purpose or destination: "for/to someone to some end." As if, through the order of art, the act of animating had to become doubly clear, everything else is left uncertain and the isolation within great extension is hinted at in the phrase "for/to someone to some end." Now it is astonishing how, at this site, where the people [*Volk*] is in fact characterized in the most abstract way, an almost wholly new figuration of the most concrete life arises from the interior of this line. Just as what is skillful

will emerge as the innermost essence of the poet (as his limit with respect to existence), just as what is skillful appears here before those who are alive as that which has been sent, so that identity arises in one form: determining and determined, center and extension. The activity of the poet finds itself determined with respect to those who are alive; the living, however, determine themselves in their concrete existence—"to/for someone to some end"—with respect to the essence of the poet. The people exists as sign and script of the infinite extension of its destiny. This destiny itself, as will become clear later, is poetry. And so, as the symbol of poetry, the *Volk* has the task of fulfilling Hölderlin's cosmos. The same result is produced by the metamorphosis that created "tongues of the people" from "poets of the people." The precondition of this poetry is more and more to transform the figures borrowed from a neutral "life" into members of a mythic order. In this locution, people and poet are included equally emphatically in this order. The departure of the genius in his mastery becomes particularly palpable in these words. For the poet, and with him the people from whose midst he sings, are wholly transposed into the circle of the song, and a planar unity of the people with its poet (in the poetic destiny) is once again the conclusion. Now, depersonalized, the people appears (may we compare this with Byzantine mosaics?) as if pressed in the surface around the great flat figure of its sacred poet. This is a different people, more definite in its essence than that of the first version. Corresponding to it is another conception of life: "Therefore, my genius, simply enter / Naked into life and have no care!." Here "life" lies outside poetic existence; in the new version it is not the precondition but the object of a movement accomplished with a mighty freedom: the poet *enters into* life; he does not wander forth in it. The incorporation of the people into that conception of life in the first version has turned into a connectedness, in destiny, between the living and the poet. "Whatever happens, let everything be suited to you." At this point the earlier version has the word "blessed" [*gesegnet*]. It is this same procedure—a dislocation of the mythological—that everywhere constitutes the inner form of the revision. "Blessed" is a notion dependent on the transcendental, the traditionally mythological, which is not grasped from out of the center of the poem (let us say, from the genius). "Opportune" [*gelegen*] reaches back again fully into the center of the poem; it means a relation of the genius itself, in which the rhetorical "let be" of this verse is sublated through the presence of this "opportunity" [*Gelegenheit*]. Spatial extension is given anew and with the same meaning as before. Once again, it is a matter of the lawful order of the good world, in which by means of the poet the situation [*Lage*] is at the same time that which is suited or opportune [*das Gelegene*], since for him it must be possible to stride upon that which is true. Hölderlin once began a poem: "Be glad! You have chosen the winning lot." Here the chosen one is meant; for him there exists only *that* lot, hence

the good one. The object of this relation of identity between poet and destiny is the living. The construction "be rhymed for joy" presupposes the sensory order of sound. And here too, in rhyme, the identity between that which determines and that which is determined is given—the way, let us say, the structure of unity appears as half a doubling. Identity is given not substantially but functionally, as law. The rhyme words themselves are not named. For of course "rhymed for joy" no more means "rhymed *with* joy" than "opportune for you" turns the "you" itself into something that is laid down, something spatial. As that which is opportune was recognized as a relation of the genius (not *to* him), so is rhyme a relation of joy (not *to* it). Rather, that dissonance of the image, which given the most radical emphasis suggests a tonal dissonance, has the function of making the inherent intellectual ordering of joy in time perceptible, audible, in the chain of an infinitely extended event corresponding to the infinite possibilities of rhyme. Thus, the dissonance in the image of the true and of the carpet evokes the ability to be stridden upon as the unifying relation of the orders, just as "opportunity" signified the intellectual-temporal identity (the truth) of the situation. Within the poetic structure, these dissonances bring into relief the temporal identity inherent in every spatial relation and hence the absolutely determining nature of intellectual existence within the identical extension. The bearers of this relation, clearly, are predominantly the living. A path and appropriate goal, articulated precisely according to the extremes of imageability [*Bildhaftigkeit*], must now become visible in a manner different from that appropriate to the idyllic world-feeling that in the earlier period preceded these verses: "or what could then / Offend you, heart, what / Encounter [you] there, whither you must?" At this point, in order to feel the growing power with which the verse approaches its end, the punctuation of both drafts may be compared. It is now for the first time entirely comprehensible how in the following verse mortals, with the same importance as heavenly ones, could be brought closer to poetry, since they found themselves fulfilled by the poetic destiny. To be understood in its forcefulness, all this must be compared with the degree of form that Hölderlin in the original version lent to the people. There the people was delighted by poetry, related to the poet, and might be articulated by the poets of the people. In this alone the more rigorous power of an image of the world might already be surmised—an image that has found what was previously striven for only from afar: the fateful significance of the people in a vision that turns the people into a sensuous-intellectual function of the poetic life.

These relations, which until now, especially with respect to the function of time, have remained obscure, achieve new distinctness when their peculiar transformation with respect to the form of the gods is followed. Through the inner configuration, which is suited to them in the new world structure, the essence of the people—as through its opposite—is more precisely estab-

lished. As little as the first version knows a significance for the living—whose inner form is their existence as drawn into the poetic destiny, determined and determining, true in space—just as little is a particular order of the gods recognizable in it. A movement, however, passes through the new version in a plastic and intensive direction, and this movement lives most strongly in the gods (next to the direction, which, represented in the people, follows a spatial trajectory toward infinite happening). The gods have turned into most particular and definite figures, with respect to whom the Law of Identity is conceived in a wholly new way. The identity of the divine world and its relation to the destiny of the poet is different from the identity in the order of the living. There something that happens, in its determination through and for the poet, was recognized as flowing from one and the same source. The poet experienced the true. In this way the people was known to him. In the divine order, however, there is, as will be shown, a particular inner identity of form. This identity we found already intimated in the image of space and, so to speak, in the determination of the plane through ornament. But having come to dominate an order, it brings about a concretizing of the living. A peculiar doubling of the form arises (connecting it with spatial determinations), in that each one once again finds its concentration in itself, bears in itself a purely immanent plasticity as the expression of its existence in time. In this direction of concentration, things strive toward existence as pure idea and determine the destiny of the poet *in* the pure world of forms. The plasticity of form is revealed as that which is intellectual. This is how the "joyful day" turned into the "thinking one." The quality of the day is not characterized by an epithet; rather, it is granted the gift that is the condition of the intellectual identity of essence: thought. Now in this new version, the day appears to the highest degree formed, at rest, at one with itself in its consciousness, as a form having the inner plasticity of existence, to which corresponds the identity of happening in the order of the living. From the standpoint of the gods, the day appears as the formed quintessence of time. A much deeper meaning is acquired from the day—as from one who, so to speak, persists—namely, that the god does not begrudge it. This conception that the day is not begrudged is to be distinguished very rigorously from a traditional mythology, which lets the day be given as a gift. For here something is already intimated that later is shown with a weightier power: that the idea leads to the concretizing of the form and that the gods are wholly delivered over to their own plasticity, are able only to begrudge or else not to begrudge the day, since they are closest to the form of the idea. Here again, one might mention the intensification of intention in the domain of pure sound—through alliteration. The significant beauty with which the day is elevated to the principle of plasticity and at the same time to the principle of contemplativeness is again found intensified at the beginning of "Chiron": "Where are you that contemplates, that must always

/ Go to one side at times? Where are you, Light?" The same vision has inwardly transformed the second line of the fifth verse and refined it to the highest degree, compared with the corresponding passage in the early version. Quite in opposition to "fleeting time," to the "ephemeral ones," that which persists—duration in the form of time and men—has been developed in the new version of these lines. The phrase "turning of time" plainly captures the instant of persistence as well, the moment of inner plasticity in time. And that this moment of inner temporal plasticity is central can become entirely clear only later, like the central importance of other hitherto demonstrated phenomena. The phrase "for us, who pass away in sleep" has the same expressive value. Once again the deepest identity of form (in sleep) is present. Here one would do well to recall the words of Heraclitus: Waking, we indeed see death—but in sleep we see sleep. The poem is about the plastic structure of thought in its intensity—the way the contemplatively fulfilled consciousness forms the ultimate basis of its structure. The same relation of identity which here leads, in an intensive sense, to the temporal plasticity of form, must lead in an extensive sense to an infinite configured form—to a plasticity which is, as it were, buried and in which form becomes identical with the formless. At the same time, the concretizing of the form in the idea signifies that it will grow forever more boundless and infinite, and that all forms will be unified in the absolute form that the gods will take. It is this form that provides the object with respect to which poetic destiny limits itself. The gods signify to the poet the immeasurable structuring of his destiny, just as the living vouch for the widest extension of something that happens as a happening within the domain of poetic destiny. This determination of destiny through configuration constitutes the objectivity of the poetic cosmos. At the same time, however, it signifies the pure world of temporal plasticity in consciousness; the idea becomes dominant in it. Whereas hitherto what is true was included in the activity of the poet, it now emerges commandingly in sensory fulfillment. In the forming of this world image, every association with conventional mythology is ever more rigorously extirpated. The more remote term "ancestor" is replaced by "father," and the sun god is transformed into a god of heaven. The plastic, indeed architectonic significance of the heavens is infinitely greater than that of the sun. At the same time, however, it is clear here how the poet progressively sublates the difference between form and the formless; and heaven signifies as much an extension as a diminishment of form, in comparison with the sun. The power of this context illuminates the lines "Drawn erect on golden / Leading strings, like children." Again the rigidity and inaccessibility of the image must remind one of oriental vision. Because the plastic connection with the god is given amid the unformed space (according to its intensity and emphasized by means of color, the only reference to color that the new version contains), this line has in the oddest way a strange and

almost killing effect. The architectonic element is so strong that it corre-
sponds to the relation that was given in the image of heaven. The forms of
the poetic world are infinite and at the same time limiting; according to the
inner law, the form must to the same degree be sublated in the existence of
the poem and dissolve in it, just as the animated powers the living. Even
the god must in the end give his utmost in service to the poem and execute
[*vollstrecken*] its law, just as the people had to be the sign of its extension
[*Erstreckung*]. This is fulfilled at the end: "And from the heavenly ones /
Bring one." The structuring, the inwardly plastic principle, is so intensified
that the fate of the dead form breaks over the god, so that—to remain within
the image—the plastic dimension is turned inside out, and now the god
becomes wholly an object. The temporal form is broken from the inside out
as something animated. The heavenly one *is brought*. Here before us is the
ultimate expression of identity: the Greek god has entirely fallen prey to his
own principle, the form. The highest sacrilege is understood as hubris,
which, attainable only by a god, transforms him into a dead form. To give
oneself form—that is the definition of "hubris." The god ceases to determine
the cosmos of the poem, whose essence—with art—freely elects for itself
that which is objective: it brings the god, since gods have already turned
into the concretized being of the world in thought. Here, already, the
admirable organization of the last verse, in which the immanent goal of all
structuration in this poem is summed up, can be discerned. The spatial
extension of the living determines itself in the temporally inward interven-
tion of the poet; this is how the word *geschickt* [sent, skillful] was explained,
in the same isolation in which the people has turned into a series of functions
of destiny. "We too are good and sent to someone to some end"—if the god
has become an object in his dead infinity, the poet seizes hold of him. The
order of people and god as dissolved in unities here becomes unity within
the poetic destiny. The multifarious identity, in which people and god as the
conditions of sensory existence are sublated, is manifest. The center of this
world by rights belongs to another.

The interpenetration of individual forms of perception and their connect-
edness in and with that which is intellectual, as idea, destiny, and so on, has
been pursued in detail far enough. In the end it cannot be a matter of
investigating ultimate elements, for the ultimate law of this world is precisely
connection—as the unity of the function of that which connects and that
which is connected. But an especially central site of this connectedness must
still be noted, one in which the limit of the poetized with respect to life is
pushed forward the farthest, and in which the energy of the inner form
shows itself all the mightier, the more surging and formless is the life that
has been denoted. At this site the unity of the poetized becomes perceptible;
the points of connection are surveyed to the widest extent; and the variations
of both versions of the poem, the deepening of the first in the second, are

recognized.—One cannot speak of a unity of the poetized in the first version. Its course is interrupted by the detailed analogy of the poet with the sun god; thereafter, however, it does not return with full intensity to the poet. In this version there still lies, in its detailed, special treatment of dying as well as in its title, the tension between two worlds—that of the poet and that of the "reality" in which death threatens and which here appears only disguised as divinity. Subsequently the duality of the worlds disappears; with death, the quality of courage falls away; and in the unfolding nothing is given except the existence of the poet. It thus becomes urgent to question the basis for a comparison of two drafts that differ so markedly in detail and exposition. Again, the fact that they are comparable emerges not in any similarity between elements but only in the coherence of any single element in a function. This function lies in the solely demonstrable functional quintessence: the poetized. The poetized of both versions—not in their likeness, which is nonexistent, but in their "comparativeness"—shall be compared. Both poems are connected in their poetic form and, to be sure, through their stance toward the world. This stance is courage, which, the more deeply it is understood, becomes less a quality than a relation of man to world and of world to man. The poetized of the first version initially knows courage only as a quality. Man and death stand rigid, opposing each other; they share no perceptual world. To be sure, the attempt was already made to find a deep relation to death in the poet, in his sacred-natural existence, yet only indirectly through the mediation of the god, to whom death in a mythological sense belonged and to whom the poet, once again in a mythological sense, was approximated. Life was still the precondition of death; the figure sprang from nature. Vision and figure were not decisively formed from one intellectual principle; thus, they did not penetrate each other. In this poem, the danger of death was overcome through beauty. In the later version, all beauty flows from the overcoming of danger. Earlier, Hölderlin had ended with the dissolution of the figure, whereas the new version ends with the pure basis of structuring. And this is now attained on one intellectual basis. The duality of man and death could be based only on a venial feeling of life. It ceased to exist, since the poetized marshaled its forces into a deeper coherence, and an intellectual principle—courage—fashioned life from itself. Courage is submission to the danger that threatens the world. It conceals a peculiar paradox, which for the first time permits the structure of the poetized of both versions to be fully understood: the danger exists for the courageous person, yet he does not heed it. For he would be a coward if he heeded it; and if it did not exist for him, he would not be courageous. This strange relation dissolves, in that the danger threatens not the courageous one himself but rather the world. Courage is the life-feeling of the man who surrenders himself to danger, so that in his death he expands that danger into a danger for the world and at the same time overcomes it. The

greatness of the danger arises in the courageous person—for only in striking him, in his total submission to it, does it strike the world. In his death, however, it is overcome; it has reached the world, which it no longer threatens. In it is liberation and at the same time stabilization of the immense forces which every day, in the form of bounded things, surround the body. In death these forces that threatened the courageous person as danger have already abruptly changed, are calmed in it. (This is the concretization of the forces, which already brought the essence of the gods closer to the poet.) The world of the dead hero is a new mythical one, steeped in danger; this is the world of the second version of the poem. In it an intellectual principle has become completely dominant: the heroic poet becomes one with the world. The poet does not have to fear death; he is a hero because he lives the center of all relations. The principle of the poetized as such is the supreme sovereignty of relationship, shaped in this particular poem as courage—as the innermost identity of the poet with the world, whose emanation is all the identities of the perceptual and the intellectual in this poem. That is the basis on which the isolated figure is repeatedly transcended in the spatiotemporal order, where it is sublated as formless, polymorphous, event and existence, temporal plasticity and spatial happening. All known relations are united in death, which is the poet's world. In death is the highest infinite form and formlessness, temporal plasticity and spatial existence, idea and sensuousness. And in this world every function of life is destiny, whereas in the first version, in the traditional way, destiny determined life. That is the Oriental, mystical principle, overcoming limits, which in this poem again and again so manifestly sublates the Greek shaping principle that creates an intellectual cosmos from pure relations of intuition, sensuous existence, and in which the intellectual is only the expression of the function that strives toward identity. The transformation of the duality of death and poet into the unity of a dead poetic world, "saturated with danger," is the relation in which the poetized of both poems stands. Now, for the first time, in this passage, reflection on the third and middle verse has become possible. It is evident that death, in the form of "return" [Einkehr], was transposed to the center of the poem; that in this center lies the origin of song, as origin of the quintessence of all functions; that here the idea of "art" and the idea of "the true" arise as expressions of the underlying unity. What was said about the sublation of the order of mortals and heavenly ones in this context appears fully assured. One can assume that the words "a lonely deer" characterize men; and this fits in very well with the title of this poem. "Timidity" has now become the authentic stance of the poet. Since he has been transposed into the middle of life, nothing awaits him but motionless existence, complete passivity, which is the essence of the courageous man— nothing except to surrender himself wholly to relationship. It emanates from him and returns to him. Thus poetry seizes hold of the living, and thus they

are known to it—no longer related. Poet and poetry in the cosmos of the poem are not differentiated. The poet is nothing but a limit with respect to life, the point of indifference, surrounded by the immense sensuous powers and the idea, which preserve the law of the poet in themselves. How utterly he signifies the untouchable center of all relation is most powerfully conveyed in the last two verses. The heavenly ones have become signs of infinite life, which, however, is limited with respect to him: "and bring One / From the heavenly ones. Yet we ourselves / Bring appropriate hands." Thus, the poet is no longer seen as a form; he is now only the principle of form—that which limits, even that which bears his own body. He brings his hands—and the heavenly ones. The intrusive caesura of this passage produces the distance that the poet ought to have from all form and the world, as its unity. The structure of the poem confirms the insight of these lines from Schiller: "Therein consists . . . the true artistic secret of the master: he eradicates the material reference through the form . . . The sensibility of the spectator and listener must remain completely free and inviolate; it must emerge from the artist's magic circle, pure and perfect as from the hands of the Creator."[7]

In the course of this investigation, the word "sobriety" [*Nüchternheit*] was deliberately avoided, a word that might often have served for purposes of characterization. Only now shall Hölderlin's phrase "sacredly sober" be uttered, now that its understanding has been determined.[8] Others have noted that these words exhibit the tendency of his later creations. They arise from the inner certainty with which those works stand in his own intellectual life, in which sobriety now is allowed, is called for, because this life is in itself sacred, standing beyond all exaltation in the sublime. Is this life still that of Hellenism? That is as little the case here as that the life of any pure work of art could be that of a people; and as little the case, too, that what we find in the poetized might be the life of an individual and nothing else. This life is shaped in the forms of Greek myth, but—this is crucial—not in them alone; the Greek element is sublated in the last version and balanced against another element that (without express justification, to be sure) was called the Oriental. Almost all the changes in the later version strive in this direction, in the images, in the ideas introduced, and finally in the new meaning of death—all of which arise as unlimited against the formed, limited appearance [*Erscheinung*] resting in itself. Whether a decisive question is concealed here—one that perhaps goes beyond an understanding of Hölderlin—cannot be determined in this context. The contemplation of the poetized, however, leads not to the myth but rather—in the greatest creations—only to mythic connections, which in the work of art are shaped into unique, unmythological, and unmythic forms that cannot be better understood by us.

But if there were words with which to grasp the relation between myth

and the inner life from which the later poem sprang, it would be those of Hölderlin from a period still later than that of this poem: "Myths, which take leave of the earth, / . . . They return to mankind."[9]

Written 1914–1915; unpublished in Benjamin's lifetime. Translated by Stanley Corngold.

Notes

1. Benjamin's essay is extraordinarily scholastic in manner and style. Gershom Scholem called it "deeply metaphysical"; it is also hieratic, cryptic, and high-flown, and in places written in a German whose tortuousness defies deciphering. The translator does not have the option of trying for effects of smoothness or vernacular familiarity that are not in the text. The point is to follow the twists and stoppages of Benjamin's syntax, while conveying something of its proud refusal to produce immediate insight or aesthetic pleasure. For this English version, the editor and translator have subordinated concerns of readability to concerns of translation.—*Trans.*
2. One of the peculiarities of Benjamin's style in this essay is the cultivation of the passive voice to a degree unheard of even in bad academic writing. This avoidance of personal agency could evoke the Benjamin of 1932, who remarked: "If I write a better German than most writers of my generation, I owe it in good part to a single rule, which runs: Never use the word 'I,' except in letters. The exceptions to the commandment I have allowed myself can be counted on one hand." The Hölderlin essay does not contain a single one of these exceptions.—*Trans.*
3. *Das Gedichtete:* that which has been poetically formed. In an ideal sense it preexists each particular poem but is realized only in the poem's creation. The English term used here has a precedent in Emerson ("The American Scholar," 1837): "Instead of the sublime and the beautiful, the near, the low, the common, was explored and poetized."—*Trans.*
4. *Odi profanum:* hatred of the base or profane.—*Trans.*
5. *Musterhaftigkeit* plays upon the double sense of the word *Muster:* the pattern in the carpet and an example or ideal.—*Trans.*
6. Compare the expression *den Rechtsweg beschreiten*—literally "to stride upon the lawful way," but meaning "to have recourse to law."—*Trans.*
7. Friedrich Schiller, *On the Aesthetic Education of Man* [*Über die aesthetische Erziehung des Menschen*], Letter 22.—*Trans.*
8. Hölderlin, "Hälfte des Lebens" [Half of Life].—*Trans.*
9. Hölderlin, "Der Herbst" [Autumn].—*Trans.*

The Life of Students

There is a view of history that puts its faith in the infinite extent of time and thus concerns itself only with the speed, or lack of it, with which people and epochs advance along the path of progress. This corresponds to a certain absence of coherence and rigor in the demands it makes on the present. The following remarks, in contrast, delineate a particular condition in which history appears to be concentrated in a single focal point, like those that have traditionally been found in the utopian images of the philosophers. The elements of the ultimate condition do not manifest themselves as form-less progressive tendencies, but are deeply rooted in every present in the form of the most endangered, excoriated, and ridiculed ideas and products of the creative mind. The historical task is to disclose this immanent state of perfection and make it absolute, to make it visible and dominant in the present. This condition cannot be captured in terms of the pragmatic de-scription of details (the history of institutions, customs, and so on); in fact, it eludes them. Rather, the task is to grasp its metaphysical structure, as with the messianic domain or the idea of the French Revolution. It is worth taking the trouble to describe the contemporary significance of students and the university, of the form of their present existence, only if they can be understood as a metaphor, as an image of the highest metaphysical state of history. Only then will it be comprehensible and possible. Such a description is neither a call to arms nor a manifesto; each of these is as futile as the other. But it casts light on the crisis that hitherto has lain buried in the nature of things. This crisis will lead on to the resolution that will overwhelm the craven-hearted and to which the stout-hearted will submit. The only way to deal with the historical significance of student life and the university is

to focus on the system as a whole. So long as the preconditions needed for this are absent, the only possibility is to liberate the future from its deformations in the present by an act of cognition. This must be the exclusive task of criticism.

The question to address is that of the conscious unity of student life. This is the starting point, for there is no point in distinguishing between specific problems—of science, politics, or ethics—if the courage to submit is missing overall. What distinguishes student life is just the opposite of that: it is the will to submit to a principle, to identify completely with an idea. The concept of "science" or scholarly discipline [*Wissenschaft*] serves primarily to conceal a deep-rooted, bourgeois indifference. To measure student life by the yardstick of this science does not necessarily imply any panlogism or intellectualism—as is commonly feared—but is a legitimate criticism, since science is normally adduced as the students' bulwark against "alien" demands. So our concern here must be with inner unity, not with critique from outside. And our reply is that for the vast majority of students, academic study is nothing more than vocational training. Because "academic study has no bearing on life," it must be the exclusive determinant of the lives of those who pursue it. The innocently hypocritical reservations people have about science include the expectation that academic study must lead to a profession for all and sundry. Yet scholarship, far from leading inexorably to a profession, may in fact preclude it. For it does not permit you to abandon it; in a way, it places the student under an obligation to become a teacher, but never to embrace the official professions of doctor, lawyer, or university professor. It leads to no good if institutes that grant titles, qualifications, and other prerequisites for life or a profession are permitted to call themselves seats of learning. The objection that the modern state cannot otherwise produce the doctors, lawyers, and teachers it needs is irrelevant. It only illustrates the magnitude of the task entailed in creating a community of learning, as opposed to a body of officials and academically qualified people. It only shows how far the development of the professional apparatuses (through knowledge and skill) have forced the modern disciplines to abandon their original unity in the idea of knowledge, a unity which in their eyes has now become a mystery, if not a fiction. Anyone who accepts the modern state as a given and believes that everything must serve its development will be forced to reject these ideas. One can only hope that such a person will not call for state protection and support for "learning." For the true sign of decadence is not the collusion of the university and the state (something that is by no means incompatible with honest barbarity), but the theory and guarantee of academic freedom, when in reality people assume with brutal simplicity that the aim of study is to steer its disciples to a socially conceived individuality and service to the state. No tolerance of opinions and teachings, however free, can be beneficial, so long as there

is no guarantee of a form of life that these ideas—the free ideas no less than the strict ones—imply, so long as people can naively deny the huge gulf between ideas and life by pointing to the link between the universities and the state. It is misleading to raise expectations in the individual if the fulfillment of these expectations negates the spirit that unites these same individuals, and the only remarkable and even astounding point to be emphasized here is the extent to which institutes of higher learning are characterized by a gigantic game of hide-and-seek in which students and teachers, each in his or her own unified identity, constantly push past one another without ever seeing one another. The students are always inferior to the teachers because they have no official status, and the legal constitution of the university—embodied in the minister of education, who is appointed by the sovereign, not by the university—is a barely veiled alliance of the academic authorities with the state over the heads of the students (and in rare, welcome instances, over the heads of the teachers as well).

The uncritical and spineless acquiescence in this situation is an essential feature of student life. It is true that the so-called independent-student organizations [*Freie Studentenschaft*], as well as others with one social tendency or another, have attempted to resolve this problem.[1] Ultimately, however, their answer lies in the complete assimilation of academic institutions into bourgeois conditions, and nothing has shown more clearly that the students of today as a community are incapable of even formulating the issue of the role of learning, or grasping its indissoluble protest against the vocational demands of the age. It is necessary to criticize the independent-student organizations and the ideas of those close to them because it will throw light on their chaotic conception of academic life. To this end, I shall quote from a speech I gave to a student audience in the hope of contributing to a reform movement.

There is a very simple and reliable criterion by which to test the spiritual value of a community. It is to ask: Does it allow all of an individual's efforts to be expressed? Is the whole human being committed to it and indispensable to it? Or is the community as superfluous to each individual as he is to it? It is so easy to pose these questions, and so easy to answer them with reference to contemporary types of social community. And the answer is decisive. Everyone who achieves strives for totality, and the value of his achievement lies in that totality—that is, in the fact that the whole, undivided nature of a human being should be expressed in his achievement. But when determined by our society, as we see it today, achievement does not express a totality; it is completely fragmented and derivative. It is not uncommon for the community to be the site where a joint and covert struggle is waged against higher ambitions and more personal goals, but where a more profoundly organic individual development is obscured. The socially relevant achievement of the average person serves in the vast majority of cases to repress the original and nonderivative,

inner aspirations of the human being. We are speaking here of academically trained people, people who for professional reasons have some kind of inner connection with the spiritual struggles and skeptical or critical attitudes of students. These people appropriate a milieu entirely alien to themselves and make it their workplace; in this remote place they create a limited activity for themselves, and the entire totality of such labor lies in its alleged utility for an often abstractly conceived society. There is no internal or authentic connection between the spiritual existence of a student and, say, his concern for the welfare of workers' children or even for other students. No connection, that is, apart from a concept of duty unrelated to his own inner labor. It is a concept based on a mechanical contrast: on the one hand, he has a stipend from the people; on the other, he is acting out his social duty. The concept of duty here is calculated, derivative, and distorted; it does not flow from the nature of the work itself. This sense of duty is satisfied not by suffering in the cause of truth, not by enduring all the doubts of an earnest seeker, or indeed by any set of beliefs connected with an authentic intellectual life. Instead this sense of duty is worked out in terms of a crude, superficial dualism, such as ideals versus materialism, or theory and practice. In a word, all that socially relevant labor represents not an ethical intensification but only the timid reaction of a spiritual life. Yet the deepest and most crucial objection is not that such socially relevant labor is simply left floating, abstractly opposed to the true activities of a student, and so constitutes an extreme and thoroughly reprehensible form of relativism, one incapable of any true synthesis and hence one that anxiously and timidly strives to ensure that every mental activity is accompanied by a physical one, every intellectual commitment by its opposite. The decisive factor, then, is not that socially relevant labor is nothing but an empty, undirected desire to be "useful." The truly decisive criticism is that despite all this it lays claim to the gesture of love, where only mechanical duty exists. This duty is often nothing more than a deflection of purpose, an evasion of the consequences of the critical, intellectual existence to which students are committed. For in reality a student is only a student because the problems of spiritual life are closer to his heart than the practice of social welfare. And last—and this is an infallible sign—this socially relevant student activity does not succeed in revolutionizing the conception and value of such social work in general. In the public mind, such work still seems to be a peculiar mixture of duty and charity on the part of the individual. Students have not been able to demonstrate its spiritual necessity and for that reason have never been able to establish a truly serious community based on it, as opposed to one bound by duty and self-interest. The Tolstoyan spirit, which laid bare the huge gulf between bourgeois and proletarian existence; the concept that service on behalf of the poor is the task of mankind, and not a spare-time student activity—that concept clearly called for a total commitment or nothing at all. The Tolstoyan spirit, which developed in the mind of the most deeply committed anarchists or in Christian monastic orders, this truly serious sense of social work, which had no need of childlike attempts to empathize with the soul of the workers or the people—this spirit failed to develop in student communities. The attempt to convert an academic community into a social-welfare organization failed because of the abstract nature of its object and the students' lack of inner connection with it.

The totality of will [*des Wollenden*] could not find any expression, because in that community its will could not be directed toward the totality.

The symptomatic importance of these attempts on the part of the independent students, including Christian-Socialists and many others, is that in their desire to demonstrate their utility in the state and in life, they reenact in the microcosm of the university that same conflict that we have noted in the relationship of the university to the state. They have conquered a sanctuary in the university for egoisms and altruisms of almost every kind, for every self-evident mode of being in the real world. Only radical doubt, fundamental critique, and the most important thing of all—the life that would be willing to dedicate itself to reconstruction—are excluded. What we see here is not the progressive spirit of the independent students as opposed to the reactionary power of the dueling fraternities. As we have tried to show, and as we can see from the uniformity and passivity of the universities as a whole, the independent students are very far from having a well-thought-out intellectual strategy. Their voice has not made itself heard on any of the issues that have been raised here. Their indecisiveness makes them inaudible. Their opposition runs on the well-oiled tracks of liberal politics; their social principles have not developed beyond the level of the liberal press. The independent students have not thought out the problem of the university, and to that extent it is bitter historical justice that on official occasions it is the dueling fraternities, who in the past did experience and confront the problem of the academic community, who now appear as the unworthy representatives of the student tradition. On fundamental issues the independent students do not display spirit that is any more exalted or determination that is any greater than those of the fraternities, and their influence is almost more pernicious than theirs. This influence is more deceptive and misleading, in that this undisciplined, bourgeois, and small-minded movement claims the role of champion and liberator in the life of the university. The modern student body cannot be found in the places where the conflicts over the spiritual rebirth of the nation are raging—in the controversies about a new art, or at the side of its writers and poets, or indeed at the sources of religious life. This is because the German student body does not exist as such. Not because it refuses to join in the latest "modern" movements, but because, as a student body, it is completely unaware of all these movements; because, as a student body, it constantly drifts in the wake of public opinion; because it is courted and spoiled by every party and alliance, is flattered by everyone, and submits to all. And with all that, it remains in every respect devoid of the nobility that up to a century ago gave German students a visible profile and enabled it to step forward as the champions of life at its best.

The perversion of the creative spirit into the vocational spirit, which we see at work everywhere, has taken possession of the universities as a whole

and has isolated them from the nonofficial, creative life of the mind. The mandarin contempt for the activities of independent artists and scholars who are alien and often hostile to the state is a painful proof of this. One of the most celebrated German university professors referred in a lecture to those "coffeehouse literati according to whom Christianity is finished." The tone and accuracy of this statement balance each other perfectly. And if a university organized in this way is hostile toward academic study, even though such study can pretend to have claims to "relevance" to the immediate concerns of the state, how much more sterile will its approach to the arts and Muses be? By directing students toward the professions, it must necessarily fail to understand direct creativity as a form of communal activity. In reality, the uncomprehending hostility of the academy toward the life that art requires can be interpreted as a rejection of every form of direct creativity that is unconnected with bureaucratic office. This is confirmed, in terms of inner consciousness, by the immaturity and schoolboyish outlook of the students. From the standpoint of aesthetic feeling, the most striking and painful aspect of the university is the mechanical reaction of the students as they listen to a lecture. Only a genuinely academic and sophisticated culture of conversation could compensate for this level of receptivity. And of course the seminars are worlds away from such a thing, since they, too, mainly rely on the lecture format, and it makes little difference whether the speakers are teachers or students. The organization of the university has ceased to be grounded in the productivity of its students, as its founders had envisaged. They thought of students as teachers and learners at the same time; as teachers, because productivity implies complete autonomy, with their minds fixed on science instead of on their instructor's personality. But where office and profession are the ideas that govern student life, there can be no true learning. There can no longer be any question of a devotion to a form of knowledge that, it is feared, might lead them astray from the path of bourgeois security. There can be neither devotion to learning nor the dedication of life to a younger generation. Yet the vocation of teaching—albeit in forms that are quite different from those current today—is an imperative for any authentic learning. Such a hazardous self-dedication to learning and youth must manifest itself in the student as the ability to love, and it must be the source of his creativity. But by the same token he must also follow in the footsteps of his elders; he must acquire his learning from his teacher, without following him in his profession. With an easy conscience, he can take his leave of the community that binds him to other producers, since that community derives its general form exclusively from philosophy. He should be an active producer, philosopher, and teacher all in one, and all these things should be part of his deepest and most essential nature. This is what defines his profession and his life. The community of creative human beings elevates every field of study to the universal through the form of

philosophy. Such universality is not achieved by confronting lawyers with literary questions, or doctors with legal ones (as various student groups have attempted). It can be brought about only if the community ensures that specialized studies (which cannot exist without a profession in mind) and all the activities of the special disciplines are firmly subordinated to the community of the university as such, since it alone is the creator and guardian of philosophy as a form of community. This philosophy, in turn, should concern itself not with limited technical philosophical matters but with the great metaphysical questions of Plato and Spinoza, the Romantics, and Nietzsche. This, rather than conducted tours through welfare institutions, is what would create the closest links between life and the professions, albeit a life more deeply conceived. This is what would prevent the degeneration of study into the heaping up of information. The task of students is to rally round the university, which itself would be in a position to impart the systematic state of knowledge, together with the cautious and precise but daring applications of new methodologies. Students who conceived their role in this way would greatly resemble the amorphous waves of the populace that surround the prince's palace, which serves as the space for an unceasing spiritual revolution—a point from which new questions would be incubated, in a more ambitious, less clear, less precise way, but perhaps with greater profundity than the traditional scientific questions. The creativity of students might then enable us to regard them as the great transformers whose task is to seize upon new ideas, which spring up sooner in art and society than in the university, and mould them into scientific shape under the guidance of their philosophical approach.

The secret tyranny of vocational training is not the worst of the deformations, whose appalling effect is that they invariably poison the essence of creative life. There is also a commonplace view of life that trades intellectual activity for various surrogates. It has met with increasing success in disguising the hazards of a life of the mind and hence in ridiculing the few surviving visionaries as starry-eyed dreamers. A deeper problem arises from the unconscious distortion of student life by the dominant erotic conventions. Just as the vocational ideology of the professions has become the accepted truth and has fully monopolized the intellectual conscience, so, too, does the concept of marriage, the idea of the family, weigh upon the notion of eros. The erotic seems to have vanished from a space that extends, empty and undefined, between childhood and founding a family of one's own. Whether unity might exist between creating and procreating, and whether this unity is to be found in the family—these questions could not be posed, so long as the tacit expectation of marriage went unquestioned, since this implied an illegitimate interlude in which the most that one could do was to erect barriers to temptation. The eros of creativity—if any group were in a position to understand it and strive to achieve it, it would have

to be the student body. But even when external bourgeois conditions were absent and no prospect of founding a family existed; even where, as in many European cities, a hydra-headed mass of women based their entire economic existence on students (through prostitution)—even in such places students failed to ask questions about the eros appropriate to themselves. They must surely have questioned whether procreation and creativity should remain separate, whether the one should apply to the family and the other to their profession, and whether, since both were distorted by this separation, neither should flow from the existence peculiar to itself. For painful and humiliating though it may be to put such a question to contemporary students, it cannot be avoided, since these two poles of human existence are closely connected chronologically. We are faced by a question that no community can leave unresolved, and which nevertheless no nation has been able to answer since the Greeks and the early Christians. The question has always weighed heavily on the great creative minds: How could they do justice to the image of mankind and at the same time share a community with women and children, whose productivity is of a different kind? The Greeks, as we know, resolved the problem by force. They subordinated procreation to creativity, so that in the long run, by excluding women and children from the life of their state, they brought about its collapse. The Christians provided a possible solution for the *civitas dei*: they repudiated separate existence in either sphere. The most progressive among the students have never gone further than endless aestheticizing talk of camaraderie with women students. They did not shrink from hoping for a "healthy" neutralization of the erotic in both men and women. And in fact, with the aid of prostitutes the erotic has been neutralized in the universities. And where it wasn't, it was replaced by an unrestrained harmlessness, a heady atmosphere of high spirits, and the unladylike young coed has been boisterously welcomed as the successor to the ugly old spinster teacher. It is difficult to resist the general observation here that the Catholic Church has a much greater (though timid) instinctive appreciation of the power and inexorable demands of the erotic than does the bourgeoisie. In the universities, a huge problem lies buried, unresolved, and denied. It is a problem that is much larger than the countless causes of friction in society. It is this: How are we to unify spiritual life, when what we find before us is the lamentable division into the intellectual autonomy of the creative spirit (in the fraternities) and an unmastered force of nature (in prostitution)—a distorted and fragmented torso of the one erotic spirit? To transform the necessary independence of the creative spirit and to bring about the necessary inclusion of women, who are not productive in a masculine sense, in a single community of creative persons—through love—this indeed is the goal to which students should aspire, because it is the form of their own lives. At present, however, we are so dominated by murderous conventions that students have not even

brought themselves to confess their guilt toward prostitutes. Moreover, people still imagine that this whole blasphemous process of human destruction can be halted by appeals to chastity, because they lack the courage to look their own more beautiful erotic nature in the face. This mutilation of youth goes too deep to waste many words on it. Rather, it should be entrusted to the minds of those who think and the resoluteness of the intrepid. It is inaccessible to polemic.

How does the younger generation regard itself? What image does it have of itself, if it can permit such an obscuring of its own ideas, such a distortion of its own values? This image has been formed by the fraternities, and they are still the most visible embodiment of the student conception of youth, at which other students, with the free-student organizations at their head, hurl their social slogans. German students are to a greater or lesser degree obsessed with the idea that they have to enjoy their youth. The entirely irrational period of waiting for marriage and a profession had to be given some value or other, and it had to be a playful, pseudo-romantic one that would help pass the time. A terrible stigma still attaches to the much-vaunted lighthearted fun of student songs, of the "Gaudeamus igitur . . ." It represents a fear of the future and simultaneously a complacent pact with the inevitable philistinism that one likes to picture fondly to oneself in the shape of the "old boys."[2] But because students have sold their souls to the bourgeoisie, along with marriage and profession, they insist on those few years of bourgeois freedom. This exchange is effected in the name of youth. Openly or in secret—in a bar or amid deafening speeches at student meetings, a dearly purchased state of intoxication is created, the right to which is not to be denied. This experience arises between a squandered youth and a bought-out old age that longs for peace and quiet, and it is here that every attempt to inspire students with higher ideals has come to grief. Yet just as this way of life makes a mockery of every reality, as revenge it finds itself punished by every natural and spiritual power, by science through the agency of the state, by eros through the agency of prostitutes, and thus, as decimation, by nature. For students are not the younger generation; they are the aging generation. For those who have wasted their early years in German schools, it is a heroic decision to acknowledge the onset of age, when their university years appeared to offer them at long last the prospect of a youth full of life, only to postpone it year after year. Nevertheless it is important to recognize that they have to be creative producers, and therefore lonely, aging people, and that a richer generation of children and youths has already been born, to whom they can only dedicate themselves as teachers. Of all feelings, this is the strangest for them. This is why they cannot accept their existence and are ill-prepared to live with children from the outset—for that is what is involved in being a teacher—because children have not yet

entered the sphere of loneliness. Because they do not acknowledge the process of aging, they idle their time away. To have admitted their yearning for a beautiful childhood and worthy youth is the precondition of creativity. Without that admission, without the regret for a greatness missed, no renewal of their lives can be possible. It is the fear of loneliness that is responsible for their lack of erotic commitment, a fear of surrendering themselves. They measure themselves against their fathers, not against posterity, and this is how they salvage the illusion of their youth. Their friendship is bereft of greatness and loneliness. That expansive friendship between creative minds, with its sense of infinity and its concern for humanity as a whole even when those minds are alone together or when they experience yearning in solitude, has no place in the lives of university students. In its place, there is only that fraternizing which is both unbridled and personally limited. It remains the same whether they are drinking in a bar or founding societies in cafés. All these institutions are nothing but a marketplace for the preliminary and provisional, like the bustling activity in lecture halls and cafés; they are simply there to fill the empty waiting time, diversions from the voice that summons them to build their lives with a unified spirit of creative action, eros, and youth. There is a chaste and abstemious form of youth that reveres those who are to succeed it, and that is echoed in Stefan George's lines:

> Inventors of rolling verse and sparkling dialogues
> by quick-witted orators: time and distance
> allow me to engrave on my memory my former foe. Do likewise!
> For on the scale of ecstasy and passion we are both in decline;
> Nevermore will the praise and rejoicing of youth flatter me;
> Never again will verses thunder thus in your ear.[3]

Faintheartedness has alienated the lives of students from insights like this. But every way of life, with its own specific rhythm, follows from the commandments that determine the lives of the creative. So long as they shy away from these, their existence will punish them with ugliness, and hopeless despair will strike the hearts of even the dullest.

At present it is this highly endangered necessity that is still the issue; it requires strict control. Everyone will discover his own imperatives, the commandments that will make the supreme demands on his life. Through understanding, everyone will succeed in liberating the future from its deformed existence in the womb of the present.

Written in 1914–1915; published in *Der neue Merkur,* 1915. Translated by Rodney Livingstone.

Notes

1. *Freie Studentenschaft*: A radical group of university students that emerged from the German Youth Movement. These "independent students" were opposed both to the conservative dueling fraternities *(Korps)*, which traced their lineage back to the nationalism of the Romantic movement, and to the more recent *Wandervögel* movement with its back-to-nature ideology. Benjamin was elected president of the Berlin branch of the *Freie Studentenschaft* in the spring semester of 1914, and held this post until the outbreak of the First World War.—*Trans.*
2. Old boys: The *alten Herrn* are the former members of fraternities who still retain influence in these organizations and are sources of patronage for the next generation.—*Trans.*
3. Stefan George, "H.H.," in *The Year of the Soul* [*Das Jahr der Seele*].—*Trans.*

Aphorisms on Imagination and Color

The gaze of the imagination is a gaze within the canon, not in accordance with it; it is therefore purely receptive, uncreative.

Works of art are beautiful only as ideas. They are not beautiful to the extent that they are made in accordance with the canon, rather than within it. (Music, Futurist painting—a striving toward the interior?)

Relation of the artistic canon to the imagination beyond color? All the arts are ultimately related to the *imagination*.

Color is beautiful, but there is no sense in producing beautiful colors, because color follows in the wake of beauty as an attribute, not as a phenomenon in its own right.

Color absorbs into itself, by imparting color and surrendering itself.

Color must be seen.

It is not possible to establish a theory of harmony for colors, because in such a theory number is merely the expression of an infinite range of possibilities that are just systematically assembled. For each basic color there is an octave through to a ninth, and so forth on an ever more diversified scale. The harmony of color is a single thing within a particular medium; it lacks multiplicity, because it is undefined and exists only in perception. A theory of harmony is possible only in the transition from light to shade— that is to say, with reference to space.

On painterly color: it arises as a simple phenomenon in the imagination, but its purity is distorted by its existence in space and this is the origin of light and shade. These form a third thing between pure imagination and creation, and in them painterly colors have their existence.

Color does not relate to optics the way line relates to geometry.

In sculpture, color is an attribute. Colored statues, in contrast to painting.

Fragment written in 1914–1915; unpublished in Benjamin's lifetime. Translated by Rodney Livingstone.

A Child's View of Color

Color is something spiritual, something whose clarity is spiritual, so that when colors are mixed they produce nuances of color, not a blur. The rainbow is a pure childlike image. In it color is wholly contour; for the person who sees with a child's eyes, it marks boundaries, is not a layer of something superimposed on matter, as it is for adults. The latter abstract from color, regarding it as a deceptive cloak for individual objects existing in time and space. Where color provides the contours, objects are not reduced to things but are constituted by an order consisting of an infinite range of nuances. Color is single, not as a lifeless thing and a rigid individuality but as a winged creature that flits from one form to the next. Children make soap bubbles. Similarly, games with painted sticks, sewing kits, decals, parlor games, even pull-out picture books, and, to a lesser extent, making objects by folding paper—all involve this view of color.

Children like the way colors shimmer in subtle, shifting nuances (as in soap bubbles), or else make definite and explicit changes in intensity, as in oleographs, paintings, and the pictures produced by decals and magic lanterns. For them color is fluid, the medium of all changes, and not a symptom. Their eyes are not concerned with three-dimensionality; this they perceive through their sense of touch. The range of distinctions within each of the senses (sight, hearing, and so on) is presumably larger in children than in adults, whose ability to correlate the different senses is more developed. The child's view of color represents the highest artistic development of the sense of sight; it is sight at its purest, because it is isolated. But children also elevate it to the spiritual level because they perceive objects according to their color content and hence do not isolate them, instead using them as a basis from

which to create the interrelated totality of the world of the imagination. The imagination can be developed only by contemplating colors and dealing with them in this fashion; only in this way can it be both satisfied and kept within bounds. Wherever it applies itself to the plastic arts, it becomes overly lush; the same applies to history, and in music it is sterile. For the fact is that the imagination never engages with form, which is the concern of the law, but can only contemplate the living world from a human point of view creatively in feeling. This takes place through color, which for that reason cannot be single and pure, for then it remains dull. Instead, wherever it is not confined to illustrating objects, it must be full of light and shade, full of movement, arbitrary and always beautiful. In this respect, coloring-in has a purer pedagogical function than painting, so long as it makes transparent and fresh surfaces, rather than rendering the blotchy skin of things. Productive adults derive no support from color; for them color can subsist only within law-given circumstances. Their task is to provide a world order, not to grasp innermost reasons and essences but to develop them. In a child's life, color is the pure expression of the child's pure receptivity, insofar as it is directed at the world. It contains an implicit instruction to a life of the spirit which is no more dependent on accidental circumstances for its creativity than color, for all its receptivity, is capable of communicating about the existence of dead, causal reality.

Children's drawings take colorfulness as their point of departure. Their goal is color in its greatest possible transparency, and there is no reference to form, area, or concentration into a single space. For a pure vision is concerned not with space and objects but with color, which must indeed be concerned with objects but not with spatially organized objects. As an art, painting starts from nature and moves cumulatively toward form. The concern of color with objects is not based on their form; without even touching on them empirically, it goes right to the spiritual heart of the object by isolating the sense of sight. It cancels out the intellectual cross-references of the soul and creates a pure mood, without thereby sacrificing the world. Colorfulness does not stimulate the animal senses because the child's uncorrupted imaginative activity springs from the soul. But because children see with pure eyes, without allowing themselves to be emotionally disconcerted, it is something spiritual: the rainbow refers not to a chaste abstraction but to a life in art. The order of art is paradisiacal because there is no thought of the dissolution of boundaries—from excitement—in the object of experience. Instead the world is full of color in a state of identity, innocence, and harmony. Children are not ashamed, since they do not reflect but only see.

Fragment written in 1914–1915; unpublished in Benjamin's lifetime. Translated by Rodney Livingstone.

Socrates

I

What is most barbaric about the figure of Socrates is that this unartistic [*unmusisch*] human being constitutes the erotic center of the relationships of the circle around Plato. If, however, his love of the general capacity to communicate dispenses with art, then by what means does he render it so effective? By means of will. Socrates makes Eros a slave to his purposes. This sacrilege is reflected in the castratedness of his person. For in the last analysis, this is what the Athenians abhor; their feeling, even if subjectively base, is historically in the right. Socrates poisons the young; he leads them astray. His love for them is neither "end" nor pure *eidos,* but rather a means. This is the magician, the maieutician who interchanges the sexes, the innocently condemned one who dies out of irony and in defiance of his opponents. His irony is nourished by the horror, yet he nevertheless still remains the suppressed, the ostracized, the despised one. He is even something of a clown.—The Socratic dialogue needs to be studied in relation to myth. What did Plato intend with it? Socrates: with this figure, Plato annihilates the old myth while adopting it. Socrates: this is the offering of philosophy to the gods of myth who demand human sacrifice. In the midst of the terrible struggle, the young philosophy attempts to assert itself in Plato.[1]

II

Grünewald painted the saints with such grandeur that their halos emerged from the greenest black. The radiant is true only where it is refracted in the

nocturnal; only there is it great, only there is it expressionless, only there is it asexual and yet of supramundane sexuality. The Thus Radiant One is the genius, the witness to every truly spiritual creation. He confirms, he guarantees its asexuality. In a society of males, there would be no genius; genius lives through the existence of the feminine. It is true: the existence of the feminine guarantees the asexuality of the spiritual in the world. Wherever a work, an action, a thought arises without knowledge of this existence, there arises something evil, dead. Wherever it develops out of this feminine itself, it is flat and weak and does not break through the night. But wherever this knowledge concerning the feminine prevails in the world, that which belongs to genius is born. Every extremely profound relation between man and woman rests on the ground of this true creativity and stands under the sign of genius. For it is false to designate the innermost contact between man and woman as covetous love, since of all the stages of such love, including male-female love, the most profound, the most splendid, and the most erotically and mythically perfect, indeed even the most radiant (if it were not so totally of the night), is the love of the female for the female. How the mere existence of the female guarantees the asexuality of the spiritual remains the greatest secret. Human beings have not been able to solve it. For them genius still remains not the expressionless one who breaks out of the night, but rather an expressive, explicit one who vibrates in the light.

In the *Symposium*, Socrates praises the love between men and youths and lauds it as the medium of the creative spirit. According to his teaching, the knower is pregnant with knowledge, and in general Socrates interprets the spiritual only as knowledge and virtue. The spiritual one, however, while perhaps not the procreator, is certainly the one who conceives without becoming pregnant. Just as immaculate conception is, for the woman, the rapturous notion of purity, so conception without pregnancy is most profoundly the spiritual mark of the male genius. It is radiance in its own way. Socrates annihilates this. In Socrates the spiritual was sexual through and through. His notion of spiritual conception is pregnancy; his notion of spiritual procreation is discharge of desire. This is revealed by the Socratic method, which is entirely different from the Platonic. The Socratic inquiry is not the holy question which awaits an answer and whose echo resounds in the response: it does not, as does the purely erotic or scientific question, already contain the *methodos* of the answer. Rather, a mere means to compel conversation, it forcibly, even impudently, dissimulates, ironizes—for it already knows the answer all too precisely. The Socratic question hounds the answer, it corners it as dogs would a noble stag. The Socratic question is neither tender nor so much creative as it is conceptive; it is not genius-like. Like the Socratic irony which lies hidden in it—if one allows a terrible image for a terrible thing—it is an erection of knowledge. Through hatred and

desire, Socrates pursues the *eidos* and attempts to make it objective because the display is denied him. (And ought Platonic love to mean un-Socratic love?) To this terrible domination of sexual views in the spiritual corresponds—precisely as a consequence of this—the impure mixture of these concepts in the natural. Socrates' talk in the *Symposium* refers to seed and fruit, procreation and birth, in daemonic indistinguishability and presents in the speaker himself the terrible mixture of castrato and faun. In truth, Socrates is a nonhuman, and his discussion of eros is inhumane, like the discussion of someone who hasn't the faintest idea of things human. For this is how Socrates and his eros stand in the hierarchy of the erotic: the female-female, the male-male, the male-female, specter, daemon, genius. Socrates was served ironic justice with Xanthippe.

Written in 1916; unpublished in Benjamin's lifetime. Translated by Thomas Levin.

Notes

1. See Friedrich Nietzsche, *The Gay Science,* trans. Walter Kaufman (New York: Vintage, 1974), p. 272.

Trauerspiel and Tragedy

To obtain a deeper understanding of the tragic, we should perhaps look not just at art but also at history.[1] At the very least, we may surmise that the tragic marks out a *frontier* of the realm of art at least as much as of the terrain of history. At specific and crucial points in its trajectory, historical time passes over into tragic time; such points occur in the actions of great individuals. There is an essential connection between the ideas of greatness in history and those in tragedy—although the two are not identical. In art, historical greatness can assume the form only of tragedy. Historical time is infinite in every direction and unfulfilled at every moment. This means we cannot conceive of a single empirical event that bears a necessary relation to the time of its occurrence. For empirical events time is nothing but a form, but, what is more important, as a form it is unfulfilled. The event does not fulfill the formal nature of the time in which it takes place. For we should not think of time as merely the measure that records the duration of a mechanical change. Although such time is indeed a relatively empty form, to think of its being filled makes no sense. Historical time, however, differs from this mechanical time. It determines much more than the possibility of spatial changes of a specific magnitude and regularity—that is to say, like the hands of a clock—simultaneously with spatial changes of a complex nature. And without specifying what goes beyond this, what else determines historical time—in short, without defining how it differs from mechanical time—we may assert that the determining force of historical time cannot be fully grasped by, or wholly concentrated in, any empirical process. Rather, a process that is perfect in historical terms is quite indeterminate empirically; it is in fact an idea. This idea of fulfilled time is the dominant

historical idea of the Bible: it is the idea of messianic time. Moreover, the idea of a fulfilled historical time is never identical with the idea of an individual time. This feature naturally changes the meaning of fulfillment completely, and it is this that distinguishes tragic time from messianic time. Tragic time is related to the latter in the same way that an individually fulfilled time relates to a divinely fulfilled one.

Tragedy may be distinguished from mourning play [*Trauerspiel*] through the different ways they relate to historical time. In tragedy the hero dies because no one can live in fulfilled time. He dies of immortality. Death is an ironic immortality; that is the origin of tragic irony. The origin of tragic guilt can be found in the same place. It has its roots in the tragic hero's very own, individually fulfilled time. This time of the tragic hero—which can be no more defined here than historical time—describes all his deeds and his entire existence as if with a magic circle. When the tragic development suddenly makes its incomprehensible appearance, when the smallest false step leads to guilt, when the slightest error, the most improbable coincidence leads to death, when the words that would clear up and resolve the situation and that seem to be available to all remain unspoken—then we are witnessing the effect of the hero's time on the action, since in fulfilled time everything that happens is a function of that time. It is almost a paradox that this becomes manifest in all its clarity at the moment when the hero is completely passive, when tragic time bursts open, so to speak, like a flower whose calyx emits the astringent perfume of irony. For it is not unusual for the fateful climax of the hero's time to reach its moment of fulfillment during moments of utter tranquillity—during his sleep, as it were. And in the same way the meaning of the fulfilled time of a tragic fate emerges in the great moments of passivity: in the tragic decision, the retarding point of the action, and in the catastrophe. The measure of Shakespearean tragedy can be found in the mastery he shows in identifying and distinguishing the different stages of tragedy from one another like the repetitions of a theme. In contrast, classical tragedy is characterized by the ever more powerful eruption of tragic forces. It deals with the tragedy of fate, Shakespeare with the tragic hero, the tragic action. Goethe rightly calls him Romantic.

A tragic death is an ironic immortality, ironic from an excess of determinacy. The tragic death is overdetermined—that is the actual expression of the hero's guilt. Hebbel may have been on the right track when he said that individuation was original sin.[2] But everything hinges on the nature of the offense given by individuation. This is the point that enables us to inquire into the connection between history and tragedy. We are not speaking here of an individuation to be comprehended with reference to man. Death in the mourning play is not based on the extreme determinacy that individual time confers on the action. It is no conclusive finality; without the certitude of a higher existence and without irony, it is the *metabasis* of all life *eis allo*

genos.[3] The mourning play is mathematically comparable to one branch of a hyperbola whose other branch lies in infinity. The law governing a higher life prevails in the restricted space of an earthly existence, and all play, until death puts an end to the game, so as to repeat the same game, albeit on a grander scale, in another world. It is this repetition on which the law of the mourning play is founded. Its events are allegorical schemata, symbolic mirror-images of a different game. We are transported into that game by death. The time of the mourning play is not fulfilled, but nevertheless it is finite. It is nonindividual, but without historical universality. The mourning play is in every respect a hybrid form. The universality of its time is spectral, not mythic. A sign that it is related in its innermost core to the mirror-nature of games is that it has an even number of acts. As in all other respects, Schlegel's *Alarcos* sets the example, just as in general it is an outstanding work in which to conduct an analysis of the mourning play.[4] Its characters are royal, as is necessarily the case in the tragic drama because of the symbolic level of meaning. This play is ennobled by the distance which everywhere separates image and mirror-image, the signifier and the signified. Thus, the mourning play presents us not with the image of a higher existence but only with one of two mirror-images, and its continuation is not less schematic than itself. The dead become ghosts. The mourning play exhausts artistically the historical idea of repetition. Consequently, it addresses a problem that is completely different from the one dealt with in tragedy. In the mourning play, guilt and greatness call not so much for definition—let alone overdetermination—as for expansion, general extension, not for the sake of guilt and greatness, but simply for the repetition of those situations.

The nature of repetition in time is such that no unified form can be based on it. And even if the relation of tragedy to art remains problematic, even if it may be both more and less than an art form, it nevertheless remains formally unified. Its temporal character is exhaustively shaped in the form of drama. The mourning play, on the other hand, is inherently nonunified drama, and the idea of its resolution no longer dwells within the realm of drama itself. And here, on the question of form, is the point where the crucial distinction between tragedy and mourning play emerges decisively. The remains of mourning plays are called music. Perhaps there is a parallel here: just as tragedy marks the transition from historical to dramatic time, the mourning play represents the transition from dramatic time to musical time.

Written in 1916; unpublished in Benjamin's lifetime. Translated by Rodney Livingstone.

Notes

1. The term *Trauerspiel,* or play of mourning, designates a series of dramas composed in Germany in the seventeenth century.—*Trans.*
2. Friedrich Hebbel (1813–1863), Austrian dramatist and master of the "bourgeois tragedy." His plays include *Maria Magdelena* (1843) and *Agnes Bernauer* (1851).—*Trans.*
3. "Transformation into another type or sort." The phrase occurs in Aristotle's "De Caelo" [On the Heavens], 281b.—*Trans.*
3. Friedrich Schlegel's *Alarcos,* a verse tragedy (Schlegel calls it a *Trauerspiel*) in two acts, was first performed in 1802 at the Weimar Court Theater under Goethe's direction.—*Trans.*

The Role of Language in *Trauerspiel* and Tragedy

The tragic is situated in the laws governing the spoken word between human beings. There is no such thing as a tragic pantomime.[1] Nor do we have tragic poems, tragic novels, or tragic events. Tragedy is not just confined exclusively to the realm of dramatic human speech; it is the only form proper to human dialogue. That is to say, no tragedy exists outside human dialogue, and the only form in which human dialogue can appear is that of tragedy. Wherever we see an "untragic" drama, the autonomous laws of human speech fail to manifest themselves; instead, we see no more than a feeling or a relationship in a linguistic context, a linguistic phase.

In its pure forms, dialogue is neither sad nor comic, but tragic. To that extent, tragedy is the classic and pure form of drama. The sad has no main focus, and its deepest and indeed only expression is to be found neither in dramatic speech nor in speech in any sense. Sadness is not confined to the mourning play [*Trauerspiel*]. What is more, the mourning play is not the saddest thing in the world. A poem can be sadder, as can a story or a life. For sadness, unlike tragedy, is not a ruling force. It is not the indissoluble law of inescapable orders that prevails in tragedy. It is merely a feeling. What is the metaphysical relation of this feeling to language, to the spoken word? That is the riddle of the mourning play. What internal relation at the heart of sadness causes it to emerge from the realm of pure feeling and enter the sphere of art?

In tragedy, speech and the tragic arise together, simultaneously, on the same spot. Every speech in the tragedy is tragically decisive. It is the pure word itself that has an immediate tragic force. How language can fill itself with sadness, how language can express sadness, is the basic question of the

mourning play, alongside that other question: How can the feeling of sadness gain entry into the linguistic order of art? When language has an impact by virtue of its pure meaning, that impact is tragic. The word as the pure bearer of its meaning is the pure word. But alongside this, we find a word of another sort that is subject to change, as it moves from its source toward a different point, its estuary. Language in the process of change is the linguistic principle of the mourning play. Words have a pure emotional life cycle in which they purify themselves by developing from the natural sound to the pure sound of feeling. For such words, language is merely a transitional phase within the entire life cycle, and in them the mourning play finds its voice. It describes the path from natural sound via lament to music. In the mourning play, sounds are laid out symphonically, and this constitutes the musical principle of its language and the dramatic principle of its breaking up and splitting into characters. The mourning play is nature that enters the purgatory of language only for the sake of the purity of its feelings; it was already defined in the ancient wise saying that the whole of nature would begin to lament if it were but granted the gift of language. For the mourning play does not describe the motion through the spheres that carries feeling from the pure world of speech out to music and then back to the liberated sorrow of blissful feeling. Instead, midway through its journey nature finds itself betrayed by language, and that powerful blocking of feeling turns to sorrow. Thus, with the ambiguity of the word, its *signifying* character, nature falters, and whereas the created world wished only to pour forth in all purity, it was man who bore its crown. This is the significance of the king in the mourning play, and this is the meaning of the *Haupt- und Staatsaktion*.[2] These plays represent a blocking of nature, as it were an overwhelming damming up of the feelings that suddenly discover a new world in language, the world of signification, of an impassive historical time; and once again the king is both man (the end of nature) and also the king (the symbol and bearer of significance). History becomes equal to significa-tion in human language; this language is frozen in signification. Tragedy threatens, and man, the crowning pinnacle of creation, is salvaged for feeling only by becoming king: a symbol as the bearer of this crown. And nature in the mourning play remains a torso in this sublime symbol; sorrow fills the sensuous world in which nature and language meet.

 The two metaphysical principles of repetition interpenetrate in the mourn-ing play and establish its metaphysical order. They are the cycle and repe-tition, the circle and the fact of duality. For it is the circle of feeling that is completed in music, and it is the duality of the word and its meaning that destroys the tranquillity of a profound yearning and disseminates sorrow throughout nature. The interplay between sound and meaning remains a terrifying phantom for the mourning play; it is obsessed by language, the victim of an endless feeling—like Polonius, who was overcome by madness

in the midst of his reflections. This interplay must find its resolution, however, and for the mourning play that redemptive mystery is music—the rebirth of the feelings in a suprasensuous nature.

It is the necessity of redemption that constitutes the playful element of this art form. For compared with the irrevocability of tragedy, which makes an ultimate reality of language and the linguistic order, every product animated by a feeling (of sorrow) must be called a game. The mourning play is built not on the foundation of actual language but on the consciousness of the unity that language achieves through feeling, a unity that unfolds in words. In this process, errant feeling gives voice to its sorrow. But this lament must dissolve itself; on the basis of that presupposed unity, it enters into the language of pure feeling—in other words, music. Sorrow conjures up itself in the mourning play, but it also redeems itself. This tension and release of feeling in its own realm is a form of play. In it sorrow is nothing more than a single tone on the scale of the feelings, and so we may say that there is no mourning play pure and simple, since the diverse feelings of the comic, the terrible, the horrifying, and many others each take their turn on the floor. Style, in the sense of a unity beyond feelings, is reserved for tragedy. The world of the mourning play is a special world that can assert its greatness and equality even in the face of tragedy. It is the site of the actual conception of the word and of speech in art; the faculties of speech and hearing still stand equal in the scales, and ultimately everything depends on the ear for lament, for only the most profoundly heard lament can become music. Whereas in tragedy the eternal inflexibility of the spoken word is exalted, the mourning play concentrates in itself the infinite resonance of its sound.

Written in 1916; unpublished in Benjamin's lifetime. Translated by Rodney Livingstone.

Notes

1. The term *Trauerspiel,* or play of mourning, designates a series of dramas composed in Germany in the seventeenth century.—*Trans.*
2. *Haupt- und Staatsaktion:* Political plays that emerged in Germany around 1700, concerned with the sudden fall of kings, dark conspiracies, and executions.—*Trans.*

On Language as Such and on the Language of Man

Every expression of human mental life can be understood as a kind of language, and this understanding, in the manner of a true method, everywhere raises new questions. It is possible to talk about a language of music and of sculpture, about a language of justice that has nothing directly to do with those in which German or English legal judgments are couched, about a language of technology that is not the specialized language of technicians. Language in such contexts means the tendency inherent in the subjects concerned—technology, art, justice, or religion—toward the communication of the contents of the mind. To sum up: all communication of the contents of the mind is language, communication in words being only a particular case of human language and of the justice, poetry, or whatever underlying it or founded on it. The existence of language, however, is coextensive not only with all the areas of human mental expression in which language is always in one sense or another inherent, but with absolutely everything. There is no event or thing in either animate or inanimate nature that does not in some way partake of language, for it is in the nature of each one to communicate its mental contents. This use of the word "language" is in no way metaphorical. For to think that we cannot imagine anything that does not communicate its mental nature in its expression is entirely meaningful; consciousness is apparently (or really) bound to such communication to varying degrees, but this cannot alter the fact that we cannot imagine a total absence of language in anything. An existence entirely without relationship to language is an idea; but this idea can bear no fruit even within that realm of Ideas whose circumference defines the idea of God.

All that is asserted here is that all expression, insofar as it is a communi-

cation of contents of the mind, is to be classed as language. And expression, by its whole innermost nature, is certainly to be understood only as *language*. On the other hand, to understand a linguistic entity, it is always necessary to ask of which mental entity it is the direct expression. That is to say: the German language, for example, is by no means the expression of everything that we could—theoretically—express *through* it, but is the direct expression of that which communicates *itself* in it. This "itself" is a mental entity. It is therefore obvious at once that the mental entity that communicates itself in language is not language itself but something to be distinguished from it. The view that the mental essence of a thing consists precisely in its language—this view, taken as a hypothesis, is the great abyss into which all linguistic theory threatens to fall,[1] and to survive suspended precisely over this abyss is its task. The distinction between a mental entity and the linguistic entity in which it communicates is the first stage of any study of linguistic theory; and this distinction seems so unquestionable that it is, rather, the frequently asserted identity between mental and linguistic being that constitutes a deep and incomprehensible paradox, the expression of which is found in the ambiguity of the word "logos." Nevertheless, this paradox has a place, as a solution, at the center of linguistic theory, but remains a paradox, and insoluble, if placed at the beginning.

What does language communicate? It communicates the mental being corresponding to it. It is fundamental that this mental being communicates itself *in* language and not *through* language. Languages, therefore, have no speaker, if this means someone who communicates *through* these languages. Mental being communicates itself in, not through, a language, which means that it is not outwardly identical with linguistic being. Mental being is identical with linguistic being only insofar as it is capable of communication. What is communicable in a mental entity is its linguistic entity. Language therefore communicates the particular linguistic being of things, but their mental being only insofar as this is directly included in their linguistic being, insofar as it is capable of being communicated.

Language communicates the linguistic being of things. The clearest manifestation of this being, however, is language itself. The answer to the question "*What* does language communicate?" is therefore "All language communicates itself." The language of this lamp, for example, communicates not the lamp (for the mental being of the lamp, insofar as it is *communicable,* is by no means the lamp itself) but the language-lamp, the lamp in communication, the lamp in expression. For in language the situation is this: *the linguistic being of all things is their language.* The understanding of linguistic theory depends on giving this proposition a clarity that annihilates even the appearance of tautology. This proposition is untautological, for it means, "That which in a mental entity is communicable *is* its language." On this "is" (equivalent to "is immediately") everything depends.—Not that

which *appears* most clearly in its language is communicable in a mental entity, as was just said by way of transition, but this *capacity* for communication is language itself. Or: the language of a mental entity is directly that which is communicable in it. Whatever is communicable *of* a mental entity, *in* this it communicates itself. Which signifies that all language communicates itself. Or, more precisely, that all language communicates itself *in* itself; it is in the purest sense the "medium" of the communication. Mediation, which is the immediacy of all mental communication, is the fundamental problem of linguistic theory, and if one chooses to call this immediacy magic, then the primary problem of language is its magic. At the same time, the notion of the magic of language points to something else: its infiniteness. This is conditional on its immediacy. For precisely because nothing is communicated *through* language, what is communicated *in* language cannot be externally limited or measured, and therefore all language contains its own incommensurable, uniquely constituted infinity. Its linguistic being, not its verbal contents, defines its frontier.

The linguistic being of things is their language; this proposition, applied to man, means: the linguistic being of man is his language. Which signifies: man communicates his own mental being *in* his language. However, the language of man speaks in words. Man therefore communicates his own mental being (insofar as it is communicable) by *naming* all other things. But do we know any other languages that name things? It should not be accepted that we know of no languages other than that of man, for this is untrue. We only know of no *naming* language other than that of man; to identify naming language with language as such is to rob linguistic theory of its deepest insights.—*It is therefore the linguistic being of man to name things.*

Why name them? To whom does man communicate himself?—But is this question, as applied to man, different when applied to other communications (languages)? To whom does the lamp communicate itself? The mountain? The fox?—But here the answer is: to man. This is not anthropomorphism. The truth of this answer is shown in human knowledge [*Erkenntnis*] and perhaps also in art. Furthermore, if the lamp and the mountain and the fox did not communicate themselves to man, how should he be able to name them? And he names them; *he* communicates himself by naming *them*. To whom does he communicate himself?

Before this question can be answered, we must again inquire: How does man communicate himself? A profound distinction is to be made, a choice presented, in the face of which an intrinsically false understanding of language is certain to give itself away. Does man communicate his mental being *by* the names that he gives thing? Or *in* them? In the paradoxical nature of these questions lies their answer. Anyone who believes that man communicates his mental being *by* names cannot also assume that it is his mental being that he communicates, for this does not happen through the names

of things—that is, through the words by which he denotes a thing. And, equally, the advocate of such a view can assume only that man is communicating factual subject matter to other men, for that does happen through the word by which he denotes a thing. This view is the bourgeois conception of language, the invalidity and emptiness of which will become increasingly clear in what follows. It holds that the means of communication is the word, its object factual, and its addressee a human being. The other conception of language, in contrast, knows no means, no object, and no addressee of communication. It means: *in the name, the mental being of man communicates itself to God.*

The name, in the realm of language, has as its sole purpose and its incomparably high meaning that it is the innermost nature of language itself. The name is that *through* which, and *in* which, language itself communicates itself absolutely. In the name, the mental entity that communicates itself is *language.* Where mental being in its communication is language itself in its absolute wholeness, only there is the name, and only the name is there. Name as the heritage of human language therefore vouches for the fact *that language as such* is the mental being of man; and only for this reason is the mental being of man, alone among all mental entities, communicable without residue. On this is founded the difference between human language and the language of things. But because the mental being of man is language itself, he cannot communicate himself by it, but only in it. The quintessence of this intensive totality of language as the mental being of man is the name. Man is the namer; by this we recognize that through him pure language speaks. All nature, insofar as it communicates itself, communicates itself in language, and so finally in man. Hence, he is the lord of nature and can give names to things. Only through the linguistic being of things can he get beyond himself and attain knowledge of them—in the name. God's creation is completed when things receive their names from man, from whom in name language alone speaks. Man can call name the language of language (if the genitive refers to the relationship not of a means but of a medium), and in this sense certainly, because he speaks in names, man is the speaker of language, and for this very reason its only speaker. In terming man the speaker (which, however, according to the Bible, for example, clearly means the name giver: "As man should name all kinds of living creatures, so should they be *called*"), many languages imply this metaphysical truth.

Name, however, is not only the last utterance of language but also the true call of it. Thus, in name appears the essential law of language, according to which to express oneself and to address everything else amounts to the same thing. Language, and in it a mental entity in it, only expresses itself purely where it speaks in name—that is, in its universal naming. So in name culminate both the intensive totality of language, as the absolutely communicable mental entity, and the extensive totality of language, as the univer-

sally communicating (naming) entity. By virtue of its communicating nature, its universality, language is incomplete wherever the mental entity that speaks from it is not in its whole structure linguistic—that is, communicable. *Man alone has a language that is complete both in its universality and in its intensiveness.*

In the light of this, a question may now be asked without risk of confusion, a question that, though of the highest metaphysical importance, can be clearly posed first of all as one of terminology. It is whether mental being—not only of man (for that is necessary) but also of things, and thus mental being as such—can from the point of view of linguistic theory be described as of linguistic nature. If mental being is identical with linguistic being, then a thing, by virtue of its mental being, is a medium of communication, and what is communicated in it is—in accordance with its mediating relationship—precisely this medium (language) itself. Language is thus the mental being of things. Mental being is therefore postulated at the outset as communicable, or, rather, is situated *within* the communicable, and the thesis that the linguistic being of things is identical with the mental, insofar as the latter is communicable, becomes in its "insofar" a tautology. *There is no such thing as a content of language; as communication, language communicates a mental entity—something communicable per se.* The differences between languages are those of media that are distinguished as it were by their density—that is, gradually; and this with regard to the density both of the communicating (naming) and of the communicable (name) aspects of communication. These two spheres, which are clearly distinguished yet united only in the name-language of man, are naturally constantly interrelated.

For the metaphysics of language, the equation of mental with linguistic being, which knows only gradual differences, produces a graduation of all mental being in degrees. This graduation, which takes place within mental being itself, can no longer be embraced by any higher category and so leads to the graduation of all being, both mental and linguistic, by degrees of existence or being, such as was already familiar to Scholasticism with regard to mental being. However, the equation of mental and linguistic being is of great metaphysical moment to linguistic theory because it leads to the concept that has again and again, as if of its own accord, elevated itself to the center of linguistic philosophy and constituted its most intimate connection with the philosophy of religion. This is the concept of revelation.— Within all linguistic formation a conflict is waged between what is expressed and expressible and what is inexpressible and unexpressed. On considering this conflict, one sees at the same time, from the perspective of the inexpressible, the last mental entity. Now, it is clear that in the equation of mental and linguistic being, the notion of an inverse proportionality between the two is disputed. For this latter thesis runs: the deeper (that is, the more

existent and real) the mind, the more it is inexpressible and unexpressed, whereas it is consistent with the equation proposed above to make the relation between mind and language thoroughly unambiguous, so that the expression that is linguistically most existent (that is, most fixed) is linguistically the most rounded and definitive; in a word, the most expressed is at the same time the purely mental. This, however, is precisely what is meant by the concept of revelation, if it takes the inviolability of the word as the only and sufficient condition and characteristic of the divinity of the mental being that is expressed in it. The highest mental region of religion is (in the concept of revelation) at the same time the only one that does not know the inexpressible. For it is addressed in the name and expresses itself as revelation. In this, however, notice is given that only the highest mental being, as it appears in religion, rests solely on man and on the language in him, whereas art as a whole, including poetry, rests not on the ultimate essence of the spirit of language but on the spirit of language in things, even in its consummate beauty. "*Language, the mother of* reason and *revelation*, its alpha and omega," says Hamann.[2]

Language itself is not perfectly expressed in things themselves. This proposition has a double meaning, in its metaphorical and literal senses: the languages of things are imperfect, and they are dumb. Things are denied the pure formal principle of language—namely, sound. They can communicate to one another only through a more or less material community. This community is immediate and infinite, like every linguistic communication; it is magical (for there is also a magic of matter). The incomparable feature of human language is that its magical community with things is immaterial and purely mental, and the symbol of this is sound. The Bible expresses this symbolic fact when it says that God breathes his breath into man: this is at once life and mind and language.—

If in what follows the nature of language is considered on the basis of the first chapter of Genesis, the object is neither biblical interpretation nor subjection of the Bible to objective consideration as revealed truth, but the discovery of what emerges of itself from the biblical text with regard to the nature of language; and the Bible is only *initially* indispensable for this purpose, because the present argument broadly follows it in presupposing language as an ultimate reality, perceptible only in its manifestation, inexplicable and mystical. The Bible, in regarding itself as a revelation, must necessarily evolve the fundamental linguistic facts.—The second version of the story of the Creation, which tells of the breathing of God's breath into man, also reports that man was made from earth. This is, in the whole story of the Creation, the only reference to the material in which the Creator expresses his will, which is doubtless otherwise thought of as creation without mediation. In this second story of the Creation, the making of man did not take place through the word: God spoke—and there was. But this

man, who is not created from the word, is now invested with the *gift* of language and is elevated above nature.

This curious revolution in the act of creation, where it concerns man, is no less clearly recorded, however, in the first story of the Creation; and in an entirely different context, it vouches, with the same certainty, for a special relationship between man and language resulting from the act of creation. The manifold rhythm of the act of creation in the first chapter establishes a kind of basic form, from which the act that creates man diverges significantly. Admittedly, this passage nowhere expressly refers to a relationship either of man or of nature to the material from which they were created, and the question whether the words "He made" envisages a creation out of material must here be left open; but the rhythm by which the creation of nature (in Genesis 1) is accomplished is: Let there be—He made (created)—He named. In individual acts of creation (Genesis 1:3 and 1:11) only the words "Let there be" occur. In this "Let there be" and in the words "He named" at the beginning and end of the act, the deep and clear relation of the creative act to language appears each time. With the creative omnipotence of language it begins, and at the end language, as it were, assimilates the created, names it. Language is therefore both creative and the finished creation; it is word and name. In God, name is creative because it is word, and God's word is cognizant because it is name. "And he saw that it was good"—that is, he had cognized it through name. The absolute relation of name to knowledge exists only in God; only there is name, because it is inwardly identical with the creative word, the pure medium of knowledge. This means that God made things knowable in their names. Man, however, names them according to knowledge.

In the creation of man, the threefold rhythm of the creation of nature has given way to an entirely different order. In it, therefore, language has a different meaning: the trinity of the act is here preserved, but in this very parallelism the divergence is all the more striking, in the threefold "He created" of 1:27. God did not create man from the word, and he did not name him. He did not wish to subject him to language, but in man God set language, which had served *him* as medium of creation, free. God rested when he had left his creative power to itself in man. This creativity, relieved of its divine actuality, became knowledge. Man is the knower in the same language in which God is the creator. God created him in his image; he created the knower in the image of the creator. Therefore, the proposition that the mental being of man is language needs explanation. His mental being is the language in which creation took place. In the word, creation took place, and God's linguistic being is the word. All human language is only the reflection of the word in name. The name is no closer to the word than knowledge is to creation. The infinity of all human language always remains limited and analytic in nature, in comparison to the absolutely unlimited and creative infinity of the divine word.

The deepest images of this divine word and the point where human language participates most intimately in the divine infinity of the pure word, the point at which it cannot become finite word and knowledge, are the human name. The theory of proper names is the theory of the frontier between finite and infinite language. Of all beings, man is the only one who names his own kind, as he is the only one whom God did not name. It is perhaps bold, but scarcely impossible, to mention the second part of Genesis 2:20 in this context: that man named all beings, "*but* for man there was not found a helper fit for him." Accordingly, Adam names his wife as soon as he receives her (woman in the second chapter, Eve in the third). By giving names, parents dedicate their children to God; the names they give do not correspond—in a metaphysical rather than etymological sense—to any knowledge, for they name newborn children. In a strict sense, no name ought (in its etymological meaning) to correspond to any person, for the proper name is the word of God in human sounds. By it each man is guaranteed his creation by God, and in this sense he is himself creative, as is expressed by mythological wisdom in the idea (which doubtless not infrequently comes true) that a man's name is his fate. The proper name is the communion of man with the *creative* word of God. (Not the only one, however; man knows a further linguistic communion with God's word.) Through the word, man is bound to the language of things. The human word is the name of things. Hence, it is no longer conceivable, as the bourgeois view of language maintains, that the word has an accidental relation to its object, that it is a sign for things (or knowledge of them) agreed by some convention. Language never gives *mere* signs. However, the rejection of bourgeois linguistic theory by mystical linguistic theory likewise rests on a misunderstanding. For according to mystical theory, the word is simply the essence of the thing. That is incorrect, because the thing in itself has no word, being created from God's word and known in its name by a human word. This knowledge of the thing, however, is not spontaneous creation; it does not emerge from language in the absolutely unlimited and infinite manner of creation. Rather, the name that man gives to language depends on how language is communicated to him. In name, the word of God has not remained creative; it has become in one part receptive, even if receptive to language. Thus fertilized, it aims to give birth to the language of things themselves, from which in turn, soundlessly, in the mute magic of nature, the word of God shines forth.

For conception and spontaneity together, which are found in this unique union only in the linguistic realm, language has its own word, and this word applies also to that conception of the nameless in the name. It is the translation of the language of things into that of man. It is necessary to found the concept of translation at the deepest level of linguistic theory, for it is much too far-reaching and powerful to be treated in any way as an afterthought, as has happened occasionally. Translation attains its full mean-

ing in the realization that every evolved language (with the exception of the word of God) can be considered a translation of all the others. By the fact that, as mentioned earlier, languages relate to one another as do media of varying densities, the translatability of languages into one another is established. Translation is removal from one language into another through a continuum of transformations. Translation passes through continua of transformation, not abstract areas of identity and similarity.

The translation of the language of things into that of man is not only a translation of the mute into the sonic; it is also the translation of the nameless into name. It is therefore the translation of an imperfect language into a more perfect one, and cannot but add something to it, namely knowledge. The objectivity of this translation is, however, guaranteed by God. For God created things; the creative word in them is the germ of the cognizing name, just as God, too, finally named each thing after it was created. But obviously this naming is only an expression of the identity of the creative word and the cognizing name in God, not the prior solution of the task that God expressly assigns to man himself: that of naming things. In receiving the unspoken nameless language of things and converting it by name into sounds, man performs this task. It would be insoluble, were not the name-language of man and the nameless language of things related in God and released from the same creative word, which in things became the communication of matter in magic communion, and in man the language of knowledge and name in blissful mind. Hamann says, "Everything that man heard in the beginning, saw with his eyes, and felt with his hands was the living word; for God was the word. With this word in his mouth and in his heart, the origin of language was as natural, as close, and as easy as a child's game . . ." Friedrich Müller, in his poem "Adams erstes Erwachen und erste selige Nächte" [Adam's First Awakening and First Blissful Nights], has God summon man to name giving in these words: "Man of the earth, step near; in gazing, grow more perfect, more perfect through the word."[3] This combination of contemplation and naming implies the communicating muteness of things (animals) toward the word-language of man, which receives them in name. In the same chapter of the poem, the poet expresses the realization that only the word from which things are created permits man to name them, by communicating itself in the manifold languages of animals, even if mutely, in the image: God gives each beast in turn a sign, whereupon they step before man to be named. In an almost sublime way, the linguistic community of mute creation with God is thus conveyed in the image of the sign.

Since the unspoken word in the existence of things falls infinitely short of the naming word in the knowledge of man, and since the latter in turn must fall short of the creative word of God, there is a reason for the multiplicity of human languages. The language of things can pass into the

language of knowledge and name only through translation—so many translations, so many languages—once man has fallen from the paradisiacal state that knew only one language. (According to the Bible this consequence of the expulsion from Paradise admittedly came about only later.) The paradisiacal language of man must have been one of perfect knowledge, whereas later all knowledge is again infinitely differentiated in the multiplicity of language, was indeed forced to differentiate itself on a lower level as creation in name. Even the existence of the Tree of Knowledge cannot conceal the fact that the language of Paradise was fully cognizant. Its apples were supposed to impart knowledge of good and evil. But on the seventh day, God had already cognized with the words of creation. And God saw that it was good. The knowledge to which the snake seduces, that of good and evil, is nameless. It is vain in the deepest sense, and this very knowledge is itself the only evil known to the paradisiacal state. Knowledge of good and evil abandons name; it is a knowledge from outside, the uncreated imitation of the creative word. Name steps outside itself in this knowledge: the Fall marks the birth of the *human word*, in which name no longer lives intact and which has stepped out of name-language, the language of knowledge, from what we may call its own immanent magic, in order to become expressly, as it were externally, magic. The word must communicate *something* (other than itself). In that fact lies the true Fall of the spirit of language. The word as something externally communicating, as it were a parody—by the expressly mediate word—of the expressly immediate, creative word of God, and the decay of the blissful Adamite spirit of language that stands between them. For in reality there exists a fundamental identity between the word that, after the promise of the snake, knows good and evil, and the externally communicating word. The knowledge of things resides in the name, whereas that of good and evil is, in the profound sense in which Kierkegaard uses the word, "prattle," and knows only one purification and elevation, to which the prattling man, the sinner, was therefore submitted: judgment. Admittedly, the judging word has direct knowledge of good and evil. Its magic is different from that of name, but equally magical. This judging word expels the first human beings from Paradise; they themselves have aroused it in accordance with the immutable law by which this judging word punishes—and expects—its own awakening as the sole and deepest guilt. In the Fall, since the eternal purity of names was violated, the sterner purity of the judging word arose. For the essential composition of language, the Fall has a threefold significance (in addition to its other meanings). In stepping outside the purer language of name, man makes language a means (that is, a knowledge inappropriate to him), and therefore also, in one part at any rate, a *mere* sign; and this later results in the plurality of languages. The second meaning is that from the Fall, in exchange for the immediacy of name that was damaged by it, a new immediacy arises: the magic of

judgment, which no longer rests blissfully in itself. The third meaning that can perhaps be tentatively ventured is that the origin of abstraction, too, as a faculty of the spirit of language, is to be sought in the Fall. For good and evil, being unnameable and nameless, stand outside the language of names, which man leaves behind precisely in the abyss opened by this question. Name, however, with regard to existing language, offers only the ground in which its concrete elements are rooted. But the abstract elements of language—we may perhaps surmise—are rooted in the word of judgment. The immediacy (which, however, is the linguistic root) of the communicability of abstraction resides in judgment. This immediacy in the communication of abstraction came into being as judgment, when, in the Fall, man abandoned immediacy in the communication of the concrete—that is, name—and fell into the abyss of the mediateness of all communication, of the word as means, of the empty word, into the abyss of prattle. For—it must be said again—the question as to good and evil in the world after the Creation was empty prattle. The Tree of Knowledge stood in the garden of God not in order to dispense information on good and evil, but as an emblem of judgment over the questioner. This immense irony marks the mythic origin of law.

After the Fall, which, in making language mediate, laid the foundation for its multiplicity, linguistic confusion could be only a step away. Once men had injured the purity of name, the turning away from that contemplation of things in which their language passes into man needed only to be completed in order to deprive men of the common foundation of an already shaken spirit of language. *Signs* must become confused where things are entangled. The enslavement of language in prattle is joined by the enslavement of things in folly almost as its inevitable consequence. In this turning away from things, which was enslavement, the plan for the Tower of Babel came into being, and linguistic confusion with it.

The life of man in the pure spirit of language was blissful. Nature, however, is mute. True, it can be clearly felt in the second chapter of Genesis how this muteness, named by man, itself became bliss, only of lower degree. Friedrich Müller has Adam say of the animals that leave him after he has named them, "And saw by the nobility with which they leaped away from me that the man had given them a name." After the Fall, however, when God's word curses the ground, the appearance of nature is deeply changed. Now begins its other muteness, which is what we mean by the "deep sadness of nature." It is a metaphysical truth that all nature would begin to lament if it were endowed with language (though "to endow with language" is more than "to make able to speak"). This proposition has a double meaning. It means, first, that she would lament language itself. Speechlessness: that is the great sorrow of nature (and for the sake of her redemption the life and language of *man*—not only, as is supposed, of the poet—are in nature). This

proposition means, second, that she would lament. Lament, however, is the most undifferentiated, impotent expression of language. It contains scarcely more than the sensuous breath; and even where there is only a rustling of plants, there is always a lament. Because she is mute, nature mourns. Yet the inversion of this proposition leads even further into the essence of nature; the sadness of nature makes her mute. In all mourning there is the deepest inclination to speechlessness, which is infinitely more than the inability or disinclination to communicate. That which mourns feels itself thoroughly known by the unknowable. To be named—even when the namer is godlike and blissful—perhaps always remains an intimation of mourning. But how much more melancholy it is to be named not from the one blessed paradisiacal language of names, but from the hundred languages of man, in which name has already withered, yet which, according to God's pronouncement, have knowledge of things. Things have no proper names except in God. For in his creative word, God called them into being, calling them by their proper names. In the language of men, however, they are overnamed. There is, in the relation of human languages to that of things, something that can be approximately described as "overnaming"—the deepest linguistic reason for all melancholy and (from the point of view of the thing) for all deliberate muteness. Overnaming as the linguistic being of melancholy points to another curious relation of language: the overprecision that obtains in the tragic relationship between the languages of human speakers.

There is a language of sculpture, of painting, of poetry. Just as the language of poetry is partly, if not solely, founded on the name language of man, it is very conceivable that the language of sculpture or painting is founded on certain kinds of thing-languages, that in them we find a translation of the language of things into an infinitely higher language, which may still be of the same sphere. We are concerned here with nameless, nonacoustic languages, languages issuing from matter; here we should recall the material community of things in their communication.

Moreover, the communication of things is certainly communal in a way that grasps the world as such as an undivided whole.

For an understanding of artistic forms, it is of value to attempt to grasp them all as languages and to seek their connection with natural languages. An example that is appropriate because it is derived from the acoustic sphere is the kinship between song and the language of birds. On the other hand, it is certain that the language of art can be understood only in the deepest relation to the doctrine of signs. Without the latter any linguistic philosophy remains entirely fragmentary, because the relation between language and sign (of which that between human language and writing offers only a very particular example) is original and fundamental.

This provides an opportunity to describe another antithesis that permeates the whole sphere of language and has important relations to the aforemen-

tioned antithesis between language in a narrower sense and signs, with which, of course, language by no means necessarily coincides. For language is in every case not only communication of the communicable but also, at the same time, a symbol of the noncommunicable. This symbolic side of language is connected to its relation to signs, but extends more widely—for example, in certain respects to name and judgment. These have not only a communicating function, but most probably also a closely connected symbolic function, to which, at least explicitly, no reference has here been made.

These considerations therefore leave us a purified concept of language, even though it may still be an imperfect one. The language of an entity is the medium in which its mental being is communicated. The uninterrupted flow of this communication runs through the whole of nature, from the lowest forms of existence to man and from man to God. Man communicates himself to God through name, which he gives to nature and (in proper names) to his own kind; and to nature he gives names according to the communication that he receives from her, for the whole of nature, too, is imbued with a nameless, unspoken language, the residue of the creative word of God, which is preserved in man as the cognizing name and above man as the judgment suspended over him. The language of nature is comparable to a secret password that each sentry passes to the next in his own language, but the meaning of the password is the sentry's language itself. All higher language is a translation of lower ones, until in ultimate clarity the word of God unfolds, which is the unity of this movement made up of language.

Written in 1916; unpublished in Benjamin's lifetime. Translated by Edmund Jephcott.

Notes

1. Or is it, rather, the temptation to place at the outset a hypothesis that constitutes an abyss for all philosophizing?
2. Johann Georg Hamann (1730–1788), German theologian and philosopher, whose rhapsodic, elliptical style and appeal to affect and intuition led to controversies with eighteenth-century rationalists (Kant among them) but exerted a powerful influence on Herder and the authors of the *Sturm und Drang.—Trans.*
3. Friedrich "Maler" Müller (1749–1825), German author, painter, and art critic.—*Trans.*

Theses on the Problem of Identity

1. All nonidentity is infinite, but this does not imply that all identity is finite.
2. The possibility that an infinite might be identical will be left aside in this discussion.
3. Nonidentical infinity can be nonidentical in two different ways.
 a. It is potentially identical, in which case it cannot be nonidentical in actuality. This is the (actual) a-identical. The a-identical lies beyond identity and nonidentity, but in the course of development is capable only of the first, not the second.
 b. It is *not* potentially identical and is nonidentical in actuality.

Note: The question of which kinds of mathematical infinity belong under (a) or (b) requires investigation.

4. Identity-relations can be established only in the case of (a), not (b), and not even in the category of infinity considered under (2).
5. The validity of identity-relations is assumed for the object of a statement, but does not have the same form for the subject of the statement as for the nonfinite universal A of the sentence $A = A$. If we nevertheless use this form to express the validity of the identity-relation for the subject of the statement, it results in tautology.
6. The relation of tautology to the problem of identity can be thought of differently. It arises with the attempt to conceive of the identity-relation as a statement.

7. The identity-relation cannot be grasped as a statement, since the first A of the sentence $A = A$ is no more a subject than the second is a predicate, for otherwise something other than the second A would be predicable of the first A, and the latter would be ascribable to something other than the first.

8. The identity-relation is not reversible. This assertion remains to be proved. Nevertheless it can be made plausible, for example, by the linguistic distinction between "I" and "self." The expression "I myself" emphasizes the identity of the "I," or if not precisely that, then at least an analogue in the sphere of the person. At the same time, this "I myself" is itself not reversible; the "myself" is, so to speak, only the inner shadow of the "I."

9. We may therefore formulate the problem of identity by saying that a nonreversible relation exists that is not made logically possible by any of the three categories of relation (substance, causality, or reciprocity).

[Stages of identification. Time and space. Abrupt transition between A and a (a), an unbroken transition between a (a) and a.]

10. The formula of identity is "$A = A$," not "A remains A." It does not assert the equality of two spatially or temporally distinct stages of A. But neither can it express the identity of any A existing in space or time, for any such assertion would already presuppose that identity. The A whose identity with A is expressed in that identity-relation must therefore exist beyond time and space.

11. Philosophy usually declines to concern itself with the problem of identity on the following grounds. (i) All propositions in general can express only identities, and therefore (ii) in any exploration of identity the latter must be presupposed. In consequence, it is not possible to ignore the fact that the sentence $A = A$ is a truism in the realm of thought. Nor can we ignore the fact that sentences (i) and (ii) are likewise truisms. They are basic laws of logic. However, the assertion that $A = A$ follows from them is a decisive mistake. For the first two sentences maintain only that propositions can assert nothing but identity and that this is presupposed in any proposition. But this does not imply that a given identity is identical with itself, and this is precisely what the sentence $A = A$ asserts—namely, that there is an identity with oneself. Its first A is therefore just as much something identical in and for itself, but not with itself (that is to say, the second A), and by the same

token the second *A* is identical in and for itself, but neither with the first *A* nor with itself. We cannot discuss here how identity with self—the possibility of which is affirmed by the principle of identity and is its actual content—differs from any other kind of identity, and whether this other kind is purely a function of formal logic determining the identity of a thought as such, as distinct from the identity of the object with itself. Only as determined in the proposition $A = A$ is *A* identical with itself, and only the *A* of this proposition, not the concrete object (see item 5 above); indeed, not even what is nonidentical in actuality (see 3b above) is identical with itself. The second possesses only a logical identity as an object of thought; the first possesses a further metaphysical identity.

(In the above discussion, it was a mistake to describe the basic objective identity $A = A$ as an identity with self. $A = A$ asserts only that an objective identity exists, whereas "identity with self" is itself an established objective identity (either the only one or one among others).

Fragment written in 1916; unpublished in Benjamin's lifetime. Translated by Rodney Livingstone.

Dostoevsky's *The Idiot*

Dostoevsky conceives the world's fate through the medium of his people's destiny. This point of view is typical of the great nationalists, according to whom humanity can develop only through the medium of a particular national heritage. The novel's greatness is revealed in the way the metaphysical laws governing the development of humanity as a whole and those governing the individual nation are shown to be interdependent. This means that there is no profound human impulse that is not firmly placed within the aura of the Russian spirit. The ability to represent such impulses together with their aura, freely suspended in the context of the nation and yet inseparable from it, is perhaps the quintessence of freedom in the great art of this writer. This can be gauged only when we compare it to the dreadful way in which authors of the cheapest kind of novel simply cobble together disparate elements to make rough-and-ready composite characters. We see representatives of the national type, human beings typical of their native land; their individual and social personas have been glued together in an infantile manner, and the repulsive façade of psychological plausibility that has been superimposed on them completes the overall marionette-like impression. Dostoevsky, by contrast, does not take the psychology of his characters as his starting point. Their psychological aspect is, in effect, nothing more than the delicate crucible in which pure humanity is produced from the fiery, primordial gas of a nation in transition. Psychology is but the expression of the marginal nature of human existence. Everything that the critics think of as a psychological problem is in reality its very opposite. They write as if what was at issue was the problem of the Russian "psyche," or the "psyche" of an epileptic. Criticism can justify its right to approach

works of art only by respecting their territory and taking care not to trespass on that forbidden soil. An example of the impertinent failure to do so is seen when a critic praises a writer for the psychological realism of his characters. For the most part, critics and writers deserve each other because the average novelist does in fact use the faded stereotypes that the critic can then recognize and even praise, simply because he does recognize them. But this is precisely the terrain from which the critic should keep his distance. It would be indecent and mistaken for the critic to measure Dostoevsky's work by such a yardstick. His task is rather to grasp the metaphysical identity of the national and human in the creative idea underlying Dostoevsky's novel.

For like every work of art this novel is based on an idea, or, as Novalis put it, "It has an a priori ideal, an implicit necessity to exist." And the task of the critic is to articulate this idea and nothing else. The entire action of the novel acquires its fundamental character from the fact that it is an episode. That is to say, an episode in the life of the principal character, Prince Myshkin. In all essentials his life, both before and after this episode, is buried in obscurity, as is clear from the fact that he spends both the preceding years and the following ones abroad. What necessity has brought this man back to Russia? His Russian existence emerges from the obscurity surrounding his stay abroad as the visible colors of the spectrum emerge from the surrounding darkness. But what light is refracted during his life in Russia? It would be impossible to describe what he actually does in this period, apart from his many mistakes and the various virtuous features of his behavior. His life passes aimlessly, even when he is at his best, and in this he resembles nothing so much as an ailing incompetent. He is seen to fail not just in society's terms; even his closest friend—if the novel's rationale did not prevent him from having one—would be unable to discover any idea or purposive goal in his life. On the contrary, he is surrounded in a quite unobtrusive way by an aura of complete isolation. All the relationships in which he becomes involved seem rapidly to enter a force-field that prevents them from becoming any more intimate. Although he is utterly modest, even humble, he is completely unapproachable, and his life emanates an order at whose center we find a solitude that is almost absolute. We observe here a quite remarkable fact: every event, however remote from him it appears to be, seems to gravitate toward him, and this process in which all things and people gravitate toward this one center constitutes the content of the novel. Yet they seem as disinclined to reach out toward him as he is to retreat before them. The tension between them is both unending and simple; it is the tension of life itself as it unfolds through its teeming ramifications into infinity, but is not dissipated. Why did Dostoevsky make the prince's house, and not that of the Yapanchins, the center of the action in Pavlovsk?

The life of Prince Myshkin is laid before us as an episode only in order

to make its immortality visible symbolically. In fact his life can no more be extinguished than can the life of nature, to which it bears a profound relation—perhaps even less so. Nature may be immortal, but the prince's life certainly is—and this is to be understood in an inward, spiritual sense. It is true of his life as well as the lives of all those in his gravitational orbit. But this immortality is not the eternity of nature, however close to this it seems, for the concept of eternity negates that of infinity, whereas infinity achieves its greatest glory in immortality. The immortal life to which this novel testifies is worlds away from immortality in its usual sense. For in the latter, life is in fact mortal, and the immortal things are flesh, energy, individuality, and spirit in its various guises. It is in this sense that Goethe, in his conversation with Eckermann, spoke of the immortality of activity, according to which nature is obliged to give us new scope for activity once this one has been taken from us. All of this is far removed from the immortality of life, of the life that pursues its idea of immortality into infinity and whose shape is defined by immortality itself. For we are not speaking here of mere duration. But what life is immortal, if it is not the immortality of nature or the individual? Of Prince Myshkin we may say indeed that his individuality is secondary to his life, just as a flower's is to its perfume, or a star's to its light. Immortal life is unforgettable; that is the sign by which we recognize it. It is the life that is not to be forgotten, even though it has no monument or memorial, or perhaps even any testimony. It simply cannot be forgotten. Such life remains unforgettable even though without form or vessel. And "unforgettable" does not just mean that we cannot forget it. It points to something in the nature of the unforgettable itself, something that makes it unforgettable. Even the prince's amnesia during his later illness is a symbol of the unforgettable nature of his life. For this seemingly lies buried in the abyss of his self-knowledge, unable any more to rise to the surface. The other characters visit him. The brief afterword to the novel stamps his life upon all the others as a life in which they were involved, though they know not how.

The pure word for life in its immortality is "youth." Dostoevsky's great act of lamentation in this novel is for the failure of the youth movement.[1] Its life remains immortal, but the "idiot" is obscured by his own brightness. Dostoevsky complains that Russia is unable to keep a hold on, or absorb into itself, its own immortality—for these people bear the youthful heart of Russia within themselves. Hence, it falls on alien soil; it goes beyond its own frontier and is stranded in Europe, "in this windy Europe." In his political writing, Dostoevsky insists again and again that regeneration from within the national heritage is the only hope. This explains why the author of this novel believes that the only salvation for young people and their nation lies in childhood. This would be evident simply from this book (in which the childlike figures of Kolya and the prince are the purest of all),

even if Dostoevsky had not gone on to develop, in *The Brothers Karamazov,* the idea of the unlimited healing powers of childlike simplicity. This young generation suffers from a damaged childhood: the damaged childhood of the Russian country and people has paralyzed their energies. It is always apparent in Dostoevsky that only in the spirit of childhood does the noble development of human life spring from the spirit of the common people. The child's inability to express itself continues to have a crippling effect on the speech of Dostoevsky's characters in general, and an overwrought yearning for childhood—or, in modern terms, hysteria—consumes the women in the novel: Lisaveta Prokofyevna, Aglaya and Nastasya Filippovna. The entire momentum of the book resembles the implosion of a gigantic crater. Because nature and childhood are absent, humanity can be arrived at only via a catastrophic process of self-destruction. The relationship of human life to the living, right down to their total destruction, the immeasurable abyss of the crater from which mighty energies may one day be released on a grand human scale—this is the hope of the Russian nation.

Written in 1917; published in *Die Argonauten,* 1921. Translated by Rodney Livingstone.

Notes

1. Benjamin here constructs an allegory of the German Youth Movement, in which he had played a prominent role. See the "Chronology" in this volume.—*Trans.*

Painting and the Graphic Arts

A picture must be held vertically before the observer. A mosaic lies horizontally at his feet. Despite this distinction, it is customary to regard the graphic arts simply as paintings. Nevertheless, the distinction is very important and far-reaching. It is possible to look at the study of a head, or a Rembrandt landscape, in the same way as a painting, or at best to leave the drawings in a neutral horizontal position. Yet consider children's drawings: viewing them vertically usually conflicts with their inner meaning. It is the same with Otto Gross's drawings: they have to be placed horizontally on the table. We see here a profound problem of art and its mythic roots. We might say that there are two sections through the substance of the world: the longitudinal section of painting and the cross-section of certain pieces of graphic art. The longitudinal section seems representational; it somehow contains the objects. The cross-section seems symbolic; it contains signs. Or is it only when *we* read that we place the page horizontally before us? And is there such a thing as an original vertical position for writing—say, for engraving in stone? Of course, what matters here is not the merely external fact but the spirit: Is it actually possible to base the problem on the simple principle that pictures are set vertically and signs horizontally, even though we may follow the development of this through changing metaphysical relations through the ages?

Kandinsky's pictures: the simultaneous occurrence of conjuring and manifestation.

Written in 1917; unpublished in Benjamin's lifetime. Translated by Rodney Livingstone.

Painting, or Signs and Marks

A. The Sign

The realm of the sign comprises various territories which are defined by the fact that, within their borders, "line" has various meanings. The possibilities include the geometric line, the written line, the graphic line, and the line of the absolute sign (that is to say, the line that has its magical character *as such*, not the line made magical by whatever it happens to represent).

a., b. The geometric and written lines will not be considered in what follows.

c. The graphic line. The graphic line is defined by its contrast with area. This contrast has a metaphysical dimension, as well as a visual one; the background is conjoined with the line. The graphic line marks out the area and so defines it by attaching itself to it as its background. Conversely, the graphic line can exist only against this background, so that a drawing that completely covered its background would cease to be a drawing. This confers on the background a specific role that is indispensable for the meaning of the drawing, so that in a drawing two lines can be related to each other only through the background—a feature, incidentally, that clearly distinguishes the graphic line from the geometric line.—The graphic line confers an identity on its background. The identity of the background of a drawing is quite different from that of the white surface on which it is inscribed. We might even deny it that identity by thinking of it as a surge of white waves (though these might not even be distinguishable to the naked eye). The pure drawing will not alter the meaningful graphic function of its background by "leaving it blank" as a white ground. This explains why, in

certain circumstances, representing clouds and sky in drawings is a risky venture and can act as a touchstone of the drawing's purity of style.

d. The absolute sign. In order to understand the absolute sign—that is to say, the mythological essence of the sign—it is necessary to know something of the realm of the sign in general, which we mentioned at the outset. At all events this realm is probably not a medium but an order that appears at the moment to be wholly mysterious to us. What is striking, however, is the antithesis of the absolute sign and the absolute mark. This antithesis, which is of *enormous* metaphysical importance, is not a given: it had first to be discovered. The sign appears to be more of a spatial relation and to have more reference to persons; the mark (as we shall show) is more temporal and tends to exclude the personal. Examples of absolute signs are the sign of Cain, the sign that the Israelites put on their houses during the Tenth Plague, and the presumably similar signs in *Ali Baba and the Forty Thieves*—with the necessary reservations we may deduce from these instances that the absolute sign has a predominantly spatial and personal significance.

B. The Mark

a. The absolute mark. Insofar as anything can be discovered about the nature of the absolute mark—that is to say, about the mythical nature of the mark—it will be of importance for the entire realm of the mark, in contrast to that of the sign. The first basic difference is that the sign is printed on something, whereas the mark emerges from it. This makes it clear that the realm of the mark is a medium. Whereas the absolute sign does not for the most part appear on living beings but can be impressed or appear on lifeless buildings, trees, and so on, the mark appears principally on living beings (Christ's stigmata, blushes, perhaps leprosy and birthmarks). The contrast between mark and absolute mark does not exist, for the mark is always absolute and resembles nothing else in its manifestation. What is striking is that, because it appears on living beings, the mark is so often linked to guilt (blushing) or innocence (Christ's stigmata); indeed, even where the mark appears in the form of something lifeless (such as the sunbeams in Strindberg's *Advent*), it is often a warning sign of guilt.[1] In that sense, however, it coincides with the sign (as in Belshazzar's Feast), and the awful nature of the apparition is based in large part on uniting these two phenomena, something of which only God is capable.[2] Since the link between guilt and atonement is a temporal and magical one, this *temporal* magic appears in the mark in the sense that the resistance of the present between the past and the future is eliminated, and these, magically fused, descend together on the head of the sinner. But the medium of the mark is not confined to this temporal meaning; as we are distressed to see in the

case of blushing, it also tends to dissolve the personality into certain of its basic components. This leads us back to the link between marks and guilt. The sign, however, appears not infrequently as something that distinguishes a person, and this distinction between sign and mark likewise seems to belong to the metaphysical sphere. As far as the realm of the mark *in general* is concerned, the only knowledge we can have of it in this respect will be described following our observations on painting. As we have said, however, everything that can be said of the absolute mark is of great significance for the medium of the mark in general.

b. Painting. A picture has no background. Nor is one color ever superimposed on another, but at most appears in the medium of another color. And even that is often difficult to determine, so that in principle it is often impossible to say in many paintings whether a color is on top or underneath. The question makes no sense, however. There is no background in painting, nor is there any graphic line. The reciprocal demarcations of the colored surfaces (the composition) of a painting by Raphael are not based on graphic line. The mistaken belief that they are stems partly from putting an aesthetic gloss on the purely technical fact that painters sketch the outlines before painting their pictures. But such composition has nothing to do with drawing. The only instance in which color and line coincide is in the watercolor, in which the pencil outlines are visible and the paint is put on transparently. In that case the background is retained, even though it is colored.

The medium of painting is that of the mark in the narrower sense; for painting is a medium, a mark, since it has neither background nor graphic line. The problem of painting becomes clear only when we understand the nature of the mark in the narrower sense, while feeling astonished that a picture can have a composition even though this cannot be reduced to a graphic design. The fact that such a composition is not an illusion—that, for example, the person who looks at a picture by Raphael does not perceive configurations of people, trees, and animals in the marks by chance or by mistake—becomes clear from the following consideration: if the picture were only a set of marks, it would be quite impossible to name it. The actual problem of painting can be discerned in the statement that a picture is indeed a set of marks; that, conversely, the marks in the narrower sense exist only in the picture; and, further, that the picture, insofar as it is a set of marks, is only a set of marks in the picture. But on the other hand, the picture may be connected with *something that it is not*—that is to say, something that is not a set of marks—and this happens by naming the picture. This relation to what the picture is named after, to what transcends the marks, is what is created by the composition. This signifies the entry of a higher power into the medium of the mark. This power, once there, remains in a state of neutrality, meaning it does not use graphic line to explode the mark but makes its home there without destroying it, because even though it is

immeasurably higher than the mark, it is not hostile toward it but related to it. This power is the linguistic word, which lodges in the medium of the language of painting, invisible as such and revealing itself only in the composition. The picture is named after the composition. From what has been said, it is self-evident that marks and composition are the elements of every picture that claims the right to be named. A picture that did not do this would cease to be one and would therefore enter into the realm of the mark as such; but this is something that we cannot imagine.

The great epochs of painting are distinguished according to composition and medium—that is to say, according to which word and into which mark the medium enters. It goes without saying that when we speak here about marks and words, we are not discussing the possibility of arbitrary combinations. For example, it is conceivable that in the pictures, say, of Raphael the name might predominate, and in the pictures of modern artists the judging word might enter the mark. To understand the connection between the word and the picture, the composition—that is, the act of naming—is decisive. In general, the metaphysical location of a given painting or a school of painting is determined by the mark and word characteristic of it and presupposes at the very least an elaborate distinction between the different types of mark and word, a study that is barely in its infancy.

c. Marks in space. The realm of the mark also occurs in spatial structures, just as the sign in a certain function of the line can without doubt acquire architectonic (and hence also spatial) significance. Such marks in space are visibly connected with the realm of the mark in general, but we need further investigation in order to say in what way. Above all, they appear as monuments to the dead or gravestones, but these are marks in the exact meaning of the word only if they have not been given an architectonic and sculptural shape.

Written in 1917; unpublished in Benjamin's lifetime. Translated by Rodney Livingstone.

Notes

1. Strindberg's *Advent:* A judge and his wife are pursued by *solkatten* (literally "sun cats")—sunbeams that remind them of their past sins.—*Trans.*
2. Belshazzar's Feast: See the Book of Daniel, chapter 5.—*Trans.*

The Ground of Intentional Immediacy

The ground of intentional immediacy that is part and parcel of every signifier, most notably the word, is the name within it. The relations among the word, name, and object of intention are as follows:

1. Neither the word nor the name is identical with the object of intention.

2. The name is something inherent in the object of intention (an element of it) that can be detached from it. For this reason, the name is not fortuitous.

3. The word is not the name, but the name occurs in the word bound to another element or elements. (Which? Signs?)

The relation between signs and the aforementioned three concepts:

4. The sign does not denote the object of intention, or anything in the object of intention. Consequently,

5. The sign does not denote the name of whatever is inherent in the object of intention. (Perhaps there are signs for names. These, however, would be not signs in the true sense but symbols.)

6. The sign denotes the word—that is to say, that which immediately, but not necessarily (unlike the name), signifies the object of intention.

These relations of signs to the abovementioned concepts remain unaffected by whether the name is bound to a sign or another element.

The singular nature of names permits them to occur bound up in *words*.

Symbols are not genuine signs; they cannot even be meaningfully called the signs of names. Instead they are the annexes of names, second-order names—that is to say, such as do not exist in the spoken language in which the first-order names are to be found. (The weakest variant of symbols, of second-order names, are coats of arms.)

Immediate and pure	Immediate and impure
Intentio prima	*Intentio secunda*
The pure name (refers to substance or essence. Does not signify, but is something inherent in the object that refers to its essential nature).	The signifying word (contains the name within it, has an unclear relation to the object's essential nature).

Mediate
Intentio tertia
The mere sign
(refers to the signifier).

NB: Concepts are not intentions but the objects of intentions, insofar as they are provided with a certain position in an epistemological scale. The latter may, however, be either present or absent in every instance without exception. We sometimes think concepts (alongside other objects); however, we never think *in* concepts, but in intentions.

In the statement "This sentence belongs to mathematics," the subject "this sentence" denotes not a universal concept (as does "sentence," for example) but a particular. It follows, then, either that "this sentence" (as the subject of the *statement*) is not a concept, or that concepts exist which denote particulars as well as universals. In the first case, one would have to accept the existence of signifieds without concepts—that is, the possibility of denoting particular objects. Riehl recognizes the existence of concepts that denote particulars.

It is striking that although logicians never have any difficulty accepting the view that words are signs, linguistic theorists refuse to admit this.

Riehl uses meaning and concept on the one hand, and word and linguistic sign on the other, as synonyms (*Beiträge zur Logik* [Contributions to Logic], vol. 1, part 1, p. 3).

Two concepts are never identical, as Riehl correctly points out. For example, the concept of an equilateral triangle is not identical with that of the equal-angled triangle. The statement "The equilateral triangle has equal angles" is not equivalent to the statement "The concept of the equilateral triangle is the concept of the equal-angled triangle." "The equilateral tri-

angle" as a concept is quite independent of the concept "the equal-angled triangle."

I object	: triangle
II concept	: triangle
III essence	: triangle
(pure name)	
IV word	: triangle
V sign	Δ

A statement refers to the object via the concept. The concept is employed for the purpose of recognizing the object.

If I mean "this table,"

This table is what is meant	M is S
This table is made of wood	M is P

$$S \text{ is not } P$$

What is meant signifies:
1. The object to which the act of meaning refers.
2. The object that the act of meaning produces through this

The relation of the concept to the object is not intentional, but a relation of derivation; the concept derives from the object and is related to it. It is a related object. Concepts are the objects that facilitate propositions about primal objects. These propositions take the form of statements, not concepts. The concepts are preserved and overcome [*aufgehoben*] in the statement. (Statements are not intentions either, but objects, sentences in themselves.)

Relations between concepts are never the object of statements, but only of definitions.

Fragment written in 1916–1917; unpublished in Benjamin's lifetime. Translated by Rodney Livingstone.

The Object: Triangle

I OBJECT : triangle
II concept : triangle
III essence : triangle
IV word : triangle
V name : triangle
VI sign Δ

Re Section VI. The sign never refers to the object, because it contains no intention, whereas the object is accessible only to an intention. The sign never refers necessarily to the signified; it therefore never refers to the object, because the object makes itself accessible only to a necessary, inward intention. The sign refers to what signifies the object; it denotes that which signifies the object. It denotes, for example, the word "triangle" or the mathematical drawing of a triangle (mathematical objects are not signified by words alone).

Re Section V. The name "triangle" does not exist in the language any more than there are names for most objects. The language has words only for those objects within which names lie concealed. By the power of names, words have their intention toward objects; they participate in objects through names. The name does not exist in them in a pure form, but is bound to a sign (see under IV). The name is the analogue of the knowledge of the object in the object itself. The object divides into name and essence. The name is supra-essence; it signifies the relation of the object to its essence. (?)

Re Section IV. Communication, symbol, sign, and name in the word. From these four elements the word is constituted.

The word is a linguistic component of incomparable simplicity and the highest significance. The theory of the concept has to be grounded in the assumption that the *word*, in one sense or another, is its basis. From that starting point the concept accumulates extraordinary powers, highly significant relations of its logical function to metaphysics. The statement cannot acquire that fundamental metaphysical significance which the concept has thanks to its grounding in the word (albeit perhaps on a very different plane), because the sentence on which it is based does not itself possess the same incomparable lack of ambiguity.

In the word lies "truth." In the concept lies *intentio,* or at most knowledge, but under no circumstances truth.

Fragment written in 1916–1917; unpublished in Benjamin's lifetime. Translated by Rodney Livingstone.

Perception Is Reading

In perception, the useful (the good) is true.[1] Pragmatism. Madness is a form of perception alien to the community. The accusation of madness leveled at the great scientific reformers. Inability of the masses to distinguish between knowledge and perception. Perception refers to symbols. Treatment of madness in earlier days.

Fragment written in 1917 or earlier; unpublished in Benjamin's lifetime. Translated by Rodney Livingstone.

Notes

1. The German word for "perception" *(Wahrnehmung)* contains the word "true" *(wahr).—Trans.*

On Perception

I. Experience and Knowledge [*Erfahrung und Erkenntnis*]

It is possible to retain the highest determinants of knowledge established by Kant, while still contradicting his view of the structure of our knowledge of nature or experience. These highest determinants of knowledge are based on the system of categories. It is well known, however, that Kant did not propose these determinants in isolation but made the validity of the categories for the experience of nature dependent on time and space. It is in this declaration of dependence that Kant's opposition to metaphysics is grounded. The assertion that a metaphysics is possible can have at least three meanings, of which Kant endorses one and disputes the other two. Kant produced a metaphysics of nature and in it described that part of the natural sciences which is pure—that is, which proceeds not from experience but simply from reason a priori. In other words, knowledge declares itself the system of nature. Knowledge goes on to explore what belongs to the concept of the existence of things in general, or particular things. In this sense the *metaphysics* of nature could be described as the a priori constituents of natural objects on the basis of the determinants of the knowledge of nature in general. This view of metaphysics could easily collapse into the concept of experience, and Kant feared nothing so much as this abyss. He first attempted to avoid it in order to guarantee the certainty of our knowledge of nature and above all to secure the integrity of ethics. His method was not only to relate all knowledge of nature, as well as the metaphysics of nature, to space and time as constitutive concepts but to distinguish these concepts absolutely from the categories. This meant that from the outset he avoided a unified epistemological center whose all-too-powerful gravita-

tional force might have sucked all experience into itself. On the other hand, this naturally created the need for a basis for a posteriori experience; that is, the continuity of knowledge and experience, if not the connection between them, was disrupted. Kant postulated the so-called material of sensation to express the separation of the forms of intuition from the categories. This "material of sensation" was artificially distanced from the animating center of the categories by the forms of intuition by which it was only imperfectly absorbed. In this way Kant achieved the separation of metaphysics and experience, or, to use his own terms, between pure knowledge and experience.

The fear of an exaggerated concept of reason and of the excesses of a concept of understanding that had ceased to be based on an actual intuition, the concern for the separate identity of moral knowledge—these were perhaps not the only factors influencing this basic thrust of the critique of pure reason. In addition, whether as a powerful element of these factors or as a result of them, we should note Kant's decisive rejection of the third concept of metaphysics (if indeed the second is the *un*restricted application of the categories—that is, what Kant calls their transcendent use). This third concept of the possibility of metaphysics is that of the *deduc*ibility of the world from the supreme principle or nexus of knowledge—in other words, the concept of "speculative knowledge" in the precise sense of the term. It is highly remarkable that in the interests of apriority and logic Kant discerns a sharp discontinuity at the very point where, from the same motives, pre-Kantian philosophers sought to establish the closest possible continuity and unity—that is, to create the closest possible connection between knowledge and experience through a speculative deduction of the world. The concept of experience that Kant relates to knowledge, without ever postulating continuity, has nothing like the same scope as that of earlier thinkers. What counts for him is the concept of scientific experience. Even this he strove in part to separate as far as possible from the ordinary meaning of experience, and in part, since this was only possible to a degree, to distance from the center of our understanding of knowledge. Moreover, these two fundamentally negative definitions of the concept of "scientific experience" had to be satisfied by the theory of the apriority of the two forms of *intuition,* as opposed to the apriority of the categories and thereby to the apriority of the other, illusory [*scheinbaren*] forms of intuition.

Presumably, Kant's interest in putting a stop to empty flights of fancy could have been achieved by other means than the theory of the Transcendental Aesthetic. Much more important and much more difficult, in contrast, is the question of his position vis-à-vis speculative knowledge. For in this respect the argument of the Transcendental Aesthetic is indeed the stumbling block that confronts every development of the transcendental idealism of experience into a speculative idealism. What was the reason for Kant's resistance to the idea of a speculative metaphysics—that is, a meta-

physics in which the concept of knowledge could be arrived at by a process of deduction? The question is all the more justifiable since the efforts of the neo-Kantian school[1] are directed toward the abolition of the strict distinction between the forms of intuition and the categories. But with the elimination of that distinction we begin to discern the outlines of a development of the transcendental philosophy of experience into a transcendental or speculative philosophy, if by "speculative philosophy" we mean one in which the whole of knowledge is deduced from first principles. We may perhaps venture the supposition that in an age in which experience was characterized by an extraordinary superficiality and godlessness, philosophy, if it was honest, could have no interest in salvaging this experience for its concept of knowledge. Admittedly, speculative metaphysics before Kant had confused two concepts of experience. But it is not true that Spinoza, for example, was induced by this confusion to develop a pressing interest in the deducibility of experience, whereas Kant was led by the same confusion to reject it. The distinction that must be made is between the immediate and natural concept of experience and the concept of experience in the context of knowledge. In other words, the confusion arose from conflating the concepts of "experience" and "knowledge of experience." For the concept of knowledge, experience is not anything new and extraneous to it, but only itself in a different form; experience as the object of knowledge is the unified and continuous manifold of knowledge. Paradoxical though it sounds, experience does not occur as such in the knowledge of experience, simply because this is knowledge of experience and hence a context of knowledge. Experience, however, is the symbol of this context of knowledge and therefore belongs in a completely different order of things from knowledge itself. The term "symbol" may be an unfortunate choice; it is employed here simply to point to different conceptual realms. This can perhaps be elucidated best by an image: if a painter sits in front of a landscape and "copies" it (as we say), the landscape itself does not occur in the picture; it could at best be described as the symbol of its artistic context. Of course by designating it in this way we endow it with a greater dignity than the picture itself, and that, too, is perfectly justifiable. / The pre-Kantian confusion of experience with the knowledge of experience dominates Kant's thinking, too, but the general world picture had changed by then. Previously the symbol of the unity of knowledge that we know of as "experience" had been an exalted one; it had, even though to varying degrees, been close to God and divine. During the Enlightenment, however, it was increasingly stripped of its proximity to God. In this changed situation the basic philosophical interest in the logical deducibility of the world, the fundamental interest of knowledge, inevitably suffered because of the abovementioned confusion between "experience" and "knowledge of experience." There was no longer any interest in the necessity of the world. Instead, philosophers now concerned themselves with scrutinizing its contingent nature, its nonde-

ducibility, since they were confronted with a godless experience which they mistakenly imagined earlier philosophers had arrived at (or had wished to arrive at) by a process of deduction. They failed to inquire what sort of "experience" they were dealing with, an experience that could have been arrived at only through deduction, if it had been a form of knowledge. Kant was as ignorant as his predecessors of the distinction between "experience" and "knowledge of experience." But he was intent on abandoning the deduction of that "empty, godless experience"; it held no further interest. Just as, despite all the efforts of the philosophers, even the most divine experience could not, then or ever, be reached by a process of deduction, and because Kant had no desire to arrive at that empty experience through a process of deduction, he also declared that experience as knowledge could never be arrived at by deductive means either. This makes it clear that everything depends on the way in which the concept of "experience" in the term "knowledge of experience" is related to "experience" in ordinary use. The first point to be made is that this linguistic usage is not an error. That is to say, the "experience" we experience in reality is identical with what we know in our knowledge of experience. If that is so, we must ask further: How must we define this identity of experience in the two instances? And why do we treat the two situations differently, inasmuch as we experience the identity in the case of experience but deduce it in the case of knowledge?

Philosophy is absolute experience deduced in a systematic, symbolic framework as language.

Absolute experience is, in the view of philosophy, language—language understood, however, as systematic, symbolic concept. It is articulated in types of language, one of which is perception. Doctrines of perception, as well as of all immediate manifestations of absolute experience, belong in the "philosophical sciences" in the broader sense. Philosophy as a whole, including the philosophical sciences, is teachings.[2]

Note:
To be in the being of knowledge is to know.

Fragment written in 1917; unpublished in Benjamin's lifetime. Translated by Rodney Livingstone.

Notes

1. The Neo-Kantians sought to ground Kant's epistemology in a theory of experience based upon rigorously mathematical and scientific models. Benjamin had studied under one leading Neo-Kantian, Heinrich Rickert, and had read extensively in the work of another, Hermann Cohen.—*Trans.*
2. The term *Lehre* signifies something between "religious doctrine" and "teachings."—*Trans.*

Comments on Gundolf's *Goethe*

At the beginning of the book we find a distinction drawn among the three concentric life circles of a creative man and of Goethe in particular. They are works, letters, and conversations. (If I recollect correctly. Or does Gundolf[1] place the last two in the same category and add a third, intermediate one? No matter.) He makes the works the central circle, and the one to which reference must chiefly be made. He resists the notion that the consideration of other sources and evidence could contribute significantly to our valuation of Goethe. The objective dishonesty in this division is as follows: The analogy on which it is based is both valid and necessary in historical writing, where it derives from a critical assessment of the relative value of historical sources. Thus, a distinction is made between written and oral sources, and this makes possible a scale covering the spectrum of possibilities between the written and oral traditions. This valid analogue of the Gundolfian falsification is important above all where the most vital distinction can be found between the two traditions—namely, in the realm of myth and religion, where the conflict and compromises reached regulate mankind's relation to its ultimate foundations (revelation). Where the distinction is legitimate, the historian should never regard it as one of value, only of significance. In Gundolf's case this is reversed. The two peripheral circles are given an almost negative value for the historiographer; they have no deeper significance for him. Moreover, their only legitimizing basis, the distinction between speech and writing, is not present at all. This means converting every conceivable aspect of the "oral tradition" (letters, conversations, and so on) into written testimony, but the total transformation of all oral evidence (including that of *private life*) into written form creates a

completely different conception of the written word from the one that obtains in the realm of myth and religion. Furthermore, it is true that within this new conception the works do have a place, but not in that false exclusivity and monumentality which Gundolf ascribes to them.

Without dwelling on the possibility of a book on Goethe in general, one must make this negative critical point: Gundolf saw himself confronted by two possibilities. First, a dignified, serious, and ambitious conception of history (pragmatic history, in short) of which the methodological distinction between written and oral sources forms an integral part. Second, an imposing sense of Goethe's presence. Both are quite indistinct, because both considerably exceed his own abilities. But how does he assimilate such great objects? (The concept of this assimilation is comparable to the basic critical concept of objective dishonesty.) He applies the categories of history *in a vacuum,* by matching them with a completely inappropriate subject— namely, Goethe as an individual. He goes on to create an apparently powerful but in reality entirely vacuous portrait of Goethe. For does Gundolf actually have an image of Goethe—that is, an idea—in mind? Anything but. He is simply attempting to use him to verify a methodological idea whose conceptual implications he is incapable of grasping. Furthermore, the actual verification is a cheat as well, since he does not apply his idea to Goethe. That would be impossible in the absence of concepts. Or, to put it subjectively, given his intellectual unscrupulousness, Gundolf instead tries to present Goethe as the empirical (!) embodiment of that methodological approach. Looked at from another angle, the morally repugnant aspect of this business can be described as the falsification of a historical individual, namely Goethe, by transforming him into a mythical hero. Moreover, since the sparse sources yield only an obscure picture, Goethe's existence has to be inferred within the broadest historical categories exclusively from his works and can therefore be described only in vague outline. This mere semblance results from the fact that the object of study has been formally emptied and converted into the barest possible descriptive scheme, something that an individual can never be. All the more welcome for the reader, then, is the optical illusion that transforms the empty formula into a demigod conjured up by the author. In reality, Gundolf has nothing convincing to say about Goethe; individual insights disintegrate into empty phrases when he tries to expand them into larger judgments, and at every point simple concepts have been replaced by the most rebarbative expressions. The whole thing is a blasphemous travesty of the idea, to which he gives no object, and of the object, whom he turns into a puppet because he attempts to portray him directly in terms of his idea. (In this void he finds space for all his whims and fancies, his arbitrary and inane linguistic hodgepodge.) More than in any other case, the biographer (or better: the historian) of Goethe's life must be a backward-looking prophet. But how cold Gundolf

is when confronted by the need to interpret Goethe's life and works as symbols of specific yet also future life and *suffering*. When that happens he falls back on the device of spinning a thread between Goethe and one or another aspect of modern literature, because the meaning of Goethe's life for the most specific and profound tasks of modern life is a closed book to him. It is no wonder: these are tasks to which he has closed his own mind. (In this respect we may say that the most insignificant scrivener of literary history exhibits a superior sensibility when he registers his own little judgments about the value or lack of value, or immortality and its opposite, of poets and their works. Even though Gundolf's own writings arose from his reaction against the spiritual poverty of such a procedure, his own weaknesses have prevented him from destroying it through his own actions.)

Once we have clarified the methods underpinning such a product [*Gebild*], we must still inquire into its possibility. This points to the deepest and as yet wholly unresolved riddles of metaphysics. *Language* itself must contain the possibility of enabling such a book to contest its own semblance [*seinen Schein bestreiten*]. This semblance is just as objectively real as the (false) contents of the proposition that $2 + 2 = 5$ are objectively real in logic. From the philosophy of language as well as epistemology, the question arises about the objective possibility of semblance and error. Such illusions and errors are what makes Gundolf's language possible. His book is a veritable falsification of knowledge.

Fragment written ca. 1917; unpublished in Benjamin's lifetime. Translated by Rodney Livingstone.

Notes

1. Friedrich Gundolf, pseudonym of Friedrich Gundelfinger (1880–1931), disciple of Stefan George, prominent literary critic and, after 1920, professor at Heidelberg. In 1917, when Benjamin wrote this text, Gundolf was Germany's most powerful critical voice.—*Trans.*

On the Program of the Coming Philosophy

The central task of the coming philosophy will be to take the deepest intimations it draws from our times and our expectation of a great future, and turn them into knowledge by relating them to the Kantian system. The historical continuity that is ensured by following the Kantian system is also the only such continuity of decisive and systematic consequence. For Kant is the most recent of those philosophers for whom what mattered was not primarily the scope and depth of knowledge but first and foremost its justification, and with the exception of Plato he is perhaps the only one. Both of these philosophers share a confidence that the knowledge of which we can give the clearest account will also be the most profound. They have not dismissed the demand for depth in philosophy, but have found their own unique way of meeting it by identifying it with the demand for justification. The more unpredictably and boldly the development of future philosophy announces itself, the more deeply it must struggle for certainty, whose criterion is systematic unity or truth.

Nevertheless, the most important obstacle to linking a truly time- and eternity-conscious philosophy to Kant is the following: The reality with which, and with the knowledge of which, Kant wanted to base knowledge on certainty and truth is a reality of a low, perhaps the lowest, order. The problem faced by Kantian epistemology, as by every great epistemology, has two sides, and Kant managed to give a valid explanation for only one of them. First of all, there was the question of the certainty of knowledge that is lasting, and, second, there was the question of the integrity of an experience that is ephemeral. For universal philosophical interest is continually directed toward both the timeless validity of knowledge and the certainty

of a temporal experience which is regarded as the immediate, if not the only, object of that knowledge. This experience, in its total structure, had simply not been made manifest to philosophers as something singularly temporal, and that holds true for Kant as well. Especially in the *Prolegomena*, Kant wanted to take the principles of experience from the sciences—in particular, mathematical physics; yet from the very beginning, and even in the *Critique of Pure Reason*, experience itself and unto itself was never identical with the object realm of that science. Even if it had become so for him, as it did for the neo-Kantian thinkers, the concept of experience thus identified and determined would still have remained the old concept of experience, which is distinguished by its relationship not only to pure consciousness but to empirical consciousness as well.[1] But this is precisely what is at issue: the concept of the naked, primitive, self-evident experience, which, for Kant, as a man who somehow shared the horizon of his times, seemed to be the only experience given—indeed, the only experience possible. This experience, however, as already indicated, was unique and temporally limited. Above and beyond this form, which it shares with every type of experience, this experience, which in a significant sense could be called a *world view,* was that of the Enlightenment. But in its most essential characteristics, it is not all that different from the experience of the other centuries of the modern era. As an experience or a view of the world, it was of the lowest order. The very fact that Kant was able to commence his immense work under the constellation of the Enlightenment indicates that he undertook his work on the basis of an experience virtually reduced to a nadir, to a minimum of significance. Indeed, one can say that the very greatness of his work, his unique radicalism, presupposed an experience which had almost no intrinsic value and which could have attained its (we may say) sad significance only through its certainty. Of the pre-Kantian philosophers, none saw himself confronted with the task in this sense. Nor did any of them have such a free hand, since an experience whose best aspect, whose quintessence, was Newtonian physics, with all its certainty, could take rough and tyrannical treatment without suffering. For the Enlightenment there were no authorities, in the sense not only of authorities to whom one would have to submit unconditionally, but also of intellectual forces who might have managed to give a higher context to experience. Just *what* the lower and inferior nature of experience in those times amounts to, just where its astonishingly small and specifically metaphysical weight lies, can only be hinted at in the perception as to how this low-level concept of experience also had a restricting effect on Kantian thought. It is obviously a matter of that same state of affairs that has often been mentioned as the religious and historical blindness of the Enlightenment, with no recognition of the extent to which these features of the Enlightenment pertain to the entire modern era.

It is of the greatest importance for the philosophy of the future to recog-

nize and sort out which elements of the Kantian philosophy should be adopted and cultivated, which should be reworked, and which should be rejected. Every demand for a return to Kant rests upon the conviction that this system, which encountered a notion of experience whose metaphysical aspect met with the approval of men such as Mendelssohn and Garve, has, by virtue of its brilliant exploration of the certainty and justification of knowledge, derived and developed a depth that will prove adequate for a new and higher kind of experience yet to come.[2] This simultaneously presents the primary challenge faced by contemporary philosophy and asserts that it can be met: it is, according to the typology of Kantian thought, to undertake the epistemological foundation of a higher concept of experience. And precisely this is to be made the theme of the expected philosophy: that a certain typology can be demonstrated and clearly drawn out from the Kantian system—a typology which can do justice to a higher experience. Nowhere does Kant deny the possibility of a metaphysics; he merely wishes to have criteria set up against which such a possibility can be proven in the individual case. The notion of experience held in the Kantian age did not require metaphysics; the only thing historically possible in Kant's day was to deny its claims, because the demand of his contemporaries for metaphysics was weakness or hypocrisy. Thus, it is a question of finding, on the basis of Kantian typology, prolegomena to a future metaphysics and, in the process, of envisioning this future metaphysics, this higher experience.

But it is not only with reference to experience and metaphysics that philosophy must be concerned with the revision of Kant. And methodically considered—that is, as true philosophy should consider it—the revision should begin not with reference to experience and metaphysics but with reference to the concept of knowledge. The decisive mistakes of Kant's epistemology are, without a doubt, traceable to the hollowness of the experience available to him, and thus the double task of creating both a new concept of knowledge and a new conception of the world on the basis of philosophy becomes a single one. The weakness of the Kantian concept of knowledge has often been felt in the lack of radicalism and the lack of consistency in his teachings. Kant's epistemology does not open up the realm of metaphysics, because it contains within itself primitive elements of an unproductive metaphysics which excludes all others. In epistemology every metaphysical element is the germ of a disease that expresses itself in the separation of knowledge from the realm of experience in its full freedom and depth. The development of philosophy is to be expected because each annihilation of these metaphysical elements in an epistemology simultaneously refers it to a deeper, more metaphysically fulfilled experience. There is—and here lies the historical seed of the approaching philosophy—a most intimate connection between that experience, the deeper exploration of which could never lead to metaphysical truths, and that theory of knowl-

edge, which was not yet able to determine sufficiently the logical place of metaphysical research. Nonetheless, the sense in which Kant uses, for instance, the term "metaphysics of Nature" seems definitely to lie in the direction of the exploration of experience on the basis of epistemologically secured principles. The inadequacies with respect to experience and metaphysics manifest themselves within epistemology itself as elements of speculative metaphysics (that is, metaphysics that has become rudimentary). The most important of these elements are, first, Kant's conception of knowledge as a relation between some sort of subjects and objects or subject and object—a conception that he was unable, ultimately, to overcome, despite all his attempts to do so; and, second, the relation of knowledge and experience to human empirical consciousness, likewise only very tentatively overcome. These two problems are closely interconnected, and even to the extent that Kant and the neo-Kantians have overcome the object nature of the thing-in-itself as the cause of sensations, there remains the subject nature of the cognizing consciousness to be eliminated. This subject nature of this cognizing consciousness, however, stems from the fact that it is formed in analogy to the empirical consciousness, which of course has objects confronting it. All of this is a thoroughly metaphysical rudiment of epistemology, a piece of just that shallow "experience" of these centuries which has crept into epistemology. It simply cannot be doubted that the notion, sublimated though it may be, of an individual living ego which receives sensations by means of its senses and forms its ideas on the basis of them plays a role of the greatest importance in the Kantian concept of knowledge. This notion is, however, mythology, and so far as its truth content is concerned, it is the same as every other epistemological mythology. We know of primitive peoples of the so-called preanimistic stage who identify themselves with sacred animals and plants and name themselves after them; we know of insane people who likewise identify themselves in part with objects of their perception, which are thus no longer *objecta*, "placed before" them; we know of sick people who relate the sensations of their bodies not to themselves but rather to other creatures, and of clairvoyants who at least claim to be able to feel the sensations of others as their own. The commonly shared notion of sensuous (and intellectual) knowledge in our epoch, as well as in the Kantian and the pre-Kantian epochs, is very much a mythology like those mentioned. In *this* respect, so far as the naive conception of the receipt of perceptions is concerned, Kantian "experience" is metaphysics or mythology, and indeed only a modern and religiously very infertile one. Experience, as it is conceived in reference to the individual living human and his consciousness, instead of as a systematic specification of knowledge, is again in all of its types the mere *object* of this real knowledge, specifically of its psychological branch. The latter divides empirical consciousness systematically into types of madness. Cognizing man, the cognizing empirical con-

sciousness, is a type of insane consciousness. This means nothing more than that within the empirical consciousness there are only gradual differences among its various types. These differences are simultaneously differences of value, but their criterion cannot be the correctness of cognitions and is never the issue in the empirical, psychological sphere; to determine the true criteria for differentiating between the values of the various types of consciousness will be one of the highest tasks of the future philosophy. Corresponding to the types of empirical consciousness are just as many types of experiences, which in regard to their relation to the empirical consciousness, so far as truth is concerned, have the value only of fantasy or hallucination. For an objective relation between the empirical consciousness and the objective concept of experience is impossible. All genuine experience rests upon the pure "epistemological (transcendental) consciousness," if this term is still usable under the condition that it be stripped of everything subjective. The pure transcendental consciousness is different in kind from any empirical consciousness, and the question therefore arises of whether the application of the term "consciousness" is allowable here. How the psychological concept of consciousness is related to the concept of the sphere of pure knowledge remains a major problem of philosophy, one which perhaps can be set aside only through recourse to the age of Scholasticism. Here is the logical place for many problems that phenomenology has recently raised anew. Philosophy is based upon the fact that the structure of experience lies within the structure of knowledge and is to be developed from it. This experience, then, also includes religion, as the true experience, in which neither god nor man is object or subject of experience but in which this experience depends on pure knowledge as the quintessence of which philosophy alone can and must think god. The task of future epistemology is to find for knowledge the sphere of total neutrality in regard to the concepts of both subject and object; in other words, it is to discover the autonomous, innate sphere of knowledge in which this concept in no way continues to designate the relation between two metaphysical entities.

It should be made a tenet of the program of future philosophy that in the course of the purification of epistemology which Kant ensured could be posed as a radical problem—while also making its posing necessary—not only a new concept of knowledge but also a new concept of experience should be established, in accordance with the relationship Kant found between the two. Of course, as was said, neither experience nor knowledge may be bound to the empirical consciousness in this process; but here, too, it would continue to be the case, indeed it would first derive its proper significance to say that the conditions of knowledge are those of experience. This new concept of experience, which would be established on the basis of the new conditions of knowledge, would itself be the logical place and the logical possibility of metaphysics. For when he made metaphysics a problem and experience the only basis of knowledge, Kant had no other reason than

the fact that, as he proceeded from his concept of experience, the possibility of a metaphysics that would have the importance of previous metaphysics (properly understood; not the possibility of having a metaphysics at all) would have had to seem excluded. Apparently, however, metaphysics is not distinguished solely by the illegitimacy of its insights, at least not for Kant, who would otherwise hardly have written prolegomena to it. Its distinctiveness lies, rather, in its universal power to tie all of experience immediately to the concept of God, through ideas. Thus, the task of the coming philosophy can be conceived as the discovery or creation of that concept of knowledge which, by relating experience *exclusively* to the transcendental consciousness, makes not only mechanical but also religious experience logically possible. This should definitely be taken to mean not that knowledge makes God possible but that it definitely does make the experience and doctrine of him possible in the first place.

In the development of philosophy called for and considered proper here, one symptom of neo-Kantianism can already be detected. A major problem of neo-Kantianism was to eliminate the distinction between intuition and intellect, a metaphysical rudiment that occupies a position like that of the theory of the faculties in Kant's work. With this—that is, with the transformation of the concept of knowledge—there also began a transformation of the concept of experience. For there is no doubt that Kant does not intend to reduce all experience so exclusively to scientific experience, no matter how much it may belong, in some respects, to the training of the historical Kant. Certainly Kant tended to avoid dividing and fragmenting experience into the realms of the individual sciences. Even if later epistemology has to deny recourse to commonly understood experience (such as occurs in Kant), on the other hand, in the interest of the continuity of experience, representation of experience as the system of the sciences as the neo-Kantians have it is still lacking. A way must be found in metaphysics to form a pure and systematic continuum of experience; indeed, it seems that the true meaning of experience is to be sought in this area. But in the neo-Kantian rectification of one of Kant's metaphysicizing thoughts (not the fundamental one), a modification of the concept of experience occurred—significantly enough, first of all in the extreme extension of the mechanical aspect of the relatively empty Enlightenment concept of experience. It should by no means be overlooked that the concept of freedom stands in a peculiar correlation to the mechanical concept of experience and was accordingly further developed in neo-Kantianism. But here, too, it must be emphasized that the entire context of ethics can no more be absorbed into the concept of morality held by Kant, the Enlightenment, and the Kantians than the context of metaphysics fits into that which they call experience. With a new concept of knowledge, therefore, not only the concept of experience but also that of freedom will undergo a decisive transformation.

One could actually argue here that, with the discovery of a concept of

experience which would provide a logical place for metaphysics, the distinction between the realms of nature and freedom would be abolished. Yet here, where we are concerned solely with a program of research and not with proof, only this much need be said: no matter how necessary and inevitable it may be to reconstruct, on the basis of a new transcendental logic, the realm of dialectics, the realm of the crossover between the theory of experience and the theory of freedom, it is just as imperative that this transformation not end up in a confounding of freedom and experience, even though the concept of experience may be changed in the metaphysical realm by the concept of freedom in a sense that is perhaps as yet unknown. For no matter how incalculable the changes may be that will reveal themselves to research here, the trichotomy of the Kantian system is one of the great features of that typology which is to be preserved, and it, more than any other, must be preserved. One may well ask whether the second part of the system (quite apart from the difficulty of the third) must still be related to ethics or whether the category of causality through freedom might have a different meaning. The trichotomy, whose metaphysically deepest aspects are still undiscovered, has its decisive foundation within the Kantian system in the trinity of the relational categories. In the absolute trichotomy of the system, which in this threefold aspect is related to the entire realm of culture, lies one of the reasons for the world-historical superiority of Kant's system over that of his predecessors. The formalist dialectic of the post-Kantian systems, however, is not based on the definition of the thesis as categorical relation, the antithesis as hypothetical relation, and the synthesis as disjunctive relation. But besides the concept of synthesis, another concept, that of a certain nonsynthesis of two concepts in another, will become very important systematically, since another relation between thesis and antithesis is possible besides synthesis. This can hardly lead to a fourfold structure of relational categories, however.

But if the great trichotomy must be preserved for the structuring of philosophy, even while the components themselves are still misdefined, the same does not hold true for all the individual schemata of the system. Just as the Marburg school has already begun with the sublation of the distinction between transcendental logic and aesthetics (even though it is possible that an analogue of this distinction might return on a higher level), so must the table of categories be completely revised, as is now generally demanded. In this very process, then, the transformation of the concept of knowledge will begin to manifest itself in the acquisition of a new concept of experience, since the Aristotelian categories are both arbitrarily posed and have been exploited in a very one-sided way by Kant in the light of mechanical experience. First and foremost, one must consider whether the table of categories must remain in its present isolation and lack of mediation, or whether it could not take a place among other members in a theory of orders

or itself be built up to such a theory, founded upon or connected to primal concepts [*Urbegriffe*]. Such a theory of orders would also comprise that which Kant discusses in the transcendental aesthetic, and, furthermore, all the basic concepts not only of mechanics but also of geometry, linguistics, psychology, the descriptive natural sciences, and many others, to the extent that these concepts had a direct relation to the categories or the other highest ordering concepts of philosophy. Outstanding examples here are the principles of grammar. Furthermore, one must recall that, with the radical elimination of all those elements in epistemology that provide the concealed answer to the concealed question about the origins of knowledge, the great problem of the false or of error is opened up, whose logical structure and order must be ascertained just like those of the true. Error can no longer be explained in terms of erring, any more than the true can be explained in terms of correct understanding. For this investigation of the logical nature of the false and the mistaken, the categories are likewise presumably to be found in the theory of the orders; everywhere in modern philosophy the recognition crops up that categorical and related orders are of central importance for the knowledge of an experience which is multiply gradated and nonmechanical. Art, jurisprudence, and history: these and other areas must orient themselves according to the theory of categories with much more intensity than Kant oriented them. But at the same time, one of the greatest problems of the system occurs in regard to the transcendental logic, specifically the question of its third part—in other words, the question of those scientific types of experience (the biological ones) which Kant did not treat on the ground of the transcendental logic; one must also inquire why he did not do so. Furthermore, the question of the relationship of art to this third part of the system and of ethics to the second part: the fixing of the concept of identity, unknown to Kant, will likely play a great role in the transcendental logic, inasmuch as it does not occur in the table of categories yet presumably constitutes the highest of transcendental logical concepts and is perhaps truly suited to founding the sphere of knowledge autonomously beyond the subject-object terminology. The transcendental dialectic already displays, in the Kantian formulation, the ideas upon which the unity of experience rests. As already mentioned, however, for the deepened concept of experience continuity is almost as indispensable as unity, and the basis of the unity and continuity of that experience which is not vulgar or only scientific, but metaphysical, must be demonstrated in the ideas. The convergence of ideas toward the highest concept of knowledge must be shown.

Just as Kantian theory itself, in order to find its principles, needed to be confronted with a science with reference to which it could define them, modern philosophy will need this as well. The great transformation and correction which must be performed upon the concept of experience, ori-

ented so one-sidedly along mathematical-mechanical lines, can be attained only by relating knowledge to language, as was attempted by Hamann during Kant's lifetime.[3] For Kant, the consciousness that philosophical knowledge was absolutely certain and a priori, the consciousness of that aspect of philosophy in which it is fully the peer of mathematics, ensured that he devoted almost no attention to the fact that all philosophical knowledge has its unique expression in language and not in formulas or numbers. This fact, however, might well ultimately prove to be the decisive one, and it is ultimately because of this fact that the systematic supremacy of philosophy over all science as well as mathematics is to be asserted. A concept of knowledge gained from reflection on the linguistic nature of knowledge will create a corresponding concept of experience which will also encompass realms that Kant failed to truly systematize. The realm of religion should be mentioned as the foremost of these. Thus, the demand upon the philosophy of the future can ultimately be put in these words: to create on the basis of the Kantian system a concept of knowledge to which a concept of experience corresponds, of which the knowledge is the teachings [*Lehre*].[4] Such a philosophy in its universal element would either itself be designated as theology or would be superordinated to theology to the extent that it contains historically philosophical elements.

Experience is the uniform and continuous multiplicity of knowledge.

Addendum

In the interest of clarifying the relation of philosophy to religion, the contents of the preceding essay should be repeated to the extent that it concerns the systematic schema of philosophy. It is concerned first of all with the relationship among the three concepts, epistemology, metaphysics, and religion. All of philosophy breaks down into epistemology and metaphysics, or, as Kant would say, into a critical and a dogmatic part. This division, however, is—not as an indication of content but as a principle of classification—not of principal importance. With it, one is trying to say only that upon the basis of all the critical ensuring of cognitive concepts and the concept of knowledge, a theory can now be built up of that on which in the very first place the concept of knowledge is epistemologically fixed. Where the critical ends and the dogmatic begins is perhaps not clearly demonstrable, because the concept of the dogmatic is supposed to designate only the transition from critique to teachings, from the more general to particular fundamental concepts.

All philosophy is thus theory of knowledge, but just that—a theory, critical and dogmatic, of all knowledge. Both parts, the critical and the dogmatic, fall completely within the realm of the philosophical. Since this is the case, since it is not true that, for instance, the dogmatic part coincides

with that of individual sciences, the question naturally arises as to the borderline between philosophy and individual sciences. The meaning of the term "metaphysical," as introduced in the foregoing, consists precisely in declaring this border nonexistent, and the reformulation of "experience" as "metaphysics" means that so-called experience is virtually included in the metaphysical or dogmatic part of philosophy, into which the highest epistemological—that is, the critical—is transformed. (For examples of this relation in the area of physics, see my essay on explanation and description.) If the relations among epistemology, metaphysics, and the individual sciences are thus very generally outlined, two questions remain. First, that of the relation of the critical to the dogmatic moment in ethics and aesthetics, which we can leave aside here since we must postulate a solution in a manner perhaps systematically analogous to that in the domain of physics. Second, there is the question of the relation between philosophy and religion. To begin with, it is now clear that what is at stake is not the issue of the relationship between philosophy and religion but that between philosophy and the teachings of religion—in other words, the question of the relation between knowledge in general and knowledge of religion. The question of existence raised by religion, art, and so on can also play a role philosophically, but only on the path of inquiry into the philosophical *knowledge* of such existence. Philosophy always inquires about knowledge, in relation to which the question of the knowledge of its existence is only a modification, albeit an incomparably marvelous modification, of the question of knowledge in general. Indeed, it must be said that philosophy in its questionings can never hit upon the unity of existence, but only upon new unities of various conformities to laws, whose integral is "existence."—The original or primal concept of epistemology has a double function. On the one hand, this concept is the one which by its specification, after the general logical foundation of knowledge, penetrates to the concepts of specific types of cognition and thus to specific types of experience. This is its real epistemological significance and simultaneously the one weaker side of its metaphysical significance. However, the original and primal concept of knowledge does not reach a concrete totality of experience in this context, any more than it reaches a concept of existence. But there is a unity of experience that can by no means be understood as a sum of experiences, to which the concept of knowledge as teaching is *immediately* related in its continuous development. The object and the content of this teaching, this concrete totality of experience, is religion, which, however, is presented to philosophy in the first instance only as teaching. Yet the source of existence lies in the totality of experience, and only in teaching does philosophy encounter something absolute, as existence, and in so doing encounter that continuity in the nature of experience. The failing of neo-Kantianism can be suspected in its neglect of this continuity. In a *purely* metaphysical respect, the original

concept of experience in its totality is transformed in a sense quite different from the way it is transformed in its individual specifications, the sciences—that is, immediately, where the meaning of this immediacy vis-à-vis the former mediacy remains to be determined. To say that knowledge is metaphysical means in the strict sense: it is related via the original concept of knowledge to the concrete totality of experience—that is, *existence*. The philosophical concept of existence must answer to the religious concept of teachings, but the latter must answer to the epistemological original concept. All of this is only a sketchy indication. The basic tendency of this definition of the relationship between religion and philosophy, however, is to meet the demands for, first, the virtual unity of religion and philosophy; second, the incorporation of the knowledge of religion into philosophy; third, the integrity of the tripartite division of the system.

Written in 1918; unpublished in Benjamin's lifetime. Translated by Mark Ritter.

Notes

1. The Neo-Kantians sought to ground Kant's epistemology in a theory of experience based upon rigorously mathematical and scientific models. Benjamin had studied under one leading Neo-Kantian, Heinrich Rickert, and had read extensively in the work of another, Hermann Cohen.—*Trans.*
2. Moses Mendelssohn (1729–1786), prominent German-Jewish moral and aesthetic philosopher; and Christian Garve (1742–1798), moral philosopher and translator of the English philosophy of the eighteenth century.—*Trans.*
3. Johann Georg Hamann (1730–1788), German theologian and philosopher whose rhapsodic, elliptical style and appeal to affect and intuition led to controversies with eighteenth-century rationalists (Kant among them) but exerted a powerful influence on Herder and the authors of the *Sturm und Drang.—Trans.*
4. The word *Lehre* figures prominently in Benjamin's discussions with Gershom Scholem during this period. It signifies something between "religious doctrine" and "teachings." Scholem recalls that Benjamin understood the *Lehre* to represent the proper understanding of not only the "status and path of mankind" but also the "transcausal connectedness of things and their constitution in God." Scholem, *Walter Benjamin: The Story of a Friendship* (Philadelphia: Jewish Publication Society of America, 1981), p. 73.—*Trans.*

Stifter

I

One misunderstanding about Stifter seems to me highly dangerous because
it ends up in the orbit of mistaken metaphysical convictions about what
man needs in his relation to the world.[1] There can be no doubt that Stifter
has given us some quite wonderful descriptions of nature, and that he has
also said some marvelous things about human life insofar as it has not yet
been transformed into destiny—that is to say, insofar as it is still concerned
with children, as in *Bergkristall* [Mountain Crystal]. But the gigantic fallacy
he commits is one that he himself has described, without recognizing it for
what it is. It is found in the preface to *Bunte Steine*,[2] where he writes about
great and small events in the world and attempts to represent the relation
between them as a deceptive and unimportant, even relative one. In fact,
he has no appreciation for the purity and sense of order that obtain in the
basic relations between man and the world; in other words, he has no sense
of justice in the highest meaning of the word. While reflecting on the way
in which he unfolds the *destiny* of his characters in his various books—
in *Abdias, Tourmaline, Brigitta,* and an episode in *Die Mappe meines
Urgroßvaters* [My Great-Grandfather's Diary]—I have constantly been
aware of the obverse, the shadow side, of his self-imposed limitation to a
depiction of the apparently insignificant aspects of life. The fact is that he
neither can nor wishes to restrict himself solely to describing these things,
and he therefore goes beyond description to extend that simplicity to the
great events of fate, even though these necessarily have a simplicity and
purity of quite a different kind, namely one that cohabits with greatness or,
better, justice. It then becomes evident that in Stifter a shadow is cast over

nature, a rebellion takes place, which turns into something horrifying and demonic. This enters his female figures (Brigitta; the colonel's wife), where its perverted and subtly disguised demonic force assumes the innocent aspect of simplicity. Stifter is conversant with nature, but at the frontier between nature and destiny his knowledge is less secure and he fails to convince as a writer. This can be quite embarrassing, as in the conclusion of *Abdias*, for example. Self-assurance in such matters can be derived only from a highly developed inner sense of justice, but in Stifter a different impulse was obsessively at work. This appeared simpler, but in truth it was a subhuman, demonic, and even phantom-like attempt to harmonize the moral world and destiny with nature. In actual fact, this harmony was a secret bastardization. On closer inspection, its uncanny features always make their appearance in passages where he is "interesting" in a quite specific sense.—Stifter has a dual nature, two faces. The impulse toward purity sometimes becomes divorced from the yearning for justice. It then loses itself in minutiae only to re-emerge like a phantom, exaggerated (this is quite possible!) in large-scale events as a mixture in which purity and impurity can no longer be distinguished.

There can be no ultimately enduring metaphysical purity without a struggle to perceive the highest and most extreme laws governing the world, and we should not forget that such a struggle was alien to Stifter.

II

He can create only on the visual plane. This does not mean that he reproduces only visible phenomena, for as an artist he possesses style. The problem of his style is that he takes all things as an approach to the metaphysically visual sphere. One immediate consequence of this is that he has no way of perceiving any revelation which can only be *heard*—that is, which belongs to the metaphysically acoustic realm. This also explains the role of the basic characteristic of his writings: their emphasis on peacefulness. For peacefulness is, above all, the absence of any acoustic sensation.

The speech of Stifter's characters is ostensive. It is the exposition of feelings and thoughts in an acoustically insulated space. He completely lacks the ability to depict any deeper emotion or "shock," for example, which must primarily be expressed in speech. The demonic aspect that characterizes his writings to a greater or lesser degree is based on this inability, and is most clearly manifest where he chooses a surreptitious line of advance because he is unable to discover the liberating utterance that lies near at hand and would assure his salvation. He is spiritually mute—that is to say, he lacks that contact with the essence of the world, with language, from which speech arises.

Written in 1918; unpublished in Benjamin's lifetime. Translated by Rodney Livingstone.

Notes

1. Adalbert Stifter (1805–1868), Austrian writer whose short prose and novels are characterized by an unusually graceful style and a reverence for natural process.—*Trans.*
2. *Bunte Steine* [Colored Stones], first published in 1853, is the collection of novellas that includes *Bergkristall* and *Tourmaline.—Trans.*

Every Unlimited Condition of the Will

Every unlimited condition of the will leads to evil. Ambition and lust are unlimited expressions of will. As the theologians have always perceived, the natural totality of the will must be destroyed. The will must shatter into a thousand pieces. The elements of the will that have proliferated so greatly limit one another. This gives rise to the limited, terrestrial will. Whatever goes beyond them and calls for the (supreme) unity of intention is not the object of the will; it does not require the intention of the *will*. Prayer, however, can be unlimited.

Fragment written in 1918; unpublished in Benjamin's lifetime. Translated by Rodney Livingstone.

Types of History

Natural history	Developmental stages of phenomena
Cosmogony	Divine history
Universal history	Linear causality from the standpoint of which:
	Natural history becomes history of creation
	Universal history becomes revelation

Natural history exists only as cosmogony or as the history of creation. Herder's conception of this is mistaken, regarded from an earthly standpoint, but the earth is, in itself, a *world*-historical individual because human beings live on it.

The correspondence between phenomena is valid not just for the cosmos but also for terrestrial nature (for which the correspondence in universal history is also relevant), as well as for *anthropos* as a phenomenon—for example, as a sexual being—up to the limits of history.

Natural history does not extend to mankind, any more than does universal history; it knows only the individual. Man is neither a phenomenon nor an effect, but a created being.

Fragment written in 1918; unpublished in Benjamin's lifetime. Translated by Rodney Livingstone.

The Concept of Criticism in German Romanticism

Above all, . . . the analyst should inquire, or rather train his eye, to see whether he has really found a mysterious synthesis or is only dealing with an aggregate, a juxtaposition, . . . and to see how this all might be modified.
—Goethe

Introduction

Delimitation of the Question

The present work is conceived as a contribution to an investigation into the history of a problem, and will endeavor to demonstrate the concept of criticism in the transformations through which it has passed. It is undeniable that such an investigation of the history of the concept of criticism is something quite different from a history of criticism itself; it addresses a philosophical or, more precisely, a problem-historical task.[1] What follows can be no more than a contribution to the solution of this task, because it presents not the historical context of the problem in its entirety but only a single moment within that development—namely, the Romantic concept of criticism of art.[2] The present work will try to hint in part at the larger problem-historical context in which this one moment stands and occupies a prominent position, but it will do so only at the end.

We can no more determine the concept of criticism without epistemological presuppositions than we could without aesthetic ones—not only because the latter imply the former, but above all because criticism contains a cognitive factor, regardless of whether one takes this to be pure cognition or value-laden cognition. Thus, the Romantic determination of the concept of criticism also stands completely upon epistemological presuppositions, which of course does not mean that the Romantics consciously derived this concept from them. But the concept as such does rest on epistemological presuppositions—as does every concept, in the end, that is rightly called such. For this reason, in the following discussion these presuppositions will

have to be demonstrated first, and never lost from view. At the same time, the work focuses upon them as upon systematically graspable moments within Romantic thought, which might display them in a higher degree and with greater significance than one commonly expects.

It is scarcely necessary to mark off the following inquiry as a problem-historical and, as such, systematically oriented one, from a purely systematic investigation into the concept of criticism.

Two other boundary determinations, however, may be more necessary: vis-à-vis questions of the history of philosophy and questions of the philosophy of history. Only in the most improper sense may investigations in the history of problems be thought of as investigations in the history of philosophy, even though in certain individual cases the boundaries between these modes of inquiry might inevitably blur. For it is, at the least, a metaphysical hypothesis that the whole of the history of philosophy in the authentic sense is at the same time and ipso facto the unfolding of a single problem. It is self-evident that the objects of a presentation concerned with the history of a problem are in various ways intertwined with those of the history of philosophy; to assume that their methods are equally intertwined signifies that the boundaries have been displaced. Since this work deals with Romanticism, a further demarcation is unavoidable. This work does not make the attempt, often undertaken with insufficient means, to demonstrate the historical essence of Romanticism; in other words, the questions germane to the philosophy of history have no place here. Nevertheless, the statements that follow, especially in regard to the peculiar systematic of Friedrich Schlegel's thought and the early Romantic idea of art, will contribute materials valuable for a definition of the essence of Romanticism without addressing the point of view through which that might be accomplished.[3]

The Romantics use the term *Kritik* in multiple senses. In what follows, it means criticism as the criticism of art, not as epistemological method and philosophical standpoint. As will be shown below, the word was elevated to the latter meaning at that time in connection with Kant—namely, as an esoteric term for the incomparable and completed philosophical standpoint; in ordinary usage, however, it carried only the sense of a well-founded judgment. And perhaps not without the influence of Romanticism, since the grounding for the critique of artworks, not for any philosophical doctrine of critique, was one of its enduring achievements. Just as the concept of criticism will not be discussed in greater detail than its connection with the theory of art requires, so, too, the Romantic theory of art will be pursued only insofar as it is important for the presentation of that concept.[4] This implies a very significant restriction of the material to be considered: theories of artistic consciousness and of artistic creation, questions of the psychology of art—all fall away, and only the concepts of the idea of art and of the

artwork remain within the horizon of our consideration. The objective grounding of the concept of criticism provided by Friedrich Schlegel has to do only with the objective structure of art as idea, and with its formations, its works. For the rest, when he speaks of art, he thinks above all of literature [*Poesie*]; the other arts, in the period in question here, occupied him almost exclusively with reference to poetry or literature. The basic laws of the latter counted for him, in all probability, as the basic laws of all art, insofar as the problem occupied him at all. In the work that follows, the term "art" will always be understood to indicate literature, in its central position among all the arts; similarly, the term "artwork" indicates individual works of literature. It would create a false impression if the present study attempted to include a remedy for this equivocation, since it designates a fundamental lack in the Romantic theory of literature, indeed of art generally. Both concepts are only unclearly distinguished from each other, to say nothing of their being oriented toward each other so that no understanding of the peculiar nature and the limits of poetic expression vis-à-vis those of the other arts could arise.

In this context, we are not interested in the judgments the Romantics passed on art if these judgments are considered as facts belonging to literary history. For the Romantic theory of the criticism of art is not to be derived from any practice (say, the method of A. W. Schlegel), but is to be systematically demonstrated in accord with the Romantic theorists of art. The method of A. W. Schlegel's critical activity has little to do with the concept of criticism developed by his brother, who established the center of gravity of that concept in the method, not in the standards of judgment, as A. W. Schlegel did. But Friedrich Schlegel himself answered fully to his ideal of criticism only in his review of *Wilhelm Meister*, which is just as much theory of criticism as criticism of Goethe's novel.

The Sources

Friedrich Schlegel's theory will be presented in the following as *the* Romantic theory of criticism. The justification for designating this theory as *the* Romantic theory rests on its representative character. Not that all the early Romantics declared themselves in agreement with it, or even took notice of it: Friedrich Schlegel often remained unintelligible even to his friends. But his view of the essence of criticism is the final word of the Romantic school on this matter. He made this problematical and philosophical object his own—although certainly not uniquely his own. For A. W. Schlegel, criticism of art was not a philosophical problem. Along with Friedrich Schlegel's writings, only those of Novalis come into consideration as "sources" in the narrower sense for this presentation, whereas Fichte's earlier writings present indispensable sources, not for the Romantic concept of criticism itself

but for its comprehension. The justification for bringing in Novalis' writings along with those of Schlegel[5] is the complete unanimity of both as regards the premises and conclusions of the theory of criticism. Novalis was less interested in the problem itself; but he shared with Schlegel the epistemological presuppositions on the basis of which the latter treated this problem, and together with him he upheld the consequences of this theory for art. He formulated both of these, sometimes more sharply and revealingly than his friend did, in the form of a remarkable mysticism of knowledge and an important theory of prose. The two friends met in the year 1792, both at the age of twenty, and beginning in 1797 they entered into the liveliest correspondence, sending each other their works as well.[6] This close companionship makes the investigation of mutual influences largely impossible; for the question at hand, it is completely superfluous.

Novalis' testimony is also of the greatest value because the presentation of Friedrich Schlegel finds itself in a difficult position. His theory of art—to say nothing of his theory of the criticism of art—is based so decisively on epistemological presuppositions that it remains unintelligible unless these are understood. Yet Friedrich Schlegel, before and around 1800, when he published these works in the *Athenaeum* (which constitutes the chief source for this essay),[7] had not laid down any philosophical system in which, by itself, we could expect a conclusive epistemological discussion. Rather, in the fragments and essays of the *Athenaeum*, the epistemological presuppositions are bound up in the most intimate way with the extralogical, aesthetic determinations and can be divorced from these and presented separately only with great difficulty. At least at this particular period, Schlegel cannot take up any idea without setting his entire thinking and all his ideas into unruly motion. This compression and close connection of the epistemological insights within the whole mass of Schlegel's thinking appear to have heightened their bold, paradoxical character, and vice versa. For an understanding of this concept of criticism, we cannot dispense with the explication and isolation, the pure exposition of that theory of knowledge. The first part of this work is dedicated to this exposition. However difficult it might be, many instances do confirm the results obtained. If, on the basis of the immanent criterion, we still find that the arguments concerning the theory of art and the criticism of art simply do not lose their apparent obscurity and arbitrariness without these epistemological presuppositions, then there remain, as a second criterion, the fragments of Novalis, to whose basic epistemological concept of reflection Schlegel's theory of knowledge—given the general, highly articulated conceptual affinity between these two thinkers—can easily be related. And indeed, closer study shows that Schlegel's theory of knowledge matches Novalis' concept exactly. Happily, the investigation of Schlegel's theory of knowledge does not depend solely and primarily on his fragments; it has at its disposal a broader basis. These are

the lectures by Friedrich Schlegel that are known as the "Windischmann lectures," after their editor. These lectures, delivered in Paris and Cologne from 1804 to 1806, and completely dominated by the ideas of the Catholic philosophy of Restoration, take up those motifs which their author preserved from the fall of the Romantic school and saved for his subsequent lifework.

The majority of the ideas in these lectures are new in Schlegel, though far from original. His erstwhile pronouncements on humanity, ethics, and art seem discredited to him. But the epistemological attitude of the previous years for the first time clearly emerges here, albeit in modified form. Though the concept of reflection, which is also Schlegel's basic epistemological conception, can be traced in his writings as far back as the second half of the 1790s, only in these lectures does it appear fully articulated and explicitly developed for the first time. In them Schlegel wished expressly to provide a system that included an epistemology. It is not too much to say that precisely these basic epistemological positions present the static, positive component of the relation between the middle and later Schlegel—while one would have to consider the inner dialectic of his development as the dynamic, negative component. These positions are important both for Schlegel's own development and, generally, for the transition from early to later Romanticism.[8] For the rest, the discussions that follow cannot and do not wish to furnish a picture of the Windischmann lectures as a whole, but wish only to consider one of their lines of thought that is important for the first part of this work. These lectures therefore stand in the same relation to the whole of the presentation as do Fichte's writings to the particular context in which they are discussed. Both are source writings of the second rank; they aid in the understanding of the chief sources—namely, Schlegel's works in the *Lyceum* and *Athenaeum* fragments, as well as those in the *Charakteristiken und Kritiken* [Characterizations and Critiques], and those fragments of Novalis which immediately define the concept of criticism.[9] Schlegel's early writings on the literature of the Greeks and Romans are touched on only occasionally within this context, in which we are showing not the genesis of his concept of criticism, but this concept itself.

Part One: Reflection

I. Reflection and Positing in Fichte

Thinking that reflects on itself in self-consciousness is the basic fact from which Schlegel's and, in large part, Novalis' epistemological considerations take their start. The relation that thinking has to itself in reflection is seen as the relation that lies closest to thinking in general; from it, all others are

developed. Schlegel says once in *Lucinde:* "Thinking has the peculiarity that, next to itself, it most of all prefers to think about that which it can think without end."[10] This indicates that thinking can find an end least of all in reflective thinking about itself. Reflection is the most frequent "type" in the thought of the early Romantics; passages confirming this statement occur among their fragments. Imitation, manner, and style: these three forms, which can very easily be applied to Romantic thinking, find their peculiar stamp in the concept of reflection. On one occasion, it is the imitation of Fichte (as, above all, in the early Novalis); on another, Mannerism (for example, when Schlegel demands of his public that it should "understand understanding").[11] Principally, however, reflection is the style of thinking[12] in which—not arbitrarily but of necessity—the early Romantics expressed their deepest insights. The "Romantic spirit seems to take pleasure in fantasizing about itself," Schlegel says of Tieck's *Sternbald*,[13] and this it does not only in early Romantic works of art, but also and above all (if more rigorously and more abstractly) in early Romantic thinking. In a fragment that is in fact based on fantasy, Novalis tries to interpret the whole of terrestrial existence as the reflection of spirits in themselves, and to interpret man within this earthly life as partly the dispelling and "breaking-through of that primitive reflection."[14] And in the Windischmann lectures, Schlegel formulates this principle, long familiar to him, with the words: "The capacity of the activity that returns into itself, the ability to be the 'I' of the 'I,' is thinking. This thinking has no other object than ourselves."[15] Thinking and reflection are thus identified with each other. But this does not occur only to guarantee for thinking that infinity which is given in reflection and which, without closer consideration, may appear to be of questionable value as merely the thinking that thinking does about itself. Rather, the Romantics saw in the reflective nature of thinking a warrant for its intuitive character. As soon as the history of philosophy, in Kant (although not for the first time), still explicitly and emphatically affirmed both the possibility of thinking an intellectual intuition and its impossibility in the realm of experience, a manifold and almost feverish endeavor emerged to recover this concept for philosophy as the guarantee of its highest claims. At the forefront of this endeavor were Fichte, Schlegel, Novalis, and Schelling.

In his first version of *The Science of Knowledge* [*Wissenschaftslehre*], in 1794, Fichte already insists upon the mutual and reciprocal givenness of reflective thinking and immediate cognition. He does so with complete clarity as regards the issue, although the expression "immediate cognition" is not found in his text. This is of great importance for the Romantic concept of reflection. Here we need to make quite clear how this concept is connected to its Fichtean counterpart. It is evidently dependent on Fichte's concept, but this is not sufficient for our present purposes. Here it is a matter of observing precisely how far the early Romantics follow Fichte, in order to

recognize clearly where they part company with him.[16] This point of separation can be determined philosophically; it cannot be predicated merely on the artist's turning away from the scientific thinker and philosopher. For with the Romantics, too, there are philosophical and indeed epistemological motives underpinning this dissociation; these are the same motives on which the construction of their theory of art and of criticism is founded.

On the question of immediate cognition, complete agreement between the early Romantics and Fichte's position in the *Wissenschaftslehre* can still be established. Fichte later deviated from this position, and never again did he stand in such close systematic relation to Romantic thought as in this work. In it he defines "reflection" as "reflection of a form," and in this way proves the immediacy of the knowledge given in it. His line of thought runs as follows: The theory of knowledge has not only content but also a form; it is the "science of something, but not this something itself." That of which the science of knowledge is knowledge is the necessary "action of intelligence," that action which is prior to everything objective in the mind and which is the pure form of anything objective.[17] "Herein lies all the material of a possible science of knowledge, but not this science itself. In order to bring about the latter, there still is needed one action of the human mind not contained under all those others—namely, that action of elevating its mode of action in general to consciousness . . . Through this free action, something that already in itself is form—the necessary action of intelligence—is taken up as content into a new form, the form of knowing or of consciousness, and accordingly that action is an action of reflection."[18] Thus, by "reflection" is understood the transformative—and nothing but transformative—activity of reflecting on a form. In another context within this treatise, but in exactly the same sense, Fichte formulates the matter thus: "[The] action of freedom, through which the form turns into the form of the form as its content and returns into itself, is called 'reflection.'"[19] This remark is worthy of the greatest attention. What is evidently at stake here is an attempt to define and legitimate immediate cognition, an attempt that deviates from Fichte's later grounding via intellectual intuition. The word "intuition" [*Anschauung*] does not yet appear in this essay. Thus, Fichte supposes that here he can ground an immediate and certain cognition through the connection of two forms of consciousness (that of form and the form of the form, or of knowing and the knowing of knowing), forms that pass over into one another and return into themselves. The absolute subject, the only thing to which the action of freedom has relation, is the center of this reflection and thus is to be known by immediate cognition. It is a question *not* of the cognition of an object through intuition, but of the self-cognition of a method, of something formal—and the absolute subject represents nothing other than this. The forms of consciousness in their transition into one another are the sole object of immediate cognition, and

this transition is the sole method capable of grounding that immediacy and making it intelligible. This theory of cognition, with its radical, mystical formalism has, as will be shown, the deepest affinity with the early Romantic theory of art. The early Romantics held to it and expanded it far beyond Fichte's outline, whereas he, for his part, in the writings that followed, based the immediacy of cognition on its intuitive nature.

Romanticism did not base its epistemology on the concept of reflection solely because this concept guaranteed the immediacy of cognition, but did so equally because the concept guaranteed a peculiar infinity in its process. Reflective thinking won its special systematic importance for Romanticism by virtue of that limitless capacity by which it makes every prior reflection into the object of a subsequent reflection. Fichte, too, frequently pointed to this remarkable structure of thinking. His opinion of the matter is opposed to the Romantic view. It is thus important, both for the indirect characterization of that view and to establish proper limits to the view, that the philosophical theorems of early Romanticism are dependent on Fichte through and through. Fichte tries everywhere to exclude the infinitude of the action of the "I" from the realm of theoretical philosophy and to assign it instead to the domain of practical philosophy, whereas the Romantics seek to make it constitutive precisely for their theoretical philosophy and thus for their philosophy as a whole, Friedrich Schlegel being little interested in practical philosophy. Fichte recognizes two infinite modes of action for the "I," adding to reflection the action of positing. We can understand Fichte's active deed formally as a combination of these two limitless modes of action by the "I"—a combination in which they seek mutually to fill out and to determine their purely formal nature, their emptiness. The active deed is a positing reflection or a reflected position: "a self-positing as positing . . . but in no way a mere positing,"[20] in Fichte's formulation. Each of these two terms says something different; both are of great importance for the history of philosophy. Whereas the concept of reflection becomes the foundation of early Romantic philosophy, the concept of positing—not without relation to that of reflection—appears in its fully developed form in Hegel's dialectic. It is perhaps not an overstatement to assert that the dialectical character of positing, just because of its combination with the concept of reflection, does not receive as full and characteristic an expression in Fichte as it will in Hegel.

According to Fichte, the "I" sees an infinite activity as its essence, which consists in positing. This proceeds as follows: The "I" posits itself (A), and in the imagination posits in opposition to itself a "not-I" (B).

Reason steps into the middle and determines the imagination to take up B into the determinate A (the subject). Now, however, A, posited as determinate, must once more be limited by a limitless B, with which the imagination proceeds

exactly as before. And thus it continues, until the point is reached where (now merely theoretical) reason completely determines itself, and no longer needs any limiting B other than reason in the imagination—that is, until it reaches the representation of what represents [*Vorstellung des Vorstellenden*]. In the practical field the imagination continues to infinity, until it reaches the abso-lutely indeterminable idea of the highest unity—a unity that would be possible only in accord with a completed infinity, which is itself impossible.[21]

Consequently, in the theoretical sphere the activity of positing does not continue to infinity. The special nature of that sphere is constituted by the preclusion of infinite positing; this preclusion lies in representation. Through representations and, in the end, through the highest of these—the repre-sentation of the activity of representing—the "I" is theoretically completed and fulfilled. The representations are those of the "not-I." The "not-I," as shown by the sentences cited above, has a double function: in the case of cognition, to lead back into the unity of the "I"; in the case of action, to lead forward into the infinite.—It will prove important for the relation between the Fichtean and early Romantic theories of knowledge that the formation of the "not-I" in the "I" rests on an unconscious function of the latter. "The single content of consciousness . . . , in the entire necessity with which it prevails therein, can be explained not on the basis of a dependence of consciousness on any kind of things in themselves, but only on the basis of the 'I' itself. Now, all conscious production is determined by grounds and thus always presupposes particular contents of representation. The primor-dial producing, whereby for the very first time the 'not-I' is obtained in the 'I,' cannot be conscious—it can only be unconscious."[22] Fichte sees "the only way out for the explanation of the given content of consciousness in the fact that the latter stems from a representing of a higher sort, a free unconscious act of representing."[23]

From the preceding, it should be clear that reflection and positing are two different acts. And indeed reflection is, at bottom, the autochthonous form of infinite positing: reflection is positing in the *absolute* thesis, where it seems related not to the material side but to the purely formal side of knowing. When the "I" posits itself in the absolute thesis, reflection arises. In the Windischmann lectures, Schlegel speaks once, entirely in Fichte's sense, of an "inner duplication"[24] in the "I."

In summary, we should say that the act of positing limits and defines itself through representation, through the "not-I," through counterpositing. On the basis of determinate counterpositings, the activity of positing, which in itself advances into the infinite,[25] is finally once again led back into the absolute "I," and there, where it coincides with reflection, arrested in the representation of representing. This restriction of the infinite activity of positing is therefore the condition for the possibility of reflection. "[The] determination of the 'I,' its reflection on itself . . . , is possible only under

the condition that it limit itself through something opposed to it."[26] Conditioned in this way, reflection itself is like positing—an infinite process. And in view of this, Fichte's attempt once more becomes visible—namely, to make reflection into a philosophical organon by destroying its infinitude. This problem is posed in the fragmentary "Versuch einer neuen Darstellung der Wissenschaftslehre" ["Search for a New Presentation of the Theory of Knowledge"] (1797). There Fichte argues as follows:

> You are conscious of your "You," you say; accordingly, you necessarily distinguish your thinking "I" from the "I" thought of in that "I"'s thinking. But in order that you can do so, *what* is thinking in that act of thinking must in turn be the object of a higher thinking, so that it can become the object of consciousness; and at the same time, you obtain a new subject, which is conscious itself of what previously was the state of *being* self-conscious. My argument here is as it was before; and after we have once begun to proceed according to this law, you can never show me a place where we must stop. Thus we shall continue, *ad infinitum,* to require a new consciousness for every consciousness, a new consciousness whose object is the earlier consciousness, and thus we shall never reach the point of being able to assume an actual consciousness.[27]

Fichte makes this argument no less than three times here in order to come to the conclusion on each occasion that, on the basis of this limitlessness of reflection, "consciousness remains inconceivable to us."[28]

Thus, Fichte looks for and finds an attitude of mind in which self-consciousness is already immediately present and does not need to be evoked through a reflection that in principle is endless. This attitude of mind is thinking. "The consciousness of my thinking is not contingent on my thinking, not something first added onto it and thereby attached to it, but it is indivisible from my thinking."[29] The immediate consciousness of thinking is identical with self-consciousness. By virtue of its immediacy, it is called intuition. In this self-consciousness—in which intuition and thinking, subject and object, coincide—reflection is transfixed, arrested, and stripped of its endlessness, without being annulled.

In the absolute "I" the infinity of reflection is overcome, as is the infinity of positing in the "not-I." Even though Fichte may not have been altogether clear in his own mind as to the relation between these two activities, it is nonetheless evident that he felt their distinction and sought to introduce each into his system in a particular way. This system cannot tolerate any kind of infinitude in its theoretical part. But in reflection (as has been shown), there are two moments: immediacy and infinity. The first of these points the way for Fichte's philosophy to seek the origin and explanation of the world in that very immediacy; yet the second obscures that immediacy and is to be eliminated from reflection by a philosophical process. Fichte shared with the early Romantics this interest in the immediacy of the highest knowledge. Their cult of the infinite, which is given its distinctive stamp

even in their theory of knowledge, divided them from Fichte and lent their thinking its most peculiar and characteristic direction.

II. The Meaning of Reflection in the Early Romantics

We would do well to base our presentation of the Romantic theory of knowledge on the paradox of consciousness which Fichte exposed—that paradox founded on reflection.[30] The Romantics, in fact, took no offense at the infinitude rejected by Fichte, and thus the question arises: In what sense did they understand and indeed emphasize the infinitude of reflection? Obviously, for the latter to come about, reflection, with its thinking of thinking of thinking and so forth, had to be for them more than an endless and empty process, and, however strange this might seem at first glance, an understanding of their ideas requires that we begin by following them in this, and by accepting their assertion as a hypothesis, in order to discover the sense in which they make that claim. This sense, thus situated, will prove to be far from abstruse, but fruitful and rich in consequences for the theory of art.—To begin with, the infinity of reflection, for Schlegel and Novalis, is not an infinity of continuous advance but an infinity of connectedness. This feature is decisive, and quite separate from and prior to its temporally incompletable progress, which one would have to understand as other than empty. Hölderlin—who, without any contact with the various ideas of the early Romantics we will encounter here, had the last and incomparably most profound word—writes, in a passage in which he wants to give expression to an intimate, most thoroughgoing connection, "They hang together infinitely (exactly)."[31] Schlegel and Novalis had the same thing in mind when they understood the infinitude of reflection as a full infinitude of interconnection: everything in it is to hang together in an infinitely manifold way— "systematically," as we would say nowadays, "exactly," as Hölderlin says more simply. This interconnection can be grasped in a mediated way from the infinitely many stages of reflection, as by degrees all the remaining reflections are run through in all directions. In this mediation by way of reflections, however, there is in principle no antithesis to the immediacy of thinking comprehension, because every reflection is immediate in itself.[32] It is thus a matter of mediation through immediacies; Friedrich Schlegel was acquainted with no other sort, and on occasion he speaks in this sense of a "transition that must always be a leap."[33] It is on this mediated immediacy, constituted in principle yet not absolute, that the vitality of their interconnection rests. To be sure, as a virtuality, even an absolute immediacy in the grasping of the context of reflection is thinkable; with this the context would grasp itself in absolute reflection. In these remarks, nothing more than a schema of Romantic theory of knowledge has been given; the chief interest

is constituted by the question, first, how the Romantics go about construct-
ing this theory in detail and, then, how they go about filling out the theory.

In the first place, so far as the construction is concerned, it has a certain
affinity in its point of departure with Fichte's theory of reflection in his
Wissenschaftslehre. Mere thinking, with its correlative thought, is matter
for reflection. It is, indeed, form vis-à-vis the thought—it is a thinking *of*
something, and for this reason one is allowed on terminological grounds to
call it the first level of reflection; in Schlegel, it is called "sense" [*Sinn*].[34]
Nonetheless, reflection properly speaking arises in its full significance only
on the second level, in the thinking of that first thinking. The relation
between these two forms of consciousness, of the first and the second
thinking, must be represented in keeping with Fichte's remarks in the work
cited. In this second thinking, or, to use Friedrich Schlegel's term, "reason,"[35]
the first act of thinking in fact returns transformed at a higher level: it has
become "the form of the form as its content"[36]—that is, the second level
has emerged from the first level, through a genuine reflection, and thus
without mediation. In other words, the thinking on the second level has
arisen from the first by its own power and self-actively[37]—namely, as the
self-knowledge of the first. "Sense that sees itself becomes spirit," as Schlegel
says, his terminology here in the *Athenaeum*[38] matching that which he later
employed in the lectures. Unquestionably, from the standpoint of the second
level, mere thinking is matter; the thinking of thinking is its form. Hence,
the epistemologically valid form of thinking—and this is fundamental for
the early Romantic conception—is not logic, which belongs to first-level
thinking, to "material" thinking. This form is the thinking of thinking. On
the basis of the immediacy of its origin out of first-level thinking, this
thinking of thinking is identified with the knowledge of thinking. It consti-
tutes for the early Romantics the basic form of all intuitive knowledge and
thus attains its dignity as method; as knowledge of thinking it comprises all
other, lower-level cognition under itself, and in this way it constitutes the
system.

In this Romantic deduction of reflection, we should not overlook a char-
acteristic difference from Fichte's deduction, despite their many similarities.
Fichte says of the absolute first principle of all knowing: "Prior to [Kant],
Descartes laid down a similar basic principle: *cogito, ergo sum*, . . . which
he may quite well have regarded as an immediate fact of consciousness.
Then it would in effect be saying: *cogitans sum, ergo sum*. . . . But then the
addition of *cogitans* is entirely superfluous; one does not necessarily think
when one exists, but one necessarily exists when one thinks. Thinking is by
no means the essence but only a particular determination of being."[39] It is
of no interest here that the standpoint of the Romantics is not that of
Descartes; likewise, we cannot raise the question whether Fichte, in this
remark from the *Grundlage der gesamten Wissenschaftslehre* [Foundation

of the Entire Science of Knowledge], does not clash with his own procedure. We need only point out that the contrast Fichte detects between himself and Descartes also obtains between him and the Romantics. Whereas Fichte thinks he can locate reflection in the original positing—that is, in the original being—for the Romantics, that special ontological determination which lies in positing falls away. Romantic thinking sublates being and positing in reflection. The Romantics start from mere thinking-oneself, as a phenomenon; this is proper to everything, for everything is a self. For Fichte, a self belongs only to the "I"[40]—that is, a reflection exists only and uniquely in correlation with a positing. For Fichte, consciousness is the "I"; for the Romantics it is the "self." Or, to put this differently: in Fichte, reflection has reference to the "I"; in the Romantics, it refers to mere thinking, and it is precisely through this latter reference, as will be shown more clearly below, that the peculiar Romantic concept of reflection is constituted.

Fichtean reflection lies in the absolute thesis; it is reflection within this thesis alone. Outside of it, because it leads into the void, it supposedly has no meaning. Within this positing, it grounds immediate consciousness—that is, intuition—and as reflection it grounds the intellectual intuition of this positing. Fichte's philosophy does certainly start from an active deed, not from a fact, but the word "act" [*Tat*] still alludes, in a subordinate meaning, to "fact" [*Tatsache*], to the "fait accompli." This active deed (in the sense that it is indeed an original action), and only this active deed, is grounded by the cooperative effect of reflection. Fichte says: "Because the subject of the proposition[41] is the absolute subject, the subject pure and simple, then in this one unique case the inner content of the proposition is posited together with its form."[42] Thus, he recognizes only a single case of the fruitful application of reflection—namely, of that reflection which occurs in intellectual intuition. What results from the function of reflection in intellectual intuition is the absolute "I," an active deed, and accordingly the thinking of intellectual intuition is a relatively objective thinking. In other words, reflection is not the method of Fichtean philosophy; this is, rather, to be seen in dialectical positing. Intellectual intuition is thinking that produces its object; reflection in the Romantics' sense, however, is thinking that produces its form. For what in Fichte occurs in only a "single" case, as a necessary function of reflection, and what in this single case has constitutive significance for something comparatively objective (namely, the active deed)—this process by which the mind becomes the "form of the form as its content" takes place, according to the Romantic intuition, incessantly, and first of all constitutes not the object but the form, the infinite and purely methodical character of true thinking.

Accordingly, the thinking of thinking turns into the thinking of thinking of thinking (and so forth), and with this the third level of reflection is attained. In the analysis of this third level, the magnitude of the difference

between Fichte's thought and that of the early Romantics fully emerges for the first time. We can understand what motivated the inimical attitude toward Fichte in the Windischmann lectures, and how Schlegel, in his review of Fichte in 1808, although certainly not wholly without prejudice, could characterize the earlier contacts of his circle with Fichte as a misunderstanding based on the polemical attitude of both toward the same enemy, an attitude that was forced on them both.[43] The third level of reflection, compared with the second, signifies something fundamentally new. The second, the thinking of thinking, is the original form, the canonical form of reflection; as such it was recognized by Fichte, too, in the "form that takes the form as its content." Nevertheless, on the third and every succeeding higher level of reflection, a disintegration in this original form takes place— one that announces itself in a peculiar ambiguity. The apparent sophistry of the following analysis can form no obstacle to the investigation; if one enters into the discussion of the problem of reflection, as the context requires, then of course subtle distinctions cannot be avoided; among them the following has an essential bearing. The thinking of thinking of thinking can be conceived and performed in two ways. If one starts from the expression "thinking of thinking," then on the third level this is either the object thought of, thinking (of the thinking of thinking), or else the thinking subject (thinking of thinking) of thinking. The rigorous original form of second-level reflection is assailed and shaken by the ambiguity in third-level reflection. But this ambiguity would have to unfold into an ever more complex plurality of meanings at each successive level. On this state of affairs rests the peculiar character of the infinitude of reflection to which the Romantics laid claim: the dissolution of the proper form of reflection in the face of the absolute. Reflection expands without limit or check, and the thinking given form in reflection turns into formless thinking which directs itself upon the absolute. This dissolution of the strict form of reflection, which is identical with the diminution of its immediacy, is, to be sure, dissolution only for circumscribed thinking. It was already indicated above that the absolute can grasp itself reflectively without mediation—that is, in closed and completed reflection—whereas lower levels of reflection can approximate the highest only in the mediation by immediacy; this mediated reflection must in turn give way to complete immediacy as soon as these lower forms attain absolute reflection. Schlegel's theorem loses the character of abstruseness once we recognize the presupposition for this line of thought. The first, axiomatic presupposition is that reflection does not take its course into an empty infinity, but is in itself substantial and filled. Only in reference to this intuition may simple absolute reflection be distinguished from its opposite pole, simple original reflection. These two poles of reflection are simple throughout; all other forms of reflection are simple only relatively, when seen in their own right and not from the viewpoint of the absolute. In order

to distinguish these two poles, one would have to assume that absolute reflection comprises the maximum of reality, whereas original reflection comprises the minimum of reality, in the sense that, though both enclose all the content of reality and all of thinking, that content is developed to its highest clarity in the former, while remaining undeveloped and unclear in the latter. This distinction among levels of clarity is, as opposed to the theory of fulfilled reflection, only an auxiliary construction serving to render more logical a line of thought that was not thought through by the Romantics with full clarity. As Fichte located the whole of the real in acts of positing—though only by virtue of a *telos* that he introduced into these—so Schlegel saw, immediately and without holding this in need of a proof, the whole of the real unfolding in its full content, with increasing distinctness up to the highest clarity in the absolute, in the stages of reflection. We must still show how he defines the substance of this reality.

Schlegel's opposition to Fichte led him, in the Windischmann lectures, to a frequently energetic polemic against Fichte's concept of intellectual intuition. For Fichte, the possibility of an intuition of the "I" rests on the possibility of confining and fixing reflection in the absolute thesis. Schlegel rejected intuition just for this reason. With reference to the "I," he speaks of the great "difficulty . . . indeed, the impossibility of a certain apprehension of the 'I' in intuition,"[44] and he asserts "the incorrectness of any view in which fixed self-intuition is set up as the source of knowledge."[45] "Perhaps it lies in the very course he[46] chose to take, starting out from self-intuition, . . . that in the end he still could not completely overcome realism[47]. . . ."[48] "We cannot intuit ourselves; the 'I' always disappears from sight when we try to do so. We can, to be sure, think ourselves. Then, to our astonishment, we appear to ourselves infinite, since in ordinary life we feel ourselves to be so thoroughly finite."[49] Reflection is not intuition but an absolutely systematic thinking, a conceiving. Nonetheless, it is self-evident that, for Schlegel, the immediacy of knowing is still to be saved; and for this he needs a break with the Kantian doctrine, according to which intuitions alone guarantee immediate cognition. Fichte still adhered to this doctrine, on the whole;[50] for him, there results the paradoxical consequence that "in ordinary consciousness . . . only concepts, . . . by no means intuitions as such," are present; "notwithstanding this, the concept is brought about only through intuition."[51] Schlegel counters: "To take thinking . . . merely as mediate and only intuition as immediate is a totally arbitrary procedure on the part of those philosophers who assert an intellectual intuition. The properly immediate, it is true, is feeling, but there exists also an immediate thinking."[52]

With this immediate thinking of reflection, the Romantics penetrate into the absolute. They seek and they find there something altogether different from what Fichte had found. Although reflection for them, in contrast to

Fichte, is full, it is not, at least for the period discussed below, a method filled by the ordinary content of science. What is meant to be derived in the Fichtean theory of science is and remains the world picture of the positive sciences. The early Romantics, thanks to their method, dissolve this world view completely into the absolute, and in this they look for a content other than that of science. Thus, once the question of the construction of the schema is answered, the question of its elaboration arises; once the question of the presentation of the method is answered, that of the system follows. The system of the lectures, the unique source for the coherence of Schlegel's philosophical views, is different from the system of the *Athenaeum* period with which we are ultimately concerned here. Still, as we explained in the introduction, the analysis of the Windischmann lectures remains a necessary condition for the understanding of Schlegel's philosophy of art around 1800. This analysis has to show which epistemological factors from the period around 1800 Schlegel incorporated in the basis of his lectures four to six years later, as the only way he could convey them to posterity, and which are the new elements that have been added subsequently and cannot be considered part of his earlier thinking. The standpoint of these lectures is overall a compromise between the rich thought of the youthful Schlegel, and the already incipient Restoration philosophy of the eventual secretary to Metternich. In the domain of his practical and aesthetic thinking, the earlier circle of ideas has almost completely dissolved, though it still survives in the theoretical domain. There is no difficulty in separating the new from the old. The following examination of the system of the lectures has to prove what was said about the methodological importance of the concept of reflection, as well as to present a few of the important features of this system insofar as the youthful period is concerned, and, finally, to mark out what is characteristic of his earlier view vis-à-vis that of his middle years.

The second task is to be given precedence: How did Friedrich Schlegel conceive the full infinity of the absolute? In the lectures, he says: "We cannot grasp that we *ought* to be infinite; at the same time, we have to admit that the 'I,' as the reservoir of everything, cannot be otherwise than infinite. If, upon careful consideration, we cannot deny that everything is in us, then we cannot explain the feeling of limitedness . . . except by assuming that we are only a part of ourselves. This leads straightaway to a belief in a 'thou'—not, as in life, as something opposing yet similar to the 'I' . . . but altogether as a 'counter-I'—and bound up with this is necessarily the belief in an 'ur-I.'"[53] This "*ur*-I" is the absolute, the quintessence of infinitely fulfilled reflection. The fulfillment of reflection, as we have already re-marked, constitutes a decisive difference between Schlegel's and Fichte's concepts of reflection; it is quite clearly said, in opposition to Fichte: "Where the thought of the 'I' is not one with the concept of the world, we can say that this pure thinking of the thought of the 'I' leads only to an eternal

self-mirroring, to an infinite series of mirror-images which always contain only one and the same thing and nothing new."[54] Schleiermacher's striking formulation of this idea belongs to the same Romantic circle of ideas: "Self-intuition and intuition of the universe are reciprocal concepts; for this reason, every reflection is infinite."[55] Novalis, too, was in liveliest sympathy with this idea—indeed, just because it was opposed to the Fichtean concept: "You are chosen to defend the upwardly striving self-thinker against Fichte's magic,"[56] he was already writing to Friedrich Schlegel in 1797. What he himself, along with many others, had against Fichte is indicated in the following words: "Could it be that Fichte was self-contradictory when he stated, 'The "I" cannot limit itself' . . .? The possibility of self-limitation is the possibility of all synthesis, of all miracle. And a miracle began the world."[57] It is, however, well known that in Fichte the "I" limits itself via the "not-I"—only it does so unconsciously. This remark, along with Novalis' demand for a genuine "Fichteanism, without check, without the 'not-I' in his sense,"[58] can only mean that the limitation of the "I" cannot be unconscious but must be conscious and thereby relative. This is, in fact, the basic tendency of the early Romantic objection, as can still be recognized in the Windischmann lectures, where Schlegel says: "The 'ur-I,' what in the 'ur-I' embraces everything, is all. Outside of it, there is nothing; we can assume nothing but 'I-ness.' The fact of being limited is not a mere faint reflection [*Widerschein*] of the 'I,' but a real 'I'; no 'not-I,' but a 'counter-I,' a 'thou.'[59] Everything is only a part of infinite 'I-ness.'"[60] Or with clearer reference to reflection: "The capacity for returning back into oneself, the ability to be the 'I' of the 'I'—this is thinking. This thinking has no other object than us ourselves."[61] The Romantics shudder at limitation through the unconscious; there should be nothing other than relative limitation, and this should occur only in conscious reflection itself. On this question, too, Schlegel offers (in contrast to his earlier standpoint) a weakened compromise solution in the lectures: the limitation of reflection does not come about in reflection itself; it is therefore not really relative, but is effected by the conscious will. Schlegel calls "will" the "ability to call a halt to reflection and to direct intuition at one's discretion on any determinate object."[62]

Schlegel's concept of the absolute has now been sufficiently defined in its opposition to Fichte. In itself, this absolute would most correctly be designated the "medium of reflection."[63] With this term, one may characterize the whole of Schlegel's theoretical philosophy, and in what follows it will be cited not infrequently under this rubric. Hence, it is necessary to explain it more exactly and to secure it. Reflection constitutes the absolute, and it constitutes it as a medium. Schlegel did not use the term "medium" himself; nonetheless, he attached the greatest importance to the constantly uniform connection in the absolute or in the system, both of which we have to interpret as the connectedness of the real, not in its substance (which is

everywhere the same) but in the degrees of its clear unfolding. Thus, he says: "The will . . . is the capacity of the 'I' to augment or diminish itself[64] to an absolute maximum or minimum; since this capacity is free, it has no limits."[65] He gives a very clear image for this relation: "The return into oneself, the 'I' of the 'I,' is a raising to a higher power; going out of oneself[66] is the derivation of a root in mathematics."[67] Novalis described this movement within the medium of reflection in quite analogous terms. This movement seems to him to stand in such close relation to the essence of Romanticism that he gives it the name "Romanticizing." "Romanticizing is nothing but a qualitative potentiation. The lower self becomes identified with a better self in this operation. Just as we ourselves are a series of such qualitative raised powers . . . Romantic philosophy . . . reciprocal elevation and reduction."[68] In order to express himself with complete clarity concerning the medial [mediale] nature of the absolute which he has in mind, Schlegel draws on an analogy with light: "The idea of the 'I' . . . is to be regarded . . . as the inner light of all ideas. All ideas are only the refracted color images of this inner light. In every idea the 'I' is the hidden light; in each thought, one finds oneself. One is always thinking only oneself or the 'I'—not, to be sure, the common, derivative self, . . . but [the self] in a higher significance."[69] Novalis enthusiastically proclaimed the same notion of the mediality [Medialität] of the absolute in his writings. For the unity of reflection and mediality, he coined the excellent expression "self-penetration," and again and again he prophesied and demanded such a condition of spirit. "The possibility of all philosophy . . . —namely, that the intelligence, by affecting itself, gives itself a movement in accordance with its own law—that is, gives itself a form of activity all its own"[70] (in other words, reflection), is at the same time "the beginning of a true self-penetrating of spirit, a process that never ends."[71] The "chaos that penetrated itself"[72] is what he calls the future world. "The first genius who penetrated himself found here the typical nucleus of a measureless world. He made a discovery that must have been the most noteworthy in world history, for he thereby began an entirely new epoch of humanity. At this stage, for the first time true history of every sort becomes possible, for the way that was hitherto traveled now forms a genuine, thoroughly explicable whole."[73]

The basic theoretical views presented in the system of the Windischmann lectures differ in one decisive point from Schlegel's views in the *Athenaeum* period. In other words, although on the whole the system and method of Schlegel's later thinking for the first time set down and preserve the epistemological motifs of his earlier thought, in one connection they depart completely from his previous thinking. The possibility of this deviation, where otherwise the greatest agreement reigns, lies in a definite peculiarity in the system of reflection itself. In Fichte this is characterized as follows: "The 'I' returns back into itself; it is asserted. Then is it not there for itself

even before this movement of return and independently of it? Must it not already be there for itself, in order to be able to make itself into the goal of an action? . . . In no way. It is first through this act . . . through an action on an action itself, where no action at all precedes this determinate action, that the 'I' originally comes to be for itself. Only for the philosopher is it previously there as a fact, because the philosopher[74] has already gone through the whole experience."[75] Windelband, in his exposition of Fichte's philosophy, gives this notion an especially clear formulation: "Although one usually sees activities as something that presuppose a being, for Fichte all being is only a product of the original deed. Function, without a being which is functioning, is for him the primary metaphysical principle. The thinking mind does not 'exist' at the start and then afterward come to self-consciousness through some occasioning causes, whatever they might be; it comes about first through the underivable, inexplicable act of self-consciousness."[76] If Friedrich Schlegel, in his "Dialogue on Poetry" of 1800, means the same[77] in saying that idealism has "as it were arisen from nothing,"[78] this line of thought, with regard to the whole preceding presentation, can be summarized in the proposition: reflection is logically the first and primary. And because reflection is the form of thinking, thinking is not logically possible without it, even though it reflects on thinking itself. Only with reflection does that thinking arise on which reflection takes place. For this reason, we can say that every simple reflection arises absolutely from a point of indifference. One is at liberty to ascribe to this indifference-point of reflection whatever metaphysical quality one likes. It is at this point that the two lines of thinking expounded in Schlegel deviate from each other. The Windischmann lectures, following Fichte, define this middle point, the absolute, as "I." In Schlegel's writings from the *Athenaeum* period, this concept plays a modest role, smaller than its role not only in Fichte but in Novalis. In the early Romantic sense, the midpoint of reflection is art, not the "I." The basic definitions of that system which Schlegel propounded in the lectures as the system of the absolute "I" have, in his earlier thinking, art as their object. Another reflection is at work in this altered notion of the absolute. The Romantic intuition of art rests on this: that in the thinking of thinking no consciousness of the "I" is understood. Reflection without the "I" is a reflection in the absolute of art. The second part of this essay is devoted to the investigation of this absolute, following the principles stated here. In it we shall treat the criticism of art as reflection in the medium of art. Above we have explained the schema of reflection not by the concept of the "I" but by that of thinking, because the former concept plays no role in the epoch of Schlegel's thought that interests us here. The thinking of thinking, on the contrary, as the primal schema of all reflection, is at the basis of Schlegel's conception of criticism. Fichte had already defined this thinking of thinking, in a decisive way, as form. He himself interpreted this form as

the "I," as the primal cell of the intellectual concept of the world; Friedrich Schlegel, the Romantic, interpreted it around 1800 as aesthetic form, as the primal cell of the idea of art.

III. System and Concept

Two questions will be raised concerning the attempt to use the concept of the medium of reflection as a methodological grid for the thought of the early Romantics—a grid on which the solutions of its problems as well as its systematic positions can be mapped. The first question—posed again and again in the secondary literature in a skeptical or even negating rhetorical tone—is as follows: whether the Romantics thought systematically at all or pursued systematic interests in their thinking. And the second: why, granting the existence of these basic systematic notions, they were registered in discourse so strikingly obscure, even mystifying. With regard to the first question, it is worth defining at the outset exactly what is supposed to be proved here. In doing so, one cannot get away so easily with speaking, as Friedrich Schlegel does, of "the spirit of system, which is something entirely different from a system,"[79] even though these words point to what is decisive. In fact, nothing is to be proved here that would fly in the face of the obvious intellectual evidence—as, for example, that Schlegel and Novalis did have, around 1800, a system, whether one common to both, or each his own. What can be proved beyond any doubt is that their thought was determined by systematic tendencies and contexts, which in any event reached only partial clarity and maturity; or, to express it in the most exact and incontrovertible form: that their thinking can be *set in relation* to systematic lines of thought, that, in fact, it can be inserted into a properly chosen system of coordinates, no matter whether the Romantics themselves completely specified this system or not. For the present task, which is pragmatically concerned not with the history of philosophy but with the history of a problem, the matter can rest completely with the proof of this restricted assertion. To demonstrate this systematic referability, however, means nothing other than demonstrating the right and the possibility of a systematic commentary on early Romantic thought by offering one. Despite the extraordinary difficulties faced by the historical comprehension of Romanticism, this right has been championed in a recent publication by a literary historian (Elkuss, *Toward an Evaluation of Romanticism and a Critique of the Scholarship*)—hence from the standpoint of a discipline that in just this question must proceed much more scrupulously than the present inquiry into the history of a problem. In the following statements, among others, Elkuss advocates the analysis of Romantic writings on the basis of systematically oriented interpretation: "We can approach this material[80] from the viewpoint of theology, or that of the history of religion, or pre-

vailing concepts of law, or the historical thinking of the present: in every case, the opportunity for understanding . . . how ideas have been constructed becomes more favorable than if one approaches it without preconceptions, in the most disastrous sense of the phrase. That produces a situation where one can no longer control the material core of the questions raised in early Romantic theories, and, in short, where one treats these as 'literature,' in which quite often the formula can become, up to a certain point, its own goal."[81] "An analysis that begins here,[82] naturally, very often presses deep into what lies behind the 'literary' sense of what the author has said and was willing to formulate or even merely capable of formulating. This kind of analysis grasps the intentional acts, when it has recognized what these mean to accomplish."[83] "For literary history . . . a consideration is justified on this basis . . . if it works back to presuppositions, even when these for the most part were not hit upon by the reflection of the author himself."[84] For the history of a problem such a consideration is downright indispensable. It would be a more unqualified reproach for the history of a problem than for a literary-historical investigation, if one had to say of it, as Elkuss does of a literary-historical study, that for a particular author, when it "characterizes his spiritual world," it remains "trapped in antitheses which, for the author himself, were the content of consciousness"—that it judges "spiritual powers only in the stylization which the author gives them" and "no longer presses forward to this stylization as an achievement itself in need of analysis."[85] In any event, it is not necessary to go far behind what is expressly said in order to begin to perceive the decisive systematic tendency in Friedrich Schlegel's thinking around the turn of the century; the usual interpretation of his relation to systematic thought is thus to be understood as a matter of taking him too little, rather than too literally, at his word. These days, the fact that an author expresses himself in aphorisms will not count for anyone as proving anything against his systematic intentions. Nietzsche, for example, wrote aphoristically, characterizing himself moreover as the enemy of system; yet he thought through his philosophy in a comprehensive and unitary manner in keeping with his guiding ideas, and in the end began to write his system. Schlegel, on the contrary, never confessed himself simply and plainly the enemy of systematic thinkers.

For all Schlegel's apparent cynicism, his own words never indicate that he was a skeptic, even during his mature period. "As a transitional condition, skepticism is logical insurrection; as a system, it is anarchy. Skeptical method would therefore be much the same as rule by insurgents," he says in the *Athenaeum* fragments.[86] In the same text, he calls logic a "science that starts from the demand of positive truth and from the presupposition of the possibility of a system."[87] The fragments published in Windischmann[88] give abundant evidence that from the year 1796 onward, Schlegel reflected vigorously on the essence of a system and the possibility

of its grounding; this was the source of ideas that flowed into the system of the lectures. "Cyclical philosophy"[89] is the rubric under which Schlegel conceived of the system at that time. Among the very few definitions of this system that he gives, the most important is the one that provides the source for its name:

> Philosophy must have at its basis not only a reciprocal proof but also a reciprocal concept. In the case of every concept, as in the case of every proof, one can in turn ask for a concept and a proof of the same. For this reason philosophy, like an epic poem, must start in the middle, and it is impossible to lecture on philosophy and to pay it out piece by piece in such a way that the first piece would be completely grounded for itself and explained. It is a whole, and thus the path to recognizing it is no straight line but a circle. The whole of fundamental science must be derived from two ideas, principles, concepts . . . without any additional matter.[90]

Later in the lectures, these reciprocal concepts are the two poles of reflection that in the end, as simple ur-reflection and as simple absolute reflection, once again join together in the form of a circle. That philosophy begins in the middle means that it does not identify any of its objects with ur-reflection, but sees in them a middle term in the medium. As a further motif in that period, there is still, for Schlegel, the question of epistemological realism and idealism, which is settled in the lectures. Only ignorance of the Windischmann lectures explains, therefore, why Kircher, looking at the fragments from 1796 on, could say: "The system of cyclical philosophy was not carried out by Schlegel. These are nothing but preparations, presuppositions; these are the subjective foundations of the system, the drives and needs of his philosophical spirit given the form of concept. This is what is preserved for us in these fragments."[91]

Still, several reasons can be adduced to explain why Schlegel in the *Athenaeum* period did not achieve full clarity concerning his systematic intentions. Systematic ideas could not, at the time, hold sway in his mind, and this goes together, on the one hand, with the fact that he did not possess sufficient logical power to elaborate these ideas from his still rich and passionate thinking at that time and, on the other hand, with the fact that he had no understanding of the value of ethics in the system. Aesthetic interest prevailed over all else. "Friedrich Schlegel was an artist-philosopher or a philosophizing artist. As such, he pursued the traditions of the philosophical guild and sought a connection with the philosophy of his time; yet he was too much an artist to remain with the purely systematic."[92] In Schlegel (to come back to the image invoked above) the grid of his ideas almost never emerges from beneath the design that covers it. If art as the absolute medium of reflection is the basic systematic conception of the *Athenaeum* period, nonetheless other designations are continually being

substituted for it, and it is this that gives his thinking the look of confusing multiformity. The absolute appears now as education, now as harmony, now as genius or irony, now as religion, organization, or history. And it should not be denied that in other contexts it is quite possible to insert one of the other designations—not art, say, but history—for that absolute, while only its character as medium of reflection is preserved. But it is incontestable that most of these designations lack precisely that philosophical fruitfulness exhibited in the analysis of the concept of criticism for the definition of the reflection-medium as art. In the *Athenaeum* period, the concept of art is a legitimate—and perhaps, besides history, the only legitimate—fulfillment of Friedrich Schlegel's systematic intentions.[93]

One of his typical displacements and coverings might here, albeit by way of anticipation, find its place: "Art, bestowing shape from the impulse of striving spirituality, binds the latter in ever new forms with the occurrence of the entire life of the present and the past. Art fastens not on particular events of history but on its totality; from the viewpoint of eternally self-perfecting mankind, it draws the complex of events together, rendering them unified and manifest. Criticism . . . seeks to vindicate and maintain the ideal of humanity by rising up to . . . that very law which, joined to earlier laws, assures an approximation to the eternal ideal of humanity."[94] This is a paraphrase of Schlegel's thought in his early critique of Condorcet (1795). In his writings around 1800, as will be seen, such amalgamations and mutual blurrings of several concepts of the absolute, which in such commingling naturally lose their fruitfulness, gain the upper hand. Anyone who wants to form a picture of the deeper essence of Schlegel's conception of art from such propositions would necessarily go astray.

Schlegel's various attempts to define the absolute spring not only from a lack, not only from unclearness. What underlies them is far more a peculiar positive tendency in his thinking. In this tendency is found the answer to the question posed above concerning the source of the obscurity in so many of Schlegel's fragments and even the source of their systematic intentions. Certainly, for Friedrich Schlegel in the *Athenaeum* period, the absolute was the system in the form of art. Rather than attempting to grasp the absolute systematically, however, he sought conversely to grasp the system absolutely. This was the essence of his mysticism and, although he thoroughly affirmed it, the perilous character of this venture did not remain hidden from him. In the Windischmann fragments, he says of Jacobi (and Enders has shown that Schlegel not infrequently turned against Jacobi in order to castigate publicly his own mistakes): "Jacobi has fallen in between the absolute and the systematic philosophy, and there his mind has been ruinously bruised"[95]—a remark that recurs in still more malicious form in the *Athenaeum* fragments.[96]

Schlegel himself was unable to keep away from the mystical impulse to

absolute comprehension of the system, the "old inclination to mysticism."[97] He makes the opposite tendency into an objection against Kant: "He polemicizes against . . . not transcendental reason, but absolute reason—or thus systematic reason, too."[98] In an unsurpassable way, he characterizes this idea of the absolute comprehension of the system with the question: "Are not all systems individuals . . . ?"[99] For, indeed, if this were the case, then one could think of penetrating systems in their totality just as intuitively as one penetrates an individuality. Schlegel, then, was clear as to the extreme consequence of mysticism: "The thoroughgoing mystic must not merely leave in suspense the communicability of all knowing, but must directly deny it: this point must be established at a depth greater than ordinary logic can attain."[100] With this thesis from 1796 one can combine a contemporaneous proposition—"The communicability of the true system can only be a limited one; this can be proved a priori"[101]—in order to recognize how consciously Schlegel felt himself to be a mystic even in his early period. This thought then receives its most undisguised expression in the lectures: "Knowledge proceeds inwardly; it is, in and for itself, incommunicable—just as, according to the common expression, the man of reflection loses himself in himself. . . . Commonality comes about . . . only through the presentation. . . . One can, of course, assume that there is an inner knowing prior to or beyond all presentation; but such knowledge is unintelligible . . . in proportion as it is without representation."[102] In this, Schlegel and Novalis are at one: philosophy "is a mystical . . . penetrating idea that drives us incessantly in every direction."[103] Novalis' terminology bears the clearest stamp of the mystical tendency of Friedrich Schlegel's philosophizing. In 1798 A. W. Schlegel wrote to Schleiermacher: "Even my brother's marginal notes I reckon a gain; for in them he succeeds far better than in whole letters, just as in fragments he succeeds better than in essays, and in self-coined phrases better than in fragments. In the end, his entire genius is concentrated in mystical terminology."[104] In truth, what A. W. Schlegel quite pertinently designates "mystical terminology" has the most exact connection with Friedrich Schlegel's genius, with his most important conceptions and his peculiar mode of thought. This made it necessary for him to seek a mediation between discursive thinking and intellectual intuition, since the one did not satisfy his imperative of intuitive comprehension, whereas the other failed to satisfy his systematic interests. He thus found himself—since his thinking did not unfold systematically, although it was indeed systematically oriented throughout—faced with the problem of combining the maximum systematic range of thought with the most extreme truncation of discursive thinking. In what especially concerns intellectual intuition, Schlegel's manner of thought, unlike that of many mystics, is distinguished by its indifference to the eidetic; he appeals neither to intellectual intuitions nor to ecstatic states. Rather (to put it in a summary formula) he searches for a noneidetic

intuition of the system, and he finds this in language. Terminology is the sphere in which his thought moves beyond discursivity and demonstrability. For the term, the concept, contained for him the seed of the system; it was, at bottom, nothing other than a preformed system itself. Schlegel's thinking is *absolutely conceptual*—that is, it is linguistic thinking. Reflection is the intentional act of the absolute comprehension of the system, and the adequate form of expression for this act is the concept. In this intuition lies the motive for Friedrich Schlegel's numerous terminological innovations and the deepest reason for the continually new names he devises for the absolute. This type of thinking is characteristic of the early Romantics; it occurs likewise in Novalis, in whom it is less pronounced than in Schlegel. The latter gave clear expression, in his lectures, to the relation of terminological thinking to the system: "The very notion, in which one can comprehend the world as a unity and which one can in turn expand into a world, . . . is what we call 'concept.'"[105] "Thus, it would probably be much better to call a system an 'encompassing concept.'"[106] And when, during the *Athenaeum* period, it is said that "it is equally fatal for the mind both to have a system and to have none—hence, it will have to decide to combine both,"[107] the organon of this conjunction can be conceived once again as nothing other than the conceptual term. It is in the concept alone that the individual nature—which Schlegel, as we have said, vindicates for the system—finds its expression. In quite general terms, he says of moral persons: "A certain mysticism of expression, which in a romantic imagination and combined with grammatical[108] sense can be something very enticing and something very good, often serves them as a symbol of their beautiful secrets."[109] Novalis writes similarly: "How often one feels the poverty of words, their inability to strike several ideas with a single stroke."[110] And, conversely, "It is an advantage for an idea to have several names."[111]

This mystical terminology played its most general role in early Romanticism in the form of wit. Along with Friedrich Schlegel, Novalis and Schleiermacher were likewise interested in the theory of wit; in Novalis' fragments, it covers a broad range. At bottom, this theory is nothing other than the theory of mystical terminology. It is the attempt to call the system by its name—that is, to grasp it in a mystical individual concept in such a way that the systematic interconnections are comprised within it. The presupposition of a continuous, medial context, of a reflective medium of concepts, is operative here. This conceptual medium makes its appearance in the witty observation, as it does in the mystical term, like a bolt of lightning. "If all wit is principle and organ of universal philosophy, and all philosophy nothing other than the spirit of universality—that is, the science of all sciences as they combine and then separate once again, a logical chemistry—then the value and worth of that absolute, enthusiastic, thoroughly material wit are infinite, that wit in which Bacon and Leibniz were . . . ,

respectively, one of the first and one of the greatest virtuosi."[112] If wit is characterized now as "logical sociability,"[113] now as "chemical . . . spirit,"[114] now as "fragmentary geniality"[115] or "prophetic capacity,"[116] or if Novalis designates it as a "magical color show in the higher spheres,"[117] all this is said of the movement of concepts in their own medium, a movement effected in the witticism and expressed in the mystical term. "Wit is the manifestation, the external lightning-flash of imagination. Hence . . . the similarity of mysticism to wit."[118] In his essay "Über die Unverständlichkeit" ["On Incomprehensibility"], Schlegel wants to show "that words often understand themselves better than do those who use them . . . that there must exist among philosophical words . . . secret bonds of association . . . and that one gets the purest and most thorough incomprehensibility precisely from the science and the art that are intrinsically absorbed by the process of comprehending and of rendering comprehensible—that is, from philosophy and philology."[119] On occasion, Schlegel spoke of a "thick, fiery reason," "that makes wit into wit and gives to the pure style its elastic and electrical quality." In opposing this to what "one commonly calls reason," he clearly designates his own style of thinking in the most striking way.[120] It was the style, we have said, of a man for whom every sudden inspiration would set in motion the whole enormous mass of his ideas, who united indolence and ardor in the expression of his mental and his corporeal physiognomy. Finally, in passing, we should pose the question of whether or not this terminological tendency, which comes out so clearly and definitively in Schlegel, takes on for all mystical thinking a typical significance, the closer investigation of which might prove worthwhile and in the end lead to that a priori which lies at the basis of every thinker's terminology.

The technical language[121] of Romanticism was fashioned not so much from polemical or purely literary motives as from those deeper tendencies we have exposed. Elkuss speaks of the "hypertrophic development"[122] of this technical language. But in saying this, he does not fail to recognize that "those speculations will have had a thoroughly real function for the consciousness of every individual, and there arises the difficult task of explicating the integral of need . . . and knowledge which the Romantic school thought it possessed in all those hieroglyphs, from transcendental poetry to magical idealism."[123] The number of these hieroglyphic expressions is indeed large; in the course of this work an explanation will be given for some of them, such as the concepts of transcendental poetry and of irony; others, like the concepts of the Romantic and of the arabesque, can be treated here only briefly, while others—for example, that of philology—will not be treated at all. In contrast, the Romantic concept of criticism is itself an exemplary instance of mystical terminology, and for that reason this study is not the reproduction of a Romantic theory of criticism but the analysis

of its concept. Here, this analysis can still not aim at its content, but can aim only at its terminological relations. These lead beyond the narrower meaning of the word "criticism," understood as criticism of art, and necessitate a look at the remarkable concatenation by which the concept of "criticism" turned into the esoteric, cardinal concept of the Romantic school, alongside that term which gives it its name.

Of all the technical terms of philosophy and aesthetics in the writings of the early Romantics, the words "criticism" and "critical" are easily the most often encountered. "You produced a criticism,"[124] Novalis writes in 1796 to his friend, when he wishes to confer on him the highest praise; and two years later Schlegel says, in full self-consciousness, that he has begun "out of the depths of criticism." Between the friends, "higher criticism"[125] is a familiar designation for all their theoretical endeavors. Through Kant's philosophical work, the concept of criticism had acquired for the younger generation an almost magical meaning; in any case, the term explicitly connoted not the sense of a merely discerning, unproductive state of mind; rather, for the Romantics and for speculative philosophy, the term "critical" meant objectively productive, creative out of thoughtful deliberation. To be critical meant to elevate thinking so far beyond all restrictive conditions that the knowledge of truth sprang forth magically, as it were, from insight into the falsehood of these restrictions. In this positive sense, the critical procedure attains the closest conceivable affinity with the reflective procedure and, in utterances like the following, the two merge: "In every philosophy that begins in observation[126] of its own procedure, in criticism, the beginning always has something peculiar about it."[127] It is the same when Schlegel supposes that "abstraction, especially practical abstraction, is in the end nothing but criticism."[128] For he had read in Fichte that "no abstraction is possible . . . without reflection, and no reflection without abstraction."[129] Hence, it is finally no longer unintelligible when, to the annoyance of his brother, who calls it "true mysticism,"[130] he makes the assertion: "every fragment is critical," "critical, and in fragments would be tautological."[131] For a "fragment"—this, too, being a mystical term—is for him, like all that is spiritual, a medium of reflection.[132] This positive emphasis in the concept of criticism does not diverge as widely as one might have thought from Kant's usage. Kant, whose terminology contains not a little of the mystical spirit, prepared the way for this emphasis by opposing to the standpoints of dogmatism and skepticism, both of which he rejected, less the true metaphysics in which his system is meant to culminate than the "criticism" in whose name that system was inaugurated. One can therefore say that the concept of criticism already has a double sense in Kant—that double sense which in the Romantics is raised to a higher power, since by the word "criticism" they refer to Kant's total historical achievement and not only to his concept of *Kritik*. And in the end they understood how to preserve and apply the unavoidably negative moment of this concept. In the long run,

the Romantics could not overlook the vast discrepancy between the claim and the accomplishment of their theoretical philosophy. The word "criticism" once again arrived at just the right time. For it affirms that, however highly one estimates the worth of a critical work, it can never furnish the last word on its subject. In this sense, under the name of criticism, the Romantics at the same time confessed the inescapable insufficiency of their efforts, sought to designate this insufficiency as necessary, and so finally alluded, in this concept, to its necessary "incompleteness of infallibility," as it might be called.

It remains to establish, at least conjecturally, one particular terminological relation that applies to the concept of criticism, even in its narrower significance for the theory of art. The term "art critic" definitively came to prevail over the older term "art connoisseur" only with the Romantics. They avoided the idea of sitting in judgment over artworks, of rendering a verdict according to written or unwritten laws; one thought in this case of Gottsched, if not still of Lessing and Winckelmann.[133] But the Romantics felt themselves equally in opposition to the theorems of *Sturm und Drang*.[134] These theorems led—not indeed because of skeptical tendencies, but because of a limitless faith in the privilege of genius—to the sublation of all fixed principles and criteria of judgment. The former direction could be understood as dogmatic; the latter, in its effects, as skeptical. Hence, it appeared quite plausible to carry out, in art theory, the overcoming of both under the same name by which Kant had arbitrated that conflict in epistemology. If one reads the survey of the artistic tendencies of his time that Schlegel provides at the beginning of his essay "Ueber das Studium der Griechischen Poesie" ["On the Study of Greek Poetry"], then one might believe that Schlegel was more or less clearly aware of the analogy between aesthetic and epistemological problematics: "Here it[135] recommended works sanctioned by the stamp of its authority as eternal models for imitation; there it established absolute originality as the highest standard of artistic merit and covered even the most remote suspicion of imitation with infinite disgrace. In the most rigorous way, it demanded, donning its scholastic armor, unqualified submission to even its most arbitrary, patently ridiculous laws; or it deified genius in mystical, oracular pronouncements, made its first principle an artificial lawlessness, and honored with imperious superstition revelations that not infrequently were quite ambiguous."[136]

IV. The Early Romantic Theory of the Knowledge of Nature

Criticism comprises the knowledge of its object. For this reason, an exposition of the early Romantic concept of the criticism of art requires a characterization of the theory of the knowledge of objects, on which that concept is based. This latter form of knowledge must be distinguished from knowledge of the system or of the absolute, the theory of which has been

given above. Nevertheless, the theory of the knowledge of objects is to be derived from the latter theory; this objective knowledge concerns natural objects and works of art, whose epistemological problematic was of more concern to the first Romantics than were the problematics of other entities. The early Romantic theory of the knowledge of art [*Kunsterkenntnis*] was elaborated, under the heading of criticism, by Friedrich Schlegel above all; that of the knowledge of nature, by Novalis, among others. In these developments, now one, now the other of the different features of a general theory of the knowledge of objects makes an emphatic appearance in one or the other of these two thinkers, so that a thorough understanding of the one development requires a brief account of the other as well. Looking at the theory of natural knowledge is indispensable for the exposition of the concept of criticism. Both depend in equal measure on general systematic presuppositions, and both, as consequences of the latter, harmonize with these and with each other.

The theory of the knowledge of objects is determined by the unfolding of the concept of reflection in its significance for the object. The object, like everything real, lies within the medium of reflection. Considered methodologically or epistemologically, however, the medium of reflection is the medium of thinking, for it is formed according to the schema of reflection in thinking, which is canonical reflection. This reflection of thinking assumes its place as canonical reflection because in it the two basic moments of all reflection are most fully manifest: self-activity and knowing. For in it, the very thing that is reflected, that is thought, is the only thing which can reflect: thinking itself. Thus, it is self-actively thought. And because it is thought as reflecting itself, it is thought as immediately knowing itself. This knowledge of thinking through itself, as was noted, comprehends all knowledge generally. That this simple reflection, however, this thinking of thinking, is a priori conceived by the Romantics as a knowledge of thinking rests on the fact that they presuppose the initial, original, material thinking—that is, sense— as already fulfilled. On the basis of this axiom, the medium of reflection turns into the system, the methodological absolute into the ontological absolute. This can be understood as determined in several ways: as nature, as art, as religion, and so on. Never, however, will it lose its character as the medium of thought, as a context of relation established by thinking. In all its determinations the absolute remains, therefore, a thinking absolute, and a thinking essence is all that fills it. With this, the basic principle of the Romantic theory of object-knowledge is given. Everything that is in the absolute, everything real, thinks; because this thinking is that of reflection, it can think only itself, or, more precisely, only its own thinking; and because its own thinking is full and substantial, it knows itself at the same time that it thinks itself. Only from a quite particular point of view is the absolute and what subsists in it to be designated "I." Schlegel sees it that way in his

Windischmann lectures, but not in the *Athenaeum* fragments; Novalis, too, often seems to reject this way of looking at things. All knowledge is self-knowledge of a thinking being, which does not need to be an "I." Moreover the Fichtean "I," which is set in opposition to the "not-I," to nature, signifies for Schlegel and Novalis only an inferior form among an infinite number of forms of the self. For the Romantics, from the standpoint of the absolute, there *is* no "not-I," no nature in the sense of a being that does not become itself. "Selfhood is the ground of all knowledge,"[137] writes Novalis. The germ-cell of all knowledge is thus a process of reflection in a thinking being through which it gains knowledge of itself. All the capacity to be known on the part of a thinking being presupposes that being's self-knowledge. "Everything that one can think, itself thinks[138]—is a problem for thinking":[139] so runs the proposition that Friedrich Schlegel placed, not gratuitously, at the head of the fragments in the edition he oversaw of his late friend's works.

Novalis never tired of affirming this dependence of any knowledge of an object on self-knowledge by the object. He puts this in the most paradoxical and at the same time clearest form with the short proposition: "Perceptibility [is] an attentiveness."[140] It does not matter whether in this sentence, over and above the attentiveness of the object to itself, its attentiveness to the one perceiving is also meant; for even when Novalis clearly enunciates this thought—"In all predicates in which we see the fossil, it sees us"[141]—that attentiveness to the one seeing can still be rightly understood only as a symptom of the thing's capacity to see itself. In addition to embracing the sphere of thinking and knowing, therefore, this basic law of the reflective medium embraces also the sphere of perception and, in the end, that of activity as well. "A matter must deal with itself in order to be dealt with,"[142] runs the law that this last sphere obeys. In particular, knowing and perceiving must be related to all dimensions of reflection, so to speak, and must be founded in all: "Do we perhaps see each body only insofar as it sees itself and insofar as we see ourselves?"[143] Just as every act of knowledge proceeds from the self alone, so it extends to this alone: "Thoughts are filled only by thoughts, only by functions of thinking, just as sights are filled only by functions of seeing and of light. The eye sees nothing but eyes, the thought-organ nothing but thought-organs or the element appertaining to these."[144] "Just as the eye sees only eyes, so the understanding only understanding, the soul souls, the reason reasons, the spirit spirits, and so on. The imagination sees only imagination, the senses senses; God is recognized only by a God."[145] In this last fragment, the idea that every being knows only itself has been modified into the proposition that every being knows only what is like itself and is known only by beings that are like it. This touches on the question of the relation of subject and object in knowledge, a relation that plays no role in self-knowledge as the Romantics conceived it.

How is knowledge outside of self-knowledge possible—that is, how is

knowledge of objects possible? In fact, on the principles of Romantic think-
ing, it is *not* possible. Where there is no self-knowledge, there is no knowing
at all; where there *is* self-knowledge, there the subject-object correlation is
abrogated—there is a subject, if you will, without a correlative object. In
spite of this, reality does not form an aggregate of monads locked up in
themselves and unable to enter into any real relations with one another. On
the contrary, all unities in reality, except for the absolute itself, are only
relative unities. They are so far from being shut up in themselves and free
of relations that through the intensification of their reflection (potentiation,
romanticization) they can incorporate other beings, other centers of reflec-
tion, more and more into their own self-knowledge. Yet this Romantic mode
of representation does not concern only individual human centers of reflec-
tion. It is not only persons who can expand their knowledge through
intensified self-knowledge in reflection; so-called natural things can do so as
well. In their case, the process has an essential relation to what is commonly
called their "being-known." That is, the thing, to the extent that it intensifies
reflection within itself and includes other beings in its self-knowledge, radi-
ates its original self-knowledge onto these other beings. In this way, too, the
human being can participate in this self-knowledge of other beings; this way
will coincide with the first in the case of the knowledge of two beings
through each other, a knowledge that is at bottom the self-knowledge of
their reflectively produced synthesis. Accordingly, everything that presents
itself to man as his knowledge of a being is the reflex in him of the
self-knowledge of the thinking in that very being. Thus, there exists no mere
being-known of a thing; just as little, however, is the thing or being limited
to a mere being-known through itself. Rather, the intensification[146] of reflec-
tion in it suspends the boundary that separates its being-known by itself
from its being-known by another; in the medium of reflection, moreover,
the thing and the knowing being merge into each other. Both are only
relative unities of reflection. Thus, there is in fact no knowledge of an object
by a subject. Every instance of knowing is an immanent connection in the
absolute, or, if one prefers, in the subject. The term "object" designates not
a relation within knowledge but an absence of relation, and loses its sense
wherever a cognitive relation comes to light. Knowledge is anchored on
every side in reflection, as the fragments by Novalis intimate: the being-
known of one being by another coincides with the self-knowledge of that
being which is being known, coincides with the self-knowledge of the
knowing being and with the being-known of the knowing being by the being
it knows. This is the most exact form of the Romantic theory's basic
principle of the knowledge of objects. Its bearing on the epistemology of
nature lies above all in the propositions concerning perception as well as
observation, propositions that depend on this basic principle.

The first of these [that is, perception] has no influence on the theory of

criticism and thus must be passed over here. Besides, it is clear that this theory of knowledge cannot lead to any distinction between perception and knowledge and that, in essence, it attributes the distinctive features of perception to knowledge as well. According to this theory, knowledge is immediate in the same high degree as only perception can be; and the readiest grounding of the immediacy of perception likewise proceeds from a medium common to the perceiver and the perceived, as the history of philosophy shows in the case of Democritus, who describes perception on the basis of a partly material interpenetration of subject and object. Thus, Novalis likewise proposes that "the star appears in the telescope and penetrates it. . . . The star is a spontaneous luminous being, the telescope or eye a receptive luminous being."[147]

The doctrine of the medium of knowledge and perception is linked to the doctrine of observation, which is of immediate importance in understanding the concept of criticism. "Observation" [*Beobachtung*] and its frequently applied synonym "experiment" [*Experiment*] are also examples of mystical terminology; in them, what the early Romantics had to explain and conceal concerning the principle of the knowledge of nature rises to a peak. The question to which the concept of observation is the answer runs as follows: What approach does the investigator have to adopt in order to achieve knowledge of nature, assuming that the real is a medium of reflection? He will understand that no knowledge is possible without the self-knowledge of what is to be known, and that this can be called into wakefulness by one center of reflection (the observer) in another (the thing) only insofar as the first, through repeated reflections, intensifies itself to the point of encompassing the second. Significantly, Fichte was the first to articulate this theory for the domain of pure philosophy, and in doing so he gave an indication of how deeply it is bound to the purely epistemological motifs of the early Romantics. He says of the *Wissenschaftslehre,* in contrast to other philosophies:

> What it makes into the object of its thinking is not a dead concept, which comports itself merely passively in the face of its investigation, but is something alive and active that from itself and by itself produces cognitions, something that the philosopher simply observes. His business in this concern is nothing more than this: he sets that living thing into suitable activity; he observes this (its activity), apprehends it, and grasps it as a unity. He gets the experiment going. But how the object expresses itself is the affair of the object. . . . In the philosophies opposed to this, there is only one sequence of thinking—that of the thoughts of the philosopher—since his subject matter itself is not introduced as thinking.[148]

What in Fichte holds true of the "I," in Novalis holds true of the natural object and becomes a central tenet of the philosophy of nature at that

time.[149] The designation of this method as experiment, already adopted by Fichte, was especially pertinent to the natural object. Experiment consists in the evocation of self-consciousness and self-knowledge in the things observed. To observe a thing means only to arouse it to self-recognition. Whether an experiment succeeds depends on the extent to which the experimenter is capable, through the heightening of his own consciousness, through magical observation, as one might say, of getting nearer to the object and of finally drawing it into himself. In this sense, Novalis says of the genuine experimenter that nature "reveals itself all the more completely through him, the more his constitution is in harmony with it,"[150] and says of the experiment that it is "the mere extension, division, diversification, augmentation of the object."[151] For this reason, he cites approvingly Goethe's opinion "that every substance has its closer rapport with itself, just as iron in magnetism."[152] He sees in such rapport the reflection of the object; we must leave undecided how far in this he actually accords with Goethe's opinion.

The medium of reflection of knowing and that of perceiving coincide for the Romantics. The term "observation" alludes to this identity of media; what is distinguished as perception and method of research in the normal experiment is united in magical observation, which is itself an experiment; for this theory, it is the only possible experiment. One can also call this magical observation in the Romantics' sense an *ironic* observation. That is, it observes in its object nothing singular, nothing determinate. No question put to nature lies at the base of this experiment. Instead, observation fixes in its view only the self-knowledge nascent in the object; or rather it, the observation, *is* the nascent consciousness of the object itself. It can rightly be called ironic, therefore, because in its not knowing—in its attending—observation knows better, being identical with the object. It would thus be permissible, if indeed not more correct, to leave this correlation generally out of play, and to speak of a coincidence of the objective and the subjective side in knowledge. Simultaneous with any cognition of an object is the actual coming-into-being of this object itself. For knowledge, according to the basic principle of knowledge of objects, is a process that first makes what is to be known into that *as* which it is known. Thus, Novalis says: "The process of observation is at the same time a subjective and objective process, an ideal and a real experiment. Proposition and product must be accomplished simultaneously if the process is to be perfectly achieved. If the object observed is already a thesis, and the process thoroughly absorbed in thought, then the result will be the very same thesis, only at a higher level."[153] With this last remark, Novalis passes from the theory of natural observation to the theory of the observation of spiritual formations. The "thesis," in his sense, can be a work of art.

Part Two: Criticism of Art

I. The Early Romantic Theory of the Knowledge of Art

Art is a determination of the medium of reflection—probably the most fruitful one that it has received. Criticism of art is knowledge of the object in this medium of reflection. Thus, the following investigation aims to show what bearing the conception of art as a medium of reflection has on the knowledge of its idea and its formations, as well as on the theory of this knowledge. The last question has been advanced through all the foregoing discussion, to such an extent that we need only recapitulate this in order to transfer our consideration from the method of Romantic criticism to its concrete achievement. It would obviously be totally mistaken to seek in the Romantics a special reason for their considering art as a medium of reflection. For them this interpretation of everything real, thus of art as well, was a metaphysical credo. It was not, as we already indicated in the introduction, the central metaphysical thesis of their world view; for this, its specifically metaphysical weight is far too slight. Yet however much the connection depends on treating this thesis as the analogue of a scientific hypothesis, on explicating it in an immanent fashion only, and on unfolding its achievements for the comprehension of the objects, we must not forget that in an investigation of Romantic metaphysics, or of the Romantic concept of history, this metaphysical intuition of everything real as a thinking entity would disclose still other sides than those it displays in relation to the theory of art, for which its epistemological tenor matters above all. Its metaphysical significance, on the other hand, will not really be taken up in this essay, but will be merely touched on in the Romantic theory of art, which indeed, for its part, reaches the metaphysical depths of Romantic thinking immediately and with far greater certainty.

In one passage of the Windischmann lectures, we can still perceive the faint echo of an idea that powerfully moved Schlegel in the *Athenaeum* period and determined his theory of art. "There is a kind of thinking that produces something and therefore has a great similarity of form to the creative capacity which we ascribe to the 'I' of nature and to the 'world-I.' This form of thinking is, namely, poetry, which in a way creates its own material."[154] In this passage, the idea no longer had any significance. It is nonetheless the clear expression of Schlegel's previous standpoint—namely, that reflection, which he earlier conceived as art, is absolutely creative, filled with content. Thus, in the period to which this investigation refers, he was still unacquainted with that moderatism in the concept of reflection in accordance with which, in the lectures, he opposes the will that limits it to reflection. Earlier he had known only a relative, autonomous limitation of

reflection by itself, a limitation that, as will be seen, plays an important role in the theory of art. The weakness and sedateness of the later work rests on a curtailment of the creative omnipotence of reflection, which for Schlegel had once revealed itself most clearly in art. In the early period, it was only in the famous 116th *Athenaeum* fragment that he characterized art as a medium of reflection with a clarity comparable to that of the passage from his lectures; in that earlier fragment, he says that Romantic poetry can, "more than any other, hover—on wings of poetic reflection, free from all interests—midway between that which is represented and him who represents it.[155] It can raise this reflection again and again to a higher power and multiply it as if in an endless series of mirrors." Of the productive and receptive relation to art, Schlegel says: "The essence of poetic feeling lies perhaps in the fact that one can affect oneself wholly from within oneself."[156] This means that the point of indifference for reflection, the point at which reflection arises from nothing, is poetic feeling. It is difficult to decide whether this formulation contains a reference to Kant's theory of the free play of the mental faculties, in which the object retreats as a nullity in order to form merely the occasion for a self-active, inner attunement of the spirit. At any rate, the investigation of the relation between the early Romantic and the Kantian theories of art does not fall within the scope of this monograph concerning the Romantic concept of criticism, because it includes no perspective through which that relation might be grasped. In many passages Novalis, too, suggested that the basic structure of art is that of the medium of reflection. The sentence, "Poetry is, indeed, only the more resolute, more active, more productive use of our organs, and perhaps thinking itself would be something not much different—and thinking and poetry therefore are one and the same,"[157] is quite close to Schlegel's remark in the lectures quoted above and points in that same direction. Quite clearly, Novalis conceives of art as the medium of reflection *kat' exochen*,[158] applies the word "art" precisely as a *terminus technicus* for this medium when he says: "The beginning of the 'I' is merely ideal. . . . The beginning arises later than the 'I'; therefore the 'I' cannot have begun. We see from this that we are here in the domain of art."[159] And when he asks, "Is there an art of invention without data, an absolute art of invention?"[160] on the one hand, this is a question concerning an absolutely neutral origin of reflection; on the other hand, he himself in his writings often enough designated poetry as that absolute art of invention without data. He protests against the Schlegel brothers' theory of Shakespeare's artificiality and reminds them that art "is, as it were, nature that contemplates itself, imitates itself, forms itself."[161] When he says this, his thought is less that nature is the substrate of reflection and of art than that the integrity and unity of the medium of reflection ought to remain preserved. Nature, in this passage, seems to

Novalis to be a better expression for this than art and, hence, even for the phenomena of poetry one should, according to him, leave this expression [that is, nature] just as it is, since it stands only for the absolute. Often, however, in complete agreement with Schlegel, Novalis will hold art to be the prototype for the medium of reflection and will then say: "Nature produces; the spirit makes. It is much easier to be made than to make oneself."[162] Thus, reflection is the originary and constructive factor in art, as in everything spiritual. Hence, religion arises only when "the heart feels itself,"[163] and it is true that poetry "is a self-forming essence."[164]

The task for the criticism of art is knowledge in the medium of reflection that is art. All the laws that hold generally for the knowledge of objects in the medium of reflection also hold for the criticism of art. Therefore, criticism when confronting the work of art is like observation when confronting the natural object; the same laws apply, simply modified according to their different objects. When Novalis says, "What is at the same time thought and observation is a critical germ,"[165] he expresses—tautologically, to be sure, for observation is a thought process—the close affinity between criticism and observation. Thus, criticism is, as it were, an experiment on the artwork, one through which the latter's own reflection is awakened, through which it is brought to consciousness and to knowledge of itself. "The genuine review ought to be the result and the presentation of a philological experiment and a literary inquiry."[166] Schlegel, for his part, terms the "so-called inquiry . . . a historical experiment,"[167] and, with a view to the critical activity in which he was himself employed in 1800, he said: "I shall not forgo experimentation with works of poetic and philosophical art—as before, so also in the future, for myself and for the sake of knowledge."[168] The subject of reflection is, at bottom, the artistic entity itself, and the experiment consists not in any reflecting *on* an entity, which could not essentially alter it as Romantic criticism intends, but in the unfolding of reflection—that is, for the Romantics, the unfolding of spirit—*in* an entity.

Insofar as criticism is knowledge of the work of art, it is its self-knowledge; insofar as it judges the artwork, this occurs in the latter's self-judgment. In this last office, criticism goes beyond observation; this shows the difference between the art object and the object of nature, which admits of no judgment. The idea of self-judgment on the basis of reflection is not alien to the Romantics even outside the domain of art. Thus, one reads in Novalis: "The philosophy of the sciences has three periods: the thetic period of the self-reflection of science; the period of the opposed, antithetic self-judgment of science; and finally the syncretic, which is self-reflection and self-judgment at once."[169] As for self-judgment in art, Schlegel writes in the review of *Wilhelm Meister* that was so important for his theory of art: "Fortunately,

it is one of those books that judge themselves."[170] Novalis says: "A review is the complement of the book. Many books need no review, only an announcement; they already contain their own review."[171]

In any case, this self-judgment in reflection is only improperly called a judgment. For in it a necessary moment of all judgment, the negative, is completely curtailed. Though the mind in every reflection elevates itself over all earlier stages of reflection and thereby negates them, it is this that gives reflection its critical coloring in the first place. But the positive moment of this heightening of consciousness far outweighs the negative. This estimation of the process of reflection can be heard in Novalis' words: "The act of overleaping oneself is everywhere the highest, the primal point, the genesis of life . . . Thus, all philosophy begins where the one who is philosophizing philosophizes himself—that is, at the same time consumes himself and renews himself . . . Thus, all living morality begins when for reasons of virtue I act contrary to virtue; with this begins the life of virtue, through which, perhaps, capacity increases infinitely."[172] In exactly this positive way, the Romantics assess self-reflection in the artwork. For the intensification of the consciousness of the work through criticism, Schlegel found a highly significant expression in a witticism. In a letter to Schleiermacher, he gives his *Athenaeum* essay "Über Goethes Meister" the shortened title "Übermeister"[173]—a perfect expression for the ultimate intention of this critique, which, more than any other, exemplifies his concept of criticism in general. On other occasions, too, he is glad to use similar coinages, without our being able to decide whether there is the same underlying tenor, because they are not written as one word.[174] The moment of self-annihilation, the possible negation in reflection, cannot therefore be of much consequence over against the thoroughly positive moment of the heightening of consciousness in the one who is reflecting. Thus, an analysis of the Romantic concept of criticism leads at once to that feature which will show itself ever more clearly as the analysis progresses and which will be demonstrated on many sides: the complete positivity of this criticism, in which the Romantic concept of criticism is radically distinguished from the modern concept, which sees criticism as a negative court of judgment.

Every critical understanding of an artistic entity is, as reflection in the entity, nothing other than a higher, self-actively originated degree of this entity's consciousness. Such intensification of consciousness in criticism is in principle infinite; criticism is therefore the medium in which the restriction of the individual work refers methodically to the infinitude of art and finally [*endlich*] is transformed into that infinitude [*Unendlichkeit*]. For it is self-evident that art, as medium of reflection, is infinite. Novalis, we indicated above, conceived medial reflection in general as "Romanticizing," and in doing so was certainly not thinking only of art. Yet what he describes is exactly the procedure for criticism of art. "Absolutizing, universalizing,

classification of the individual moment is the true essence of Romanticiz-
ing."[175] "In giving the finite the look of infinity, I romanticize it."[176] Novalis
also conceives the critical task from the standpoint of the critic, for it is as
such that the term "true reader" in the following remark is to be understood:
"The true reader must be the extended author. He is the higher tribunal who
receives the case already worked up in advance by the lower authorities. In
the course of reading, it is feeling . . . that decides in turn the crudeness and
the culture of the book, and if the reader should adapt the book according
to his own idea, then a second reader would refine it still more. Thus, in
the end . . . the mass becomes . . . an organ of the effective spirit."[177] That
is, the individual work of art should be dissolved in the medium of art, but
this process can be appropriately enacted by a number of critics each
displacing the others, if these are not empirical intellects but stages of
reflection personified. It is quite obvious that the potentiation of reflection
in the work can also be marked in the critique of the work, something that
itself has infinitely many levels. In this sense, Schlegel says: "Every philo-
sophical[178] review should at the same time be a philosophy of reviews."[179]
This critical procedure can never come into conflict with the original recep-
tion of the artwork by pure feeling, for, in addition to the heightening of
the work itself, it is also the heightening of its comprehension and reception.
In his critique of *Wilhelm Meister,* Schlegel says: "It is fine and necessary to
abandon oneself utterly to the impression a poetic work makes . . . and
perhaps only in particular cases to confirm one's feeling through reflection
and to raise it to the level of thought . . . and complete it. But it is no less
necessary to be able to abstract from all that is particular, so that—hover-
ing—one grasps the universal."[180] This grasping of the universal is conceived
as "hovering" because it is a matter of infinitely rising reflection that never
settles into an enduring point of view, according to Schlegel's indications in
the 116th *Athenaeum* fragment.

Thus, reflection grasps precisely the central—that is, universal—moments
of the work and immerses them in the medium of art, as the critique of
Wilhelm Meister is meant to demonstrate. On closer inspection Schlegel
wants to find, in the role that the different forms of art play in the education
of the hero, a system secretly indicated, whose distinct unfolding and ar-
ticulation within the totality of art would be a task for the criticism of the
work. In this procedure, the critique is not meant to do anything other than
discover the secret tendencies of the work itself, fulfill its hidden intentions.
It belongs to the meaning of the work itself—that is, in its reflection that
the criticism should go beyond the work and make it absolute. This much
is clear: for the Romantics, criticism is far less the judgment of a work than
the method of its consummation. It is in this sense that the Romantics called
for poetic criticism, suspending the difference between criticism and poetry
and declaring: "Poetry can be criticized only through poetry. An aesthetic

judgment that is not itself a work of art, . . . as representation of the necessary impression in its emergence,[181] . . . has no rights of citizenship in the realm of art."[182] "This poetic criticism . . . will present the representation anew, will once again form what is already formed . . . It will complement, rejuvenate, newly fashion the work."[183] For the work is incomplete. "Only the incomplete can be understood, can lead us further. What is complete can only be enjoyed. If we want to understand nature, then we must posit it as incomplete."[184] This holds true of the artwork, too, not as a fiction but in truth. Every work is, in relation to the absolute of art, necessarily incomplete, or—what amounts to the same thing—it is incomplete in relation to its own absolute idea. "For this reason, there should be journals of criticism that treat authors in an artistically clinical and surgical manner, and do not merely track down the illness and make it known with malicious joy . . . Authentic police . . . seek to ameliorate . . . the pathological tendency."[185] Novalis has examples of such perfecting, positive criticism in mind when he says of certain sorts of translations that he calls "mythical": "They present the pure, perfected character of the individual work of art. They give us not the actual work of art, but its ideal. There still does not exist, as I believe, any complete model of this. But in the spirit of many criticisms and descriptions of artworks, one comes across brilliant traces. It calls for a head in which poetic spirit and philosophic spirit have interpenetrated in their entire fullness."[186] It may be that, in bringing criticism and translation close to each other, Novalis was thinking of a medial, continuous transposition of the work from one language into another—a conception which, given the infinitely riddling nature of translation, is from the start as admissible as any other.

"If one wants to see and must see what is characteristic of the modern critical spirit in its refusal of all dogmatism, in its respect for the unique sovereignty of the productive creativity of artist and thinker, then the Schlegels awakened this modern critical spirit and brought it to what is in principle its highest manifestation."[187] Enders applies these words to the whole Schlegel literary family. More than any of the other members of this family, Friedrich Schlegel is responsible for the decisive overcoming of aesthetic dogmatism, and in addition—though Enders does not mention it here—for the equally important securing of criticism against the skeptical tolerance that is traceable, in the end, to the boundless cult of creative power understood as the mere expressive force of the creator. In the one respect he overcame the tendencies of rationalism, whereas in the other he surmounted the destructive moments intrinsic to the theory of *Sturm und Drang;* with respect to this last, the criticism of the nineteenth and twentieth centuries has once again fallen away from his standpoint. He fixed the laws of the spirit in the work of art itself, instead of making the latter into a mere by-product of subjectivity, as so many modern authors, following the train

of their own thinking, have misunderstood him to have done. From what has been said above, one can appreciate the spiritual vitality and tenacity that were required to secure this standpoint, which in part, as the overcoming of dogmatism, has come to be taken for granted as the legacy of modern criticism. From the viewpoint of modern criticism, which is determined not by any theory but only by a deteriorated praxis, the fullness of positive presuppositions worked into the negation of dogmatism cannot be measured. Modern criticism overlooks the fact that these presuppositions, along with their liberating achievement, secured a basic concept that could not have been previously introduced into the theory with any definiteness: the concept of the work. For not only did Schlegel's concept of criticism achieve freedom from heteronomous aesthetic doctrines, but it made this freedom possible in the first place by setting up for artworks a criterion other than the rule—namely, the criterion of an immanent structure specific to the work itself. He did this not with the general concepts of harmony and organization which, in the case of Herder or Moritz,[188] were incapable of establishing a criticism of art, but with a genuine theory of art—even though one still absorbed in concepts—a theory of art as a medium of reflection and of the work as a center of reflection. With this he secured, from the side of the object or structure, that very autonomy in the domain of art that Kant, in the third *Critique,* had lent to the power of judgment. The cardinal principle of critical activity since the Romantic movement—that is, the judgment of works by immanent criteria—was attained on the basis of Romantic theories which in their pure form certainly would not completely satisfy any contemporary thinker. Schlegel transfers the focus of his absolutely new basic principle of criticism to *Wilhelm Meister* when he calls it "the absolutely new and unique book which one can learn to understand only from the book itself."[189] Novalis is at one with Schlegel again in this basic principle: "To find formulas for art-individuals—formulas through which they can first be understood in the most authentic sense—is the business of an artistic critic, whose labors prepare the way for the history of art."[190] He says of taste, to which rationalism appealed for its rules (insofar as these were not grounded purely historically): "Taste by itself judges only negatively."[191]

Thus, a precisely determined concept of the work becomes, through this Romantic theory, a correlate to the concept of criticism.

II. The Work of Art

The Romantic theory of the artwork is the theory of its form. The early Romantics identified the limiting nature of form with the limitedness of any finite reflection, and by this one consideration they determined the concept of the work of art within their world view. Quite analogously to the thought with which Fichte, in the first version of the *Wissenschaftslehre,* sees reflec-

tion as manifesting itself in the mere form of knowledge, the pure essence of reflection announces itself to the early Romantics in the purely formal appearance of the work of art. Thus, form is the objective expression of the reflection proper to the work, the reflection that constitutes its essence. Form is the possibility of reflection in the work. It grounds the work a priori, therefore, as a principle of existence; it is through its form that the work of art is a living center of reflection. In the medium of reflection, in art, new centers of reflection are continually forming. Each time, according to their spiritual seed, they embrace, as they reflect, larger or smaller contexts. The infinitude of art attains to reflection first of all only in such a center, as in a limiting value; that is, it attains to self-comprehension and therewith to comprehension generally. This limit-value is the form of presentation of the individual work. On it rests the possibility of a relative unity and closure of the work in the medium of art.—But since every single reflection in this medium can be only an isolated and fortuitous one, the unity of the work vis-à-vis the unity of art can be only a relative unity; the work remains burdened with a moment of contingency. It is precisely the function of form to admit this particular contingency as in principle necessary or unavoidable, to acknowledge it through the rigorous self-limitation of reflection. That is, practical, determinate reflection and self-restriction constitute the individuality and form of the work of art. In order for criticism, as set forth above, to be the suspension of all limitation, the work must rest on limitation. Criticism fulfills its task insofar as, with greater closure of reflection and more rigorous form in the work, it drives these the more manifoldly and intensively out of itself, dissolves the original reflection in one higher, and so continues. In this project, criticism depends on the germ cells of reflection, the positively formal moments of the work that it resolves into universally formal moments. It thus represents the relation of the individual work to the idea of art and thereby the idea of the individual work itself.

Friedrich Schlegel, especially around 1800, did indeed provide definitions of the content of the true work of art; these, however, rest on the already mentioned covering up and obscuring of the basic concept of the medium of reflection, in which the concept loses its methodological potency. Where he defines the absolute medium no longer as art but as religion, he can grasp the work of art from the side of its content only in an unclear way. Despite all his efforts, he cannot elucidate his presentiment of a worthy content. This remains a mere tendency. He longs to rediscover in content[192] the peculiar features of his religious cosmos, but due to this lack of clarity, his idea of form actually gains nothing.[193] Prior to this alteration in his world picture, and in those passages where the older doctrines still remained intact, he had, together with Novalis, championed a rigorous concept of the work as a new achievement in the Romantic school, connecting it with a concept of form derived from the philosophy of reflection: "What you find said in

the philosophy books about art and form pretty much suffices to explain the clockmaker's art. On the subject of higher art and form, you never find the least work."[194] The higher form is the self-restriction of reflection. In this sense, the 37th *Lyceum* fragment treats of the "value and . . . dignity of self-restriction, which for the artist as for the man . . . is the highest and most necessary thing. The most necessary: for wherever one does not limit oneself, the world imposes limits, whereby one becomes a slave. The highest: for one can limit oneself only at *those* points and on *those* sides where one has infinite[195] power—self-creation and self-annihilation . . . An author . . . who is willing and able to go on speaking to the last word . . . is much to be deplored. One need only be on guard against . . . errors. What seems like unconditioned arbitrariness and should seem so . . . must nonetheless at bottom be once again absolutely necessary; otherwise illiberality arises, and self-annihilation takes the place of self-restriction." This "liberal self-restriction," which Enders rightly calls "a strict requirement of Romantic criticism,"[196] is achieved by the presentational form of the work. Nowhere are the essentials of this perception expressed more clearly than in a fragment by Novalis, which concerns not art but civic morals: "Since the spirit is most effectively at work in what is most alive, and since also the workings of the spirit there are reflections, and yet reflection in its essence is formative, and since therefore the beautiful or consummate reflection is allied to what is most alive, so also will the expression of the citizen in proximity to the king . . . be an expression of the most reserved fullness of power, an expression of the liveliest stirrings of feeling governed by the most respectful consideration."[197] Here one need only substitute the work of art for the citizen and the absolute of art for the king in order to find the clearest indication of how the formative power of reflection stamps the form of the work according to the views of early Romanticism. The term "work" was used emphatically by Friedrich Schlegel for what is formed thus determinately. In the *Dialogue on Poetry* [*Gespräch über die Poesie*], Lothario speaks of what is self-sufficient and complete in itself, for which he "now finds no other word than 'works' and is accordingly glad to reserve it for this usage."[198] In the same context, one reads the following exchange: "*Lothario:* . . . Only because it is one and all does a work become a work. Only through this is it distinguished from a study. *Antonio:* And yet I could name you studies that are at the same time 'works' in your sense."[199] The answer here contains a corrective hinting at the double nature of the work: it is only a relative unity; it remains an essay, in which "one and all" find a mooring. And in his review of Goethe's works, in 1808, Schlegel is still saying that "in the fullness of its inner formation, *Wilhelm Meister* perhaps takes precedence over all other works of our poet; no other is to the same degree a *work*."[200] By way of summary, Schlegel characterizes the significance of reflection for work and form in the following words: "A work

is formed when it is everywhere sharply delimited, but within those limits is limitless . . ., when it is wholly true to itself, is everywhere the same, yet elevated above itself."[201] If, by virtue of its form, the work of art is a moment of the absolute medium of reflection, then there is nothing in itself unclear about Novalis' proposition, "Every work of art has an a priori ideal, an intrinsic necessity, to exist"[202]—a proposition in which the overcoming, in principle, of dogmatic rationalism in aesthetics is perhaps at its clearest. For this is a standpoint to which an assessment of the work in accordance with rules could never lead, any more than could a theory that understands the work only as the product of a genial mind. "Do you by chance consider it impossible to construct future poems a priori?"[203] asks Schlegel's Ludovico, in complete agreement with the proposition.

Next to the translation of Shakespeare, the permanent poetic achievement of Romanticism was the appropriation of Romance art forms for German poetry. In full consciousness, Romanticism strove toward the conquest, cultivation, and purification of these forms. Still, its relation to them was entirely different from that of preceding generations. The Romantics, unlike the Enlightenment, did not conceive of form as a rule for judging the beauty of art, or the observance of this rule as a necessary precondition for the pleasing or edifying effect of the work. Form did not count for the Romantics either as a rule in itself or even as dependent on rules. This conception, without which the truly important work of A. W. Schlegel in translating from Italian, Spanish, and Portuguese is unthinkable, was the focus of his brother's philosophical intentions. Every form as such counts as a peculiar modification of the self-limitation of reflection; it needs no other justification, because it is not a means to the representation of a content. The Romantics' endeavors to reach purity and universality in the use of forms rests on the conviction that, by critically setting free the condensed potential and many-sidedness of these forms (by absolutizing the reflection bound up in them), the critic will hit upon their connectedness as moments within the medium. The idea of art as a medium thus creates for the first time the possibility of an undogmatic or free formalism—a liberal formalism, as the Romantics would say. Early Romantic theory grounds the validity of forms independently of the ideal of determinate structures. To determine the entire philosophical bearing of this attitude, in its positive and negative aspects, is one of the main tasks of the present essay.

When, therefore, Friedrich Schlegel demands that thinking, in its concern with the objects of art, should contain "absolute liberality united with absolute rigorism,"[204] one can apply this requirement also to the artwork itself, in regard to its form. He calls such a unification, "in the more noble and original sense of the word, 'correct,' since it signifies the intentional development . . . of what is innermost . . . in the work according to the spirit of the whole; it signifies the practical[205] reflection of the artist."[206]

This is the structure of the work for which the Romantics demand an immanent criticism. This postulate conceals in itself a peculiar paradox. For one cannot foresee how a work could be criticized in its own proper tendencies, because these tendencies, insofar as they are indisputably determinable, are fulfilled, whereas insofar as they are unfulfilled, they are not indisputably determinable. This latter possibility must in the extreme case assume a form such that inner tendencies are altogether lacking and, accordingly, immanent criticism impossible. The Romantic concept of criticism makes possible the resolution of both these paradoxes. The immanent tendency of the work and, accordingly, the standard for its immanent criticism are the reflection that lies at its basis and is imprinted in its form. Yet this is, in truth, not so much a standard of judgment as, first and foremost, the foundation of a completely different kind of criticism—one which is not concerned with judging, and whose center of gravity lies not in the evaluation of the single work but in demonstrating its relations to all other works and, ultimately, to the idea of art. Friedrich Schlegel names this as the tendency of his critical work: "in spite of an often laborious concern with particulars, . . . nevertheless to understand and to explain everything as part of a whole, rather than to appraise it judgmentally."[207] Thus, in complete antithesis to the present-day conception of its nature, criticism in its central intention is not judgment but, on the one hand, the completion, consummation, and systematization of the work and, on the other hand, its resolution in the absolute. Both of these processes coincide in the end, as will be shown below. The problem of immanent criticism loses its paradox[208] in the Romantic definition of this concept, according to which it does not mean a judgment of the work, for which it would be absurd to specify an immanent standard. Criticism of a work is, rather, its reflection, which can only, as is self-evident, unfold the germ of the reflection that is immanent to the work.

Of course, the consequences of the theory of criticism extend in many cases also to the theory of the judgment of works. These consequences can be expressed in three basic propositions, which for their part yield an immediate response to the paradox of the notion of immanent judgment sketched out above. These three basic theses of the Romantic theory of the judgment of artworks can be formulated as the principle of the mediacy of judgment, the principle of the impossibility of a positive scale of values, and the principle of the uncriticizability of inferior work.

The first principle, a clear consequence of what has been expounded, affirms that the judgment of a work must never be explicit, but rather must always be implicit in the fact of its Romantic critique (that is, its reflection). For the value of a work depends solely on whether it makes its immanent critique possible or not. If this is possible—if there is present in the work a reflection that can unfold itself, absolutize itself, and resolve itself in the

medium of art—then it is a work of art. The criticizability of a work demonstrates on its own the positive value judgment made concerning it; and this judgment can be rendered not through an isolated inquiry but only by the fact of critique itself, because there is no other standard, no other criterion for the presence of a reflection than the possibility of its fruitful unfolding, which is called criticism. That implicit judgment of artworks in Romantic criticism is remarkable in a second way: it has no scale of values at its disposal. If a work can be criticized, then it is a work of art; otherwise it is not—and although a mean between these two cases is unthinkable, no criterion of the difference in value among true works of art may be contrived either. This is what Novalis means when he says: "Criticism of poetry is an absurdity. It is very difficult to decide whether something is poetry or not; still, this is the only possible decision."[209] And Friedrich Schlegel formulates the same thought when he says that the material of criticism "can only be classical and absolutely eternal."[210] In the basic principle of the uncriticizability of the inferior work, we see one of the hallmarks of the Romantic conception of art and of its criticism. Schlegel expressed it most clearly in the conclusion of his essay on Lessing: "True criticism can . . . take no notice of works that contribute nothing to the development of art . . .; indeed, in accordance with this, there can be no true criticism of what does not stand in relation to that organism of cultivation and of genius, of what does not authentically exist for the whole and in the whole."[211] "It would be illiberal not to assume that every philosopher can be . . . reviewed. . . . But it would be presumptuous to treat poets in the same way—unless the critique were poetry through and through and, as it were, a living and acting artwork," Schlegel says in the 67th *Athenaeum* fragment. The Romantic *terminus technicus* for the posture that corresponds to the axiom of the uncriticizability of the bad—not only in art, but in all realms of intellectual life—is "annihilate." It designates the indirect refutation of the nugatory through silence, through ironic praise, or through the high praise of the good. The mediacy of irony is, in Schlegel's mind, the only mode in which criticism can directly confront the nugatory.

It should be recalled that the early Romantics did not furnish these important material determinations of criticism in an explicit context, that clear-cut formulations of a systematic rigor were certainly in part quite foreign to them, and that none of the three axioms was strictly adhered to in their practice. Here it is a matter neither of the investigation of their critical habits, nor of assembling what can be found of their statements concerning criticism; rather, it is a matter of analyzing this concept in accordance with its most particular philosophical intentions. Criticism, which for the contemporary understanding is the most subjective of things, for the Romantics was the regulator of all subjectivity, contingency, and arbitrariness in the genesis of the work. Whereas in contemporary concep-

tions criticism is compounded of objective knowledge and the evaluation of the work, the distinctive element of the Romantic concept of criticism lies in its freedom from any special subjective estimation of the work in a judgment of taste. Valuation is immanent to the objective investigation and knowledge of the work. The critic does not pass judgment on the work; rather, art itself passes judgment, either by taking up the work in the medium of criticism or by rejecting it and thereby appraising it as beneath all criticism. Criticism should, by the choice of what it treats, arrive at the finest selection among works. Its objective intention is not expressed in its theory alone. If, in aesthetic matters, the persisting historical validity of assessments provides a clue to what one can sensibly call their objectivity, then at least the validity of the critical judgments of Romanticism has been confirmed. Up to the present day, these judgments have determined the basic assessment of the historical works of Dante, Boccaccio, Shakespeare, Cervantes, Calderón, as well as that of their immediate contemporary, Goethe.[212]

The force of objective intentions in early Romanticism has been little valued by most authors. Since Friedrich Schlegel himself consciously turned his back on the epoch of his "revolutionary rage for objectivity," turned away from unqualified esteem for the Greek artistic spirit, people have searched above all in the writings of his more mature period for documentation of his reaction against these youthful ideas, and they have found this in abundance. But however numerous the proofs of a high-spirited subjectivity in these writings, a consideration of the ultraclassical beginnings and the strict Catholic ending of this author is calculated to moderate the emphasis on the subjectivist formulas or formulations from the period 1796 to 1800. For, in fact, it is partly a question of mere formulations in his most subjective utterances; they are coinings that one need not always take for hard cash. Friedrich Schlegel's philosophical standpoint in the *Athenaeum* period has mostly been characterized by way of his theory of irony. This theory must be treated here, first because under this rubric objections can be raised in principle to the emphasis on the objective moments of his thinking; and, beyond that, because the theory in one definitive respect, far from contradicting those objective moments, stands in close connection with them.

Numerous elements are to be distinguished in the different pronouncements about irony; indeed, it would in part be quite impossible to unify these different elements in a single concept without contradictions. For Schlegel, the concept of irony acquired its central importance not only through its relation to certain theoretical issues, but even more as a purely intentional attitude. As such, this attitude was not concerned with one issue, but lay in readiness as the expression of an ever lively opposition to prevailing ideas and often as a mask of helplessness before them. Hence, the concept of irony can easily be overestimated, not in its importance for his

individuality but for Schlegel's picture of the world. Clear insight into this concept is hindered, finally, by the fact that even when it indisputably alludes to certain issues among the manifold relationships into which it enters, one cannot always easily establish those that figure in the particular case, and one has difficulty establishing those that are generally decisive. To the extent that these issues concern not art but epistemology and ethics, they must be left out of account here.

The concept of irony has a double significance for the theory of art, and in one of its aspects it is indeed the expression of a pure subjectivism. It is *only* in this aspect that the literature on Romanticism has thus far considered the concept, and as a consequence of just this one-sided understanding it has been thoroughly overvalued as evidence of the subjectivism in question. Romantic poetry recognizes "as its first law . . . that the willfulness of the poet is subject to no law"[213]—so it is stated, apparently without any ambiguity. Yet on closer examination, the question arises whether this sentence is meant to provide a positive statement of the legal rights of the creative artist or only an extravagant formulation of the demand that Romantic poetry places on its poets. In both cases, we shall have to resolve to make the sentence meaningful and intelligible through interpretation. Starting from the second case, we would have to understand that the Romantic poet is to be "poetry through and through,"[214] which Schlegel, unconvinced, in another passage proposes as a paradoxical ideal. If the artist is poetry itself, then, to be sure, his will does not tolerate any law over it, because his arbitrary will is nothing but a paltry metaphor for the autonomy of art. The proposition remains empty. In the first case, however, we may take the proposition to be a judgment concerning the artist's domain of power, but must then resolve to understand by "poet" something other than a being who makes something that he himself calls a poem. One must understand by "poet" the true, prototypical poet, and one has immediately thereby understood this willfulness as the willfulness of the true poet, which is confined within limits. The author of genuine artworks is restricted within those relationships in which the work of art is subject to the objective lawfulness of art—if, that is, one does not want (as in the other case of interpretation) to understand the author as a mere personification of art, which in this case perhaps, and in any event in several other passages, was Schlegel's intended meaning. The objective lawfulness to which the artwork is subjected by art consists, as has been noted, in the *form* of the work. The willfulness of the true poet therefore has its field of play only in the material, and, to the extent it holds sway consciously and playfully, it turns into irony. This is subjectivist irony. Its spirit is that of the author who elevates himself above the materiality of the work by despising it. Yet Schlegel also entertains the thought that perhaps even the material itself might be "poeticized" [*poetisiert*], ennobled in such a process, although for this, in his view, one needs still other positive moments, ideas of the art of life which are por-

trayed in the material. Enders rightly calls irony the capacity "to move oneself immediately from what is represented in the invention to the representing center, and to observe the former from this latter point,"[215] yet he does not consider that this procedure, according to the Romantic perception, can take place only with respect to the material.

Nevertheless, as a glance at the poetic production of early Romanticism shows, there does exist an irony that not only takes hold of the material but also disregards the unity of poetic form. This is the irony that has encouraged the notion of a Romantic subjectivism *sans phrase*,[216] because the thoroughgoing difference between this ironization of the artistic form and that of the material has not been recognized with sufficient clarity. The latter rests on a demeanor of the subject; the former presents an objective moment in the work itself. The Romantics contribute their share to this lack of clarity, as they do to most of the obscurities that persist about their doctrines. They themselves never gave expression to the distinction that is indicated by the subject matter.

The ironization of form consists in its freely willed destruction, a process that Tieck's comedies exhibit in the most extreme form among Romantic productions and, indeed, within literature as a whole. Among all literary forms, dramatic form can be ironized to the greatest extent and in the most impressive way, because it contains the highest measure of the power of illusion and thereby can receive irony into itself to a high degree without disintegrating. Schlegel says of the destruction of illusion in Aristophanes' comedies: "This infringement is not ineptitude but thought-out wantonness, overflowing fullness of life, and often has no ill effect but rather heightens the deception, for it cannot destroy it. The highest agility of life . . . infringes . . ., in order to provoke without destroying."[217] Pulver invokes the same idea when he writes: "If we summarize what moved Friedrich Schlegel to the highest appreciation of a perfectly conceived comedy, it is [its] creative play with itself, its purely aesthetic display, which no disruption and infringement of the illusion can destroy."[218] Thus, the ironization of form, according to these statements, assails the form without destroying it, and the disturbance of the illusion in comedy should have this provocation in view. This relation bears a striking affinity to criticism, which irrevocably and earnestly dissolves the form in order to transform the single work into the absolute work of art, to romanticize it.

> Yes, even the work purchased dearly remains precious to you;
> But as much as you love it, you yourself bring it death,
> Holding the work in view; of the works of mortals, none ends well.
> For from the death of the single work, blossoms the form of the whole.[219]

"We must elevate ourselves above our own love and be able in thought to annihilate what we adore, otherwise we lack . . . the sense for the infinite."[220] In these statements, Schlegel expressed himself clearly about the

destructive element in criticism, its decomposition of the art form. Far from presenting a subjective velleity of the author, this destruction of form is the task of the objective tribunal in art, of criticism. And, on the other side, Schlegel makes exactly the same thing the essence of the poet's ironic expression when he designates irony as a mood "that surveys all and infinitely elevates itself above everything conditioned, even above its own art, virtue, or genius."[221] Hence, in this kind of irony, which arises from the relation to the unconditioned, it is a question not of subjectivism and play but of the assimilation of the limited work to the absolute, of its complete objectivization at the price of its ruin. This form of irony stems from the spirit of art, not from the will of the artist. It is obvious that irony, like criticism, can demonstrate itself only in reflection.[222] The ironization of the material is also reflective, but this rests on a subjective, playful reflection of the author. The irony of the material annihilates the material; it is negative and subjective. The irony of the form, in contrast, is positive and objective. The peculiar positivity of this irony is at the same time the mark that distinguishes it from criticism which has an equally objective direction. What relation is there between the destruction of illusion in the art form by means of irony and the destruction of the work through criticism? Criticism sacrifices the work totally for the sake of the single sphere of connection. On the other hand, the procedure which preserves the work itself, while still making palpable its total referential connection to the idea of art, is (formal) irony. Not only does it not destroy the work on which it fastens, but it draws the work nearer to indestructibility. Through the destruction, in irony, of the particular form of presentation of the work, the relative unity of the individual work is thrust back deeper into the unity of art as universal work; it is fully referred to the latter unity, without being lost in it. For only by degrees is the unity of the single work distinguished from that of art, from that into which it is continually being shifted in irony and criticism. The Romantics themselves could not have experienced irony as something artistic if they had seen in it the absolute dissolution of the work. It is for this reason that Schlegel, in the remark already cited, emphasizes the indestructibility of the work.

In order to give this relation definitive clarity, we must introduce a double concept of form. The particular form of the individual work, which we might call the presentational form, is sacrificed to ironic dissolution. Above it, however, irony flings open a heaven of eternal form, the idea of forms (which we might call the absolute form), and proves the survival of the work, which draws its indestructible subsistence from that sphere, after the empirical form, the expression of its isolated reflection, has been consumed by the absolute form. The ironization of the presentational form is, as it were, the storm blast that raises the curtain on the transcendental order of art, disclosing this order and in it the immediate existence of the work as a

mystery. The work is not, as Herder regarded it, essentially a revelation and a mystery of creative genius, which one could well call a mystery of substance; it is a mystery of order, the revelation of its absolute dependence on the idea of art, its eternal, indestructible sublation in that idea. In this sense Schlegel recognizes "limits of the visible work,"[223] beyond which the realm of the invisible work, the idea of art, opens up. Belief in the indestructibility of the work, as it is expressed in Tieck's ironic dramas and in Jean Paul's shapeless novels, was a basic mystical conviction of early Romanticism. Only on the basis of this belief does it become intelligible why the Romantics did not content themselves with the demand for irony as a sentiment of the artist, but sought to see it exhibited in the work itself. Irony has a function other than that of sentiments which, however desirable they might be, cannot appear independently in the work if they are demanded only with respect to the artist. Formal irony is not, like diligence or candor, an intentional demeanor of the author. It cannot be understood in the usual manner as an index of a subjective boundlessness, but must be appreciated as an objective moment in the work itself. It presents a paradoxical venture: through demolition to continue building on the formation, to demonstrate in the work itself its relationship to the idea.

III. The Idea of Art

The climax of the Romantic theory of art is the concept of the idea of art. In the analysis of this concept are to be sought the confirmation of all the other doctrines and the key to their ultimate intentions. Far from being a schematic point of reference for the theorems concerning criticism, the work, irony, and so on, this concept is articulated in the most substantial and significant way. Only in it can we find the innermost inspiration that guided the Romantics in their thinking about the essence of art. In terms of method, the entire Romantic theory of art rests on the definition of the medium of absolute reflection as art—more precisely, as the idea of art. Since the organ of artistic reflection is form, the idea of art is defined as the medium of reflection of forms. In this medium all the presentational forms hang constantly together, interpenetrate one another, and merge into the unity of the absolute art form, which is identical with the idea of art. Thus, the Romantic idea of the unity of art lies in the idea of a continuum of forms. For example, tragedy, for the observer, would continuously cohere with the sonnet. A distinction between the Kantian concept of judgment and the Romantic concept of reflection can be indicated in this context without difficulty: reflection is not, as judgment is, a subjectively reflecting process; rather, it lies enclosed in the presentational form of the work and unfolds itself in criticism, in order finally to reach fulfillment in the lawful continuum of forms. In [Schlegel's] "Herkules Musagetes," it is said of the poet, with

reference to that distinction outlined above in the terms "presentational form" and "absolute form": "Every form will become his own, / Ingeniously he can gather forms toward the higher form in a delicate web."[224] In the 116th *Athenaeum* fragment, the aim of Romantic poetry is more explicitly "to reunite all the separate genres of poetry . . . It embraces everything so long as it is poetic, from the greatest systems of art that contain in themselves still other systems, to the sigh, to the kiss that the musing child breathes out in artless song. . . . The Romantic genus of poetry is the only one that is more than genus and is, so to speak, poetry itself." The continuum of art forms could hardly be characterized more clearly. At the same time, in designating this artistic unity as Romantic poetry or poetic genus, Schlegel means to attribute to it the most determinate qualitative description. This Romantic genus is what he has in mind when he says: "We already have so many theories of poetic genres. Why do we still not have any concept of poetic genre? Perhaps we would then have to make do with a single theory of poetic genres."[225] Romantic poetry is therefore the idea of poetry itself; it is the continuum of art forms. Schlegel made the most intensive efforts to give expression to the determinateness and fullness in which he conceived this idea. "If ideals do not have as much individuality for a thinker as the gods of antiquity have for the artist, then all involvement with ideas is nothing but a boring and irksome dice-game with empty formulas."[226] Especially: "A sense for poetry . . . lives in him for whom it is an individual."[227] And: "Are there not individuals that contain within themselves entire systems of individuals?"[228] Poetry, at least, as the reflection medium of forms, must be such an individual. One would certainly assume that Novalis is thinking of the work of art when he says: "An infinitely characterized individual is a member of an *infinitorium*."[229] In any case, he enunciates for philosophy and art the principle of a continuum of ideas; the ideas of poetry are, according to the Romantic conception, the presentational forms. "The philosopher who in his philosophy transforms all separate philosophemes into a single one, who can make out of all individual forms of philosophy one individual, attains the maximum in his philosophy. He attains the maximum as a philosopher when he unites all philosophies into one single philosophy. . . . The philosopher and artist proceed organically, if I may say so. . . . Their principle, their unifying idea is an organic seed that develops freely and forms itself into a structure containing innumerable individuals, an infinitely individual, omniplastic structure—an idea that is itself rich in ideas."[230] "Art and science seize upon everything to pass from one thing to another, and so from one thing to all, rhapsodically or systematically; [this is] the spiritual art of wisdom, the art of divination."[231] This art of wisdom is obviously criticism, which Friedrich Schlegel also called "divinatory."[232]

In order to express the individuality of this unity of art, Schlegel strains his concepts and grasps at a paradox. Otherwise the project of expressing

the highest universality as individuality was not to be consummated. For its part, nonetheless, this project in no way has as its ultimate theme an absurdity or even an error; rather, Schlegel simply gave a false interpretation to a valuable and valid motive. This was the effort to secure the concept of the idea of art from the misunderstanding of those who would see it as an abstraction from empirical artworks. He wanted to define this concept as an idea in the Platonic sense, as a *proteron té phusei*, as the real ground of all empirical works, and he committed the old error of confounding "abstract" and "universal" when he believed he had to make that ground into an individual. It is only with this in view that Schlegel repeatedly and emphatically designates the unity of art, the continuum of forms itself, as one work. It is this invisible work which takes up into itself the visible work of which he speaks in a passage cited above (note 223). This conception came to Schlegel in his study of Greek poetry, and from there he transferred it to poetry generally: "The systematic Winckelmann, who read all the ancients as though they were a single author, who saw all as a whole and concentrated his entire force on the Greeks, laid the initial groundwork for a material doctrine of antiquity through his perception of the absolute difference between ancient and modern. Only when the standpoint and the conditions of the absolute identity of the ancient and the modern—in past, present, or future—have been discovered, can we say that at least the contours of the science[233] are visible and we can now proceed to methodical investigation."[234] "All poems of antiquity link up to one another, until the whole is formed out of continually greater masses and members. . . . And thus it is no mere empty metaphor to say that ancient poetry is a single, indivisible, perfected poem. Why shouldn't what has already been come about once again? In a different way, obviously. And why not in a more beautiful, greater way?"[235] "All the classical poems of the ancients conjoin, inseparably; they form an organic whole, and are, rightly seen, a single poem, the only one in which the art of poetry itself is completely manifest. In a similar way, in perfect poetry all books should be only a single book."[236] "Thus, the individual [work] of art, when it is taken fundamentally, must lead to an immeasurable whole. Or do you in fact believe that everything else, indeed, can be a poem and a work, only not poetry itself?"[237] For the evolving unity of poetry, as for the unity of the invisible work, the equalization and reconciliation of forms is the visible and authoritative process. Ultimately the mystical thesis that art itself is one work (Schlegel foregrounded this thesis in his thoughts around 1800, especially) stands in exact correlation with the principle which asserts the indestructibility of works that are purified in irony. Both principles make it clear that, in art, idea and work are not absolute opposites. The idea is a work and also the work is an idea, provided that the former overcomes the limitations imposed by its presentational form.[238]

Schlegel made the exhibition of the idea of art in the total work into the

task of progressive, universal poetry; this characterization of poetry points to nothing other than that task. "Romantic poetry is a progressive universal poetry. . . . The Romantic way of writing is still in the process of becoming; indeed, this is its proper essence—that it is eternally coming to be and can never be completed."[239] The following holds true of it: "An idea cannot be grasped in a proposition. An idea is an infinite series of propositions, an irrational magnitude, incapable of being posited,[240] incommensurable. . . . Yet the law of its progression can be laid down."[241] The concept of progressive universal poetry is easily exposed to modernizing misunderstanding if its connection with the concept of the medium of reflection is not considered. This misunderstanding would consist in seeing endless progression as a mere function of the indeterminate infinite of the task, on the one hand, and the empty infinity of time, on the other. But we have already indicated how much Schlegel strove for the determinacy, for the individuality of the idea that sets the task for progressive universal poetry. The endlessness of the progression should not, therefore, divert one's attention from the determinateness of its task, and if in this determinacy limits are not already present, then the following formulation could be misleading: "[Regarding] this emergent poetry . . . there are . . . no limits to progress, to further development."[242] For this statement does not lay stress on what is essential. The essential is, rather, that the task of progressive universal poetry be given in a medium of forms as the ever more exact and thorough regulating and ordering of that medium in the most determinate way. "Beauty is . . . not merely the empty notion of something that is to be produced . . . but also a fact—namely, an eternally transcendental fact."[243] It is this as a continuum of forms, as a medium, whose manifestation through chaos as the scene of pervading governance has already been encountered in Novalis. And in the following remark by Schlegel, chaos is nothing other than the emblem of the absolute medium: "Yet the highest beauty, indeed the highest order, is still only that of chaos—namely, a chaos that awaits but the touch of love to unfold into a harmonious world."[244] It is a question, therefore, not of a progress into the void, a vague advance in writing ever-better poetry, but of a continually more comprehensive unfolding and enhancement of poetic forms. The temporal infinity in which this process takes place is likewise a medial and qualitative infinity.[245] For this reason, progredibility [*Progredibilität*] is not at all what is understood by the modern term "progress"; it is not some merely relative connection of cultural stages to one another. Like the entire life of mankind, it is an infinite process of fulfillment, not a mere becoming. If nonetheless it cannot be denied that in these notions Romantic messianism is not at work in its full force, still they are not in contradiction with Schlegel's fundamental stand on the ideology of progress, as expressed in *Lucinde*: "What, then, is the purpose of this unconditioned striving and advancing without cessation or centerpoint? Can this *Sturm und Drang*

supply the infinite plant of humanity, which grows and takes form all by itself, with nourishing sap or formation? It is nothing more, this empty restless forcing, than a Nordic vice."[246]

The much contested concept of transcendental poetry can be explained in this context precisely and without difficulty. Like the concept of progressive universal poetry, it is a determination of the idea of art. If the former presents, in conceptual concentration, the relation this idea has to time, the concept of transcendental poetry points back to the systematic center from which the Romantic philosophy of art proceeded. It therefore presents Romantic poetry as the absolute poetic reflection; in the world of Friedrich Schlegel's thought during the *Athenaeum* period, transcendent poetry is precisely what the concept of the primal "I" is in the Windischmann lectures. To prove this, one need only attend to the contexts in which the concept of the transcendental occurs in Schlegel and Novalis. One finds that they everywhere lead back to the concept of reflection. Thus, Schlegel says about humor: "Its real essence is reflection. Whence its affinity with . . . everything transcendental."[247] "It is the highest task of education to take possession of the transcendental self, to be at one and the same time the 'I' of its 'I'"[248]— that is, to comport oneself reflectively. Reflection transcends the spiritual level reached at any one time, in order to pass on to a still higher level. Thus, Novalis says, with reference to the act of reflection involved in self-penetration: "That place *outside* the world is given, and now Archimedes can fulfill his promise."[249] The origin of higher poetry in reflection is hinted at in the following fragment:

> There are certain poetic modes in us that seem to have an entirely different character from the usual ones, for they are accompanied by a feeling of necessity, yet there is simply no external reason for their existence. It seems to man that he is caught up in a dialogue and that some unknown spiritual being provokes him in a marvelous fashion to develop the most incontestable notions. This being must be a higher being, because it places itself in a relationship to man which is not possible for any being tied to appearances. It must be a homogenous being, because it treats him as a spiritual being and incites him only to the rarest kind of self-activity. This "I" of a higher sort is related to man the way man is to nature, or a wise adult to a child.[250]

The poetic works springing from the activity of the higher self are members of transcendental poetry, whose delineation coincides with the idea of art inscribed in the absolute work. "Poetries up until now have for the most part operated dynamically; the future transcendental poetry, one could call 'organic.' When it is invented, then we shall see that all genuine poets before this have composed, without knowing it, organically—but that this lack of consciousness had an essential influence on the whole of their work, so that for the most part only in individual cases were they genuinely poetic, while

on the whole they were usually unpoetic."[251] The poetry of the entire work, according to Novalis' conception, depends on knowledge of the essence of the absolute unity of art.

Insight into this clear and simple meaning of the term "transcendental poetry" has been made extraordinarily difficult due to a particular circumstance. In the very fragment whose primary idea should be considered the chief exhibit for the train of thought being discussed, Schlegel defined the expression in question differently[252] and distinguished it from a term with which, according to his and Novalis' linguistic usage, it should have been synonymous. In fact "transcendental poetry" means in Novalis—as, logically, it should in Schlegel as well—the absolute reflection of poetry, which Schlegel, in this particular fragment, distinguishes from transcendental poetry by describing it as "poetry of poetry":

> There exists a poetry whose one and all is the relation between the ideal and the real and which, by analogy with philosophical terminology, would have to be called "transcendental poetry". . . . But, just as one would attach little importance to a transcendental philosophy that was not critical, did not exhibit the producer along with the product, and did not contain in a system of transcendental thoughts at the same time a characterization of transcendental thinking, so, too, this poetry should unite what is not unfamiliar among modern poets—transcendental materials and preparatory exercises, toward a poetic theory of poetic capacity—with artistic reflection and beautiful self-mirroring . . . and ought, in each of its presentations, to present itself as well and everywhere be at once poetry and poetry of poetry.[253]

The whole difficulty occasioned by the concept of transcendental poetry for the presentation of Romantic philosophy, the obscurity in which it seems to persist, rests on the fact that in the fragment above this expression is used not with reference to the reflective moment in poetry but with reference to Schlegel's earlier questioning of the relation of Greek to modern poetry. Since Schlegel designates Greek poetry as "real" and modern poetry as "ideal,"[254] he coins the term "transcendental poetry" with a quasi-mystical allusion to the entirely different philosophical conflict between metaphysical idealism and realism and its resolution through the transcendental method of Kant. In the final analysis, however, Schlegel's usage still agrees with what Novalis calls transcendental poetry and with what he himself calls poetry of poetry. For reflection, which is what is intended in both of these designations, is precisely the method for resolving Schlegel's "transcendental" aesthetic aporia. It is through reflection in the work of art itself, as we have seen, that the artwork's strictly formal closure (of Greek type), which remains relative, is, on the one hand, cultivated, but, on the other, released from its relativity and elevated to the absolute of art through critique and irony (of the modern type).[255] "Poetry of poetry" is the comprehensive expression for

the reflexive nature of the absolute. It is poetry conscious of itself, and since, according to early Romantic doctrine, consciousness is only a heightened spiritual form of that *of* which it is conscious, it follows that consciousness of poetry is itself poetry. It is poetry of poetry. Higher poetry "is itself nature and life . . .; but it is the nature of nature, the life of life, the human being in the human being; and I think this distinction, for one who perceives it at all, is truly determined and decisive enough."[256] These formulations are not flights of rhetoric but designations of the reflexive nature of transcendental poetry. "I suspect that in you—sooner or later, and apropos of Shakespeare —art will mirror itself in art,"[257] Friedrich Schlegel writes to his brother.

The organ of transcendental poetry, as that very form which in the absolute survives the downfall of profane forms, Schlegel designates as the symbolic form. In the literary retrospective with which he opens the review *Europa*, in 1803, he says of the issues of *Athenaeum*: "In the early issues, critique and universality are the primary goal; in the later parts, the spirit of 'mysticism' is essential. One shouldn't shrink from using this word.[258] It signifies the proclamation of the mysteries of art and science, which would not deserve their names without such mysteries; most of all, however, it signifies the powerful defense of symbolic forms and their necessity against the profane mind."[259] The expression "symbolic form" points in two directions: in the first place it marks the reference to the different conceptual rubrics of the poetic absolute, principally the reference to mythology. The arabesque, for example, is a symbolic form that alludes to a mythological content. In this sense, the symbolic form does not belong to this context. In the second place, it is the imprint of the pure poetic absolute in the form itself. Thus, Lessing is honored by Schlegel "on account of the symbolic form of his works . . . ; because of this . . . his works . . . belong in the realm of higher art, since precisely this symbolic form . . . is the one deciding mark of higher art."[260] Nothing other than the symbolic form is meant by the general expression "symbol" when Schlegel says of the highest task of poetry: "It has already often been achieved by the same means whereby everywhere the show of the finite is set in relation to the truth of the eternal and thereby dissolved into it . . . through symbols, through which meaning takes the place of illusion—meaning, the one real thing in existence."[261] The symbolic form endows works of transcendental poetry with this meaning— that is, reference to the idea of art—by way of reflection. The "symbolic form" is the formula under which the range of reflection for the work of art is concentrated. "Irony and reflection are the basic attributes of the symbolic form of Romantic poetry."[262] Since, however, reflection is at the basis also of irony and is therefore, in the artwork, completely identical with symbolic form, it should be said more precisely that, on the one hand, the fundamental properties of symbolic form consist in such purity of the presentational form that this is refined into a mere expression of the self-

limitation of reflection and is distinguished from the profane forms of presentation;[263] on the other hand, they consist in the (formal) irony in which reflection elevates itself to the absolute. Criticism of art exhibits this symbolic form in its purity; it disentangles it from all the inessential moments to which it may be bound in the work, and finishes with the dissolution of the work. The fact that in the framework of Romantic theories, despite all conceptual coinages, full clarity can never be reached in the distinction between profane and symbolic form, between symbolic form and critique, forces itself on our attention. Only at the price of such hazy demarcations can all the concepts of art theory which the Romantics ultimately undertook be drawn into the region of the absolute.

Among all the forms of presentation, there is one in which the Romantics find reflexive self-limitation and self-extension developed in the most decisive way and at this apex passing into each other without distinction. This highest symbolic form is the novel. What strikes one first of all about this form is its external license and irregularity. The novel can in fact reflect upon itself at will, and, in ever new considerations, can mirror back every given level of consciousness from a higher standpoint. That it comes to this by the nature of its form, whereas this is possible for other genres only through the bold stroke of irony, neutralizes irony in the novel. But, in contrast, just because the novel never oversteps its form, every one of its reflections can be viewed as limited by itself, for there is no rule-bound form of presentation to limit them. This neutralizes in it the presentational form, which prevails in the novel only in its purity, not in its rigor. Although that external license, since it lies open to hand, requires no emphasis, the steadiness and pure composure in the form of the novel are stressed by the Romantics again and again. Schlegel, on the occasion of his review of *Wilhelm Meister*, says that "the spirit of contemplation and of return into itself . . . is a common characteristic of all very spiritual poetry."[264] The novel is the most spiritual poetry; its retarding character is an expression of the reflection proper to it: "Through its retarding nature, the play can seem akin to the novel, which has its essence precisely in that,"[265] he says in the same place regarding *Hamlet*. Novalis: "The retarding nature of the novel[266] is manifest preeminently in the style."[267] Proceeding from the consideration that novels are constituted by complexes reflexively closed upon themselves, Novalis says: "The style of the novel must not be a continuum; it must be a structure articulated in each and every period. Each small piece must be something cut off, delimited, a whole on its own."[268] It is just this mode of writing that Schlegel praises in *Wilhelm Meister*: "Through . . . the differences in the individual masses . . . every necessary part of the one and indivisible novel becomes a system for itself."[269] For Schlegel, the presentation of reflection counts as the highest legitimation of Goethe's mastery in this novel: "The representation of a nature that is again and again perceiving

itself, as though looking into the infinite, was the finest proof that an artist could give of the unfathomable depths of his ability."[270] The novel is the highest among all symbolic forms; Romantic poetry is the idea of poetry itself.—The ambiguity that lies in the expression "romantic" was certainly taken gladly into account by Schlegel, if not exactly sought after. It is well known that in the usage of the day "romantic" meant "knightly," "medieval," and Schlegel, as he loved to do, concealed his own meaning behind this signification—a meaning one has to read from the etymology of the word. Hence, we are to understand throughout, as Haym does, the essential meaning of the term "romantic" as "novelistic" [*romangemäss*]. This means that Schlegel upholds the doctrine "that the genuine novel is a *ne plus ultra*, a *summa* of all that is poetic, and he consistently designates this poetic ideal with the name 'romantic' poetry."[271] As this *summa* of all that is poetic, in the sense of Schlegel's theory of art, the novel is therefore a designation of the poetic absolute: "A philosophy of the novel . . . would be the keystone"[272] of a philosophy of poetry in general. It is often emphasized that the novel is not one genre among others, and that the romantic manner is not one among many, but that they are ideas. Schlegel says of *Wilhelm Meister:* "To want to judge this book . . . in accordance with a concept of genre that arises from custom and creed, and that is thrown together from accidental experiences and arbitrary conclusions, is the same as if a child should want to grasp the moon and the stars with his hand and pack them into his little satchel."[273]

Early Romanticism not only classified the novel as the highest form of reflection in poetry, but, by setting it in a further, immediate relation to its basic conception of the idea of art, it found in it the extraordinary, transcendent confirmation of its aesthetic theory. According to this conception, art is the continuum of forms, and the novel, in the interpretation of the early Romantics, is the comprehensible manifestation of this continuum. It is this thanks to prose. The idea of poetry has found its individuality (that for which Schlegel was seeking) in the form of prose; the early Romantics know no deeper or better determination for it than "prose." In this seemingly paradoxical but in truth very profound intuition, they find an entirely new basis for the philosophy of art. On this ground rests the entire philosophy of art of early Romanticism, especially its concept of criticism, for the sake of which our investigation has been pursued to this point through apparent digressions.—The idea of poetry is prose. This is the final determination of the idea of art, and also the real meaning of the theory of the novel, which only in this way is understood in its deep intention and freed of an exclusively empirical reference to *Wilhelm Meister.* What the Romantics meant when they said that prose is the idea of poetry is to be gathered from the following passage of a letter that Novalis sent to A. W. Schlegel on January 12, 1798:

If poetry wishes to extend itself, it can do so only by limiting itself, by contracting itself, by abandoning its caloric matter and congealing. It will acquire a prosaic look, its constituent parts will no longer stand in the same close community—or, therefore, under such strict rhythmic laws—and it will become more capable of portraying that which is limited. But it remains poetry and hence faithful to the essential laws of its nature; it becomes, so to speak, an organic being, whose whole structure betrays its origin from the flux, its originally elastic nature, its unlimitedness, its omnipotence. Only the mixture of its elements is without rule; the order of these, their relation to the whole, is still the same. Every charm extends outward on all sides. Here, too, only the parts move around the one, eternally resting whole. . . . The simpler, more uniform, and calmer the movements of the sentences are here, the more harmonious their mixtures in the whole and the looser the connection, the more transparent and colorless the expression—so much the more perfect is this indolent poetry in its seeming dependence on objects, and its contrast to all ornate prose.[274] Here poetry seems to slacken off from the rigor of its requirements, to become more complacent, more tractable. But it will soon become evident to one who makes trial of poetry under these conditions how difficult it is to realize it fully in this form. Such extended poetry is precisely the highest problem of the poetic artist—a problem that can be solved only by approximation and that is actually part of the higher poetry. . . . Here is still an immeasurable field, an infinite domain in the most authentic sense. One could call this higher poetry the poetry of the infinite.[275]

The reflective medium of poetic forms appears in prose; for this reason, prose may be called the idea of poetry. Prose is the creative ground of poetic forms, all of which are mediated in it and dissolved as though in their canonical creative ground. In prose, all metrical rhythms pass over into one another and combine into a new unity, the prosaic unity, which in Novalis[276] is known as the "romantic rhythm."[277] "Poetry is the prose among arts."[278] Only from this viewpoint can the theory of the novel be understood in its profoundest intention and be extricated from the empirical relation to *Wilhelm Meister*. Because the unity of poetry as a whole, as one single work, constitutes a poem in prose, the novel affords the highest poetic form. It is probably in allusion to the unifying function of prose that Novalis says: "Shouldn't the novel comprehend all genres of style in a sequence differentially bound by a common spirit?"[279] Friedrich Schlegel grasped the prosaic element less purely than Novalis, though he intended it no less deeply. Thus, in his exemplary novel, *Lucinde*, he sometimes cultivates the multiplicity of forms (whose unification is his task) perhaps more than he does the purely prosaic (which fulfills this task). He wanted to insert many poems into the second part of the novel. But both of these tendencies, the multiplicity of forms and the prosaic, have in common an opposition to limited form and an aspiration to the transcendental. Except that in some places in Friedrich Schlegel's prose, this is less demonstrated than postulated. Even in Schlegel's

theory of the novel, the notion of prose, although it undoubtedly conditions its characteristic spirit, fails to stand clearly at its center. Schlegel complicated this notion with the doctrine of the poeticizing of the material.[280]

The conception of the idea of poetry as that of prose determines the whole Romantic philosophy of art. And it is this determination that has made the Romantic philosophy of art so historically rich in consequences. Not only did it spread with the spirit of modern criticism, without being "agnosticized" in its presuppositions or essence, but it also entered, in more or less clearly marked form, into the philosophical foundations of later schools of art, such as French Romanticism (which succeeded it) and German Neo-Romanticism. Above all, however, this fundamental philosophical conception founds a peculiar relation within a wider Romantic circle, whose common element, like that of the narrower [Romantic] school, remains undiscoverable so long as it is sought only in poetry and not in philosophy as well. From this point of view, one spirit moves into the wider circle, not to say into its center—a spirit who cannot be comprehended merely in his quality as a "poet" in the modern sense of the word (however high this must be reckoned), and whose relationship to the Romantic school, within the history of ideas, remains unclear if his particular philosophical identity with this school is not considered. This spirit is Hölderlin, and the thesis that establishes his philosophical relation to the Romantics is the principle of the sobriety of art. This principle is the essentially quite new and still incalculably influential leading idea of the Romantic philosophy of art; what is perhaps the greatest epoch in the West's philosophy of art is distinguished by this basic notion. Its connection with the methodological procedure of that philosophy—namely, reflection—is obvious. In ordinary usage, the prosaic—that in which reflection as the principle of art appears uppermost—is, to be sure, a familiar metaphorical designation of the sober. As a thoughtful and collected posture, reflection is the antithesis of ecstasy, the mania of Plato. Just as, for the early Romantics, light occasionally operates as a symbol of the medium of reflection, of infinite mindfulness, so Hölderlin, too, says: "Where are you, thoughtful one, who must always / Turn aside at times? Where are you, Light?"[281] "Circumspection [*Besonnenheit*] is the earliest muse of the man striving for cultivation,"[282] says even the unphilosophical A. W. Schlegel, and Novalis calls this proposition a "ray of light striking the earliest poetry."[283] In a very peculiar and beautiful image, Novalis expresses the sober nature of reflection: "Isn't reflection upon oneself . . . of a consonating nature?[284] Song sung inwardly: inner world. Speech-prose-criticism."[285] In these words we have the entire context of the Romantic philosophy of art at its highest level (as still remains in part to be developed) schematically indicated.

In his later writings, Hölderlin sought to gain knowledge of "holy-sober" poetry.[286] Here, only one preeminent passage will be cited, in order to

prepare the way for understanding the less clear statements of Friedrich Schlegel and Novalis, which aim at the same goal:

> It will be good in securing for poets, also among us, a civic existence if we elevate poetry, also among us, to the status of the *mechane* of the ancients, discounting the distinction of times and constitutions. Other artworks, too, compared with Greek ones, lack reliability; at least they have been judged, up until now, more by the impressions they make than by their lawful calculus or any other procedure whereby the beautiful is brought forth. But modern poetry is especially lacking in a school and in the craftsmanlike, in the means whereby its procedures can be calcated and taught and, once learned, reliably repeated thereafter in practice. Among human beings, in the case of every thing, we must principally look to see that it is something—in other words, that it is knowable in the means (manner) of its appearance, that the way it is constituted can be determined and taught. For this reason and for even deeper reasons, poetry needs especially definite and characteristic principles and limits. To these now belongs just that lawful calculus.[287]

Novalis: "Truly artistic poetry is remunerable."[288] "Art . . . is mechanical."[289] "The seat of genuine art is solely in the understanding."[290] "Nature engenders, the spirit makes. *Il est beaucoup plus commode d'être fait que de se faire lui-[sic!]même.*"[291] The manner of this making, then, is reflection. Proofs of this conscious activity in the work are, above all, the "secret intentions . . . which we can never too much presuppose. . . in the case of genius,"[292] as Schlegel says. "Deliberate . . . cultivation . . . of the smallest detail"[293] testifies to poetic mastery. In radical fashion (and a certain lack of clarity is the ground of this radicalism), he says in the *Athenaeum:* "One often thinks to shame authors by comparisons with manufacturing. But shouldn't the true author also be a manufacturer? Shouldn't he devote his whole life to the business of working literary material into forms that in great manner are purposeful and useful?"[294] "So long as the artist . . . is inspired, he finds himself, at least where any communication is concerned, in an illiberal condition."[295] The Romantics were thinking of "made" works, works filled with prosaic spirit, when they formulated the thesis of the indestructibility of genuine art objects. What dissolves in the ray of irony is the illusion alone; but the core of the work remains indestructible, because this core consists not in ecstasy, which can be disintegrated, but in the unassailable, sober prosaic form. By means of mechanical reason, moreover, the work is soberly constituted within the infinite—at the limit-value of limited forms. The novel is the prototype for this mystical constitution of the work beyond the bounded forms that are beautiful in their appearance ("poetic" in the narrow sense). The extent to which this theory breaks with traditional views about the essence of art is ultimately manifest in the place it assigns to those "beautiful" forms, to beauty in general. We have already mentioned that form is no longer the expression of beauty but an expression

of art as the idea itself. In the final analysis, the concept of beauty has to retreat from the Romantic philosophy of art altogether, not only because, in the rationalist conception, this concept is implicated with that of rules, but above all because as an object of "delight," of pleasure, of taste, beauty seemed incompatible with the austere sobriety that, according to the new conception, defines the essence of art. "A genuine doctrine of poetic art would begin with the absolute disparity, the eternally unresolvable separation of art and raw beauty. . . ."[296] To superficial dilettantes without enthusiasm or wide learning, such a poetics would have to appear as a trigonometry book does to a child who wanted to draw pictures."[297] "The highest works of art are absolutely unaccommodating; they are ideals that can and should please only *approximando,* as aesthetic imperatives."[298] The doctrine that art and its works are essentially neither appearances of beauty nor manifestations of immediately inspired emotion, but media of forms, resting in themselves, has not fallen into oblivion since the Romantics, at least not in the spirit of artistic development itself. If one wanted to extract the basic principles of the theory of art in so eminently conscious a master as Flaubert, or in the Parnassians, or in the George circle, then we would surely find among them the principles expounded here. We wanted here to formulate these basic principles, to demonstrate their origin in the philosophy of early German Romanticism. These are so peculiar to the spirit of this epoch that Kircher could justly maintain: "These Romantics were aiming to fend off precisely the 'Romantic'—as it was understood then and as it is understood today."[299] "I am beginning to love what is sober but makes genuine progress, and gets one further,"[300] Novalis writes in 1799 to Caroline Schlegel. On this matter, too, Friedrich Schlegel provides the most extreme formulation: "This is the real point—that we do not so completely depend upon our 'temper' alone when the highest thing is at issue."[301] The only task that remains is to conclude the exposition of the Romantic concept of criticism on the basis of the preceding discussions. It is no longer a matter of the methodological structure, which has been demonstrated, but only of its final contentual determination. Apropos of this, we have already said that the task of criticism is the consummation of the work. Schlegel utterly rejects an informational or pedagogic function. "The goal of criticism, people say, is to educate the readers! Whoever wants to be educated, let him educate himself. This is impolite, but so matters stand."[302] We have shown that criticism is just as little a matter of passing judgment, an expression of opinion about a work. Criticism is, rather, a formation whose origin is occasioned by the work but whose continued existence is independent of it. As such, it cannot be distinguished in principle from the work of art. The 116th *Athenaeum* fragment, which deals with the synthesis in all concepts, says: "Romantic poetry . . . would and also should . . . fuse together . . . originality and criticism." Another statement in the *Athenaeum* leads to this

same principle: "A so-called *recherche* is a historical experiment. The object and the result of this experiment are a fact. Whatever is to be a fact must have strict individuality, must be at one and the same time a secret and an experiment—namely, an experiment of formative nature."[303] In this context, it is only the concept of fact that is new. This is found again in the *Dialogue on Poetry*. "A true judgment of art, . . . a cultivated, thoroughly accomplished estimation of a work, is always a critical *fact,* if I may speak this way. But it is also *only* a fact, and, for just this reason, to wish to motivate it is a vain endeavor, for the motive itself would then have to contain a new fact or a closer determination of the first fact."[304] It is through the concept of fact that criticism is meant to be most sharply distinguished from judgment as mere opinion. Criticism needs no motivation, any more than an experiment does, which, in fact criticism undertakes to perform on the artwork by unfolding the work's reflection. An unmotivated judgment, on the other hand, would surely be an absurdity.—The theoretical assurance of the highest positivity of all criticism was the vehicle for the positive achievements of the Romantic critics. They wanted not so much to conduct guerilla warfare against the bad[305] as to promote the perfection of the good and, through this, the annihilation of the nugatory. In the final account, this assessment of criticism rests on the completely positive evaluation of its medium, prose. The legitimation of criticism—which is not to posit criticism as an objective court of judgment on all poetic production—consists in its prosaic nature. Criticism is the preparation of the prosaic kernel in every work. In this, the concept "preparation" [*Darstellung*] is understood in the chemical sense, as the generation of a substance through a determinate process to which other substances are submitted. This is what Schlegel means when he says of *Wilhelm Meister,* "The work not only judges itself—it also prepares itself."[306] The prosaic is grasped by criticism in both of its meanings: in its literal meaning through the form of expression, as criticism expresses itself in prose; in its figurative meaning through criticism's object, which is the eternal sober continuance of the work. This criticism, both as process and as product, is a necessary function of the classical work.

The Early Romantic Theory of Art and Goethe[307]

The theory of art propounded by the early Romantics and that formulated by Goethe are opposed to each other in their principles.[308] Indeed, the study of this opposition greatly widens our knowledge of the history of the concept of art criticism. For this opposition at the same time signifies the critical stage of this history: the problem-historical relation between the Romantics' concept of criticism and Goethe's concept, the pure problem of the criticism of art, comes immediately to light. The concept of a criticism of art, however, itself bespeaks an unambiguous dependence on the center of the

philosophy of art. This dependence is most acutely formulated in the problem of the criticizability of the artwork. Whether this is denied or affirmed is thoroughly dependent on the basic philosophical concepts that form the basis of the theory of art. The entire art-philosophical project of the early Romantics can therefore be summarized by saying that they sought to demonstrate in principle the criticizability of the work of art. Goethe's whole theory of art proceeds from his view of the uncriticizability of works. Not that he stressed this opinion more than occasionally, or that he had written no works of criticism himself. He was not interested in the conceptual elaboration of this view, yet in his later period, which is the one mainly at issue here, he composed more than a few critical works. One finds in many of them, though, a certain ironic reserve, not only in regard to the work but in regard to his own occupation; at all events, the intention of these critiques was only exoteric and pedagogic.

The category under which the Romantics conceive of art is the idea. The idea is the expression of the infinitude of art and of its unity. For the Romantic unity is an infinity. Everything the Romantics say about the essence of art is a determination of its idea; this is true as well of the form which, in its dialectic of self-limitation and self-expansion, brings to expression the dialectic of unity and infinity in the idea. "Idea" in this context means the a priori of a method; corresponding to it, then, is the ideal as the a priori of a correlative content. The Romantics do not acknowledge an *ideal* of art. They merely attain a semblance of this through accouterments of the poetic absolute, such as ethics and religion. All the definitions that Friedrich Schlegel gave of the content of art (especially in the *Dialogue on Poetry*), in contrast to his comprehension of form, are lacking in any more precise relation to what is characteristic of art, to say nothing of his having found an a priori of this content. Goethe's philosophy of art takes its start from an a priori of this kind. Its actuating motive is the question of the ideal of art. The ideal, too, is a supreme conceptual unity, the unity of the content. Its function, therefore, is completely different from that of the idea. It is not a medium that shelters in itself and builds out of itself the context of forms, but a unity of a different sort. It can be grasped only in a limited plurality of pure contents, into which it decomposes. Thus, the ideal manifests itself in a limited, harmonic discontinuum of pure contents. In this conception, Goethe makes contact with the Greeks. The idea of the Muses under the sovereignty of Apollo, interpreted by the philosophy of art, is the idea of the pure contents of all art. The Greeks counted nine such subject areas, and certainly neither their kind nor their number was arbitrarily determined. The quintessence of pure contents, the ideal of art, can therefore be characterized as the museworthy [*das Musische*]. Just as, in contrast to the idea, the inner structure of the ideal is discontinuous, so, too, the connection of this ideal with art is not given in a medium but is designated by a refraction.

The pure contents as such are not to be found in any work. Goethe calls them the "primal images." Works cannot attain to those invisible—but evident—archetypes whose guardians the Greeks knew under the name of the Muses; they can resemble them only in a more or less high degree. This "resembling," which conditions the relation of works to the original images, must be shielded from a ruinous materialist misunderstanding. It cannot, in principle, lead to equivalence and it cannot be reached by imitation. For those images are invisible, and "resemblance" signifies precisely the relation of what is perceptible in the highest degree to what in principle is only intuitable. In this, the object of intuition is the necessity that the content, which announces itself in the feelings as pure, become completely perceptible. The sensing of this necessity is intuition. The ideal of art as object of intuition is therefore necessary perceptibility—which never appears purely in the artwork itself, which remains the object of perception.—For Goethe, the works of the Greeks were, above all others, those that came closest to the archetypes; they became for him, as it were, relative archetypes, prototypes. As works of the ancients, these prototypes display a double analogy to the primal images themselves; they are, like these, consummate in the double sense of the word: they are perfect, and they are complete. For only the wholly concluded product can be an archetype. It is not in eternal becoming, in creative movement within the medium of forms, that the primal source of art, according to Goethe's understanding, resides. Art itself does not create its archetypes; they rest, prior to all created work, in that sphere of art where art is not creation but nature. To grasp the idea of nature and thereby make it serviceable for the archetype of art (for pure content) was, in the end, Goethe's mission in his investigation of the *ur*-phenomena. In a deeper sense, therefore, the proposition that the work of art imitates nature can be correct if, as the content of the artwork, only nature itself and not the truth of nature is understood. It follows from this that the correlate of the content, what is presented (hence nature), cannot be compared with the content. The concept of "what is presented" is ambiguous. Here it does not have the meaning of the "representation," for this is identical with the content. Moreover, this passage directly grasps the concept of true nature—in accordance with what was said above about intuition—as identical with the realm of archetypes or *ur*-phenomena or ideals, without bothering about the concept of nature as an object of science. It will not do, however, to define the concept of nature quite naively as simply a concept of art theory. More pressing is the question of how nature appears to science, and the concept of intuition would perhaps contribute nothing to an answer. This concept remains, that is, within the theory of art (here, at the place where the relation between work and archetype is addressed). "What is presented" can be seen only in the work; outside the work, it can only be intuited. Artistic content that is true to nature would presuppose

that nature is the criterion by which the work is measured; this content itself, however, should be visible nature. Goethe is thinking in accord with the sublime paradox of that ancient anecdote in which sparrows alight on the grapes painted by a great Greek master. The Greeks were no naturalists, and the extreme truth to nature at issue in the tale seems only a grand circumlocution for true nature as the content of the works themselves. Here everything turns on the more exact definition of the concept of "true nature," since this "true," visible nature, which is supposed to constitute the contents of the artwork, not only must not be immediately identified with the appearing, visible nature of the world, but rather must first be rigorously distinguished from that nature on a conceptual level, whereas afterward, to be sure, the problem of a deeper, essential unity of the "true" visible nature in the artwork and of the nature present in the phenomena of visible nature (present though perhaps invisible, only intuitable, *ur*-phenomenal) would be posed. And it may be that this problem would finally admit of a paradoxical resolution—namely, that the true, intuitable, *ur*-phenomenal nature would become visible after the fashion of a likeness, not in the nature of the world but *only* in art, whereas in the nature of the world it would indeed be present but hidden (that is, overshadowed by what appears).

With this way of seeing, however, it is manifest that every single work in a certain way exists contingently over against the ideal of art, whether one attributes the pure content of the latter to the Muses or to nature, in either case seeking, like Goethe, a new canon of the muse. For that ideal is not created but is, in its epistemological determination, an "idea" in the Platonic sense; in its sphere, embraced in art, is unity and the absence of beginning, the Eleatic stasis. Single works, indeed, have a share in the archetypes, but there is no transition from the archetypal realm to the single works, such as exists in the medium of art from the absolute form to the single forms. In relation to the ideal, the single work remains, as it were, a torso.[309] It is an individuated endeavor to represent the archetype; only as a prototype can it last with others of its sort, but they can never vitally coalesce into the unity of the ideal itself.

About the relation of works to the unconditioned and thereby to one another, Goethe thought by renouncing thought. In Romantic thinking, on the other hand, everything rebelled against this solution. Art was the region in which Romanticism strove to carry through most purely the immediate reconciliation of the conditioned with the unconditioned. Certainly Friedrich Schlegel, in his early period, still stood close to Goethe's conception and gave it pregnant formulation in referring to Greek art as that "whose particular history would be the natural history of art in general." This passage continues: "The thinker . . . requires a perfect intuition. In part as example and authentication for his concept, in part as fact and document

of his investigation. . . . The pure law is empty. For it to be filled out . . . it requires . . . a highest aesthetic archetype . . . no other word than imitation for the activity of the one . . . who dedicates himself to the lawfulness of that primal image."[310] But what prevented Schlegel from adopting this solution, the more he came to his own position, was the fact that it leads to an extremely qualified assessment of the single work. In the same essay in which he strives to fix his own evolving standpoint, he already basically opposes necessity, infinity, and idea to imitation, perfection, and the ideal, when he says: "The goals of man are in part infinite and necessary, in part bounded and contingent. Art is therefore . . . a free art of ideas."[311] Even more decisively, around the turn of the century, he says about art: "Every part in this highest product of the human spirit wants at the same time to be the whole, and should this wish be in reality unattainable, as sophists . . . would make us believe, then the vain and perverted beginning[312] might as well be abandoned completely. . . ."[313] "Every poem, every work should signify the whole, really and truly signify it, and through the signification . . . also really and truly be it."[314] The overcoming of contingency, of the torso character of works, is the intention in Friedrich Schlegel's concept of form. In relation to the ideal, the torso is a legitimate shape; it has no place in the medium of forms. The work of art cannot be a torso; it must be a mobile transitory moment in the living transcendental form. By limiting itself in its own form, it makes itself transitory in a contingent figure, but in that fleeting figure it makes itself eternal through criticism.[315]

The Romantics wanted to make the lawfulness of the work of art absolute. But it is only with the dissolution of the work that the moment of contingency can be dissolved or, rather, transformed into something lawful. Therefore the Romantics, to be consistent, had to conduct a radical polemic against Goethe's doctrine of the canonical validity of Greek works. They could not acknowledge prototypes, autonomous works complete in themselves, definitively fashioned entities exempted from eternal progression. Novalis turned against Goethe in the most high-spirited and witty way: "Nature and insight into nature arise at the same time,[316] just as antiquity and knowledge of antiquity; for one makes a great error if one believes that the ancients exist. Only now is antiquity starting to arise. . . . It is the same with classical literature as with antiquity. It is not actually given to us—it is not already there; rather, it must first be produced by us. A classical literature arises for us only through diligent and spirited study of the ancients—a classical literature such as the ancients themselves did not possess."[317] "Only let us not cling too obstinately to the belief that antiquity and the consummate are made—'made' in the sense that we call something made. They are made in the sense that the beloved is made by the prearranged sign of the lover in the night, as the sparks by the contact of the conductor, or the star through the movement in the eye."[318] This means that

antiquity arises only where a creative spirit recognizes it; it is not a "fact" in Goethe's sense. The same assertion is made in another passage: "The ancients are simultaneously products of the future and products of the remote past."[319] And immediately afterward: "Is there a central antiquity or universal spirit of the ancients?" The question accords with Schlegel's thesis about the unity of ancient poetry resembling that of a work, and they both are to be understood as anticlassical. For Schlegel, it is of great importance to dissolve the ancient works, as well as the ancient genres, into one another. "It was in vain that individuals completely expressed the ideal of their genre, if the genres themselves were not also . . . strictly and sharply isolated. . . . But to transpose oneself at will now into this sphere, now into that sphere . . . is possible only for a mind that . . . contains within it an entire system of persons and in whose inwardness the universe . . . is . . . ripe."[320] Therefore, "All classical genres of poetry, in their strict purity, are now laughable."[321] And finally: "You cannot force anyone to look on the ancients as classical, or as ancient; that depends, in the end, on maxims."[322]

The Romantics define the relation of artworks to art as infinity in totality—which means that the infinity of art is fulfilled in the totality of works. Goethe defines it as unity in plurality—which means that the unity of art is found again and again in the plurality of works. This infinity is that of pure form; this unity is that of pure content.[323] The question of the relation between the Goethean and Romantic theories of art thus coincides with the question of the relation between pure content and pure (and, as such, rigorous) form. It is in this sphere that the question of the relation between form and content is to be raised, a question often misleadingly posed with respect to the single work and in that case never answerable with precision. For these are not substrata in the empirical product, but relative distinctions in it, drawn on the basis of necessarily pure distinctions within the philosophy of art. The *idea* of art is the idea of its form, as its *ideal* is the ideal of its content. Hence, the fundamental systematic question of the philosophy of art can be formulated as the question of the relation between the idea and the ideal of art. The present investigation cannot pass beyond the threshold of this question; it could only work out a problem-historical connection to the point where it indicated, with complete clarity, a systematic connection. Even today the problematic of German philosophy of art around 1800, as exhibited in the theories of Goethe and the early Romantics, is legitimate. The Romantics did not resolve, or even pose, this question, any more than Goethe did. They all work together to introduce this question to the history of problems. Only systematic thought can resolve it.

As we have emphasized, the Romantics were not enabled to grasp the ideal of art. It only remains to point out that Goethe's solution of the problem of form does not have the philosophical importance of his determination of content. Goethe interprets the form of art as style. Yet he saw

in style the principle of form for the work of art only because he had in view a more or less historically determinate style: representation of a typifying sort. The Greeks embodied this for plastic art; for poetry, he aimed to establish the prototype himself. But even though the content of the work is the archetype, the type in no way needs to define its form. Thus, in the concept of style, Goethe provided not a philosophical clarification of the problem of form but only a reference to the criterion of certain prototypes. The intention that disclosed to him the depths of the problem of content in art became the source of a sublime naturalism in the face of the problem of form. Insofar as an archetype, a nature, was meant to show itself in relation to the form as well, and since nature in itself could not be this, an art-nature as it were (for that is what style means in this sense) had to be made into the archetype of the form. Novalis saw this with great clarity. He rejects it, calling it Goethean: "The ancients are of another world; it is as though they have fallen from the sky."[324] With this, he designates in fact the essence of that art-nature which Goethe posits in style as the archetype. But the concept of the archetype loses its meaning for the problem of form as soon as it is supposed to be thought of as its solution. It is the privilege of ancient thinkers, who sometimes pose the deepest questions of philosophy in the shape of mythical solutions, to circumscribe the problem of art in its total scope, according to form and content, by means of the concept of archetype. In the final analysis, Goethe's concept of style also relates a myth. And the objection to it can arise on the basis of the lack of distinction prevailing in it between form of presentation and absolute form. For the question of the presentational form still must be distinguished from the problem of form previously examined—namely, that of absolute form. Moreover, it scarcely needs emphasizing that the former has an entirely different meaning in Goethe from what it has in the early Romantics. It is the measure sustaining beauty, the measure that makes its appearance in the constituents of the work. The concept of measure is remote from Romanticism, which paid no heed to an a priori of content, something to be measured in art. With respect to the concept of beauty, Romanticism rejected not simply rule but measure as well, and its literary production is not only ruleless but measureless.

Goethe's theory of art leaves unresolved not only the problem of absolute form but also that of criticism. But although it does acknowledge the former in a veiled way and is competent to express the magnitude of this question, it seems to negate the latter. And in fact, according to Goethe's ultimate intention, criticism of an artwork is neither possible nor necessary. At most, a reference to the good might be necessary, a warning against the bad; and an apodictic judgment of works is possible for an artist who has an intuition of the archetype. But Goethe refuses to recognize criticizability as an essential moment in the work of art; although methodologically—that is, objectively—necessary, criticism is, from his standpoint, impossible. Yet not only

is criticism, in Romantic art, possible and necessary, but in the theory of Romantic art one cannot avoid the paradox that criticism is valued more highly than works of art. Even as practicing critics, the Romantics had no consciousness of the rank the poet occupies over the reviewer. The cultivation of criticism and of the forms, in both of which they won the highest honor, are established in their theory at the deepest level. In this they achieved complete unanimity in deed and thought, and they fulfilled exactly what to them mattered most. The lack of poetic productivity, with which people from time to time tax Friedrich Schlegel in particular, does not belong in the strict sense to his image. For he did not want primarily to be a poet in the sense of a creator of works. The absolutizing of the created work, the critical activity, was for him the highest. This can be illustrated in an image as the generation of dazzling brilliance in the work. This dazzling—the sober light—extinguishes the plurality of works. It is the idea.

Written in 1919; published as a monograph in 1920 by Verlag von A. Francke. Translated by David Lachterman, Howard Eiland, and Ian Balfour.

Notes

1. Investigations into the history of problems can concern nonphilosophical disciplines as well. In order to avoid any ambiguity, therefore, it would be necessary to coin the term "philosophico-problem-historical" [*philosophieproblemgeschichtlich*], and the expression given above in the text should always be understood as an abbreviation for this. [In the notes that follow, the editors have completed all partial bibliographic references.]

2. Although later Romanticism knows no unified, theoretically circumscribed concept of the criticism of art [*Kunstkritik*], we may in the present context, where it is a question exclusively or primarily of early Romanticism, make use of the term "Romantic" without risking equivocation. The same goes for the use of the words "Romanticism" and "Romantics" in this study.

3. This point of view may be sought in Romantic messianism. "The revolutionary desire to realize the kingdom of God on earth is the elastic point of progressive civilization and the inception of modern history. Whatever has no relation to the kingdom of God is strictly of secondary importance in this history" (Friedrich Schlegel, *Athenaeum Fragments*, no. 222). "As for religion, dear friend, the time is ripe to found one; for us, this is no joke but the gravest of concerns. It is the goal of all goals and the very midpoint. Indeed, I see the greatest birth of modern times already emerging—as unassuming as early Christianity, which no one could have suspected would soon eclipse the Roman Empire, just as this great catastrophe in its widening surge will swallow up the French Revolution that engendered it and that perhaps had its only real merit in doing so" Friedrich Schlegel, *Briefe an seinen Bruder, August Wilhelm* [Letters to His Brother, August Wilhelm] (Berlin, 1890), p. 421. See also Schlegel, *Ideen* [Ideas], nos. 50,

56, and 92; and Novalis, *Briefwechsel mit Friedrich und August Wilhelm, Charlotte und Caroline Schlegel* [Correspondence with Friedrich and August Wilhelm, Charlotte and Caroline Schlegel] (Mainz, 1880), pp. 82ff., as well as many other places in the works of both writers. "Roundly denied is an ideal of human fulfillment that would be realized in infinity; rather, what was demanded was the 'kingdom of God' at this very moment—in time and on earth. . . . Fulfillment at every point of existence, realized ideal on every level of life: this is the categorical imperative out of which Schlegel's new religion emerges." Charlotte Pingoud, *Grundlinien der ästhetischen Doktrin Fr. Schlegels* [Outline of Friedrich Schlegel's Aesthetic Doctrine] (Stuttgart, 1914), pp. 52ff.

4. In accordance with what was stated above, wherever the context does not dictate otherwise, the bare term "criticism" [*Kritik*] will be understood to refer to the critique of artworks.

5. Refers hereafter in every case to Friedrich Schlegel.

6. "Your notebooks are haunting my inner life tremendously" (Novalis, *Briefwechsel*, p. 37).

7. The *Athenaeum*, which appeared twice a year between 1798 and 1800, was the theoretical organ of the early Romantic movement in Germany. It was edited by Friedrich and August Wilhelm Schlegel, and included contributions by Novalis, Friedrich Schleiermacher, and the editors.—*Trans.*

8. In his important posthumous publication, *Zur Beurteilung der Romantik und zur Kritik ihrer Erforschung* [On the Evaluation of Romanticism and the Criticism of Research on It] (Munich and Berlin, 1918), Siegbert Elkuss has shown, through fundamental considerations, how important Friedrich Schlegel's later period and the theories of the later Romantics are for the exploration of the entire picture of Romanticism: "So long as one continues as before to concern oneself in essence with the early period of these great spirits, and generally neglects to ask what thoughts they managed to carry over into their positive period, . . . there is hardly any possibility of understanding and evaluating their historical achievement" (p. 75). But Elkuss appears skeptical toward the attempt—fruitless as it often is, of course—to determine the achievement of the *youthful* ideas of the Romantics as something precisely positive. That this undertaking is nonetheless possible, if not without explicit reference to their later period, the present work hopes to establish for its field. [Certain aspects of Benjamin's argument are based on a fundamental misconception. Friedrich Schlegel developed a systematic position in a series of lectures delivered at Jena University in 1800–1801. These were considered lost at the time Benjamin worked on his study. The Jena lectures contradict much of what Benjamin surmises from the later Windischmann texts.—*Trans.*]

9. A number of Schlegel's fragments appeared in the Berlin journal *Lyceum der schönen Künste* [Lyceum of the Fine Arts], to which he was a regular contributor. He collected much of his occasional criticism and essays in the volume *Charakteristiken und Kritiken*, which he edited with his brother August Wilhelm (1801).—*Trans.*

10. *Lucinde*, p. 83, "A Reflection."

11. *Seine prosaischen Jugendschriften* [Juvenile Works in Prose] (Vienna, 1906), vol. 2, p. 426.

12. On this use of the term "style," see Elkuss, p. 45, with reference to the Romantics.

13. *Athenaeum Fragments*, no. 418. [Ludwig Tieck (1773–1853), Romantic author loosely associated with the circle around the Schlegels. Tieck was a prolific writer; his best-known works include the parodic drama *Der gestiefelte Kater* (Puss in Boots, 1797); a series of novellas modeled on the *Märchen* tradition, including "Der blonde Eckbert" (Blond Eckbert, 1797) and "Der Runenberg" (Rune Mountain, 1797); and the novel *Franz Sternbalds Wanderungen* (1798).—*Trans.*]

14. *Schriften* (Berlin, 1901), vol. 2, p. 11.

15. *Philosophische Vorlesungen aus den Jahren 1804 bis 1806* [Philosophical Lectures, 1804–1806] (Bonn, 1846), p. 23.

16. With reference to Fichte and Friedrich Schlegel, [Rudolf] Haym writes: "Given an epoch so rich in ideas, who would want to dwell pedantically on the relative derivation of individual thoughts or the property rights of individual minds?" Haym, *Die Romantische Schule* [The Romantic School] (Berlin, 1870), p. 264. Here, too, it is a matter not of pinning down a particular derivation or influence, which is obvious, but of specifying what is less appreciated: the considerable differences between the two intellectual orbits.

17. Fichte, *Sämmtliche Werke* [Complete Works] (Berlin, 1845–1846), vol. 1, p. 67.

18. Fichte, pp. 71ff.

19. Fichte, p. 67.

20. Fichte, p. 528.

21. Fichte, p. 217.

22. Wilhelm Windelband, *Die Geschichte der neueren Philosophie* [The History of Recent Philosophy] (Leipzig, 1911), vol. 2, p. 223.

23. Windelband, vol. 2, p. 224.

24. *Vorlesungen*, p. 109.

25. Cf. Fichte, p. 216.

26. Fichte, p. 218.

27. Fichte, p. 526.

28. Fichte, p. 527.

29. Ibid.

30. See above, in Section I of the text.

31. *Untreue der Weisheit* [Faithlessness of Wisdom] (Munich, 1916), p. 309. [Translation from Pindar, "Das Unendliche," with commentary.—*Trans.*]

32. See above, in Section I of the text.

33. *Jugendschriften*, vol. 2, p. 176.

34. *Vorlesungen*, p. 6.

35. Ibid.

36. Fichte, p. 67.

37. "Here (in philosophy) arises that living reflection which, with careful nurturance, subsequently expands on its own to form an infinitely configured intellectual universe—the kernel and germ of an all-inclusive organization" (Novalis, *Schriften*, p. 58).

38. No. 339.

39. Fichte, pp. 99ff.

40. "Self . . . presupposes the concept of the 'I'; and everything therein that is thought of the absolute derives from this concept" (Fichte, p. 530n).

41. That is, of the proposition "I am I."

42. Fichte, p. 69.

43. *August Wilhelm und Friedrich Schlegel: In Auswahl* [August Wilhelm and Friedrich Schlegel: A Selection], selected by Oskar Walzel, ed. Joseph Kürschner (Stuttgart, 1892), p. 315. Hereafter cited as Kürschner.

44. *Vorlesungen,* p. 11.

45. Ibid.

46. That is, Fichte.

47. Which Schlegel necessarily saw in the act of positing.

48. *Vorlesungen,* p. 26.

49. *Vorlesungen,* p. 13.

50. For him, too, immediate knowledge is found only in intuition. It was already suggested above: because the absolute "I" is conscious of itself immediately, Fichte names the mode in which it appears "intuition," and because it is conscious of itself in reflection, this intuition is termed "intellectual." The pivotal theme of this argumentation lies in reflection, which is the true ground of the immediacy of knowledge; it is only later—in assimilating the Kantian usage—that Fichte characterizes this ground as intuition. In fact, in the *Wissenschaftslehre* of 1794, as also indicated above, Fichte did not yet think of immediate knowledge as intuitive knowledge. And therefore the Fichtean "intellectual intuition" has no relation to the Kantian. With this term, "Kant designated the supreme conceptual boundary of his 'metaphysics of knowledge': the supposition of a creative spirit that engenders not only the forms of its thinking but also the contents, the noumena, things-in-themselves. For Fichte, this understanding of the concept became superfluous and untenable, like the concept of the thing-in-itself. Intellectual intuition for him was only that function of the intellect which has regard for itself and its actions" (Windelband, vol. 2, p. 230).—If one wants to compare Schlegel's concept of sense (understood as the primal cell out of which reflection arises) with Kant's and Fichte's concepts of intellectual intuition, then one can do this—presupposing a more specific interpretation—by using Pulver's words: "If intellectual intuition for Fichte is the organ of transcendental thinking, then Friedrich [Schlegel] allows . . . the instrument of his world conception to hover as a medial between Kant's and Fichte's definitions of intellectual intuition." Max Pulver, *Romantische Ironie und romantische Komödie* [Romantic Irony and Romantic Comedy] (St. Gallen, 1912), p. 2. This medial is not, however, as Pulver would like to conclude, something indeterminate: "sense" has the creative capacity of Kant's *intellectus archetypus* and the reflecting movement of Fichte's intellectual intuition.

51. Fichte, p. 533.

52. *Vorlesungen,* p. 43.

53. *Vorlesungen,* p. 19.

54. *Vorlesungen,* p. 38.

55. Cited in Wilhelm Dilthey, *Leben Schleiermachers* [Life of Schleiermacher], vol. 1 (Berlin, 1870), p. 118.

56. *Briefwechsel*, pp. 38ff.
57. *Schriften*, p. 570. For contrasting observations by Novalis, see [Heinrich] Simon, *Die theoretischen Grundlagen des magischen Idealismus von Novalis* [The Theoretical Basis of Novalis' Magic Idealism] (Heidelberg, 1905), pp. 14ff. As a consequence of the incompleteness of Novalis' writings, and of the exceptional character of the tradition in which nearly everything that may have passed through his head has been preserved, there are a great many sayings of his for which an opposing statement may be found. It is a question here of the relevant problem-historical context in which Novalis can and must be cited.
58. Novalis, *Schriften* [Works], ed. J. Minor (Jena, 1907), vol. 3, p. 332.
59. It is a figure of reflection, one could say.
60. *Vorlesungen*, p. 21n.
61. *Vorlesungen*, p. 23.
62. *Vorlesungen*, p. 6.
63. The ambiguity of the designation in this case entails no lack of clarity. For, on the one hand, owing to its continuous context, reflection itself is a medium, and, on the other hand, the medium in question is one such that reflection moves within it—for reflection, as the absolute, moves within itself.
64. That is, in reflection.
65. *Vorlesungen*, p. 35.
66. That is to say, the lowering of the level of reflection.
67. *Vorlesungen*, p. 35.
68. *Schriften*, pp. 304ff.
69. *Vorlesungen*, pp. 37ff.
70. *Schriften*, p. 63.
71. *Schriften*, p. 58.
72. Novalis, *Schriften*, ed. Minor, vol. 2, p. 309.
73. *Schriften*, p. 26.
74. On the basis of his participation in the transcendental "I."
75. Fichte, pp. 458ff.
76. Windelband, vol. 2, pp. 221ff.
77. In the later lectures his thought has grown woolly. To be sure, his point of departure there is likewise not a being, but neither is it an act of thought. It is, rather, pure will or love. (*Vorlesungen*, pp. 64ff.)
78. *Jugendschriften*, vol. 2, p. 359.
79. *Briefe*, p. 111.
80. That is, "what is meant in the formulations of Romanticism."
81. Elkuss, p. 31.
82. That is, "with the material grounds of the problematic."
83. Elkuss, p. 74.
84. Elkuss, p. 75.
85. Elkuss, p. 33.
86. No. 97.
87. No. 91.
88. *Vorlesungen*, pp. 405ff.
89. See *Vorlesungen*, p. 421.
90. *Vorlesungen*, p. 407.

91. Erwin Kircher, *Philosophie der Romantik* [Philosophy of Romanticism] (Jena, 1906), p. 147.
92. Pingoud, p. 44.
93. It would be very interesting to study how the transition from the definition of the medium of reflection as art to its definition as absolute "I" is gradually prepared. It is brought about through the idea of humanity. See *Ideas* (1800), nos. 45, 98. This concept, too, is understood as a medium. See also the theory of the mediator in the *Athenaeum Fragments*, no. 234; in Novalis' *Schriften*, pp. 18ff.; and elsewhere.
94. Pingoud, pp. 32ff.
95. *Vorlesungen*, p. 419. [Friedrich Heinrich Jacobi (1743–1819), novelist of the late Enlightenment whose best-known work, *Woldemar* (1779), was the target of a scathing attack by Schlegel in 1797.—*Trans.*]
96. No. 346.
97. *Jugendschriften*, vol. 2, p. 387.
98. *Vorlesungen*, pp. 416ff.
99. *Athenaeum Fragments*, no. 242.
100. *Vorlesungen*, p. 405.
101. *Vorlesungen*, p. 408.
102. *Vorlesungen*, p. 57.
103. *Schriften*, p. 54.
104. *Aus Schleiermachers Leben*, in *Briefen* (Berlin, 1858–1863), vol. 3, p. 71.
105. *Vorlesungen*, p. 50.
106. Vorlesungen, p. 55.
107. *Athenaeum Fragments*, no. 53.
108. That is to say, etymological. In mystical allusion to *gramma*, meaning "letter." See Schlegel: "The letter [*Buchstab'*] is the true magic wand [*Zauberstab*]" (Novalis, *Briefwechsel*, p. 90).
109. *Athenaeum Fragments*, no. 414.
110. *Schriften*, p. 18.
111. *Schriften*, p. 10.
112. *Athenaeum Fragments*, no. 220; and see further on in this fragment.
113. *Lyceum Fragments* (1797), no. 56.
114. *Athenaeum Fragments*, no. 366.
115. *Lyceum Fragments*, no. 9.
116. *Lyceum Fragments*, no. 126.
117. *Schriften*, p. 9.
118. *Ideas*, no. 26.
119. *Jugendschriften*, vol. 2, p. 387.
120. *Lyceum Fragments*, no. 104.
121. Elkuss, p. 44.
122. Ibid.
123. Elkuss, p. 20.
124. *Briefwechsel*, p. 17.
125. *Schriften*, p. 428, and *Athenaeum Fragments*, no. 121; also "absolute criticism."
126. That is, conscious, reflective observation.

127. *Vorlesungen,* p. 23.
128. *Vorlesungen,* p. 421.
129. Fichte, p. 67.
130. *Aus Schleiermachers Leben,* vol. 3, p. 71.
131. *Briefe,* p. 344.
132. On this, compare *Athenaeum Fragments,* nos. 22 and 206.
133. Benjamin here cites three preeminent figures of the German Enlightenment. Johann Christoph Gottsched (1700–1766) was a rationalist author, a neoclassical literary theorist, and Germany's virtual literary pope. His *Versuch einer Critischen Dichtkunst vor die Deutschen* (Essay on a Critical Poetics for the Germans, 1729) is the most important and most frequently attacked poetics of the first half of the century. Gotthold Ephraim Lessing (1729–1781) was already for his contemporaries a synonym for the era of the Enlightenment. His main achievements include a poetics (*Laokoön,* 1766) and a number of seminal dramas (*Minna von Barnhelm,* 1767; *Emilia Galotti,* 1772; and *Nathan der Weise,* 1779). Johann Joachim Winckelmann (1717–1768) was a founder of classical archaeology and was recognized by his contemporaries as the leading authority on classical art in Europe. His major work, *Geschichte der Kunst des Alterthums* (History of Ancient Art, 1764) contains his famous characterization of antique sculpture—namely, that it has a "noble simplicity and quiet grandeur" *(edle Einfalt und stille Größe).—Trans.*
134. *Sturm und Drang* (Storm and Stress) was a short-lived but intense outpouring of theoretical and dramatic texts by a group of young writers around Goethe in the 1770s. Often treated (erroneously) as a kind of pre-Romanticism, the dramas were characterized by their expression of untrammeled emotions. The best-known authors include J. M. R. Lenz and Friedrich Maximilian Klinger. A decade later, Schiller composed his early plays in a style derived from *Sturm und Drang.—Trans.*
135. That is, art.
136. *Jugendschriften,* vol. 1, p. 90.
137. *Schriften,* p. 579.
138. That is, thinks itself.
139. *Schriften,* p. 285.
140. *Schriften,* p. 293.
141. *Schriften,* p. 285.
142. *Schriften,* ed. Minor, vol. 3, p. 166.
143. *Schriften,* p. 285.
144. *Schriften,* p. 355.
145. *Schriften,* p. 190.
146. In fact, where knowledge is concerned, it can be a question only of a heightening, a potentiation of reflection; a retrogressive movement appears inconceivable both for the thought-scheme of reflection and for recognition through reflection, despite the falsely schematizing statements which Schlegel and Novalis made in this connection. Besides, they never posit such a movement in the individual instance. For reflection may very well be intensified if not diminished again; neither a synthesis nor an analysis makes for diminution. Only a breaking off, never a lessening, of heightened reflection is thinkable.

Therefore, all interrelations among centers of reflection—not to mention their relations to the absolute—can rest only on intensifications of reflection. This objection seems warranted at least by inner experience, which of course is difficult to elucidate with any certitude. Apropos of this isolated critical remark, it should be said that in this study the theory of the reflective medium will not be followed further than the Romantics developed it; for the systematic exposition of their concept of criticism, this suffices. To be sure, for the sake of purely critical, logical interest, a further elaboration of this theory at the boundaries where the Romantics left it in the dark would be welcome; it is to be feared, however, that such an elaboration would in fact also lead only into darkness. The theory which was delineated according to circumscribed metaphysical concerns, and out of which several theorems were brought to peculiar fruition in the theory of art, leads in its totality to purely logical, unresolvable contradictions—above all, with the problem of primordial reflection.

147. *Schriften*, p. 563.

148. Fichte, p. 454.

149. This perception bears on Goethe as well. Clearly, the ultimate intention of his regard for nature does not at all coincide with the romantic theory in question, from which he stood removed. Nevertheless, considered from other perspectives, Goethe's work displays a concept of experience [*Empirie*] which is very close to the Romantic concept of observation. "There is a tender empiria that conforms intimately to its object and that, through identification with it, becomes its true and proper theory. Such heightening of the spiritual faculty, however, bespeaks a highly cultivated age." Goethe, *Werke* (Weimar, 1887–1914), part 2, vol. 2, pp. 128ff. This "empiricism" grasps what is essential in the object itself; therefore, Goethe says: "The highest thing would be to understand that everything factual is already theory. The blue of the sky reveals to us the fundamental law of chromatics. Only one must not look for anything behind the phenomena; they are themselves the doctrine" (*Werke*, part 2, vol. 2, p. 131). By virtue of its self-awareness, the phenomenon is the lesson for the Romantics, too.

150. *Schriften*, p. 500.

151. *Schriften*, p. 447.

152. *Schriften*, p. 355.

153. *Schriften*, p. 453.

154. *Vorlesungen*, p. 63.

155. The poet and his object are to be thought of here as poles of reflection.

156. *Athenaeum Fragments*, no. 433.

157. *Schriften*, ed. Minor, vol. 3, p. 14.

158. *Kat' exochen*: par excellence.—*Trans.*

159. *Schriften*, p. 496.

160. *Schriften*, p. 478.

161. *Schriften*, p. 277.

162. *Schriften*, p. 490. [Novalis writes the last sentence in incorrect French.—*Trans.*]

163. *Schriften*, pp. 278ff.

164. *Schriften*, p. 331.

165. *Schriften*, p. 440.

166. *Athenaeum Fragments*, no. 403.

167. *Athenaeum Fragments*, no. 427.

168. *Jugendschriften*, vol. 2, 423.

169. *Schriften*, p. 441.

170. *Jugendschriften*, vol. 2, p. 172.

171. *Schriften*, p. 460.

172. *Schriften*, p. 318.

173. *Aus Schleiermachers Leben*, vol. 3, p. 175. ["On Goethe's (Wilhelm) Meister" becomes the "Over- or Super-Meister."—*Trans.*]

174. *Caroline Schlegel-Schelling: Briefe* [Letters] (Leipzig, 1871), vol. 1, p. 257. *Aus Schleiermachers Leben*, vol. 3, p. 138. [Caroline Schlegel-Schelling (1763–1809), author, was the wife of A. W. Schlegel and later of the philosopher F. W. J. Schelling.—*Trans.*]

175. *Schriften*, p. 499.

176. *Schriften*, p. 304.

177. *Schriften*, p. 34.

178. By which qualification the dignity rather than the object of philosophy is presumably signified.

179. *Athenaeum Fragments*, no. 44.

180. *Jugendschriften*, vol. 2, p. 169.

181. That is, as unfolding of the reflection immanent to the work of art.

182. *Lyceum Fragments*, no. 117.

183. *Jugendschriften*, vol. 2, p. 177. This poetic criticism, which, according to the review of *Wilhelm Meister*, should be the affair of "poets and artists" alone, is for the most part Schlegel's own mode of doing criticism and the one he valued most highly. With its distinction from the character sketch [*die Charakteristik*], a distinction made in the passage just cited, compare the following remark from the review of [F. W. Jacobi's] *Woldemar*: "Only a philosophy that has reached, or almost reached, a high point of necessary development in the cultivation of the philosophic spirit may be systematized and, through the cutting away of excrescences and the filling up of lacunae, made more integral and more faithful to the meaning. By contrast, a philosophy . . . whose basis, goal, working laws and total ensemble are themselves not philosophical but personal can only study character" (*Jugendschriften*, vol. 2, pp. 89ff.). The character sketch is thus, on the one hand, adapted to mediocre work and, on the other hand, according to the review of *Wilhelm Meister*, the business generally of unpoetic critics.—That systematizing and filling out is, with good reason, recognized by Haym (p. 227) as constituting the sort of poetic criticism which, in the sense outlined above, and also in relation to the art of poetry itself, Schlegel intends. The title "Characterizations and Critiques," which the brothers Schlegel gave to the collection of their reviews, thus juxtaposes the unpoetic and the poetic criticism. The former—that is, the character study—has nothing whatever to do with the essentials of Schlegel's concept of criticism.

184. *Schriften*, pp. 104ff. See above, Part One, Section IV: the object is heightened, completed in knowledge; it can therefore be known only if it is incomplete. This perception belongs together with the problem of learning, of *anamnesis*, of knowledge not yet conscious, and with its mystical ventures at solution, according to which the object at issue is incomplete and indeed inwardly given.

185. *Schriften,* p. 30.
186. *Schriften,* pp. 16ff.
187. Carl Enders, *Friedrich Schlegel: Die Quellen seines Wesens und Werdens* [Friedrich Schlegel: The Sources of His Nature and Growth] (Leipzig, 1913), p. 1.
188. Karl Phillip Moritz (1756–1793) was a novelist and an authority on art, linguistics, mythology, and psychology. He and others, especially Johann Gottfried Herder (1744–1803), philosopher, historian, and theologian, developed aesthetic positions—based on an early theory of historicism—that clearly differentiated them from their rationalist predecessors and contemporaries, such as Gottsched, Lessing, and Kant.—*Trans.*
189. *Jugendschriften,* vol. 2, p. 171.
190. *Schriften,* p. 13.
191. *Schriften,* p. 80.
192. See the "Rede über Mythologie" ["Discourse on Mythology"], *Jugendschriften,* vol. 2, p. 357.
193. With reference to the formal, methodological moments, Haym (p. 481) could therefore say of Schlegel's philosophy of religion around 1800: "Seen aright, [this philosophy] merely evinces the fact that he has carried some of his favorite categories of poetry, as cultivated in the field of aesthetics, over into religion." The general tendency of this philosophy of religion is, however, not adequately characterized with these words.
194. *Jugendschriften,* vol. 2, p. 427.
195. That is, reflective.
196. Enders, p. 357.
197. *Schriften,* p. 39.
198. *Jugendschriften,* vol. 2, p. 366.
199. Ibid.
200. Kürschner, p. 389.
201. *Athenaeum Fragments,* no. 297.
202. *Schriften,* ed. Minor, vol. 2, p. 231. In this saying, the term "ideal" is completely congruent with the concept introduced as "idea" in the concluding section of the present study.
203. *Jugendschriften,* vol. 2, p. 384.
204. *Lyceum Fragments,* no. 123.
205. That is, determinate (see above, p. 156).
206. *Athenaeum Fragments,* no. 253.
207. *Jugendschriften,* vol. 2, p. 423.
208. Such as exists, it goes without saying, not in the province of science but only in that of art.
209. *Schriften,* p. 379.
210. *Athenaeum Fragments,* no. 404. The fragment displays in its context a mystical-terminological fusion of the aesthetic concept of criticism with the philological concept.
211. *Jugendschriften,* vol. 2, pp. 424ff.
212. This determination bespeaks, among other works: for Dante, A. W. Schlegel's translation fragments from the *Divine Comedy* and the *Vita Nuova,* together with his work on this poet; for Boccaccio, Friedrich Schlegel's "Report on the Poetic Works of Giovanni Boccaccio"; for Shakespeare and Calderón (along

with the translation of Calderón by [Johann Diederich] Gries) A. W. Schlegel's translations; for Cervantes (along with the translation by [Dietrich Wilhelm] Soltau), those by Tieck, which were planned at the suggestion of the Schlegels and welcomed by them; for Goethe, especially Friedrich Schlegel's review of *Wilhelm Meister* and his brother's review of *Hermann and Dorothea*.

213. *Athenaeum Fragments*, no. 116.

214. *Athenaeum Fragments*, no. 67.

215. Enders, p. 358.

216. Contributing to this notion is a wholly false modernization of Romantic doctrines. Although very widespread, it is seldom expressed so baldly as in the following utterance: "Aesthetic freedom constitutes man's essence, and so in his works man must step into the foreground (Schlegel calls this Romantic), whereas the work itself gains value only as the mirror of personality, of that which creates and destroys in eternal play." Paul Lerch, *Friedrich Schlegels philosophische Anschauungen in ihrer Entwicklung und systematischen Ausgestaltung* [Friedrich Schlegel's Philosophical Views in Their Development and Systematic Formation] (Berlin, 1905), p. 13.

217. *Jugendschriften*, vol. 1, p. 18.

218. Pulver, p. 8.

219. *Jugendschriften*, vol. 2, p. 431.

220. *Jugendschriften*, vol. 2, p. 169.

221. *Lyceum Fragments*, no. 42.

222. The reflexive character of irony is particularly clear in Tieck's dramas. In all literary comedy, as is well known, there is an interplay among audience, author, and theater personnel. Pulver at one point identifies a fourfold reflection: the "sensibility of the enjoyer" marks the initial mirroring; the "spectator on the scene," the second; then "the actor in his role as mime begins to reflect upon himself"; and finally he "sinks into ironic self-anatomizing" (Pulver, p. 21).

223. *Jugendschriften*, vol. 2, p. 177.

224. *Jugendschriften*, vol. 2, p. 431.

225. *Lyceum Fragments*, no. 62.

226. *Athenaeum Fragments*, no. 121.

227. *Athenaeum Fragments*, no. 415.

228. *Athenaeum Fragments*, no. 242.

229. *Schriften*, p. 505.

230. *Schriften*, pp. 84ff.

231. *Schriften*, p. 139.

232. *Athenaeum Fragments*, no. 116 and elsewhere.

233. That is, the philosophy of art.

234. *Athenaeum Fragments*, no. 149.

235. *Jugendschriften*, vol. 2, p. 358.

236. *Ideas*, no. 95.

237. *Jugendschriften*, vol. 2, p. 424; see also *Jugendschriften*, vol. 2, p. 427.

238. It remains notable that in one instance, with the word "work," linguistic usage marks out an "invisible" unity, one analogous to the unity of art expounded by Schlegel—namely, the body of works of a master, above all in the plastic arts.

239. *Athenaeum Fragments*, no. 116.

240. But certainly not incapable of being reflected. An allusion directed against Fichte.
241. *Schriften*, p. 159.
242. Ricarda Huch, *Blüthezeit der Romantik* [Golden Age of Romanticism] (Leipzig, 1901), p. 112.
243. *Athenaeum Fragments*, no. 256.
244. *Jugendschriften*, vol. 2, p. 358.
245. This follows from Romantic messianism and cannot be substantiated here.
246. *Lucinde*, p. 28, "An Idyll of Idleness."
247. *Athenaeum Fragments*, no. 305.
248. *Schriften*, p. 8.
249. *Schriften*, p. 27.
250. *Schriften*, p. 61.
251. *Schriften*, p. 82.
252. Perhaps we should see in this fragment an initial confrontation with the term "transcendental poetry," one which for that very reason is not in accord with the later usage; otherwise we would have to assume a conscious, playful equivocation.
253. *Athenaeum Fragments*, no. 238. Enders understands the conclusion of the fragment incorrectly when he asserts that "poetry of poetry . . . is at bottom nothing but an intensification, and it is synonymous with Romantic, as opposed to non-Romantic, poetry" (p. 376). He fails to notice that the expression "poetry of poetry" is patterned on the schema of reflection (thinking of thinking) and is to be understood accordingly. He also falsely identifies it with the expression "poetic poetry" on the basis of *Athenaeum* fragment 247, where the term is only derived from this.
254. Compare the invectives against Schiller's very different usage of the word "ideal," which is not oriented toward the philosophy of history.
255. Hence, for Schlegel in the *Athenaeum* period, artwork of Greek type (real, naive) remains thinkable only under the auspices of irony, under the provisional suspension occasioned by its resolution. The naive, for Schlegel, can only be a question of a sort of larger-than-life reflection. He celebrates the "instinct taken to the point of irony" (*Athenaeum Fragments*, no. 305) and maintains: "The great practical abstraction [synonymous with reflection] is what makes the ancients—among whom it was instinct—really the ancients" (*Athenaeum Fragments*, no. 121). In this sense, he recognizes the naive in Homer, Shakespeare, Goethe. See his *Geschichte der Poesie der Griechen und Römer* [History of Greek and Roman Literature], as well as *Athenaeum Fragments*, nos. 51, 305.
256. *Jugendschriften*, vol. 2, p. 428.
257. *Briefe*, p. 427.
258. Schlegel evidently neglects to distinguish profane mysticism [*Mystizismus*], something inauthentic, from the higher mysticism [*Mystik*].
259. Kürschner, p. 305.
260. *Jugendschriften*, vol. 2, p. 426.
261. *Jugendschriften*, vol. 2, p. 427.
262. Frieda Margolin, *Die Theorie des Romans in der Frühromantik* [Theory of the Novel in Early Romanticism] (Stuttgart, 1909), p. 27.

263. As such, therefore, the presentational form does not need to be wholly profane. Through sustained purity, it can have a share in the absolute or symbolic form and in the end turn into it.

264. *Jugendschriften*, vol. 2, p. 177.

265. Ibid.

266. The reference is to *Wilhelm Meister.*

267. *Schriften*, ed. Minor, vol. 3, p. 17.

268. *Schriften*, ed. Minor, vol. 2, pp. 307ff.

269. *Jugendschriften*, vol. 2, p. 173.

270. *Jugendschriften*, vol. 2, p. 179.

271. Haym, p. 251. Haym's argument that Schlegel, always "on the lookout for new constructions and new formulas," derived this doctrine from *Wilhelm Meister,* even if substantially correct, does not touch on what it was objectively in this doctrine that Schlegel wanted decisively to emphasize. His assessment, as will become clearer, is to be understood immanently along the lines of his philosophical sphere of thought. Haym himself occasionally points to this connection among reflection, transcendental poetry, and the theory of the novel when he speaks of Schlegel's "taking account of modern poetry from the perspective of the novel and, in conjunction with the concepts of infinite self-reflection, of the transcendental, . . . which he got from Fichte's philosophy" (p. 802).

272. *Athenaeum Fragments*, no. 252.

273. *Jugendschriften*, vol. 2, p. 171.

274. For the context in which this passage occurs, see Novalis' *Briefwechsel,* pp. 54ff. In view of the fact, (noted above) that the style of the novel, according to Novalis, must be no mere continuum but an articulated order, he calls this ornate prose—which has nothing at all to do with art but which concerns rhetoric—a "flowing along . . ., a river."

275. *Briefwechsel*, pp. 55ff.

276. *Briefwechsel*, p. 57.

277. The same perspective on prose is displayed in "Prose and Poetry," the 92nd aphorism of Nietzsche's *Joyful Science.* Only here the gaze travels not, as in Novalis, from poetic forms to prosaic forms but vice versa.

278. *Schriften*, p. 538.

279. *Schriften*, p. 512.

280. This doctrine [of *Poetisierung*] does not belong in this context. It comprises two moments: first, the abrogation of the subject matter in subjective, playful irony, and, second, its elevation and ennobling in mythological content. The (substantive) irony and probably also the humor in the novel are to be understood as arising from the first principle; from the second arises the arabesque.

281. Friedrich Hölderlin, *Sämtliche Werke,* ed. Hellingrath (Munich and Leipzig, 1913–1916), vol. 4, p. 65.

282. *Briefwechsel*, p. 52.

283. Ibid.

284. Consonant as distinguished from vowel and understood as a retarding principle: an expression of mindfulness [*Besinnung*]. Compare: "If the novel is of a retarding nature, then in truth it is poetically prosaic, a consonant" (*Schriften,* p. 539).

285. *Schriften*, p. 539.
286. Hölderlin, vol. 4, p. 60.
287. Hölderlin, vol. 5, p. 175. Although in these words Hölderlin directly parallels certain tendencies in Schlegel and Novalis, what is otherwise asserted of these authors in this study does not hold for him. What was certainly, on the one hand, a powerful tendency in the establishment of the Romantic philosophy of art, but, on the other hand, a tendency little developed or clarified—and therefore, where it was explicitly postulated, only a very remote outpost of their thinking—was Hölderlin's domain. This expanse he governed and kept watch over, whereas for Friedrich Schlegel and also for Novalis, who saw into it more clearly, it remained a promised land. Apart, then, from this central idea of the sobriety of art, there is little to found a direct comparison between these two philosophies of art, just as between their respective progenitors there was no personal relationship.
288. *Schriften*, ed. Minor, vol. 3, p. 195.
289. *Schriften*, p. 206.
290. *Schriften*, p. 69.
291. *Schriften*, p. 490. See also: "Mathematics is true science because it contains simulated knowledge, . . . because it generates methodically" (*Schriften*, ed. Minor, vol. 2, p. 262).
292. *Jugendschriften*, vol. 2, p. 170.
293. *Athenaeum Fragments*, no. 253.
294. *Athenaeum Fragments*, no. 367.
295. *Lyceum Fragments*, no. 37.
296. If at another point within this fragment, in reference to the philosophy of poetry, there is talk of the "beautiful" in a positive sense, then the term has an entirely different meaning: it denotes the sphere of value.
297. *Athenaeum Fragments*, no. 252. The last sentence points not only to the unintelligibility but to the dryness and sobriety of such a work.
298. *Schriften*, p. 565.
299. Kircher, p. 43.
300. *Briefwechsel*, p. 101.
301. *Jugendschriften*, vol. 2, p. 361. One of the most noteworthy expressions of this frame of mind is Friedrich Schlegel's love of the didactic in poetry, understood as a warrant of sobriety. This love makes its appearance quite early in his career—a proof of how deeply rooted in him the tendencies expounded here were. "Idealist poetry, whose end is the philosophically interesting, I call didactic poetry. . . . The tendency of most of the truly superior and best-known modern poems is philosophical. Indeed, modern poetry in its way seems to have reached here a certain consummation, a highest point. The didactic class is its pride and its ornament, its most original product . . . begotten out of the hidden depths of its elemental power" (*Jugendschriften*, vol. 1, pp. 104ff.). This stress on didactic poetry in the essay "On the Study of Greek Poetry" [1795] is actually a harbinger of the emphasis on the novel in Schlegel's later poetic theory. But even then, in conjunction with this emphasis, the didactic does not cease to preoccupy him: "To this genre [of esoteric poetry] we would assign not only didactic poems—whose purpose can only be . . . once more

to mediate and overcome the truly unnatural . . . rift between poetry and science—. . . but also . . . the novel" (Kürschner, p. 308). "Every poem should properly . . . be 'didactic' in this wider sense of the word, where it designates the tendency of a deep infinite sense" (*Jugendschriften*, vol. 2, p. 364). Eight years later, however, we find him saying: "And just because both of these, the novel as well as the didactic poem, actually lie outside the natural bounds of poetry, they are not really genres; rather, every novel and every didactic poem, so long as it is truly poetic, is a separate individual in itself" (Kürschner, p. 402). Here, then (from the year 1808), is the final stage in the development of Schlegel's thinking about the didactic: if at the outset he had remarked that the didactic comprises a particularly distinguished genre within modern poetry, then in the period of the *Athenaeum* he increasingly dissolved this genre as such, together with that of the novel, coloring thereby the whole of poetry, whereas in the end, very much at variance with this, he had to isolate them both as much as possible (placing them beneath the genre, not elevating them above it) in order once again to establish a conventional concept of poetry. The higher significance of the prosaic modes of poetry did not stay with him.

302. *Lyceum Fragments,* no. 86.

303. *Athenaeum Fragments,* no. 427. On the term *recherche* in the sense of "critique" (perhaps it has a further significance in this passage), see *Athenaeum* fragment 403, cited above.

304. *Jugendschriften,* vol. 2, p. 383.

305. To which A. W. Schlegel, under external pressure, did indeed stoop.

306. *Jugendschriften,* vol. 2, p. 172.

307. The concluding section of Benjamin's dissertation was not submitted to the faculty; it was intended as an "esoteric afterword" for his friends, and for the further development of his own thoughts.—*Trans.*

308. No evidence can be offered within this narrow framework for the exposition of the Goethean theory of art laid out below; the relevant passages would require as detailed an interpretation as the propositions of the early Romantics do. This will be pursued elsewhere in the widened context it demands. As for the way in which the question is posed in the following discussion, see especially the corresponding treatment in E. Rotten, *Goethes Urphänomen und die platonische Idee* [Goethe's Primal Phenomenon and the Platonic Idea], ch. 8— which, however, answers the question differently.

309. A form which, for its part, becomes intelligible only within this view of art and belongs to it as the fragment to the Romantic view.

310. *Jugendschriften,* vol. 1, pp. 123ff. See also *Briefwechsel,* p. 83. Here, too, with the concept of imitation, Schlegel overtaxes his original thought.

311. *Jugendschriften,* vol. 1, p. 104. On "free art of ideas," also *Jugendschriften,* vol. 2, p. 361.

312. That is, of poetry.

313. *Jugendschriften,* vol. 2, p. 427.

314. *Jugendschriften,* vol. 2, p. 428.

315. Regarding the contingent character of individual works, their status as torso, the precepts and techniques of poetics were available. It was partly in consideration of these that Goethe had studied the laws of artistic genres. The

Romantics, too, looked into them, not in order to define the genres of art but with a view to finding the medium, the absolute, in which works were to be critically dissolved. They conceived these investigations as analogous to morphological studies, which were designed to elicit the relations of the creature to life, whereas the propositions of normative poetics were comparable to anatomical studies having as their object not so directly life itself, as the fixed structure of individual organisms. Research into the genres of art, insofar as the Romantics are concerned, refers only to art, whereas in Goethe's case it extends beyond this to normative, pedagogic tendencies concerning the individual work and its composition.

316. See above, Part One, Section IV.
317. *Schriften,* pp. 69ff.
318. *Schriften,* p. 563.
319. *Schriften,* p. 491.
320. *Athenaeum Fragments,* no. 121.
321. *Lyceum Fragments,* no. 60.
322. *Athenaeum Fragments,* no. 143.
323. There is, of course, an equivocation here in the meaning of the term "pure." In the first place, it designates the methodological dignity of a concept (as in "pure reason"), but it can also have a substantively positive and, so to speak, morally tinged significance. Both of these meanings figure above in the concept of "pure content," as exemplified in the Muses, whereas the absolute form is to be conceived as "pure" only in the methodological sense. For its concrete determination—which corresponds to the purity of the content—is presumably rigor. And this the Romantics have not brought out in their theory of the novel, in which the entirely pure—but not rigorous—form was raised to the absolute. Here, too, is a sphere of thought in which Hölderlin surpassed them.
324. *Schriften,* p. 491.

Fate and Character

Fate and character are commonly regarded as causally connected, character being the cause of fate. The idea underlying this is the following: if, on the one hand, the character of a person, the way in which he reacts, were known in all its details, and if, on the other, all the events in the areas entered by that character were known, both what would happen to him and what he would accomplish could be exactly predicted. That is, his fate would be known. Contemporary ideas do not permit immediate logical access to the idea of fate, and therefore modern men accept the idea of reading character from, for example, the physical features of a person, finding knowledge of character as such somehow generally present within themselves, whereas the notion of analogously reading a person's fate from the lines in his hand seems unacceptable. This appears as impossible as "predicting the future"; for under this category the foretelling of fate is unceremoniously subsumed, while character appears as something existing in the present and the past and therefore as perceptible. It is, however, precisely the contention of those who profess to predict men's fate from no matter what signs, that for those able to perceive it (who find an immediate knowledge of fate as such in themselves) it is in some way present or—to put this more cautiously— accessible. The supposition that some "accessibility" of future fate contradicts neither that concept itself nor the human powers of perception predicting it is not, as can be shown, nonsensical. Like character, fate, too, can be apprehended only through signs, not in itself. For even if this or that character trait, this or that link of fate, is directly in view, these concepts nevertheless signify a relationship—one that is never accessible except through signs, because it is situated above the immediately visible level. The

system of characterological signs is generally confined to the body, if we disregard the characterological significance of those signs investigated by the horoscope, whereas in the traditional view all the phenomena of external life, in addition to bodily ones, can become signs of fate. However, the connection between the sign and the signified constitutes in both spheres an equally hermetic and difficult problem (though different in other respects), because despite all the superficial observation and false hypostatizing of the signs, they do not in either system signify character or fate on the basis of causal connections. A nexus of meaning can never be founded causally, even though in the present case the existence of the signs may have been produced causally by fate and character. The inquiry that follows is not concerned with what such a system of signs for character and fate is like, but merely with what it signifies.

It emerges not only that the traditional conception of the nature and the relationship of character and fate remains problematic, insofar as it is incapable of making the possibility of a prediction of fate rationally comprehensible, but that it is false, because the distinction on which it rests is theoretically untenable. For it is impossible to form an uncontradictory concept of the exterior of an active human being whose core is taken to be character. No definition of the external world can disregard the limits set by the concept of the active man. Between the active man and the external world, all is interaction; their spheres of action interpenetrate. No matter how different their conceptions may be, their concepts are inseparable. Not only is it impossible to determine in a single case what finally is to be considered a function of character and what a function of fate in a human life (this would make no difference here if the two merged only in experience); the external world that the active man encounters can also in principle be reduced, to any desired degree, to his inner world, and his inner world similarly to his outer world, indeed regarded in principle as one and the same thing. Considered in this way character and fate, far from being theoretically distinct, coincide. Such is the case when Nietzsche says, "If a man has character, he has an experience [*Erlebnis*] that constantly recurs." This means: if a man has character, his fate is essentially constant. Admittedly, it also means: he has no fate—a conclusion drawn by the Stoics.

If a concept of fate is to be attained, therefore, it must be clearly distinguished from that of character, which in turn cannot be achieved until the latter has been more exactly defined. On the basis of this definition, the two concepts will become wholly divergent; where there is character there will, with certainty, not be fate, and in the area of fate character will not be found. In addition care must be taken to assign both concepts to spheres in which they do not, as happens in common speech, usurp the rank of higher spheres and concepts. For character is usually placed in an ethical context and fate in a religious context. We must banish them from both regions by

revealing the error by which they were placed there. This error arises, as regards the concept of fate, through association with that of guilt. Thus, to mention a typical case, fate-imposed misfortune is seen as the response of God or the gods to a religious offense. Doubts concerning this are aroused, however, by the absence of any corresponding relation of the concept of fate to the concept that necessarily accompanies that of guilt in the ethical sphere, namely that of innocence. In the Greek classical development of the idea of fate, the happiness granted to a man is understood not at all as confirmation of an innocent conduct of life but as a temptation to the most grievous offense, hubris. There is, therefore, no relation of fate to innocence. And—this question strikes even deeper—has fate any reference to good fortune, to happiness? Is happiness, as misfortune doubtless is, an intrinsic category of fate? Happiness is, rather, what releases the fortunate man from the embroilment of the Fates and from the net of his own fate. Not for nothing does Hölderlin call the blissful gods "fateless." Happiness and bliss are therefore no more part of the sphere of fate than is innocence. But an order whose sole intrinsic concepts are misfortune and guilt, and within which there is no conceivable path of liberation (for insofar as something is fate, it is misfortune and guilt)—such an order cannot be religious, no matter how the misunderstood concept of guilt appears to suggest the contrary. Another sphere must therefore be sought in which misfortune and guilt alone carry weight, a balance on which bliss and innocence are found too light and float upward. This balance is the scale of law. The laws of fate—misfortune and guilt—are elevated by law to measures of the person; it would be false to assume that only guilt is present in a legal context; it is demonstrable that all legal guilt is nothing other than misfortune. Mistakenly, through confusing itself with the realm of justice, the order of law—which is merely a residue of the demonic stage of human existence, when legal statutes determined not only men's relationships but also their relation to the gods—has preserved itself long past the time of the victory over the demons. It was not in law but in tragedy that the head of genius lifted itself for the first time from the mist of guilt, for in tragedy demonic fate is breached. But not by having the endless pagan chain of guilt and atonement superseded by the purity of the man who has expiated his sins, who is reconciled with the pure god. Rather, in tragedy pagan man becomes aware that he is better than his god, but the realization robs him of speech, remains unspoken. Without declaring itself, it seeks secretly to gather its forces. Guilt and atonement it does not measure justly in the balance, but mixes indiscriminately. There is no question of the "moral world order" being restored; instead, the moral hero, still dumb, not yet of age—as such he is called a hero—wishes to raise himself by shaking that tormented world. The paradox of the birth of genius in moral speechlessness, moral infantility, is the sublimity of tragedy. It is probably the basis of all sublimity, in which genius,

rather than God, appears.—Fate shows itself, therefore, in the view of life, as condemned, as having essentially first been condemned and then become guilty. Goethe summarizes both phases in the words "the poor man you let become guilty." Law condemns not to punishment but to guilt. Fate is the guilt context of the living. It corresponds to the natural condition of the living—that semblance [*Schein*], not yet wholly dispelled, from which man is so far removed that, under its rule, he was never wholly immersed in it but only invisible in his best part. It is not therefore really man who has a fate; rather, the subject of fate is indeterminable. The judge can perceive fate wherever he pleases; with every judgment he must blindly dictate fate. It is never man but only the life in him that it strikes—the part involved in natural guilt and misfortune by virtue of semblance. In the manner of fate, this life can be coupled to cards as to planets, and the clairvoyante makes use of the simple technique of placing it in the context of guilt by means of the first calculable, definite things that come to hand (things unchastely pregnant with certainty). Thereby she discovers in signs something about a natural life in man that she seeks to substitute for the head of genius mentioned earlier; as, on his side, the man who visits her gives way to the guilty life within himself. The guilt context is temporal in a totally inauthentic way, very different in its kind and measure from the time of redemption, or of music, or of truth. The complete elucidation of these matters depends on determining the particular nature of time in fate. The fortune-teller who uses cards and the seer who reads palms teach us at least that this time can at every moment be made simultaneous with another (not present). It is not an autonomous time, but is parasitically dependent on the time of a higher, less natural life. It has no present, for fateful moments exist only in bad novels, and it knows past and future only in curious variations.

There is therefore a concept of fate—and it is the genuine concept, the only one that embraces equally fate in tragedy and the intentions of the fortuneteller, that is completely independent of the concept of character, having its foundation in an entirely different sphere. The concept of character must be developed to a similar level. It is no accident that both orders are connected with interpretive practices and that in chiromancy character and fate coincide authentically. Both concern the natural man—or, better, the nature of man, the very being that makes its appearance in signs that either occur spontaneously or are experimentally produced. The foundation of the concept of character will therefore need likewise to be related to a natural sphere and to have no more to do with ethics or morality than fate has with religion. On the other hand, the concept of character will have to be divested of those features that constitute its erroneous connection to that of fate. This connection is effected by the idea of a network that knowledge can tighten at will into a dense fabric, for this is how character appears to superficial observation. Along with the broad underlying traits, the trained

eye of the connoisseur of men is supposed to perceive finer and closer connections, until what looked like a net is tightened into cloth. In the threads of this weft a weak understanding believes it possesses the moral nature of the character concerned and can distinguish its good and bad qualities. But, as moral philosophy is obliged to demonstrate, only actions and never qualities can be of moral importance. Appearances are admittedly to the contrary. Not only do terms such as "thievish," "extravagant," "courageous" seem to imply moral valuations (even leaving aside the apparent moral coloration of the concepts), but, above all, words like "self-sacrificing," "malicious," "vengeful," "envious" seem to indicate character traits that cannot be abstracted from moral valuation. Nevertheless, such abstraction is in all cases not only possible but necessary for grasping the meaning of the concept. This abstraction must be such that valuation itself is fully preserved; only its moral accent is withdrawn, to give way to such conditional evaluations, in either a positive or a negative sense, as are expressed by the morally indifferent descriptions of qualities of the intellect (such as "clever" or "stupid").

Comedy shows the true sphere to which these pseudo-moral character descriptions are to be consigned. At its center, as the main protagonist in a comedy of character, stands often enough an individual whom, if we were confronted by his actions in life instead of by his person on the stage, we would call a scoundrel. On the comic stage, however, his actions take on only the interest shed with the light of character, and the latter is, in classical examples, the subject not of moral condemnation but of high amusement. It is never in themselves, never morally, that the actions of the comic hero affect his public; his deeds are interesting only insofar as they reflect the light of character. Moreover, one notes that a great comic playwright—for example, Molière—does not seek to define his creations by the multiplicity of their character traits. On the contrary, he excludes psychological analysis from his work. It has nothing to do with the concerns of psychology if, in *L'Avare* and *Le malade imaginaire,* miserliness and hypochondria are hypostatized as the foundation of all action. About hypochondria and miserliness these dramas teach nothing; far from making these traits comprehensible, they depict them with an intensifying crassness. If the object of psychology is the inner life of man understood empirically, Molière's characters are of no use to it even as means of demonstration. Character develops in them like a sun, in the brilliance of its single trait, which allows no other to remain visible in its proximity. The sublimity of character comedy rests on this anonymity of man and his morality, alongside the utmost development of individuality through its exclusive character trait. While fate brings to light the immense complexity of the guilty person, the complications and bonds of his guilt, character gives this mystical enslavement of the person to the guilt context the answer of genius. Complication becomes simplicity,

fate freedom. For the character of the comic figure is not the scarecrow of the determinist; it is the beacon in whose beams the freedom of his actions becomes visible.—To the dogma of the natural guilt of human life, of original guilt, the irredeemable nature of which constitutes the doctrine, and its occasional redemption the cult, of paganism, genius opposes a vision of the natural innocence of man. For its part, this vision remains in the realm of nature, yet its essence is still close to moral insights—just as the opposed idea does in the form of tragedy, which is not its only form. The vision of character, on the other hand, is liberating in all its forms: it is linked to freedom, as cannot be shown here, by way of its affinity to logic.—The character trait is not therefore the knot in the net. It is the sun of individuality in the colorless (anonymous) sky of man, which casts the shadow of the comic action. (This places Cohen's profound dictum that every tragic action, however sublimely it strides upon its cothurnus, casts a comic shadow, in its most appropriate context.)[1]

Physiognomic signs, like other mantic symbols, served the ancients primarily as means for exploring fate, in accordance with the dominance of the pagan belief in guilt. The study of physiognomy, like comedy, was a manifestation of the new age of genius. Modern physiognomics reveals its connection with the old art of divination in the unfruitful, morally evaluative accent of its concepts, as well as in the striving for analytic complexity. In precisely this respect the ancient and medieval physiognomists saw things more clearly, recognizing that character can be grasped only through a small number of morally indifferent basic concepts, such as those that the doctrine of temperaments tried to identify.

Written in 1919; published in *Die Argonauten,* 1921. Translated by Edmund Jephcott.

Notes

1. Hermann Cohen (1842–1918) combined important work in philosophy (he was the cofounder of the Marburg school of Neo-Kantianism) and Jewish theology. Benjamin drew widely on both branches of Cohen's thought.—*Trans.*

Analogy and Relationship

Preliminary remark: The lack of clarity in the following observations is partly explained by the fact that the concept of similarity, which surely belongs with the concepts of analogy and relationship, has been omitted from the discussion, or rather has not been distinguished from analogy. It is not synonymous with analogy. Analogy is presumably a metaphorical similarity—that is to say, a similarity of relations—whereas only substances can be similar in a real (nonmetaphorical) sense. The similarity of two triangles, for example, would have to show the similarity of some "substance" within them whose manifestation would then be the identity [*Gleichheit*] (not similarity!) of certain relations they had in common. Relationship cannot be adequately inferred from either analogy or similarity. Though in certain cases similarity may proclaim relationship, analogy can never do this.

Analogy never provides a sufficient reason for relationship. Thus, children are not related to their parents *through* their similarities (here there is a failure to distinguish between analogy and similarity!), nor are they related to them *in* their similarities. Instead the relationship refers undivided to the whole being, without the need for any particular expression of it. (Expressionlessness of relationships.) Nor does a causal nexus form the basis of a relationship any more than of an analogy. A mother is related to her child because she has given birth to it—but that is no causal connection. The father is related to the child because he has begotten it, but certainly not by virtue of that aspect of the act of begetting which is, or seems to be, the cause of birth. That is to say, what has been begotten (the son) is determined by the begetter (the father) in a manner different from the way an effect is determined by its cause—not by causality, but by relationship. The nature of a relationship is enigmatic. It is whatever is common to married couples

and parents and children (freely chosen relationships and blood relation-
ships); it is also what is shared in the relationship of the father and mother
to the child.

One needs a peculiarly dispassionate and steady gaze to consider relation-
ship. The more fleeting glance can easily be misled by analogy. Gustav
Theodor Fechner was an observer of analogy;[1] Nietzsche was a discoverer
of relationships (as his aphorism "Appearances are against the historian"
in *Daybreak* [Morgenröte] demonstrates). Analogy is a scientific, rational
principle. However valuable it may be, it cannot be examined too soberly.
We can succeed in fathoming the principle and in finding the common
factor in a particular analogy (its subject will presumably be a relationship).
Feeling should not allow itself to be guided by analogy because feelings are
unable to influence it. In the realm of feeling, analogy is no principle at all;
the illusion that it is arises if the rational nature of analogy is not taken
seriously enough. A ship's rudder and a tail are analogous: for a bad poet,
this fact is merely subject matter, but for a reflective person (say, an engineer)
it is a topic for investigation. Father and son are related: that is a relation-
ship which is not constituted by reason, even if it can be comprehended
rationally.

The conflation of analogy and relationship is an utter perversion. It occurs
either when analogy is regarded as the principle determining a relationship,
or when relationship is taken for the principle governing an analogy. We
find the first type of confusion in people who imagine something while
listening to music—a landscape, event, a poem. They seek something (ra-
tionally) analogous to the music. Obviously there is no such thing, unless
we reduce it very crudely to a program. No doubt, music can be compre-
hended rationally, not indeed through analogy but by universal laws. It is
impossible to move from music to an analogue; music recognizes only
relationship. Pure feeling is related to music; this is knowable, and in it
music is, too. The Pythagoreans attempted to understand music by means
of numbers.—(A case of substituting similarity for relationship is the argu-
ment in natural law that takes as its starting point "everything that has
human features." In the human face, relationships have to be *sought*—such
appearances can never be made into the principle of a relationship without
being reduced to the object of an analogy. Relationships are not established
by similarity. Only where the latter shows itself superior to analogy—which
ultimately may be shown everywhere—can it indicate relationship, which
can be directly perceived only in feeling (neither in intuition, nor in reason),
but can be rigorously and modestly comprehended by reason. Relationships
between human beings are directly perceived by popular feeling.)

To regard relationship as a principle of analogy is a peculiar feature of a
modern view of authority and the family. This view expects to discover
analogies between related people, and regards alignment as a goal of edu-

cation to which authority should aspire. For its part, true authority is an immediate relationship based in feeling; it does not find its object in the analogies of behavior, choice of profession, or obedience, but can at best indicate itself through them.

The type of person who is defined by either of these confusions between relationship and analogy is the sentimentalist. In authentic relationship he seeks only the familiar, but he lets his feeling roam rudderless on the broad waves of analogy, and has no inkling of the seabed beneath. This is Wallenstein's reaction to Max's death, when he says, "The flower has vanished from my life." He mourns the flower, and does his utmost to express his feelings about it. But Wallenstein may feel only what is related to his suffering, not what would be analogous to it.[2]

Fragment written in 1919; unpublished in Benjamin's lifetime. Translated by Rodney Livingstone.

Notes

1. Gustav Theodor Fechner (1801–1887), physician, physicist, and early experimental psychologist. His *Elemente der Psychophysik* (Elements of psychophysics), published in 1860, is particularly concerned with parallels between events in the physical world and psychological processes.—*Trans.*
2. Friedrich Schiller, *Wallenstein's Death,* Act V, scene 3.—*Trans.*

The Paradox of the Cretan

In its classical Greek form, the paradox of the Cretan is easily resolved. When Epimenides says, "All Cretans are liars," and is himself a Cretan, this by no means implies that his first assertion is untrue. The concept of the liar does not mean that a liar departs from the truth every time he opens his mouth, nor, even if he did so, that what he says would be the absolute contrary of the truth. At most it remains at the level of a contradiction. Therefore, we may not draw from the two premises the inference that all Cretans tell the truth, from which we might further deduce that Epimenides' first assertion too was true, thus reinstating the first premise and leading to a vicious circle.

On the other hand, the ancient fallacy allows us to explore a truly seminal problem. To elaborate on this we have to set aside the aforementioned considerations and instead argue as follows: Epimenides maintains that all Cretans, whenever they open their mouths, assert the contrary of what is true. Epimenides is a Cretan. These premises would indeed lead to the chain of contradictions happily avoided above. But at the same time it becomes clear that the syllogistic form does not fit the original problem. On the contrary, the whole dilemma should be explained as a straightforward deduction from a proposition. And that proposition, reduced to its simplest form, would have to read: "Every one of my assertions without exception implies the contrary of the truth." This would indeed entail the consequence: "Including this one." "Therefore, every one of my assertions without exception accords with the truth." "Including, therefore, the first assertion above." And with this we return to our starting point and the vicious circle must begin once again.

This "fallacy" is insoluble within logic itself.

There are three points to be made about this in the first instance. (1) This assertion, arising from a source of insolubly contradictory inferences, may well be the only one of its kind. (2) It forms its insoluble chain of contradictions in the realm of logic, without being in any way meaningless or nonsensical in itself—that is to say, on the ontological plane. On the contrary, you have only to imagine the Cartesian demon of deception transposed from the sphere of perception to that of logic to realize that it could not carry out its deception better than by making this paradox its own. This suggests that the proposition is not *absolutely* nonsensical. (3) In any case it is evident that this proposition leads to contradictions only if it is uttered by the person to whom it applies, whereas it can be asserted of any other person that every one of his statements means the contrary of what they claim to mean, without this leading to contradiction.

In summary, we may say that the Cretan's statement *appears* to be logically unimpeachable, so long as there is no logical court of appeals that would annul its rightness and the correctness of the inferences to be drawn from it. For the law of contradiction to operate, the statement would have to be contradictory in *every* sense. But as we have shown above under (2), this is not the case. Yet the need to refute the statement nevertheless remains urgent. On both the logical and the ontological planes. But whereas ontologically it can become a topic of discussion only where its subject can be assigned a privileged ontological place, as is the case with Descartes' demon, a logical refutation must be called for in all circumstances because of the contradictions to which the Cretan's assertion gives rise.

The logical unassailability of the Cretan's assertion—since once it has been asserted, its implications are fixed—must prove to be mere appearance [*Schein*], for otherwise logic as such would collapse. Moreover, this appearance must be an authentic—that is, objective—appearance. In other words, it is not, as the modern view of appearance would suggest, an appearance that arises from the accidental or necessary failure of knowledge to correspond to the truth, but rather an appearance that cannot be resolved in the truth—it can only be destroyed by it. In short, it is appearance based on an autonomous principle of appearance, a principle of deception; or better, of lying. This appearance is, as the Cretan paradox proves, of such powerful metaphysical intensity that its roots can penetrate the very depths of formal logic. Objectively, then, it exists not just as a counterweight to reality, but, since it is encountered in a realm that lies beyond that of reality—namely, the sphere of formal logic—it must be regarded as an objective counterweight to truth.

So how might it be dispelled? As we have shown, this cannot be achieved within logic, and so it may be possible only within metaphysics. Here the solution must be sought in the "I-form" of the proposition, which, as we

have seen, is crucial for it to function. Its appearance of logicality is constituted through its subjective form. Hence we see the need not only to conceive of subjectivity as an alogical authority in contradiction to objectivity and universal validity, but, more precisely, to view subjectivity as a principle contrary to objective validity, characterized by a tendency to undermine that validity. According to the metaphysical thesis designed to resolve that logical appearance, subjectivity is not alogical but antilogical. This statement must be given a metaphysical grounding.

See A. Rüstow, *Der Lügner* [The Liar, 1910].

Fragment written in 1919 or 1920; unpublished in Benjamin's lifetime. Translated by Rodney Livingstone.

The Currently Effective Messianic Elements

The currently effective messianic elements of the work of art manifest themselves as its content; the retarding elements, as its form. Content makes its way toward us. Form holds back, permits us to approach. The retarding (formal) elements of music probably dwell in the memory, where listening forms an accumulation. In any case, art of every kind and every work of art contain something that causes perception to accumulate, and this is the essence of the artwork's form.

Fragment written in 1919; unpublished in Benjamin's lifetime. Translated by Rodney Livingstone.

Angelus Novus, 1920–1926

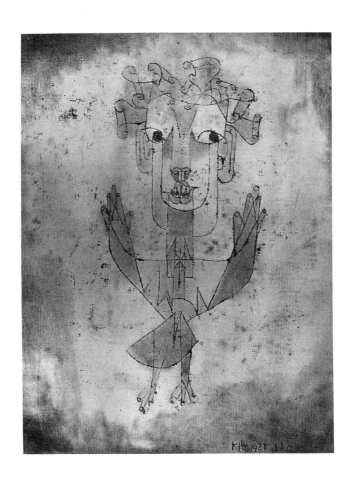

Paul Klee, *Angelus Novus*. Hand-colored ink drawing, 1920. Israel Museum, Jerusalem. Benjamin planned to title his journal *Angelus Novus* after this drawing, which he owned in the 1920s.

The Theory of Criticism

The unity of philosophy—its system—is, as an answer, of a higher order than the infinite number of finite questions that can be posed.[1] It is of a higher kind and a higher order than that to which the quintessence of all these questions can lay claim, because a *unity* of the answer cannot be obtained through any questioning. The unity of philosophy therefore belongs to a higher order than any single philosophical question or problem can claim.—If there were questions that nevertheless called for a unified answer, their relation to philosophy would be fundamentally different from that of philosophical problems generally. In responses to such problems, there is a constant tendency to ask further questions—a tendency that has led to superficial talk to the effect that philosophy is an infinite task. The yearning for a unity that cannot be arrived at by questions turns, in its disappointment, to the alternative that could be called a counterquestion. This counterquestion then pursues the lost unity of the question, or seeks a superior question, which would simultaneously be a search for a unified answer.—If such questions—questions that seek a unity—did exist, the answers to them would permit neither further questioning nor counterquestioning. But no such questions exist; the system of philosophy as such cannot be interrogated. And to this virtual question (which can be inferred only from the answer) there could obviously be only one answer: the system of philosophy itself. Nevertheless there are constructs that bear the deepest affinity to philosophy, or rather to the ideal form of its problem, without constituting philosophy themselves—even though they are not the answer to that hypothetical question, or hypothetical, or even the question. These constructs, which are thus actual, not virtual, and are neither questions nor

answers, are works of art. Works of art do not compete with philosophy as such. They do, however, enter into the profoundest relation with it through their affinity to the ideal of its problem. The ideal of the philosophical problem is an idea that can be called an ideal, because it refers not to the immanent form of the problem but to the transcendent content of its solution, even though only through the concept of the problem and thus through the concept that it possesses a unified answer to the problem. According to a lawfulness that is probably grounded in the essence of the ideal as such, the ideal of the philosophical problem can be represented only in a multiplicity (just as the ideal of pure content in art is to be found in the plurality of the Muses). Therefore, the unity of philosophy can in principle be explored only in a plurality or multiplicity of virtual [this word was subsequently crossed out—*Ed.*] questions. This multiplicity lies immured in the multiplicity of true works of art, and their promotion is the business of critique. What critique basically seeks to prove about a work of art is the virtual possibility of the formulation of its contents as a philosophical problem, and what makes it call a halt—in awe, as it were, of the work of art itself, but equally in awe of philosophy—is the actual formulation of the problem. For critique arrives at its formulation on the assumption (which is never made good) that interrogating the philosophical system as such is possible. In other words, critique asserts that, if the system were complete, it would turn out to have been interrogated during the investigation of one problem or another. Critique makes the ideal of the philosophical problem manifest itself in a work of art, or enter into one of its manifestations; if, however, critique wishes to speak of the work of art as such, it can say only that the artwork symbolizes this ideal. The multiplicity of works of art is harmonious, as the Romantics perceived, and, as the latter also suspected, this harmony does not stem from a vague principle peculiar to art and implicit in art alone. Rather, it arises from the fact that works of art are ways in which the ideal of the philosophical problem makes itself manifest.

When we assert that everything beautiful somehow relates to the true and that its virtual place in philosophy is determinable, this means that a manifestation of the ideal of the philosophical problem can be discovered in every work of art. And we should add that such a manifestation may be assigned to every philosophical problem as its aura [*Strahlenkreis*], so to speak. At every point the hypothetical approach to the unity to be interrogated is available, and the work of art in which it is contained is therefore related to certain authentic philosophical problems, even though it may be precisely distinguished from them.

Corresponding to this manifestation of the true as well as of the individual truth in the individual work of art is a further manifestation of the beautiful in the true. This is the manifestation of the coherent, harmonious totality

of the beautiful in the unity of the true. Plato's *Symposium,* at its climax, deals with this topic. Its message is that beauty achieves this virtual manifestation only within the truth as a whole.

What remains to be investigated is the common ground for these two relations between art and philosophy.

(The true: unity.

The beautiful: multiplicity assembled into a totality.)

(Perhaps there is a virtual relation between other realms, too. Can't morality appear virtually in freedom?)

Comparison: Suppose you make the acquaintance of a young person who is handsome and attractive, but who seems to be harboring a secret. It would be tactless and reprehensible to try to penetrate this secret and wrest it from him. But it is doubtless permissible to inquire whether he has any siblings, to see whether their nature could not perhaps explain somewhat the enigmatic character of the stranger. This is exactly how the true critic inquires into the siblings of the work of art. And every great work has its sibling (brother or sister?) in the realm of philosophy.

Just as philosophy makes use of symbolic concepts to draw ethics and language into the realm of theory, in the same way it is possible for theory (logic) to be incorporated into ethics and language in symbolic form. We then see the emergence of ethical and aesthetic critique.

Fragment written in 1919–1920; unpublished in Benjamin's lifetime. Translated by Rodney Livingstone.

Notes

1. Benjamin uses the term "criticism" (*Kunstkritik:* literally "art criticism") as the general designation for all criticism of literature, art, music, etc. In this text, as well as in *The Concept of Criticism in German Romanticism* and "Goethe's Elective Affinities," the term "critique" (*Kritik*) usually designates a specific, philosophically informed aspect of criticism.—*Trans.*

Categories of Aesthetics

The concept of creation does not enter the philosophy of art as a causal term. For "creation" defines the quality of cause in only a single respect, namely what "has been created." Now, the work of art has not been "created." It has "sprung" from something; those without understanding may wish to call it something that has "arisen" or "become"; but it is not a "created" thing under any circumstances. For a created object is defined by the fact that its life—which is higher than that of what has "sprung" from something—has a share in the intention of redemption. An utterly unrestricted share. Nature (the theater of history) still possesses such a share, to say nothing of humanity, but the work of art does not.—For this reason the relation between creation and the work of art cannot be described in terms of cause and effect. Nevertheless, it is by no means unusual for creation to have a connection with the great work of art. Namely as its content. Creation is one of the most powerful themes of art. One could name an entire class of forms, a type of form, which deals with "creation," in which the theme of creation becomes visible once it has undergone the

mutations of intuition. Perhaps these works will be distinguished by the high degree of the expressionless [*das Ausdruckslose*] in them; perhaps, however, creation can become manifest even in the most insignificant and colorful works. The form of works whose theme is "creation" can be described as a "punched-out" form. These are forms that seem to contain as much shadow and chaos as the hollow punched-out or hammered-out inner side of metal relief-work. Such forms, however, are not creation; they are not even "created." They merely depict creation, or rather they depict their content—which is their authentic nature—in the noble and sublime state of creation. Perhaps all forms have something of the punched-out form, insofar as all works of art have creation as their content in some sense.

Works of art, and with them their forms, are not created. This fact leaves its stamp on both the works and their forms. Mörike's profound line, "But whatever is beautiful is (!) blissful in itself," establishes a connection between semblance [*Schein*] and beauty, admittedly only the beauty of art.[1] Beauty in art is indeed tied to semblance. It is tied to the semblance of totality and perfection, and for that reason is tied by means of semblance. The higher the type of beauty, the higher the type of perfection and totality it appears to carry along with itself. On the lowest plane, it is the totality and perfection of sensuous reality; and on the highest plane, those of bliss. Nevertheless, certain limits are placed on these categories. Never can the beauty of art appear sacred. *Beauty without semblance ceases to be essentially beautiful, but is something greater. By the same token a beauty whose appearance ceases to tie itself to totality and perfection, and which remains free by intensifying its beauty, is no longer artistic beauty but demonic beauty. The seductive nature of beauty is based on the shamelessness, the nakedness, of the semblance that arms it ("Temptation of Saint Anthony").*

Form is the law according to which the beautiful ties itself to perfection and totality. All form is mysterious and enigmatic because it arises from the unfathomability of beauty, where it is bound to semblance. This is why Goethe observes, "Beauty can never obtain clarity about itself." Form arises in the realm of unfathomability, but a created object is created out of nothing.

Created being and configuration—artifact and form: these are related to each other as what has been created is related to what has sprung into being. Without a creator, there is no eidetic creation or created being; artifacts and forms, however, exist eidetically even without an artist.

What is decisive, however, is that the act of creation is directed at the perpetuation of creation, the perpetuation of the world. From the outset, the origin of the work is directed at its perceptibility. This is implicit in the original tendency of semblance. The life of creation remains veiled in obscurity, in the shadow of the creator, until he detaches himself from it. The creator's act of detachment is a moral act. It constitutes the sphere of

perception in an unbroken, linear intention from the act of creation, which is good and, by virtue only of being seen as "good," can constitute "seeing."

[The following paragraph has been crossed out.—*Ed.*]

The intention of beauty, however, does not break the resistance of intuition so utterly as to enter into the sphere of perception as a configuration of beauty. Instead the work subordinates itself to the necessity of its purity and rigor.

The nature of creation is paradigmatic for the moral determination of utopian perception. To the degree that a work breaks through the realm of art and becomes utopian perception, it is creation—meaning that it is subject to moral categories in relation not just to human beings in the act of conception, but to man's existence in the sphere of perception. The moral nature of creation gives the work the stamp of the expressionless. With reference to the beginnings of Genesis, it is important to reveal the order according to which creation can be perceived only morally.

Fragment written in 1919–1920; unpublished in Benjamin's lifetime. Translated by Rodney Livingstone.

Notes

1. Eduard Mörike (1804–1875), post-Romantic author of prose fiction and poetry.—*Trans.*

On Semblance

"Not everything is possible, but the semblance of everything is."
—Hebbel

Semblance [*Schein*] that must be explained (for example, error):[1]

that must be eschewed (for example, Sirens);

that should be ignored (for example, will-o'-the-wisps).

Another classification of semblance:

Semblance behind which something is concealed (for example, the seductive: the Lady World of medieval legend whose back is devoured by worms, while from the front she looks beautiful).

Semblance behind which nothing lies concealed (for example, a fata morgana or chimera?).

Connection between semblance and the world of the visual.—An eidetic experiment: A man is crossing the street when out of the clouds a coach with four horses appears, coming toward him. During another walk he hears a voice from the clouds, saying, "You have left your cigarette case at home." In our analysis of the two events, if we set aside the possibility of hallucination—that is, the possibility that this semblance has a subjective cause—we find, in the first case, it is conceivable that nothing lies behind the manifestation, but in the second case this is inconceivable. The semblance in which nothing appears is the more potent one, the authentic one. This is conceivable only in the visual realm.

Does the intentional object that appears as semblance, as the consequence of a subjective cause (such as hallucinations), have the authentic character of semblance?—And if so, is this the same as a purely objective semblance?

"On our way there, we perceived at the end of the rue des Chanoines, as if framed by a camera obscura, the twin towers of the old Saint-Étienne (l'Abbaye-aux-Hommes) veiled in a mist which made them more beautiful; for veils embellish all they conceal and all they reveal: women, horizons, and monuments!"—Barbey D'Aurevilly, *Memoranda*.

Nietzsche's definition of semblance in *The Birth of Tragedy*.

In every work and every genre of art, the beautiful semblance is present; everything beautiful in art can be ascribed to the realm of beautiful semblance. [Last sentence crossed out.—*Ed*.] This beautiful semblance should be clearly distinguished from other kinds of semblance. Not only is it to be found in art, but all true beauty *in art* must be assigned to it. Furthermore, both inside and outside art, only the beautiful shall be assigned to it; and nothing ugly, whether in art or elsewhere, belongs, even if it is semblance, to the realm of beautiful semblance. There are different degrees of beautiful semblance, a scale that is determined not by the greater or lesser degree of beauty but by the extent to which a thing has more or less the character of semblance. The law governing this scale is not just fundamental for the theory of beautiful semblance, but essential for metaphysics in general. It asserts that in an artifact of beautiful semblance, the semblance is all the greater the more alive it seems. This makes it possible to define the nature and limits of art, as well as to establish a hierarchy of its modes from the point of view of semblance.

No work of art may appear completely alive without becoming mere semblance, and ceasing to be a work of art. The life quivering in it must appear petrified and as if spellbound in a single moment. The life quivering within it is beauty, the harmony that flows through chaos and—that only appears to tremble. What arrests this semblance, what holds life spellbound and disrupts the harmony, is the expressionless [*das Ausdruckslose*]. That quivering is what constitutes the beauty of the work; the paralysis is what defines its truth. For just as an interruption can, by a word of command, extract the truth from the speech of a liar, in the same way the expressionless compels the trembling harmony to stop and immortalizes that quivering through its objection [*Einspruch*]. In this immortalization the beautiful must vindicate itself, but it now seems to be interrupted in its vindication. The expressionless is the critical violence which, while unable to separate semblance from truth in art, prevents them from mingling. But it possesses this violence as a moral dictum. In the expressionless, the sublime violence of the true appears as it determines the symbolism of the existing universe according to the laws of the moral universe. Quivering life is never symbolic, because it lacks form; but the beautiful is even less so, because it is semblance. But that which has been spellbound, that which is petrified and mortified, is undoubtedly in a position to indicate the symbolic. It achieves this thanks to the power of the expressionless.—For the expressionless

destroys whatever legacy of chaos still survives in the beautiful semblance: the false, the mendacious, the aberrant—in short, the absolute. It is this that completes the work by shattering it into fragments, reducing it to the *smallest* totality of semblance, a totality that is a great fragment taken from the true world, the fragment of a symbol.

Fragment written in 1919–1920; unpublished in Benjamin's lifetime. Translated by Rodney Livingstone.

Notes

1. Throughout this fragment, and throughout his essay "Goethe's Elective Affinities" (to which it is intimately related), Benjamin plays on the words *Schein* (mere semblance, but also the glimmer of the numinous in the Romantic symbol) and *erscheinen* (to appear).—*Trans.*

World and Time

1. World and time.

In the revelation of the divine, the world—the theater of history—is subjected to a great process of decomposition, while time—the life of him who represents it—is subjected to a great process of fulfillment. The end of the world: the destruction and liberation of a (dramatic) representation. Redemption of history from the one who represents it. / But perhaps in this sense the profoundest antithesis to "world" is not "time" but "the world to come."

2. Catholicism—the process of the development of anarchy.

The problem of Catholicism is that of the (false, secular) theocracy. The guiding principle here is: authentic divine power can manifest itself *other than destructively* only in the world to come (the world of fulfillment). But where divine power enters into the secular world, it breathes destruction. That is why in this world nothing constant and no organization can be based on divine power, let alone domination as its supreme principle. (Compare also the notes on the critique of theocracy.)

3a. My definition of politics: the fulfillment of an unimproved humanity.

b. We would be wrong to speak of a profane legislation decreed by religion, as opposed to one required by it. The Mosaic laws, probably without exception, form no part of such legislation. Instead they belong to the legislation governing the realm of the body in the broadest sense (presumably) and occupy a very special place: they determine the location and method of *direct* divine intervention. And just where this location has its frontier, where it retreats, we find the zone of politics, of the profane, of a bodily realm that is without law in a religious sense.

c. The meaning of anarchy for the realm of the profane must be defined from the locus of freedom in the philosophy of history. (A difficult matter to prove: this is where we find the basic question of the relation of individuality to the body.)

4. In its present state, the social is a manifestation of spectral and demonic powers, often, admittedly, in their greatest tension to God, their efforts to transcend themselves. The divine manifests itself in them only in revolutionary force. Only in the community, nowhere in "social organizations," does the divine manifest itself either with force or without. (In this world, divine power is higher than divine powerlessness; in the world to come, divine powerlessness is higher than divine power.) Such manifestations are to be sought not in the sphere of the social but in perception oriented toward revelation and, first and last, in language, sacred language above all.

5a. What is at issue here is not the "realization" of divine power. On the one hand, this process is the supreme reality; on the other, divine power contains its reality in itself. (Bad terminology!)

b. The question of "manifestation" is central.

c. "Religious" is nonsense. There is no essential distinction between religion and religious denomination, but the latter concept is narrow and in most contexts peripheral.

Fragment written in 1919–1920; unpublished in Benjamin's lifetime. Translated by Rodney Livingstone.

According to the Theory of Duns Scotus

According to the theory of Duns Scotus, references to certain *modi essendi* are founded on what these references mean. If that is so, then this naturally invites the question of how it is possible to separate out a more general and formal element of the signified and thereby of the *modus essendi* of the signifier, which might then function as the foundation of the signifier. And furthermore, how it might be possible, with regard to this question of foundation, to abstract from the total correlation between signifier and signified in such a manner as to avoid the vicious circle in which the signifier both points to and is based on the signified.—This problem must be solved by reflection on the realm of language. To the extent that the linguistic [*Sprachliches*] can be separated out and gleaned from signifieds, the latter should be regarded as the *modus essendi* of that knowledge and therewith as the foundation of the signifier. The realm of language extends as a critical medium between the realm of the signifier and the signified. We may say, therefore, that the signifier points to the signified and simultaneously is based on it, insofar as its material determination is concerned—not in an unlimited manner, however, but only with regard to the *modus essendi* that is determined by language.

Fragment written in 1920; unpublished in Benjamin's lifetime. Translated by Rodney Livingstone.

On Love and Related Matters

(A *European* Problem)

(On marriage, see pp. 68ff. in the other notebook.) This age is participating in one of the greatest revolutions ever to take place in the relations between the sexes. Only someone who is aware of this development is entitled to speak about sexuality and the erotic in our day. An essential precondition is the realization that centuries-old forms, and along with them an equally ancient knowledge about relations between the sexes, are ceasing to be valid. Nothing forms a greater obstacle to realizing this than the conviction that those relations are immutable at their deeper levels—the mistaken belief that only the more ephemeral forms of erotic fashion are subject to change and to history, because the deeper and supposedly unalterable ground beneath is the domain of the eternal laws of nature. But how can anyone sense the scope of these questions and not know that what history shows most powerfully are the revolutions in nature? It may well be that every pre-apocalyptic world contains a residue of immutable existence, but if so, this residue lies at an infinitely deeper stratum than is implied by the trite assertions of those accustomed to writing about the eternal war between the sexes. Even if this war does belong among the eternal verities, the forms it assumes certainly do not. But if it constantly flares up anew, and continues to do so, the cause lies in the unity of the erotic and the sexual in woman. A most unfortunate act of concealment contrives to make this unity appear natural, except when men are enabled by an incomparable act of creative love to recognize it as supernatural. Again and again this conflict flares up because of man's inability to perceive this, particularly when, as at the present time, yet again, the historical forms of such creativity have withered and died. Today European man is as incapable as ever of confronting that

unity in woman which induces a feeling of something close to horror in the more alert and the superior members of his sex, since even they remain blind to its exalted origins. Failing to perceive it to be supernatural and blindly imagining it to be natural, they flee from it. Oppressed by the blindness of men, the supernatural life of women atrophies and declines into the merely natural, and thereby into the unnatural. This alone explains the strange process of dissolution brought about in our day by the primitive instincts of men, as the result of which women can be understood only in terms of the simultaneous images of the whore and the untouchable beloved. This untouchable purity, however, is no more a part of the immediate spiritual definition of woman than is base desire; it, too, is profoundly instinctual and coerced. The great, authentic symbol for the permanence of earthly love has always been the single night of love before death. Only now it is not the night of love, as it was earlier, but the night of impotence and renunciation. This is the classic experience of love of the younger generation. And who knows for how many future generations it will remain the primary experience? Both, however, impotence and desire alike, represent a new, unprecedented path for the man who finds the old path blocked: to arrive at knowledge through possession of a woman. He now seeks the new path: to arrive at possession through his knowledge. But like recognizes like. So man tries to make himself similar to woman, indeed like her. And this is the starting point for the vast and, in a deeper sense, almost planned metamorphosis of masculine sexuality into feminine sexuality through the medium of the mind. Now it is Adam who picks the apple, but he is equal to Eve. The old serpent can vanish, and in the repurified Garden of Eden nothing remains but the question whether it is paradise or hell.

As we peer into the darkness of the transformations taking place in that great flowing stream of human physicality, our sight fails as we contemplate a future for which it has perhaps been determined that though no prophet shall pierce its veil, it may be won by the most patient man. Here flows the dark stream that for the most noble may prove to be their predestined grave. The only bridge that spans that stream is the spirit. Life will pass over it in a triumphal chariot, but perhaps only slaves will remain to be harnessed to it.

Fragment written in 1920; unpublished in Benjamin's lifetime. Translated by Rodney Livingstone.

The Right to Use Force

Journal for Religious Socialism, vol. 1, no. 4[1]

Re Section I

1. "The legal system tends to react to attempts to destroy it by resorting to coercion, whether it be coercively to preserve or to restore the right order."

This statement is correct in itself, but it is a mistake to explain it with reference to the internal tendency of the law to establish its authority. What is at issue here is a subordinate reality which the law addresses. What is at issue is the violent rhythm of impatience in which the law exists and has its temporal order, as opposed to the good (?) rhythm of expectation in which messianic events unfold.

2. "Only the state has the right to use force" (and every use of its force stands in need of a particular law).

If the state is conceived as the supreme organ of law, then the validity of (2) follows necessarily from (1). Moreover, it is irrelevant whether the supreme authority of the state derives from its own authority or from an authority outside itself. In other words, (2) holds good also for an earthly theocracy. A definition of the relation of the state to the legal system other than the two outlined in the preceding sentence is not conceivable.

Re Section II

Critical possibilities:[2,3]

A. To deny the right of the state and the individual to use force.

B. To recognize unconditionally the right of the state and the individual to use force.

C. To recognize the state's right to use force.

D. To recognize the individual's sole right to use force.

Re (A): This view is described by the author as ethical anarchism. His refutation of it cannot be sustained. (1) For the idea of a level of cultural development that has been attained "by force" and allegedly justifies the use of force is a *contradictio in adjecto*. (2) It is a very modern error springing from very mechanistic ways of thinking to argue that any cultural order can be built up from the satisfaction of minimal needs such as the securing of physical existence. We can perhaps establish the indices of cultural progress that could then become the goals of human aspirations. But these would certainly not be the minimal factors mentioned above. (3) It is quite wrong to assert that, in a constitutional state, the struggle for existence becomes a struggle for law. On the contrary, experience shows conclusively that the opposite is the case. And this is necessarily so, since the law's concern with justice is only apparent, whereas in truth the law is concerned with self-preservation. In particular, with defending its existence against its own guilt. In the last analysis, a normative *force always* comes down in favor of existing reality. (4) The conviction that, despite any objections the ethical philosopher may advance, coercion "influences the inner attitudes of human beings" is based on a crude *quaternio terminorum*,[4] inasmuch as "inner attitude" is confused with "ethical attitude." For otherwise this argument fails to prove anything about moral attitudes.—In contrast, so-called ethical anarchism is invalid for quite different reasons. See my essay "Life and Force."[5]

Re (B): This thesis, which the author advances in II under (2), is self-contradictory. The state is not a person like any other but the supreme legal authority, which, when it is given ethical recognition as in the statement above, excludes any absolute right of individuals to use force. The author, however, seems to accept that very belief, since, without renouncing the claims of the state, he acknowledges that individuals may have the right to use force.

Re (C): This statement can be defended in principle where the view prevails that the ethical order generally assumes the form of a legal system which then can be conceived of only as mediated by the state. The prevailing law at the time calls for the recognition of this statement, without implementing it. (In present circumstances its implementation is scarcely conceivable.)

Re (D): This is a thesis whose factual impossibility seems so obvious to the author that he does not realize it is a specific point of view whose logical possibility is not in doubt. Instead he dismisses it as an illogical one-sided application of the idea of ethical anarchism. Nevertheless, it must be defended where, on the one hand (in contrast to (A)), no contradiction in

principle can be discerned between force and morality, and, on the other hand (in contrast to (C)), a contradiction in principle is perceived between morality and the state (or the law). An exposition of this standpoint is one of the tasks of my moral philosophy, and in that connection the term "anarchism" may very well be used to describe a theory that denies a moral right not to force as such but to every human institution, community, or individuality that either claims a monopoly over it or in any way claims that right for itself from any point of view, even if only as a general principle, instead of respecting it in specific cases as a gift bestowed by a divine power, as *absolute power.*

Two comments on the editor's Afterword.

I. "Ethical anarchism" is actually fraught with contradictions as a political plan—that is, as a plan of action concerned with the emergence of a new world order. Nevertheless, the other arguments brought against it are themselves open to objection. (1) If it is asserted that "every nonadult" in fact has no other means of combating a violent attack, we may retort that frequently adults have no other recourse either (and anyway this has nothing to do with adulthood). Moreover, nothing is further from the mind of "ethical anarchism" than to propose a weapon against force. (2) There can be no objection to the "gesture" of nonviolence, even where it ends in martyrdom. In morality, above all in questions of moral action, Mignon's dictum, "So let me seem, until I become,"[6] has absolute validity. No appearance can better transfigure a person than this. (3) As to the prognoses about the political success of this strategy of nonviolence as well as of the permanent rule of force on earth, the greatest skepticism is not unjustified, particularly with regard to this last point—insofar as by "force" we are to understand "physical action."

On the other hand (invalid as "ethical anarchism" may be as a political program), a form of action along the lines it recommends can (as we have already suggested under (2)) elevate the morality of the individual or the community to the greatest heights in situations where they are suffering because God does not appear to have commanded them to offer violent resistance. When communities of Galician Jews let themselves be cut down in their synagogues without any attempt to defend themselves, this has nothing to do with "ethical anarchism" as a political program; instead the mere resolve "not to resist evil" emerges into the sacred light of day as a form of moral action.

II. It is both possible and necessary to reach a universally valid conclusion about the right to use force, because the truth about morality does not call a halt at the illusion of moral freedom.—However, if we set aside what we have already maintained and allow ourselves to indulge in *ad hominem* arguments, we can see that a subjective decision in favor of or against the use of force in the abstract cannot really be entertained, because a truly

subjective decision is probably conceivable only in the light of specific goals and wishes.

Fragment written in 1920; unpublished in Benjamin's lifetime. Translated by Rodney Livingstone.

Notes

1. Herbert Vorwerk, "Das Recht zur Gewaltanwendung" [The Right to Use Force], *Blätter für religiösen Sozialismus*, ed. Carl Mennicke (Berlin, 1920), vol. 1, no. 4.—*Trans.*
2. In these disjunctions the individual stands opposed not to the living community but to the state.
3. For the state, the options listed here hold good in its dealings with other states, as well as in those with its citizens.
4. A syllogism may have only three terms, but if one is used ambiguously, a fourth term is inadvertently created. This is the *quaternio terminorum,* or Fallacy of Four Terms.—*Trans.*
5. An essay from the early 1920s, now lost.—*Trans.*
6. See J. W. von Goethe, *Wilhelm Meister's Apprenticeship*. Mignon has dressed up as an angel for a theatrical performance; her statement expresses her premonitions of death.—*Trans.*

The Medium through Which Works of Art Continue to Influence Later Ages

The medium through which works of art continue to influence later ages is always different from the one in which they affect their own age. Moreover, in those later times its impact on older works constantly changes, too. Nevertheless, this medium is always relatively fainter than what influenced contemporaries at the time it was created. Kandinsky expresses this by saying that the permanent value of works of art appears more vividly to later generations, since they are less receptive toward their contemporary value. Yet the concept of "permanent value" is perhaps not the best expression of the relation. We ought instead to investigate which aspect of the work (quite apart from the question of value) really seems more evident to later generations than to contemporaries.

For the creative person, the medium surrounding his work is so dense that he may find himself unable to penetrate it directly in terms of the response that it requires from its public; he may be able to penetrate it only in an indirect manner. The composer might perhaps see his music, the painter hear his picture, or the poet feel the outline of his poem when he seeks to come as close to it as possible.

Fragment written in 1920; unpublished in Benjamin's lifetime. Translated by Rodney Livingstone.

Critique of Violence

The task of a critique of violence can be summarized as that of expounding its relation to law and justice.[1] For a cause, however effective, becomes violent, in the precise sense of the word, only when it enters into moral relations. The sphere of these relations is defined by the concepts of law and justice. With regard to the first of these, it is clear that the most elementary relationship within any legal system is that of ends to means, and, furthermore, that violence can first be sought only in the realm of means, not in the realm of ends. These observations provide a critique of violence with premises that are more numerous and more varied than they may perhaps appear. For if violence is a means, a criterion for criticizing it might seem immediately available. It imposes itself in the question whether violence, in a given case, is a means to a just or an unjust end. A critique of it would then be implied in a system of just ends. This, however, is not so. For what such a system, assuming it to be secure against all doubt, would contain is not a criterion for violence itself as a principle, but, rather, the criterion for cases of its use. The question would remain open whether violence, as a principle, could be a moral means even to just ends. To resolve this question a more exact criterion is needed, which would discriminate within the sphere of means themselves, without regard for the ends they serve.

The exclusion of this more precise critical approach is perhaps the predominant feature of a main current of legal philosophy: natural law. It perceives in the use of violent means to just ends no greater problem than a man sees in his "right" to move his body in the direction of a desired goal. According to this view (for which the terrorism in the French Revolution provided an ideological foundation), violence is a product of nature, as it

were a raw material, the use of which is in no way problematical unless force is misused for unjust ends. If, according to the natural-law theory of the state, people give up all their violence for the sake of the state, this is done on the assumption (which Spinoza, for example, poses explicitly in his *Tractatus Theologico-Politicus*) that the individual, before the conclusion of this rational contract, has *de jure* the right to use at will the violence that is *de facto* at his disposal. Perhaps these views have been recently rekindled by Darwin's biology, which, in a thoroughly dogmatic manner, regards violence as the only original means, besides natural selection, appropriate to all the vital ends of nature. Popular Darwinistic philosophy has often shown how short a step it is from this dogma of natural history to the still cruder one of legal philosophy, which holds that the violence that is, almost alone, appropriate to natural ends is thereby also legal.

This thesis of natural law, which regards violence as a natural datum, is diametrically opposed to that of positive law, which sees violence as a product of history. If natural law can judge all existing law only in criticizing its ends, then positive law can judge all evolving law only in criticizing its means. If justice is the criterion of ends, legality is that of means. Notwithstanding this antithesis, however, both schools meet in their common basic dogma: just ends can be attained by justified means, justified means used for just ends. Natural law attempts, by the justness of the ends, to "justify" the means, positive law to "guarantee" the justness of the ends through the justification of the means. This antinomy would prove insoluble if the common dogmatic assumption were false, if justified means on the one hand and just ends on the other were in irreconcilable conflict. No insight into this problem could be gained, however, until the circular argument had been broken, and mutually independent criteria both of just ends and of justified means were established.

The realm of ends, and therefore also the question of a criterion of justness, are excluded for the time being from this study. Instead, the central place is given to the question of the justification of certain means that constitute violence. Principles of natural law cannot decide this question, but can only lead to bottomless casuistry. For if positive law is blind to the absoluteness of ends, natural law is equally so to the contingency of means. On the other hand, the positive theory of law is acceptable as a hypothetical basis at the outset of this study, because it undertakes a fundamental distinction between kinds of violence independently of cases of their application. This distinction is between historically acknowledged, so-called sanctioned force and unsanctioned force. Although the following considerations proceed from this distinction, it cannot, of course, mean that given forms of violence are classified in terms of whether they are sanctioned or not. For in a critique of violence, a criterion for the latter in positive law can concern not its uses but only its evaluation. The question that concerns us is: What

light is thrown on the nature of violence by the fact that such a criterion or distinction can be applied to it at all? In other words, what is the meaning of this distinction? That this distinction supplied by positive law is meaningful, based on the nature of violence, and irreplaceable by any other distinction will soon enough be shown, but at the same time light will be shed on the sphere in which alone such a distinction can be made. To sum up: if the criterion established by positive law to assess the legality of violence can be analyzed with regard to its meaning, then the sphere of its application must be criticized with regard to its value. For this critique a standpoint outside positive legal philosophy but also outside natural law must be found. The extent to which it can be furnished only by a philosophico-historical view of law will emerge.

The meaning of the distinction between legitimate and illegitimate violence is not immediately obvious. The misunderstanding in natural law by which a distinction is drawn between violence used for just ends and violence used for unjust ends must be emphatically rejected. Rather, it has already been indicated that positive law demands of all violence a proof of its historical origin, which under certain conditions is declared legal, sanctioned. Since the acknowledgment of legal violence is most tangibly evident in a deliberate submission to its ends, a hypothetical distinction between kinds of violence must be based on the presence or absence of a general historical acknowledgment of its ends. Ends that lack such acknowledgment may be called natural ends; the other type may be called legal ends. The differing function of violence, depending on whether it serves natural or legal ends, can be most clearly traced against a background of specific legal conditions. For the sake of simplicity, the following discussion will relate to contemporary European conditions.

Characteristic of these, so far as the individual as legal subject is concerned, is the tendency to deny the natural ends of such individuals in all those cases in which such ends could, in a given situation, be usefully pursued by violence. This means: this legal system tries to erect, in all areas where individual ends could be usefully pursued by violence, legal ends that can be realized only by legal power. Indeed, the system strives to limit by legal ends even those areas in which natural ends are admitted in principle within wide boundaries, like that of education, as soon as these natural ends are pursued with an excessive measure of violence, as in the laws relating to the limits of educational authority to punish. It can be formulated as a general maxim of present-day European legislation that all the natural ends of individuals must collide with legal ends if pursued with a greater or lesser degree of violence. (The contradiction between this and the right to self-defense will be resolved in what follows.) From this maxim it follows that law sees violence in the hands of individuals as a danger undermining the legal system. As a danger nullifying legal ends and the legal executive?

Certainly not; for then what would be condemned would not be violence as such but only that which is directed to illegal ends. It will be argued that a system of legal ends cannot be maintained if natural ends are anywhere still pursued violently. In the first place, however, this is mere dogma. To counter it one might perhaps consider the surprising possibility that the law's interest in a monopoly of violence vis-à-vis individuals is explained not by the intention of preserving legal ends but, rather, by the intention of preserving the law itself; that violence, when not in the hands of the law, threatens it not by the ends that it may pursue but by its mere existence outside the law. The same may be more drastically suggested, for one reflects how often the figure of the "great" criminal, however repellent his ends may have been, has aroused the secret admiration of the public. This can result not from his deed but only from the violence to which it bears witness. In this case, therefore, the violence that present-day law is seeking in all areas of activity to deny the individual appears really threatening, and arouses even in defeat the sympathy of the masses against the law. By what function violence can with reason seem so threatening to the law, and be so feared by it, must be especially evident where its application, even in the present legal system, is still permissible.

This is above all the case in the class struggle, in the form of the workers' guaranteed right to strike. Today organized labor is, apart from the state, probably the only legal subject entitled to exercise violence. Against this view there is certainly the objection that an omission of actions, a nonaction, which a strike really is, cannot be described as violence. Such a consideration doubtless made it easier for a state power to concede the right to strike, once this was no longer avoidable. But its truth is not unconditional, and therefore not unrestricted. It is true that the omission of an action, or service, where it amounts simply to a "severing of relations," can be an entirely nonviolent, pure means. And as in the view of the state, or the law, the right to strike conceded to labor is certainly a right not to exercise violence but, rather, to escape from a violence indirectly exercised by the employer, strikes conforming to this may undoubtedly occur from time to time and involve only a "withdrawal" or "estrangement" from the employer. The moment of violence, however, is necessarily introduced, in the form of extortion, into such an omission, if it takes place in the context of a conscious readiness to resume the suspended action under certain circumstances that either have nothing whatever to do with this action or only superficially modify it. Understood in this way, the right to strike constitutes in the view of labor, which is opposed to that of the state, the right to use force in attaining certain ends. The antithesis between the two conceptions emerges in all its bitterness in the face of a revolutionary general strike. In this, labor will always appeal to its right to strike, and the state will call this appeal an abuse (since the right to strike was not "so intended") and will take emer-

gency measures. For the state retains the right to declare that a simultaneous use of strikes in all industries is illegal, since the specific reasons for strikes admitted by legislation cannot be prevalent in every workshop. In this difference of interpretation is expressed the objective contradiction in the legal situation, whereby the state acknowledges a violence whose ends, as natural ends, it sometimes regards with indifference but in a crisis (the revolutionary general strike) confronts inimically. For however paradoxical this may appear at first sight, even conduct involving the exercise of a right can nevertheless, under certain circumstances, be described as violent. More specifically, such conduct, when active, may be called violent if it exercises a right in order to overthrow the legal system that has conferred it; when passive, it is nevertheless to be so described if it constitutes extortion in the sense explained above. It therefore reveals an objective contradiction in the legal situation, but not a logical contradiction in the law, if under certain circumstances the law meets the strikers, as perpetrators of violence, with violence. For in a strike the state fears above all else that function of violence which it is the object of this study to identify as the only secure foundation of its critique. For if violence were, as first appears, merely the means to secure directly whatever happens to be sought, it could fulfill its end as predatory violence. It would be entirely unsuitable as a basis for, or a modification to, relatively stable conditions. The strike shows, however, that it can be so, that it is able to found and modify legal conditions, however offended the sense of justice may find itself thereby. It will be objected that such a function of violence is fortuitous and isolated. This can be rebutted by a consideration of military force.

The possibility of military law rests on exactly the same objective contradiction in the legal situation as does that of strike law—namely, on the fact that legal subjects sanction violence whose ends remain for the sanctioners natural ends, and can therefore in a crisis come into conflict with their own legal or natural ends. Admittedly, military force is used quite directly, as predatory violence, toward its ends. Yet it is very striking that even—or, rather, precisely—in primitive conditions that scarcely know the beginnings of constitutional relations, and even in cases where the victor has established himself in invulnerable possession, a peace ceremony is entirely necessary. Indeed, the word "peace," in the sense in which it is the correlative to the word "war" (for there is also a quite different meaning, similarly unmetaphorical and political, the one used by Kant in talking of "Eternal Peace"), denotes this a priori, necessary sanctioning, regardless of all other legal conditions, of every victory. This sanction consists precisely in recognizing the new conditions as a new "law," quite regardless of whether they need de facto any guarantee of their continuation. If, therefore, conclusions can be drawn from military violence, as being primordial and paradigmatic of all violence used for natural ends, there is a lawmaking character inherent in all such violence. We shall return later to the implications of this insight.

It explains the abovementioned tendency of modern law to divest the individual, at least as a legal subject, of all violence, even that directed only to natural ends. In the great criminal this violence confronts the law with the threat of declaring a new law, a threat that even today, despite its impotence, in important instances horrifies the public as it did in primeval times. The state, however, fears this violence simply for its lawmaking character, being obliged to acknowledge it as lawmaking whenever external powers force it to concede them the right to conduct warfare, and classes force it to concede them the right to strike.

If in the last war the critique of military violence was the starting point for a passionate critique of violence in general—which taught at least one thing, that violence is no longer exercised and tolerated naively—nevertheless, violence was subject to criticism not only for its lawmaking character but also, perhaps more annihilatingly, for another of its functions. For a duality in the function of violence is characteristic of militarism, which could come into being only through general conscription. Militarism is the compulsory, universal use of violence as a means to the ends of the state. This compulsory use of violence has recently been scrutinized as closely as, or still more closely than, the use of violence itself. In it violence shows itself in a function quite different from its simple application for natural ends. It consists in the use of violence as a means toward legal ends. For the subordination of citizens to laws—in the present case, to the law of general conscription—is a legal end. If that first function of violence is called the lawmaking function, this second will be called the law-preserving function. Since conscription is a case of law-preserving violence that is not in principle distinguished from others, a really effective critique of it is far less easy than the declamations of pacifists and activists suggest. Rather, such a critique coincides with the critique of all legal violence—that is, with the critique of legal or executive force—and cannot be performed by any lesser program. Nor, of course—unless one is prepared to proclaim a quite childish anarchism—is it achieved by refusing to acknowledge any constraint toward persons and by declaring, "What pleases is permitted." Such a maxim merely excludes reflection on the moral and historical spheres, and thereby on any meaning in action, and beyond this on any meaning in reality itself, which cannot be constituted if "action" is removed from its sphere. More important is the fact that even the appeal, so frequently attempted, to the categorical imperative, with its doubtless incontestable minimum program— act in such a way that at all times you use humanity both in your person and in the person of all others as an end, and never merely as a means—is in itself inadequate for such a critique.[2] For positive law, if conscious of its roots, will certainly claim to acknowledge and promote the interest of mankind in the person of each individual. It sees this interest in the representation and preservation of an order imposed by fate. While this view, which claims to preserve law in its very basis, cannot escape criticism,

nevertheless all attacks that are made merely in the name of a formless "freedom" without being able to specify this higher order of freedom remain impotent against it. And they are most impotent of all when, instead of attacking the legal system root and branch, they impugn particular laws or legal practices that the law, of course, takes under the protection of its power, which resides in the fact that there is only one fate and that what exists, and in particular what threatens, belongs inviolably to its order. For law-preserving violence is a threatening violence. And its threat is not intended as the deterrent that uninformed liberal theorists interpret it to be. A deterrent in the exact sense would require a certainty that contradicts the nature of a threat and is not attained by any law, since there is always hope of eluding its arm. This makes it all the more threatening, like fate, which determines whether the criminal is apprehended. The deepest purpose of the uncertainty of the legal threat will emerge from the later consideration of the sphere of fate in which it originates. There is a useful pointer to it in the sphere of punishments. Among them, since the validity of positive law has been called into question, capital punishment has provoked more criticism than all others. However superficial the arguments may in most cases have been, their motives were and are rooted in principle. The opponents of these critics felt, perhaps without knowing why and probably involuntarily, that an attack on capital punishment assails not legal measure, not laws, but law itself in its origin. For if violence, violence crowned by fate, is the origin of law, then it may be readily supposed that where the highest violence, that over life and death, occurs in the legal system, the origins of law jut manifestly and fearsomely into existence. In agreement with this is the fact that the death penalty in primitive legal systems is imposed even for such crimes as offenses against property, to which it seems quite out of "proportion." Its purpose is not to punish the infringement of law but to establish new law. For in the exercise of violence over life and death, more than in any other legal act, the law reaffirms itself. But in this very violence something rotten in the law is revealed, above all to a finer sensibility, because the latter knows itself to be infinitely remote from conditions in which fate might imperiously have shown itself in such a sentence. Reason must, however, attempt to approach such conditions all the more resolutely, if it is to bring to a conclusion its critique of both lawmaking and law-preserving violence.

In a far more unnatural combination than in the death penalty, in a kind of spectral mixture, these two forms of violence are present in another institution of the modern state: the police. True, this is violence for legal ends (it includes the right of disposition), but with the simultaneous authority to decide these ends itself within wide limits (it includes the right of decree). The ignominy of such an authority—which is felt by few simply because its ordinances suffice only seldom, even for the crudest acts, but are

therefore allowed to rampage all the more blindly in the most vulnerable areas and against thinkers, from whom the state is not protected by law—lies in the fact that in this authority the separation of lawmaking and law-preserving violence is suspended. If the first is required to prove its worth in victory, the second is subject to the restriction that it may not set itself new ends. Police violence is emancipated from both conditions. It is lawmaking, because its characteristic function is not the promulgation of laws but the assertion of legal claims for any decree, and law-preserving, because it is at the disposal of these ends. The assertion that the ends of police violence are always identical or even connected to those of general law is entirely untrue. Rather, the "law" of the police really marks the point at which the state, whether from impotence or because of the immanent connections within any legal system, can no longer guarantee through the legal system the empirical ends that it desires at any price to attain. Therefore, the police intervene "for security reasons" in countless cases where no clear legal situation exists, when they are not merely, without the slightest relation to legal ends, accompanying the citizen as a brutal encumbrance through a life regulated by ordinances, or simply supervising him. Unlike law, which acknowledges in the "decision" determined by place and time a metaphysical category that gives it a claim to critical evaluation, a consideration of the police institution encounters nothing essential at all. Its power is formless, like its nowhere-tangible, all-pervasive, ghostly presence in the life of civilized states. And though the police may, in particulars, appear the same everywhere, it cannot finally be denied that in absolute monarchy, where they represent the power of a ruler in which legislative and executive supremacy are united, their spirit is less devastating than in democracies, where their exist. ce, elevated by no such relation, bears witness to the greatest conceivable degeneration of violence.

All violence as a means is either lawmaking or law-preserving. If it lays claim to neither of these predicates, it forfeits all validity. It follows, however, that all violence as a means, even in the most favorable case, is implicated in the problematic nature of law itself. And if the importance of these problems cannot be assessed with certainty at this stage of the investigation, law nevertheless appears, from what has been said, in so ambiguous a moral light that the question poses itself whether there are no other than violent means for regulating conflicting human interests. We are above all obligated to note that a totally nonviolent resolution of conflicts can never lead to a legal contract. For the latter, however peacefully it may have been entered into by the parties, leads finally to possible violence. It confers on each party the right to resort to violence in some form against the other, should he break the agreement. Not only that; like the outcome, the origin of every contract also points toward violence. It need not be directly present in it as lawmaking violence, but is represented in it insofar as the power

that guarantees a legal contract is, in turn, of violent origin even if violence is not introduced into the contract itself. When the consciousness of the latent presence of violence in a legal institution disappears, the institution falls into decay. In our time, parliaments provide an example of this. They offer the familiar, woeful spectacle because they have not remained conscious of the revolutionary forces to which they owe their existence. Accordingly, in Germany in particular, the last manifestation of such forces bore no fruit for parliaments. They lack the sense that they represent a lawmaking violence; no wonder they cannot achieve decrees worthy of this violence, but cultivate in compromise a supposedly nonviolent manner of dealing with political affairs. This remains, however, a "product situated within the mentality of violence, no matter how it may disdain all open violence, because the effort toward compromise is motivated not internally but from outside, by the opposing effort, because no compromise, however freely accepted, is conceivable without a compulsive character. 'It would be better otherwise' is the underlying feeling in every compromise."[3]—Significantly, the decay of parliaments has perhaps alienated as many minds from the ideal of a nonviolent resolution of political conflicts as were attracted to it by the war. The pacifists are confronted by the Bolsheviks and Syndicalists. These have effected an annihilating and on the whole apt critique of present-day parliaments. Nevertheless, however desirable and gratifying a flourishing parliament might be by comparison, a discussion of means of political agreement that are in principle nonviolent cannot be concerned with parliamentarianism. For what a parliament achieves in vital affairs can be only those legal decrees that in their origin and outcome are attended by violence.

Is any nonviolent resolution of conflict possible? Without doubt. The relationships among private persons are full of examples of this. Nonviolent agreement is possible wherever a civilized outlook allows the use of unalloyed means of agreement. Legal and illegal means of every kind that are all the same violent may be confronted with nonviolent ones as unalloyed means. Courtesy, sympathy, peaceableness, trust, and whatever else might here be mentioned are their subjective preconditions. Their objective manifestation, however, is determined by the law (whose enormous scope cannot be discussed here) that says unalloyed means are never those of direct solutions but always those of indirect solutions. They therefore never apply directly to the resolution of conflict between man and man, but apply only to matters concerning objects. The sphere of nonviolent means opens up in the realm of human conflicts relating to goods. For this reason, technique in the broadest sense of the word is their most particular area. Its profoundest example is perhaps the conference, considered as a technique of civil agreement. For in it not only is nonviolent agreement possible, but also the exclusion of violence in principle is quite explicitly demonstrable by one significant factor: there is no sanction for lying. Probably no legislation on

earth originally stipulated such a sanction. This makes clear that there is a sphere of human agreement that is nonviolent to the extent that it is wholly inaccessible to violence: the proper sphere of "understanding," language. Only late and in a peculiar process of decay has it been penetrated by legal violence in the penalty placed on fraud. For whereas the legal system at its origin, trusting to its victorious power, is content to defeat lawbreaking wherever it happens to appear, and deception, having itself no trace of power about it, was, on the principle *ius civile vigilantibus scriptum est,* exempt from punishment in Roman and ancient Germanic law, the law of a later period, lacking confidence in its own violence, no longer felt itself a match for that of all others. Rather, fear of the latter and mistrust of itself indicate its declining vitality. It begins to set itself ends, with the intention of sparing law-preserving violence more taxing manifestations. It turns to fraud, therefore, not out of moral considerations but for fear of the violence that it might unleash in the defrauded party. Since such fear conflicts with the violent nature of law derived from its origins, such ends are inappropriate to the justified means of law. They reflect not only the decay of its own sphere but also a diminution of pure means. For in prohibiting fraud, law restricts the use of wholly nonviolent means because they could produce reactive violence. This tendency of law has also played a part in the concession of the right to strike, which contradicts the interests of the state. It grants this right because it forestalls violent actions the state is afraid to oppose. Did not workers previously resort at once to sabotage and set fire to factories?—To induce men to reconcile their interests peacefully without involving the legal system, there is, in the end, apart from all virtues, one effective motive that often enough puts into the most reluctant hands pure instead of violent means: it is the fear of mutual disadvantages that threaten to arise from violent confrontation, whatever the outcome might be. Such motives are clearly visible in countless cases of conflict of interests between private persons. It is different when classes and nations are in conflict, since the higher orders that threaten to overwhelm equally victor and vanquished are hidden from the feelings of most, and from the intelligence of almost all. Space does not here permit me to trace such higher orders and the common interests corresponding to them, which constitute the most enduring motive for a policy of pure means.[4] We can therefore point only to pure means in politics as analogous to those which govern peaceful intercourse between private persons.

As regards class struggles, in them strikes must under certain conditions be seen as a pure means. Two essentially different kinds of strikes, the possibilities of which have already been considered, must now be more fully characterized. Sorel has the credit—from political rather than purely theoretical considerations—of having first distinguished them. He contrasts them as the political strike and the proletarian general strike. They are also antithetical in their relation to violence. Of the partisans of the former he

says, "The strengthening of state power is the basis of their conceptions; in their present organizations the politicians (namely, the moderate socialists) are already preparing the ground for a strong centralized and disciplined power that will be impervious to criticism from the opposition, and capable of imposing silence and issuing its mendacious decrees."[5] "The political general strike demonstrates how the state will lose none of its strength, how power is transferred from the privileged to the privileged, how the mass of producers will change their masters." In contrast to this political general strike (which incidentally seems to have been summed up by the abortive German revolution), the proletarian general strike sets itself the sole task of destroying state power. It "nullifies all the ideological consequences of every possible social policy; its partisans see even the most popular reforms as bourgeois." "This general strike clearly announces its indifference toward material gain through conquest by declaring its intention to abolish the state; the state was really . . . the basis of the existence of the ruling group, who in all their enterprises benefit from the burdens borne by the public." Whereas the first form of interruption of work is violent, since it causes only an external modification of labor conditions, the second, as a pure means, is nonviolent. For it takes place not in readiness to resume work following external concessions and this or that modification to working conditions, but in the determination to resume only a wholly transformed work, no longer enforced by the state, an upheaval that this kind of strike not so much causes as consummates. For this reason, the first of these undertakings is lawmaking but the second anarchistic. Taking up occasional statements by Marx, Sorel rejects every kind of program, of utopia—in a word, of lawmaking—for the revolutionary movement: "With the general strike, all these fine things disappear; the revolution appears as a clear, simple revolt, and no place is reserved either for the sociologists or for the elegant amateurs of social reforms or for the intellectuals who have made it their profession to think for the proletariat."[6] Against this deep, moral, and genuinely revolutionary conception, no objection can stand that seeks, on grounds of its possibly catastrophic consequences, to brand such a general strike as violent. Even if it can rightly be said that the modern economy, seen as a whole, resembles much less a machine that stands idle when abandoned by its stoker than a beast that goes berserk as soon as its tamer turns his back, nevertheless the violence of an action can be assessed no more from its effects than from its ends, but only from the law of its means. State power, of course, which has eyes only for effects, opposes precisely this kind of strike for its alleged violence, as distinct from partial strikes, which are for the most part actually extortionate. Sorel has explained, with highly ingenious arguments, the extent to which such a rigorous conception of the general strike per se is capable of diminishing the incidence of actual violence in revolutions.—By contrast, an outstanding example of violent omission,

more immoral and cruder than the political general strike, akin to a blockade, is the strike by doctors, such as several German cities have seen. Here is revealed at its most repellent an unscrupulous use of violence which is positively depraved in a professional class that for years, without the slightest attempts at resistance, "secured death its prey," and then at the first opportunity abandoned life of its own free will. More clearly than in recent class struggles, the means of nonviolent agreement have developed in thousands of years of the history of states. Only occasionally does the task of diplomats in their transactions consist of modifying legal systems. Fundamentally they must, entirely on the analogy of agreement between private persons, resolve conflicts case by case, in the name of their states, peacefully and without contracts. A delicate task that is more robustly performed by referees, but a method of solution that in principle is above that of the referee because it is beyond all legal systems and therefore beyond violence. Accordingly, like the intercourse of private persons, that of diplomats has engendered its own forms and virtues, which were not always mere formalities, even though they have become so.

Among all the forms of violence permitted by both natural law and positive law, not one is free of the gravely problematic nature, already indicated, of all legal violence. Since, however, every conceivable solution to human problems, not to speak of deliverance from the confines of all the world-historical conditions of existence obtaining hitherto, remains impossible if violence is totally excluded in principle, the question necessarily arises as to what kinds of violence exist other than all those envisaged by legal theory. It is at the same time a question of the truth of the basic dogma common to both theories: just ends can be attained by justified means, justified means used for just ends. How would it be, therefore, if all the violence imposed by fate, using justified means, were of itself in irreconcilable conflict with just ends, and if at the same time a different kind of violence arose that certainly could be either the justified or the unjustified means to those ends but was not related to them as means at all but in some different way? This would throw light on the curious and at first discouraging discovery of the ultimate insolubility of all legal problems (which in its hopelessness is perhaps comparable only to the possibility of conclusive pronouncements on "right" and "wrong" in evolving languages). For it is never reason that decides on the justification of means and the justness of ends: fate-imposed violence decides on the former, and God on the latter. An insight that is uncommon only because of the stubborn prevailing habit of conceiving those just ends as ends of a possible law—that is, not only as generally valid (which follows analytically from the nature of justice) but also as capable of generalization, which, as could be shown, contradicts the nature of justice. For ends that in one situation are just, universally acceptable, and valid are so in no other situation, no matter how similar the

situations may be in other respects.—The nonmediate function of violence at issue here is illustrated by everyday experience. As regards man, he is impelled by anger, for example, to the most visible outbursts of a violence that is not related as a means to a preconceived end. It is not a means but a manifestation. Moreover, this violence has thoroughly objective manifestations in which it can be subjected to criticism. These are to be found, most significantly, above all in myth.

Mythic violence in its archetypal form is a mere manifestation of the gods. Not a means to their ends, scarcely a manifestation of their will, but primarily a manifestation of their existence. The legend of Niobe contains an outstanding example of this. True, it might appear that the action of Apollo and Artemis is only a punishment. But their violence establishes a law far more than it punishes the infringement of a law that already exists. Niobe's arrogance calls down fate upon her not because her arrogance offends against the law but because it challenges fate—to a fight in which fate must triumph and can bring to light a law only in its triumph. How little such divine violence was, to the ancients, the law-preserving violence of punishment is shown by the heroic legends in which the hero—for example, Prometheus—challenges fate with dignified courage, fights it with varying fortunes, and is not left by the legend without hope of one day bringing a new law to men. It is really this hero and the legal violence of the myth native to him that the public tries to picture even now in admiring the miscreant. Violence therefore bursts upon Niobe from the uncertain, ambiguous sphere of fate. It is not actually destructive. Although it brings a cruel death to Niobe's children, it stops short of claiming the life of their mother, whom it leaves behind, more guilty than before through the death of the children, both as an eternally mute bearer of guilt and as a boundary stone on the frontier between men and gods. If this immediate violence in mythic manifestations proves closely related, indeed identical, to lawmaking violence, it reflects a problematic light on lawmaking violence, insofar as the latter was characterized above, in the account of military violence, as merely a mediate violence. At the same time this connection promises to provide further illumination of fate, which in all cases underlies legal violence, and to conclude in broad outline the critique of the latter. For the function of violence in lawmaking is twofold, in the sense that lawmaking pursues as its end, with violence as the means, *what* is to be established as law, but at the moment of instatement does not dismiss violence; rather, at this very moment of lawmaking, it specifically establishes as law not an end unalloyed by violence but one necessarily and intimately bound to it, under the title of power. Lawmaking is powermaking, assumption of power, and to that extent an immediate manifestation of violence. Justice is the principle of all divine endmaking, power the principle of all mythic lawmaking.

An application of the latter that has immense consequences is found in constitutional law. For in this sphere the establishing of frontiers, the task

of "peace" after all the wars of the mythic age, is the primal phenomenon of all lawmaking violence. Here we see most clearly that power, more than the most extravagant gain in property, is what is guaranteed by all lawmaking violence. Where frontiers are decided, the adversary is not simply annihilated; indeed, he is accorded rights even when the victor's superiority in power is complete. And these are, in a demonically ambiguous way, "equal" rights: for both parties to the treaty, it is the same line that may not be crossed. Here appears, in a terribly primitive form, the mythic ambiguity of laws that may not be "infringed"—the same ambiguity to which Anatole France refers satirically when he says, "Poor and rich are equally forbidden to spend the night under the bridges." It also appears that Sorel touches not merely on a cultural-historical truth but also on a metaphysical truth when he surmises that in the beginning all right was the prerogative of kings or nobles—in short, of the mighty; and that, *mutatis mutandis*, it will remain so as long as it exists. For from the point of view of violence, which alone can guarantee law, there is no equality, but at the most equally great violence. The act of establishing frontiers, however, is also significant for an understanding of law in another respect. Laws and circumscribed frontiers remain, at least in primeval times, unwritten laws. A man can unwittingly infringe upon them and thus incur retribution. For each intervention of law that is provoked by an offense against the unwritten and unknown law is called "retribution" (in contradistinction to "punishment"). But however unluckily it may befall its unsuspecting victim, its occurrence is, in the understanding of the law, not chance, but fate showing itself once again in its deliberate ambiguity. Hermann Cohen, in a brief reflection on the ancients' conception of fate, has spoken of the "inescapable realization" that it is "fate's orders themselves that seem to cause and bring about this infringement, this offense."[7] Even the modern principle that ignorance of a law is not protection against punishment testifies to this spirit of law, just as the struggle over written law in the early period of the ancient Greek communities should be understood as a rebellion against the spirit of mythic statutes.

Far from inaugurating a purer sphere, the mythic manifestation of immediate violence shows itself fundamentally identical with all legal violence, and turns suspicion concerning the latter into certainty of the perniciousness of its historical function, the destruction of which thus becomes obligatory. This very task of destruction poses again, ultimately, the question of a pure immediate violence that might be able to call a halt to mythic violence. Just as in all spheres God opposes myth, mythic violence is confronted by the divine. And the latter constitutes its antithesis in all respects. If mythic violence is lawmaking, divine violence is law-destroying; if the former sets boundaries, the latter boundlessly destroys them; if mythic violence brings at once guilt and retribution, divine power only expiates; if the former threatens, the latter strikes; if the former is bloody, the latter is lethal without

spilling blood. The legend of Niobe may be contrasted with God's judgment on the company of Korah, as an example of such violence. God's judgment strikes privileged Levites, strikes them without warning, without threat, and does not stop short of annihilation. But in annihilating it also expiates, and a profound connection between the lack of bloodshed and the expiatory character of this violence is unmistakable. For blood is the symbol of mere life. The dissolution of legal violence stems (as cannot be shown in detail here) from the guilt of more natural life, which consigns the living, innocent and unhappy, to a retribution that "expiates" the guilt of mere life—and doubtless also purifies the guilty, not of guilt, however, but of law. For with mere life, the rule of law over the living ceases. Mythic violence is bloody power over mere life for its own sake; divine violence is pure power over all life for the sake of the living. The first demands sacrifice; the second accepts it.

This divine power is not only attested by religious tradition but is also found in present-day life in at least one sanctioned manifestation. The educative power, which in its perfected form stands outside the law, is one of its manifestations. These are defined, therefore, not by miracles directly performed by God but by the expiating moment in them that strikes without bloodshed, and, finally, by the absence of all lawmaking. To this extent it is justifiable to call this violence, too, annihilating; but it is so only relatively, with regard to goods, right, life, and suchlike, never absolutely, with regard to the soul of the living.—The premise of such an extension of pure or divine power is sure to provoke, particularly today, the most violent reactions, and to be countered by the argument that, if taken to its logical conclusion, it confers on men even lethal power against one another. This, however, cannot be conceded. For the question "May I kill?" meets its irreducible answer in the commandment "Thou shalt not kill." This commandment precedes the deed, just as God was "preventing" the deed. But just as it may not be fear of punishment that enforces obedience, the injunction becomes inapplicable, incommensurable, once the deed is accomplished. No judgment of the deed can be derived from the commandment. And so neither the divine judgment nor the grounds for this judgment can be known in advance. Those who base a condemnation of all violent killing of one person by another on the commandment are therefore mistaken. It exists not as a criterion of judgment, but as a guideline for the actions of persons or communities who have to wrestle with it in solitude and, in exceptional cases, to take on themselves the responsibility of ignoring it. Thus it was understood by Judaism, which expressly rejected the condemnation of killing in self-defense.—But those thinkers who take the opposite view refer to a more distant theorem, on which they possibly propose to base even the commandment itself. This is the doctrine of the sanctity of life, which they either apply to all animal and even vegetable life, or limit to human life. Their argument, exemplified in an extreme case by the revolutionary killing

of the oppressor, runs as follows: "If I do not kill, I shall never establish the world dominion of justice . . . that is the argument of the intelligent terrorist. . . . We, however, profess that higher even than the happiness and justice of existence stands existence itself."[8] As certainly as this last proposition is false, indeed ignoble, it shows the necessity of seeking the reason for the commandment no longer in what the deed does to the victim, but in what it does to God and the doer. The proposition that existence stands higher than a just existence is false and ignominious, if existence is to mean nothing other than mere life—and it has this meaning in the argument referred to. It contains a mighty truth, however, if "existence," or, better, "life" (words whose ambiguity is readily dispelled, like that of "freedom," when they are used with reference to two distinct spheres), means the irreducible, total condition that is "man"; if the proposition is intended to mean that the nonexistence of man is something more terrible than the (admittedly subordinate) not-yet-attained condition of the just man. The proposition quoted above owes its plausibility to this ambiguity. Man cannot, at any price, be said to coincide with the mere life in him, any more than it can be said to coincide with any other of his conditions and qualities, including even the uniqueness of his bodily person. However sacred man is (or however sacred that life in him which is identically present in earthly life, death, and afterlife), there is no sacredness in his condition, in his bodily life vulnerable to injury by his fellow men. What, then, distinguishes it essentially from the life of animals and plants? And even if these were sacred, they could not be so by virtue only of being alive, of being in life. It might be well worthwhile to track down the origin of the dogma of the sacredness of life. Perhaps, indeed probably, it is relatively recent, the last mistaken attempt of the weakened Western tradition to seek the saint it has lost in cosmological impenetrability. (The antiquity of all religious commandments against murder is no counterargument, because these are based on ideas other than the modern theorem.) Finally, this idea of man's sacredness gives grounds for reflection that what is here pronounced sacred was, according to ancient mythic thought, the marked bearer of guilt: life itself.

The critique of violence is the philosophy of its history—the "philosophy" of this history because only the idea of its development makes possible a critical, discriminating, and decisive approach to its temporal data. A gaze directed only at what is close at hand can at most perceive a dialectical rising and falling in the lawmaking and law-preserving forms of violence. The law governing their oscillation rests on the circumstance that all law-preserving violence, in its duration, indirectly weakens the lawmaking violence it represents, by suppressing hostile counterviolence. (Various symptoms of this have been referred to in the course of this study.) This lasts until either new forces or those earlier suppressed triumph over the hitherto lawmaking violence and thus found a new law, destined in its turn to decay. On the breaking of this cycle maintained by mythic forms of law, on the suspension

of law with all the forces on which it depends as they depend on it, finally therefore on the abolition of state power, a new historical epoch is founded. If the rule of myth is broken occasionally in the present age, the coming age is not so unimaginably remote that an attack on law is altogether futile. But if the existence of violence outside the law, as pure immediate violence, is assured, this furnishes proof that revolutionary violence, the highest manifestation of unalloyed violence by man, is possible, and shows by what means. Less possible and also less urgent for humankind, however, is to decide when unalloyed violence has been realized in particular cases. For only mythic violence, not divine, will be recognizable as such with certainty, unless it be in incomparable effects, because the expiatory power of violence is invisible to men. Once again all the eternal forms are open to pure divine violence, which myth bastardized with law. Divine violence may manifest itself in a true war exactly as it does in the crowd's divine judgment on a criminal. But all mythic, lawmaking violence, which we may call "executive," is pernicious. Pernicious, too, is the law-preserving, "administrative" violence that serves it. Divine violence, which is the sign and seal but never the means of sacred dispatch, may be called "sovereign" violence.

Written in 1921; published in *Archiv für Sozialwissenschaft und Sozialpolitik,* 1921. Translated by Edmund Jephcott.

Notes

1. Benjamin's term is *Gewalt,* which means both "violence" and "force." The latter meaning should be kept in mind when Benjamin turns to relationships between states.—*Trans.*
2. One might, rather, doubt whether this famous demand does not contain too little—that is, whether it is permissible to use, or allow to be used, oneself or another in any respect as a means. Very good grounds for such doubt could be adduced.
3. Erich Unger, *Politik und Metaphysik* [Politics and Metaphysics] (Berlin, 1921), p. 8.
4. But see Unger, pp. 18ff.
5. Sorel, *Réflexions sur la violence* [Reflections on Violence], 5th ed. (Paris, 1919), p. 250.
6. Ibid., pp. 265, 195, 249, 200.
7. Hermann Cohen, *Ethik des reinen Willens* [Ethics of the Pure Will], 2nd ed. (Berlin, 1907), p. 362. [Cohen (1842–1918), a leading member of the Marburg school of Neo-Kantianism, combined work on Jewish theology and Kantian philosophy. His writings on philosophy and on religion exerted an important influence on Benjamin.—*Trans.*]
8. Kurt Hiller, "Anti-Cain," in *Das Ziel: Jahrbücher für geistige Politik* [The Goal: Yearbook for Spiritual Politics] (Munich, 1919), p. 25.

The Task of the Translator

In the appreciation of a work of art or an art form, consideration of the receiver never proves fruitful. Not only is any reference to a particular public or its representatives misleading, but even the concept of an "ideal" receiver is detrimental in the theoretical consideration of art, since all it posits is the existence and nature of man as such. Art, in the same way, posits man's physical and spiritual existence, but in none of its works is it concerned with his attentiveness. No poem is intended for the reader, no picture for the beholder, no symphony for the audience.

Is a translation meant for readers who do not understand the original? This would seem to explain adequately the fact that the translation and the original have very different standing in the realm of art. Moreover, it seems to be the only conceivable reason for saying "the same thing" over again. For what does a literary work "say"? What does it communicate? It "tells" very little to those who understand it. Its essential quality is not communication or the imparting of information. Yet any translation that intends to perform a transmitting function cannot transmit anything but communication—hence, something inessential. This is the hallmark of bad translations. But do we not generally regard that which lies beyond communication in a literary work—and even a poor translator will admit that this is its essential substance—as the unfathomable, the mysterious, the "poetic"? And is this not something that a translator can reproduce only if he is also—a poet? Such, actually, is the cause of another characteristic of inferior translation, which consequently we may define as the inaccurate transmission of an inessential content. Whenever a translation undertakes to serve the reader, it demonstrates this. However, if it were intended for the reader, the same

would have to apply to the original. If the original does not exist for the reader's sake, how could the translation be understood on the basis of this premise?

Translation is a form. To comprehend it as a form, one must go back to the original, for the laws governing the translation lie within the original, contained in the issue of its translatability. The question of whether a work is translatable has a dual meaning. Either: Will an adequate translator ever be found among the totality of its readers? Or, more pertinently: Does its nature lend itself to translation and, therefore, in view of the significance of this form, call for it? In principle, the first question can be decided only contingently; the second, however, apodictically. Only superficial thinking will deny the independent meaning of the latter question and declare both to be of equal significance. It should be pointed out in refutation of such thinking that certain correlative concepts retain their meaning, and possibly their foremost significance, if they are not from the outset used exclusively with reference to man. One might, for example, speak of an unforgettable life or moment even if all men had forgotten it. If the nature of such a life or moment required that it be unforgotten, that predicate would imply not a falsehood but merely a claim unfulfilled by men, and probably also a reference to a realm in which it *is* fulfilled: God's remembrance. Analogously, the translatability of linguistic creations ought to be considered even if men should prove unable to translate them. Given a strict concept of translation, would they not really be translatable to some degree? The question as to whether the translation of certain linguistic creations is called for ought to be posed in this sense. For this thought is valid here: If translation is a form, translatability must be an essential feature of certain works.

Translatability is an essential quality of certain works, which is not to say that it is essential for the works themselves that they be translated; it means, rather, that a specific significance inherent in the original manifests itself in its translatability. It is evident that no translation, however good it may be, can have any significance as regards the original. Nonetheless, it does stand in the closest relationship to the original by virtue of the original's translatability; in fact, this connection is all the closer since it is no longer of importance to the original. We may call this connection a natural one, or, more specifically, a vital one. Just as the manifestations of life are intimately connected with the phenomenon of life without being of importance to it, a translation issues from the original—not so much from its life as from its afterlife. For a translation comes later than the original, and since the important works of world literature never find their chosen translators at the time of their origin, their translation marks their stage of continued life. The idea of life and afterlife in works of art should be regarded with an entirely unmetaphorical objectivity. Even in times of narrowly prejudiced thought, there was an inkling that life was not limited to organic corpore-

ality. But it cannot be a matter of extending its dominion under the feeble scepter of the soul, as Fechner tried to do, or, conversely, of basing its definition on the even less conclusive factors of animality, such as sensation, which characterizes life only occasionally. The concept of life is given its due only if everything that has a history of its own, and is not merely the setting for history, is credited with life. In the final analysis, the range of life must be determined by the standpoint of history rather than that of nature, least of all by such tenuous factors as sensation and soul. The philosopher's task consists in comprehending all of natural life through the more encompassing life of history. And indeed, isn't the afterlife of works of art far easier to recognize than that of living creatures? The history of the great works of art tells us about their descent from prior models, their realization in the age of the artist, and what in principle should be their eternal afterlife in succeeding generations. Where this last manifests itself, it is called fame. Translations that are more than transmissions of subject matter come into being when a work, in the course of its survival, has reached the age of its fame. Contrary, therefore, to the claims of bad translators, such translations do not so much serve the works as owe their existence to it. In them the life of the originals attains its latest, continually renewed, and most complete unfolding.

As the unfolding of a special and high form of life, this process is governed by a special high purposiveness. The relationship between life and purposiveness, seemingly obvious yet almost beyond the grasp of the intellect, reveals itself only if the ultimate purpose toward which all the individual purposivenesses of life tends is sought not in its own sphere but in a higher one. All purposeful manifestations of life, including their very purposiveness, in the final analysis have their end not in life but in the expression of its nature, in the representation of its significance. Translation thus ultimately serves the purpose of expressing the innermost relationship of languages to our answer. It cannot possibly reveal or establish this hidden relationship itself; but it can represent it by realizing it in embryonic or intensive form. This representing of something signified through an attempt at establishing it in embryo is of so singular a nature that it is rarely met with in the sphere of nonlinguistic life. In its analogies and symbols, it can draw on other ways of suggesting meaning than intensive—that is, anticipative, intimating—realization. As for the posited innermost kinship of languages, it is marked by a peculiar convergence. This special kinship holds because languages are not strangers to one another, but are, a priori and apart from all historical relationships, interrelated in what they want to express.

With this attempt at an explication, our study appears to rejoin, after futile detours, the traditional theory of translation. If the kinship of languages is to be demonstrated by translations, how else can this be done but by conveying the form and meaning of the original as accurately as possible?

To be sure, that theory would be hard put to define the nature of this accuracy and therefore could shed no light on what is important in a translation. Actually, however, the kinship of languages is brought out by a translation far more profoundly and clearly than in the superficial and indefinable similarity of two works of literature. To grasp the genuine relationship between an original and a translation requires an investigation analogous in its intention to the argument by which a critique of cognition would have to prove the impossibility of a theory of imitation. In the latter, it is a question of showing that in cognition there could be no objectivity, not even a claim to it, if this were to consist in imitations of the real; in the former, one can demonstrate that no translation would be possible if in its ultimate essence it strove for likeness to the original. For in its afterlife—which could not be called that if it were not a transformation and a renewal of something living—the original undergoes a change. Even words with fixed meaning can undergo a maturing process. The obvious tendentiousness of a writer's literary style may in time wither away, only to give rise to immanent tendencies in the literary creation. What sounded fresh once may sound hackneyed later; what was once current may someday sound archaic. To seek the essence of such changes, as well as the equally constant changes in meaning, in the subjectivity of posterity rather than in the very life of language and its works would mean—even allowing for the crudest psychologism—confusing the root cause of a thing with its essence. More precisely, it would mean denying, by an impotence of thought, one of the most powerful and fruitful historical processes. And even if one tried to turn an author's last stroke of the pen into the *coup de grâce* of his work, this still would not save that dead theory of translation. For just as the tenor and the significance of the great works of literature undergo a complete transformation over the centuries, the mother tongue of the translator is transformed as well. While a poet's words endure in his own language, even the greatest translation is destined to become part of the growth of its own language and eventually to perish with its renewal. Translation is so far removed from being the sterile equation of two dead languages that of all literary forms it is the one charged with the special mission of watching over the maturing process of the original language and the birth pangs of its own.

If the kinship of languages manifests itself in translations, this is not accomplished through the vague resemblance a copy bears to the original. It stands to reason that resemblance does not necessarily appear where there is kinship. The concept of "kinship" as used here is in accord with its more restricted usage: it cannot be defined adequately by an identity of origin between the two cases, although in defining the more restricted usage the concept of "origin" remains indispensable. Where should one look to show the kinship of two languages, setting aside any historical connection? Certainly not in the similarity between works of literature or in the words they

use. Rather, all suprahistorical kinship between languages consists in this: in every one of them as a whole, one and the same thing is meant. Yet this one thing is achievable not by any single language but only by the totality of their intentions supplementing one another: the pure language. Whereas all individual elements of foreign languages—words, sentences, associations—are mutually exclusive, these languages supplement one another in their intentions. This law is one of the fundamental principles in the philosophy of language, but to understand it precisely we must draw a distinction, in the concept of "intention," between what is meant and the way of meaning it. In the words *Brot* and *pain*, what is meant is the same, but the way of meaning it is not. This difference in the way of meaning permits the word *Brot* to mean something other to a German than what the word *pain* means to a Frenchman, so that these words are not interchangeable for them; in fact, they strive to exclude each other. As to what is meant, however, the two words signify the very same thing. Even though the way of meaning in these two words is in such conflict, it supplements itself in each of the two languages from which the words are derived; to be more specific, the way of meaning in them is supplemented in its relation to what is meant. In the individual, unsupplemented languages, what is meant is never found in relative independence, as in individual words or sentences; rather, it is in a constant state of flux—until it is able to emerge as the pure language from the harmony of all the various ways of meaning. If, however, these languages continue to grow in this way until the messianic end of their history, it is translation that catches fire from the eternal life of the works and the perpetually renewed life of language; for it is translation that keeps putting the hallowed growth of languages to the test: How far removed is their hidden meaning from revelation? How close can it be brought by the knowledge of this remoteness?

This, to be sure, is to admit that all translation is only a somewhat provisional way of coming to terms with the foreignness of languages. An instant and final rather than a temporary and provisional solution to this foreignness remains out of the reach of mankind; at any rate, it eludes any direct attempt. Indirectly, however, the growth of religions ripens the hidden seed into a higher development of language. Although translation, unlike art, cannot claim permanence for its products, its goal is undeniably a final, conclusive, decisive stage of all linguistic creation. In translation the original rises into a higher and purer linguistic air, as it were. It cannot live there permanently, to be sure; neither can it reach that level in every aspect of the work. Yet in a singularly impressive manner, it at least points the way to this region: the predestined, hitherto inaccessible realm of reconciliation and fulfillment of languages. The original cannot enter there in its entirety, but what does appear in this region is that element in a translation which goes beyond transmittal of subject matter. This nucleus is best defined as that

element in the translation which does not lend itself to a further translation. Though one may glean as much of that subject matter as one can from a translation, and translate that, the element with which the efforts of the real translation were concerned remains at a quite inaccessible remove, because the relationship between content and language is quite different in the original and the translation. Whereas content and language form a certain unity in the original, like a fruit and its skin, the language of the translation envelops its content like a royal robe with ample folds. For it signifies a more exalted language than its own and thus remains unsuited to its content, overpowering and alien. This disjunction prevents translation and at the same time makes it superfluous. For any translation of a work originating in a specific stage of linguistic history represents, in regard to a specific aspect of its content, translation into all other languages. Thus, ironically, translation transplants the original into a more definitive linguistic realm, since it can no longer be displaced by a secondary rendering. The original can only be raised there anew and at other points of time. It is no mere coincidence that the word "ironic" here brings the Romantics to mind. They, more than any others, were gifted with an insight into the life of literary works—an insight for which translation provides the highest testimony. To be sure, they hardly recognized translation in this sense, but devoted their entire attention to criticism—another, if lesser, factor in the continued life of literary works. But even though the Romantics virtually ignored translation in their theoretical writings, their own great translations testify to their sense of the essential nature and the dignity of this literary mode. There is abundant evidence that this sense is not necessarily most pronounced in a poet; in fact, he may be least open to it. Not even literary history suggests the traditional notion that great poets have been eminent translators and lesser poets have been indifferent translators. A number of the most eminent ones, such as Luther, Voss, and Schlegel, are incomparably more important as translators than as creative writers; some of the great among them, such as Hölderlin and Stefan George, cannot be simply subsumed as poets, and quite particularly not if we consider them as translators. Just as translation is a form of its own, so, too, may the task of the translator be regarded as distinct and clearly differentiated from the task of the poet.

The task of the translator consists in finding the particular intention toward the target language which produces in that language the echo of the original. This is a feature of translation that basically differentiates it from the poet's work, because the intention of the latter is never directed toward the language as such, at its totality, but is aimed solely and immediately at specific linguistic contextual aspects. Unlike a work of literature, translation finds itself not in the center of the language forest but on the outside facing the wooded ridge; it calls into it without entering, aiming at that single spot where the echo is able to give, in its own language, the reverberation of the

work in the alien one. Not only does the intention of a translation address or differ from that of a literary work—namely a language as a whole, taking an individual work in an alien language as a point of departure—but it is also qualitatively different altogether. The intention of the poet is spontaneous, primary, manifest; that of the translator is derivative, ultimate, ideational. For the great motif of integrating many tongues into one true language informs his work. This language is that in which the independent sentences, works of literature, and critical judgments will never communicate—for they remain dependent on translation; but in it the languages themselves, supplemented and reconciled in their way of meaning, draw together. If there is such a thing as a language of truth, a tensionless and even silent depository of the ultimate secrets for which all thought strives, then this language of truth is—the true language. And this very language, in whose divination and description lies the only perfection for which a philosopher can hope, is concealed in concentrated fashion in translations. There is no muse of philosophy, nor is there one of translation. But despite the claims of sentimental artists, these two are not philistine. For there is a philosophical genius that is characterized by a yearning for that language which manifests itself in translations. *"Les langues imparfaites en cela que plusieurs, manque la suprême: penser étant écrire sans accessoires, ni chuchotement mais tacite encore l'immortelle parole, la diversité, sur terre, des idiomes empêche personne de proférer les mots qui, sinon se trouveraient, par une frappe unique, elle-même matériellement la vérité."*[1] If what Mallarmé evokes here is fully fathomable to a philosopher, translation, with its rudiments of such a language, is midway between poetry and theory. Its work is less sharply defined than either of these, but it leaves no less of a mark on history.

If the task of the translator is viewed in this light, the roads toward a solution seem to be all the more obscure and impenetrable. Indeed, the problem of ripening the seed of pure language in a translation seems to be insoluble, determinable in no solution. For is not the ground cut from under such a solution if the reproduction of the sense ceases to be decisive? Viewed negatively, this is actually the meaning of all the foregoing. The traditional concepts in any discussion of translation are fidelity and license—the freedom to give a faithful reproduction of the sense and, in its service, fidelity to the word. These ideas seem to be no longer serviceable to a theory that strives to find, in a translation, something other than reproduction of meaning. To be sure, traditional usage makes these terms appear as if in constant conflict with each other. What can fidelity really do for the rendering of meaning? Fidelity in the translation of individual words can almost never fully reproduce the sense they have in the original. For this sense, in its poetic significance for the original, is not limited to what is meant but rather wins such significance to the degree that what is meant is bound to the way

of meaning of the individual word. People commonly convey this when they say that words have emotional connotations. A literal rendering of the syntax casts the reproduction of meaning entirely to the winds and threatens to lead directly to incomprehensibility. The nineteenth century considered Hölderlin's translations of Sophocles monstrous examples of such literalness. Finally, it is self-evident how greatly fidelity in reproducing the form impedes the rendering of the sense. Thus, no case for literalness can be based on an interest in retaining the meaning. The preservation of meaning is served far better—and literature and language far worse—by the unrestrained license of bad translators. Of necessity, therefore, the demand for literalness, whose justification is obvious but whose basis is deeply hidden, must be understood in a more cogent context. Fragments of a vessel that are to be glued together must match one another in the smallest details, although they need not be like one another. In the same way a translation, instead of imitating the sense of the original, must lovingly and in detail incorporate the original's way of meaning, thus making both the original and the translation recognizable as fragments of a greater language, just as fragments are part of a vessel. For this very reason translation must in large measure refrain from wanting to communicate something, from rendering the sense, and in this the original is important to it only insofar as it has already relieved the translator and his translation of the effort of assembling and expressing what is to be conveyed. In the realm of translation, too, the words *En archēi ēn ho logos* ["In the beginning was the word"] apply. On the other hand, as regards the meaning, the language of a translation can—in fact, must—let itself go, so that it gives voice to the *intentio* of the original not as reproduction but as harmony, as a supplement to the language in which it expresses itself, as its own kind of *intentio*. Therefore, it is not the highest praise of a translation, particularly in the age of its origin, to say that it reads as if it had originally been written in that language. Rather, the significance of fidelity as ensured by literalness is that the work reflects the great longing for linguistic complementation. A real translation is transparent; it does not cover the original, does not block its light, but allows the pure language, as though reinforced by its own medium, to shine upon the original all the more fully. This may be achieved, above all, by a literal rendering of the syntax which proves words rather than sentences to be the primary element of the translator. For if the sentence is the wall before the language of the original, literalness is the arcade.

Fidelity and freedom in translation have traditionally been regarded as conflicting tendencies. This deeper interpretation of the one apparently does not serve to reconcile the two; in fact, it seems to deny the other all justification. For what does freedom refer to, if not to the reproduction of the sense, which must thereby give up its lawgiving role? Only if the sense of a linguistic creation may be equated with that of the information it

conveys does some ultimate, decisive element remain beyond all communication—quite close and yet infinitely remote, concealed or distinguishable, fragmented or powerful. In all language and linguistic creations, there remains in addition to what can be conveyed something that cannot be communicated; depending on the context in which it appears, it is something that symbolizes or something symbolized. It is the former only in the finite products of language; the latter, in the evolving of the languages themselves. And that which seeks to represent, indeed to produce, itself in the evolving of languages is that very nucleus of the pure language; yet though this nucleus remains present in life as that which is symbolized itself, albeit hidden and fragmentary, it persists in linguistic creations only in its symbolizing capacity. Whereas in the various tongues that ultimate essence, the pure language, is tied only to linguistic elements and their changes, in linguistic creations it is weighted with a heavy, alien meaning. To relieve it of this, to turn the symbolizing into the symbolized itself, to regain pure language fully formed from the linguistic flux, is the tremendous and only capacity of translation. In this pure language—which no longer means or expresses anything but is, as expressionless and creative Word, that which is meant in all languages—all information, all sense, and all intention finally encounter a stratum in which they are destined to be extinguished. This very stratum furnishes a new and higher justification for free translation; this justification does not derive from the sense of what is to be conveyed, for the emancipation from this sense is the task of fidelity. Rather, freedom proves its worth in the interest of the pure language by its effect on its own language. It is the task of the translator to release in his own language that pure language which is exiled among alien tongues, to liberate the language imprisoned in a work in his re-creation of that work. For the sake of the pure language, he breaks through decayed barriers of his own language. Luther, Voss, Hölderlin, and George have extended the boundaries of the German language.—What remains for sense, in its importance for the relationship between translation and original, may be expressed in the following simile. Just as a tangent touches a circle lightly and at but one point—establishing, with this touch rather than with the point, the law according to which it is to continue on its straight path to infinity—a translation touches the original lightly and only at the infinitely small point of the sense, thereupon pursuing its own course according to the laws of fidelity in the freedom of linguistic flux. Without explicitly naming or substantiating it, Rudolf Pannwitz has characterized the true significance of this freedom. His observations are contained in *Die Krisis der europäischen Kultur,* and rank with Goethe's notes to the *Westöstlicher Divan* as the best comment on the theory of translation that has been published in Germany. Pannwitz writes: "Our translations, even the best ones, proceed from a mistaken premise. They want to turn Hindi, Greek, English into German instead of turning

German into Hindi, Greek, English. Our translators have a far greater reverence for the usage of their own language than for the spirit of the foreign works. . . . The basic error of the translator is that he preserves the state in which his own language happens to be instead of allowing his language to be powerfully affected by the foreign tongue. Particularly when translating from a language very remote from his own, he must go back to the primal elements of language itself and penetrate to the point where work, image, and tone converge. He must expand and deepen his language by means of the foreign language. It is not generally realized to what extent this is possible, to what extent any language can be transformed, how language differs from language almost the way dialect differs from dialect. However, this last is true only if one takes language seriously enough, not if one takes it lightly."

The extent to which a translation manages to be in keeping with the nature of this form is determined objectively by the translatability of the original. The lower the quality and distinction of its language, the greater the extent to which it is information, the less fertile a field it is for translation, until the utter preponderance of content, far from being the lever for a well-formed translation, renders it impossible. The higher the level of a work, the more it remains translatable even if its meaning is touched upon only fleetingly. This, of course, applies to originals only. Translations, in contrast, prove to be untranslatable not because of any inherent difficulty but because of the looseness with which meaning attaches to them. Confirmation of this as well as of every other important aspect is supplied by Hölderlin's translations, particularly those of the two tragedies by Sophocles. In them the harmony of the languages is so profound that sense is touched by language only the way an aeolian harp is touched by the wind. Hölderlin's translations are prototypes of their form; they are to even the most perfect renderings of their texts as a prototype is to a model, as can be aptly demonstrated by comparing Hölderlin's and Rudolf Borchardt's translations of Pindar's Third Pythian Ode. For this very reason, Hölderlin's translations in particular are subject to the enormous danger inherent in all translations: the gates of a language thus expanded and modified may slam shut and enclose the translator in silence. Hölderlin's translations from Sophocles were his last work; in them meaning plunges from abyss to abyss until it threatens to become lost in the bottomless depths of language. There is, however, a stop. It is vouchsafed in Holy Writ alone, in which meaning has ceased to be the watershed for the flow of language and the flow of revelation. Where the literal quality of the text takes part directly, without any mediating sense, in true language, in the Truth, or in doctrine, this text is unconditionally translatable. To be sure, such translation no longer serves the cause of the text, but rather works in the interest of languages. This case demands boundless confidence in the translation, so that just as language

and revelation are joined without tension in the original, the translation must write literalness with freedom in the shape of an interlinear version. For to some degree, all great texts contain their potential translation between the lines; this is true above all of sacred writings. The interlinear version of the Scriptures is the prototype or ideal of all translation.

Written in 1921; published in *Charles Baudelaire, "Tableaux parisiens": Deutsche Übertragung mit einem Vorwort über die Aufgabe des Übersetzers, von Walter Benjamin* [Charles Baudelaire, "Tableaux parisiens": German Translation, with a Foreword on the Task of the Translator, by Walter Benjamin], 1923. Translated by Harry Zohn.

Notes

1. "The imperfection of languages consists in their plurality; the supreme language is lacking: thinking is writing without accessories or even whispering, the immortal word still remains silent; the diversity of idioms on earth prevents anyone from uttering the words which otherwise, at a single stroke, would materialize as truth."—*Trans.*

Notes for a Study of the Beauty of Colored Illustrations in Children's Books

Reflections on Lyser[1]

Compare the dialogue on the rainbow.[2] The paint applied in watercolors there differs from the colors of painting, which make marks. What appears in the shape of marks addresses through the act of perception the entire metaphysical nature of man, and the imagination speaks in it inseparably from the authentic and morally tinged yearning of mankind. By the same token, where the color, the transparent or glowing brightness of the color, impairs its relation to the surface, painting, however delightful it may be, always verges on the empty effect, in which the imagination is unharnessed from the heart and races around aimlessly (a picture by Dosso Dossi springs to mind).—In the pictures in children's books, the object and the great autonomy of the graphic medium (woodcut or engraving) ensures that there can be no question of the kind of synthesis of heart and imagination which painting achieves with marks. On the contrary, here the imagination may and even must be allowed to roam free, so that it can produce in its own medium what the spirit of the drawing has in mind.

Children's books do not serve to introduce their readers directly into the world of objects, animals, and people, into so-called life. Rather, if anything remotely similar to the Platonic anamnesis actually exists, it would take place in the lives of children, for whom picture books are paradise. By remembering, they learn; what you put into their hands should have, insofar as human hand can impart it to paper, the color of paradise, just as a butterfly's wings have their patina. Children learn in the memory of their first intuition. And they learn from bright colors, because the fantastic play of color is the home of memory without yearning, and it can be free of yearning because it is unalloyed. In that sense, the Platonic anamnesis is not quite the form of memory specific to children. For it is not without yearning

and regret, and this tension with the messianic is the exclusive effect of genuine art, whose recipient learns not from memory alone but from the yearning that it satisfies too soon and therefore too slowly.

If our painters nowadays again evoke these colors in their aquarelles, this should not seduce us into too great a pleasure, too liberated a joy, in looking at them; and where this does happen, it is rare for the painter (Richard Seewald) to be quite without guilt. A complete renunciation of the spirit of true art is the precondition for the imaginative use of color. Incomparable, however, is the feeling of calm that steals over us when we see such pictures modestly and namelessly dedicated to children. Paradise is as far removed from the apocalypse (though this apocalypse is a hesitant one) as the latter is from art.

For adults, the yearning for paradise is the yearning of yearnings. Not the yearning for fulfillment, but the yearning to be without yearning.

The gray Elysium of the imagination is, for the artist, the cloud in which he rests and the wall of cloud on the horizon of his visions. This wall opens up for children, and more brightly colored walls can be glimpsed behind it.

> Motto: A soft green glow in the evening red.
> —Fritz Heinle

Plan:

1. Pure color and mark

2. Space, color, and imagination

3. *Pure color and memory*

4. Paradise

5. Children and the memory of paradise

Aspects of style in Heinrich Hoffmann's books for children:

Fantasy and irony, both thoroughly Romantic. But the imagination of Jean Paul, not that of Tieck; extreme exuberance.[3] Furthermore, rejection of every synthetic principle. The strictest individualization through color. Görres' critique of bouquets.[4] (Unable to find it!)

See the "background" in the watercolor illustrations in children's books, in contrast to those of pictures in "Signs and Marks."[5]

Fragment written in 1918–1921; unpublished in Benjamin's lifetime. Translated by Rodney Livingstone.

Notes

1. Johann Peter Lyser (1804–1870), author, graphic artist, and music critic. Benjamin admired his illustrations for children's books; see his remarks in "Old Forgotten Children's Books," below.—*Trans.*

2. Benjamin's own text, "Der Regenbogen"; see *Gesammelte Schriften,* vol. 7, pp. 19–26.
3. Benjamin here contrasts the rather controlled, self-conscious, high Romantic imagination of Ludwig Tieck (1773–1853) with the wild effulgence of Jean Paul Richter (1763–1825), who continues to escape categorization.—*Trans.*
4. Joseph von Görres (1776–1848), journalist and historian, was the publisher of the important liberal newspaper *Der Rheinische Merkur.*—*Trans.*
5. See Benjamin's essay "Painting, or Signs and Marks," in this edition.

Riddle and Mystery

Riddles appear where there is an emphatic intention to elevate an artifact or an event that seems to contain nothing at all, or nothing out of the ordinary, to the plane of symbolic significance. Since mystery dwells at the heart of symbol, an attempt will be made to uncover a "mysterious" side to this artifact or event. In the case of "profane" objects in the narrower sense, however, this attempt is doomed never to reach its goal. If you try to capture its mysterious side in a description that relates to it as a riddle does to its solution, then the appearance [*Schein*] of mystery will last only so long as that solution has not been found. In other words, since the solution exists objectively, the appearance is merely subjective. The only objective element is the intention that addresses a mystery, the insoluble aspect of the artifact or event, an intention that is ultimately disappointed. Nonetheless, the disappointment is not total, since in the last analysis there is an objective reason for the subjective appearance of the mystery inherent in an artifact or event. But that reason does not lie in the fact that the artifacts or events are a mystery; it lies in the fact that they, like all being, have a share in mystery—a share that, in the case of the profane, can never achieve an independent existence but is always bound to something else: to a solution in the case of a riddle, to a meaning in the case of a word. For precisely as word all being exists in a state of mystery by virtue of the symbolic force of the word, and in an ambiguous sense—which is constitutive for the nature of a riddle, the key to the riddle [*Rätselwort*]—is not only its solution, as the thing that thwarts it, but also its intention, its precondition, its foundation and the "resolution" of the intent to puzzle that is concealed in it. Since the words that are a "riddle" from the outset contain a symbolic core,

beyond the meaning communicated in it, a core that is the symbol of noncommunicability.

For this reason many riddles can be solved simply through an image, but they can be redeemed only through the word.—In this context riddles such as word puzzles, homonyms, syllable puzzles, and the like, all of which are based on words and are relatively recent in origin, are less significant than the riddles of primitive peoples, which are often or indeed always based on situations that do not need to be rooted in words. The question they pose can be *solved* only in words that break in with their entire immediacy and are all the more potent in helping the concealed intent of the riddle to arrive at its redemption.

For in the final analysis, mystery can be thought only in the acts of the living being that carries them out, not in things. It follows from this that the symbol which is a mystery can be thought only as the act of a living being that itself is completely at rest. This living being is always God.

Adam's naming of the creatures in Genesis is intended as a repudiation of the mythical view that names are riddles that have to be guessed—as, for example, in Theodor Storm's *Regentrude,* and in fairy tales. The Jewish name (in Hebrew) is a mystery.

See Wolfgang Schultz, *Rätsel, aus dem hellenischen Kulturkreis* [Riddles, from Hellenic Culture]. Collected and edited, 2 parts (Berlin, 1909–1912).

Fragment written in 1920–1921; unpublished in Benjamin's lifetime. Translated by Rodney Livingstone.

Outline for a *Habilitation* Thesis

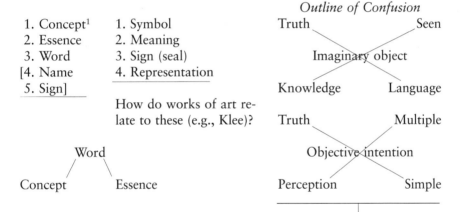

1. Concept[1] 1. Symbol
2. Essence 2. Meaning
3. Word 3. Sign (seal)
[4. Name 4. Representation
5. Sign]
 How do works of art re-
 late to these (e.g., Klee)?

Outline of Confusion

Truth Seen
 Imaginary object
Knowledge Language

Truth Multiple
 Objective intention
Perception Simple

Word
Concept Essence

Theorems on Symbolism

1. No material objects as such correspond to God.

2. No material object and no symbol reaches God.

3. Certain material objects can be fulfilled only in an ascribed objective intention, and they then *point* to God. These are objects of the highest order.

4. The object of a symbol is imaginary. A symbol means nothing, but is, in accordance with its essence, the unity of the sign and the intention that fulfills its object. This unity is an *objectively* intentional one; its object is imaginary.

5. We may not ask what the meaning of a symbol is, but may ask only how, in the realm of what objective intention and what signs, it has come about.

6. There is a great multiplicity of objective intentions. (Memory—remembrance, fidelity (in portraying something)—copy, philosophy—truth, penance—purification, and so on.)

Remembrance = Holy Communion

Regarding point 4:
Equivocations in the concept of symbol

We call symbol

1. the totality (e.g., the Cross of Christ)

2. the sensuous part of this (e.g., the Cross)

Now the *actual material* aspect of (1) and (2) coincide. We must therefore say that the symbol (as in (2)) is identical with itself (1) in the sense of what is meant. (In other words, the cross is the cross of Christ. Or, as in Luther, the bread *is* the body of Christ.) To say "means" instead of "is" would be even more false. What is the totality? Apart from the identity, nothing can be said about it. The imaginary nature of the object is shown by the way in which predicative judgments just dry up. Therefore, in the last analysis the Greek *sumballein* is unimportant because it applies only to the actual materiality in the symbol.

Correct terminology

1. Symbol: the Cross of Christ

2. Symbolizer: a cross

3. Symbolized: an imaginary object

———— symbol
———— perception
———— knowledge

Fragment written in 1920–1921; unpublished in Benjamin's lifetime. Translated by Rodney Livingstone.

Notes

1. In 1920 and 1921 Benjamin's interest in the philosophy of language led him to explore the possibility of writing a *Habilitation* thesis (the "second dissertation" required of German academics), while he was in Switzerland. This fragment, as well as "According to the Theory of Duns Scotus" and "Language and Logic (I–III)," was composed as part of that process.—*Trans.*

Language and Logic

I

Sheet of paper has gone missing; must look for it at home. It contained:

1. The discussion of the concept of "system" and the doctrine of the extinguishing of intention in the truth, explained in terms of the veiled image of Sais.[1]
2. Discussion of the concept of "essence" as the mark of truth.

II

. . . and so the characteristics of human beings are to be counterpoised as alien to one another, and so the harmony of the spheres resounds from their orbits, which do not come into contact with one another. Every essential being is a sun and relates to beings like itself, as suns in fact relate to one another. This also applies in the realm of philosophy, which is the only realm in which the truth becomes manifest, namely with a sound like music. And this is the harmonic concept of truth, which we must acquire so that the false quality of watertightness that characterizes its delusion vanishes from the authentic concept, the concept of truth. The truth is not watertight. Much that we expect to find in it slips through the net.

The relation of these things to the forms of a system remains to be investigated. See, too, the "veiling power of knowledge" in the notes to "The New Melusine."[2]

The relation between concepts—and this relation governs the sphere of knowledge—is one of subsumption. The lower concepts are contained in

the higher ones—that is to say, in one sense or another what is known loses its autonomy for the sake of what it is known as. In the sphere of essences, the higher does not devour the lower. Instead, it rules over it. This explains why the regional separation between them, their disparateness, remains as irreducible as the gulf between monarch and people. The legitimacy that characterizes their relations possesses canonical validity for the relation between the unity of essence and the multiplicity of essences. (The unity of essence is of the same kind as the essence of whose multiplicity we are speaking. But it is *not* the unity *of* the essences.) The relation between monarch and people makes very clear that in the sphere of essence questions of legitimacy are questions of authenticity and ultimately of origins. In this context, the question of origins is quite different from the pseudo-question of origins in the relations between concept and subconcept. For here the derivation is an illusion, since the mode and number of specifics of the concept that occur in the subconcept are a matter of chance. In contrast, every essence possesses from the outset a limited—and moreover determinate—multiplicity of essences, which do not derive from the unity in a deductive sense but are empirically assigned to it as the condition of its representation and articulation. The essential unity reigns over a multiplicity of essences in which it manifests itself, but from which it always remains distinct. A thoroughgoing system of control of this sort can be called the integration of manifestations into systems of multiple essences.

The multiplicity of languages is such a plurality of essences. The doctrine of the mystics concerning the degeneration of the true language stands on false ground if it bases its argument on the dissolution into many languages. That multiplicity would simply amount to the contradiction of a primordial and God-willed unity, but the multiplicity of languages is not the product of decadence any more than is the multiplicity of peoples, and indeed is so far removed from any such decay that we might be justified in asserting that this multiplicity expresses their essential character. Therefore, this doctrine should not focus on the dissolution into many languages as the primary issue, but, rather, must speak of the fact that the integral power to rule becomes increasingly impotent. If we interpret this in the spirit of the mystics as pointing to a revealed unity of a linguistic kind, it will mean not just that this primordial language is the one originally spoken, but that the harmony originally created by those spoken languages was of incomparably greater power than any of the individual languages could possibly possess.

III

"In a certain sense it may be doubted whether Plato's theory of 'Ideas' would have been possible, if the very meaning of the word had not suggested to the philosopher, who was familiar only with his mother tongue, a deification of the verbal concept, a deification of the words. Plato's 'Ideas' are basi-

cally—if for once we may consider them from this one-sided standpoint—nothing but deified words and verbal concepts." Hermann Güntert, *Von der Sprache der Götter und Geister* [The Language of Gods and Spirits] (Halle an der Saale, 1921), p. 49.

"In olden times the reputation of the priest and magician, the medicine man and shaman, was based in large measure on his knowledge and understanding of the formulas and [magic] words of the spirit language, and this higher 'knowledge' was almost everywhere an anxiously kept secret; druids, brahmins, and shamans all understood exactly the basis of their own power" (ibid., p. 35).—Nothing would justify describing such linguistic knowledge as a mere agglomeration of magic formulas. On the contrary, the power of these formulas was guaranteed by a knowledge, a theoretical knowledge, which is tied to language. That a pure type of such knowledge beyond the depths of magic can exist in truth as a system remains to be proved by an understanding of the relations of language and logic.

The taboo that is placed on certain words can lead to their extinction (ibid., p. 17).

"In olden times in particular, names and words are something like a spiritual substance, at all events something real, actual, existing, something that was felt to have the same value as body and soul. From the Old Indian and especially Buddhist philosophy, we have the expression *namarupa*—'name and appearance,' to designate the essence of a thing;[3] in the teachings of Mimamsa, we encounter a similar concept, *namaguna*—'name and attribute.'"[4]

"The well-known ambiguity and obscurity of the oracles is based entirely on . . . periphrases which do no more than hint at what is meant, but do not express it sharply and clearly. In this sense the celebrated word *EI*, which enigmatically greeted the stranger to the temple in Delphi is symptomatic of the general practice of the Pythia. To say 'wooden walls' instead of 'ships' is then a stylistic peculiarity of sacred speech, and it is surprising that in Homer the emergence of special periphrases in religious speech, these *sacred metaphors*, begins in the speech of the Gods themselves. 'The Lord to whom the oracle in Delphi belongs says nothing and conceals nothing; instead he signifies,' remarks Heraclitus" (ibid. p. 121).—The language of philosophers, too, is periphrastic in a certain sense: it steps back from the ordinary. And in this context, it is also significant that philosophical discourse cannot, by its very nature, allow itself to be drawn into providing examples by way of illustration. "It does not speak the language of mankind."

Fragment written in 1920–1921; unpublished in Benjamin's lifetime. Translated by Rodney Livingstone.

Notes

1. In *The Origin of German Trauerspiel* Benjamin remarks, "Truth is the death of intention. This, indeed, is just what could be meant by the story of the veiled image of Sais, the unveiling of which was fatal for anyone who thought to learn the truth thereby. It is not some enigmatic cruelty in actual meaning that brings this about, but the very nature of truth, in the face of which even the purest fire of the spirit of inquiry is quenched."—*Trans.*

2. See J. W. von Goethe, *Wilhelm Meister's Wanderings* [*Wilhelm Meisters Wanderjahre*]. "The New Melusine" is a self-contained story inserted into the novel.—*Trans.*

3. S. Oldenburg, *Buddha* (1906), pp. 46, 262ff; and idem, *Weltanschauung der Brahmanischen Texte* [World View of the Brahmanic Texts] (1919), p. 105.

4. *Satapatha Brahmana* XI, 2, 3, 1. It says there, "The universe extends as far as shape and name." See Güntert, p. 5.

Theory of Knowledge

The *truth* of a given circumstance is a function of the constellation of the true *being* of all other circumstances. This function is identical with the function of the system. The true *being* (which as such is naturally unknowable) is part and parcel of the infinite task. However, we have to ask about the medium in which truth and true being are conjoined. What is this neutral medium?

Two things must be overcome:

1. The false disjunction: knowledge is either in the consciousness of a knowing subject or else in the object (alternatively, identical with it).

2. The appearance of the knowing man (for example, Leibniz, Kant).

The two tasks facing the theory of knowledge are:

1. The constitution of things in the now of knowability;[1]

2. The limitation of knowledge in the symbol.

Regarding point 1. The sentence: Truth belongs in one sense or another to the perfected state of the world, grows catastrophically to that other sentence, grows by the dimension of the "now": the world is knowable *now.* Truth resides in the "now of knowability." Only in this is there a (systematic, conceptual) *nexus*—a nexus between existing things and also with the perfected state of the world. The now of knowability is *logical time,* which has to replace that of timeless validity. Perhaps the concept of "universal validity" belongs in this nexus.

Regarding point 2. Acts, like perception, enter only disjointedly, inauthen-

tically, and without reality into the now of knowability. They become authentic and unbroken only in the perfected state of the world. Truth, too, is authentic and unbroken in the perfected state of the world, but it alone is also whole in the now of knowability. In other words, it contains *unbroken* only itself. An act is—in connection with the perfected state of the world—not what happens *now* or "soon"; a demand cannot demand, or command, anything now. They enter disjointedly, in *symbolic concepts,* into the now of knowability, for this now is filled and governed exclusively by knowability. The now of an act, its authentic existence in the perfected state of the world, is not, like that of truth, also in the now of knowability. That existence *in* the perfected state of the world exists then without context, and even without any connections with *this* state of the world. Actually, however, it is erratic, disconnected, utterly unknowable. The symbolic concepts: primal phenomena.

Fragment written in 1920–1921; unpublished in Benjamin's lifetime. Translated by Rodney Livingstone.

Notes

1. Benjamin's phrase *das Jetzt der Erkennbarkeit* emerges in the 1930s at the center of the theory behind the Arcades Project. Owing to the different context, it is translated there as "the now of recognizability."—*Trans.*

Truth and Truths / Knowledge and Elements of Knowledge

"Knowledge" in the objective sense is defined as the quintessence of all acts of knowing. If the word "all" in this definition is taken in its strict and absolute sense, if it extends to the totality of knowledges in general and not just to all that is known of a particular subject, then the *concept of knowledge* marks an illusory point of intersection. Only in its multiplicity does the concept of knowledge stand up. Its unity cannot lie in its own sphere; it cannot be a summation, a judgment. If by "unity" is meant a unity not just of knowings but also as knowledge, then there is no such thing as a unity of knowings.

Truth rightly occupies the systematic place that has been so frequently usurped by the illusory aggregate of knowledge. Truth is the quintessence of knowings as symbol. Yet it is not the aggregate of all truths. Truth expresses itself in a system or in its conceptual summary. Truths, however, can be expressed neither systematically nor conceptually—much less with acts of knowledge in judgments—but only in art. Works of art are the proper site of truths. There are as many ultimate truths as there are authentic works of art. These ultimate truths are not elements but genuine parts, pieces, or fragments of the truth; in themselves, however, they offer no possibility of interconnection and are not to be completed through one another. The instances of knowledge, in contrast, are neither parts nor fragments of the truth and therefore are not of the same nature as it; they are lower and, as it were, less well-organized material from which the higher portion is constructed (as though from its elements?).

The chimerical nature of the aggregate of knowledge should be shown.

On the relation of knowledge to truth, see Goethe, *Materialen zur*

Geschichte der Farbenlehre [Materials on the History of the Theory of Color], section 1: Greeks and Romans—Observations . . .

> Since in knowledge, as in reflection, no totality can be created, because the first lacks the inner [*das Innere*] and the second the outer [*das Äußere*], we must necessarily think of science as art if we are to hope for totality of any kind from it. Moreover, we are not to look for this totality in the general, in the superabundant, but since art always constitutes itself wholly in every work of art, science, too, should manifest itself entirely in each application.

He immediately follows this up by speaking of science in the sense of a work of art, "whatever its content may be" (Goethe, *Sämtliche Werke* [Complete Works; Stuttgart, 1875], vol. 10, p. 361).

An accurate judgment is described as knowledge. I may judge this knowledge to be "correct." But I may not judge what I call "correct" to be "true" as well. If I call a judgment correct, I mean the judgment as a whole, unchanged, as it stands. But if I say it is true, I mean that it is true that this judgment is correct. The correctness of the judgment has a bearing on its truth, and this is what I mean when I say, "This sentence is true." The correctness of a piece of knowledge is never identical with its truth, but every correct assertion has a relation with the truth. Moreover, all correct statements are of the same kind. The statement "Every fly has six legs" is correct in exactly the same way as the statement 2 x 2 = 4. However, the truth of these two statements is different in each case. For the correctness of the second assertion has a profounder relation to truth than that of the first.

Knowledge and truth are never identical; there is no true knowledge and no known truth. Nevertheless, certain pieces of knowledge are indispensable for an account of the truth.

Fragment written in 1920–1921; unpublished in Benjamin's lifetime. Translated by Rodney Livingstone.

Imagination

The German language possesses no native term to describe the forms [*Gestalten*] of the imagination. Only the word "manifestation" [*Erscheinung*] may in one specific sense be regarded as such. And in fact imagination has nothing to do with forms or formations. It does indeed take its manifestations from them, but the connection between them and the imagination is so far from being inexorable that we might rather describe the manifestations of the imagination as the de-formation [*Entstaltung*] of what has been formed. It is characteristic of all imagination that it plays a game of dissolution with its forms. The world of new manifestations that thus comes into being as the result of this dissolution of what has been formed has its own laws, which are those of the imagination. Its supreme law is that, while the imagination de-forms, it never destroys. Instead the manifestations of the imagination arise in that region of the form in which the latter dissolves itself. That is to say, the imagination does not itself dissolve, for where it attempts this it becomes fantastic. Fantastic objects arise where the process of de-formation does not proceed from within the heart of the form itself. (The only legitimate form of the fantastic is the grotesque, in which the imagination does not de-form in a destructive fashion but destructively over-forms [*überstaltet*]. The grotesque is a marginal form in the realm of the imagination; it stands at the extreme margins where the latter strives once again to become form.) All fantastic objects possess an element of the constructive—or (seen from the standpoint of the subject) of spontaneity. Genuine imagination, in contrast, is unconstructive, purely de-formative—or (from the standpoint of the subject) purely negative.

The imaginative de-formation of objects is distinguishable from the de-

structive collapse of the empirical by two features. First, it is without compulsion; it comes from within, is free and therefore painless, and indeed gently induces feelings of delight. Second, it never leads to death, but immortalizes the doom it brings about in an unending series of transitions. The first of these features means that, through a pure act of conceiving, the objective realm of imaginative de-formation, a world of painless birth, corresponds to the subjective conception of the imagination. Thus, all de-formation of the world will imagine a world without pain that is nevertheless permeated by a rich flow of events. This de formation shows further—as the second feature makes clear—the world caught up in the process of unending dissolution; and this means eternal ephemerality. It is like the sun setting over the abandoned theater of the world with its deciphered ruins. It is the unending dissolution of the purified appearance of beauty, freed from all seduction. However, the purity of this appearance in its dissolution[1] is matched by the purity of its birth. It appears different at dawn and at dusk, but not less authentic. Thus, there is a pure appearance, a burgeoning one, at the dawn of the world. This is the radiance that surrounds the objects in Paradise.[2] Last, there is a third, pure appearance: the reduced, extinguished, or muted one. It is the gray Elysium we see in pictures by Marées.[3] These are the three worlds of pure appearance that belong to the imagination.

De-formation is not confined to the world of light, even if, as pure appearance, it is most obvious there. De-formation occurs also in the acoustic realm (so that, for example, the night can reduce noises to a single great humming), or the tactile (as when the clouds dissolve in the blue or the rain). All manifestations of de-formation in nature must be surveyed, if the world of the imagination is to be described.

Pure conceiving is the basis of every work of art. And it is always directed at two features: at the ideas and at nature in the process of de-forming itself. This means that every work of art is grounded in the imagination. Perhaps, even probably, to varying degrees. However, imagination is always incapable of constructing a work of art because as a de-forming agent it must always refer to something formed beyond itself, which then, when it enters the work, must itself become of fundamental importance for the work. Whenever such a formed element does not enter the work but is kept at a distance from it, for reasons of sentiment, pathos, or irony, such works regard the world of forms as a text to which they provide a commentary or an arabesque. Because they point beyond themselves, they are no more pure works of art than are riddles. This criticism applies to most of the works of Jean Paul, who had the greatest imagination and who, in this spirit of pure conceiving, came closest to the minds of children.[4] It was this that enabled him to become the outstanding pedagogue that he was.—In the expression of the work, only language sometimes has the power to incor-

porate the imagination, for only language is able, in the most fortunate case, to keep the de-forming powers under control. They mainly eluded Jean Paul's grasp. Shakespeare is—in his comedies—their incomparable master. This power of language over the imagination stands in need of explanation. It would also be important to demonstrate that a chasm separates Romantic irony from true imagination, for all the interaction between them in the shift from early to late Romanticism.

[The exact opposite of imagination is prophetic vision. Pure prophetic vision cannot form the basis of a work, yet such vision enters into every great work of art. Prophetic vision is the ability to perceive the forms of the future; imagination is the awareness of the de-formations of the future. Prophecy is genius for premonition; imagination is the genius for forgetting. Their perceptive intention is not based in either case on a cognitive intention (anymore than clairvoyance), but in a different manner in each instance.

The imagination knows only constantly changing transitions.

In the great drama of the passing away of nature, the resurrection of nature repeats itself as an act. (Sunrise) / Imagination plays a role on the last day of the world and the first.]

Pure imagination is concerned exclusively with nature. It creates no new nature. Pure imagination, therefore, is not an inventive power.

Fragment written in 1920–1921; unpublished in Benjamin's lifetime. Translated by Rodney Livingstone.

Notes

1. This purity of nature in the process of perishing corresponds to the destruction of mankind.
2. One is reminded of Otto Runge. [Philipp Otto Runge (1777–1810): he and Caspar David Friedrich were the most important painters associated with German Romanticism.—*Trans.*]
3. Hans von Marées (1837–1887), German painter.—*Trans.*
4. Jean Paul Richter (1763–1825) wrote a series of wildly extravagant, highly imaginative novels that, in their combination of fantasy and realism, continue to defy categorization.—*Trans.*

Beauty and Semblance

I

Every living thing that is beautiful has semblance [*ist scheinhaft*].

II

Every artistic thing that is beautiful has semblance [*Schein*] because it is alive in one sense or another.

III

There remain only natural, dead things which can perhaps be beautiful without having semblance.

Fragment written in 1920–1921; unpublished in Benjamin's lifetime. Translated by Rodney Livingstone.

The Philosophy of History of the Late Romantics and the Historical School

In a certain sense, the sterility that attaches to this philosophy of history,[1] despite this philosophy's important ideas, originated in one of its characteristic modern features. With many scientific theories of the modern age, it shares an absolutism of method. Since the Middle Ages, we have lost our insight into the complex layers that compose the world and its best features. These layers have in part an ontological status, which is to say they form a scale that advances from existence to appearance.—The philosophy of history of the Restoration goes down in our esteem in proportion as it insists on the "growth" of history as the sole form of historical movement. And to the same degree, apparent insights take the place of insights into the appearances that also govern history.—What has come to be seen as the problem of this philosophy of history can be formulated as the question of its treatment of the problem of growth. Its philosophical genius lies in the fact that its theoretical and practical stances were identical—lies in the only mode of behavior it acknowledged. This consisted in observation. For the Romantics, unlike modern thinkers, observation was not just a theoretical form of behavior. If we may distinguish between an early and a late Romantic theory of observation, we should discover at the theory's center, in the former case, reflection, and, in the latter case, love. What they had in common was a belief in the efficacy of observation. For the Late Romantics, observation was a sun beneath whose rays the object of love opens up to further growth. But if its rays were withheld, the object of love remained in the dark and wilted. In the spectrum of variations in these modes of behavior, practical as well as scientific points of view were relevant. For the power that is ascribed here to observation is basically identical to the gaze of the father in education. The growing child must be conscious not just of the

vigilance of the paternal eye but of what can ensue when that eye brightens or clouds over. This nonviolent control, which admittedly must start as soon as the child is born, has more influence on the child in essential matters than anything else (more than corporal punishment and above all more than the much-vaunted power of example). By the same token, it is much more important for the father, too, than reflection. For as his gaze follows, his eye learns to see what is appropriate to the child. And only he who has learned from the sight of many things possesses the power of contemplation. This defines precisely the stance of the scholars of the Historical School. Nevertheless, the hypothesis that forms the foundation of their approach fails, the more the contemplation of history lays claim to a universality that goes beyond the obligations of a father's love. For the latter is in fact essentially, if not exclusively, concerned with growth. Its attitude to all human growth is exemplary. Contrast the historian. His pedagogic authority is all the more insecurely based because the scope of his investigations is incalculable. Moreover, they are by no means confined to the soil of peaceful growth but necessarily encompass the realm of bloody conflict. This realm should not be ignored. We may regard it as one of those regions whose particular sovereignty—and the categories appropriate to it—can no longer be grasped by modern thought, let alone that the latter might have been capable of bearing the entire universe of history, divided into its particular spheres. In the "organic" view of the world, too many things collapsed into one another. But ultimately this view betrays its own limitations when its preoccupation with the ideal of an unspoiled state of nature and its belief in the "beautiful" development of a nation leads it openly to abandon true historical—that is to say, religious and pragmatic—observation, and lapse into a stance that oscillates helplessly between the ethical and the aesthetic, a lapse that no methodology can escape if it lacks the power to disentangle the various strata of the real world. The links between them can be clarified by theology, but only where the mediations of philosophy leave their natural tensions unresolved.

On chronicles. The system of categories outlined here applies to them.

The relation between historical contemplation and historical construction.

Fragment written in 1921; unpublished in Benjamin's lifetime. Translated by Rodney Livingstone.

Notes

1. The Historical School of Law denied that law could be deduced from universal abstract principles (natural law) and claimed instead that it arose from the collective unconscious (the "spirit of the people") in the course of a historical process. Accordingly, it could be comprehended only historically. Its founder was Karl Friedrich von Savigny (1779–1861).—*Trans.*

The Meaning of Time in the Moral Universe

It is customary to regard the legal institutions which permit us to establish the facts and judgments that obtained in times long past as nothing but the consolidated intentions of morality. What endows the law with this interest in the distant past and with power over it, however, is something very different indeed from the representation of the presence of morality in the past. The law actually derives these features from a tendency that sets it off sharply from the moral universe. This is the tendency to retribution. In modern law, retribution is confined to thirty years, a generation, even in the extreme case of murder—as if it were afraid to exceed the span of a human life. Yet we know from older forms of law that the power of retribution was able to extend its sway to succeeding, increasingly distant generations. Retribution is fundamentally indifferent to the passage of time, since it remains in force for centuries without dilution, and even today what is actually, at bottom, a heathen conception still pictures the Last Judgment along these lines. The Last Judgment is regarded as the date when all postponements are ended and all retribution is allowed free rein. This idea, however, which mocks all delay as vain procrastination, fails to understand the immeasurable significance of the Last Judgment, of that constantly postponed day which flees so determinedly into the future after the commission of every misdeed. This significance is revealed not in the world of law, where retribution rules, but only in the moral universe, where forgiveness comes out to meet it. In order to struggle against retribution, forgiveness finds its powerful ally in time. For time, in which Ate[1] pursues the evildoer, is not the lonely calm of fear but the tempestuous storm of forgiveness which precedes the onrush of the Last Judgment and against which

she cannot advance. This storm is not only the voice in which the evildoer's cry of terror is drowned; it is also the hand that obliterates the traces of his misdeeds, even if it must lay waste to the world in the process. As the purifying hurricane speeds ahead of the thunder and lightning, God's fury roars through history in the storm of forgiveness, in order to sweep away everything that would be consumed forever in the lightning bolts of divine wrath.

What we have expressed here metaphorically must be capable of being formulated clearly and distinctly in conceptual form: the meaning of time in the economy of the moral universe. In this, time not only extinguishes the traces of all misdeeds but also—by virtue of its duration, beyond all remembering or forgetting—helps, in ways that are wholly mysterious, to complete the process of forgiveness, though never of reconciliation.

Fragment written in 1921; unpublished in Benjamin's lifetime. Translated by Rodney Livingstone.

Notes

1. Atē, a daughter of Zeus, was the personification of infatuation or moral blindness in which right and wrong cannot be distinguished. See Homer, *Iliad,* book 19, lines 87ff.—*Trans.*

Capitalism as Religion

A religion may be discerned in capitalism—that is to say, capitalism serves essentially to allay the same anxieties, torments, and disturbances to which the so-called religions offered answers. The proof of the religious structure of capitalism—not merely, as Weber believes, as a formation conditioned by religion, but as an essentially religious phenomenon—would still lead even today to the folly of an endless universal polemic. We cannot draw closed the net in which we are caught. Later on, however, we shall be able to gain an overview of it.

Nevertheless, even at the present moment it is possible to distinguish three aspects of this religious structure of capitalism. In the first place, capitalism is a purely cultic religion, perhaps the most extreme that ever existed. In capitalism, things have a meaning only in their relationship to the cult; capitalism has no specific body of dogma, no theology. It is from this point of view that utilitarianism acquires its religious overtones. This concretization of cult is connected with a second feature of capitalism: the permanence of the cult. Capitalism is the celebration of a cult *sans rêve et sans merci* [without dream or mercy]. There are no "weekdays." There is no day that is not a feast day, in the terrible sense that all its sacred pomp is unfolded before us; each day commands the utter fealty of each worshiper. And third, the cult makes guilt pervasive. Capitalism is probably the first instance of a cult that creates guilt, not atonement. In this respect, this religious system is caught up in the headlong rush of a larger movement. A vast sense of guilt that is unable to find relief seizes on the cult, not to atone for this guilt but to make it universal, to hammer it into the conscious mind, so as once

and for all to include God in the system of guilt and thereby awaken in Him an interest in the process of atonement. This atonement cannot then be expected from the cult itself, or from the reformation of this religion (which would need to be able to have recourse to some stable element in it), or even from the complete renouncement of this religion. The nature of the religious movement which is capitalism entails endurance right to the end, to the point where God, too, finally takes on the entire burden of guilt, to the point where the universe has been taken over by that despair which is actually its secret *hope*. Capitalism is entirely without precedent, in that it is a religion which offers not the reform of existence but its complete destruction. It is the expansion of despair, until despair becomes a religious state of the world in the hope that this will lead to salvation. God's transcendence is at an end. But he is not dead; he has been incorporated into human existence. This passage of the planet "Human" through the house of despair in the absolute loneliness of his trajectory is the ethos that Nietzsche defined. This man is the superman, the first to recognize the religion of capitalism and begin to bring it to fulfillment. Its fourth feature is that its God must be hidden from it and may be addressed only when his guilt is at its zenith. The cult is celebrated before an unmatured deity; every idea, every conception of it offends against the secret of this immaturity.

Freud's theory, too, belongs to the hegemony of the priests of this cult. Its conception is capitalist through and through. By virtue of a profound analogy, which has still to be illuminated, what has been repressed, the idea of sin, is capital itself, which pays interest on the hell of the unconscious.

The paradigm of capitalist religious thought is magnificently formulated in Nietzsche's philosophy. The idea of the superman transposes the apocalyptic "leap" not into conversion, atonement, purification, and penance, but into an apparently steady, though in the final analysis explosive and discontinuous intensification. For this reason, intensification and development in the sense of *non facit saltum* are incompatible.[1] The superman is the man who has arrived where he is without changing his ways; he is historical man who has grown up right through the sky. This breaking open of the heavens by an intensified humanity that was and is characterized (even for Nietzsche himself) by guilt in a religious sense was anticipated by Nietzsche. Marx is a similar case: the capitalism that refuses to change course becomes socialism by means of the simple and compound interest that are functions of *Schuld* (consider the demonic ambiguity of this word).[2]

Capitalism is a religion of pure cult, without dogma.

Capitalism has developed as a parasite of Christianity in the West (this must be shown not just in the case of Calvinism, but in the other orthodox Christian churches), until it reached the point where Christianity's history is essentially that of its parasite—that is to say, of capitalism.

A comparison between the images of the saints of the various religions and the banknotes of different states. The spirit that speaks from the ornamental design of banknotes.

Capitalism and law. The heathen character of law. Sorel, *Réflexions sur la violence* [Reflections on Violence], p. 262.

The overcoming of capitalism by migration. Unger, *Politik und Metaphysik* [Politics and Metaphysics], p. 44.

Fuchs, *Structure of Capitalist Society,* or something of the sort.

Max Weber, *Collected Essays on the Sociology of Religion* [*Aufsätze zur Religionssoziologie*], 2 vols., 1919–1920.

Ernst Troeltsch, *The Social Teachings of the Christian Churches* [*Die Soziallehren der christlichen Kirchen und Gruppen*] (*Gesammelte Werke,* vol. I, 1912).

See especially Schönberg's bibliography under II.

Landauer, *Aufruf zur Sozialismus* [Call to Socialism], p. 144.

Worries: a mental illness characteristic of the age of capitalism. Spiritual (not material) hopelessness in poverty and in vagrant, mendicant monkhood. A condition that is so bereft of hope causes guilt feelings. "Worries" are the index of the sense of guilt induced by a despair that is communal, not individual and material, in origin.

The Christianity of the Reformation period did not favor the growth of capitalism; instead it transformed itself into capitalism.

Methodologically, one should begin by investigating the links between myth and money throughout the course of history, to the point where money had drawn so many elements from Christianity that it could establish its own myth.

Wergeld / thesaurus of good works / the salary due the *priest* / Pluto as the god of wealth.

Adam Müller, *Reden über die Beredsamkeit* [Speeches on Eloquence], 1816, pp. 56ff.

Link between the dogma of the destructive—but for us both redemptive and murderous—nature of knowledge, and capitalism: the balance sheet as a knowledge that both redeems and eliminates.

It adds to our understanding of capitalism as a religion to realize that, to begin with, the first heathens certainly did not believe that religion served a "higher," "moral" interest but that it was severely practical. In other words, religion did not achieve any greater clarity then about its "ideal" or "transcendental" nature than modern capitalism does today. Therefore it, too, regarded individuals who were irreligious or had other beliefs as members of its community, in the same way that the modern bourgeoisie now regards those of its members who are not gainfully employed.

Fragment written in 1921; unpublished in Benjamin's lifetime. Translated by Rodney Livingstone.

Notes

1. *Non facit saltum:* Latin for "he cannot make the leap." In rationalist philosophy, the phrase expresses the notion that God leaves no gaps in nature.—*Trans.*
2. The German word *Schuld* means both "debt" and "guilt."—*Trans.*

Announcement of the Journal *Angelus Novus*

The journal whose plan we present here hopes to create confidence in its content by giving an account of its form.[1] This form arises from reflecting on the nature of a journal: a journal should both make a program superfluous and avoid it as an incitement to pseudo-productivity. Programs are valid only when individuals or groups have particular, well-defined goals. A journal that sets out to articulate the experience of a particular way of thinking is always far more unpredictable and unconscious than any expression of will, but by the same token it holds greater promise for the future and is capable of much greater development. Hence, such a journal would be poorly placed to give an account of itself, no matter what terms it chose to express its position. Insofar as reflection is expected of it—and in the right sense no limits can be set to reflection—it should concern itself less with ideas and credos than with foundations and governing principles, just as human beings should not be expected to have full knowledge of their own innermost tendencies but should be conscious of their vocation.

The vocation of a journal is to proclaim the spirit of its age. Relevance to the present is more important even than unity or clarity, and a journal would be doomed—like the newspapers—to insubstantiality if it did not give voice to a vitality powerful enough to salvage even its more dubious components by validating them. In fact, a journal whose relevance for the present has no historical justification should not exist at all. The Romantic *Athenäum*[2] is still a model today precisely because its claim to historical relevance was unique. At the same time it proves—if proof were needed— that we should not look to the public to supply the yardstick by which true relevance to the present is to be measured. Every journal ought to follow

the example of the *Athenäum*. It should be rigorous in its thought and unwavering in its readiness to say what it believes, without any concessions to its public, particularly where it is a matter of distilling what is truly relevant from the sterile pageant of new and fashionable events, the exploitation of which can be left to the newspapers.

Moreover, for any journal that conceives itself in this way, criticism remains the guardian of the house. If in its infancy criticism was forced to combat commonplace viciousness, the situation nowadays is different. Formerly, the stage was dominated by products that were backward-looking and tasteless and by producers who were naive bunglers. Now it is confronted at every point by talented fakes. Furthermore, for over a century every grubby literary rag in Germany has advertised itself as an organ of criticism, so that redoubled efforts are needed to restore criticism to its former strength. Both critical discourse and the habit of judgment stand in need of renewal. Only a terrorist campaign will suffice to overcome that imitation of great painting that goes by the name of literary Expressionism. If in such annihilating criticism it is essential to fill in the larger context—and how else could it succeed?—the task of positive criticism, even more than before and even more than for the Romantics, must be to concentrate on the individual work of art. For the function of great criticism is not, as is often thought, to instruct by means of historical descriptions or to educate through comparisons, but to cognize by immersing itself in the object. Criticism must account for the truth of works, a task just as essential for literature as for philosophy. Such a view of the importance of criticism is incompatible with reserving a few columns for it at the end of each issue, as an act of duty. This journal will have no "critical section" and will not stamp its critical contributions with the mark of Cain by distinguishing them typographically from the rest of the journal.

Precisely because the journal intends to devote itself to literature as much as to philosophy and criticism, the last-named must not remain silent about what it has to say concerning the first. If we are not deceived, a dangerous and in every sense crucial period for German literature began at the turn of the century. Hutten's words about the age and the joys of living in it,[3] words whose tone seemed de rigueur in the program of every journal, are as difficult for literary artists to adopt as they are for anyone else in Germany at the present time. Ever since [Stefan] George's recent enrichments of the German language have begun to look obsolete, the first work of every aspiring young writer seems to consist of a new poetic thesaurus. And little as may be expected from a school whose most enduring monument may be seen in its vigorous exposure of the limitations of a great master, even less do the transparent mechanisms of their latest productions inspire confidence in the language of their authors. Even more clearly than in the age of Klopstock—many of whose poems sound as if they are what contemporary

poets aspire to—even more completely than for centuries past, the crisis of German poetry coincides with the fate of the German language, a fate that will not be determined by knowledge, education, or taste and that in a certain sense will be decided only once the crucial statements have been ventured. However, once the frontier has been reached beyond which a provisional declaration of intent cannot responsibly go, it is superfluous to state that contributions in prose and verse will bear the above in mind and that the literary contributions of the first issue in particular desire to be understood as decisions in this spirit. Alongside these, there will be space subsequently for the work of other writers who, taking up a place in the shadow of the first group or even under their protection, but purged of the free-floating violence of our celebrated rhapsodists, will strive to tend a fire they have not themselves ignited.

Once again, German writing in its current state stands in need of a genre that has always had a beneficial effect on it in its periods of great crisis: translation. In the present instance, however, the translations of the journal wish to be understood not just as providing models to be emulated, as was the case in earlier times, but also as the strict and irreplaceable school of language-in-the-making. Where the latter is at a loss to discover a substance of its own on which it might feed, important works from other, related cultures offer themselves along with the challenge to abandon superannuated linguistic practices, while developing new ones. In order to make this—the formal merit of true translation—clearer, every work that should be judged primarily according to this criterion will be accompanied by its original text. The first issue will go into the question at greater length.

The intellectual universality contained in the plan for this journal will not be confused with an attempt to achieve universality in terms of content. For on the one hand, it will not lose sight of the fact that a philosophical treatment confers universal meaning on every scientific or practical topic, on every mathematical line of inquiry as much as on any political question. And on the other hand, it will bear in mind that even the literary or philosophical themes of immediate interest will be given a welcome only because of this approach and on the condition that it be adopted. This philosophical universality is the touchstone that will enable the journal to demonstrate its true contemporary relevance most accurately. In its eyes, the universal validity of spiritual [*geistig*] utterances must be bound up with the question of whether they can lay claim to a place within future religious orders. Not as if such orders were already visible on the horizon. What is visible is the fact that without them, none of the things that are struggling for life can make their appearance and mark these days as the first of a new epoch. For that very reason, it would seem to be the right time to lend an ear not to those who imagine that they have already discovered the arcanum but to those who objectively, dispassionately, and unobtrusively give expres-

sion to hardship and need, if only because the journal is not a place for the great. Even less should it be a place for the petty; it should be reserved, then, for those who have found by hard thinking as much as by soul searching that a renewal of things can come about only through confession. This, however, must be arrived at by an honest path: spiritualist occultism, political obscurantism, and Catholic expressionism will be encountered in these pages only as the targets of unsparing criticism. And even though these pages will eschew the comfortable obscurity of esotericism, they will keep their distance equally from any easy expectation of greater elegance and accessibility for what they offer. Those qualities can only reward still greater hard, sober effort. Golden fruits in silver bowls are not to be expected.[4] Instead we shall aspire to rationality throughout, and because none but free spirits are to discuss religion, the journal will feel free to go beyond the frontiers of our language, indeed of the West, and move to a consideration of other religions. It is a fundamental principle that only in regard to poetry shall we confine ourselves to the German language.

Needless to say, there is no guarantee that the universality aspired to will be fully achieved. For just as in its outer appearance the journal will exclude every direct manifestation of the plastic arts, in the same way—although less obviously—it will keep its distance from all science, because there, far more than in the arts and philosophy, the topical and the essential almost always seem to part company. In the list of subjects to be treated in a journal, science forms a link to the problems of practical life, whose burden of true contemporary relevance is normally obscured beneath the surface and yields itself up only to the rarest philosophical scrutiny.

These limitations count for little compared to the inevitable limitations of the editor. Perhaps he may be allowed a few words to outline his awareness of the boundaries of his own horizons and his readiness to acknowledge them. In fact, he makes no claim to survey the intellectual horizons of the age from on high. And, to continue with the image, he would prefer that of the man who stands on his own threshold in the evening when his work is done and in the morning before he sets out on his daily tasks, and who takes in the familiar horizon with a glance, rather than scanning it searchingly, so as to retain whatever new thing greets him there. The editor regards philosophy as his own special field, and this metaphor tries to express the idea that the reader will encounter nothing absolutely alien in the pages that follow, and that the editor will feel some affinity with whatever will be found there. But an even more emphatic implication of the metaphor is that to assess the degree and kind of affinity is not something which will fall to the public, and that nothing links the contributors with one another beyond their own will and consciousness. For just as the journal will refrain from attempting to ingratiate itself with the public, so too shall we resist the equally dishonest attempts of the contributors to curry favor

or create an atmosphere of mutual understanding and community. Nothing appears more important to the editor than that the journal should forgo all appearance and simply express the truth of the situation, which is that even the purest will and the most patient labor among the different collaborators will prove unable to create any unity, let alone a community. The journal should proclaim through the mutual alienness of their contributions how impossible it is in our age to give a voice to any communality—even though this common forum might suggest otherwise—and should make plain to what degree even this connection remains on trial only, while responsibility to substantiate it rests entirely with the editor.

This point touches on the ephemeral aspect of this journal—a point that has been kept in mind throughout. For it is the fair price exacted by the journal's call for true contemporary relevance. After all, according to a legend in the Talmud, the angels—who are born anew every instant in countless numbers—are created in order to perish and to vanish into the void, once they have sung their hymn in the presence of God. It is to be hoped that the name of the journal will guarantee it contemporary relevance, which is the only true sort.

Written in 1922; unpublished in Benjamin's lifetime. Translated by Rodney Livingstone.

Notes

1. On Benjamin's plans for the journal—which were never realized—see the Chronology in this volume. The journal was to have taken its title from that of the watercolor by Paul Klee which Benjamin had recently acquired.
2. The *Athenäum*, which appeared twice a year between 1798 and 1800, was the theoretical organ of the early Romantic movement in Germany. It was edited by Friedrich and August Wilhelm Schlegel, and included contributions by Novalis, Friedrich Schleiermacher, and the editors.—*Trans.*
3. Ulrich von Hutten (1488–1523), Reformation theologian and humanist. See his letter to Willibald Pirckheymer, December 25, 1518.—*Trans.*
4. See Goethe's *Conversations with Eckermann* [*Gespräche mit Eckermann*], December 25, 1825.—*Trans.*

Goethe's Elective Affinities

Dedicated to Jula Cohn

I

Whoever chooses blindly is struck in the eyes
By the smoke of sacrifice.
—Klopstock

The writings we have on works of literature suggest that the minuteness of detail in such studies be reckoned more to the account of the interests of philology than of critique. The following exposition of *Elective Affinities* [*Die Wahlverwandtschaften*], which also goes into detail, could therefore easily prove misleading about the intention with which it is being presented. It could appear to be commentary; in fact, it is meant as critique. Critique seeks the truth content of a work of art; commentary, its material content. The relation between the two is determined by that basic law of literature according to which the more significant the work, the more inconspicuously and intimately its truth content is bound up with its material content. If, therefore, the works that prove enduring are precisely those whose truth is most deeply sunken in their material content, then, in the course of this duration, the concrete realities rise up before the eyes of the beholder all the more distinctly the more they die out in the world. With this, however, to judge by appearances, the material content and the truth content, united at the beginning of a work's history, set themselves apart from each other in the course of its duration, because the truth content always remains to the same extent hidden as the material content comes to the fore. More and more, therefore, the interpretation of what is striking and curious—that is, the material content—becomes a prerequisite for any later critic. One may

compare him to a paleographer in front of a parchment whose faded text is covered by the lineaments of a more powerful script which refers to that text. As the paleographer would have to begin by reading the latter script, the critic would have to begin with commentary. And with one stroke, an invaluable criterion of judgment springs out for him; only now can he raise the basic critical question of whether the semblance/luster [*Schein*][1] of the truth content is due to the material content, or the life of the material content to the truth content. For as they set themselves apart from each other in the work, they decide on its immortality. In this sense the history of works prepares for their critique, and thus historical distance increases their power. If, to use a simile, one views the growing work as a burning funeral pyre, then the commentator stands before it like a chemist, the critic like an alchemist. Whereas, for the former, wood and ash remain the sole objects of his analysis, for the latter only the flame itself preserves an enigma: that of what is alive. Thus, the critic inquires into the truth, whose living flame continues to burn over the heavy logs of what is past and the light ashes of what has been experienced.

Not the existence but for the most part the meaning of the concrete realities in the work will no doubt be hidden from the poet and the public of his time. But because what is eternal in the work stands out only against the ground of those realities, every contemporary critique, however eminent, comprehends in the work more the moving truth than the resting truth, more the temporal effect than the eternal being. Yet however valuable concrete realities may be for the interpretation of the work, it hardly needs to be said that the production of a Goethe cannot be viewed in the same way as that of a Pindar. On the contrary, there was surely never a time before Goethe's when the thought was more foreign that the most essential contents of existence are capable of stamping their imprint on the world of things, indeed that without such imprinting they are incapable of fulfilling themselves. Kant's critical work and Basedow's *Treatise on the Elements*[2]— the one dedicated to the meaning and the other to the perception of the experience of their times—testify in very different yet equally conclusive ways to the poverty of their material contents. In this crucial feature of the German if not of the entire European Enlightenment, an indispensable precondition of Kant's lifework, on the one hand, and of Goethe's productivity, on the other, can be glimpsed. For at the exact moment when Kant's work was completed and a map through the bare woods of reality was sketched, the Goethean quest for the seeds of eternal growth began. There came that direction of classicism which sought to grasp not so much the ethical and historical as the mythic and philological. Its thought did not bear on the evolving ideas but on the formed contents preserved in life and language. After Herder and Schiller, it was Goethe and Wilhelm von Humboldt who took the lead.[3] If the renewed material content available in the

literary works of Goethe's old age escaped his contemporaries whenever it did not call attention to itself, as in the *Divan,* this stemmed from the fact that, utterly unlike the corresponding phenomenon in the life of antiquity, the very search for such a thing was foreign to them.

How clearly the most sublime spirits of the Enlightenment had a premonition of the content [*Gehalt*] or an insight into the matter [*Sache*], yet how incapable even they were of raising themselves to the perception of its material content [*Sachgehalt*], becomes compellingly clear with regard to marriage. It is marriage, as one of the most rigorous and objective articulations of the content of human life, that in Goethe's *Elective Affinities* attests, also for the first time, to the author's new meditation, turned toward the synthetic perception of the material contents. Kant's definition of marriage in *The Metaphysics of Morals,* which is now and again remembered solely as an example of a rigoristic stereotype or a curiosity of his senile late period, is the most sublime product of a *ratio* that, incorruptibly true to itself, penetrates infinitely deeper into the facts of the matter than sentimental ratiocination. Of course the material content itself, which yields only to philosophical perception—or, more precisely, to philosophical experience— remains inaccessible to both, but whereas the latter leads into the abyss, the former attains the very ground where true knowledge is formed. Accordingly it defines marriage as

> the union of two persons of different sexes for the purpose of lifelong mutual possession of their sexual organs. The goal of begetting and rearing children may be a goal of nature for which the inclination of the sexes to one another was implanted; but it is not requisite for human beings who marry to make this their end in order for their union to be compatible with rights, for otherwise the marriage would dissolve of its own accord when procreation ceases.

Of course, the philosopher made his gravest mistake when he supposed that from his definition of the nature of marriage, he could deduce its moral possibility, indeed its moral necessity, and in this way confirm its juridical reality. From the objective nature of marriage, one could obviously deduce only its depravity—and in Kant's case this is what it willy-nilly amounts to. That, however, is precisely the crucial point: its content can never be deduced from the real matter [*Sache*] but instead must be grasped as the seal which presents this matter. Just as the form of a seal cannot be deduced from the material of the wax or from the purpose of the fastening or even from the signet (in which one finds concave what in the seal is convex), and just as it can be grasped only by someone who has had the experience of sealing and becomes evident only to the person who knows the name that the initials merely indicate, so the content of the matter cannot be deduced by means of insight into its constitution or through an exploration of its

intended use or even from a premonition of its content; rather, it is graspable only in the philosophical experience of its divine imprint, evident only to the blissful vision of the divine name. In this way the achieved insight into the material content of subsisting things finally coincides with insight into their truth content. The truth content emerges as that of the material content. Nonetheless, the distinction between them—and with it the distinction between the commentary and the critique of the works—is not futile, insofar as the striving for immediacy is nowhere more misguided than here, where the study of the matter and its intended use, like the intuition of its content, must precede each and every experience. In such a materially real determination of marriage, Kant's thesis is perfect and, in the consciousness of its cluelessness, sublime. Or, amused by his theses, do we forget what precedes them? The beginning of that paragraph reads:

> Sexual commerce (*commercium sexuale*) is the reciprocal use that one human being makes of the sexual organs and sexual capacities of another (*usus membrorum et facultatum sexualium alterius*). This is either a natural use (by which procreation of a being of the same kind is possible) or an unnatural use, and this unnatural use takes place either with a person of the same sex or with an animal of a nonhuman species.

Thus Kant. If Mozart's *The Magic Flute* is put alongside this passage from *The Metaphysics of Morals,* they would seem to represent the most extreme and at the same time most profound views of marriage which the age possessed. For to the extent that this is possible in opera, *The Magic Flute* takes precisely conjugal love as its theme. This is something which even Cohen, in whose late study of Mozart's librettos the two works meet in so dignified a spirit, does not really seem to have recognized.[4] The subject of the opera is not so much the desires of the lovers as the steadfastness of husband and wife. They must go through fire and water not only to win each other but to remain united forever. Here, however much the spirit of freemasonry had to dissolve all material bonds, the intuition into the content has found its purest expression in the feeling of fidelity.

Is Goethe in *Elective Affinities* really closer than Kant or Mozart to the material content of marriage? One would have to deny this roundly if, in the wake of all the literary scholarship on Goethe, one were seriously determined to take Mittler's words on this subject as the writer's own.[5] Nothing authorizes this assumption; but it is only too understandable. After all, the vertiginous gaze looked for support in this world, which sinks away as if circling in a whirlpool. There were only the words of the grim blusterer, which readers were glad to be able to take just as they found them.

> "Anyone who attacks the state of marriage," Mittler cried, "who undermines this foundation of all moral society by word or deed, will have to reckon with me; or else, if I cannot better him, I will have nothing to do with him. Marriage

is both the base and the pinnacle of culture. It makes barbarians tame, and it gives the most cultivated of people an opportunity to demonstrate their gentleness. It must be indissoluble; it brings so much luck that individual misfortunes cannot be weighed against it. And why speak of misfortune? Misfortune is really impatience that comes over people from time to time, and then they like to see themselves as unlucky. If you let the moment pass, you will think yourself fortunate that something that has stood the test of time still exists. There is no sufficient reason for separation. The human condition is so highly charged with joy and sorrow that one cannot calculate what two spouses owe each other. It is an infinite debt that can be paid only in eternity. It may be unpleasant at times—I can well believe it—but that is right and proper. Are we not also married to our conscience, which we would often like to get rid of, since it is more disagreeable than any man or woman could ever be?"[6]

Here, even those who did not notice the cloven foot of that strict moralist would have to reflect that it did not occur even to Goethe, who often proved to have few enough scruples when it came to rebuking dubious persons, to resort to glossing Mittler's words. On the contrary, it is highly significant that the man who expounds a philosophy of marriage is himself unmarried and appears as the lowest-ranking of all the men of his circle. Whenever, on important occasions, Mittler gives his tongue free rein, his words are out of place, whether at the baptism of the newborn or in the last moments that Ottilie spends with her friends. And even if the tastelessness of his words is here perceptible enough in their effects, Goethe still concluded after Mittler's famous apology for marriage: "He would have gone on speaking in this forceful way for a long time." [R138]. Such talk can indeed be indefinitely pursued—talk which, in Kant's words, is a "disgusting mishmash," "patched together" out of baseless humanitarian maxims and muddy, delusive juridical instincts. The uncleanness of it—that indifference to truth in the life of husband and wife—should escape no one. Everything comes down to the claims of the statute. Yet in truth, marriage is never justified in law (that is, as an institution) but is justified solely as an expression of continuance in love, which by nature seeks this expression sooner in death than in life. For the writer, however, an imprint of the juridical norm in this work was indispensable. After all, he did not want, like Mittler, to establish a foundation for marriage but wished, rather, to show the forces that arise from its decay. Yet these are surely the mythic powers of the law, and in them marriage is only the execution of a decline that it does not decree. For its dissolution is pernicious only because it is not the highest powers that produce it. And solely in this disaster-vexed-into-life lies the ineluctable horror of the proceedings. With this, however, Goethe in fact touched on the material content of marriage. For even if he was not so minded to show this in an undistorted way, his insight into the declining relationship remains powerful enough. In its decline it becomes, for the first time, the juridical

one that Mittler holds it up to be. Yet it never occurred to Goethe, even if he never really did obtain pure insight into the moral constitution of this bond, to want to justify marriage by matrimonial law. For him, the morality of marriage was least free of doubt at its deepest and most secret level. Its opposite, which he wishes to portray through the conduct of the count and the baroness, is not so much immorality as nullity. This is shown precisely by the fact that they are conscious neither of the moral character of their present relationship nor of the juridical character of the ones they have abandoned.—The subject of *Elective Affinities* is not marriage. Nowhere in this work are its ethical powers to be found. From the outset, they are in the process of disappearing, like the beach under water at floodtide. Marriage here is not an ethical problem, yet neither is it a social problem. It is not a form of bourgeois conduct. In its dissolution, everything human turns into appearance, and the mythic alone remains as essence.

This is, of course, contradicted by a routine glance. According to it, no loftier spirituality is imaginable in a marriage than in one where even its disintegration is unable to detract from the customary behavior of those affected. But in the domain of civility, what is noble is bound to the relation of the person to his expression. Nobility is in question wherever the noble expression does not conform to the person. And this law—whose validity may not, of course, without gross error be described as unrestricted—extends beyond the domain of civility. If there are unquestionably areas of expression whose contents are valid regardless of who gives them a distinct stamp—if, indeed, these are the highest—the former binding condition nonetheless remains inviolable for the domain of freedom in the widest sense. To this domain belongs the individual imprint of propriety, the individual imprint of the spirit—everything that is called cultivation [*Bildung*]. This is manifested above all by persons who are on intimate terms. Does that manifestation truly conform to their situation? Less hesitation might produce freedom, less silence clarity, less leniency the decision. Thus, cultivation keeps its value only where it is free to manifest itself. This is clearly shown by the novel's plot, as well.

The principals, as cultivated human beings, are almost free of superstition. If now and again it comes out in Eduard, then it is at the outset merely in the more likeable form of his clinging to happy portents; only the more banal character of Mittler, despite his complacent behavior, shows traces of that truly superstitious fear of evil omens. He alone is reluctant to walk on cemetery ground as he would on any other ground—held back not by a pious reluctance but by a superstitious one—while to the friends it does not appear either scandalous to stroll there or forbidden to do as they please. Without scruple, indeed without consideration, they line up the gravestones along the church wall and leave the leveled ground, wound through by a footpath, for the minister to sow clover in. One cannot imagine a more conclusive liberation from tradition than that liberation from the graves of

the ancestors, which, in the sense not only of myth but of religion, provide a foundation for the ground under the feet of the living. Where does their freedom lead those who act thus? Far from opening up new perspectives for them, it blinds them to the reality that inhabits what they fear. And this because these perspectives are unsuited to them. Nothing but strict attachment to ritual—which may be called superstition only when, torn from its context, it survives in rudimentary fashion—can promise these human beings a stay against the nature in which they live. Charged, as only mythic nature is, with superhuman powers, it comes menacingly into play. Whose might, if not that of mythic nature, calls down the minister who cultivates his clover on the land of the dead? Who, if not it, sets the embellished scene in a pallid light? For such a light, in the more literal or more circumscribed sense, pervades the entire landscape, which nowhere appears in sunlight. And never, even when so much is said about the estate, is there a discussion of its crops or of any rural business that serves not ornament but sustenance. The sole allusion of this sort—the prospect of the vintage—leads away from the scene of the action to the estate of the baroness. All the more clearly does the magnetic power of the interior of the earth speak. Goethe said of it in his *Theory of Color* [*Die Farbenlehre*]—possibly around the same time—that to the attentive spectator nature is "never dead or mute. It has even provided a confidant for the rigid body of earth, a metal whose least fragment tells us about what is taking place in the entire mass." Goethe's characters are in league with this power, and they are as pleased with themselves in playing with what lies below ground as in playing with what lies above. Yet what else, finally, are their inexhaustible provisions for its embellishment except a new backdrop for a tragic scene? Thus, a hidden power manifests itself ironically in the existence of the landed gentry.

Its expression is borne, as by the tellurian element, by watery expanses. Nowhere does the lake deny its unholy nature under the dead plane of the mirroring surface. An older work of criticism speaks revealingly of the "daemonically terrible fate that holds sway over the summer lake." Water as the chaotic element of life does not threaten here in desolate waves that sink a man; rather, it threatens in the enigmatic calm that lets him go to his ruin. To the extent that fate governs, the lovers go to their ruin. Where they spurn the blessing of firm ground, they succumb to the unfathomable, which in stagnant water appears as something primeval. One sees the old might of it literally conjure them. For at the end, that union of the waters, as they gradually destroy the firm land, results in the restoration of the mountain lake that used to be located in the region. In all this it is nature itself which, in the hands of human beings, grows superhumanly active. Indeed, even the wind, "which drives the canoe toward the plane trees," "rises up" (as the reporter of the *Church News* scornfully surmises) "probably by order of the stars."

Human beings must themselves manifest the violence of nature, for at no

point have they outgrown it. With respect to these characters, this fact constitutes the particular foundation of that more general understanding according to which the characters in a fiction can never be subject to ethical judgment. And, to be sure, not because such judgment, like that passed on human beings, would surpass all human discernment. Rather, the grounds of such judgment already forbid, incontrovertibly, its application to fictional characters. It remains for moral philosophy to prove in rigorous fashion that the fictional character is always too poor and too rich to come under ethical judgment. Such a judgment can be executed only upon real human beings. Characters in a novel are distinguished from them by being entirely rooted in nature. And what is crucial in the case of fictional characters is not to make ethical findings but rather to understand morally what happens. The enterprise of a Solger, and later, too, of a Bielschowsky, remains foolish: to produce a confused moral judgment of taste—which should never have dared to make an appearance—at the first place it can snatch applause. When the figure of Eduard does this, it is not out of gratitude to anyone. How much more profound than theirs, however, is the insight of Cohen, who—according to the exposition in his *Aesthetics*—believes it is absurd to isolate the figure of Eduard from the totality of the novel. Eduard's unreliableness, indeed coarseness, is the expression of fleeting despair in a lost life. "In the entire disposition of this relationship," he appears "exactly the way he characterizes himself" to Charlotte: "'For in reality I depend on you alone.' [R117]. To be sure, he is the plaything not of whims, which Charlotte in no way has, but of the final goal of elective affinities, toward which her central nature, with its undeviating center of gravity, strives, out and away from all vacillations." From the start, the characters are under the spell of elective affinities. But in Goethe's profound and prescient view, their wondrous movements form the ground not for an intensely inward spiritual harmony of beings but only for the particular harmony of the deeper natural strata. For it is these strata that are intended by what is slightly amiss in every one of their conjunctures. Certainly, Ottilie adapts herself to Eduard's flute playing, but his playing is false. Certainly, when he reads with Ottilie, Eduard puts up with something he forbids to Charlotte—but this is a bad habit. Certainly, he feels wonderfully entertained by her, but she keeps silent. Certainly, the two of them even suffer in common, but their affliction is only a headache. These characters are not natural, for children of nature—in a fabulous or real state of nature—are human beings. At the height of their cultivation, however, they are subject to the forces that cultivation claims to have mastered, even if it may forever prove impotent to curb them. These forces have given them a feeling for what is seemly; they have lost the sense for what is ethical. This is meant as a judgment not on their actions but rather on their language. Feeling, but deaf, seeing, but mute, they go their way. Deaf to God and mute before the world. Rendering account

eludes them, not because of their actions but because of their being. They fall silent.

Nothing links the human being more closely to language than does his name. Scarcely any literature, however, is likely to offer a narrative of the length of *Elective Affinities* in which there are so few names. This parsimony of name giving can be interpreted otherwise than as a reference to Goethe's penchant for typical characters—the customary view. It belongs, rather, most intimately to the essence of an order whose members live out their lives under a nameless law, a fatality that fills their world with the pallid light of a solar eclipse. All names, with the exception of Mittler's, are simply Christian names. In the name Mittler ["mediator"] one should see not playfulness—that is, an allusion on the part of the author—but rather a locution that designates with incomparable certainty the essence of the bearer. He must be considered as a man whose self-love allows no abstraction from the allusions that appear to be given to him by his name, which in this way degrades him. Besides his, there are six names in the narrative: Eduard, Otto, Ottilie, Charlotte, Luciane, and Nanny. But the first of these is, as it were, fake. It is arbitrary, chosen for its sound, a trait that can surely be perceived as analogous to the displacement of the tombstones. Furthermore, an omen attaches to the doubling of his name, because it is his initials, E.O., which determine that one of the drinking-glasses from the count's youth shall be a token of his good fortune in love.[7]

The abundance of premonitory and parallel features in the novel has never escaped the critics. They have long considered these features to have been amply appreciated as the most obvious expression of the novel's character. Nevertheless, quite apart from its interpretation, the depth to which this expression penetrates the entire work does not appear ever to have been fully grasped. Only when it is viewed in the right light does one clearly see that what is at stake is neither a bizarre predilection of the author nor a simple increase in tension. Only then does the chief content of these features come more precisely into the light of day. It is a symbolism of death. "One can see right at the outset that one must go forth to evil houses," reads a strange turn of phrase in Goethe. (Possibly, it is of astrological origin; it is not in Grimm's *Dictionary*.) On another occasion the author referred to the feeling of "dread" that, with the moral decay in *Elective Affinities,* is supposed to arise in the reader. It is also reported that Goethe laid weight on "how swiftly and irresistibly he brought about the catastrophe." In its most hidden features, the entire work is woven through by that symbolism. Yet only a sensibility that is intimately familiar with this symbolism can effortlessly take in its language, where only exquisite beauties are proffered to the naive understanding of the reader. In a few passages Goethe gave clues even to this latter kind of understanding, and by and large these have remained the only ones to be noticed. They are all connected with the

episode of the crystal glass, which, destined to shatter, is caught in mid-flight and preserved. It is a sacrifice to the building—a sacrifice that is rejected at the consecration of the house in which Ottilie will die. But here, too, Goethe adheres to his secret procedure by tracing back to joyous exuberance the gesture that completes this ceremony. In a clearer way, a sepulchral admonition is contained in the words with a Masonic ring at the laying of the foundation stone: "It is a serious matter, and our invitation to you is a serious one, for this ceremony takes place in the depths of the earth. Here in this narrow, hollowed-out space you do us the honor of appearing as witnesses to our secret task." [R133]. From the preservation of the glass, greeted with joy, arises the great theme of delusion. Eduard seeks by every means to safeguard precisely this sign of the rejected sacrifice. After the feast, he acquires it at a high price. With good reason an old review says: "How strange and frightening! As the unheeded omens all prove true, so this, the only one that is heeded, is found to be deceptive." And indeed, there is no lack of omens that go unheeded. The first three chapters of the second part are entirely filled with preparations and conversations about the grave. In the course of the latter ones, the frivolous, indeed banal interpretation of the dictum "Say nothing but good of the dead" is remarkable. "I once heard someone ask why one speaks well of the dead unreservedly, but of the living always with a certain degree of hesitation. The answer was that we have nothing to fear from the dead, whereas the living could cross us at some future point" [R178]. Here, too, how a fate appears ironically to betray itself! Through this fate the speaker, Charlotte, learns how sternly two deceased persons block her way. The three days that prefigure death fall on the birthday celebration of the three friends. Like the laying of the foundation stone on Charlotte's birthday, the ceremony of the raising of the roof beams must take place, under inauspicious signs, on Ottilie's. No blessing is promised to the residence. Eduard's friend, however, peacefully consecrates the completed tomb on his birthday. In a quite distinctive way, Ottilie's relation to the emerging chapel, whose purpose is of course as yet unspoken, is set against Luciane's relation to the tombstone of Mausolos. Ottilie's nature profoundly touches the builder; Luciane's effort on a related occasion to rouse his interest remains ineffectual. Here, the play is overt and the seriousness secret. Such hidden likeness—which, when discovered, is all the more striking for having been hidden—is also found in the theme of the little casket. This gift to Ottilie, which contains the fabric of her shroud, corresponds to the receptacle in which the architect keeps his finds from prehistoric graves. The first is acquired from "tradespeople and fashion dealers"; of the other, we are told that its contents, through the way in which they were arranged, took on "a somewhat prettified air," that it "could be looked at with the same enjoyment as the display cases of a fashion dealer" [R179].

Things that correspond to one another in this manner—in the instances above, they are all symbols of death—are likewise not simply explained, as R. M. Meyer tries to do, by the typology of Goethe's compositions. Rather, reflection hits the mark only when it recognizes that typicality as having the character of fate. For the "Eternal Return of the Same," as it stonily prevails over the most intimately varied feelings, is the sign of fate, whether it is self-identical in the life of many or repeats itself in the individual. Twice Eduard offers his sacrifice to destiny: first in the drinking-glass, and thereafter—even if no longer willingly—in his own life. He recognizes this connection himself. "A glass with our initials on it was tossed into the air at the foundation-stone laying, but it did not break; someone caught it, and now I have it back. 'In just the same way,' I said to myself after so many doubtful hours in this lonesome spot, 'I will take the place of that glass and make myself a token whether we may be united or not. I will go and seek death, not as one who has taken leave of his senses but as one who hopes to survive" [R233]. Likewise, in the depiction of the war into which he throws himself, that tendency toward the typical as an aesthetic principle has been rediscovered. But even here the question arises whether Goethe did not also treat the war in so general a manner because he had in mind the hated war against Napoleon. Be that as it may: what is to be grasped, above all, in that typicality is not only a principle of art but a theme of fateful being. Throughout the work the author has exfoliated this fateful kind of existence, which encompasses living natures in a single nexus of guilt and expiation. It is not, however, as Gundolf thinks, to be compared with the existence of plants. One cannot imagine a more precise contradiction to this. No—not "by analogy with the relation of seed, blossom, and fruit is Goethe's conception of law, his notion of fate and character, in *Elective Affinities* to be conceived." Neither those of Goethe nor those of anyone else whose notions would be valid. For fate (character is something else) does not affect the life of innocent plants. Nothing is more foreign to it. On the contrary, fate unfolds inexorably in the culpable life. Fate is the nexus of guilt among the living. This is the impression Zelter[8] got from this work when, comparing it with *Die Mitschuldigen* [The Accomplices], he remarks of the comedy: "Yet precisely for this reason it fails to evoke pleasure, because it knocks at everyone's door, because it also takes aim at the good; and so I compared it with *Elective Affinities*, where even the best have something to hide and must blame themselves for not keeping to the right path." The fateful cannot be more accurately characterized. And thus it appears in *Elective Affinities*: as the guilt which is bequeathed through life.

Charlotte is delivered of a son. The child is born from a lie. As a sign thereof it bears the features of the captain and Ottilie. As the offspring of a lie, it is condemned to death. For only truth is essential. The guilt for his death must

fall to those who, by failing to master themselves, have not atoned for the guilt of the child's inwardly untrue existence. These are Ottilie and Eduard.—This is how the natural-philosophical ethical schema that Goethe sketched for the final chapters would probably have run.

This much is incontrovertible in [Albert] Bielschowsky's conjecture: it corresponds wholly to the order of fate that the child, who enters it as a newborn, does not expiate the ancient rift but, in inheriting its guilt, must pass away. It is a question here not of ethical guilt (how could the child acquire it?) but rather of the natural kind, which befalls human beings not by decision and action but by negligence and celebration. When they turn their attention away from the human and succumb to the power of nature, then natural life, which in man preserves its innocence only so long as natural life binds itself to something higher, drags the human down. With the disappearance of supernatural life in man, his natural life turns into guilt, even without his committing an act contrary to ethics. For now it is in league with mere life, which manifests itself in man as guilt. He does not escape the misfortune that guilt conjures upon him. In the way that every one of his velleities brings fresh guilt upon him, every one of his deeds will bring disaster upon him. The writer takes this up in the ancient fable of the man who endlessly importunes: the man who is fortunate, who gives too abundantly, binds a *fatum* indissolubly to himself. This, too, is the behavior of the deluded.

When once man has sunk to this level, even the life of seemingly dead things acquires power. Gundolf quite correctly pointed out the significance of the thing-like in the events of the novel. The incorporation of the totality of material things into life is indeed a criterion of the mythic world. Among them, the first has always been the house. Thus, to the extent that the house approaches completion, fate closes in. The laying of the foundation stone, the celebration of the raising of the roof beams, and moving in mark just so many stages of decline. The house lies isolated, without a view of other dwellings, and it is occupied almost unfurnished. Charlotte, in a white dress, appears on its balcony, while she is away, to her woman friend. Consider, too, the mill at the shady bottom of the woods, where for the first time the friends have gathered together in the open air. The mill is an ancient symbol of the underworld. It may be that this derives from the pulverizing and metamorphosing nature of the act of milling.

In this circle, the powers that emerge from the disintegration of the marriage must necessarily win out. For they are precisely those of fate. Marriage seems a destiny more powerful than the choice to which the lovers give themselves up. "One must persevere there, where destiny more than choice places us. Among a people, in a city, with a prince, a friend, a wife to hold fast, relate everything to it; therefore to do everything, renounce

everything, and endure everything: that is valuable." This is how Goethe, in his essay on Winckelmann, formulates the contrast in question. Judged from the standpoint of destiny, every choice is "blind" and leads headlong into disaster. The violated law stands opposed to such choice, powerful enough to exact sacrifice for the expiation of the shattered marriage. In the mythic archetype of sacrifice, therefore, the symbolism of death fulfills itself through this destiny. Ottilie is predestined for it. As a reconciler, "Ottilie stands there in the splendid tableau vivant; she is the being rich in pain, the sad and grieving one, whose soul is pierced by the sword," says [B. R.] Abeken in the review that the poet Goethe so much admired. Similarly, [Karl Wilhelm Ferdinand] Solger's equally leisurely essay, equally respected by Goethe: "She is indeed the true child of nature and at the same time its sacrifice." Yet the content of the course of events must have completely escaped both reviewers, because they started out not from the whole of the depiction but only from the nature of the heroine. Only in the first case does Ottilie's passing away emerge unmistakably as a sacrificial action. That her death is a mythic sacrifice—if not in the author's intention, then surely in the more decisive one of his work—is made evident by two things. First of all, it is contrary not only to the meaning of the novel's form to shroud in darkness the decision in which Ottilie's deepest being speaks as nowhere else; no, the immediate, almost brutal way its work takes effect seems foreign even to the tone of the novel. Furthermore, what that darkness conceals does emerge clearly from everything else: the possibility, indeed the necessity, of the sacrifice according to the deepest intentions of this novel. Thus, not only is it as a "victim of destiny" that Ottilie falls—much less that she actually "sacrifices herself"—but rather more implacably, more precisely, it is as the sacrifice for the expiation of the guilty ones. For atonement, in the sense of the mythic world that the author conjures, has always meant the death of the innocent. That is why, despite her suicide, Ottilie dies as a martyr, leaving behind her miraculous remains.

Nowhere, certainly, is the mythic the highest material content, but it is everywhere a strict indication of it. As such, Goethe made it the basis of his novel. The mythic is the real material content of this book; its content appears as a mythic shadowplay staged in the costumes of the Age of Goethe. It is tempting to set such a surprising conception against Goethe's own thoughts on his work. Not as though the path of critique should be staked out in advance by the author's statements; yet the more critique removes itself from them, the less will it want to evade the task of understanding them, too, on the basis of the same hidden jurisdictions as the work. The sole principle of such an understanding, of course, cannot lie in these spheres. Biographical considerations, which do not enter at all into commentary and critique, have their place here. Goethe's remarks about this

work are also motivated by his effort to meet contemporary judgments. Hence, a glance at these would be appropriate, even if a much more immediate interest than that indicated by this reference did not direct attention to them. Among contemporary voices, the ones that have little weight (mostly the voices of anonymous judges) are those which greet the work with the conventional respect that even at that time was owed to everything of Goethe's. The important judgments are those of a distinctive stamp that are preserved under the name of prominent individual commentators. They are not for this reason atypical. Rather, foremost among such writers were precisely those who dared to say outright what lesser ones, solely out of respect for the author, refused to admit. Nevertheless, Goethe sensed the attitude of his audience, and from bitter, unaltered recollection reminds Zelter in 1827 that, as he probably will remember, readers had "reacted" to his *Elective Affinities* "as if to the robe of Nessus."[9] Dumbfounded, dazed, as if stunned, readers stood before a work in which they believed they were obliged only to look for help in escaping the confusions of their own lives, without selflessly wanting to become immersed in the essence of another's life. The judgment in Madame de Staël's *On Germany* is representative of this: "One cannot deny that there is in this book a profound understanding of the human heart, but it is a discouraging one. Life is presented as a thing of indifferent value, however one regards it—sad when one gets to the bottom of it, pleasant enough when one evades it, prone to moral ills, which one must cure if one can and of which one must die if one cannot." Something similar seems to be indicated more expressly in Wieland's laconic turn of phrase (taken from a letter, whose addressee, a woman, is unknown): "I confess to you, my friend, that I have read this truly terrifying work not without feeling sincere concern."[10] The concrete motives behind a rejection, which might hardly have become conscious in readers who were mildly put off, come glaringly to light in the verdict of the Church. The obviously pagan tendencies of the work could not escape its more gifted fanatics. For although the author sacrificed all the happiness of the lovers to those dark powers, an unerring instinct would feel the lack of a divine, transcendental aspect in the consummation. The lovers' decline in this life, after all, could not be enough. What was to guarantee that they would not triumph in a higher one? Indeed, wasn't this precisely what Goethe seemed to wish to suggest in his concluding words? For this reason, F. H. Jacobi calls the novel a "heavenly ascension of wicked desires." In his Protestant church newspaper, just a year before Goethe's death, Hengstenberg delivered what is surely the broadest criticism of all. His irritated sensibility, to whose rescue came no wit of any sort, offered a model of malicious polemic.[11] All this, however, trails far behind Werner.[12] Zacharias Werner, who at the moment of his conversion was least likely to lack a flair for the somber ritualistic tendencies in this sequence of events, sent to

Goethe, simultaneously with the news of his conversion, his sonnet "Elective Affinities"—a piece of prose, which, in letter and poem, Expressionism would be unable to match—even a hundred years later—with anything more fully achieved. Goethe perceived rather late what confronted him and let this noteworthy document conclude their correspondence. The enclosed sonnet reads:

Elective Affinities

Past graves and tombstones,
Which, beautifully disguised, await that certain prey,
Winds the path to Eden's garden
Where the Jordan and the Acheron unite.

Erected on quicksand, Jerusalem wants to appear
Towering; only the hideous tender
Sea-nixies,[13] who have already waited six thousand years,
Long to purify themselves in the lake, through sacrifice.

There comes a divinely insolent child,
The angel of salvation bears him, son of sins.
The lake swallows everything! Woe is us!—It was a jest!

Does Helios then mean to set the earth on fire?
No! He only burns lovingly to embrace it!
You may love the demigod, trembling heart!

Precisely from such mad, undignified praise and blame, one thing seems to come to light: that Goethe's contemporaries were aware—not through insight but by feeling—of the mythic content of the work. The situation has changed today, since the hundred-year tradition has done its work and almost buried the possibility of original understanding. Today, if a work of Goethe's strikes its reader as strange or hostile, benumbed silence will soon enough take possession of him and smother the true impression.—With undisguised joy, Goethe welcomed the two who raised their voices, however faintly, against the common judgment. Solger was one, Abeken the other. As far as the well-meaning words of the latter are concerned, Goethe did not rest until they were put in the form of a critique, which was published in a visible place. For in them he found emphasized the human element that the work so deliberately puts on display. No one more than Wilhelm von Humboldt seemed to have his vision of the basic content so dimmed by this. He made the strange judgment: "Above all I feel the lack of fate and inner necessity in it."

Goethe had two reasons for not following the conflict of opinion in silence. He had his work to defend—that was one. He had its secret to keep—that was the other. Together they serve to give his explanation a

character quite different from that of interpretation. It has an apologetic strain and a mystifying strain, which unite splendidly in its main brief. One could call it the fable of renunciation. In it Goethe found the support he needed to deny knowledge a deeper access. At the same time, it could also serve as the reply to many a philistine attack. Goethe made a series of statements in a conversation reported by Riemer,[14] and these henceforth determined the traditional image of the novel. There he says,

> [The struggle of morality with affection is] displaced behind the scenes, and one sees that it must have gone on before. The persons conduct themselves like persons of distinction, who for all their inner division still maintain external decorum.—Moral struggles never lend themselves to aesthetic representation. For either morality triumphs or it is defeated. In the first instance, one does not know what was represented or why; in the second, it is ignominious to be its spectator. For in the end, one moment or another must indeed give the sensual the preponderance over the moral, and precisely to this moment the spectator does not accede but demands an even more striking one, which some other, a third person, keeps eluding, the more moral he himself is.—In such representations the sensual must always gain the upper hand, but punished by fate—that is, by moral nature, which salvages its freedom through death.— Thus, Werther must shoot himself after he has allowed sensuality to gain the upper hand over him. Thus, Ottilie must suffer, and Eduard, too, once they have given free reign to their inclination. Only now does morality celebrate its triumph.

Goethe was fond of insisting on these ambiguous sentences, as well as on every sort of draconianism, something he loved to emphasize in conversation on this matter, since atonement for the juridical trespass in the violation of marriage—the mythical inculpation—was so abundantly provided through the downfall of the hero. Except that, in truth, this was not atonement arising from the violation but rather redemption arising from the entrapment of marriage. Except that despite these remarks, no struggle between duty and affection takes place either visibly or secretly. Except that here the ethical never lives triumphantly but lives only in defeat. Thus, the moral content of this work lies at much deeper levels than Goethe's words lead one to suspect. Their evasions are neither possible nor necessary. For his reflections are not only inadequate in their opposition between the sensual and the moral but obviously untenable in their exclusion of the inner ethical struggle as an object of poetic construction. Indeed, what else would remain of the drama, of the novel itself? But in whatever way the content of this poetic work might be grasped morally, it does not contain a *fabula docet*;[15] and it is not touched on, even from afar, with the feeble exhortation to renounce, with which from the beginning learned criticism leveled off its abysses and peaks. Moreover, [Alfred] Mézières has already correctly noted the epicurean tendency that Goethe lends to this attitude. Therefore, the

confession from the *Correspondence with a Child* strikes much deeper, and one allows oneself only reluctantly to be persuaded that Bettina, for whom in many respects the novel was alien, may possibly have made it up.[16] Bettina says that "here Goethe gave himself the task of gathering, in this invented destiny, as in a funerary urn, the tears for many a lost opportunity [*Versäumtes*]." One does not, however, call what one has renounced something one has missed or lost. Hence, it was probably not renunciation that was of the first importance to Goethe in so many relations in his life but rather his having neglected to do things [*Versäumnis*]. And when he recognized the irretrievability of what he had thus let slip, the irretrievability of what he had neglected, only then did renunciation offer itself to him, if only as a last attempt still to embrace in feeling what was lost. That may also have pertained to Minna Herzlieb.[17]

To wish to gain an understanding of *Elective Affinities* from the author's own words on the subject is wasted effort. For it is precisely their aim to forbid access to critique. The ultimate reason for this is not the inclination to ward off foolishness but the effort to keep unperceived everything that denies the author's own explanation. With respect to the technique of the novel, on the one hand, and the circle of motifs, on the other, their secret was to be kept. The domain of poetic technique forms the boundary between an exposed upper layer and a deeper, hidden layer of the works. What the author was conscious of as his technique, what contemporary criticism had also already recognized in principle, certainly touches on the concrete realities in the material content; yet it forms the boundary opposite its truth content, of which neither the author nor the critics of his time could be entirely conscious. These are necessarily noticeable in the technique, which, in contrast to the form, is decisively determined not through the truth content but rather through the material contents alone. Because for the author the representation of the material contents is the enigma whose solution is to be sought in the technique. Thus, through technique, Goethe could assure himself of stressing the mythic powers in his work. Their ultimate significance had to escape him, as it did the *Zeitgeist*. The author sought, however, to keep this technique as his artistic secret. He appears to allude to this when he says that the novel was worked out according to an idea. The latter may be understood as an idea about technique. Otherwise the postscript that calls into question the value of such a procedure would hardly be intelligible. It is, however, perfectly understandable that the infinite subtlety which the richness of relation in the book concealed could at one time appear doubtful to the author. "I hope that you shall find in it my old manner. I have put many things in it, and hidden much in it. May this open secret give pleasure to you, too." Thus writes Goethe to Zelter. In the same sense, he insists on the thesis that there was more in the work "than anyone would be capable of assimilating at a single reading." The

destruction of the drafts, however, speaks more clearly than anything else. For it could hardly be a coincidence that not even a fragment of these was preserved. Rather, the author had evidently quite deliberately destroyed everything that would have revealed the purely constructive technique of the work.—If the existence of the material contents is in this way concealed, then the essence of those contents conceals itself. All mythic meaning strives for secrecy. Therefore, Goethe, sure of himself, could say precisely of this work that the poetized [*das Gedichtete*], like the event [*das Geschehene*], asserts its rights. Such rights are here indeed owed, in the sarcastic sense of the word, not to the poetic work but rather to the poetized—to the mythic material layer of the work. In awareness of this, Goethe was able to abide unapproachably, not above, to be sure, but in his work, according to the words that conclude Humboldt's critical remarks: "But that is not the sort of thing one can actually say to him. He has no freedom with respect to his own things and grows silent at the slightest reproach." This is how Goethe in old age stands vis-à-vis all criticism: as olympian. Not in the sense of the empty *epitheton ornans,* or handsome-looking figure, that the moderns give him. This expression—it is ascribed to Jean Paul—characterizes the dark, deeply self-absorbed, mythic nature that, in speechless rigidity, indwells Goethean artistry. As olympian, he laid the foundation of the work and with scant words rounded out the dome.

In the twilight of his artistry, the eye meets that which is most hidden in Goethe. Features and connections that do not emerge in the light of everyday reflection become clear. And once again it is thanks to them alone that the paradoxical appearance of the preceding interpretation increasingly disappears. Thus, a fundamental motive for Goethean research into nature emerges only here. This study rests upon an ambiguity—sometimes naive, sometimes doubtless more meditated—in the concept of nature. For it designates in Goethe at once the sphere of perceptible phenomena and that of intuitable archetypes. At no time, however, was Goethe able to give an account of this synthesis. Instead of resorting to philosophical investigation, his studies seek in vain through experiments to furnish empirical evidence for the identity of both spheres. Since he did not define "true" nature conceptually, he never penetrated to the fruitful center of an intuition that bade him seek the presence of "true" nature as ur-phenomenon in its appearances—something he presupposed in works of art. Solger notes that this particular connection exists precisely between *Elective Affinities* and Goethean research in the natural sciences—a connection also emphasized in the author's advertisement. Solger writes: "The *Theory of Color . . .* has to a certain extent surprised me. God knows, I had formed beforehand no definite expectation at all; for the most part, I believed I would find mere experiments in it. Now, there is a book in which nature has become alive, human, and companionable. I think it also sheds light on *Elective Affini-*

ties." The genesis of the *Theory of Color* is also chronologically close to that of the novel. Goethe's studies in magnetism everywhere intrude quite distinctly into the work itself. This insight into nature, with which the author believed he could always accomplish the verification of his works, completed his indifference toward criticism. There was no need of it. The nature of the *ur*-phenomena was the standard; the relation of every work to it was something one could read off it. But on the basis of the double meaning in the concept of nature, the *ur*-phenomena as archetype [*Urbild*] too often turned into nature as model [*Vorbild*]. This view would never have grown powerful if, in the resolution of the posited equivocation, Goethe had grasped that only in the domain of art do the *ur*-phenomena—as ideals— present themselves adequately to perception, whereas in science they are replaced by the idea, which is capable of illuminating the object of perception but never of transforming it in intuition. The *ur*-phenomena do not exist before art; they subsist within it. By rights, they can never provide standards of measurement. If, in this contamination of the pure domain and the empirical domain, sensuous nature already appears to claim the highest place, its mythic face triumphs in the comprehensive totality of its appearances. It is, for Goethe, only the chaos of symbols. For it is as such that the *ur*-phenomena appear in his work jointly with the others, as the poems in the collection *God and the World* [*Gott und Welt*] so clearly illustrate. Nowhere did the author ever attempt to found a hierarchy of the *ur*-phenomena. The abundance of their forms presents itself to his spirit no differently than the confused universe of sounds presents itself to the ear. One might properly insert into this analogy a description that he gives of it [in *Scientific Studies*], because it, like little else, reveals so clearly the spirit in which he regards nature. "Let us shut our eyes, let us open our ears and sharpen our sense of hearing. From the softest breath to the most savage noise, from the simplest tone to the most sublime harmony, from the fiercest cry of passion to the gentlest word of reason, it is nature alone that speaks, revealing its existence, energy, life, and circumstances, so that a blind man to whom the vast world of the visible is denied may seize hold of an infinite living realm through what he can hear." If, then, in this most extreme sense, even the "word of reason" can be reckoned to the credit of nature, it is no wonder that, for Goethe, the empire of the *ur*-phenomena could never be entirely clarified by thought. With this tenet, however, he deprived himself of the possibility of drawing up limits. Without distinctions, existence becomes subject to the concept of nature, which grows into monstrosity, as the Fragment of 1780 teaches us. And even in advanced old age, Goethe declared his allegiance to the theses of this fragment—"Nature" [in *Scientific Studies*]—whose concluding passage reads: "She has brought me here; she will lead me away. I trust myself to her. She may do as she wants with me. She will not hate her work. It is not I who has spoken of her. No, what is

true and what is false—all this she has spoken. Hers is the blame, hers the glory." In this world view lies chaos. To that pass at last leads the life of the myth, which, without master or boundaries, imposes itself as the sole power in the domain of existence.

The rejection of all criticism and the idolatry of nature are the mythic forms of life in the existence of the artist. That in Goethe they acquire utmost suggestiveness may be gathered from the sobriquet "the Olympian." It designates at the same time the luminous element in the essence of the mythic. But corresponding to it is something dark that, in the gravest way, has cast a shadow on the existence of man. Traces of this can be seen in *Poetry and Truth* [*Wahrheit und Dichtung*]. Yet the least of it came through Goethe's confessions. Only the concept of the "daemonic" stands, like an unpolished monolith, on their plane. With this concept, Goethe introduced the last section of his autobiographical work.

> In the course of this biographical recital, we have seen in detail how the child, the boy, the youth tried to approach the metaphysical by various paths—first affectionately looking to natural religion, then attaching himself lovingly to the positive one, next testing his own abilities by withdrawing into himself, and at last joyously yielding to the universal faith. While meandering in the spaces between these areas, seeking and looking about, he encountered some things that seemed to fit into none of these categories, and he became increasingly convinced that it was better to divert his thoughts from vast and incomprehensible subjects.—He believed that he perceived something in nature (whether living or lifeless, animate or inanimate) that manifested itself only in contradictions and therefore could not be expressed in any concept, much less in any word. It was not divine, for it seemed irrational; not human, for it had no intelligence; not diabolical, for it was beneficent; and not angelic, for it often betrayed malice. It was like chance, for it lacked continuity, and like Providence, for it suggested context. Everything that limits us seemed penetrable by it, and it appeared to do as it pleased with the elements necessary to our existence, to contract time and expand space. It seemed only to accept the impossible and scornfully to reject the possible.—This essence, which appeared to infiltrate all the others, separating and combining them, I called "daemonic," after the example of the ancients and others who had perceived something similar. I tried to save myself from this fearful thing.[18]

One need hardly point out that these words, more than thirty-five years later, express the same experience of the incomprehensible ambivalence in nature that was expressed in the famous fragment. The idea of the daemonic, which is again found as a conclusion in the *Egmont* quotation from *Poetry and Truth* and at the beginning of the first stanza of "Primal Words, Orphic" ["Urworte, Orphisch"], accompanies Goethe's vision all his life. It is this which emerges in the idea of fate in *Elective Affinities;* and if mediation between the two were needed, then that, too, which for millennia has been closing the circle, is not lacking in Goethe. The primal words refer plainly—

the memoirs of his life, allusively—to astrology as the canon of mythic thinking. *Poetry and Truth* concludes with the reference to the daemonic and begins with a reference to the astrological. And his life does not appear to have entirely escaped astrological reflection. Goethe's horoscope, as it was drawn up half-playfully and half in earnest in [Franz] Boll's *Sternglaube und Sterndeutung* [*Belief in and Interpretation of the Stars*; Leipzig and Berlin, 1918], refers for its part to the clouding of this existence. "And the fact that the ascendant closely follows Saturn and thereby lies in the wicked Scorpio casts some shadows onto this life; the zodiacal sign considered 'enigmatic,' in conjunction with the hidden nature of Saturn, will cause at least a certain reserve in old age; but also"—and this anticipates what follows—"as a zodiacal creature that crawls on the ground, in which the 'telluric planet' Saturn stands, that strong worldliness, which clings 'in grossly loving zest, / With clinging tendrils' to the earth."

"I sought to save myself from this terrible being." Mythic humanity pays with fear for intercourse with daemonic forces. In Goethe, such fear often spoke out unmistakably. Its manifestations are to be taken out of the anecdotal isolation in which they are recollected, almost reluctantly, by the biographers and are to be put into the light of a reflection that of course shows terribly clearly the power of primeval forces in the life of this man— who, however, could not have become the greatest writer of his nation without them. The fear of death, which includes all other fears, is the most blatant. For death most threatens the formless panarchy of natural life that constitutes the spell of myth. The author's aversion to death and to every-thing that signifies it bears all the features of the most extreme superstition. It is well known that no one was ever allowed to speak in his presence of anyone's death, but less well known that he never came near the deathbed of his wife. His letters reveal the same sentiment toward the death of his own son. Nothing is more characteristic than the letter in which he reports the loss to Zelter—and the truly daemonic close: "And so, onward over graves!" In this sense, the truth of the words attributed to the dying Goethe gains credence. In them, mythic vitality finally opposes its impotent desire for light to the near darkness. The unprecedented cult of the self that marked the last decades of his life was also rooted in this attitude. *Poetry and Truth*, the *Daybooks and Yearbooks* [*Tag- und Jahreshefte*], the edition of his correspondence with Schiller, the care he devoted to the correspondence with Zelter are so many efforts to frustrate death. More clearly still, every-thing he says of the survival of the soul speaks of that heathen concern which, instead of keeping immortality as a hope, demands it as a pledge. Just as the idea of immortality belonging to myth was shown to be an "incapacity to die," so, too, in Goethe's thought, immortality is not the journey of the soul to its homeland but rather a flight from one boundless-ness into another. Above all, the conversation after the death of Wieland—a conversation reported by [J. D.] Falk—wants to understand immortality in

accordance with nature, and also, as if to emphasize the inhuman in it, wants to concede it only and most truly to great spirits.

No feeling is richer in variations than fear. Anxiety in the face of death is accompanied by anxiety in the face of life, as is a fundamental tone by its countless overtones. Tradition moreover neglects, passes over in silence, the baroque play of fear in the face of life. Its concern is to set up a norm in Goethe; with this it is far removed from noting the struggle between forms of life that he carried out in himself, a struggle he concealed too deeply within himself. Whence the loneliness in his life and, now painful and now defiant, his falling silent. Gervinus' description of the early Weimar period, in his study *Über den Göthischen Briefwechsel* [On Goethe's Correspondence], shows how soon this sets in.[19] Gervinus was the first among all the others to call attention to these phenomena in Goethe's life, and he did so in the surest manner: he was perhaps the only one to intuit their importance, no matter how erroneously he judged their value. Hence, neither Goethe's taciturn withdrawal into himself during the later period, nor his concern, exaggerated into paradox, for the material contents of his own life, escapes him. Out of them both, however, speaks the fear of life: from reflection speaks the fear of its power and breadth—the fear of its flight from the embrace that would contain it. In his text, Gervinus establishes the turning point separating the work of the old Goethe from that of the earlier periods: he situates it in the year 1797, the time of the projected journey to Italy. In a letter to Schiller written at the same time, Goethe deals with objects that without being "wholly poetic" had awakened in him a certain poetic mood. He says: "I have therefore precisely observed the objects that produce such an effect and noted to my surprise that they are actually symbolic." The symbolic, however, is that in which the indissoluble and necessary bonding of truth content to material content appears. The same letter continues:

> If with the further progress of the journey, one were henceforth to direct one's attention not so much to what is strange as to what is significant, then one would ultimately have to reap a fine harvest for oneself and others. While still here, I want to try to note what I can of the symbolic, but especially [to] practice in foreign places that I am seeing for the first time. If that should succeed, then one would necessarily—without wanting to pursue the experience on a vast scale, yet by going into depth at every place, at every moment, to the extent it was granted to one—still carry away enough booty from familiar lands and regions.

"One really might say," Gervinus continues, "that this is almost universally the case in his later poetic products and that in them he measures experiences that he had formerly presented in sensuous breadth, as art requires, according to a certain spiritual depth, whereby he often loses himself in the abyss. Schiller very acutely sees through this new experience, which is so mysteri-

ously veiled . . . ; a poetic demand without a poetic mood and without a poetic object would seem to be his case. Indeed what matters here, if the object is to signify something to him, is much less the object itself than the soul [*Gemüt*]." (And nothing is more characteristic of Classicism than this striving, in the same phrase, both to grasp and to relativize the symbol.)

It would be the spirit that here draws the boundary; and here, too, as everywhere, he can find the commonplace and the brilliant only in the treatment and not in the choice of material. What those two places meant for him, he thinks, every street, bridge, and so on would have meant to him in an excited mood. If Schiller had been able to divine the practical consequences of this new mode of vision in Goethe, he would hardly have encouraged him to devote himself entirely to it, because through such a view of objects an entire universe would be introduced into the singular. . . . And so the immediate consequence is that Goethe begins to accumulate bundles of files, into which he puts all official papers, newspapers, weeklies, clippings from sermons, theater programs, decrees, price lists, and so forth, adds his comments, confronts them with the voice of society, adjusts his opinion accordingly, once again files away the new lesson, and in so doing hopes to preserve materials for future use! This already fully anticipates the later solemnity—developed to an utterly ridiculous point—with which he holds diaries and notes in the highest esteem, and considers the most miserable thing with the pathetic mien of the wisdom seeker. From then on, every medal bestowed on him, every piece of granite bestowed by him, is for him an object of the highest importance; and when he drills rock salt—which Frederick the Great, despite all his orders had not succeeded in finding—he sees in this I know not what miracle and sends a symbolic knife-pointful of it to his friend Zelter in Berlin. There is nothing more characteristic of this later mental disposition, which develops steadily as he grows older, than the fact that he makes it his principle to contradict with zeal the old *nil admirari* and, instead, to admire everything, to find everything "significant, marvelous, incalculable."

In this attitude, which Gervinus portrays so unsurpassingly and without exaggeration, admiration certainly has its portion, but so does fear. The human being petrifies in the chaos of symbols and loses the freedom unknown to the ancients. In taking action, he lands among signs and oracles. They were not lacking in Goethe's life. Such a sign showed him the way to Weimar: indeed, in *Poetry and Truth,* he recounted how, while on a walk, torn between his calling to poetry and his calling to painting, he set up an oracle. Fear of responsibility is the most spiritual of all those kinds of fear to which Goethe's nature subjected him. It is a foundation of the conservative position that he brought to the political, the social, and in his old age probably the literary, too. It is the root of the missed opportunities in his erotic life. That it also determined his interpretation of *Elective Affinities* is certain. For it is this work of art that sheds light on the foundations of his own life—foundations which, because his confession does not betray them,

also remain concealed from a tradition that has not yet freed itself from the spell of that life. This mythic consciousness may not, however, be addressed with the trivial flourish under which one was often pleased to perceive a tragic dimension in the life of the Olympian. The tragic exists only in the being of the dramatic persona—that is to say, the person enacting or representing himself—never in the existence of a human being. And least of all in the quietist being of a Goethe, in whom such self-dramatizing moments are scarcely to be found. And so what counts for this life, as for every human life, is not the freedom of the tragic hero in death but rather redemption in eternal life.

II

Therefore, since all around
the summits of Time are heaped,
Around clearness,
And the most loved live near, growing faint
On most separate mountains,
Give us innocent water, then,
Oh, give us pinions, most faithful in mind,
To cross over and to return.
—Hölderlin

If every work is able, like *Elective Affinities,* to shed light on the life and essence of the author, then the usual sort of reflection falls all the more short of this the more it believes it adheres to it. For if an edition of a classic author only rarely fails to stress in its introduction that its content, more than that of almost any other book, is understandable solely in terms of the author's life, then this judgment already basically contains the *proton pseudos*[20] of the method that seeks to represent the development of the work in the author by the cliché of an essential image and an empty or incomprehensible "lived experience." This *proton pseudos* in almost all modern philology—that is, in the kind that is not yet determined by the study of word and subject matter [*Sache*]—is calculated, in proceeding from the essence and from the life, if not quite to derive the poetic work as a product of them, nevertheless to make it more accessible to the lazy understanding. To the extent, however, that it is unquestionably appropriate to erect knowledge on the basis of what is certain and demonstrable, then wherever insight addresses itself to content and essence, the work must by all means stand in the foreground. For nowhere are these more lastingly, more distinctively, and more comprehensibly evident than in the work. That even there they appear quite difficult enough, and to many people forever inaccessible, may be a sufficient reason for these people to base the study of the history of art not on precise insight into the work but on the study of the author and his

relations; but it cannot induce the critic to give credence to them, let alone to follow them. Rather, he will keep in mind that the sole rational connection between creative artist and work of art consists in the testimony that the latter gives about the former. Not only does one gain knowledge of the essence of a human being through his outward manifestations (and in this sense the works, too, are a part of his essence); no, such knowledge is determined first and foremost by the works. Works, like deeds, are non-derivable, and every reflection that acknowledges this principle in general so as to contradict it in particular has given up all pretention to content.

What in this way escapes banal representation is not only insight into the value and mode of works but, equally, insight into the essence and life of their author. All knowledge of the essence of the author, according to his totality, his "nature," is from the outset rendered vain through neglect of the interpretation of the work. For if this, too, is unable to render a complete and final intuition of the essence, which for various reasons is indeed always unthinkable, then, when the work is disregarded, the essence remains utterly unfathomable. But even insight into the life of the creative artist is inaccessible to the traditional biographical method. Clarity about the theoretical relation of essence and work is the basic condition of every view of the artist's life. Until now so little has been accomplished in this respect that psychological categories are generally considered the best means of insight, even though nowhere so much as here is one obliged to renounce every inkling of the true material content so long as such terms remain in vogue. For this much can be asserted: the primacy of the biographical in the picture one forms of the life of a creative artist—that is, the depiction of his life as that of a human being, with that double emphasis on what is decisive and what is undecidable in the ethical sphere—would have a place only where knowledge of the fathomlessness of the origin excludes each of his works, delimited according to their value and their content, from the ultimate meaning of his life. For if the great work does not take shape in ordinary existence, if, indeed, it is even a guarantee of the purity of ordinary existence, ultimately it is still only one among its various elements. And thus the work can clarify the life of the artist only in a wholly fragmentary way, more in its development than its content. The complete uncertainty as to the significance that works can have in the life of a human being has led to this: peculiar types of content are attributed to the life of creative artists, reserved for it and justified in it alone. Such a life is not only supposed to be emancipated from all moral maxims; no, it is supposed to partake of a higher legitimation and be more distinctly accessible to insight. No wonder that for such a view every genuine life-content, which always comes forth in the works as well, carries very little weight. Perhaps this view has never been more clearly displayed than with regard to Goethe.

In this conception, according to which the life of creative artists would

rule over autonomous contents, the trivial habit of thought accords so precisely with a much deeper thought that one might presume the first to be merely a deformation of the latter and original sort, which only recently came to light again. If, in fact, in the traditional view, work, essence, and life are mingled equally without definition, then the former, original view explicitly attributes unity to these three. In this way it constructs the appearance of the mythic hero. For in the domain of myth, essence, work, and life in fact form the unity that is otherwise assigned to them only in the mind of the lax literatus. There the essence is daemon; life, fate; and the work, which gives a distinct stamp only to the two of them, living form. There the work simultaneously contains the ground of essence and the content of life. The canonical form of mythic life is precisely that of the hero. In it the pragmatic is at the same time symbolic; in it alone, in other words, the symbolic form and with it the symbolic content of human life are rendered intelligible in the same manner. But this human life is actually superhuman and hence different from the truly human, not only in the existence of its form but, more decisively, in the essence of its content. For while the hidden symbolism of the latter is based in binding fashion just as much on the individual dimension as on the human dimension of what is alive, the manifest symbolism of the heroic life attains neither to the sphere of individual particularity nor to that of moral uniqueness. The type, the norm, even if superhuman, distinguishes the hero from the individual; his role as representative separates him from the moral uniqueness of responsibility. For he is not alone before his god; rather, he is the representative of mankind before its gods. In the moral domain, all representation is of a mythic nature, from the patriotic "one for all" to the sacrificial death of the Redeemer.

In the heroic life, typology and representation culminate in the concept of the task. The presence of this task and of its evident symbolism distinguishes the superhuman from the human life. It characterizes Orpheus, who descends into Hades, no less than the Hercules of the Twelve Tasks; the mythic bard as much as the mythic hero. One of the most powerful sources of this symbolism flows from the astral myth: in the superhuman type of the Redeemer, the hero represents mankind through his work on the starry sky. The primal words of the Orphic poem apply to him: it is his daemon— the sunlike one; his *tychē,* the one that is as changeable as the moon; his fate, ineluctable like the astral *anankē.* Even Eros does not point beyond them—only Elpis does.[21] And so it is no accident that the author came across Elpis when he sought something close to the human in the other primal words; no accident that, among them all, Elpis alone was found to need no explanation; yet no accident, too, that not Elpis but rather the rigid canon of the other four furnished the scheme for Gundolf's *Goethe.* Accordingly, the question of method that is posed to biographical study is less doctrinaire

than this mode of deduction would allow one to surmise. For in Gundolf's book, after all, the attempt has been made to portray Goethe's life as a mythic one. Not only does this conception demand consideration because mythic elements operate in the existence of this man, but it demands it all the more in the contemplation of a work [*Elective Affinities*] to which, because of its mythic moments, it could appeal. For if the conception succeeds in corroborating this claim, it would be impossible to isolate the layer in which the meaning of that novel autonomously reigns. Where the existence of no such special domain can be proved, we are dealing not with a literary work of art but solely with its precursor: magical writing. And so every close reading of a work by Goethe, but most especially of *Elective Affinities,* depends on the repudiation of this attempt. With that, insight is at once conducted into a luminous kernel of redemptive content, something which in *Elective Affinities,* as everywhere else, eludes that position.

The canon that corresponds to the life of the demigod appears in a peculiar displacement in the conception of the poet that is proclaimed by the George school. This school assigns to the poet, like the hero, his work as a task; hence, his mandate is considered divine. From God, however, man receives not tasks but only exactions, and therefore before God no privileged value can be ascribed to the poetic life. Moreover, the notion of the task is also inappropriate from the standpoint of the poet. The literary work of art in the true sense arises only where the word liberates itself from the spell of even the greatest task. Such poetry does not descend from God but ascends from what in the soul is unfathomable; it has a share in man's deepest self. Since the mission of poetry seems, for the George circle, to stem directly from God, not only does this mission grant to the poet an inviolable though merely relative rank among his people, but, on the contrary, it grants to him a thoroughly problematic supremacy simply as a human being and hence grants problematic supremacy to his life before God, to whom, as a super-man, he appears to be equal. The poet, however, is a more provisional manifestation of human essence than the saint—not, as might be supposed, in the sense of degree but in the sense of type. For in the essence of the poet, the relation of the individual to the communal life of his people is determined; in the essence of the saint, the relation of the human being to God.

From the abyss of thoughtless linguistic confusion a second, no less important error adheres confusingly and fatally to the heroizing attitude of the members of the George circle, as they supply the basis for Gundolf's book.[22] Even if the title of "creator" certainly does not belong to the poet, it has already devolved upon him in that spirit which does not perceive the metaphorical note in it—namely, the reminder of the true Creator. And indeed the artist is less the primal ground or creator than the origin or form giver [*Bildner*], and certainly his work is not at any price his creature but

rather his form [*Gebilde*]. To be sure, the form, too, and not only the creature, has life. But the basis of the decisive difference between the two is this: only the life of the creature, never that of the formed structure [*des Gebildeten*], partakes, unreservedly, of the intention of redemption. In whatever way figurative language may speak of the creativity of the artist, therefore, creation is able to unfold the *virtus* that is most its own—namely, that of cause—not through his works but solely through creatures. Hence, that unreflective linguistic habit which draws edification from the word "creator" leads one automatically to consider not the works but rather the life as the product that most belongs to the artist. Yet whereas the fully articulated structure, whose form is struggle, represents itself in the life of the hero by virtue of his complete symbolic transparency, the life of the poet—like the life of any other man—scarcely displays an unambiguous task, any more than it displays an unambiguous and clearly demonstrable struggle. A form must still be conjured up, however, and the only one that offers itself, on the far side of the form that lives in battle, is the form that petrifies in literature. So triumphs the dogma which, having enchanted the work into life, now through a no less seductive error allows it, as life, to petrify back into work; and which purposes to grasp the much-vaunted "form" of the poet as a hybrid of hero and creator, in whom nothing further can be distinguished yet about whom, with a show of profundity, anything can be affirmed.

The most thoughtless dogma of the Goethe cult, the most jejune confession of the adepts, asserts that among all the works of Goethe the greatest is his life; Gundolf's *Goethe* took this up. Accordingly, Goethe's life is not rigorously distinguished from that of the works. Just as the poet, in an obviously paradoxical image, once termed colors the "deeds and sufferings of light," Gundolf, in an extremely murky perception, turns Goethe's life into this light, which would ultimately be no different in kind from his colors, his works. This position achieves two things for him: it eliminates every moral concept from the horizon, and, at the same time, by attributing to the hero-as-creator the form which goes to him as victor, it achieves the level of blasphemous profundity. Thus, he says that in *Elective Affinities* Goethe "brooded over the juridical procedures of God." But the life of a man, even that of a creative artist, is never that of the creator. It cannot be interpreted any more than the life of the hero, who gives form to himself. In such a perspective, Gundolf produces his commentary. For it is not with the faithful attitude of the biographer that the material content of this life is grasped—something which indeed must be done precisely for the sake of what has not been understood in it—nor is it grasped with the great modesty of authentic biographism, as the archive containing the documents (by themselves undecodable) of this existence. Instead, material content and truth content are supposed to stand in plain daylight and, as in the life of the hero, correspond to each other. Only the material content of the life lies

open, however, and its truth content is hidden. Certainly the particular trait and the particular relation can be illuminated, but not the totality—unless it, too, is grasped as a merely finite relation. For, in itself, it is infinite. Therefore, in the realm of biography, there is neither commentary nor critique. In violation of this principle, two books—which might, moreover, be termed the antipodes of the literature on Goethe—strangely encounter each other: the work by Gundolf and the presentation by Baumgartner. Whereas the latter undertakes to fathom the truth content directly (without, however, having the slightest inkling of the place where it is buried) and hence must pile one critical failure upon another to an inordinate extent, Gundolf plunges into the world of the material contents of Goethe's life, in which, to be sure, he can only allegedly present their truth content. For human life cannot be considered on the analogy of a work of art. Yet Gundolf's critical principle for dealing with sources bespeaks the fundamental determination to produce such disfigurement. If, in the hierarchy of sources, the works are always placed in first position, and the letter—not to mention the conversation—is subordinated to them, then this stance is solely explicable from the fact that the life itself is seen as a work. For only with respect to such an entity [the work] does the commentary based on sources of this kind possess a higher value than that based on any other. But this happens only because, through the concept of the work, a strictly circumscribed sphere of its own is established—one which the life of the poet is unable to penetrate. If that hierarchy was perhaps an attempt to distinguish materials that were originally written from those that were initially oral, then this, too, is the crucial question only for genuine history, while biography, even where it makes the highest claim to content, must keep to the breadth of a human life. To be sure, at the beginning of his book, the author emphatically rejects the interests of biography; yet the lack of dignity which often goes with present-day biographical writing should not allow one to forget that a canon of concepts underlies it—concepts without which every historical reflection on a human being ultimately falls into vacuousness. No wonder, then, that with the inner formlessness of this book a formless type of poet takes shape, one which calls to mind the monument sketched by Bettina in which the enormous forms of this venerated man dissolve into shapelessness, into hermaphroditism. This monumentality is a fabrication, and—to speak in Gundolf's own language—it turns out that the image which arises from the impotent Logos is not so unlike the one fashioned by immoderate Eros.

Only persistent interrogation of its method can make headway against the chimerical nature of this work. Without this weapon, it is wasted effort to try conclusions with the details, for they are armored in an almost impenetrable terminology. What emerges from this is the meaning, fundamental to all knowledge, of the relation between myth and truth. This

relation is one of mutual exclusion. There is no truth, for there is no unequivocalness—and hence not even error—in myth. Since, however, there can just as little be truth about it (for there is truth only in objective things [*Sachen*], just as objectivity [*Sachlichkeit*] lies in the truth), there is, as far as the spirit of myth is concerned, only a knowledge of it. And where the presence of truth should be possible, it can be possible solely under the condition of the recognition of myth—that is, the recognition of its crushing indifference to truth. Therefore, in Greece genuine art and genuine philosophy—as distinct from their inauthentic stage, the theurgic—begin with the departure of myth, because art is not based on truth to any lesser extent than is philosophy, and philosophy is not based on truth to any greater extent than is art. So unfathomable, however, is the confusion instituted by the conflation of truth and myth that, with its hidden efficacy, this initial distortion threatens to shield almost every single sentence of Gundolf's work from critical suspicion. Yet the whole craft of the critic here consists in nothing else but catching hold, like a second Gulliver, of a single one of these lilliputian sentencelets, despite its wriggling sophisms, and examining it in one's own time. "Only" in marriage "were united . . . all the attractions and repulsions that arise from the suspension of man between nature and culture, from this human duality: that with his blood he borders on the beast; with his soul, on divinity. . . . Only in marriage does the fateful and instinctual union or separation of two human beings . . . through the pro-creation of a legitimate child become, in pagan language, a mystery, and, in Christian language, a sacrament. Marriage is not only an animal act but also a magical one, an enchantment." A formulation that is distinguished from the mentality of a fortune-cookie motto only by the bloodthirsty mysticism of its wording. How securely, by contrast, stands the Kantian explanation, whose strict allusion to the natural component of marriage—sexuality—does not obstruct the path to the logos of its divine component—fidelity. For what is proper to the truly divine is the logos: the divine does not ground life without truth, nor does it ground the rite without theology. On the contrary, the common feature of all pagan vision is the primacy of cult over doctrine, which most surely shows itself as pagan in being exclusively esoteric. Gundolf's *Goethe,* this ungainly pedestal for his own statuette, reveals in every sense a person initiated in an esoteric doctrine, who only out of forbearance suffers philosophy's struggle over a mystery, the key to which he holds in his hands. Yet no mode of thinking is more disastrous than that which bewilderingly bends back into the myth the very thing that has begun to grow out of it, and which, of course, through this imposed immersion in monstrosity, would at once have sounded an alert in any mind for which a sojourn in a tropical wilderness[23] is unacceptable—a sojourn in a jungle where words swing themselves, like chattering monkeys, from branch to branch, from bombast to bombast,[24] in order not to have to touch

the ground which betrays the fact that they cannot stand: that is, the ground of logos, where they ought to stand and give an account of themselves. But they avoid this ground with so much show because in the face of every sort of mythic thinking, even one surreptitiously obtained, the question of truth comes to naught in it. According to this sort of thinking, in fact, it is of no importance if the blind earth-stratum of mere material content is taken for the truth content in Goethe's work; and if, instead of purifying (using an idea like that of fate) truthful content by means of knowledge, it is spoiled by sentimentality, with a "nose" that empathizes with that knowledge. Thus, along with the fake monumentality of the Goethean image appears the counterfeit legitimacy of the knowledge of that image; and the investigation of the logos of this knowledge, aided by insight into the infirmity of its method, encounters the verbal pretension of the knowledge and thus strikes its heart. Its concepts are names; its judgments, formulas. For in this knowledge, language—the radiance of whose *ratio* even the poorest wretch has not yet been able to extinguish entirely—is precisely the thing that has to spread a darkness which it alone could illuminate. With this, the last shred of belief in the superiority of this work to the Goethe literature of the older schools must vanish—this work which an intimidated philology approved as its legitimate and greater successor, not solely on account of its own bad conscience but also because it was unable to take the measure of the work with its stock concepts. Nevertheless, the almost unfathomable perversion of the mode of thinking of this work does not withdraw from philosophical meditation an endeavor which even then would pronounce sentence on itself, if it did not wear the depraved appearance of success.

Wherever an insight into Goethe's life and work is in question, the mythic world—however visibly it may come to light in them, too—cannot provide the basis of knowledge. A particular mythic moment may very well be an object of reflection; on the other hand, where it is a matter of the essence and the truth in the work and in the life, the insight into myth, even in its concrete relations, is not final. For neither Goethe's life nor any one of his works is fully represented in the domain of myth. If, insofar as it is a question of the life, this is warranted simply by his human nature, the works teach it in detail, to the extent that a struggle which was kept secret in life emerges in the last of them. And only in the works does one encounter mythic elements in the content and not just in the subject. They can indeed be regarded, in the context of this life, as valid testimony of its final course. They testify not only, and not at the deepest level, to the mythic world in Goethe's existence. For there is in him a struggle to free himself from its clutches, and this struggle, no less than the essence of that world, is attested to in Goethe's novel. In the tremendous ultimate experience of the mythic powers—in the knowledge that reconciliation with them cannot be obtained except through the constancy of sacrifice—Goethe revolted against them. If

he made a constantly renewed attempt during the years of his manhood—an attempt undertaken with inner despondency, yet with an iron will—to submit to those mythic orders wherever they still rule (indeed, for his part to consolidate their rule, in just the way this is done by one who serves the powerful), this attempt broke down after the final and most difficult submission of which he was capable, after his capitulation in the more than thirty-year struggle against marriage, which struck him as the threatening symbol of arrest by the mythic powers. And a year after his marriage, which had forced itself on him at a time of fateful pressure, he began *Elective Affinities,* with which he then registered his protest—a protest that unfolded ever more powerfully in his later work, against the world with which he had concluded the pact in the years of his manhood. *Elective Affinities* constitutes a turning point in this body of work. With it begins the last series of his productions, from no one of which he was able to detach himself completely, because until the end their heartbeat was alive in him. Whence one understands the gripping diary entry of 1820 stating that he "began to read *Elective Affinities,*" and understands as well the wordless irony of a scene reported by Heinrich Laube: "A lady addressed Goethe on the subject of *Elective Affinities:* 'I do not approve of this book at all, Herr von Goethe; it is truly immoral and I do not recommend it to any woman.'—Thereupon Goethe kept a serious silence for a while, and finally, with a good deal of emotion, replied: 'I am sorry, for it is my best book.'" That last series of works attests to and accompanies his purification, which was no longer allowed to be a liberation. Perhaps because his youth had often taken all-too-swift flight from the exigencies of life into the domain of literature, age, by a terribly punishing irony, made poetry the tyrant of his life. Goethe bent his life to the hierarchies that made it the occasion of his poetry. This is the moral significance of his meditation in old age on the objective contents. *Truth and Poetry, West-Östlicher Divan* [West-Easterly Divan], and the second part of *Faust* became the three great documents of such masked penance. The historicizing of his life, as it was entrusted first to *Truth and Poetry* and later to the daily and annual notebooks, had to prove—and invent—how much this life had been an *ur*-phenomenon of a life full of poetic content, full of themes and opportunities for "the poet." The occasion of poetry, of which we are speaking here, is not only something different from the lived experience which modern convention puts at the basis of poetic invention, but is the exact opposite of it. The thesis that is continually handed down through histories of literature—the cliché that Goethe's poetry had been an "occasional poetry"—means that his poetry was a poetry of experience; with regard to the last and greatest works, therefore, the thesis speaks the opposite of the truth. For the occasion provides the content, and the lived experience leaves only a feeling behind. Related and similar to the connection between these two is the link between the words *Genius* and *Genie.* On the lips of the moderns, the latter ulti-

mately amounts to a title which, no matter how they position themselves, will never be suited to catching in its essential character the relation of a human being to art. The word *Genius* succeeds in this, and Hölderlin's verses vouch for it:

> Are not many of the living known to you?
> Does not your foot stride upon what is true, as upon carpets?
> Therefore, my genius, only step
> Naked into life, and have no care!
> Whatever happens, let it all be opportune for you!

This is precisely the ancient vocation of the poet, who from Pindar to Meleager, from the Isthmian Games to the hour of love, found only sundry high (but as such always worthy) occasions for his bardic song, which he therefore never thought to base on experience. And so the concept of lived experience is nothing but a paraphrase of that lack of consequence in poetry—a lack of consequence longed for also by that most sublime (because still just as cowardly) philistinism which, robbed of the relation to truth, is unable to rouse responsibility from its sleep. In his old age, Goethe had penetrated profoundly enough into the essence of poetry to feel with horror the absence of every occasion for poetry in the world that surrounded him, yet want to stride solely and forever upon that carpet of truth. It was late when he stood on the threshold of German Romanticism. He was not allowed—any more than Hölderlin was—access to religion, no matter what the form of conversion, no matter what the turning toward community. Goethe abhorred religion in the Early Romantics. But the laws that they vainly sought to satisfy by converting, and thus by extinguishing their lives, kindled in Goethe—who also had to submit to these laws—the highest flame of his life. It burned away the dross of every passion; and thus in his correspondence, up to the end of his life, he was able to keep his love for Marianne[25] so painfully close that more than a decade after the time in which their affection for each other declared itself, he could compose what is perhaps the most powerful poem of the *Divan*: "No longer on a leaf of silk / I write symmetric rhymes." And the final phenomenon of this literature that governed his life, and indeed ultimately even the duration of his life, was the conclusion to *Faust*. If in the series of these works from his old age *Elective Affinities* is the first, then a purer promise, no matter how darkly the myth holds sway in it, must already be visible there. But in a treatment like Gundolf's, it will not come to light. As little as that of other authors does Gundolf's take account of the novella "Die wunderlichen Nachbarskinder" [The Curious Tale of the Childhood Sweethearts].

Elective Affinities itself was originally planned as a novella in the orbit of *Wilhelm Meister's Apprenticeship,* but its growth forced it out of that orbit. The traces of its original formal conception, however, are preserved, despite

everything that made the work become a novel. Only Goethe's consummate mastery, which is here at its height, was able to prevent the inherent tendency of the novella from bursting the novel form. The conflict appears to be subdued—and the unity attained—with violence, in that he ennobles (so to speak) the form of the novel through that of the novella. The compelling artistic device that made this possible, and which imposed itself equally imperiously from the side of the content, lies in the author's refusal to summon the reader's sympathy into the center of the action itself. The fact that the action remains in effect so thoroughly inaccessible to the immediate intention of the reader, as is most clearly illuminated by the unsuspected death of Ottilie, betrays the influence of the novella-form upon that of the novel; and it is precisely in the presentation of this death that a break, too, most vividly betrays itself, when, finally, that center of the action, which in the novella permanently closes itself off, makes itself felt with doubled force.[26] It may be part of the same formal tendency, as R. M. Meyer has already pointed out, that the story likes to arrange groups. And, to be sure, the story's pictorialness is fundamentally unpainterly; it may be called plastic, perhaps stereoscopic. This, too, appears novella-like. For if the novel, like a maelstrom, draws the reader irresistibly into its interior, the novella strives toward distance, pushing every living creature out of its magic circle. In this way, despite its breadth, *Elective Affinities* has remained novella-like.[27] In its effectiveness of expression, it is not superior to the actual novella contained in it. In it a boundary form has been created, and by virtue of this fact it stands further removed from other novels than those novels stand from one another. "[In *Wilhelm*] *Meister* and in *Elective Affinities,* the artistic style is thoroughly determined by the fact that we feel the storyteller everywhere. Absent here is the formal-artistic realism . . . which makes events and human beings depend entirely on themselves so that they produce their effect strictly as immediate presences, as if from the stage. Instead, they are really a 'story' sustained by the storyteller standing in the background, palpable. . . . Goethe's novels unfold inside the categories of the 'storyteller.'" "Recited" is the word Simmel uses elsewhere for this style.[28] But whatever the explanation for this phenomenon (which does not appear further analyzable to Simmel) in *Wilhelm Meister,* in *Elective Affinities* it stems from Goethe's preserving jealously for himself exclusive rule within the life-circle of his literary work. Such restrictions upon the reader are the hallmarks of the classic form of the novella: Boccaccio gives his own novellas a frame; Cervantes writes a prologue for his. Thus, however much in *Elective Affinities* the form of the novel calls attention to itself, it is precisely this emphasis and exaggeration of type and contour that betray it as novella-like.

Nothing could make more inconspicuous the remaining residue of ambiguity than the insertion of a novella, which, the more the main work stood out against it as a pure example of its kind, the more it had to be made to

appear similar to a true novel. On this is based the significance of the composition "The Curious Tale of the Childhood Sweethearts," which is meant to count as a model novella even where consideration is restricted to its form. Furthermore, Goethe wanted to establish this tale—not less than the novel, indeed to a certain extent even more—as exemplary. For although the event which it reports is conceived in the novel itself as a real one, the story is nonetheless characterized as a novella. It is meant to be considered "a Novella" just as rigorously as the main work is meant to be considered "a Novel." In the clearest way, the thus-conceived lawful character of its form (namely, the untouchability of the center—that is to say, the mystery as an essential characteristic) stands out in bold relief. For in it, the mystery is the catastrophe, which, as the animating principle of the story, is conducted into its center, while in the novel the significance of the catastrophe, the concluding event, remains phenomenal. The enlivening power of this catastrophe, although so much in the novel corresponds to it, is so difficult to fathom that to an unguided reader the novella appears no less independent yet also hardly less enigmatic than "Die pilgernde Törin" [The Foolish Pilgrim]. But in this novella a brilliant light holds sway. From the outset everything, sharply contoured, is at a peak. It is the day of decision shining into the dusk-filled Hades of the novel. Hence, the novella is more prosaic than the novel. It confronts the novel in prose of a higher degree. To this corresponds the genuine anonymity of its characters and the partial, undecided anonymity of those of the novel.

While in their life seclusion prevails, which completes the guaranteed freedom of their actions, the characters in the novella come forth closely surrounded on all sides by their human environment, their relatives. Although in the novel Ottilie relinquishes, at the urging of her beloved, not only the medallion of her father but even the memory of her home in order to consecrate herself wholly to love, in the novella even those who are united do not feel themselves independent of the paternal blessing. This small difference most deeply characterizes the couples. For it is certain that the lovers step out maturely from the ties with their parental home, and no less certain that they transform its inner power; for if just one of them were to remain by himself caught up within it, the other, with his love, would carry him on out past it. If, in another way, there is any such thing for lovers as a sign, then it is this: that for both of them not only the abyss of sex but even that of family has closed. In order for such a loving vision to be valid, it may not withdraw weak-spiritedly from the sight, let alone the knowledge, of one's parents, which is what Eduard imposes on Ottilie. The power of lovers triumphs by eclipsing even the full presence of the parents in the beloved. How much they are able in their radiance to release each other from all ties is shown in the novella by the image of the garments in which the children are scarcely recognized anymore by their parents. The lovers in

the novella enter into relations not only with them but also with the rest of their human environment. And whereas for the novel's characters independence only seals all the more rigorously the temporal and local circumstances of their subjection to fate, for the novella's characters it holds the most invaluable guarantee that, with the climax of their own distress, their companions in travel run the risk of foundering. What this says is that even the greatest extremity does not expel the two young lovers from the circle of their own people, whereas the lifestyle of the characters in the novel, perfect in its form, can do nothing against the fact that, until the sacrifice occurs, each and every moment excludes them more inexorably from the community of the peaceful. The lovers in the novella do not obtain their freedom through sacrifice. That the girl's fatal leap does not have that meaning is indicated by the author in the most delicate and precise manner. For this alone is her secret intention when she throws the garland wreath to the boy: to assert that she does not want to "die in beauty," be wreathed in death like a sacrifice. The boy, whose mind is only on steering, testifies for his part that, whether knowingly or not, he does not have a share, as if it were a sacrifice, in any such deed. Because these human beings do not risk everything for the sake of a falsely conceived freedom, no sacrifice falls among them; rather, the decision befalls within them. In fact, freedom is as clearly removed from the youth's saving decision as is fate. It is the chimerical striving for freedom that draws down fate upon the characters in the novel. The lovers in the novella stand beyond both freedom and fate, and their courageous decision suffices to tear to bits a fate that would gather to a head over them and to see through a freedom that would pull them down into the nothingness of choice. In the brief instants of their decision, this is the meaning of their action. Both dive down into the living current, whose beneficent power appears no less great in this event than the death-dealing power of the still waters in the other. Through an episode in the latter, the strange masquerade in the wedding clothes found by the two young people is fully illuminated. For there, Nanny refers to the shroud prepared for Ottilie as her "bridal gown." Hence, it is surely permitted to explicate accordingly that strange feature of the novella and—even without the mythic analogies that can probably be discovered—to recognize the wedding vestments of these lovers as transformed burial shrouds henceforth immune to death. The complete security of existence, which at the end opens itself to them, is also otherwise indicated. Not only because their garb conceals them from their friends, but above all through the great image of the boat landing at the place of their union, the feeling is aroused that they no longer have a fate and that they stand at the place where the others are meant to arrive some day.

With all this, it can certainly be considered incontrovertible that this novella is of decisive importance in the structure of *Elective Affinities*. Even

if it is only in the full light of the main story that all its details are revealed, the ones mentioned proclaim unmistakably that the mythic themes of the novel correspond to those of the novella as themes of redemption. Thus, if in the novel the mythic is considered the thesis, then the antithesis can be seen in the novella. Its title points to this. It is precisely to the characters in the novel that those neighbors' children must seem most "curious," and it is those characters, too, who then turn away from them with deeply hurt feelings. A hurt that, in accordance with the secret matter of the novella— one that was, perhaps, in many respects even hidden from Goethe—motivated him in an external way without thus robbing this matter of its inner significance. Whereas the characters of the novel linger more weakly and more mutely, though fully life-sized in the gaze of the reader, the united couple of the novella disappears under the arch of a final rhetorical question, in the perspective, so to speak, of infinite distance. In the readiness for withdrawal and disappearance, is it not bliss that is hinted at, bliss in small things, which Goethe later made the sole motif of "The New Melusine"?[29]

III

Before you know the bodies on this star,
I shape you dreams among eternal stars.
—Stefan George

The umbrage taken at every critique of art that supposedly stands too close to the work, by those who do not find in that critique an afterimage of their own self-complacent reveries, testifies to so much ignorance of the essence of art that a period for which the rigorously determined origin of art is becoming ever more vivid does not owe this complaint a refutation. Yet an image that speaks home truths to sentimentality in the most straightforward way is perhaps allowed. Let us suppose that one makes the acquaintance of a person who is handsome and attractive but impenetrable, because he carries a secret with him. It would be reprehensible to want to pry. Still, it would surely be permissible to inquire whether he has any siblings and whether their nature could not perhaps explain somewhat the enigmatic character of the stranger. In just this way critique seeks to discover siblings of the work of art. And all genuine works have their siblings in the realm of philosophy. It is, after all, precisely these figures in which the ideal of philosophy's problem appears.—The totality of philosophy, its system, is of a higher magnitude of power than can be demanded by the quintessence of all its problems taken together, because the unity in the solution of them all cannot be obtained by questioning. If, that is to say, it were possible to obtain the very unity in the solution to all problems as the answer to a question, then with respect to the question seeking this unity, a new question

would immediately arise, on which the unity of its answer together with that of all the others would be founded. It follows that there is no question which, in the reach of its inquiry, encompasses the unity of philosophy. The concept of this nonexistent question seeking the unity of philosophy by inquiry functions in philosophy as the ideal of the problem. Even if, however, the system is in no sense attainable through inquiry, there are nevertheless constructions which, without being questions, have the deepest affinity with the ideal of the problem. These are works of art. The work of art does not compete with philosophy itself—it merely enters into the most precise relation to philosophy through its affinity with the ideal of the problem. And to be sure, according to a lawfulness grounded in the essence of the ideal as such, the ideal can represent itself solely in a multiplicity. The ideal of the problem, however, does not appear in a multiplicity of problems. Rather, it lies buried in a manifold of works, and its excavation is the business of critique. The latter allows the ideal of the problem to appear in the work of art in one of its manifestations. For critique ultimately shows in the work of art the virtual possibility of formulating the work's truth content as the highest philosophical problem. That before which it stops short, however—as if in awe of the work, but equally from respect for the truth—is precisely this formulation itself. That possibility of formulation could indeed be realized only if the system could be the object of inquiry and thereby transform itself from an appearance of the ideal into the existence of the ideal—an existence that is never given. As such, however, it says simply that the truth in a work would be known not as something obtained in answer to a question, to be sure, but as something obtained on demand. If, therefore, one may say that everything beautiful is connected in some way to the true, and that the virtual site of the true in philosophy can be determined, then this is to say that in every true work of art an appearance of the ideal of the problem can be discovered. Hence, one comes to see that, from the moment reflection raises itself up from the foundations of the novel to the vision of its perfection, philosophy not myth is called upon to guide it.

With this, the figure of Ottilie steps forth. It is, after all, in this figure that the novel appears most visibly to grow away from the mythic world. For even though she falls victim to dark powers, it is still precisely her innocence which, in keeping with the ancient requirement that the sacrificial object be irreproachable, forces on her this terrible destiny. To be sure, chastity, to the extent that it may arise from intellectuality, is not manifested in the figure of this girl (indeed, such untouchability, in Luciane, practically constitutes a fault); nonetheless, her wholly natural behavior, despite the complete passivity that characterizes Ottilie in the erotic as well as in every other sphere, makes her as unapproachable as someone in a trance. In its impertinent way, Werner's sonnet also announces that the chastity of this child

harbors no consciousness. But is not its merit only all the greater? In the scenes in which Goethe shows her with the baby Jesus and with Charlotte's dead child in her arms, he indicates just how deeply chastity is rooted in her nature. Ottilie comes to both without a husband. The author, however, has said still more with this. For the "living" picture, which portrays the grace and, transcending all ethical rigor, the purity of the Mother of God, is precisely the artificial one. The one that nature offers only a little later shows the dead boy. And this is what unveils the true essence of that chastity, whose sacred infertility, in itself, in no way ranks higher than the impure turbulence of sexuality that draws the estranged spouses to each other, and whose privilege is valid only in delaying a union in which husband and wife would have to lose each other. In the figure of Ottilie, however, this chastity lays claim to far more. It evokes the semblance of an innocence of natural life. The pagan if not indeed the mythic idea of this innocence owes to Christianity at least its formulation—a formulation most extreme and fraught with consequences—in the ideal of virginity. If the grounds of a mythic primal guilt are to be sought in the bare, vital drive of sexuality, then Christian thought finds its counterpart where that drive is furthest removed from drastic expression: in the life of the virgin. But this clear, if not clearly conscious, intention includes an error full of grave consequence. To be sure, like natural guilt, there is also a natural innocence of life. The latter, however, is tied not to sexuality—not even in the mode of denial—but rather solely to its antipode, the spirit (which is equally natural). Just as the sexual life of man can become the expression of natural guilt, his spiritual life, based on the variously constituted unity of his individuality, can become the expression of natural innocence. This unity of individual spiritual life is "character." Unequivocalness, as its essential constitutive moment, distinguishes it from the daemonism of all purely sexual phenomena. To attribute to a human being a complicated character can only mean, whether rightly or wrongly, to deny him character, whereas for every manifestation of bare sexual life the seal of its recognition remains the insight into the equivocalness of its nature. This is also confirmed in virginity. Above all, the ambiguity of its intactness is evident. For that which is considered the sign of inner purity is precisely what desire most welcomes. But even the innocence of unknowingness is ambiguous. For on its basis affection passes willy-nilly over into desire, which is felt as sinful. And precisely this ambiguity returns in an extremely characteristic manner in the Christian symbol of innocence, the lily. The severe lines of the plant, the whiteness of the calyx, are joined to numbingly sweet scents that are scarcely still vegetal. The author has also given Ottilie this dangerous magic of innocence, which is most intimately related to the sacrifice celebrated by her death. For the very fact that she appears innocent in this manner prevents her from escaping the spell of that consummation. Not purity but its semblance spreads itself out with such

innocence over her form. And the untouchableness of that semblance places her out of reach of her lover. The same sort of semblance-like nature is also hinted at in Charlotte's being, which only appears to be completely pure and irreproachable, while in truth her infidelity to her friend disfigures it. Even in her appearance as mother and housewife, in which passivity befits her very little, she strikes one as phantom-like. Yet nobility presents itself in her only at the price of this indefiniteness. Hence, at the deepest level, she is not unlike Ottilie, who among the phantoms is the sole semblance. In general, then, one must—if one is to gain insight into this work—search for its key not in the contrast among the four partners but rather in the equally strong contrast that obtains between them and the lovers in the novella. The characters of the main story differ from one another less as individuals than as pairs.

Does Ottilie's essence have its share in that genuine natural innocence which has as little to do with equivocal intactness as with blessed guiltlessness? Does she have character? Is her nature, not so much thanks to her own openheartedness as by dint of her free and open expression, clear before our eyes? Rather, the opposite of all this characterizes her. She is reserved; more than this, nothing she says or does can deprive her of reserve. Plant-like muteness, which speaks so clearly from the Daphne-motif of pleadingly upraised hands, lies about her being and darkens it even in the most extreme moments of distress—moments that, in the case of anyone else, place the person's being in a bright light. Her decision to die remains a secret until the end, and not only to her friends; it seems to form itself, completely hidden, in a manner incomprehensible to her, too. And this hiddenness touches the root of the morality of her decision. For if the moral world shows itself anywhere illuminated by the spirit of language, it is in the decision. No moral decision can enter into life without verbal form and, strictly speaking, without thus becoming an object of communication. That is why, in Ottilie's complete silence, the morality of the will to die that animates her becomes questionable. In truth, what underlies it is not a decision but a drive. Therefore, her dying is not—as she seems ambiguously to express it—sacred. If she herself recognizes that she has strayed from her "path," then this phrase can in truth only be saying that death alone can save her from internal ruin. Death is thus very probably atonement, in the sense of fate but not holy absolution—which voluntary death can never be for human beings and which only the divine death imposed on them can become. Ottilie's death, like her virginity, is merely the last exit of the soul, which flees from ruin. In her death drive, there speaks the longing for rest. Goethe has not failed to indicate how completely it arises from what is natural in her. If Ottilie dies by depriving herself of food, then Goethe has also made it clear in the novel how often, even in happier times, food was repugnant to her. Ottilie's existence, which Gundolf calls sacred, is an

unhallowed one, not so much because she trespassed against a marriage in dissolution as because in her seeming and her becoming, subjected until her death to a fateful power, she vegetates without decision. This—her lingering, at once guilty and guiltless, in the precincts of fate—lends her, for the fleeting glance, a tragic quality. Thus, Gundolf can speak of "the pathos of this work, no less tragically sublime and shattering than that from which Sophocles' *Oedipus* arises." Before him [André] François-Poncet had already spoken in a similar vein in his shallow, bloated book on the "affinités électives." Yet this is the falsest of judgments. For in the tragic words of the hero, the crest of decision is ascended, beneath which the guilt and innocence of the myth engulf each other as an abyss. On the far side of Guilt and Innocence is grounded the here-and-now of Good and Evil, attainable by the hero alone—never by the hesitant girl. Therefore, it is empty talk to praise her "tragic purification." Nothing more untragic can be conceived than this mournful end.

But this is not the only place in which the speechless drive is revealed; Ottilie's life, too, seems to be without foundation when exposed to the luminous circle of moral orders. Yet only a complete lack of sympathy for this work appears to have opened the critic's eyes to it. Thus, it was reserved for the pedestrian common sense of a Julian Schmidt to raise the question that must have posed itself immediately to the unprejudiced reader of these events: "There would have been nothing to say against it if passion had been stronger than conscience, but how is this silencing of conscience to be understood?" "Ottilie commits a wrong; afterward she feels it very deeply, more deeply than necessary. But how does it come about that she does not feel it earlier? . . . How is it possible that someone as well constituted and well brought up as Ottilie is supposed to be does not feel that by her behavior toward Eduard she wrongs Charlotte, her benefactress?" No insight into the innermost relations of the novel can invalidate the plain justice of this question. Misrecognizing its obligatory character leaves the essence of the novel in darkness. For this silencing of the moral voice is not to be grasped, like the muted language of the affects, as a feature of individuality. It is not a determination within the boundaries of human being. With this silence, the semblance has installed itself consumingly in the heart of the noblest being. And this curiously calls to mind the taciturnity of Minna Herzlieb, who died insane in old age. All speechless clarity of action is semblance-like, and in truth the inner life of those who in this way preserve themselves is no less obscure to them than to others. Only in Ottilie's diary, ultimately, does her human life appear still to stir. The whole of her linguistically gifted existence is finally to be sought increasingly in these mute notations. Yet they, too, merely erect a monument for someone who has slowly died away. Their revelation of secrets that only death might unseal inures one to the thought of her passing away; and by announcing the

taciturnity of the living person, they also foretell the fact that she will become entirely mute. The semblance-like dimension, which governs the life of the girl who writes, penetrates even her spiritual, detached mood. For if it is the danger of the diary as such to lay bare prematurely the germs of memory in the soul and prevent the ripening of its fruits, the danger must necessarily become fatal when the spiritual life expresses itself only in the diary. Yet all the power of internalized existence stems finally from memory. It alone guarantees love a soul. It breathes in that Goethean recollection: "Oh, you were in times lived through / My sister or my wife." And as in such association even beauty survives itself as memory, so in its blossoming, too, beauty is inessential without memory. The words of Plato's "Phaedrus" testify to this: "But when one who is fresh from the mystery and who saw much of the vision beholds a godlike face or bodily form that truly expresses beauty, he is at first seized with shuddering and a measure of that awe which the vision inspired, then with reverence as if at the sight of a god; and but for fear of being deemed a madman, he would offer sacrifice to his beloved, as to the holy image of a deity. . . . At this sight, his memory returns to that form of beauty, and he sees her once again enthroned by the side of temperance upon her holy seat."

Ottilie's existence does not awaken such memory: in it beauty really remains what is foremost and essential. All her favorable "impression comes exclusively from her appearance; despite the numerous diary pages, her inner essence remains closed off. She is more reserved than any female figure of Heinrich von Kleist." With this insight, Julian Schmidt echoes an old critique that says with odd exactitude: "This Ottilie is not an authentic child of the poet's spirit but is conceived in sinful fashion, in a doubled memory of Mignon[30] and an old picture by Masaccio or Giotto." Indeed, with Ottilie's figure the limits of epic vis-à-vis painting are overstepped. For the appearance of the beautiful as the essential content in a living being lies outside the sphere of epic material. Yet the appearance of the beautiful does stand at the center of the novel. For one does not overstate the case if one says that the belief in Ottilie's beauty is the fundamental condition for engagement with the novel. This beauty, as long as the novel's world en-dures, may not disappear: the coffin in which the girl rests is not closed. In this work, Goethe has left far behind the famous Homeric example of the epic depiction of beauty. For not only does Helen herself in her mockery of Paris appear in a more decisive manner than Ottilie ever does in her words; but above all, in the representation of Ottilie's beauty, Goethe has not followed the famous rule drawn from the admiring speeches of the old men gathered on the wall. Those distinctive epithets, which are bestowed on Ottilie even against the laws of novelistic form, serve only to remove her from the epic plane in which the writer reigns, and to transmit a strange vitality to her for which he is not responsible. Thus, the farther away she

stands from Homer's Helen, the closer she stands to Goethe's Helena. In ambiguous innocence and semblance-like beauty, like her, she stands, like her, in expectation of her expiatory death. And conjuration is also in play in her appearance.

Confronting the episodic figure of the Greek woman, Goethe maintained perfect mastery, since he illuminated in the form of dramatic representation even the conjuration; and in this sense it seems hardly a matter of chance that the scene in which Faust was supposed to implore Persephone to give him Helena was never written. In *Elective Affinities,* however, the daemonic principles of conjuration irrupt into the very center of the poetic composition. For what is conjured is always only a semblance—in Ottilie, a semblance of living beauty—which strongly, mysteriously, and impurely imposed itself in the most powerful sense as "material." Thus, the aura of Hades in what the author lends to the action is confirmed: he stands before the deep ground of his poetic gift like Odysseus with his naked sword before the ditch full of blood, and like him fends off the thirsty shades, in order to suffer only those whose brief report he seeks. This taciturnity is a sign of Ottilie's ghostly origin. It is this origin that produces the peculiar diaphanousness, at times preciosity, in layout and execution. That formulaic quality, found primarily in the composition of the novel's second part (which in the end was significantly expanded, after the completion of the basic conception), comes out well marked in the style—in its countless parallelisms, comparisons, and qualifications, with their suggestive proximity to the late-Goethean manner. In this sense, Görres[31] declared to Arnim that a lot in *Elective Affinities* seemed to him "as if highly polished rather than chiseled." An expression that might especially be applied to the *Maximen und Reflexionen* [Maxims and Reflections]. Still more problematic are the features which can in no way be disclosed to the purely receptive intention—those correspondences which reveal themselves only to philological research that completely eschews aesthetics. In such correspondences the presentation encroaches, quite undeniably, upon the domain of incantatory formulas. That is why it so often lacks the ultimate immediacy and finality of artistic vivification—why it lacks form. In the novel this form does not so much construct figures, which often enough on their own authority insert themselves formlessly as mythic figures. Rather, it plays about them hesitantly—in the manner of an arabesque, so to speak; it completes and with full justification dissolves them. One may view the effect of the novel as the expression of an inherent problematic. The latter distinguishes this novel from others that find the greatest part if not always the highest stage of their effect in the unselfconscious feelings of the reader, in exercising the most disconcerting influence upon those feelings. A turbid power, which in kindred spirits may rise to rapturous enthusiasm and in more remote spirits to sullen consternation, was always peculiar to this novel; only an incorruptible

rationality, under whose protection the heart might abandon itself to the prodigious, magical beauty of this work, is able to cope with it.

Conjuration intends to be the negative counterpart of creation. It, too, claims to bring forth a world from nothingness. With neither of them does the work of art have anything in common. It emerges not from nothingness but from chaos. However, the work of art will not escape from chaos, as does the created world according to the idealism of the doctrine of emanations. Artistic creation neither "makes" anything out of chaos nor permeates it; and one would be just as unable to engender semblance, as conjuration truly does, from elements of that chaos. This is what the formula produces. Form, however, enchants chaos momentarily into world. Therefore, no work of art may seem wholly alive, in a manner free of spell-like enchantment, without becoming mere semblance and ceasing to be a work of art. The life undulating in it must appear petrified and as if spellbound in a single moment. That which in it has being is mere beauty, mere harmony, which floods through the chaos (and, in truth, through this only and not the world) but, in this flooding-through, seems only to enliven it. What arrests this semblance, spellbinds the movement, and interrupts the harmony is the expressionless [das Ausdruckslose]. This life grounds the mystery; this petrification grounds the content in the work. Just as interruption by the commanding word is able to bring out the truth from the evasions of a woman precisely at the point where it interrupts, the expressionless compels the trembling harmony to stop and through its objection [Einspruch] immortalizes its quivering. In this immortalization the beautiful must vindicate itself, but now it appears to be interrupted precisely in its vindication, and thus it has the eternity of its content precisely by the grace of that objection. The expressionless is the critical violence which, while unable to separate semblance from essence in art, prevents them from mingling. It possesses this violence as a moral dictum. In the expressionless, the sublime violence of the true appears as that which determines the language of the real world according to the laws of the moral world. For it shatters whatever still survives as the legacy of chaos in all beautiful semblance: the false, errant totality—the absolute totality. Only the expressionless completes the work, by shattering it into a thing of shards, into a fragment of the true world, into the torso of a symbol. As a category of language and art and not of the work or of the genres, the expressionless can be no more rigorously defined than through a passage in Hölderlin's *Anmerkungen zum Ödipus* [Annotations to Oedipus], whose fundamental significance for the theory of art in general, beyond serving as the basis for a theory of tragedy, seems not yet to have been recognized. The passage reads: "For the tragic transport is actually empty, and the least restrained.—Thereby, in the rhythmic sequence of the representations wherein the transport presents itself, there becomes necessary what in poetic meter is called caesura, the pure word, the counter-

rhythmic rupture—namely, in order to meet the onrushing change of representations at its highest point, in such a manner that not the change of representation but the representation itself very soon appears." The "occidental Junoian sobriety"—which Hölderlin, several years before he wrote this, conceived as the almost unattainable goal of all German artistic practice—is only another name for that caesura, in which, along with harmony, every expression simultaneously comes to a standstill, in order to give free reign to an expressionless power inside all artistic media. Such power has rarely become clearer than in Greek tragedy, on the one hand, and in Hölderlin's hymnic poetry, on the other. Perceptible in tragedy as the falling silent of the hero, and in the rhythm of the hymn as objection. Indeed, one could not characterize this rhythm any more aptly than by asserting that something beyond the poet interrupts the language of the poetry. Here lies "the reason a hymn will seldom (and with complete justification perhaps never) be called 'beautiful.'" If in that lyric it is the expressionless, in Goethe's it is the beautiful that comes forth to the limit of what can be grasped in the work of art. What stirs beyond this limit is, in one direction, the offspring of madness, and, in the other, the conjured appearance. In the latter direction, German poetry may not venture one step beyond Goethe without mercilessly falling prey to a world of semblance, whose most alluring images were evoked by Rudolf Borchardt.[32] Indeed, there is no lack of evidence that even the work of Borchardt's master did not always escape the temptation closest to the master's genius: that of conjuring the semblance.

Thus, Goethe recalls the work on the novel with the words: "One is happy enough when in these agitated times one can take refuge in the depth of tranquil passions." If here the contrast of choppy surface and tranquil depth can only remind one fleetingly of a body of water, such a simile is found much more expressly in Zelter. In a letter dealing with the novel, he writes to Goethe: "What ultimately remains suited to it is a writing style like the clear element, whose fleet inhabitants swim pell-mell among one another and, twinkling or casting shadow, dart up and down without going astray or getting lost." What is thus expressed in Zelter's manner—a manner never sufficiently valued—clarifies how the formulaically spellbound style of the author is related to the spellbinding reflection in water. And beyond stylistics it points to the signification of that "pleasure lake," and finally to the meaning of the entire work. Just as the semblance-like soul shows itself ambiguously in it, luring with innocent clarity and leading down below into the deepest darkness, water, too, partakes of this strange magic. For on the one hand, it is black, dark, unfathomable; but on the other hand, it is reflecting, clear, and clarifying. The power of this ambiguity, which had already been a theme of "The Fisherman" ["Der Fischer"],[33] has become dominant in the essence of the passion in *Elective Affinities*. If the ambiguity thus leads into the novel's center, still it points back again to the mythic

origin of the novel's image of the beautiful life and allows that image to be recognized with complete clarity.

> In the element from which the goddess [Aphrodite] arose, beauty appears truly to be at home. She is praised at flowing rivers and fountains; one of the Oceanides is named *Schönfließ* [Beautiful Flow];[34] among the Nereids the beautiful form of Galatea stands out; and numerous beautiful-heeled daughters arise from the gods of the sea. The mobile element, as it first of all washes round the foot of the walker, moistens the feet of the goddesses, dispensing beauty; and silver-footed Thetis always remains the model for the poetic imagination of the Greeks when they depict this part of the body in their creations. . . . Hesiod does not attribute beauty to any man or to any god conceived as masculine; here, too, beauty does not yet denote any sort of inner worth. It appears quite predominantly in the external form of the woman, connected to Aphrodite and the Oceanian forms of life.

If, as Julius Walter says in his *Ästhetik im Altertum* [Aesthetics in Antiquity], the origin of a merely beautiful life (according to the indications of myth) thus lies in the world of harmonic-chaotic wave motion, a deeper sensibility sought the origin of Ottilie there. Where Hengstenberg thinks in a malicious way of Ottilie's "nymphish meal" and Werner gropingly imagines his "hideous tender sea-nixies," there with incomparable sureness of touch Bettina [von Arnim] struck the inmost link: "You're in love with her, Goethe—I've suspected it for a long time already. That Venus surged out of the foaming sea of your passion, and after sowing a harvest of pearly tears, she vanishes back into it with supernatural radiance."

With the semblance-like character that determines Ottilie's beauty, insubstantiality also threatens the salvation that the friends gain from their struggles. For if beauty is semblance-like, so, too, is the reconciliation that it promises mythically in life and death. Its sacrifice, like its blossoming, would be in vain, its reconciling a semblance of reconciliation. In fact, true reconciliation exists only with God. Whereas in true reconciliation the individual reconciles himself with God and only in this way conciliates other human beings, it is peculiar to semblance-like reconciliation that the individual wants others to make their peace with one another and only in this way become reconciled with God. This relation of semblance-like reconciliation to true reconciliation again evokes the opposition between novel and novella. For it is to this point that the bizarre quarrel which perplexes the lovers in their youth finally intends to reach: the point at which their love, because it risks life for the sake of true reconciliation, achieves this reconciliation and with it the peace in which their bond of love endures. Because true reconciliation with God is achieved by no one who does not thereby destroy everything—or as much as he possesses—in order only then, before God's reconciled countenance, to find it resurrected. It follows that a death-

defying leap marks that moment when—each one wholly alone for himself before God—they make every effort for the sake of reconciliation. And only in such readiness for reconciliation, having made their peace, do they gain each other. For reconciliation, which is entirely supermundane and hardly an object for concrete depiction in a novel, has its worldly reflection in the conciliation of one's fellow men. How much noble consideration falls short of that tolerance and gentleness which, ultimately, only increases the distance in which the figures of the novel know themselves to stand. Since they always avoid quarreling openly, though Goethe did not balk at depicting excessiveness even in the violent deed of a young woman, conciliation must remain inaccessible to them. So much suffering, so little struggle. Hence the silencing of all affects. They never appear externally as enmity, revenge, envy, yet neither do they live internally as lament, shame, or despair. For how could the desperate actions of the unrequited compare with the sacrifice of Ottilie—a sacrifice that puts in God's hand not the most precious good but the most difficult burden, and anticipates his decree. Thus, her semblance is thoroughly lacking in all the annihilating character of true reconciliation, just as, insofar as possible, everything painful and violent remains remote from the manner of her death. And not with this alone does an impious providence inflict on those all-too-peaceable folk the threatening time of trouble. For what the author shrouds in silence a hundred times can be seen quite simply enough from the course of things as a whole: that, according to ethical laws, passion loses all its rights and happiness when it seeks a pact with the bourgeois, affluent, secure life. This is the chasm across which the author intends, in vain, to have his figures stride with somnambulistic sureness upon the narrow path of pure human civility. That noble curbing and controlling is unable to replace the clarity that the author certainly knew just how to remove from himself, as well as from them. (In this, Stifter is his perfect epigone.) In the mute constraint that encloses these human beings in the circle of human custom, indeed of bourgeois custom, hoping there to salvage for them the life of passion, lies the dark transgression which demands its dark expiation. Basically they flee from the verdict of the law that still has power over them. If, to judge from appearances, they are exempted from it through their noble being, in reality only sacrifice can rescue them. Therefore, the peace that harmony ought to lend them does not fall to their lot; their art of life in the Goethean manner only makes the sultriness closer. For what reigns here is the quiet before a storm; in the novella, however, thunderstorm and peace prevail. While love guides the reconciled, only beauty, as a semblance of reconciliation, remains behind with the others.

For those who truly love, the beauty of the beloved is not decisive. If it was beauty that first attracted them to each other, they will forget it again and again for greater splendors, in order, of course, to become conscious of

it again and again, in memory, until the end. It is otherwise with passion. Every waning of beauty, even the slightest decline, makes it despair. Only for love is the beautiful woman the most precious boon; for passion, the *most* beautiful woman is the most precious. Passionate, then, is also the disapproval with which the friends turn away from the novella. For them the surrender of beauty is indeed unbearable. That wildness which disfigures the young woman [in the novella] is not Luciane's empty, destructive kind either, but rather the urgent, healing wildness of a more noble creature: however much grace is paired with it, it is enough to lend her something off-putting to rob her of the canonical expression of beauty. This young woman is not essentially beautiful. Ottilie is. In his own way, even Eduard is: not for nothing is the beauty of this couple praised. Goethe himself not only expended—beyond the limits of art—all the conceivable power of his gifts to conjure this beauty, but with the lightest touch gives sufficient evidence for the reader to intuit that the world of this gentle veiled beauty is the center of the poetic work. In the name "Ottilie" he alludes to the saint who was the patron of those suffering from eye disease and to whom a convent on the Odilienberg in the Black Forest was dedicated. Goethe calls her a "consolation for the eyes" of the men who see her; indeed, in her name one may also catch a hint of the mild light which is the blessing of sick eyes and in itself the hearth of all semblance. To this light he contrasted the radiance that shines painfully in the name and appearance of Luciane, and to her wide sunny circle he contrasted the secret lunar environment of Ottilie. Yet just as he places alongside Ottilie's gentleness not only Luciane's false wildness but also the true wildness of the child lovers, so the gentle shimmer of her being is placed in the middle between hostile brilliance and sober light. The furious attack described in the novella was directed against the eyesight of the beloved; the character of this love, which is averse to all semblance, could not be more rigorously intimated. Passion remains caught in its spell, and in itself it is unable to lend support, even in fidelity, to those who are inflamed. Subjected as it is to the beauty beneath every semblance, its chaotic side must break out devastatingly, unless a more spiritual element, which would be able to pacify the semblance, were to find its way to it. This is affection.

In affection the human being is detached from passion. It is the law of essence that determines this, just as it determines every detachment from the sphere of semblance and every passage to the realm of essence; it determines that gradually, indeed even under a final and most extreme intensification of the semblance, the change comes about. Thus, passion appears, even in the emergence of affection, to turn completely—and ever more than before—into love. Passion and affection are the elements of all semblance-like love, which reveals itself as distinct from true love not in the failure of feeling but rather uniquely in its helplessness. And so one must emphasize that it is not true love which reigns in Ottilie and Eduard. Love becomes perfect

only where, elevated above its nature, it is saved through God's intervention. Thus, the dark conclusion of love, whose daemon is Eros, is not a naked foundering but rather the true ransoming of the deepest imperfection which belongs to the nature of man himself. For it is this imperfection which denies to him the fulfillment of love. Therefore, into all loving that human nature alone determines, affection enters as the real work of *Eros thanatos*—the admission that man cannot love. Whereas in all redeemed true love, passion, like affection, remains secondary, the history of affection and the transition of the one into the other makes up the essence of Eros. Of course, blaming the lovers, as Bielschowsky ventures to do, does not lead to this result. Nonetheless, even his banal tone does not allow the truth to be misunderstood. Having intimated the misbehavior—indeed the unbridled selfishness—of Eduard, he says further of Ottilie's unswerving love: "Now and again, we may encounter in life so abnormal a phenomenon. But then we shrug our shoulders and say we don't understand it. To offer such an explanation with regard to a poetic work is its gravest condemnation. In literature we want to and must understand. For the poet is a creator. He creates souls." To what extent this may be conceded will certainly remain extremely problematic. Yet it is unmistakable that those Goethean figures can appear to be not created [*geschaffen*] or purely constructed [*gebildet*], but conjured [*gebannt*]. Precisely from this stems the kind of obscurity that is foreign to works of art and that can be fathomed only by someone who recognizes its essence in the semblance. For semblance in this poetic work is not so much represented as it is in the poetic representation itself. It is only for this reason that the semblance can signify so much; and only for this reason that the representation signifies so much. The collapse of that love is revealed more cogently this way: every love grown within itself must become master of this world—in its natural exitus, the common (that is, strictly simultaneous) death, or in its supernatural duration, marriage. Goethe said this expressly in the novella, since the moment of shared readiness for death through God's will gives new life to the lovers, following which old rights lose their claim. Here he shows the life of the two lovers saved in precisely the sense in which marriage preserves it for the pious ones; in this pair he depicted the power of true love, which he prohibited himself from expressing in religious form. Opposed to this, in the novel, within this domain of life, is the double failure. While the one couple, in isolation, dies away, marriage is denied to the survivors. The conclusion leaves the captain and Charlotte like shades in Limbo. Since the author could not let true love reign in either of the couples (it would have exploded this world), in the characters of the novella he supplied his work inconspicuously but unmistakably with its emblem.

The norm of law makes itself master of a vacillating love. The marriage between Eduard and Charlotte, even in its dissolution, brings death to such

love, because in it lies embedded—albeit in mythic disfigurement—the greatness of the decision to which choice is never equal. And thus the title of the novel pronounces judgment on them—a judgment of which Goethe was half-unconscious, it seems. For in the advertisement that he wrote for the book, he seeks to rescue the concept of choice for moral thought: "It seems that this strange title was suggested to the author by the experiments he conducted in the physical sciences. He may well have noticed that, in the natural sciences, ethical analogies are very often used to bring closer to the circle of human knowledge things far remote from it; and therefore he was very likely all the more inclined, in an ethical instance, to refer a chemical discourse of likenesses back to its spiritual origin, since, indeed, everywhere there is but One Nature, and the traces of disturbing passionate necessity run incessantly through the serene empire of rational freedom—traces that can be entirely extinguished only by a higher hand, and perhaps not in this life." But more clearly than these sentences—which appear to seek in vain God's empire, where the lovers dwell—in that domain of serene freedom of reason, the bare word speaks. "Affinity" [*Verwandtschaft*] is already, in and of itself, conceivably the purest word to characterize the closest human connection, as much on the basis of value as on that of motives. And in marriage it becomes strong enough to make literal what is metaphorical in it. This cannot be strengthened through choice; nor, in particular, would the spiritual dimension of such affinity be founded on choice. This rebellious presumption, however, is proved most incontrovertibly by the double meaning of the word "choice" [*Wahl*], which does not cease to signify both what is seized in the act and the very act of choosing. As always, that affinity becomes the object of a resolution; it strides over the stage of choice to decision. This annihilates choice in order to establish loyalty: only the decision, not the choice, is inscribed in the book of life. For choice is natural and can even belong to the elements; decision is transcendent.—Only because the highest legitimacy is not reserved for that love, it follows that the greater power inheres in this marriage. Yet the author never in the least wanted to attribute to the foundering marriage a right of its own. Marriage can in no sense be the center of the novel. On this point Hebbel,[35] too, like countless others, was completely in error when he wrote: "In Goethe's *Elective Affinities* one aspect still remains abstract: the immense importance of marriage for the state and for humanity is, to be sure, indicated argumentatively but has not been made visible in the frame of representation, which would have been equally possible and would have greatly reinforced the impression of the entire work." And even earlier, in the preface to *Maria Magdalene:* "I could not explain to myself how Goethe, who was an artist through and through, a great artist, could have committed in *Elective Affinities* such an offense against inner form: not unlike an absent-minded dissector who brings to the anatomical theater an automaton instead of a

real body, he placed at the center of his representation a marriage a priori empty, indeed immoral, like that between Eduard and Charlotte, and treated and used this relation as if it were quite the opposite, a perfectly legitimate one." Apart from the fact that the marriage is not the center of the action but rather the means, Goethe did not make it appear, and did not want to have it appear, in the form in which Hebbel conceives it. For he would have sensed too deeply that "a priori" nothing at all could be said about them; their morality could prove to be only fidelity, their immorality only infidelity. Let alone that passion, for instance, could form its basis. Tritely but not incorrectly, Baumgartner, a Jesuit, says: "They love each other but without that passion which, for sickly and sentimental souls, constitutes the sole charm of existence." But for this reason, conjugal fidelity is not less conditioned. Conditioned in both senses: by a necessary condition, as well as by a sufficient condition. The former lies in the foundation of decision. It is certainly not more arbitrary, because passion is not its criterion. Rather, this criterion resides—all the more unambiguous and rigorous—in the character of the experience preceding the decision. For only this experience is able to sustain the decision that, beyond all later occurrences and comparisons, reveals itself to the experiencing agent as essentially singular and unique, whereas every attempt by upright human beings to found decision on lived experience sooner or later fails. If this necessary condition of conjugal fidelity is given, then fulfillment of duty amounts to its sufficient condition. Only when one of the two can remain free of doubt as to whether it was there can the cause of the rupture in the marriage be stated. Only then is it clear whether the rupture is necessary "a priori": whether, through reversal, salvation is still to be hoped for. And with this, that prehistory which Goethe devised for the novel comes forth as evidence of the most unerring feeling. Earlier, Eduard and Charlotte already loved one another, yet despite this they entered into an empty marriage bond before uniting with each other. Only in this one way, perhaps, could the question remain in the balance: the question of where, in the life of both spouses, the blunder lies—whether in their earlier irresoluteness or in their present infidelity. For Goethe had to sustain the hope that a bonding which had already once been victorious was destined to last now, too. Yet the fact that this marriage could not, either as a juridical form or as a bourgeois one, confront the semblance that seduces it can hardly have escaped the author. Only in the sense of religion, in which marriages "worse" than this one have their inviolable subsistence, would this facility be given to it. Accordingly, the failure of all attempts at union is motivated particularly deeply by the fact that these attempts issue from a man who, with the authority of priestly consecration, has himself renounced the power and the law that alone could justify such things. Yet since union is no longer granted to the couple, at the end the question prevails, which, doing the work of exculpation, accompanies everything:

Wasn't that merely liberation from an undertaking which was misguided from the start? However that may be, these human beings are torn out of the path of marriage in order to find their essence under other laws.

Sounder than passion yet not more helpful, affection likewise only brings about the ruin of those who renounce passion. But it does not drive the lonely ones to ruin like them. It tenaciously escorts the lovers in their descent: they reach the end conciliated. On this final path they turn to a beauty that is no longer arrested by semblance, and they stand in the domain of music. Goethe called the third poem of the trilogy, in which passion comes to rest, "Conciliation." It is the "double happiness of sounds and of love" which here—not at all as a fulfillment but rather as a first weak premonition, as the almost hopeless shimmer of dawn—gleams to the tormented ones. Music, of course, knows conciliation in love, and for this reason the last poem of the trilogy alone bears a dedication, whereas the "leave me alone" of passion slips out from "The Elegy," both in its motto and in its conclusion.[36] Reconciliation, however, which remained in the domain of the worldly, had already thereby to unveil itself as semblance, and presumably to the passionate ones for whom it finally grew dim. "The higher world— how it fades away before the senses!" "There music hovers on angelic wings," and now the semblance promises for the first time to retreat entirely, now for the first time longs to grow dim and become perfect. "The eye grows moist, feels in loftier longing / The divine value of [musical] sounds as of tears." These tears, which fill one's eyes when one listens to music, deprive those eyes of the visible world. And thus is indicated that deep set of connections, which appears according to a fleeting remark to have guided Hermann Cohen, who in a manner akin to that of the aged Goethe was perhaps more sensitive than all the interpreters. "Only the lyric poet, who comes to perfection in Goethe, only the man who sows tears, the tears of infinite love, could endow this novel with such unity." Of course, that is nothing more than a presentiment: from here, too, no path leads interpretation further. For this direction can be provided only by the knowledge that that "infinite" love is much less than the simple one (which people say lasts beyond death), that it is affection which leads to death. But in this its essence has an effect, and the unity of the novel, if you will, is announced here: affection, like the veiling of the image through tears in music, thus summons forth in conciliation the ruin of the semblance through emotion. For emotion is precisely that transition in which the semblance—the semblance of beauty as the semblance of reconciliation—once again dawns sweetest before its vanishing. Neither humor nor tragedy can verbally grasp beauty; beauty cannot appear in an aura of transparent clarity. Its most exact opposite is emotion. Neither guilt nor innocence, neither nature nor the beyond, can be strictly differentiated for beauty. In this sphere Ottilie appears; this veil must lie over her beauty. For the tears of emotion, in which the gaze grows

veiled, are at the same time the most authentic veil of beauty itself. But emotion is only the semblance of reconciliation. And that deceptive harmony in the lovers' flute playing—how unsteady and moving it is! Their world is wholly deserted by music. Thus it is that the semblance, which is linked to emotion, can become so powerful only in those who, like Goethe, are not from the beginning moved in their innermost being by music and are proof against the power of living beauty. To rescue what is essential in it is Goethe's struggle. In this struggle the semblance of this beauty grows more and more turbid, like the transparency of a fluid in the concussion by which it forms crystals. For it is not the little emotion, which delights in itself, but only the great emotion of shattering in which the semblance of reconciliation overcomes the beautiful semblance and with it, finally, itself. The lament full of tears: that is emotion. And to it as well as to the tearless cry of woe, the space of Dionysian shock lends resonance. "The mourning and pain of the Dionysian, as the tears that are shed for the continual decline of all life, form gentle ecstasy; it is 'the life of the cicada, which, without food or drink, sings until it dies.'" Thus Bernoulli on the one hundred forty-first chapter of *Matriarchy,* in which Bachofen discusses the cicada, the creature which, originally indigenous to the dark earth, was elevated by the mythic profundity of the Greeks into the association of Uranic symbols.[37] What else was the meaning of Goethe's meditations on Ottilie's departure from life?

The more deeply emotion understands itself, the more it is transition; for the true poet, it never signifies an end. This is the precise implication when shock emerges as the best part of emotion, and Goethe means the same thing (albeit in a strange context) when he writes in "On Interpreting Aristotle's *Poetics*" ["Nachlese zu Aristoteles *Poetik*"]: "Whoever, now, advances on the path of a truly moral inner development will feel and admit that tragedies and tragic novels in no way assuage the spirit but rather put the soul and what we call the heart in commotion and lead them toward a vague and indeterminate state. Youth loves this state and is therefore passionately inclined to such works." Emotion, however, will be a transition from the confused intuition "on the path of a truly moral . . . development" only to the uniquely objective correlative of shock, to the sublime. It is precisely this transition, this going over, that is accomplished in the going under of the semblance. That semblance which presents itself in Ottilie's beauty is the one that goes under. It is not to be understood, however, as if external need and force bring about Ottilie's destruction; rather, her type of semblance itself is the basis for the imperative that the semblance be extinguished, and extinguished soon. This semblance is quite different from the triumphant one of dazzling beauty, which is that of Luciane or of Lucifer. And whereas the figure of Goethe's Helena and the more famous one of the Mona Lisa owe the enigma of their splendor to the conflict between these two kinds of semblance, the figure of Ottilie is governed throughout by only

the one semblance, which is extinguished. The writer has inscribed this into every one of her movements and gestures, so that ultimately she will—in her diary, in the most melancholy as well as tender fashion—increasingly lead the life of one who is dwindling away. Hence, what has revealed itself in Ottilie is not the semblance of beauty as such, which doubly manifests itself, but solely that one—the vanishing one which is her own. Yet this semblance, of course, opens up insight into the beautiful semblance as such and makes itself known for the first time in it. Therefore, to every view that takes in the figure of Ottilie, the old question arises whether beauty is semblance.

Everything essentially beautiful is always and in its essence bound up, though in infinitely different degrees, with semblance. This union attains its highest intensity in that which is manifestly alive and precisely here, in a clear polarity between the triumphant semblance and the semblance that extinguishes itself. For everything living (the higher the quality of its life, the more this is so) is lifted up beyond the domain of the essentially beautiful; accordingly, the essentially beautiful manifests itself, in its form, most of all as semblance. Beautiful life, the essentially beautiful, and semblance-like beauty—these three are identical. In this sense, the Platonic theory of the beautiful is connected with the still older problem of semblance, since, according to the *Symposium*, it first of all addresses physically living beauty. If this problem still remains latent in the Platonic speculation, it is because to Plato, a Greek, beauty is at least as essentially represented in the young man as in the young woman—but the fullness of life is greater in the female than in the male. Nonetheless, a moment of semblance remains preserved in that which is least alive, if it is essentially beautiful. And this is the case with all works of art, but least among them music. Accordingly, there dwells in all beauty of art that semblance—that is to say, that verging and bordering on life—without which beauty is not possible. The semblance, however, does not comprise the essence of beauty. Rather, the latter points down more deeply to what in the work of art in contrast to the semblance may be characterized as the expressionless; but outside this contrast, it neither appears in art nor can be unambiguously named. Although the expressionless contrasts with the semblance, it stands in such a fashion of necessary relationship to the semblance that precisely the beautiful, even if it is itself not semblance, ceases to be essentially beautiful when the semblance disappears from it. For semblance belongs to the essentially beautiful as the veil and as the essential law of beauty, shows itself thus, that beauty appears as such only in what is veiled. Beauty, therefore, is not itself semblance, as banal philosophemes assert. On the contrary, the famous formula, in the extreme shallowness of Solger's final development of it—beauty is truth become visible—contains the most fundamental distortion of this great theme. Simmel likewise should not have taken this theorem so venially out of Goethe's sentences, which often recommend themselves to

the philosopher by virtue of everything except their literal wording. This formula—which, since truth is not in itself visible and its becoming visible could rest only on traits not its own, makes beauty into a semblance—amounts in the end, quite apart from its lack of method and reason, to philosophical barbarism. For nothing else is signified when the thought is nourished in it that the truth of the beautiful can be unveiled. Beauty is not a semblance, not a veil covering something else. It itself is not appearance but purely essence—one which, of course, remains essentially identical to itself only when veiled. Therefore, even if everywhere else semblance is deception, the beautiful semblance is the veil thrown over that which is necessarily most veiled. For the beautiful is neither the veil nor the veiled object but rather the object in its veil. Unveiled, however, it would prove to be infinitely inconspicuous [*unscheinbar*]. Here is the basis of the age-old view that that which is veiled is transformed in the unveiling, that it will remain "like unto itself" only underneath the veiling. Thus, in the face of everything beautiful, the idea of unveiling becomes that of the impossibility of unveiling. It is the idea of art criticism. The task of art criticism is not to lift the veil but rather, through the most precise knowledge of it as a veil, to raise itself for the first time to the true view of the beautiful. To the view that will never open itself to so-called empathy and will only imperfectly open itself to a purer contemplation of the naive: to the view of the beautiful as that which is secret. Never yet has a true work of art been grasped other than where it ineluctably represented itself as a secret. For that object, to which in the last instance the veil is essential, is not to be characterized otherwise. Since only the beautiful and outside it nothing—veiling or being veiled—can be essential, the divine ground of the being of beauty lies in the secret. So then the semblance in it is just this: not the superfluous veiling of things in themselves but rather the necessary veiling of things for us. Such veiling is divinely necessary at times, just as it is also divinely determined that, unveiled at the wrong time, what is inconspicuous evaporates into nothing, whereupon revelation takes over from secrets. Kant's doctrine, that the foundation of beauty is a relational character, accordingly carries through victoriously, in a much higher sphere than the psychological, its methodical tendencies. Like revelation, all beauty holds in itself the orders of the history of philosophy. For beauty makes visible not the idea but rather the latter's secret.

For the sake of that unity, which veil and veiled compose in it, beauty can essentially be valid only where the duality of nakedness and veiling does not yet obtain: in art and in the appearances of mere nature. On the other hand, the more distinctly this duality expresses itself in order finally to confirm itself at the highest in man, the more this becomes clear: in veilless nakedness the essentially beautiful has withdrawn, and in the naked body of the human being are attained a being beyond all beauty—the sublime—and a work beyond all creations—that of the creator. The last of those saving

correspondences thereby opens itself up—one in which, with incomparably rigorous precision, the delicately formed novella corresponds to the novel. When, in the novella, the youth unclothes the beloved, he does so not out of lust but for life's sake. He does not look [*betrachtet*] at her naked body, and just for that reason he perceives its majesty. The author does not choose his words idly when he says: "The desire to save a life was all that mattered" [*Hier überwand die Begierde zu retten jede andere Betrachtung;* R228]. For, in love, looking is unable to dominate. It is not from the will to happiness—which only fleetingly lingers unbroken in the rarest acts of contemplation, in the "halcyon" stillness of the soul—that love has arisen. Its origin is the presentiment of a life of bliss. But where love as the bitterest passion frustrates itself, where in it the *vita contemplativa* is still the mightiest and where the view of the most splendid is more longed for than union with the beloved—this *Elective Affinities* presents in the fate of Eduard and Ottilie. Accordingly, no feature of the novella is in vain. With regard to the freedom and necessity that it reveals vis-à-vis the novel, the novella is comparable to an image in the darkness of a cathedral—an image which portrays the cathedral itself and so in the midst of the interior communicates a view of the place that is not otherwise available. In this way it brings inside at the same time a reflection of the bright, indeed sober day. And if this sobriety seems sacred, shines sacredly, the most peculiar thing is that it is not so, perhaps, only for Goethe. For his literary composition remains turned toward the interior in the veiled light refracted through multicolored panes. Shortly after its completion, he writes to Zelter: "Wherever my new novel finds you, accept it in a friendly manner. I am convinced that the transparent and opaque veil will not prevent you from seeing inside to the form truly intended." This mention of "veil" was more to him than an image—it is the veil that again and again had to affect him where he was struggling for insight into beauty. Three figures from his lifework have grown out of this struggle, which shook him like no other; the figures are Mignon, Ottilie, and Helena.

> So let me seem till I become:
> Take not this garment white from me!
> I hasten from the joys of earth
> Down to that house so fast and firm.

> There will I rest in peace a while,
> Till opens wide my freshened glance
> Then I will cast my dress aside.
> Leaving both wreath and girdle there.[38]

And Helena, too, abandons it: "Dress and veil remain in his arms." Goethe knows what was fabulated about the deception of this semblance. He has Faust warned in these words:

Hold fast what of it remains to you.
The robe, do not let go of it.
Demons are already tugging at the corners, would like
To snatch it down into the underworld. Hold fast!
It is no longer the goddess whom you lost,
Yet it is divine.[39]

In contrast to these, however, the veil of Ottilie remains as her living body. Only in her case does the law, which manifests itself with the others more haltingly, express itself clearly: the more life disappears, the more disappears all beauty having the character of semblance—that beauty which is able to adhere uniquely to the living, until with the complete end of the one, the other, too, must vanish. Thus, nothing mortal is incapable of being unveiled. When, therefore, the *Maxims and Reflections* duly characterize the most extreme degree of such incapacity to unveil with the profound words, "Beauty can never become lucid about itself," God still remains, in whose presence there is no secret and everything is life. The human being appears to us as a corpse and his life as love, when they are in the presence of God. Thus, death has the power to lay bare like love. Only nature cannot be unveiled, for it preserves a mystery so long as God lets it exist. Truth is discovered in the essence of language. The human body lays itself bare, a sign that the human being itself stands before God.

Beauty that does not surrender itself in love must fall prey to death. Ottilie knows her path to death. Because she recognizes it, prefigured, in the innermost region of her young life, she is—not in action but in essence—the most youthful of all the figures whom Goethe created. No doubt age lends a readiness to die; youth, however, is readiness for death. How hidden was the way in which Goethe said that Charlotte "was very fond of living"! Never in any other work did he give to youth what he granted it in Ottilie: the whole of life, in the way that, from its own duration, it has its own death. Indeed, one may say that if he was in truth blind to anything, it was precisely to this. If Ottilie's existence, in the pathos which distinguishes it from all others, nevertheless refers to the life of youth, then only through the destiny of her beauty could Goethe become conciliated with this view, to which his own being refused assent. For this there is a peculiar reference, to a certain extent constituting a source. In May 1809 Bettina sent Goethe a letter touching on the rebellion of the Tiroleans—a letter in which she says: "Yes, Goethe, during this time things took quite a different turn in me . . . Somber halls, which contain prophetic monuments of mighty heroes in death, are the center of my dark imaginings . . . Oh, do join with me in remembering [the Tiroleans] . . . It is the poet's glory that he secure immortality for the heroes!" In August of the same year, Goethe wrote the final version of Part II, Chapter 3, of *Elective Affinities,* where one reads in Ottilie's diary: "There is one grim notion held by ancient civilizations that

might seem terrifying to us. They imagined their forebears to be sitting in silent conversation on thrones arranged in a circle in large caves. If the newcomer entering were sufficiently worthy, they stood and bowed in welcome. Yesterday, while I was sitting in the chapel, I noticed that several carved seats had been placed in a circle opposite my own, and the thought seemed pleasant and agreeable to me. 'Why can you not sit still?' I thought to myself. 'Sit silent and withdrawn for a long, long time, until at last the friends would come for whom you would stand and whom you would show to their places with a friendly bow'" [R185]. It is easy to understand this allusion to Valhalla as an unconscious or knowing reminiscence of the passage in the letter from Bettina. For the affinity of mood of those short sentences is striking, striking in Goethe the thought of Valhalla, striking, finally, how abruptly it is introduced into Ottilie's note. Would it not be a sign of the fact that, in those gentler words of Ottilie, Goethe had drawn closer to Bettina's heroic demeanor?

Let one judge, after all this, whether it is truth or idle mystification when Gundolf maintains with sham frankness, "The figure of Ottilie is neither the main character nor the real problem of *Elective Affinities*"; and whether it makes any sense when he adds, "But without the moment when Goethe saw that which in the work appears as Ottilie, it is very unlikely that the content would have been 'thickened' or the problem formulated in these terms." For what is clear in all of this, if not one thing: that it is the figure—indeed the name—of Ottilie which spellbound Goethe to this world, so that he could truly rescue someone perishing, could redeem in her a loved one? He confessed as much to Sulpiz Boisserée, who has recorded it with the wonderful words in which, thanks to his most intimate perception of the author, he at the same time alludes more deeply to the secret of Goethe's work than he might ever have been aware of. "During the journey, we came to speak of *Elective Affinities*. He emphasized how rapidly and irresistibly he had brought on the catastrophe. The stars had risen; he spoke of his relation to Ottilie, of how he had loved her and how she had made him unhappy. At the end, his speeches became almost mysteriously full of foreboding.—In between, he would recite light-hearted verse. Thus, weary, stimulated, half-full of foreboding, half-asleep, we arrived in Heidelberg in the most beautiful starlight." If it did not escape this reporter how, with the rising of the stars, Goethe's thoughts steered themselves toward his work, Goethe himself was quite probably hardly aware—a fact to which his language attests—how sublime beyond measure the moment was and how clear the warning of the stars. In such admonition, what had long ago faded away as lived experience [*Erlebnis*] persisted as traditional experience [*Erfahrung*]. For in the symbol of the star, the hope that Goethe had to conceive for the lovers had once appeared to him. That sentence, which to speak with Hölderlin contains the caesura of the work and in which, while the embracing lovers seal their fate, everything pauses, reads: "Hope shot across the

sky above their heads like a falling star" [R239]. They are unaware of it, of course, and it could not be said any more clearly that the last hope is never such to him who cherishes it but is the last only to those for whom it is cherished. With this comes to light the innermost basis for the "narrator's stance." It is he alone who, in the feeling of hope, can fulfill the meaning of the event—quite as Dante assumes in himself the hopelessness of the lovers, when, after the words of Francesca da Rimini, he falls "as if a corpse fell." That most paradoxical, most fleeting hope finally emerges from the semblance of reconciliation, just as, at twilight, as the sun is extinguished, rises the evening star which outlasts the night. Its glimmer, of course, is imparted by Venus. And upon the slightest such glimmer all hope rests; even the richest hope comes only from it. Thus, at the end, hope justifies the semblance of reconciliation, and Plato's tenet that it is absurd to desire the semblance of the good suffers its one exception. For one is permitted to desire the semblance of reconciliation—indeed, it must be desired: it alone is the house of the most extreme hope. Thus, hope finally wrests itself from it; and like a trembling question, there echoes at the end of the book that "How beautiful" in the ears of the dead, who, we hope, awaken, if ever, not to a beautiful world but to a blessed one. "Elpis" remains the last of the primal words: the certainty of blessing that, in the novella, the lovers take home with them corresponds to the hope of redemption that we nourish for all the dead. This hope is the sole justification of the faith in immortality, which must never be kindled from one's own existence. But precisely because of this hope, those Christian-mystical moments at the end are out of place, arising as they do—in a manner unlike the way they arose in the Romantics—from the striving to ennoble everything mythic at ground level. Hence, not this Nazarene essence but rather the symbol of the star falling over the heads of the lovers is the form of expression appropriate to whatever of mystery in the exact sense of the term indwells the work. The mystery is, on the dramatic level, that moment in which it juts out of the domain of language proper to it into a higher one unattainable for it. Therefore, this moment can never be expressed in words but is expressible solely in representation: it is the "dramatic" in the strictest sense. An analogous moment of representation in *Elective Affinities* is the falling star. The novel's epic basis in the mythic, its lyrical breadth in passion and affection, is joined by its dramatic crowning in the mystery of hope. If music encloses genuine mysteries, this world of course remains a mute world, from which music will never ring out. Yet to what is it dedicated if not redemption, to which it promises more than conciliation? This is inscribed in the "tablet" that Stefan George has placed over the house in Bonn in which Beethoven was born:

Before you wage the battle of your star,
I sing of strife and gains on higher stars.

Before you know the bodies on this star,
I shape you dreams among eternal stars.

The phrase "Before you know the bodies" appears destined for a sublime irony. Those lovers never seize the body. What does it matter if they never gathered strength for battle? Only for the sake of the hopeless ones have we been given hope.

Written in 1919–1922; published in *Neue Deutsche Beiträge,* 1924–1925. Translated by Stanley Corngold.

Notes

I have profited from consulting prior, partial translations of this essay, including those of Harry Zohn, Philippe Lacoue-Labarthe, John McCole, J. Hillis Miller, Rainer Nägele, and James Rolleston. Ian Balfour graciously referred me to most of these translations and allowed me to consult his own incisive versions. I have also profited from consulting the complete translations of J. J. Slawney and James MacFarland. Excerpts from the following translations have been used here: *The Works of Stefan George,* trans. Olga Marx and Ernst Morwitz (Chapel Hill: University of North Carolina Press, 1974); Johann Wolfgang von Goethe, *Elective Affinities,* trans. Judith Ryan (New York: Suhrkamp, 1988); idem, *From My Life: Poetry and Truth, Part IV,* trans. Robert R. Heitner (New York: Suhrkamp, 1987); idem, *Scientific Studies,* trans. Douglas Miller (New York: Suhrkamp, 1983); idem, *Wilhelm Meister's Apprenticeship,* trans. Eric A. Blackall (New York: Suhrkamp, 1988); Friedrich Hölderlin, *Essays and Letters on Theory,* trans. Thomas Pfau (Albany: State University of New York Press, 1988; idem, *Selected Verse,* trans. Michael Hamburger (Baltimore: Penguin, 1961); Immanuel Kant, *The Metaphysics of Morals,* trans. Mary Gregor (New York: Cambridge University Press, 1991); and Plato, "Phaedrus," in *Collected Dialogues,* trans. Lane Cooper et al. (Princeton: Princeton University Press, 1989).—*Trans.*

1. *Schein* connotes both something negative, mere appearance or illusion, and something positive; it is the luster that marks the point, in German idealism and Romanticism, at which the numinous shines through the material symbol.—*Trans.*

2. Johann Bernhard Basedow (1723–1790) was the preeminent theorist of education in Germany in the eighteenth century. His *Elementarwerk* [Elementary Work] of 1774 was widely read and its ideas were long applied to education.—*Trans.*

3. Johann Gottfried Herder (1744–1803) was, along with Vico, one of the first thinkers to develop a historicist position. The dramatist Friedrich Schiller (1759–1805) and especially Goethe and Wilhelm von Humboldt (1767–1835)—the statesman, linguist, and philosopher who founded the university in Berlin, which served as the model for the modern Western university—were intensely interested in the historical development of national cultures.—*Trans.*

4. Hermann Cohen (1842–1918) did important work combining philosophy—he was the cofounder of the Marburg school of neo-Kantianism and published books on ethics, epistemology, and aesthetics—and Jewish theology. In this essay, Benjamin draws extensively (though without explicit citation) on Cohen's *Religion der Vernunft aus den Quellen des Judentums* [Religion of Reason from the Sources of Judaism; 1919]. Cohen there distinguishes sharply between a rational monotheism and a myth-ridden polytheism.—*Trans.*

5. Goethe's novel appeared in 1809. In Part I, the aristocrat Eduard has finally been able to marry his first love, Charlotte, after both had been forced into socially advantageous marriages. Living at Eduard's country estate, they are joined by his friend, the Captain, and then by Charlotte's niece, Ottilie. The foolish Mittler—his name connotes that he will mediate between or even introduce previously separated individuals—plays a smaller role in the novel than in Benjamin's reading. While Charlotte and the Captain struggle against their growing attraction, first Eduard and then finally the innocent Ottilie acknowledge their love for each other. In a night of passion, Eduard and Charlotte embrace, while each longs intensely for a different partner. The next day, they openly declare their love, respectively, for Ottilie and the Captain. Charlotte, however, insists that they renounce these affinities and remain together. The Captain leaves the estate just as Eduard learns that Charlotte will bear the child conceived on that fateful night. Eduard, seeing himself deprived of Ottilie, throws himself into war, longing for death.

The novel's second part is suffused with symbols of death. The action stagnates, as the narrator focuses on Ottilie's psychological processes, which are conveyed primarily by lengthy excerpts from her diary. The child is an ever-present reminder of infidelity: it resembles not its parents but Ottilie and the Captain. As Eduard returns from battle, he visits the Captain and proposes that each marry the person he truly loves; at the estate, he explains the child's origins to Ottilie and asks for her hand. Ottilie accepts, on the condition that Charlotte also accept the Captain. It is at this point that the passage so important to Benjamin's reading occurs: "Hope shot across the sky above their heads like a falling star." Yet the emotional turmoil produced in Ottilie by her love for Eduard brings on the catastrophe: as she returns across the lake, the child falls from the rocking boat and drowns. Eduard greets the loss as an act of providence that has removed the final obstacle to his desire; even Charlotte agrees to the new arrangement, acknowledging the extent to which her rigorous moralism precipitated the disaster. But Ottilie, now recognizing her complicity in the events, renounces Eduard and seeks shelter in a convent. Eduard's passionate intervention robs her of even this recourse, and she chooses total passivity, refusing to speak or eat, believing that this will help her achieve not merely absolution but a form of holiness. Shortly after her death—effectively a suicide—Eduard dies also, and they are buried together in the estate's funeral chapel.—*Trans.*

6. Johann Wolfgang von Goethe, *Elective Affinities*, trans. Judith Ryan, in Goethe, *Collected Works* (New York: Suhrkamp, 1988), vol. 11, p. 138. Further references to this work will appear in the text as "R" followed by the page number.—*Trans.*

7. Here Benjamin mistakenly ennobles Eduard, who is actually a baron.—*Trans.*

8. Carl Friedrich Zelter (1758–1832), composer, critic, and Goethe's principal informant on music.—*Trans.*

9. Robe of Nessus: a mythological allusion that has a chiastic parallel to the events in the novel. Hercules had shot the centaur Nessus with a poisoned arrow for having attempted to rape his wife, Deianeira. As he died, the centaur dipped his robe in his blood and gave it to Deianeira. When Hercules abandoned her for Iole, Deianeira sent him the robe as revenge: when he put it on, he was wracked with pain and died, throwing himself onto a burning pyre in order to escape from the torment.—*Trans.*

10. Christoph Martin Wieland (1733–1813), late-Enlightenment author and benevolent literary godfather of Goethe's generation. His most important works are the novel *Geschichte des Agathon* [Agathon's Story] (1766–1777) and the narrative poem *Musarion* (1768).—*Trans.*

11. Ernst Wilhelm Hengstenberg (1862–1869), professor of theology in Berlin and prominent exponent of religious orthodoxy.—*Trans.*

12. Friedrich Ludwig Zacharias Werner (1768–1823) was the best-known author of the "fate drama," a rough German dramatic parallel to the Gothic novel.—*Trans.*

13. A water sprite of Germanic folklore.—*Trans.*

14. Friedrich Wilhelm Riemer (1744–1845), classicist and poet. Riemer enjoyed exceptionally close ties to Goethe, as the tutor of his son, August, as his principal informant on classical literature, and as the coauthor of a text ("Elpenor").—*Trans.*

15. *Fabula docet:* Latin for "the story teaches."—*Trans.*

16. Bettina von Arnim (1785–1859), prominent Romantic writer and much younger friend of Goethe's, published *Briefwechsel mit einem Kind* [Correspondence with a Child] in 1835. It is a highly subjective—and highly influential—recollection of exchanges with Goethe.—*Trans.*

17. Wilhelmine Herzlieb (1789–1865), object of Goethe's passionate though unrequited love, served as the primary model for the character of Ottilie in the novel.—*Trans.*

18. At the end of the passage, Benjamin excised the words: "by taking refuge, as usual, behind an image."—*Trans.*

19. Georg Gervinus (1805–1871), whose great history of German literature demythologizes Goethe.—*Trans.*

20. *Proton pseudos:* Latin for "the first falsehood."—*Trans.*

21. In this passage, Benjamin inserts a tacit reading of Goethe's poem "Primal Words Orphic" ["Urworte, Orphisch"] as a commentary on the novel. Elpis is the personification of (perfidious) hope.—*Trans.*

22. Friedrich Gundolf, pseudonym of Friedrich Gundelfinger (1880–1931), disciple of Stefan George, prominent literary critic, and, after 1920, professor at Heidelberg. In 1917, when Benjamin wrote the first version of this portion of his essay, Gundolf was Germany's most powerful critical voice.—*Trans.*

23. The German word *der Trope* means "trope" or "figure of speech," but in the plural *(die Tropen)* it also means "tropics."—*Trans.*

24. Benjamin's word *Bombast* means "bombast" but contains the word *Ast*, mean-

ing "branch." His rhetorical monkey business is untranslatable, unless these monkey-figures can be thought of as swinging from one tropical bombranch to another.—*Trans.*

25. Marianne von Willemer (1784–1860), the model for the figure of Suleika in Goethe's lyric cycle "West-Easterly Divan" (1819), to which she contributed several poems.—*Trans.*

26. Goethe inserts a novella, "Die Wunderlichen Nachbarskinder" [The Marvelous Young Neighbors], into the second half of *Elective Affinities*. Two children from important families are intended by their parents to wed; as they grow up, however, they become increasingly antagonistic. The young man enters military service and is widely loved and respected; the young woman pines away without knowing why. At home on leave, he finds the young woman with a fiancé; she in turn realizes that she has always loved her neighbor. As he prepares to return to service, she determines to kill herself, at once declaring her love and exacting a kind of revenge. The young man invites the girl, her fiancé, and the two families for a pleasure cruise on a large boat. The young man, at the wheel to relieve the sleeping master of the boat, sees a treacherous passage approach; just then the girl leaps overboard. The boat runs aground, and he leaps in after her, only to find her almost lifeless body. He takes her ashore, to the cottage of a recently married young couple, where he revives her. To cover the naked bodies of the unexpected visitors, the couple offer the only dry clothes they have: their wedding outfits. When the boat finally lands on the nearby shore, the young people emerge from the bushes with the words, "Give us your blessing!"—*Trans.*

27. Here and throughout, Benjamin treats "Elective Affinities" as a plural noun and speaks literally of "their" breadth. Benjamin appears always to think directly to its content, to the affinities themselves.—*Trans.*

28. Georg Simmel (1858–1918), social philosopher and sociologist, developed a theory of modernity starting with his *Philosophy of Money* [*Philosophie des Geldes*] (1900) and continuing in such classic essays as "The Metropolis and Mental Life" ["Die Großstadt und das Geistesleben"]. His work exerted enormous influence on the following generation of social philosophers, some of whom were his students: Benjamin, Ernst Cassirer, Ernst Bloch, Georg Lukács, and Siegfried Kracauer.—*Trans.*

29. "The New Melusine" is a fairy tale by Goethe first published in 1817 and later included in the novel *Wilhelm Meister's Wanderings*. It is a tale of a simple barber and the lovely princess of the dwarves who grows to human size in order to win the barber's love and so allow her line to live on.—*Trans.*

30. Mignon is the mysteriously androgynous young girl adopted by Wilhelm in *Wilhelm Meister's Apprenticeship*.—*Trans.*

31. Joseph von Görres (1776–1848), journalist and historian, was the publisher of the important liberal newspaper *Der Rheinische Merkur*.—*Trans.*

32. Rudolf Borchardt (1877–1945), conservative author and essayist, who promoted the literary models of classical antiquity and the Middle Ages.—*Trans.*

33. In Goethe's ballad, the fisherman, "cool to the depths of his heart," is nonetheless lured out of his boat and into the depths by the seductive voice of a woman who emerges mysteriously from the water.—*Trans.*

34. Schönflies is the maiden name of Benjamin's mother and his own middle name.—*Trans.*
35. Friedrich Hebbel (1813–1863), Austrian dramatist and master of the "bourgeois tragedy." His plays include *Maria Magdalena* (1843) and *Agnes Bernauer* (1851).—*Trans.*
36. A reference to Goethe's poems "Trilogy of the Passions" and "Elegy."—*Trans.*
37. Johann Jakob Bachofen (1815–1887), professor of law and historian, is best known for his book *Matriarchy* [*Das Mutterrecht*] (1861), a study of matriarchal societies. See Benjamin's review of Bernoulli's book on Bachofen, above.—*Trans.*
38. The voice is that of Mignon, from Goethe's poem of the same name in *Wilhelm Meister's Apprenticeship*. "My dress" is Eric Blackall's rendering of the phrase *die reine Hülle* ("the pure veil").—*Trans.*
39. *Faust,* Part II, lines 9945–9950.—*Trans.*

Baudelaire

II

An image to characterize Baudelaire's way of looking at the world. Let us compare time to a photographer—earthly time to a photographer who photographs the essence of things. But because of the nature of earthly time and its apparatus, the photographer manages only to register the negative of that essence on his photographic plates. No one can read these plates; no one can deduce from the negative, on which time records the objects, the true essence of things as they really are. Moreover, the elixir that might act as a developing agent is unknown. And there is Baudelaire: he doesn't possess the vital fluid either—the fluid in which these plates would have to be immersed so as to obtain the true picture. But he, he alone, is able to read the plates, thanks to infinite mental efforts. He alone is able to extract from the negatives of essence a presentiment of its real picture. And from this presentiment speaks the negative of essence in all his poems.

Underlying Baudelaire's writings is the old idea that knowledge is guilt. His soul is that of Adam, to whom Eve (the world) once upon a time offered the apple, from which he ate. Thereupon the spirit expelled him from the garden. Knowledge of the world had not been enough for him; he wanted to know its good and evil sides as well. And the possibility of this question, which he was never able to answer, is something he bought at the price of eternal remorse [Remord]. His soul has this mythical prehistory, of which he knows, and thanks to which he knows more than others about redemption. He teaches us above all to understand the literal meaning of the word "knowledge" in the story of Eden.

Baudelaire as *littérateur*. This is the only vantage point from which to discuss his relationship with Jeanne Duval. For him as a *littérateur*, the hedonistic and hieratic nature of the prostitute's existence came to life.

III

The ambiguity of "Fair is foul, and foul is fair." The witches mean it in the sense of mixing things up, and in this sense it can be understood only morally. But applied to the objects of Baudelaire's poetry it means not mixing but reversing—that is to say, it is to be imagined not in the sphere of morality but in that of perception. What speaks to us in his poetry is not the reprehensible confusion of [moral] judgment but the permissible reversal of perception.

A school of writers who praise recent French poetry, but would be at a loss to distinguish clearly between *la morgue* and Laforgue.

The significance of the life legend Baudelaire imagined for himself.

Eckart von Sydow, *Die Kultur der Dekadenz* [The Culture of Decadence], Dresden: Sybillen-Verlag, 1921.

Hans Havemann, *Der Verworfene* [The Reprobate], Zweemann-Verlag.

The Souffleur, II, 3, p. 1 / *Nouveaux prétextes* by Gide, Paris 1911.

Spleen et idéal. Because of the abundance of connotations in this title, it is not translatable. Each of the two words on its own contains a double meaning. Both *spleen* and *idéal* are not just spiritual essences but also an intended effect upon them, as is expressed in [Stefan] George's translation *Trübsinn und Vergeistigung* [Melancholy and Spiritualization]. But they do not express only that intended effect; in particular, the sense of a radiant and triumphant spirituality—such as is evoked in the sonnet "L'Aube spirituelle," among many others—is not rendered adequately by *Vergeistigung*. *Spleen*, too, even when understood merely as intended effect, not as archetypal image, is more than *Trübsinn*. Or rather, it is *Trübsinn* only in the final analysis: first and foremost, it is that fatally foundering, doomed flight toward the ideal, which ultimately—with the despairing cry of Icarus—comes crashing down into the ocean of its own melancholy. In both the oldest and the most recent foreign word in his language, Baudelaire indicates the share of time and eternity in these two extreme realms of the spirit. And doesn't this ambiguous title also imply that archetypal image and intended effect are mysteriously intertwined? Doesn't the title mean that it is the melancholic above all whose gaze is fixed on the ideal, and that it is the images of melancholy that kindle the spiritual most brightly?

Fragment written in 1921–1922; unpublished in Benjamin's lifetime. Translated by Rodney Livingstone.

Calderón's *El Mayor Monstruo, Los Celos* and Hebbel's *Herodes und Mariamne*

Comments on the Problem of Historical Drama

It is a great error of the modern, unpoetic centuries, but one that has never been satisfactorily refuted, to demand of poets that they should be "original" in the sense that they should refrain from making use of the inventions and ideas of others. In our age, which is one in which art has been torn from its organic context, in which poets are isolated and denied any lively interaction with one another, such borrowings are deemed plagiarisms, whereas in all the truly great epochs of poetry they have been common practice. The poet's isolation from the sources that flow into the works of others cuts him off from the roots from which he might derive a rich and healthy sustenance. It leads him to affect an independence, to snatch after novelty and originality; and here we have, alongside other causal factors, one reason for the depressing fact that the literatures of the present day are so completely lacking in inner unity and organic development.

This is the belief of Graf Schack in volume 3 of his *Geschichte der dramatischen Literatur und Kunst in Spanien* [History of Dramatic Literature and Art in Spain], which appeared in Berlin in 1846. Four years later, Hebbel published the first edition of his *Herodes und Mariamne*—the play that, more than any other of the ones he wrote, makes use of a subject that is an integral part of world literature and that has never ceased to preoccupy the West, in an unbroken tradition extending from the religious dramas of the Middle Ages and the Jesuit drama down through the major national theaters, those of Italy, Spain, France, Germany, and England. This is a phenomenon sufficient to give force to Graf Schack's assertion, and to command more respect for it than commonly occurs. For it is scarcely deniable that the veritable flood of research into the history of subjects and motifs has

hardly ever been accompanied by comparable insight into the value of such research. After all, it is not enough to show the influences that have led a writer in one direction or another, or occasionally to prove what model he rejected. The history of literary subjects is fraught with deeper and more general problems. The general theory of art cannot evade such questions as: Is it really true, as is so often claimed, that what counts in art is not *what* is depicted but *how* it is presented? In other words, how can we explain that Goethe, a preeminent connoisseur of the plastic arts, could so often have been content to discuss paintings in terms of their subject matter? For if a work of art possesses the unity that all aesthetic theories have agreed is its outstanding defining characteristic, then it must be impossible in principle to distinguish the form from the content, let alone give one priority over the other. But they are distinguished from each other, nevertheless, when it comes to critical method, and here it is often asserted that the investigation of form and content can be completely successful so long as the analysis of each is carried out in isolation and to its logical conclusion. However, it is rarely admitted that the analysis of literary subjects has been carried out with such rigor, and such judgments may have been influenced by the fact that research into subject matter has generally remained on a fairly primitive and superficial level. Nevertheless, such an approach seems tailor-made for the comparison of plays with a common subject, and its claims will have been strengthened if the following observations, which take subject matter as their starting point, are able to throw light on the works under discussion, and even provide insight into their form.

Subject matter has the same significance for the individual work as nature has for art. We can formulate three types of theory. (1) Nature has no meaning for art. This first idea has scarcely ever been advanced; it is untenable. Even a school like Cubism turned its back on the world of objects only in order to come closer to the space they inhabit. (2) The next alternative is to regard nature as the arsenal of the arts from which the latter may duly make a selection of pieces and fragments for new compositions. This is the eclecticism that has often been too casually imported into the artistic theory of classical and neoclassical periods. (3) The third theory, the oldest of all, is the Platonic and Aristotelian theory of *mimesis*. It teaches that art imitates nature and, rightly understood, is the direct opposite of eclecticism. It is not insignificant that Aristotle regarded the drama as the paradigm of this mimetic function of art, and he therefore analyzed tragedy as the specially constructed mimesis of an event. We need only recollect that what determined the subject matter of Greek tragedy was the world of saga in order to realize how little support such a definition gives to the naturalism that it seems to imply to the modern reader. After all, saga provided nothing more than the general framework for an action whose detailed form was understood and shaped by every landscape and every city in its own way.

Hence, with every individual poetic reworking or variant of the original story, a new appraisal of the saga material entered into the mimesis of this fundamental and (if we may apply the term) ceremonial action that is represented by saga—whether this be the march of the Seven against Thebes, the death of Antigone, or the rescue of Admetus. And it remains to be seen whether any such mimesis represents an eloquent affirmation of the fate contained in the saga, or whether it is an often premature questioning of that fate. To anticipate our discussion, we would suggest that the latter is the case.

The meaning of mimesis for Greek drama may be clear enough, but it leaves open the question whether the Aristotelian concept is capable of providing a general category of content criticism—that is to say, whether modern drama can be seen as mimesis. Our discussion shall be confined to historical drama. This is clearly distinct from tragedy, which is based on myth. The sequence of ceremonial images that form the nucleus of myth around which tragedy crystallizes cannot be expected in the realm of history. In tragedy, every simple yet incalculably profound interpretation of the saga material is capable of damaging the mythic world order and of undermining it prophetically with unassuming words. When confronted by history, however, the writer can be certain of nothing except that his duty is to establish the unity of source and interpretation. In each of its self-contained saga complexes, myth is meaningful in itself. Not so history. Hence, the original image of art is never history—for the original image [Urbild] is the object of mimesis, not the model [Vorbild]—and consequently neither can history serve as such for the historical drama. On the contrary, we might say, to put it briefly, that the historical drama involves the representation of nature as something that embraces all the vicissitudes of history and triumphs in it. The nature of humanity, or rather the nature of things, is precisely the end result of historical drama. Where such an intention is absent, every historical subject disintegrates into an endless sequence of scenes that are no more than the impotent attempt to render the turbulence of history instead of nature, which incorporates historical events as established facts and makes them into genuine literary material. Nature presents the factual reality of historical events as fate. In fate lies concealed the latent resistance to the never-ending flow of historical development. Wherever there is fate, a piece of history has become nature. Hence, the task of the modern dramatist is to construct a necessary totality out of the plausible details that his historical sources offer him. In classical tragedy, the emphasis lies on the conflict with fate; in historical drama, on its representation. This consideration, which must be borne in mind in what follows, leads us back to Graf Schack's statement, quoted earlier. If there are subjects that hint at the presence of fate within themselves, then it would be unworthy of the dramatist to let himself be inhibited purely by the mere fact of earlier

treatments. Any such inhibition would be all the more dangerous as it is by no means clear whether the dramatic suitability of certain subjects springs from their age or from the series of previous adaptations. For the longer such a list is, the more hints it will contain about the writer's true task. In a word, the older a given subject is and the more it has been worked on, the more it becomes the object of poetry, as opposed to the pretext for it. The new work takes the older ones as its starting point and builds on them, but it also enters into them and imitates them, to the point where the poet finds himself tempted to one extreme or the other, as was the case with Goethe in his *Achilleis*. But the age of a given subject is not important only as a precondition of earlier cultivation. In addition, the older a story is, the more it appears to be colored by fate, and in this respect it is infinitely superior to any timeless or modern subject. For it is complete in itself, and may even act as a determining factor in the world we live in. And we are willing to acknowledge the power of fate far more readily in everything that determines us, rather than directly in our own lives. Indeed, we encourage the notion of fate for everything that predetermines our lives, whereas we reject it for our own existence. The validity of this law is much more easily discerned in the lives of nations than in the life of an individual. So if a subject is historically memorable, the interest in the manifestations of fate is much more evident. The dramatist takes greater interest in these manifestations than others do. Hebbel, as we know, initially believed that insofar as the Herod story was concerned this interest had been fully satisfied by the account that Josephus provided.[1] This is not the place to show that at the same time he was laboring under a fundamental delusion and that fate cannot adequately be represented either historically or in narrative form—it can be represented adequately only in drama. We must point out, however, that by mythologizing his source in this way—a consequence of his having kept so closely to Josephus' chronicle, and so converting it into a saga— Hebbel laid the foundation for a catastrophic confusion of styles. In fact this drama set itself a twofold task. It strove to construe fate in the spirit of modernity, and at the same time to "judge" fate in the Greek sense. In consequence, Hebbel is able to do justice to neither.—If Herod's marriage is to present itself to the poet not just as the suitable motif for a novel but as a subject intensified by age, it must also satisfy the claims of history, as well as the intrinsic logic of the story; not in its exact observation of individual detail, perhaps, but in the style of the work as a whole. This must convincingly recreate the style of life in Roman Jerusalem in the early Christian era, if not from a modern standpoint then at least from some conceivable vantage point. Unless it achieves this, even the greatest adaptation will have something absurd about it. This marks the point where Calderón failed.

In general, the contribution of criticism to the history of literary subjects

is far from contemptible, but this kind of approach is particularly appropriate in the present discussion of Hebbel's and Calderón's Herod plays, since it offers the securest foundation for a comparison of two works that in other respects are worlds apart. Even the story lines of the two works have very little in common, and beyond that they share only one feature: the economical paring down—one might even say the transparency—of the story in their hands, in contrast to the treatment of the theme by the mass of other writers. These two authors have almost entirely dispensed with the characterization of Herod as a man gone berserk, which is what defines the tetrarch in the majority of the religious and secular plays alike; Calderón's play has even less of the characterization than Hebbel's does. This is all the more remarkable as Calderón supplemented Josephus with a chapbook, which was in fact his principal source, although [Wolfgang von] Wurzbach records the absence in Calderón of some of the main features of the story as it figures in the only chapbook of the period known in Spain. However that may be, the moderation of Calderón's Herod remains noteworthy, and his eccentricity flows entirely from a single profound passion: his love for Mariamne. For Herod had always been seen as a raving lunatic, not only in the chapbooks but in general. This is what determines the climax in the play, which should be regarded as the ancestor of all the secular Herod tragedies.[2] In 1565, thirty-five years before Calderón's birth, the Italian tragedian Lodovico Dolce published his play *La Marianna*. This work may be regarded as the true ancestor because—in complete contrast to its only predecessor, Hans Sachs's *Der Wüterich König Herodes* [Mad King Herod][3]—it had a profound influence on all the plays on this theme. Not, however, in its most inspired feature, which admittedly Dolce develops rather crudely. In his play, Herod, not unlike Othello, falls victim to an intrigue. With his trust in Mariamne still unimpaired, he gives her a chance to justify herself. But Mariamne, suddenly recollecting that Herod has murdered her brother Aristobulus, sees in this nothing but a pretext to get rid of her. She says as much, and all at once boundless hatred erupts between husband and wife. It is plain that this motif could not be used by Calderón. His is the first play in which Herod unambiguously occupies the leading role, and the problem of the character as he saw it was precisely to prevent Herod's jealousy from turning into hatred. Instead, he wished to ensure that it was always accompanied by passionate love. What Calderón, like many other adapters, did take from Dolce was, first, the dream or prophecy that anticipates the dénouement, and, second, the title of his play. In Dolce, a mythological prologue introduces Jealousy in person as the greatest monster. In his *Geschichte des Dramas* [History of (English) Drama] Klein[4] tries to show that Shakespeare knew Dolce's play. But his evidence is hardly compelling. *Othello* may have borrowed a few motifs from Dolce, but it is as far removed from the world of the Herod plays as one can possibly imagine.

For in all these plays the catastrophe is brought about by the relationship between the spouses, whereas in Shakespeare they are united in death by their shared innocence. Shakespeare, then, abandons a dialectic that still predominates in the other plays. The subtlety of a story that leaves both married partners "in the right" (to use Hebbel's phrase) inevitably proved too much for less talented writers—including, ultimately, Hebbel himself. When the depiction of jealousy ends in hatred and loses sight of jealousy's origins in love, all dramatic interest is forfeited. In the Herod plays, Calderón is perhaps the only dramatist to have overcome this dilemma. But in the majority of adaptations, this is not the issue on which the action has turned. In the Baroque period, above all, writers were influenced by motifs that were far older and more primitive. The Herod theme was at its most popular during the Baroque age. We may go so far as to say that it must have been predestined for an age that was struggling to free itself from the stereotype of the martyr tragedies. It is the very paradigm of the *Haupt- und Staatsaktion.*[5] At the time, its use was not confined to drama. The work that Gryphius wrote in his youth, the Latin-language Herod epic,[6] shows clearly which aspects of the story fascinated the readers of his generation: the seventeenth-century sovereign—the pinnacle of creation—erupting in rage like a volcano and destroying himself, together with his entire court. Both on stage and in the plastic arts, a favorite way of depicting him was to show him overwhelmed by madness, with an infant in either hand, ready to smash them to death. Marino focused on the Slaughter of the Innocents in a poem which appeared in German in a translation by Brockes as late as the eighteenth century.[7] A terrible secret surrounded this king, one that was not confined to this period. As a ranting tyrant, he was the emblem of a disordered creation, but before that he had been even more abhorrent to early Christendom as a kind of anti-Christ. Tertullian is not alone in mentioning a sect of Herod's followers who worshiped him as the Messiah. This is the first reference to the afterlife of this figure in historical memory, and is important, although of course without any historical substance. For in all probability, the term "Herodians" alluded to the followers of the dynasty of Herod Antipater, or to the dynasty of the Romans.—In the seventeenth century or the beginning of the eighteenth, there are a number of relatively independent groups of plays on the Herod theme, which we have no need to discuss here in detail. After Dolce, the Italians (Cicognini,[8] Reggioni,[9] Lalli[10]) mainly produced operatic versions that were probably influenced by Calderón. Later on, Gasparo Gozzi followed in the footsteps of Voltaire's *Mariamne.* It is not really possible to speak of a Spanish preoccupation with the Herod theme. Around the time of the first version of Calderón's play, Tirso de Molina's *La vida de Herodes* appeared.[11] Octavian's love, which in Calderón is kindled at the sight of a picture (much like the lust of Mark Antony in Josephus), takes a quite eccentric turn in Molina, in whose play

Herod falls passionately in love after catching sight of Mariamne's picture in the gallery of the king of Armenia. The motif of the encounter with the portrait of the beloved is suggested in Josephus and recurs in almost all the Herod plays; it is probably of oriental origin. In Calderón it acquires a very particular meaning. Octavian has had a life-sized portrait of the apparently dead Mariamne painted from a miniature. In a scene in which Herod is approaching him from behind with a drawn dagger, the picture falls from the wall. As a premonition of disaster to come, the dagger strikes not the Roman but the picture of Mariamne. Calderón discovered this motif in the Spanish tradition (in Tirso de Molina and Salustio de Poyo),[12] but not in the context of the Herod story. The first version of Calderón's play appeared in 1636 under the title *El mayor monstruo del mundo* [The Greatest Monster in the World]; it belongs, therefore, among the writer's early works. The second version, which he insisted was the only authentic one, was written around 1667. This second version—in which, toward the end, he protests against both the stage production and the printed version of the earlier play—had its premiere in 1667 in Madrid. It was performed in 1700 in Frankfurt-on-Main, and even earlier in Dresden. One may assume that it had an influence on the texts of German traveling theater companies—texts that are now known only by their titles. After Hans Sachs, the first German Herod play was Johann Klaj's *Herodes der Kindermörder* [Herod the Child-Murderer], which appeared in Nuremberg in 1645. It derives not from Calderón but from the *Herodes Infanticida* of Heinsius.[13] This play has acquired some literary notoriety, less from its own merits than from the splenetic criticism it attracted from Johann Elias Schlegel,[14] who was using the play to settle accounts with Harsdörffer, Klaj's protector. Of the English adaptations, we may mention Massinger, a seventeenth-century dramatist, with his *Duke of Millain*.[15] This play transposes Josephus' story to the court of Ludovico Sforza. As is well known, when it was produced in Germany in 1849 in Deinhardtstein's version, Hebbel, secure in the knowledge that he had completed a Herod play of his own, subjected it to a merciless critique.—Even the most superficial overview makes clear that the Herod story is a Baroque subject. And this is confirmed by the fact that almost all post-Baroque plays on this theme either remained uncompleted projects by major writers like Lessing and Grillparzer, or are simply unimportant, like the versions by Rückert or Stephen Phillipps. Hebbel himself is the most striking exception to this rule. Of all the plays on this theme, his is the only one worthy of detailed comparison with Calderón's.

Until today, no notice has been taken of this in Germany. The explanation is obvious, even though it has rarely been made explicit. Calderón's play seemed to suffer so much from the comparison that critics preferred to ignore it. For the essential components all seem lacking: a logical plot, depth of psychological motivation, and a fitting atmosphere, faithful to its subject.

And there is so much in the play that critics would rather were not there at all: the stage props of the fate drama, such as the dagger and picture; Gongoresque bombast; the sonnets inserted at intervals into the dramatic dialogue; women's choruses; and music. Of course, these are all obligatory components of Calderón's writing, and if the Herod play is something of an exception in his oeuvre, that cannot be said of these features. The exceptional status that Spaniards grant the work and that Gries[16] may endorse by having chosen it for translation, far from rendering it unworthy of comparison, elevates it to the first rank of his works. A Spanish authority—the editor of the *Tesauro de teatro español*—mentions it first in a list of the four works that might represent the pinnacle of Spanish drama of the future. This much is plain: if German writers hesitate to take cognizance of the play in the course of their discussions of Hebbel, the reason lies not in Calderón's inferiority but in the fact that the conventions within which he writes are, and have always been, so alien to German eyes. Unless we confront this alienness, no examination of individual plays is likely to prove profitable. In Germany, perhaps only one man has made the effort to gain an understanding of Calderón's barely accessible works: Goethe. Goethe's reading of Calderón should be approached not through Dorer's worthless book[17] but by quarrying the treasures of Schuchardt's review of it.[18] Quite apart from their intrinsic worth, their historical value should not be overlooked by anyone who seeks an insight into Calderón's works from a German vantage point. Goethe's reading and not August Wilhelm Schlegel's. The famous fourteenth and thirty-fifth lectures on dramatic art and literature are anything but the indispensable discussions of the spirit of Calderón, despite the fact that they contain a number of important and apposite comments. On the contrary, they exalt Calderón without restraint and in such a high-handed manner that their lack of urbanity inevitably offends the informed reader. It is scarcely surprising, then, that Tieck, Graf Schack, and Klein, in their writings on Spanish drama, should distance themselves from Schlegel by coming out in support of Lope de Vega and regarding Calderón more or less as the poet of political decadence. Questionable though it may be to draw parallels between pragmatic history and literary history in this way, it is undeniable that in Germany Schlegel has done more to stimulate an interest in Calderón than to lay the foundations for a proper understanding of him. One feels tempted to assign Schlegel the role of a diplomat. And indeed anyone who considers more closely the intrigues surrounding the name of the great Spaniard at the beginning of the nineteenth century might easily imagine that he has migrated from the realm of literature into that of high politics. Everyone who was interested in Calderón strove to win over Schlegel to his point of view. But Gries was not the only one to receive no reply when he sent Schlegel the first volumes of his translation. Even the great quarrel between Böhl von Faber, a German, and

Joaquín de Mora in Spain, in which the former attempted to establish the literary merits of Calderón and denounce the superficial French theater that was making inroads into Spain, did not persuade Schlegel to break his silence after he had been invited to side with his fellow countryman.[19] So jealously did he guard what he thought of as his exclusive right to disburse literary praise. An additional factor was that his own translations were greatly surpassed in quality by those of Gries, and that he was forced to share the role of cultural mediator with Wilhelm von Humboldt, at least so far as Goethe was concerned. Humboldt's letters from Spain also drew Goethe's attention to Calderón. And there is a well-known account of Goethe's public reading of *El príncipe constante* [The Constant Prince] in Weimar in which, toward the end, when the ghost of the dead prince marches at the head of his singing troops, Goethe was so moved that he hurled the book down on the table. In this context, Schuchardt has very perceptively reminded us of the Calderonesque apotheosis of *Egmont*. For Goethe, this enthusiasm was the beginning of a struggle with the mind of the Spaniard which continued over a period of years and had many ups and downs. In the course of it, he produced ideas that are very indirect but that nevertheless have canonical importance for the relationship of German criticism to Calderón. If we are not mistaken, Goethe brought three highly developed gifts to this debate, in which he showed himself to be not just the equal of the Spaniard but also similar to him. These gifts—imagination, generosity of spirit, and a sense of artistry—allowed him to understand the alien genius more profoundly than was granted to any other German poet. Hebbel lacked the two last qualities entirely. It is easy to see why Calderón always remained alien to him. In particular, there can scarcely have been another German writer of Hebbel's quality who was so lacking as he in the sense of artistry. Whether this should be understood as praise or something else, it undoubtedly precludes any insight into Calderón. When it comes to grasping Calderón's nature as a writer, this element is more important than the critic's religious position. Goethe was as far removed from Catholicism as Hebbel, but as an artist he knew—with regard to both his own works and those of others—that Catholicism might on occasion be allowed a certain role in the economy of the drama. In his initial, unqualified enthusiasm, he claimed that if poetry were to vanish from the earth he would be able to reconstitute it from *El príncipe constante*. This mood did not last, but as late as 1812 he could still in a passing remark place Calderón above Shakespeare. Goethe's reservations come still later, in connection with the "abstruse"—that is, the abstruse content (the Catholicism) and the abstruse form, by which he meant the theatrical pomp. It was this that he had in mind when he observed that Calderón had never influenced himself, but that he might have been a danger to Schiller. Yet even at this late stage, when he is attempting to make a definitive statement about his relationship

to Calderón in the course of a review of *La hija del aire* [Daughter of Air], he insists on a knowledge of the historical context in which the Spaniard wrote—not, let it be said, to make excuses for his limitations but in order to get a better grasp of his unlimited essence. For example, he says in his notes to his translation of *Le neveu de Rameau:* "We should just reflect on Calderón and Shakespeare! They could withstand scrutiny from even the highest aesthetic seat of judgment, and if any ingenious critic were stubbornly to accuse them of certain faults, they would be able to smile at him and point to a picture of the nation, the age for which they had worked, not simply as an excuse but because they could happily accommodate themselves to it in order to earn fresh laurels."[20]

The question of what Calderón actually accommodated himself to has to be answered as the precondition for an understanding of his plays: it was the Church and the court. Calderón was a man who enjoyed high spiritual and worldly honors, and what molded his drama was not the threat of censorship but the power of the ideas at work in those institutions. The sense in which this applied to the Church has been brilliantly explained by [Hermann] Ulrici in his book *Über Shakespeares dramatische Kunst und sein Verhältnnis zu Calderón und Goethe* [On Shakespeare's Dramatic Art and Its Relation to Calderón and Goethe].[21] He states there that in Calderón, "because of the assumed and actual reconciliation of the elements of conflict—because, in short, man has already been redeemed by God . . .— the plot has to be organized and man's desires and actions have to be brought into conflict with the divine order by means of particular circumstances in such a way that God's direct, external intervention acquires at least the appearance of necessity."

Of course, the direct intervention of God that Ulrici presupposes is not always present, least of all in the Herod drama. The secret of Calderón's strange "externality" is not unlocked so easily. Nevertheless, Ulrici's question remains valid: What profane materials can still possess authentic dramatic interest in a world whose deepest ethical impulses (even down to the level of detail: think of the casuistry of the day) are irrevocably transcendental? However we may choose to answer this question at the level of detail, it is evident from the outset that in such dramas the element of play will be much more prominent than usual. At the same time, it is obvious that any understanding of these dramas will be frustrated by the attempt to regard them as tragedies. Ulrici, who did not have any alternative categories to work with, finally protested in some perplexity: "In these plays, human nobility and greatness of character do not perish from their earthly fallibility and wrongness. Instead, in their struggle with the opposing power of evil and disaster, they are destroyed by their ethical and religious qualities." *Il príncipe constante*, the subject of this statement, is a martyr drama. But even in the other plays, and especially the Herod drama, it should be possible to

show that there can be no question of an authentic *tragic* guilt (which always entails a certain paradoxicality), or the genuine reinstatement of an ethical world order and so forth. Sadness accompanies the downfall of the high-minded husband—a sadness that would be boundless, were it not for the presence of that intentionality which Goethe deems an essential component of every work of art, and which manifests itself with an assertiveness that fends off mourning. A mourning-game [*Trauer-Spiel*], in short. And it is fitting that, at a time when Goethe was strongly influenced by Calderón, he should have tried to write a play on a subject from the age of Charlemagne—a play to which he gave the apocryphal subtitle "A Mourning Drama [*Trauerspiel*] from the World of Christendom."

When the drama of play is confronted with historical subjects, it finds itself compelled to develop the logic of fate as a game. This is the conflict that constitutes "romantic tragedy." Among modern writers, it was Schiller who struggled hardest to wrest the ultimate seriousness of classical tragedy, its true pathos, from subjects that have long ceased to have anything in common with the myths of true tragedy. Whereas Goethe inclined toward significant and well-founded mediations, Schiller's theater sought to explore both the naturalistic and historical elements that still seemed viable for the dramatization of classical fate in the modern world. Both tendencies fizzled out subsequently—the one in the Hohenstaufen dramas of someone like Raupach,[22] the other in fate dramas like [Ibsen's] *Ghosts*. For Schiller, the importance of the idea of freedom was that it seemed able, by a sort of reflex, to reveal history as fate. Yet how unsuccessful he was in evoking a truly classical seriousness in *Maria Stuart* or *Die Jungfrau von Orleans!* How operatic the opening scene of *Wilhelm Tell* is! And how paradoxical it is that his most radical attempt to appropriate classical fatality—in *Die Braut von Messina*—should have ended up in the heart of Romantic fate tragedy and far from the spirit of Greece! When we contemplate these facts we can see the justice of Goethe's remark that Calderón might have been a danger for Schiller. And in his turn, he may have had reason to feel secure when, at the end of the second part of *Faust,* he consciously and soberly adopted an approach that had partly imposed itself on Schiller against his will and partly irresistibly attracted him. In contrast, the fact that Hebbel could ever be bracketed with Calderón must be a matter of some astonishment, and it is not adequately explained by Treitschke's remark that "a wild imagination is intimately related to the aberrations of an over-refined intellect."[23]

Despite all the similarities, Calderón's drama remains fundamentally different from Schiller's, thanks to a clearly defined Romantic element and to the clearly defined consciousness that this implies. On the other hand, Graf Schack has discerned in Calderón the source of the fate tragedies of German Romanticism, and has even singled out the Herod play because it contains

"the first seeds of those chaotic works." However that may be, a recent treatise entitled *Calderóns Schicksalstragödien* [Calderón's Fate Tragedies][24] is too glib in its attempt to deny the problem of the fate tragedy any fundamental significance by asserting that the fate tragedy was defined as a literary genre in its own right only by German criticism and literature. The concept may indeed have been introduced by the critics, but the reality was not introduced by German literature. Even Berens is forced to admit that Calderón's Herod play, in particular, does "have an affinity with the fate tragedies of German Romanticism." And for all that, it is not less typical of Calderón. A glance at the plot soon brings us face to face with the outstanding features of the fate drama. It begins with a prophecy. Mariana complains to her husband about the prophecy of a magician, who foretells a twofold disaster: she will fall victim to the most terrible monster in the world, and Herodes will stab to death with his dagger the thing he holds most dear. The play is so constructed that once these words have been uttered, the audience never again loses sight of the dagger during the rest of the action. Herodes, who is relatively unconcerned about the prophecy, hurls his dagger into the sea, in order to proclaim his freedom. Cries of pain float up to him from there. The dagger has wounded the messenger who is bringing the news of Octaviano's victory over the fleet belonging to Marco Antonio's allies. Herodes, summoned to Memphis by Octaviano to explain himself, sees the life-size picture of his wife hanging above the door of the royal audience chamber. A miniature portrait that has fallen into the Roman's hands as part of the spoils of war has caused Octaviano to fall in love with the woman depicted in it, Mariana. Her brother, Aristóbolo, Octaviano's prisoner, who has a premonition of the disaster that will come to pass as a result of this passion, has said that she is dead but has not revealed her name. Octaviano has had a life-size copy made of the miniature; this picture has then been hastily mounted above the door. Herodes is greatly agitated by the sight of the picture, but since he is hard pressed to defend himself, he does not have the opportunity to ask how the picture came to be there. Yet no shadow of suspicion falls on Mariana. If we were to choose from the plethora of felicitous passages in this play, it would have to be the scene in which the tetrarch, disarmed by the sight of the painting whose subject is known to him alone, stands there—a picture of distress—before the arrogant conqueror who misinterprets the situation. Finally, as Octaviano turns to leave, he cannot resist insulting the king. Herodes is about to fall on him and stab him in the back. At that very moment the picture falls from the wall, and, as it lands between the two enemies, Herodes inadvertently thrusts the dagger into the image of Mariana. In the dungeon in Memphis, he gives Aristóbolo's servant the order to kill Mariana, and the servant then escapes and goes to Jerusalem. There he is discovered by Mariana—not, as in Josephus and Hebbel, thanks to the servant's own behavior but through an intentionally external piece of motivation. The

servant, Tolomeo, quarrels with his girlfriend, and in a fit of jealousy she suspects that the letter containing the order is a secret love letter. Mariana witnesses the quarrel and snatches up the torn letter. She then reflects on its contents in the following words, which reveal the character of the work at a climactic moment:

> What message do these leaves contain?
> Their very first word is *death;*
> *Honor* is their second breath,
> And what do I see here, but *Mariana?*
> What does this mean? Help me, Heavens!
> Three little words say so much:
> *Mariana, death,* and *honor.*
> It says here: *on the quiet;*
> And here: *dignity;* here: *requires;*
> And here: *striving;* and here: *I am dying,*
> It goes on.
> But what need I doubt? The very folds in the paper,
> Unfolding such crimes,
> Show me how they
> All refer to one another.
> O meadow! Upon thy green carpet
> Let me piece them into one!

Thus far the first two acts. Act III depicts Octaviano's entry into Jerusalem and his pardoning of the king in response to Mariana's pleadings, after he recognizes her as the original of the portrait. Her speech asking for mercy and her thanks contain hints that she is deeply impressed by the respect felt by the victor for her value and her beauty, in contrast to the disdain expressed toward her by the vanquished Herodes. In the palace, after a very long monologue, she renounces Herodes and disappears. In the entire play, there is only one conversation between husband and wife. It takes place at the beginning and concerns the prophecy. The abandoned Herodes blames the innocent Tolomeo for the disaster, and threatens to kill him. Tolomeo flees to Octaviano, and, in order to explain his presence, tells him untruthfully that Herodes is plotting to kill Mariana. Immediately, even though it is late in the evening, Octaviano rushes to Mariana's palace. He finds her with her women, about to undress for bed, and assaults her passionately. Mariana flees, with him in pursuit. The tetrarch appears on the empty stage; he misinterprets the scene that appears before his eyes. On the floor lies the dagger which Octaviano had taken after Herodes had tried to kill him and which Mariana had seized from him in order to kill herself rather than yield to him. She now returns, with Octaviano at her heels, whereupon Herodes snatches up the dagger and falls upon his enemy, only to strike down his wife in the dark. He ends his own life by hurling himself into the sea. According to Berens, "It would have been natural to explain Mariana's

death as the result of Herodes' jealousy. Such a solution seems almost inescapable, and it is obvious that Calderón has done everything in his power to frustrate it in order to give the 'fate drama' an appropriate conclusion." This statement goes to the heart of Calderón's play, but only so that this critic, like others, can push its meaning to one side as an incomprehensible quirk that has spoiled the logic of the play. Yet the structure of the play, as well as its great beauty, will reveal itself only to an observer who is able to gain insight into its conception of dramatic fate. Nothing could clarify this more than a glance at Sophocles' *Oedipus Rex*. At the center of both plays there is an oracle. In both, the oracle's prediction is fulfilled against the hero's will. In the case of Oedipus, it is revealed to him like a flash of lightning during his conversation with the shepherd as something that has long since come to pass. In contrast, the plot in Calderón remains attracted to the prophecy as if to a magnet from which it can never be pried loose. It is the stage props that bind the plot to the oracle. This is the criterion that distinguishes the authentic Romantic fate drama from a classical tragedy, which in the last analysis repudiates fate. Indeed, it is not objects alone that assume the character of stage props in the modern play. Herodes does not kill his wife from jealousy, but it is through jealousy that she dies. It is through jealousy that Herodes is tied to fate, and fate makes use of it—the dangerously inflamed side of human nature—to bring about disaster and the portents of disaster in the same way that it makes use of inanimate nature in the form of daggers and pictures. What we have in Calderón's Herod play is not the ethical unfolding of a mythical action, as takes place in tragedy. Instead, we witness the representation of a natural process that unfolds without tension but with the force of fate. Yet precisely because the strange and truly monstrous jealousy of the tetrarch is removed from the realm of morality (because the voice of fate has uttered its judgment) and enters the plot as a stage prop, it becomes possible for love to acquire space to unfold in all its splendor beside it. In the king, jealousy is overcome by love. Monstrous though his jealousy is, he has nothing of the monster about him. Calderón is unique in his ability to portray the most intense love in union with the most corrosive jealousy. Herodes' doubts about Mariana's fidelity do not imply doubts about her love. For in an incomparable, indeed shattering turn of events, Calderón has shown us Mariana through Herodes' eyes as being caught up in an unresolvable conflict. It is not for nothing that, following Josephus, Calderón emphasizes the wife's beauty (which plays only a trivial part in Hebbel) with an almost opera-like intensity. Hence, in Calderón, Herodes' complaint is not the lament of men married to fickle wives, but takes quite a different course:

Woe to the cursed man,
Woe to him a thousand times,

Who dared to call a woman
Of the greatest beauty his own!
For his own wife should not
Have the highest repute; may she
Have no more than grace in all things,
But not overwhelming magic.
For beauty always threatened by danger
Is an ermine: if it does not defend itself, it dies;
If it defends itself, its beauty is lost.

Mariana—and here, as elsewhere, Spanish ethics have become the agent for the transmission of enduring values—owes absolute fidelity only to the living. After Herodes' death, his fortunate successor could lay claim to her along with the throne, and she might possibly serve that successor with the same sense of duty. If this means stressing the queen's extreme passivity, then the force of his jealousy strikes the tetrarch with full force without its even occurring to him to insult his wife, or to doubt her love even for a moment. On the contrary, he is entirely certain of her love, as the poet emphasizes in the scene preceding the issuing of the order to kill her. Hurtful in another way, however, are the actions that flow from his jealousy. Yet despite this, how mild some of Mariana's comments on her husband's jealousy are!

It may be possible to take yet a further step in our efforts to dispel the aura of the abstruse that surrounds this work. Such efforts will always revert to the question of the validity of the "fate tragedy." Without wishing to become involved in extensive debate about the concept of fate, we must emphasize one point above all others: fate does not involve the inescapable nexus of cause and effect as such. It will never be true, regardless of how often it is repeated, that the task of the dramatist is to present the audience with a plot governed by the logic of causality. How could art put itself in the position of supporting a hypothesis that lies at the heart of determinism? The only philosophical ideas that can enter into the structure of art are those which concern the meaning of existence. Doctrines about the facticity of the course of world events remain irrelevant to art, even where they concern its totality. Since the determinist view is a theory about the laws of nature, it cannot give shape to any work of art. But the authentic idea of fate, whose decisive feature is its assumption of the eternal validity of such determining, is different. This determinism need not operate through the laws of nature, though; a miracle, too, can make its eternal meaning manifest. Such meaning does not lie in factual inevitability. The heart of the concept of fate lies, rather, in the conviction that it is guilt alone which makes causality the instrument of an inexorably approaching fate. Guilt in this context is always creaturely guilt (not unlike original sin); it is never the result of the moral fallibility of the human agent. Fate is the entelechy of a process at whose center we find the guilty person. Outside the realm of guilt, fate loses all its

power. The center of gravity toward which the movement of fate unfolds is death. Death not as punishment but as atonement—as the expression of the fact that the guilt-ridden life is doomed to succumb to the law of natural life. In this sense, then, death in the fate drama is quite different from the victorious death of the hero of tragedy. And it is precisely this succumbing of the guilt-ridden life to the laws of nature that expresses itself in the unrestrained passions of the guilt-laden hero. The power that lifeless objects acquire in the vicinity of the guilty person during his lifetime is the harbinger of death. His passion sets the theater props in motion. These are, in essence, merely the seismographic needle that registers the human shocks. In the fate drama, human nature expresses itself through the passions, just as the nature of things expresses itself in chance, and both are governed by the general law of fate. The more wildly the needle vibrates, the more clearly this law emerges. In that respect, it is not a matter of indifference whether, as in so many German fate dramas, the hero is oppressed by a paltry instrument in the course of petty intrigues, or whether age-old motifs are allowed to speak—for example, the victim scorned (as represented by the dagger) or the magic embodied in the stabbed portrait. In this context, we see the validity of Schlegel's assertion that he knows of "no dramatist who is able to poeticize the effect so well." Calderón was incomparable in this respect, because the effect was an internal necessity for the form he had made his own: the fate drama.

To repeat: the world of fate was self-contained. It was the "sublunar" world in the strict sense—a world of the wretched or glorious creature where again and again the rules of fate to which every creature is subject were to confirm their validity in an astonishing and virtuosic way, *ad maiorem dei gloriam* and for the enjoyment of the spectators. Calderón's theoretical views, too, so far as we can infer them from statements in his plays, seem to point in this direction. It is no coincidence that a writer like Zacharias Werner should have tried his hand at the fate drama before seeking refuge in the Catholic Church. What appears to be the illusion of heathen world-liness is ultimately the complement of the religious mystery drama in the empire of Philip IV, where everything worldly throve so luxuriantly that it inevitably colonized the stage. But what attracted the theoretically inclined Romantics so magnetically to Calderón—to the extent that he might be regarded, despite their admiration for Shakespeare, as their own special dramatist—is that he fulfilled to perfection one condition they strove for above all else. This was that infinity should be guaranteed through mere reflection. The entire Herod play is criss-crossed with the most absurd debates about human will and the power of fate. The action is playfully diminished by the reflections that Calderón's heroes always have at their fingertips. This enables them, so to speak, to twist and turn the entire order of fate in their hands like a ball so that you can examine it, now from this

side, now from that. What, after all, had been the ultimate goal of the Romantics if not to see genius, even when bound by the golden chains of authority, still irresponsibly absorbed in its own reflections?

If this interpretation of Calderón's fate drama is valid, it does entail one strange conclusion: nature, as the epitome of all creatures, would have to have a real dramatic meaning. For the critic whose gaze remains fixed on the German drama of the past two centuries, this is hard to understand. It is admittedly easier for anyone who pauses to reflect on German dramatists who were contemporary with Calderón, particularly Gryphius. However that may be, the fact that nature occupied a striking position in the Spaniard's drama was a fact about which the most competent German critics agreed. Here, for example, are the words of August Wilhelm Schlegel:

> His poetry, whatever its object may apparently be, is an incessant hymn of joy on the majesty of the creation; he celebrates the productions of nature and human art with an astonishment always joyful and always new, as if he saw them for the first time in an unworn festal splendor. It is the first awakening of Adam, coupled with an eloquence and skill of expression, with a thorough acquaintance with the most mysterious relations of nature, such as high mental cultivation and mature contemplation alone can give.[25]

In a similar vein, Goethe confessed in 1816 that the translations from Calderón transported him "into a glorious land, surrounded by the sea, rich in blossoms and fruits, and illuminated by the clear light of the stars." Admittedly, he subsequently talks about him in quite different terms, remarking that Calderón is "theatrical" [bretterhaft] and that he lacks any authentic observation of nature. In itself, this judgment is comprehensible. If we reflect, for example, on the account of the naval battle in the Herod drama, where the Creation remains vividly present in all human passions and in all the fortuitous incidents of the plot as the vehicle of all natural life, it is easy to understand Goethe's displeasure. (Although it should be added that there is perhaps not a single Calderonesque extravagance that could not be found replicated at some point or other in the second part of *Faust*.) We may add that in Calderón the social order and its representative, the court, likewise appear as a natural phenomenon at the highest stage of development. Herodes' honor is its first law. With extraordinary boldness, the poet depicts the solidarity of the political and the natural order in creation, by showing how Herodes seeks mastery of the world for the sake of his love and for that alone. From any other standpoint, this would diminish his majesty. But here this tie magnifies it, since, by fusing with his love, his honor shows itself to be at one with creation. It is worth observing, incidentally, that Calderón rarely misses the opportunity to intensify the paradoxes of the national Spanish conception of honor, by showing them to be the expression of a baleful and irresistible manifestation of fate, to

which created beings must bow like trees in a storm. The only means of salvation is through never-ending dialectical reflection. In this context, Berens rightly observes: "If the classical fate tragedy works through the crushing burden of suffering and if German Romantic drama works through its ghostly atmosphere, then the corresponding characteristic in the Spanish dramatist is his intellectuality, the dominance of thought." The critic notes perceptively that this feature is proclaimed in the fact that the action of the plays normally takes place in daylight. The Herod tragedy is the exception here, and it is the intensified crudeness of this that may have influenced the German fate tragedy. This provides further confirmation of the distance we have traveled here from true tragedy, particularly if we are to believe [René Le] Bossu's shrewd remark (as cited by Jean Paul in the *Aesthetics*) that no tragedy should take place at night.

No sharper light can be cast on the tragic drama—or, more precisely, on fate dramas like Calderón's Herod play (since of course not every tragic drama is a fate drama)—than the comparison with the typical historical drama that Hebbel has provided in his treatment of this theme. The further we take the comparison, the more complete the insight we obtain. We can give only the broad outlines here, however. To begin with, we must state that it is unclear why critics assume that Hebbel was acquainted with Calderón's play. Hebbel himself does not mention it. The Calderón translation with which he is familiar is the one by [Ernst Friedrich Georg Otto von der] Malsburg, which does not contain this play. It is not very likely, to say the least, that Hebbel would have missed the opportunity to contrast his own treatment of the subject with Calderón's. Calderón had fascinated him as an object of criticism; we might reasonably have expected him to discuss the play in the spirit of his earlier reviews of Calderón. For there can be no doubt that he would have found his annihilating condemnation of 1845 confirmed by this play. At that time he said of *Aurora de Copacabana* and *La sibila de oriente* [The Sibyl of the East]:

> It goes without saying that, in judging these plays, the standpoint I adopt is that of Christianity, Catholicism in particular, since they are meaningless from any other. But even considered in this light, they appear to me to be utterly worthless and without substance, for when poetry concerns itself with mysteries, it should strive to give them meaning—that is to say, to humanize them. It should not imagine that it is achieving anything by waving a magic wand, so to speak, and causing one miracle to give birth to another. The plays under consideration here do not even provide a negative reason for such thoughts, for the view of Christianity they contain is so primitive and heathen, and so utterly lacking in ideas, that the problem is to know whether to simply dismiss them as grotesque or to castigate them as immoral.

The picture is no different if we look at Hebbel's other statements on Calderón, which in any case are not very numerous. To put our finger once

again on what it was that made it impossible for Hebbel to understand the Spanish dramatists (for his opinion of Lope de Vega did not differ significantly from his opinion of Calderón) and what it was that went to the heart of his own writings, we would have to say that he was unable to recognize any element of play either in drama or in art generally. Even comedy had nothing playful about it in his eyes. Nothing so clearly points to his outsider status or determines the place of his art—and it is no very distinguished one—as this fact. An oppressive earnestness has become the inalienable mark of his works. It determines his conception of historical drama and his theory of drama in general. For a solitary autodidact like Hebbel, it was all too easy for his meditations to lead him to the conviction that the art of drama contained the key to reality as such. I am not referring here to the legitimate faith of the artist in his ability to grasp the essence of reality through his work. Nor am I accusing Hebbel of overestimating himself personally. I am, rather, attempting to define his skewed and (if one may put it thus) uncomprehending and mistakenly monumental view of drama itself, which he thereby made into a special subject, albeit one that was all-inclusive. This pinpoints the absolute nullity of his "pantragism," both as a term and as a reality; and, to repeat, it is a nonsense that arises from his autodidactic and limited cast of mind. This much is certain: Hebbel's tragedies can claim a unique place in modern literature, thanks to the earnestness peculiar to him—an earnestness which is not relieved either by humor or even irony but which characterizes his conviction that it constitutes a form that does justice to its historical context. We have suggested that Calderón took the large subject of the Herod drama and inserted it into a strictly defined space in order to allow fate to unfold playfully. And how incomparably Schiller displayed *his* understanding of art in *Die Jungfrau von Orleans* or *Wallenstein*, when he made use of the marvelous and of the rule of the stars in a completely Calderonesque spirit! For fate is postulated as a reality only in the inferior, unromantic fate tragedies. (Though we must note that "romantic" is not used here in its historical sense; Romanticism has enough bad fate tragedies on its conscience that are not redeemed by any superior framework.) On the other hand, where in authentic tragedy all playful elements are put to one side, we find not history, on which fate feeds, but myth, in which the dramatist prophetically deals a blow to the iron rule of fate. In contrast to this, Hebbel's historical drama may be regarded as the attempt to reinterpret history, because of its inexorable causal conditioning, as the onward march of fate. But fate resides in the realm of teleology, not causality, and is therefore less likely to emerge from detailed motivation, however meticulous, than from the miraculous. Yet this is something that never became clear to a thinker caught up in the naturalism of the mid-nineteenth century. And *as a theoretician* he never really understood the necessity of the fundamental reworking of content by form—a necessity that cannot be made good by even the most thorough-

going immersion in that content. But the mistakes here are much more those of Hebbel the theoretician than of Hebbel the practicing dramatist, and no one has found in himself a more unfortunate interpreter than Hebbel. This comment is one that will retain its validity so long as his admirers continue to borrow their arguments from his diaries.—In the meantime, the problematic theory of historical necessity is not without its share of the blame for the woodenness of Hebbel's Herod drama—a woodenness of which so many of his critics have been so painfully conscious. One of the first to draw attention to this was Emil Kuh, in a discussion that can scarcely be gainsaid:

> Two passionate people at odds with each other are pitted against each other, in conformity with the character of each; but despite the powerful emotions involved, this is achieved in such a manner that our sympathies shift from a position in which we are moved and persuaded to one in which we become psychological observers. The arguments and counterarguments are put forward with an urgency that we cannot deny, but they cool our ability to identify with the poetry. Both Herodes and Mariamne address the problem and, as it were, articulate the tragic motif by name, and in drama this always has the effect of a dry east wind before which the hot flowers wilt and fade.

It is true enough that the gift of letting oneself go, which seems to be the most precious dowry of every one of Shakespeare's characters, is seldom given to Hebbel's. In this respect, the figure of Joseph towers above all the others in this play. If the critic's task were to fill out the picture, there would be much to say in evidence. One point in particular must not be omitted, even though a very detailed discussion would be required to prove its accuracy. Hebbel has failed in the indispensable task of demonstrating the noble qualities of his characters and of the conflicts in which they are enmeshed. Quite frequently, the most important events and situations are handled in an inexpressibly sterile way. One example is the scene of what was meant to be the glittering party thrown by Mariamne. The construction of the play hands over to the director tasks that should have been carried out by the author. An instance can be found in the final scenes, where both Herodes and Mariamne are partnered by the figure of Titus, who is very much a cardboard figure. This leads to a diminution in the dignity and remoteness of the aristocratic personages just when they are most needed to demonstrate that these are the very qualities which have engineered the catastrophe. The same holds good for Titus' short-winded protest during the court proceedings, and we are tempted to ask ourselves what speech Shakespeare might have given Titus to replace his "This is no true court! Forgive me! [He turns to leave]" (V, 5, line 2919). And are the following lines of Herodes in keeping with the thrust of the play?

With all your rigid defiance, which alone stands firm
On earth where all does totter;
With every fine day that I spent with you . . .

These lines speak the language of a bourgeois family quarrel. It might appear irresponsible to dwell on such lapses, were it not that the absence of nobility in the characters and speeches points to a fundamental flaw in the work. Take, for example, Mariamne's speech to Titus: "But one word more before going to sleep, / While my last chambermaid prepares my bed—" (V, 6, lines 2959–60). Nothing can remove from her confession the stain of an act of vengeance devoid of all passion. Her death is overshadowed by an ambiguous tone of resentment. Indeed, Hebbel resorts explicitly to the same formula of resentment when, in reply to Titus' words, "I feel also much sympathy with him / And your vengeance is too great for me," he makes her give the profoundly ignoble reply (V, 6, lines 3057–62):

Upon my own head be it!
And to prove that it was not
For the sake of life that the death
Of the sacrificial beast enraged me,
I'll show you, I'll throw my life away!

Enough! Hebbel was a great enough writer to place upon his critics the obligation of interpreting his faults as aberrations from true conceptions. The play could not possibly have been clear in his mind right from the outset, given the distortions that a theory like his would have imposed on even the greatest genius. In actual fact, a careful study uncovers a motif that hovers somewhere in the background of the finished work but that may have been the original cause of his interest in the subject—if indeed this motif is, as it appears, truly his own. We may question whether jealousy is as central to Hebbel's play as it was for Calderón. The jealousy aroused by the murder of Aristobolus, and later on by the discovery of the order to have Mariamne murdered, should rather be seen as the pretext for the exposition of a different problem, one very characteristic of Hebbel's way of seeing things. This is the question of whether it is ever legitimate for lovers to test each other's love, as both partners do in this play. Hebbel himself appears to be undecided on the matter, since the catastrophic end to the tests seems to be ascribable both to the criminal nature of the tests and to the inhuman radicalism with which husband and wife carry them out. Furthermore, the important dramatic intention of criticizing the test of love is significantly undermined by the failure to explain Herod's initial uncertainty, particularly in the light of his murder of Aristobolus. Subjectively, this event lends plausibility to Herodes' wish to test Mariamne. Objectively, however, it means that we can see the negative end of the experiment in advance, and since the experiment is conducted by a man who is himself not free of guilt, it becomes almost indefensible, even subjectively. So Hebbel has in effect cheated himself out of the real drama of the test of love—its necessary immorality and its necessary failure—through the extremes of character and situation that he created. The problem that

may have inspired him in the most successful passages is that of the emergence of an undying hatred between the couple in consequence of the test of love. We see this in an outburst on Mariamne's part that shows hints both of Shakespearian power and of Strindbergian implacability: "Death! Death! Death is among us! / Unannounced, as he always comes!" (IV, 8, lines 2526–27). This tragedy, whose subject may well appear to be a dramatist's mirage, reaches its climax in Hebbel in a blazing upsurge of hatred. We cannot imagine where this might have led him, had it not been for his striving for a moderatist aesthetic of classical beauty, a pale imitation of which was more successfully achieved by his untalented contemporaries, but a true revival of which was inconceivable.

The underlying vehemence in his plays did not escape the attention of those contemporaries.[26] Theodor Mundt calls his works the "poetry of sexual fate." And [Rudolf von] Gottschall talks of a destructiveness "that lies concealed beneath the veneer of architectonic structuring. Hebbel is the greatest ethical revolutionary of all German poets, but he hides his moral Jacobinism beneath the artful mask of the tragedian." Every great tendency has to create its own form (the form in which it ceases to be known as "tendentious literature"). Perhaps all great dramatic forms have their origins in tendencies that have no direct connection with art. Hebbel was full of such tendencies, but never ventured to write a play that was not guaranteed in advance by its form. This is why he clung to the historical drama, which he was concerned to write with the maximum of verisimilitude. But if history can lay claim to dramatic truth only as fate, then the attempt to write unromantic historical plays is doomed to failure. It is possible, however, that Hebbel's most powerful tendencies remained to some extent unexpressed. He once confessed shyly to [Gustav] Kühne what was at stake: "My mood has significantly lightened, particularly since the conflicts that provided the impulse for my previous plays have become the topic of conversation in the streets and have been resolved historically. For the rotten state of the world weighed on me, as if I were the only one who suffered from it, and it seemed to me that art was not an unworthy medium to show how untenable it all was." In his early plays he went far beyond this rather tame formula, and for that reason *Judith* and *Genoveva* may perhaps prove to have the greatest vitality of all his works.

Written in 1923; unpublished in Benjamin's lifetime. Translated by Rodney Livingstone.

Notes

1. Flavius Josephus, *De bello judaico*, Book 7 (I, 17–22); Flavius Josephus, *Antiquitates judaicae*, Book 20 (XV, 2–3, 6–7). [See Josephus, *The Jewish War* (Harmondsworth: Penguin, 1977), ch. 4, pp. 80–96.—*Trans.*]

2. On the following, see Marcus Landau, "Die Dramen von Herodes und Mariamne," *Zeitschrift für vergleichende Literaturgeschichte*, n.s. 8 (1895): 175–212 and 279–317, as well as n.s. 9 (1896): 185–223. These articles are written in a casual tone and provide a sometimes unreliable account of the content of a large number of plays on the Herod theme.

3. Hans Sachs, *Tragedia mit 15 Personen zu agiren, Der Wüterich König Herodes, wie der sein drey Sön und sein Gemahel umbbracht, unnd hat 5 Actus* (1552). [Hans Sachs (1494–1576), Meistersinger and dramatist, wrote comedies and tragedies—many based on classical and biblical sources—as well as the *Fastnachtsspiele*, or carnival plays, for which he is best known.—*Trans.*]

4. Julius Leopold Klein, *Geschichte des englischen Dramas* (Leipzig, 1876).

5. These plays, which emerged around 1700, were "political" dramas, concerned with the sudden fall of kings, dark conspiracies, and executions.—*Trans.*

6. Andreas Gryphius, *Herodis furiae et Rachelis lacrymae* (1634); idem, *Dei vindicis impetus et Herodis interitus* (1635).

7. Giovan Battista Marino (1569–1625) was an Italian baroque poet. Barthold Heinrich Brockes (1680–1747) was a German poet and translator whose work, especially the collection of his poems titled *Irdisches Vergnügen in Gott* [Earthly Satisfaction in God; 1721–1748], reveals him as a transitional figure between the Baroque and the Enlightenment.—*Trans.*

8. G. A. Cicognini, *Il maggior monstro del mondo: Opera tragica* (Perugia, 1656).

9. J. B. Reggioni, *La felonia d'Erode* (Bologna, 1672).

10. Domenico Lalli, *La Mariana* (performed in Venice, 1724).

11. Tirso de Molina, *La vida de Herodes* (1636).

12. Damián Salustio del Poyo, *La próspera fortuna del famoso Ruy López de Avalos*.

13. Nicolas Heinsius (1656–1718), Dutch novelist and dramatist.—*Trans.*

14. Johann Elias Schlegel, *Nachricht und Beurtheilung von Herodes dem Kindermörder: Einem Trauerspiele Johann Klajs*. In *Beyträge zur kritischen Historie der deutschen Sprache, Poesie und Beredsamkeit*, vol. 7 (1741). Also in Johann Elias Schlegel, *Werke*, part 3, ed. Johann Heinrich Schlegel (Copenhagen and Leipzig, 1764), pp. 1–26.

15. Philip Massinger, *The Duke of Millain* (1623).

16. Don Pedro Calderón de la Barca, *Schauspiele* [Dramas], vol. 1, trans. Johann Diedrich Gries (Berlin, 1815).

17. *Goethe und Calderón: Gedenkblätter zur Calderónfeier* [Goethe and Calderón: Memorial Essays for the Calderón Celebration], ed. Edmund Dorer (Leipzig, 1881).

18. Hugo Schuchardt, *Romanisches und Keltisches: Gesammelte Aufsätze* [Romance and Celtic Literatures: Collected Essays] (Strasbourg, 1886), pp. 120–149.

19. See Camille Pitollet, *La querelle caldéronienne de Johan Nikolas Böhl von Faber et José Joaquín de Mora* (Paris, 1901).

20. See Goethe, *Gedenkausgabe der Werke, Briefe und Gespräche* [Memorial Edition of the Works, Letters, and Conversations], ed. Ernst Beutler (Zurich and Stuttgart, 1964), vol. 15, pp. 1034f.

21. Halle, 1839.

22. Ernst Raupach (1784–1852), a once popular, but now-forgotten author of historical dramas. *Die Hohenstaufen* was a cycle of sixteen plays dating from 1837.—*Trans.*

23. Heinrich von Treitschke, "Zeitgenössische Dichter, III: Friedrich Hebbel" ["Contemporary Writers, III: Friedrich Hebbel"], in *Preußische Jahrbücher,* ed. Rudolph Haym, 5 vols. (Berlin, 1860), 6th issue, p. 559.

24. Peter Berens, "Calderóns Schicksalstragödien," *Romanische Forschungen* 39, issue 1 (November 1921): 1–66.

25. August Wilhelm Schlegel, *A Course of Lectures on Dramatic Art and Literature,* trans. John Black (London, Edinburgh, and Dublin: Baldwick, Cradock and Joy, 1815), vol. 2, p. 349.—*Trans.*

26. See H. Wütschke, ed., *Hebbel in der zeitgenössischen Kritik* [Hebbel in the Eyes of his Contemporaries], in *Deutsche Literaturdenkmale des 18. und 19. Jahrhunderts,* 3rd ser., no. 23 (Berlin, 1910). Also the article on Hebbel in Konstantin von Wiglach, *Biographisches Lexikon des Kaisertums Österreich* [Biographical Lexicon of the Austrian Empire] (Vienna, 1862).

Letter to Florens Christian Rang

December 9, 1923

Dear Christian,

My heartfelt thanks to you for the loyal and sympathetic way in which you have urged me to review my position in the light of my "Reply."[1] I have taken your hint and contacted Frankfurt directly, and the fact that I received confirmation from them is something you can deduce from my recent silence.[2] Needless to say, the confirmation I have had was anything but "official," but it came from [Gottfried] Salomon, who knows the situation, and I have to be content with that. The flow of proofs to me has recently ceased. Is this because I have already sent you my "Reply" or because the book is now ready to appear? I hope the latter is the case, since not only am I looking forward with some impatience to the prospect of being able to respond to it as a whole myself, but I have also managed, as much as I could, to raise the most eager expectations about it here as well. I cannot recollect whether I already mentioned in my last letter to you what a profound and positive impression Hofmannsthal made on me by his support for your manifesto. I only hope that he will be as good as his word; in my opinion, that would mean a lot for him and for our view of him. This morning I started to read the adaptation of Thomas Otway's *Venice Preserv'd* that he made some years ago; I am reading it in connection with my study of the tragic drama. Do you know it? In the meantime I have of course sent him my agreement, together with a copy of the Baudelaire, which has just appeared. It is the dubious prerogative of all those close to me—and

that includes yourself first of all—to have to wait a while for their copy. The impression is gaining ground that [Richard] Weissbach (thanks to a legal trick of the first order which it would be imprudent to describe in writing) is set to cheat me of the entire honorarium and almost all the free copies. The position will become clearer shortly. Once I had sent off my letter to Hofmannsthal, I began to wonder whether I had not expressed myself too formally, notwithstanding my respectful statements of gratitude. In particular, in my initial comments I decided to refrain from referring to the Heinle business (which he had not mentioned), lest I appear too insistent.[3] I trust I may ask you to raise the matter with him if the occasion arises, should he fail to mention it in due course to either of us. And I should like to ask you to resume, for a moment, your role as mediator in one further matter—in your very next letter. This concerns the return of (1) the *Argonauten* essay,[4] and (2) especially the study of *Elective Affinities,* which I simply have to see once again before it goes to the printer. The fact is that I have neither a copy nor my own MS, and urgently need to consult parts of it for my present work. As to that present work, it is strange how in the last few days I have been wrestling with the very questions that according to your last letter have been preoccupying you. To be able to discuss them with you in person would be of infinite value to me, particularly since I have been suffering from a certain isolation arising from my situation and the topic of my work. I have been reflecting on the way in which works of art relate to historical life. In so doing, I proceed from the conviction that there is no such thing as art history. In human life, for example, not only does the concatenation of temporal events contain essential causal links, but we may also say that, were there no such links to constitute development, maturity, death, and similar categories, human life as such would not really exist. With works of art, on the other hand, the position is quite different. Art is in essence ahistorical. The attempt to insert the work of art into historical life does not open new perspectives into its inner existence, as is the case with the life of nations, where the same procedure points to the role of the different generations and other essential factors. The current preoccupations of art history all amount to no more than the history of contents or forms, for which works of art seem to provide merely examples or models; a history of the works of art themselves is not considered. They possess nothing that links them extensively and essentially; they have nothing comparable to the hereditary relationships between successive generations which supply the extensive and essential connections in the history of nations. The essential links between works of art remain intensive. In this respect works of art resemble philosophical systems, since the "history" of philosophy is either an uninteresting history of dogmas or perhaps of philosophers, or else the history of problems. As such, it constantly threatens

to lose contact with extension in time and to pass over into a timeless, intensive process of interpretation. The specific historicity of works of art is likewise one that can be unlocked only in interpretations, not in "art history." For the process of interpretation brings to light connections between works of art that are timeless, yet not without a historical dimension. The same forces that become explosively and extensively temporal in the revealed world (that is, history) emerge intensively in the taciturn world (that is, the world of nature and art). Please forgive these skimpy and provisional thoughts. They are meant merely to lead me to where our ideas can meet: the ideas are stars, in contrast to the sun of revelation. They do not appear in the daylight of history; they are at work in history only invisibly. They shine only into the night of nature. Works of art, then, may be defined as the models of a nature that awaits no day, and thus no Judgment Day; they are the models of a nature that is neither the theater of history nor the dwelling place of mankind. The redeemed night. In the context of these considerations, where criticism is identical with interpretation and in conflict with all current methods of looking at art, criticism becomes the representation of an idea. Its intensive infinity characterizes ideas as monads. My definition is: criticism is the mortification of the works. Not the intensification of consciousness in them (that is Romantic!), but their colonization by knowledge. The task of philosophy is to name the idea, as Adam named nature, in order to overcome the works, which are to be seen as nature returned.—Leibniz's entire way of thinking, his idea of the monad, which I adopt for my definition of ideas and which you evoke with your equation of ideas and numbers—since for Leibniz the discontinuity of whole numbers was of decisive importance for the theory of monads—seems to me to comprise the *summa* of a theory of ideas. The task of interpreting works of art is to concentrate creaturely life in ideas. To establish the presence of that life.—Forgive me if not all of this is comprehensible. Your basic idea has certainly come through to me. In the last analysis, it can be summed up in the insight that all responsible human knowledge must take the form of interpretation and this form alone, and that ideas are the instruments of rigorous interpretation designed to establish that presence. The need now is for a theory of different kinds of texts. In the *Symposium* and the *Timaeus*, Plato defined the scope of the theory of ideas as the domain of art and nature. The interpretation of historical or sacred texts may not have been envisaged in any theory of ideas hitherto. If these musings were able, for all their sketchiness, to provoke you into making a response, I would be delighted. In any event, we shall have to have many discussions about the entire subject.—The failure of [Eugen] Rosenstock now provides me with a belated justification of my earlier view of him. I was never comfortable with seeing his name on the title page.[5] Morally speaking, he

has now deleted it himself. More warmest greetings to Helmuth and both of you, and from our household to yours.

Yours,
Walter

Unpublished in Benjamin's lifetime. Translated by Rodney Livingstone.

Notes

1. Rang had published a book, *Deutsche Bauhütte: Ein Wort an uns Deutsche über mögliche Gerechtigkeit gegen Belgien und Frankreich* [German Masons' Guild: A Word to Us Germans about the Possibility of Justice toward Belgium and France] (Leipzig: Sannerz, 1924), which included "replies" from a number of well-known figures, among them Martin Buber, Alfons Paquet, and Benjamin.—*Trans.*

2. Benjamin was in the process of having his dissertation for the *Habilitation* examined. University officials at Frankfurt had asked for copies of other writings, including Benjamin's essay on Goethe's novel *Elective Affinities*. Benjamin had sent the only copy to Hugo von Hofmannsthal, and in some embarrassment had recently had to ask Rang to retrieve it for the Frankfurt authorities.—*Trans.*

3. Benjamin had sent Hofmannsthal not only copies of his own essays, but also a sheaf of poems by his friend Fritz Heinle, who had killed himself in 1914.—*Trans.*

4. That is, the essay "Fate and Character," which had been published in the journal *Die Argonauten.*—*Trans.*

5. Eugen Rosenstock (1888–1973) was a sociologist and philosopher whose Romantic-utopian pedagogical projects initially met with stinging criticism. He emerged, however, as one of the most effective proponents of workers' and adult education in the Weimar Republic. What Benjamin seems to object to here is Rosenstock's association with the Patmos Verlag in Würzburg; the Patmos circle contained a number of vocal converts to Christianity. See Benjamin's letter to Gershom Scholem of December 30, 1922.—*Trans.*

Stages of Intention

Intention	Object
Thought	Knowledge
Perceive	Perception
(Imagination	Paradise—Elysium)
Objective intention	Symbol

The relation between works of art and the objects of perceiving and of the imagination has to be established. Works of art are objects neither of pure perception nor of pure imagination; they are objects of an intermediate intention.

The hierarchy of stages of intention is to be understood in terms of the philosophy of history, not epistemologically. For that reason, the meaning of objects of the imagination should be considered in this context. An investigation into their objective status may also be appropriate here.

The imagination is the intention of perception that is not based on the intention of knowledge. (Dream, childhood.) Pure objects of this intention are (as yet?) not available. (But there are yet other intentions of perception that can be so described: visionary powers, clairvoyance.)

Is there a *logical* progression from one question to the next, just as there is from question to answer and answer to answer?

The order of questions is in conflict with the Aristotelian principle of the conceptual pyramid. (Compare Karl Mannheim, *The Structural Analysis of*

the Theory of Knowledge [*Die Strukturanalyse der Erkenntnistheorie*], in supplementary issue no. 57 of *Kant-Studien*, Berlin, 1922.)

Fragment written in 1922–1923; unpublished in Benjamin's lifetime. Translated by Rodney Livingstone.

Outline of the Psychophysical Problem

I. Mind and Body [*Geist und Leib*][1]

They are identical, and distinct simply as ways of seeing, not as objects. The zone of their identity is marked by the term "form" [*Gestalt*]. At every stage of its existence, the form of the historical is that of mind and body combined. This combined mind and body is the category of its "now" [*Nu*], its momentary manifestation as an ephemeral yet immortal being. Mind and body in the sense identified with body are the supreme formal categories of the course of world events, but not the categories of its eternal contents, which is how they are regarded by the George school. Our body, then, is not integrated into the historical process, but only dwells in it from time to time; its modification from one form to the next is not the function of the historical process itself, but merely the particular, detached relation of a life to it. Thus, a body may be proper to reality in all its forms, but not as the substratum of its particular being, as our corporeal substance is. Instead, it manifests itself in the light of the historical "now." The embodied mind might most aptly be called "genius" [*ingenium*].

In general, we may say that everything real is a "form" insofar as it is regarded historically as meaningfully related to the historical totality in its "now," its innermost temporal presence. All form can thus manifest itself in two identical modes, which may relate to each other as two opposite poles: as genius and as body.

II. Spirit and Corporeal Substance [*Geist und Körper*]

Whereas body and genius can be proper to the real because of its present relation to the historical process (but not to God himself), spirit and the corporeal substance to which it belongs are based not on a relation but on existence as such. Corporeal substance is one of the realities that stand within the historical process itself. The distinction between it and the body can best be shown with reference to man. Everything that a human being can distinguish in himself as having his form as a totality, as well as such of his limbs and organs that appear to have a form—all that belongs to his body. All limitation that he sensuously perceives in himself belongs, as form, likewise to his body. It follows that the sensuously perceived individual existence of man is the perception of a relation in which he discovers himself; it is not, however, the perception of a substratum, of a substance of himself, as is the case with his corporeal substance, which represents such a substance sensually. The latter manifests itself, in contrast, in a twofold polar form: as pain and pleasure. In these two, no form of any sort, and hence no limitation, is perceived. If, therefore, we know about our corporeal substance only—or chiefly—through pleasure or pain, we know of no limitation on it. It is now advisable for us to look around among the modes of consciousness for those to which limitation is just as alien as the states of pain or pleasure, which at their most intense culminate in intoxication [*Rausch*]. Such states include those of perception. Admittedly, we must distinguish here between different degrees. The sense least bound by limitation is perhaps that of sight, which we might call centrifugal, in contrast to the more centripetal senses of taste and especially touch. Sight shows our corporeal substance to be, if not without limits, then at least with fluctuating, formless delimitations.

Thus, we may say in general that what we know of perception we know of our corporeal substance, which in contrast to our body is extended but has no sharply delimited form. This corporeal substance is not, indeed, the ultimate substratum of our existence, but it is at least a substance in contrast to our body, which is only a function. Our corporeal substance is objective in a higher sense, and therefore must be more concerned with the clarification of the spiritual "nature" of living beings bound to and subservient to our corporeal substance than with the elucidation of the genius that is identical with the body. The difficult problem that now emerges is that the "nature" whose adherence to our corporeal substance has been asserted nevertheless strongly points to the limitation and individuality of the living being. That limited reality which is constituted by the establishment of a spiritual nature in a corporeal substance is called the "person." The person is indeed limited, but is not formed. The uniqueness which one may in one sense attribute to it derives therefore not from itself but from the orbit of

its maximum extension. This is how it stands, then, both with its nature and its corporeal substance: they are not limited by their form, but they are nevertheless limited by their maximum extension, the people.

III. Body and Corporeal Substance [*Leib und Körper*]

Man's body and his corporeal substance place him in universal contexts. But a different context for each: with his body, man belongs to mankind; with his corporeal substance, to God. Both have fluctuating boundaries with nature; the expansion of both affects the course of the world, and for the profoundest reasons. The body, the function of the historical present in man, expands into the body of mankind. "Individuality" as the principle of the body is on a higher plane than that of single embodied individuals. Humanity as an individual is both the consummation and the annihilation of bodily life. "Annihilation" because with it the historical existence, whose function the body is, reaches its end. In addition to the totality of all its living members, humanity is able partly to draw nature, the nonliving, plant, and animal, into this life of the body of mankind, and thereby into this annihilation and fulfillment. It can do this by virtue of the technology in which the unity of its life is formed. Ultimately, everything that subserves humanity's happiness may be counted part of its life, its limbs.

Bodily nature advances toward its dissolution; that of corporeal substance, however, advances toward its resurrection. Here, too, the power to decide about this lies in the hands of man. For man, corporeal substance is the seal of his solitariness, and this will not be destroyed—even in death—because this solitariness is nothing but the consciousness of his direct dependence on God. What every man encompasses in the realm of perception, his pain and his greatest pleasure, is salvaged with him in the resurrection. (This greatest pleasure has, of course, nothing to do with happiness.) Pain is the ruling, pleasure the evaluative(?) principle of human physicality.

Hence, natural history contains the two great processes of dissolution and resurrection.

IV. Spirit and Sexuality / Nature and Body [*Körper*]

Spirit and sexuality are the two basic polar forces of human "nature." Nature is not something that belongs especially to every individual body. Rather, it relates to the singularity of the body as the different currents that flow into the sea relate to each drop of water. Countless such drops are carried along by the same current. In like fashion, nature is the same, not indeed in all human beings but in a great many of them. Moreover, this nature is not just alike; it is in the full sense identical, one and the same. It is not constant; its current changes with the centuries, and a greater or lesser

number of such currents are to be found simultaneously. Sexuality and spirit are the two vital poles of this natural life that flows into our physical being and becomes differentiated in it. Thus, originally, spirit, like sexuality, is something natural and appears through this process as something corporeal. The content of a life depends on the extent to which the living person is able to define its nature corporeally. In the utter decay of corporeality, such as we are witnessing in the West at the present time, the last instrument of its renewal is the anguish of nature which can no longer be contained in life and flows out in wild torrents over the body. Nature itself is a totality, and the movement into the inscrutable depths of total vitality is fate. The movement upward from these inscrutable depths is art. But because total vitality has its conciliatory effect only in art, every other form of expression must lead to destruction. The representation of total vitality in life causes fate to end in madness. For all living reactivity is bound to differentiation, whose preeminent instrument is the body. This is an essential function of the body. Only the body can be viewed as an instrument with which to differentiate between the vital reactions and at the same time can be comprehended in terms of its psychic animation. All psychic energy can be differentially located in it, just as the old anthroposophy attempted this when it regarded the body as an analogue of the macrocosm. One of the body's most important organs of this differentiation is perception. The zone of perceptions also shows clearly the variability to which it is subject as a function of nature. If nature changes, the body's perceptions change, too.

The body is a moral instrument. It was created to fulfill the Commandments. It was fashioned at the Creation according to this purpose. Even its perceptions indicate how far they draw the body away from its duty or bind it close.

V. Pleasure and Pain

In the physical differences between pleasure and pain, the metaphysical distinction between them may be discerned. Among these physical differences, two ultimately remain primary and irreducible. From the point of view of pleasure, it is its uniform, lightning character that separates it from pain; from the point of view of pain, its chronic and diverse character is what distinguishes it from pleasure. Only pain, never pleasure, can become the chronic feeling accompanying constant organic processes. It alone, and never pleasure, is capable of extreme differentiation according to the nature of the organ from which it proceeds. This is hinted at in language, since in German only the superlatives of sweetness or delight exist to express a maximum of pleasure; and of these, only the first is authentically and unambiguously sensuous. The least of the senses, then, the sense of taste, lends the description appropriate to its own positive experience to the

expression of sensuous enjoyment of every kind. The position with expressions of pain is quite different. With the words "pain," "hurt," "agony," "suffering" we see very clearly what is only hinted at in such a word as "delight" in the realm of pleasure—namely, that in pain, without any recourse to metaphor, the sensuous words directly implicate the soul. This may be explained by the fact that the feelings of pain are incomparably more capable of expressing genuine diversity than the feelings of pleasure, which differ mainly in degree. Undoubtedly there is a connection between the fact that the feeling of pain applies more consistently to the whole nature of man and its ability to endure. This endurance, in turn, leads directly to the metaphysical differences between the two feelings, which both correspond to and explain the physical differences. Only the feeling of pain, both on the physical and metaphysical planes, is capable of such an uninterrupted flow—what might be termed a "thematic treatment." Man is the most consummate instrument of pain: only in human suffering does pain find its adequate expression; only in human life does it flow to its destination. Of all the corporeal feelings, pain alone is like a navigable river which never dries up and which leads man down to the sea. Pleasure, in contrast, turns out to be a dead end, wherever man tries to follow its lead. In truth, it is a premonition from another world—unlike pain, which is a link between worlds. This is why organic pleasure is intermittent, whereas pain can be permanent.

This comparison of pleasure and pain explains why the cause of pain is irrelevant for the understanding of a man's nature, whereas the source of his greatest pleasure is extremely important. For every pain, even the most trivial one, can lead upward to the highest religious suffering, whereas pleasure is not capable of any enhancement, and owes any nobility it possesses to the grace of its birth—that is to say, its source.

VI. Nearness and Distance

These are two factors that may be as important for the structure and life of the body as other spatial categories (up and down, right and left, etcetera). They are particularly prominent in the life of eros and sexuality. The erotic life is ignited by distance. On the other hand, there is an affinity between nearness and sexuality.—As regards distance, it would be instructive to compare Klages' studies on dreaming.[2] Even less well known than the effects of distance on physical contacts are those of nearness. The phenomena associated with these were probably repudiated and downgraded thousands of years ago.—Furthermore, there is a precise relation between stupidity and nearness: stupidity stems ultimately from too close a scrutiny of ideas (the cow staring at a new gate). But this all-too-close (mindless) examination of

ideas is the source of an enduring (nonintermittent) beauty. Thus transpires the relation of beauty and stupidity.

Literature

Ludwig Klages, "Vom Traumbewußtsein" [Dream Consciousness], *Zeitschrift für Pathopsychologie* 3, no. 4 (1919).

"Geist und Seele" [Mind and Soul], *Deutsche Psychologie* 1, no. 5 (1917) and 2, no. 6 (1919).

Vom Wesen des Bewußtseins [The Nature of Consciousness] (Leipzig: J. A. Barth, 1921).

Mensch und Erde [Man and the Earth] (Munich and Jena: Georg Müller, 1920).

Vom kosmogonischen Eros [Eros and the Cosmos] (Munich and Jena: Georg Müller, 1922).

VI. Nearness and Distance (Continued)

The less a man is imprisoned in the bonds of fate, the less he is determined by what *lies nearest at hand,* whether it be people or circumstances. On the contrary, a free man is in complete control of what is close to him: it is he who determines it. The things that determine his life with the force of fate come to him from a distance. He acts not with "regard" to what is coming, as if it might catch up with him, but with "prudence" toward what is distant, to which he submits. This is why interrogating the stars—even considering them allegorically—is more deeply founded than any brooding over what is to come. For the distant things that determine a man's life should be nature itself, and nature's influence is the more undivided, the purer he is. Nature may then frighten the neurotic with the smallest signs of her presence, and her stars may drive the demonic, but her profoundest harmonies—and these alone—influence only the pious. Moreover, the impact of nature falls not on people's actions but on their lives, which alone are subject to fate. It is here, not in the realm of action, that freedom has its home. For it is the power of freedom that releases the living human being from the influence of individual natural events, and lets him follow the guidance of nature as a whole in the conduct of his affairs. He is guided, but like a sleeper. The perfect man lives only in such dreams, from which he never wakes. For the more perfect a man is, the deeper is his sleep—the sounder and the more confined to a basic chord in his being. Hence, it is a sleep untouched by dreams that are provoked by sounds in his vicinity or by the voices of his fellow creatures, untouched by dreams in which the surf, the spheres, and the wind can be heard. This sea of sleep, deep in the foundations of human

nature, has its high tide at night: every slumber indicates only that it washes a shore from which it retreats in waking hours. What remains are the dreams; however marvelously they are formed, they are no more than the lifeless remains from the womb of the depths. The living remains in him and secure in him: the ship of a waking life, and the fish as the silent booty in the nets of artists.

Thus, in this way the sea is the symbol of human nature. As sleep—in a deeper, figurative sense—it bears the ship of life on its current, which is accompanied from a distance by the wind and the stars; as slumber, it arises at night like the tide breaking on the shore of life, on which it leaves dreams lying the next day.

Nearness [and distance?] are, incidentally, no less important for dreams than for the erotic. But in an attenuated, degraded form. The difference is one that remains to be explored. In itself we see the greatest nearness in the dream; and also—perhaps—the furthest distance?

As to the problem of the reality of dreams, we may assert that when we consider the relation of the dream world to waking life, we must make a sharp distinction between the relation of dreams to the *actual* world and their relation to the *true* world. In truth or in the "true world," dream and waking as such do not exist; at best, they may be the symbols on which such representations depend. For in the world of truth, the world of perception has lost its reality. Indeed, the world of truth may well not be the world of any consciousness. That is to say, the problem of the relation of dreaming to waking is a problem not of the "theory of knowledge" but of the "theory of perception." Perceptions, however, cannot be true or false, and disagreements can arise only about the status of their meanings. The system of such possible meanings in general is human nature. The problem here, then, is what in human nature concerns the meaning of dreams and what in it concerns the meaning of waking perceptions. So far as "knowledge" is concerned, both are significant in exactly the same way—namely, as objects.—With regard to perception in particular, the usual questions about the superiority of one or another of these modes of perception on the grounds that it satisfies a greater number of criteria are senseless. This is because it would be necessary to demonstrate (1) that the *consciousness of truth* as such exists, and (2) that it is characterized by the fact that it can satisfy a relative majority of relevant criteria. In reality, (1) the comparison in such theoretical studies is meaningless, and (2), for consciousness in general, only the relation to life—not the relation to truth—is relevant. And neither of the two modes of consciousness is "truer" to life; they merely have different meanings for it.

A complete balance between nearness and distance in perfect love—"you come flying, fascinated." Dante places Beatrice among the stars. But the stars could be close to him in Beatrice. For in the beloved, the forces of

distance appear close to a man. In this way, distance and nearness are opposite poles in the life of eros: this is why presence and separation are crucial in love.—The spell is the magic of nearness.

Eros is the binding element in nature whose energies run free wherever he is not in control.

> "A great spirit, Socrates, is Eros, and like all spirits he is intermediate between the divine and the mortal."—"And what," I said, "is his power?"—"He interprets," she replied," between gods and men, conveying and taking across to the gods the prayers and sacrifices of men, and to men the commands and replies of the gods; he is the mediator who spans the chasm which divides them, and therefore in him all is bound together, and through him the arts of the prophet and the priest, their sacrifices, mysteries and charms, and all prophecy and incantation, find their way. For God mingles not with man; but through Love all the intercourse and converse of the gods with man, whether awake or asleep, is carried on." (Plato, *Symposium*)[3]

The very type and primal phenomenon of binding, which is to be found in every particular bond, is that of nearness and distance. Therefore, it is the primordial work of Eros above all other things.

There is a particular relation of distance and nearness in the sexes. For the man, the powers of distance are supposed to be the determining ones, whereas the powers of nearness enable him to determine others. Yearning is a state of being-determined. What is the force that enables the man to influence the things near to him? It has been lost. Flight is the movement from yearning. What is the spellbinding movement that influences nearness? Spell and flight combine in the dreamtype of a low-level flight above the ground. (Nietzsche's life is typical for someone who is determined wholly by distance; it is the fate of the highest among mature men.) Because of the failure of the spellbinding power, they can do nothing to "keep their distance." And whatever comes close to them is uncontrolled. For this reason, nearness has become the realm of the uncontrolled, something that assumes a terrible form with the extreme closeness of sexual relations in married couples, as Strindberg experienced. But when intact, Eros has binding, spellbinding power even in what is closest.

"Die Verlassenen" [The Abandoned Ones], by Karl Kraus, is the counterpart to Goethe's "Blessed Yearning" ["Selige Sehnsucht"]. In the latter, the movement of the wing and the flight; in the former, the spellbound silence of feeling. Goethe's poem is a powerful, continuous movement; Kraus's is prodigiously discontinuous, pausing in the middle stanza that separates the first and the last like a mysterious chasm. This abyss is the primordial fact that is experienced in every passionate, erotic intimacy.

Fragment written in 1922–1923; unpublished in Benjamin's lifetime. Translated by Rodney Livingstone.

Notes

1. This essay distinguishes between *Leib* and *Körper*, both of which mean "body," although there are slight differences in usage. *Körper*, the more common word, is the opposite of *Geist* (as in "mind and body") and denotes human physicality. *Leib* is the opposite of *Seele* (as in "body and soul") and denotes the human body as the repository of the soul; it belongs to a slightly higher register (as in *der Leib Christi*, "the body of Christ"). I have translated *Körper* as "corporeal substance" here, but I use the more natural word "body" in Sections IV and VI, where the contrast with *Leib* is not crucial.—*Trans.*

2. Ludwig Klages (1872–1956), philosopher and psychologist who attempted to found a "metaphysical psychology" which would study human beings in their relationship to reality, a reality which for Klages is made up of archetypal images.—*Trans.*

3. Scott Buchanan, *The Portable Plato*, trans. Benjamin Jowett (Harmondsworth: Penguin, 1982), pp. 160–161.—*Trans.*

Even the Sacramental Migrates into Myth

Even the sacramental migrates into myth. That is the fact underlying this strange situation: Two couples become acquainted; the bonds uniting them are loosened. Two of them, who had not known each other previously, are mutually attracted to each other. Very soon the other two also enter into the most intimate relationship. We gain the impression that simple matters are difficult and laborious so long as God is dealing with them, but no sooner does the Devil intervene than even the most difficult problem can be easily and successfully resolved. The banal explanation for these developments is obvious. Yet even though explanations like "the need to be comforted," "being in the same situation," and "the desire to get even" do have some force, they completely fail to explain a situation that is so overwhelmingly and triumphantly beautiful, and that seems so remote from excuses and evasiveness. The flames flare up out of mirror-magic, and flicker in the triumphant encounter of the abandoned couple. For in their case, love is not the prime mover; what decides them is the situation in which the ancient sacramental powers of a collapsing marriage seek to insinuate their way between them in the guise of mythical, natural forces. That, and not love, is the hidden, inner side of that symbiosis, the ostensibly "identical" situation in which the abandoned couple finds itself. The new mundane existence that is now their lot holds the sacrament of marriage exposed within itself: they see each other constantly, like a married couple. To the best of their ability, the former spouses promote the new relationship of the couple now turning away from them. Love, here, is nothing but the semblance of life. It is an illusion that adds to the blind, raging passion of the alchemists and also to the revealed, indeed exposed sacrament of love. The spirit of

the Black Mass lives here again: the sacrament takes the place of love; love replaces the sacrament. The spirit of satanic victory rules, and holds the mirror up to marriage. For Satan is a dialectician, and a kind of spurious success—the semblance by which Nietzsche was deeply captivated—betrays him, just as does the spirit of gravity.

Fragment written in about 1923; unpublished in Benjamin's lifetime. Translated by Rodney Livingstone.

On the Topic of Individual Disciplines and Philosophy

1. It has to be shown that the "contradictions" by means of which the individual disciplines seek to discredit philosophy are to be found just as much in the individual disciplines themselves. At every point in them, moreover. Furthermore, they do not contradict the concept of truth, because there is no truth about an object. Truth is only *in* it. And the truth *in* an object may become manifest, depending on the time and the context, in fundamentally different forms that only appear to contradict each other—namely, with regard to a point of view *about* it, not however with regard to a point of view *in* it.

2. Our gaze must strike the object in such a way that it awakens something within it that springs up to meet the intention. Whereas the reporter who adopts the stance of the banal philosopher and specialized scientist indulges himself in lengthy descriptions of the object at which his gaze is directed, the intensive observer finds that something leaps out at him from the object, enters into him, takes possession of him, and something different—namely, the nonintentional truth—speaks from out of the philosopher.

3. This language of the intentionless truth (that is to say, of the object itself) possesses authority. This authority of the mode of speaking is the *yardstick* of objectivity [*Sachlichkeit*]. It, not the empirical object, in which the intentionless truth subsists and against which it cannot measure itself, since it cannot discover the object outside itself. On the contrary, this authority stands in opposition to the conventional concept of objectivity because its validity, that of the nonintentional truth, is historical—that is to say, anything but timeless; it is bound to a particular historical base and changes with history. "Timelessness" must therefore be unmasked as an

exponent of the bourgeois concept of truth. The authority we have described, then, contains within it a precise concept of time, since it comes and goes depending on the temporal constellation. But it does not come into being merely because an opinion is gradually declared to be "correct" and so becomes correct. On the contrary, it leaps into existence as the result of an immersion of the object in itself provoked by the external gaze.

4. This authority proves its worth by testing itself against forms of expression, even nonobjective ones, as befits the legitimacy of every authority. So much so, that the decisive factor at the moment becomes that meticulousness [*Akribie*] which is the least objective tool of a broadly conceived philosophical methodology and also the guarantor of a sovereign mastery of all the methods for creating an authority that would eliminate this same meticulousness. This is how it should be understood in my work on the Baroque. Insofar as truth is intentionless, it seizes the whole inductive apparatus, which has now become external, and thrusts it back into the work. There, secure in the heart of the matter, it manipulates it—playfully, at will—in the interest of authority.

5. The objectivity of science, therefore, is of exactly the same type as the alleged objectivity of criticism.

Fragment written in 1923; unpublished in Benjamin's lifetime. Translated by Rodney Livingstone.

"Old Forgotten Children's Books"

"Why do you collect books?"—Have the bibliophiles ever been invited to reflect on their own activities? How interesting the replies would be—the honest ones, at least! For only the uninitiated outsider could imagine that there is nothing worth hiding or glossing over here. Arrogance, loneliness, bitterness—those are the dark sides of many a highly educated and contented collector. Now and then, every passion lifts the veil on its demonic aspect; the history of book collecting might tell a few tales about this with the best of them.—There is no sign of that in the collector's credo of Karl Hobrecker, whose great collection of children's books is now placed before the public with the appearance of this work.[1] Even a reader who might miss the evidence which is in this man's warm and refined character, or which is revealed on every page of his book, will see from a single moment's reflection that only a person who has held on to a childlike delight in this field—children's books—would have chosen it as the subject of a collection. That childlike pleasure is the origin of his library, and every such collection must have something of the same spirit if it is to thrive. A book, even a single page or a mere picture in an old-fashioned volume handed down from mother and grandmother, may suffice as the support around which the first tender shoots of this passion entwine. It doesn't matter if the cover is loose, or if pages are missing, or if clumsy hands have colored in some of the woodcuts. The search for a beautiful copy has its place, but is more likely here than elsewhere to break the neck of the pedant. And it is good that the patina that has been deposited by unwashed children's hands will keep the book snob at a distance.

Twenty-five years ago, when Hobrecker started his collection, old chil-

dren's books were just so much waste paper. He was the first to provide them with a haven where, for the foreseeable future, they could feel safe from the paper mill. Of the several thousand that fill his shelves, there may be hundreds of which he possesses the only surviving copy. Even though he is the first archivist of children's books, he does not step before the public with a sense of dignity and official rank. He does not solicit respect for his work, but only invites us to share the beauty that it has revealed to him. The scholarly apparatus, in particular a bibliographic appendix of some two hundred of the most important titles, is secondary. It will be welcome to the collector without distracting the nonscholar. Children's literature in German (the author tells us in his introduction to its history) began with the Enlightenment. With their emphasis on education, the Philanthropists put their great humanitarian cultural program to the test.[2] If man was pious, good, and sociable by nature, it had to be possible to transform children, who were creatures of nature in its purest form, into the most pious, the best, and the most sociable beings of all. And since, in all forms of education inspired by theory, a grasp of practical technique tends to be discovered only at a late stage and the beginnings tend to be full of problematic admonitions, we find that children's books are likewise edifying and moralistic, and that they modulate the catechism, along with its interpretations, in the direction of deism. Hobrecker takes a stern view of these texts. It cannot be denied that they are often dry as dust, and even incomprehensible to children. But these faults, which have long since been overcome, are trifling compared to the follies fashionable today, thanks to supposed insights into the child's psyche—follies such as the depressingly distorted jolliness of rhyming stories and the pictures of grinning babies' faces supplied by God-forsaken, child-loving illustrators. Children want adults to give them clear, comprehensible, but not childlike books. Least of all do they want what adults think of as childlike. Children are perfectly able to appreciate serious matters, even when these may seem remote and indigestible, so long as they are sincere and come straight from the heart. For this reason, there may still be something to be said for some of those old-fashioned texts. At the beginnings of children's literature, we find—in addition to primers and catechisms—illustrated lexicons and illustrated alphabet books, or whatever name we wish to give to the *Orbis pictus* of Amos Comenius. This genre, too, is one that the Enlightenment appropriated after its own fashion, as exemplified by Basedow's monumental *Elementarwerk*.[3] This book is a pleasure in many respects, even textually. For next to long-winded, encyclopedic learning which, in the spirit of its age, emphasizes the "utility" of all things—from mathematics to tightrope walking—we find moral stories that are so graphic that they verge, not unintentionally, on the comic. Together with these two works, the later *Picture-Book for Children* deserves a mention. Published in Weimar between 1792 and 1847 under the editorship of F. J. Bertuch, it

consists of twelve volumes, each with a hundred colored copperplate illustrations. The care lavished upon the production of this picture encyclopedia shows the dedication with which people worked for children in those days. Nowadays most parents would be horrified at the suggestion that such precious books should be given to children. Yet in his preface Bertuch does not hesitate to invite children to cut the pictures out. Finally, fairy tales and songs—and, to a lesser degree, chapbooks and fables as well—provide children's literature with its sources. Only the purest sources, of course. Recent novelistic writings for the young, writings that resemble a rootless excrescence full of more-than-dubious sap, have been inspired by a thoroughly modern prejudice. According to this prejudice, children are such esoteric, incommensurable beings that one needs quite exceptional ingenuity in order to discover ways of entertaining them. It is folly to brood pedantically over the production of objects—visual aids, toys, or books—that are supposed to be suitable for children. Since the Enlightenment, this has been one of the mustiest speculations of the pedagogues. Their infatuation with psychology keeps them from perceiving that the world is full of the most unrivaled objects for children's attention and use. And the most specific. For children are particularly fond of haunting any site where things are being visibly worked on. They are irresistibly drawn by the detritus generated by building, gardening, housework, tailoring, or carpentry. In waste products they recognize the face that the world of things turns directly and solely to them. In using these things, they do not so much imitate the works of adults as bring together, in the artifact produced in play, materials of widely differing kinds in a new, intuitive relationship. Children thus produce their own small world of things within the greater one. The fairy tale is such a waste product—perhaps the most powerful to be found in the spiritual life of humanity: a waste product that emerges from the growth and decay of the saga. Children are able to manipulate fairy stories with the same ease and lack of inhibition that they display in playing with pieces of cloth and building blocks. They build their world out of motifs from the fairy tale, combining its various elements. The same is true of songs. And the fable— "The fable in its proper form can be a spiritual product of wonderful profundity, but its value is seldom recognized by children." We may also question whether young readers admire the fable for the moral tagged on at the end, or whether they use it to school their understanding, as was the traditional wisdom and, above all, the desire of people who were strangers to the nursery. Children enjoy the spectacle of animals that talk and act like people far more than they enjoy any text burdened with good thoughts. "Literature intended specifically for the young," we read elsewhere, "began with a great fiasco—this much is certain." And, we may add, this situation still obtains to this day in a great many instances.

One thing redeems even the most old-fashioned and self-conscious prod-

ucts of that era: their illustrations. These were beyond the reach of philanthropic theories, so artists and children swiftly came to an understanding over the heads of the pedagogues. Yet it is not as if the artists had worked exclusively with children in mind. The collections of fables show that related formulas recur in the remotest places with larger or smaller variations. In like fashion, picture-books go back even further, as we can see from the way in which, for example, illustrations of the Seven Wonders of the World can be traced back to the copper engravings of the seventeenth century, and perhaps to earlier times. We may perhaps venture to surmise that the illustrations of these works have some connection with the emblem books of the Baroque period. These are not such very different worlds as might be supposed. At the end of the eighteenth century, a type of picture-book appeared: such books show, on each page, a motley collection of objects without any pictorial connection between them. These are objects that begin with the same letter of the alphabet—apple, anchor, atlas, and so forth—and are accompanied by their equivalents in one or more foreign languages. The task of the artist in this situation is not unrelated to the problems faced by the graphic artists of the Baroque in designing pictographic combinations of allegorical objects; both epochs produced ingenious and highly significant solutions. Nothing is more striking than the fact that the nineteenth century, which was compelled to sacrifice so much of the cultural capital of the preceding age in order to accommodate the huge growth in universal knowledge, nevertheless retained so many of the texts and illustrations of children's books. It is true that after 1810 such sophisticated works as the Viennese edition of *Aesop's Fables* (second edition, Heinrich Friedrich Müller, Vienna, n.d.), a book I consider myself fortunate to be able to add to Hobrecker's list, cease to be produced. In general, refinement in drawing and coloring is not a feature in which the children's books of the nineteenth century are able to compete with their predecessors. Their charm lies partly in their primitive nature, in the fact that the documents of the time show how the old forms of production have to engage with the early stages of more modern techniques. After 1840 lithography became dominant, whereas earlier, in copper engravings, eighteenth-century motifs are still frequently encountered. In the Biedermeier of the 1820s and 1830s, only the coloring is characteristic and novel.

> It seems to me that in that Biedermeier period, there is a preference for carmine, orange, and ultramarine; a brilliant green is also used. When set beside these glittering clothes, this sky-blue azure, the vivid flickering flames of volcanoes and great conflagrations, what is left of the simple black-and-white copper engravings and lithographs which had been good enough for boring grown-ups in the past? Where shall we again see such roses in bloom, where are such rosy-cheeked apples and faces to be found, where will we see such hussars in their green dolmans and madder-red uniforms with yellow bands? Even the

plain, mouse-gray top hat of the noble father and the pale-yellow headscarf of the beautiful mother elicit our admiration.

This resplendent, self-sufficient world of colors is the exclusive preserve of children's books. When in paintings the colors, the transparent or glowing motley of tones, interfere with the design, they come perilously close to effects for their own sake. But in the pictures in children's books, the object depicted and the independence of the graphic design usually exclude any synthesis of color and drawing. In this play of colors, the imagination runs riot. After all, the role of children's books is not to induct their readers directly into the world of objects, animals, and people—in other words, into so-called life. Very gradually their meaning is discovered in the outside world, but only in proportion as they are found to correspond to what children already possess within themselves. The inward nature of this way of seeing is located in the color, and this is where the dreamy life that objects lead in the minds of children is acted out. They learn from the bright coloring. For nowhere is sensuous, nostalgia-free contemplation as much at home as in color.

But the most remarkable publications emerged in the 1840s, toward the end of the Biedermeier period, concurrently with the growth of technical civilization and that leveling of culture which was not unrelated to it. The dismantling of the hierarchical society of the Middle Ages was now complete. In the course of this process, the finest and best substances often sank to the bottom, and so it comes to pass that the keener observer is often able to rediscover them in the lower reaches of printed and graphic publications, such as children's books, when he might search for them in vain in the generally recognized documents of culture. The merging of all intellectual classes and modes of action becomes particularly clear in a bohemian figure from those days who unfortunately finds no place in Hobrecker's account, even though some of the most perfect children's books (albeit some of the rarest) owe their existence to him. I am thinking of Johann Peter Lyser, the journalist, poet, painter, and musician. The *Fabelbuch* [Book of Fables] by A. L. Grimm, with illustrations by Lyser (Grimma, 1827), the *Buch der Mährchen für Töchter und Söhne gebildeter Stände* [Book of Fairy Tales for the Sons and Daughters of the Educated Classes] (Leipzig, 1834), text and illustrations by Lyser, and *Linas Mährchenbuch* [Lina's Book of Fairy Tales], text by A. L. Grimm, illustrations by Lyser (Grimma, n.d.)—these are three of his finest books for children. The color of their lithographs contrasts with the vivid coloring of Biedermeier books and fits much better with the careworn, emaciated features of many of its characters, the shadowy landscape and the fairy-tale atmosphere, which is not without an ironic, satanic streak. The cheap sensationalism that forms the background against which this original art developed can be seen most strikingly in the many volumes of the *Thousand and One Nights of the West,* with its original

lithographs. This is an opportunistic hodgepodge of fairy tale, saga, local legend, and horror story, which was assembled from dubious sources and published in Meissen in the 1830s by F. W. Goedsche. The most uninteresting towns of central Germany—Meissen, Langensalza, Potschappel, Grimma, and Neuhaldensleben—appear to the collector in a magical topographic combination. Schoolteachers may often have acted as writers and illustrators at the same time, and it is easy to imagine the sort of book that introduces the gods and goddesses of the Edda to the youth of Langensalza in thirty-two pages and eight lithographs.

For Hobrecker, however, the focal point of interest is not so much here as in the 1840s to 1860s, especially in Berlin, where the graphic artist Theodor Hosemann applied his charming talents above all to the illustration of writings for young people. Even the less worked-on sheets have been given an identity by the cool, graceful coloring and a sympathetic astringency in the expressions of the figures, which will warm the heart of any native Berliner. Admittedly, the earlier, less schematic and less numerous works of the master will rank higher in the eyes of the connoisseur than the better-known ones, which can be recognized by their uniform format and the trademark of their publisher, Winckelmann and Sons of Berlin, and can be found in every secondhand bookshop. An example of the former can be found in the charming illustrations to *Puppe Wunderhold* [Wunderhold the Doll], an outstanding jewel of the Hobrecker collection. Alongside Hosemann, other artists active at the time include [Johann Heinrich] Ramberg, [Adrian Ludwig] Richter, [Otto] Speckter, and [Franz Graf von] Pocci, not to mention lesser talents. For children, a whole new world opens up in their black-and-white woodcuts. The original value of these woodcuts is not inferior to that of the colored prints; they are, in fact, their polar complement. The colored picture immerses the child's imagination in a dream state within itself. The black-and-white woodcut, the plain, prosaic illustration, leads him out of himself. The compelling invitation to describe, which is implicit in such pictures, arouses the child's desire to express himself in words. And describing these pictures in words, he also describes them by enactment. The child inhabits them. Their surface, unlike that of colored pictures, is not a *Noli me tangere*—either in itself or in the mind of the child. On the contrary, it seems incomplete and so can readily be filled out. Children fill them with a poetry of their own. This is how it comes about that children *in*scribe the pictures with their ideas in a more literal sense: they scribble on them. At the same time as they learn language, they also learn how to write: they learn hieroglyphics. The true meaning of these simple illustrated children's books is very different, then, from the tedious and absurd reasons that induced rationalist pedagogues to recommend them in the first place. Yet here, too, we see the truth of the old saying, "Philistines are often right about something, but never for the right reasons." For no other pictures can introduce children to both language and writing as these

can—a truth that was expressed in the old primers when they first provided a picture to illustrate the words. Colored picture-books as we now know them are an aberration. In the kingdom of monochrome pictures, children awaken, just as they dream their dreams in the realm of color.

The debates about the most recent past are the most acrimonious in all of historiography. This holds true even in the harmless history of children's literature. Opinions will differ most when it comes to judging the children's books from the last quarter of the nineteenth century on. Although Hobrecker castigated the older literature for its hectoring didactic tone, he perhaps tended to overlook less obvious defects in more recent books. They were also perhaps further removed from his own concerns. A pride in our psychological insight into the internal life of the child, which can nowhere compete with the older pedagogical methods contained in such books as Jean Paul's *Levana*,[4] has engendered a literature whose complacent courting of the modern public obscures the fact that it has sacrificed an ethical content which lent dignity even to the most pedantic efforts of neoclassical pedagogy. This ethical content has been replaced by a slavish dependence on the slogans of the daily press. The secret understanding between the anonymous craftsman and the childlike reader has vanished. Both writers and illustrators increasingly address children via the impure medium of acute contemporary anxieties and fashions. Cloying gestures, which are directed not at children but at decadent conceptions of children, have made their home in the illustrations. The format has lost its unpretentious refinement and has become too insistent. Amid all this kitsch, precious documents of cultural history are to be found, but they are still too new for our pleasure in them to be unalloyed.

However that may be, Hobrecker's book itself, both in its contents and its appearance, is suffused with the charm of the best Romantic children's books. Woodcuts, full-page color illustrations, silhouettes, and delicately colored pictures in the text make it a delightful family book which can give pleasure to adults, while even children could take it up in order to attempt to spell out the old texts or to use the pictures to copy. Only the collector will see a shadow fall over his pleasure: he fears that prices will rise. In exchange, he will be able to hope that a few volumes which might otherwise have been heedlessly destroyed will owe their survival to this work.

Written in 1924; published in the *Illustrierte Zeitung*, 1924. Translated by Rodney Livingstone.

Notes

1. Karl Hobrecker, *Alte vergessene Kinderbücher* (Berlin: Mauritius-Verlag, 1924), 160 pages.

2. Philanthropism was a pedagogical reform movement of the late eighteenth century. Its main theorist was Johann Bernhard Basedow (1723–1790), who derived many of his ideas from Rousseau. Basedow's school, the "Philanthropin" in Dessau, became the model for a number of similar institutions throughout Germany and Switzerland.—*Trans.*

3. Basedow's *Elementarwerk* [Elementary Work] of 1774 is his fundamental treatise on education.—*Trans.*

4. Jean Paul Richter (1763–1825) is remembered for a series of wildly extravagant novels that are indebted to Sterne. He was one of Benjamin's favorite authors. *Levana* (1807) is a treatise on education. *Trans.*

Naples

Written with Asja Lacis

Some years ago a priest was drawn on a cart through the streets of Naples for indecent offenses. He was followed by a crowd hurling maledictions. At a corner, a wedding procession appeared. The priest stands up and makes the sign of a blessing, and the cart's pursuers fall on their knees. So absolutely, in this city, does Catholicism strive to reassert itself in every situation. Should it disappear from the face of the earth, its last foothold would perhaps be not Rome but Naples.

Nowhere can this people live out its rich barbarism, which has its source in the heart of the city itself, more securely than in the lap of the Church. It needs Catholicism, for even its excesses are then legalized by a legend, the feast day of a martyr. This is the birthplace of Alfonso de Liguori, the saint who made the practice of the Catholic Church supple enough to accommodate the trade of the swindler and the whore, in order to control it with more or less rigorous penances in the confessional, for which he wrote a three-volume compendium. Confession alone, not the police, is a match for the self-administration of the criminal world, the *camorra*.

So it does not occur to an injured party to call the police if he is eager to seek redress. Through civic or clerical mediators, if not personally, he approaches a *camorrista*. Through him, he agrees on a ransom. From Naples to Castellamare, the length of the proletarian suburbs, run the headquarters of the mainland *camorra*. For these criminals avoid neighborhoods in which they would be at the disposal of the police. They are dispersed over the city and the suburbs. That makes them dangerous. The traveling citizen who gropes his way as far as Rome from one work of art to the next, as if along a stockade, loses his nerve in Naples.

No more grotesque demonstration of this could be provided than in the convocation of an international congress of philosophers. It disintegrated without trace in the fiery haze of this city, while the seventh-centennial celebration of the university—whose tinny halo was supposed to be, in part, formed of that congress—unfolded amid the uproar of a popular festival. Complaining guests, who had been summarily relieved of their money and identification papers, appeared at the secretariat. But the banal tourist fares no better. Even Baedeker cannot propitiate him. Here the churches cannot be found, the starred sculpture always stands in the locked wing of the museum, and the word "mannerism" warns against the work of the native painters.

Nothing is enjoyable except the famous drinking water. Poverty and misery seem as contagious as they appear in descriptions aimed at children, and the foolish fear of being cheated is only a scanty rationalization for this feeling. If it is true, as Péladan said,[1] that the nineteenth century inverted the medieval, natural order of the vital needs of the poor, making shelter and clothing obligatory at the expense of food, such conventions have here been abolished. A beggar lies in the road propped against the sidewalk, waving his empty hat like a leave-taker at a station. Here poverty leads downward, just as two thousand years ago it led down to the crypt. Even today, the way to the catacombs passes through a "garden of agony"; in it, even today, the disinherited are the leaders. At the hospital San Gennaro dei Poveri, the entrance is through a white complex of buildings that one passes via two courtyards. On either side of the road stand benches for the invalids, who follow those going out with glances that do not reveal whether they are clinging to their garments with hopes of being liberated or with hopes of satisfying unimaginable desires. In the second courtyard, the doorways of the chambers have gratings; behind them cripples display their deformities, and the shock given to daydreaming passers-by is their joy.

One of the old men leads, and holds the lantern close to a fragment of an early Christian fresco. Now he utters the centuries-old magic word "Pompeii." Everything that the foreigner desires, admires, and pays for is "Pompeii." "Pompeii" makes the plaster imitation of the temple ruins, the lava necklace, and the louse-ridden person of the guide irresistible. This fetish is all the more miraculous as only a small minority of those whom it sustains have ever seen it. It is understandable that the miracle-working Madonna enthroned there is receiving a brand-new, expensive church for pilgrims. In this building, and not in that of the Vettii, Pompeii lives for the Neapolitans. And to it, again and again, swindling and wretchedness finally come home.

Fantastic reports by travelers have touched up the city. In reality it is gray: a gray-red or ocher, a gray-white. And entirely gray against sky and sea. It

is this, not least, that disheartens the tourist. For anyone who is blind to forms sees little here. The city is craggy. Seen from a height not reached by the cries from below, from the Castell San Martino, it lies deserted in the dusk, grown into the rock. Only a strip of shore runs level; behind it, buildings rise in tiers. Tenement blocks of six or seven stories, with staircases climbing their foundations, appear against the villas as skyscrapers. At the base of the cliff itself, where it touches the shore, caves have been hewn. As in the hermit pictures of the *Trecento,* a door is seen here and there in the rock. If it is open, one can see into large cellars, which are at the same time sleeping places and storehouses. Farther on, steps lead down to the sea, to fishermen's taverns installed in natural grottoes. Dim light and thin music come up from them in the evening.

As porous as this stone is the architecture. Building and action interpenetrate in the courtyards, arcades, and stairways. In everything, they preserve the scope to become a theater of new, unforeseen constellations. The stamp of the definitive is avoided. No situation appears intended forever, no figure asserts it "thus and not otherwise." This is how architecture, the most binding part of the communal rhythm, comes into being here: civilized, private, and ordered only in the great hotel and warehouse buildings on the quays; anarchic, embroiled, village-like in the center, into which large networks of streets were hacked only forty years ago. And only in these streets is the house, in the Nordic sense, the cell of the city's architecture. In contrast, within the tenement blocks, it seems held together at the corners, as if by iron clamps, by the murals of the Madonna.

No one orients himself by house numbers. Shops, wells, and churches are the reference points—and not always simple ones. For the typical Neapolitan church does not ostentatiously occupy a vast square, visible from afar, with transepts, gallery, and dome. It is hidden, built in; high domes are often to be seen only from a few places, and even then it is not easy to find one's way to them, impossible to distinguish the mass of the church from that of the neighboring secular buildings. The stranger passes it by. The inconspicuous door, often only a curtain, is the secret gate for the initiate. A single step takes him from the jumble of dirty courtyards into the pure solitude of a lofty, whitewashed church interior. His private existence is the baroque opening of a heightened public sphere. For here his private self is not taken up by the four walls, among wife and children, but by devotion or despair. Side alleys give glimpses of dirty stairs leading down to taverns, where three or four men, at intervals, hidden behind barrels as if behind church pillars, sit drinking.

In such corners, one can scarcely discern where building is still in progress and where dilapidation has already set in. For nothing is concluded. Porosity results not only from the indolence of the southern artisan, but also, above all, from the passion for improvisation, which demands that space and

opportunity be preserved at any price. Buildings are used as a popular stage. They are all divided into innumerable, simultaneously animated theaters. Balcony, courtyard, window, gateway, staircase, roof are at the same time stage and boxes. Even the most wretched pauper is sovereign in the dim, dual awareness of participating, in all his destitution, in one of the pictures of Neapolitan street life that will never return, and of enjoying in all his poverty the leisure to follow the great panorama. What is enacted on the staircases is an advanced school of stage management. The stairs, never entirely exposed, but still less enclosed in the gloomy box of the Nordic house, erupt fragmentarily from the buildings, make an angular turn, and disappear, only to burst out again.

In their materials, too, the street decorations are closely related to those of the theater. Paper plays the main part. Strips of red, blue, and yellow flypaper, altars of glossy colored paper on the walls, paper rosettes on the raw chunks of meat. Then the virtuosity of the variety show. Someone kneels on the asphalt, a little box beside him, and it is one of the busiest streets. With colored chalk he draws the figure of Christ on the stone, below it perhaps the head of the Madonna. Meanwhile a circle has formed around him. The artist gets up, and while he waits beside his work for fifteen minutes or half an hour, sparse, counted-out coins fall from the onlookers onto the limbs, head, and trunk of his portrait. He gathers them up, everyone disperses, and in a few minutes the picture is erased by feet.

Not the least example of such virtuosity is the art of eating macaroni with the hands. This is demonstrated to foreigners for remuneration. Other things are paid for according to tariffs. Vendors give a fixed price for the cigarette butts that, after a café closes, are culled from the chinks in the floor. (Earlier, they were sought by candlelight.) Alongside the leavings from restaurants, boiled cat skulls, and mussels, they are sold at stalls in the harbor district. Music parades about—not mournful music for the courtyards, but brilliant sounds for the street. A broad cart, a kind of xylophone, is colorfully hung with song texts. Here they can be bought. One of the musicians turns the organ while the other, beside it, appears with his collection cup before anyone who stops dreamily to listen. So everything joyful is mobile: music, toys, ice cream circulate through the streets.

This music is both a residue of the last and a prelude to the next feast day. Irresistibly, the festival penetrates each and every working day. Porosity is the inexhaustible law of life in this city, reappearing everywhere. A grain of Sunday is hidden in each weekday. And how much weekday there is in this Sunday!

Nevertheless, no city can fade, in the few hours of Sunday rest, more rapidly than Naples. It is crammed full of festal motifs nestling in the most inconspicuous places. When the blinds are taken down before a window,

the effect is similar to that of flags being raised elsewhere. Brightly dressed boys fish in deep-blue streams and look up at rouged church steeples. High above the streets, washlines run, with garments suspended on them like rows of pennants. Faint suns shine from glass vats of iced drinks. Day and night the pavilions glow with the pale, aromatic juices that teach even the tongue what porosity can be.

If politics or the calendar offers the slightest pretext, however, this secret, scattered world condenses into a noisy feast. And regularly it is crowned with a fireworks display over the sea. From July to September, an unbroken band of fire runs, in the evenings, along the coast between Naples and Salerno. Now over Sorrento, now over Minori or Praiano, but always over Naples, stand fiery balls. Here fire is substance and shadow. It is subject to fashion and artifice. Each parish has to outdo the festival of its neighbor with new lighting effects.

In these festivals, the oldest element of their Chinese origin—weather magic, in the form of the rockets that spread like kites—proves far superior to terrestrial splendors: the earthbound suns and the crucifix surrounded by the glow of Saint Elmo's fire. On the shore, the stone-pines of the Giardino Pubblico form a cloister. Riding under them on a festival night, you see a rain of fire in every treetop. But here, too, nothing is dreamy. Only explosions win an apotheosis popular favor. On Piedigrotta, the Neapolitans' main holiday, this childish joy in tumult puts on a wild face. During the night of September seventh, bands of men, up to a hundred strong, roam through every street. They blow on gigantic paper cornets, whose orifices are disguised with grotesque masks. Violently if necessary, one is encircled, and from countless horns the hollow sound clamors in the ears. Whole trades are based on the spectacle. Newspaper boys drag out the names of their wares, *Roma* and the *Corriere di Napoli,* as though they were sticks of gum. Their trumpeting is part of urban manufacture.

Trade, deeply rooted in Naples, borders on a game of chance and adheres closely to the holiday. The well-known list of the seven deadly sins situated pride in Genoa, avarice in Florence (the old Germans were of a different opinion—their term for what is known as "Greek love" was *Florenzen*), voluptuousness in Venice, anger in Bologna, greed in Milan, envy in Rome, and indolence in Naples. Lotteries, alluring and consuming as nowhere else in Italy, remain the archetype of business life. Every Saturday at four o'clock, crowds form in front of the house where the numbers are drawn. Naples is one of the few cities with its own draw. With the pawnshop and the lottery, the state holds the proletariat in a vise: what it advances to them in one hand it takes back in the other. The more discreet and liberal intoxication of Try-Your-Luck, in which the whole family takes part, replaces that of alcohol.

And business life is assimilated to it. A man stands in an unharnessed carriage on a street corner. People crowd around him. The lid of the coachman's box is open, and from it the vendor takes something, singing its praises all the while. It disappears before one has caught sight of it into a piece of pink or green paper. When it is thus wrapped, he holds it aloft, and in a trice it is sold for a few *soldi*. With the same mysterious gesture he disposes of one article after another. Are there lots in this paper? Cakes with a coin in every tenth one? What makes the people so covetous and the man as inscrutable as Mograby? He is selling toothpaste.

A priceless example of such business manners is the auction. When, at eight in the morning, the street vendor begins unpacking his goods—umbrellas, shirt fabric, shawls—presenting each item individually to his public, mistrustfully, as if he first had to test it himself; when, growing heated, he asks fantastic prices, and, while serenely folding up the large piece of cloth that he has spread out for five hundred lire, drops the price at every fold, and finally, when it lies diminished on his arm, is ready to part with it for fifty, he has been true to the most ancient fairground practices. There are delightful stories of the Neapolitans' playful love of trade. In a busy piazza, a fat lady drops her fan. She looks around helplessly; she is too unshapely to pick it up herself. A cavalier appears and is prepared to perform his service for fifty lire. They negotiate, and the lady receives her fan for ten.

Blissful confusion in the storehouses! For here they are still one with the vendors' stalls: they are bazaars. The long passageway is favored. In a glass-roofed one, there is a toyshop (in which perfume and liqueur glasses are also on sale) that would hold its own beside fairy-tale galleries. Like a gallery, too, is the main street of Naples, the Toledo. Its traffic is among the densest on earth. On either side of this narrow alley, all that has come together in the harbor city lies insolently, crudely, seductively displayed. Only in fairy tales are lanes so long that one must pass through without looking left or right, if one is to avoid falling prey to the devil. There is a department store—the type that in other cities is the rich, magnetic center of consumerism. Here it is devoid of charm, outdone by the tightly packed multiplicity. But with a tiny offshoot—rubber balls, soap, chocolates—it reemerges somewhere else among the stalls of the small-scale merchants.

Similarly dispersed, porous, and commingled is private life. What distinguishes Naples from other large cities is something it has in common with the African *kraal*: each private attitude or act is permeated by streams of communal life. To exist—for the northern European the most private of affairs—is here, as in the *kraal*, a collective matter.

So the house is far less the refuge into which people retreat than the inexhaustible reservoir from which they flood out. Life bursts not only from doors, not only into front yards, where people on chairs do their work (for

they have the ability to make their bodies into tables). From the balconies, housekeeping utensils hang like potted plants. From the windows of the top floors come baskets on ropes, to fetch mail, fruit, and cabbage.

Just as the living room reappears on the street, with chairs, hearth, and altar, so—only much more loudly—the street migrates into the living room. Even the poorest one is as full of wax candles, biscuit saints, sheaves of photos on the wall, and iron bedsteads as the street is of carts, people, and lights. Poverty has brought about a stretching of frontiers that mirrors the most radiant freedom of thought. There is no hour, often no place, for sleeping and eating.

The poorer the neighborhood, the more numerous the eating houses. Those who can do so fetch what they need from stoves in the open street. The same foods taste different at each stall; things are not cooked randomly but are prepared according to proven recipes. In the way that, in the window of the smallest trattoria, fish and meat lie heaped up for inspection, there is a nuance that goes beyond the requirements of the connoisseur. In the fish market, this seafaring people has created a marine sanctuary as grandiose as those of the Netherlands. Starfish, crayfish, cuttlefish from the gulf waters, which teem with creatures, cover the benches and are often devoured raw with a little lemon. Even the banal beasts of dry land become fantastic. In the fourth or fifth stories of these tenement blocks, cows are kept. The animals never walk on the street, and their hoofs have become so long that they can no longer stand.

How could anyone sleep in such rooms? To be sure, there are beds—as many as the room will hold. But even if there are six or seven, there are often more than twice as many occupants. For this reason, one sees children late at night—at twelve, even at two—still in the streets. At midday they then lie sleeping behind a shop counter or on a stairway. This sleep, which men and women also snatch in shady corners, is thus not the protected northern sleep. Here, too, there is interpenetration of day and night, noise and peace, outer light and inner darkness, street and home.

This extends even into toys. With the pale, watery colors of the Munich *Kindl,* the Madonna stands on the walls of the houses. The child that she holds away from her like a scepter is to be found, just as stiff, wrapped and without arms or legs, in the form of a wooden doll in the poorest shops of Santa Lucia. With these toys, the urchins can hit whatever they like. The Byzantine savior still asserts himself today—a scepter and a magic wand even in *their* fists. Bare wood at the back; only the front is painted. A blue garment, white spots, red hem, and red cheeks.

But the demon of profligacy has entered some of these dolls that lie beneath cheap notepaper, clothespins, and tin sheep. In the overpopulated neighborhoods, children are also soon acquainted with sex. But if their increase becomes devastating, if the father of a family dies or the mother

wastes away, close or distant relatives are not needed. A neighbor takes a child to her table for a shorter or longer period, and thus families interpenetrate in relationships that can resemble adoption. The true laboratories of this great process of intermingling are the cafés. Life is unable to sit down and stagnate in them. They are sober, open rooms resembling the political People's Café—the opposite of everything Viennese, of the confined, bourgeois, literary world. Neapolitan cafés are bluntly to the point. A prolonged stay is scarcely possible. A cup of excessively hot *caffé espresso* (this city is as unrivaled in hot drinks as in sherbets, spumoni, and ice cream) ushers the visitor out. The tables have a coppery shine; they are small and round, and a companion who is less than stalwart turns hesitantly on his heel in the doorway. Only a few people sit down here, briefly. Three quick movements of the hand, and they have placed their order.

The language of gestures goes further here than anywhere else in Italy. The conversation is impenetrable to anyone from outside. Ears, nose, eyes, breast, and shoulders are signaling stations activated by the fingers. These configurations return in their fastidiously specialized eroticism. Helping gestures and impatient touches attract the stranger's attention through a regularity that excludes chance. Yes, here his cause would be hopelessly lost, but the Neapolitan benevolently sends him away, sends him a few kilometers farther on to Mori. *"Vedere Napoli e poi Mori,"* he says, repeating an old pun. "See Naples and die," says the foreigner after him.

Written in 1925; published in the *Frankfurter Zeitung*, 1925. Translated by Edmund Jephcott.

Notes

1. Josephin Péladan (1859–1918), French author whose works attempt a synthesis of the observation of nature with an interest in the mystical and the occult.—*Trans.*

Curriculum Vitae (I)

I was born on July 15, 1892. My parents are Emil Benjamin, a businessman, and his wife, Pauline, née Schönflies. Both my parents are living. My religion is Judaism. I attended school in the *Gymnasium* division of the Kaiser-Friedrich School in Charlottenburg. My schooling there was interrupted for two years, when I was fourteen and fifteen—a period that I spent as a boarder at the Haubinda School in Thuringia. I passed my final examinations at Easter 1912. I then studied at the universities of Freiburg-im-Breisgau, Berlin, Munich, and Berne. My chief interests were philosophy, German literature, and the history of art. Accordingly, the lectures I attended included those of professors Cohn, Kluge, Rickert, and Witkop in Freiburg; Cassirer, Erdmann, Goldschmidt, Hermann, and Simmel in Berlin; Geiger, von der Leyen, and Wölfflin in Munich; and Häberlin, Herbertz, and Maync in Berne. In June 1919 I was awarded my doctorate *summa cum laude* at the University of Berne. The title of my dissertation was "The Concept of Criticism in German Romanticism." I majored in philosophy and minored in modern German literary history and psychology. Since the center of gravity of my scholarly interests lies in aesthetics, my philosophical and literary studies have increasingly converged. A study of the Parnassians' theoretical ideas and tendencies regarding language led to an attempt at a translation of Baudelaire, the principal results of which are summed up in a preface on the theory of language, "The Task of the Translator." From another angle, I have been concerned with the meaning of the connection between the beautiful and appearance [*Schein*] in the realm of language. This was one of the motifs behind my study "Goethe's Elective Affinities," which I intend to follow up with a study of *The New Melusine*. In a number

of the sections of my treatise "The Origin of German *Trauerspiel*," I have attempted to explore the implications of my arguments on language theory for the concrete study of literary history. In my extremely brief attempts to link a discussion of the problems of aesthetics with the great works of the German literary tradition, I see adumbrated the methods that my future studies will adopt.

Written in 1925; unpublished in Benjamin's liftetime. Translated by Rodney Livingstone.

Reflections on Humboldt

It goes without saying that Humboldt everywhere overlooks the magical side of language. In fact, he also overlooks its aspects relating to both mass psychology and individual psychology (in short, its anthropological dimension, especially in the pathological sense). His interest in language is confined to language as part of objective spirit (in Hegel's sense). One could say that insofar as the poetic side of language cannot fully be penetrated without contact with a realm that we may, if need be, call magical (Mallarmé has illuminated it best), this side of language is one that Humboldt fails to penetrate at all. (For his limited views, see the Akademie edition, p. 431.)[1]

Humboldt declares the word to be the most important component of language (vol. 4, p. 20);[2] it is for language what the individual is for the living world. Isn't there something arbitrary about this view? Mightn't we also compare the word to the index finger on the hand of language, or to the skeleton in relation to the human being as a whole?

It is probably of some importance to show that Humboldt never allows anything nakedly dialectical to emerge in his thinking; what he writes is always mediated.

There is something inflexible about Humboldt's style and mode of argumentation. See Steinthal on Humboldt's prose.[3] Sentences such as the one in vol. 5, p. 2, line 16 from the top.[4]

Humboldt talks of the "subtle and never completely comprehensible interaction between thought and expression." See vol. 5, p. 7, line 6 etcetera, from the bottom.

Written in 1925; unpublished in Benjamin's lifetime. Translated by Rodney Livingstone.

Notes

1. Wilhelm von Humboldt, *Gesammelte Schriften,* ed. A. Leitzmann (Berlin, 1905), vol. 4: "Über den nationalen Charakter der Sprachen" [On the National Character of Languages], p. 431.—*Trans.*
2. Ibid., vol. 4: "Über das vergleichende Sprachstudium in Beziehung auf die verschiedenen Epochen der Sprachentwicklung" [The Comparative Study of Language with Reference to the Different Epochs of Linguistic Development], p. 20.—*Trans.*
3. Hajim Steinthal, *Die sprachphilosophischen Werke Wilhelms von Humboldt* [Wilhelm von Humboldt's Works on the Philosophy of Language] (Berlin, 1884), pp. 23–34.—*Trans.*
4. See vol. 5, p. 2: "Inwiefern läßt sich der ehemalige Kulturzustand der eingeborenen Völker aus den Überresten ihrer Sprache beurteilen?" ("To what extent can we judge the former cultural condition of the natives from the vestiges of their language?")—*Trans.*

Review of Bernoulli's *Bachofen*

Carl Albrecht Bernoulli, *Johann Jacob Bachofen and the Natural Symbol: An Appreciation* (Basel: Benno Schwabe, 1924), 697 pages.

There exists a book entitled *Geschichte der klassischen Mythologie und Religionsgeschichte während des Mittelalters im Abendland und während der Neuzeit* [History of Classical Mythology and Religion during the Middle Ages in the West and in the Modern World]. It was written by Otto Gruppe, a learned scholar of note. In the course of its 250 pages, which relentlessly pursue the most eccentric mythographic speculations, there is not even a single mention of Bachofen. This is the extent to which it has become an unquestioned truth that the Basel scholar who wrote during the second half of the last century—*Gräbersymbolik der Alten* [Symbolism of Graves in Antiquity], *Das Mutterrecht* [Matriarchy], and *Die Sage von Tanaquil* [The Saga of Tanaquil] are his three principal works—simply does not exist in the eyes of the official world of classical studies.[1] At best he is considered an outsider whose great learning and great fortune enabled him to indulge his private passion for the mysticism of antiquity. In contrast to this, it is common knowledge that his name is always mentioned where sociology, anthropology, and philosophy attempt to venture from the beaten track. References to Bachofen can be encountered in Engels, Weininger, and, recently, with particular emphasis, in Ludwig Klages.[2] The book *Kosmogonis der Eros* [Eros and the Cosmos] by this great philosopher and anthropologist—a description which, *despite* Klages himself, I prefer to the inadequate term "psychologist"—is the first to refer authoritatively to Bachofen's ideas. His book depicts the system of natural and anthropological data that served as the subsoil of the classical cult which Bachofen identifies

as the patriarchal religion of "Chthonism" (the cult of the earth and the dead). In the first rank of the realities of "natural mythology," which Klages attempts in his studies to retrieve from an oblivion that has lasted thousands of years, he posits the true and effective existence of certain elements he calls "images." It is only with the aid of these that a deeper world can be revealed to mankind in a state of ecstasy and can impinge through human agency on the mechanical world of the senses. These images, however, are souls, be they of things or people; the distant souls of the past form the world in which the primitives, whose consciousness is comparable to the dream consciousness of modern man, can receive their perceptions. Bernoulli's study of Bachofen is dedicated to Klages and attempts to transfer the entire breadth of Bachofen's world onto the grid of Klages' system in an orderly fashion. This enterprise is all the more productive since it simultaneously attempts to grapple with Klages and his doomed attempt to reject the existing "technical," "mechanized" state of the modern world. In his discussion, he does not evade the challenge represented by the philosophical—or rather theological—center from which Klages directs his prophecy of doom with a force that forever puts the efforts of other critics of our culture in the shade, including those produced by the George circle. But we cannot judge Bernoulli's campaign a total success, although we remain even more convinced of the need for it than he is. A satisfactory reckoning is still awaited. It would be deeply regrettable if the excessive scope of this book were to distract the philosophical reader's attention from the great importance of its central message. Unfortunately, Bernoulli succumbed to the temptation to include every issue of the day connected with Bachofen, however ephemeral. The result is that a suffocating boudoir-atmosphere occasionally threatens to stifle his narrative. His polemical purpose may have justified a similar approach in his book on Overbeck and Nietzsche, but here it has become an irritant rooted in the same casual approach as his numerous stylistic lapses. These defects, however, should not be allowed to detract from the extraordinary merits of the book. It has been issued in a worthy edition by the old Basel publishing house of Benno Schwabe, which published a second edition of *Matriarchy* and which has provided Bernoulli's book with an affectingly beautiful portrait of Bachofen.

Written in 1926; published in *Die literarische Welt*, 1926. Translated by Rodney Livingstone.

Notes

1. Johann Jacob Bachofen (1815–1887), Swiss legal scholar and historian.—*Trans.*
2. Ludwig Klages (1872–1956), philosopher and psychologist who based his psychology on a theory of archetypal images.—*Trans.*

Johann Peter Hebel (I)

On the Centenary of His Death

If today, on the centenary of his death, Johann Peter Hebel cannot be exhumed and recommended to the public as someone "neglected," this is due much more to his own virtues than to those of posterity.[1] His overwhelming modesty would resist such a role, even posthumously; it cheated an entire century of the realization that the *Schatzkästlein des rheinischen Hausfreundes* [Treasure Chest of the Rhenish Family-Friend] is one of the purest achievements of the filigree craft of German prose. But if such a view appears novel or even paradoxical, the fault lies with that same nineteenth century—that posterity with its ghastly cultural arrogance, which has induced it to cast away the key to this treasure and consign it to children and peasants, because popular writers are supposedly inferior to even the most godforsaken "poet." Especially if their source flows in dialect. And dialect, it must be admitted, is a murky source, if it is stubborn enough to be sufficient unto itself, too vain to acknowledge the national literature, and blind toward the larger concerns of mankind. Hebel's enlightened humanism protects him from such vanity, however. Nothing could be further removed from a blinkered and provincial local art than the explicit cosmopolitanism of the settings of his tales. Moscow and Amsterdam, Jerusalem and Milan form the horizon of his world at whose core—as is just—lie Segringen, Brassenheim, and Tuttlingen. This is the mark of all true spontaneous popular art: it articulates the exotic and monstrous with the same affection and in the same tone of voice that mark its descriptions of the affairs of its own home territory. The wide-eyed and observant gaze of this parson and philanthropist is able to find room for the whole universe inside the village economy, and Hebel tells of the planets, moon, and comets as a chronicler,

not as a teacher. For example, he says of the moon (which he shows us, startlingly, as a landscape—just as Chagall does in his famous picture): "In any one place there, a day lasts roughly as long as about two of our weeks, and the same goes for the night, so that a night watchman must take great care not to lose track of the time when the clock strikes 223 or 309."

After reading sentences like this one, it is not hard to guess that Jean Paul[2] was this man's favorite writer. It is evident that such men are "delicate" empiricists (to quote Goethe's expression), because to their way of thinking everything factual is already theory—particularly since the local event, the anecdotal, the criminal, the amusing all contained a moral theorem—and has a highly bizarre, scurrilous, and unpredictable connection with the larger reality. In his *Levana,* Jean Paul recommends brandy for babies and demands that they be given beer. Much less controversially, Hebel incorporates crimes, swindles, and other villainy as illustrative material in his popular calendars. And here, as in all his writings, the moral always appears where you least expect it. Everyone knows how the barber's boy in Segringen agrees to cut the beard of the "stranger from the army" because no one else has the courage to do so. [The soldier says,] "If you cut me, I shall stab you to death." And then, at the end, [the barber's boy replies], "You wouldn't have stabbed me, Sir, because if you had twitched and I had nicked your face, I would have got in first. I would have slit your throat in a trice and run off as fast as my legs would carry me." This is Hebel's method of moralizing.

Hebel took numerous rogue's-tales from older sources. But the temperament of Firebrand Fred, Heiner, and Red Dieter—that of the highwayman and swindler—was all his own. As a boy he was notorious for his practical jokes, and there is a story about the adult Hebel and his meeting with [Franz Joseph] Gall, the famous early phrenologist who once visited Baden. Hebel was introduced to him and asked his opinion. Gall felt Hebel's head, but apart from some indistinct mumbling, he said nothing but "very powerfully developed." Whereupon Hebel asked him, "Do you mean my thief's-bump?"

The extent to which Hebel's comic tales contain a strand of the demonic can be seen in the great lithographs that Dambacher used in 1842 to illustrate an edition of the *Schwänke des rheinischen Hausfreundes* [Comic Tales from the Rhenish Family-Friend]. These uncommonly powerful illustrations are, as it were, the card-sharps' and smugglers' secret marks which link Hebel's more innocent rogues'-gallery with the more sinister and terrifying petty bourgeois figures from Büchner's *Wozzeck.* For this parson—who has no equal among German writers when it comes to the narration of incident, and whose repertoire encompassed the entire gamut of human experience, from the lowest horse trader to acts of the greatest generosity—was not the man to overlook the element of the demonic in bourgeois business life. His eye was sharpened by his theological schooling. Protestant

discipline also had a direct impact on Hebel's prose style. Even though this is often understood too narrowly, it is indubitably the case that modern German prose exhibits a highly tense, highly dialectical relationship between two opposite poles, a constant one and a variable one. The first is the German of Luther's Bible; the second is dialect. The way in which the two coalesce in Hebel is the key to his mastery as an artist. But this is obviously much more than just a matter of language. "Unverhofftes Wiedersehen" [Unexpected Reunion] contains this incomparable description of the passing of fifty years during which a bride mourns the death of her beloved, a miner, in an accident:

> In the meantime the city of Lisbon in Portugal was destroyed by an earthquake, and the Seven Years War came and went, and the emperor Francis I died, and the Society of Jesus was banned, and Poland was partitioned, and the empress Maria Theresa died, and Struensee[3] was executed, and America gained its freedom, and the combined French and Spanish forces failed to capture Gibraltar. The Turks locked up General Stein in the Veterani cave in Hungary, and the emperor Joseph died, too. King Gustav of Sweden conquered Russian Finland, and the French Revolution and the long wars broke out, and the emperor Leopold II went to his grave. Napoleon conquered Prussia and the English bombarded Copenhagen, and the farmers sowed and reaped. The miller ground his corn, and the smiths hammered, and the miners dug for metal ore in their subterranean workshop. But in 1809, when the miners in Falun . . .

When he describes the passing of fifty years of mourning in this manner, we can see an experientially grounded [erfahren] metaphysics at work—a metaphysics that matters more than anything "experienced" [jedes "erlebte"].

In other cases, however, his unbounded artistic freedom is based on a use of language that is at times dictatorial, not unlike Goethe's in the second part of *Faust*. Such authority does not of course derive from the dialect pure and simple, which always remains diffident and lacking in authority, but probably comes from the tense and critical interplay between the traditional High German and the dialect. As with Luther, the impact of one on the other causes all sorts of wonderfully bizarre expressions to fly like wood-shavings from a plane—expressions that then enter the standard language. "Then [the man of good sense] goes on his way and thinks good thoughts . . . and he can't see enough of the trees in bloom and the colorful meadows all around." Such sentences—and the *Schatzkästlein* is an almost uninterrupted succession of them—ought at long last to be made available in a complete edition that would be conceived neither as the pretext for fashionable illustrations nor as a cheap school prize, but as a monument of German prose. Such an edition, which we still do not have, would be an invaluable reference work. For it is a peculiarity of these tales by Hebel, and the seal of their perfection, that we see how easy it is to forget them. No sooner do you believe that you have fixed one in your mind than the richness of the

text proves you wrong. A dénouement which you can never really "know," but which at best you can just learn by heart, quite frequently rewards you for all that has gone before. "This piece is the legacy of the civil servant who is now in Dresden. After all, he sent the Family-Friend a fine pipe bowl as a souvenir; there is a winged boy on it and a girl, and they are doing something together. But he'll be back again, that civil servant." This is the end of "Die Probe" [The Test]. Anyone who does not discover Hebel gazing out at him from such a sentence will not find him in any other. But to intervene in the story like this is not a sign of Romanticism. It is, rather, in the style of the immortal Sterne.

Written in 1926; published in the *Westdeutsche Allgemeine Zeitung,* 1926. Translated by Rodney Livingstone.

Notes

1. Johann Peter Hebel (1760–1826) was a journalist and author; he was much esteemed for the use of dialect in his writings, a practice that had fallen prey to eighteenth-century enlightened universalism. As editor and chief writer of the *Badischer Landkalendar,* an annual publication not unlike the American *Old Farmer's Almanac,* Hebel produced an enormous volume of prose and poetry. A typical calendar would include a cosmology embellished with anecdotes and stories, practical advice for the homeowner and farmer, reports on crime and catastrophe, short biographies, riddles, and, finally, political observations on the year just past. Hebel's narrative persona, the "Rhenish Family-Friend," narrates and comments; Sterne-like ironic interjections are not infrequent.—*Trans.*
2. Jean Paul Richter (1763–1825) wrote eccentric, discursive novels in the manner of Lawrence Sterne. *Levana* (1807) is a treatise on education.—*Trans.*
3. Johann Friedrich, Graf von Struensee (1737–1772), court doctor to the mentally ill Christian VII, king of Denmark, was arrested and executed on charges of consorting with the queen.—*Trans.*

Johann Peter Hebel (II)

A Picture Puzzle for the Centenary of His Death

Not every writer benefits from being recommended. To speak of Hebel is difficult, to recommend him is superfluous, and to set him before the people, as is the custom, is reprehensible.[1] He will never fit into the ranks of the cultural grenadiers whom the German schoolmaster parades before his ABC marksmen. Hebel is a moralist, but his morality is not that which the business of the big bourgeoisie has established. That was just in the process of emerging in Hebel's day, and he took a very close look at it indeed, precisely because he knew all about business ethics. As the sworn expert of an age that operated with huge business risks, he evaluated this morality. For he had experienced the French Revolution as a grown man, and knew what it means when a nation withdraws credit en masse from its ruling class. No doubt he was on good terms with the best representatives of that ruling class, with the solid small businessmen; but for that very reason, he wanted to teach them the only method of accounting that brings happiness. "With God" is the expression that should stand in the folio edition of his *Rheinischer Hausfreund* [Rhenish Family-Friend], with its classical examples of such pious calculations neatly set out in different categories for household use. Double-entry bookkeeping—and it always comes out right. On the credit side: the everyday life of peasant and burgher, the possession of interest-bearing minutes, the paid-up capital of labor and guile. And on the debit side: the Day of Judgment, the one that is not counted in minutes, that has no glory to disburse, and no damnation, but only the heartfelt, homey tranquillity that apportions true, historical security to the most private things of life; for with the passage of time, a person's location in his generation provides a sense of security, much as a hearth does in space. Both

to the right and to the left, Hebel has undeniably provided an equal balance. His morality does not preach; it is the straight line at the bottom, drawn with the long ruler. Once you have arrived at that point, you can turn the light out and sleep the sleep of the just. No writer of short stories could be freer of "mood." The present of all his works is not the years 1760–1826; the time in which his characters live is not numbered in years. Just as theology (for Hebel was a theologian, and even a member of an ecclesiastical committee) thinks of history in generations, in the same way Hebel perceives in all the activities of his characters the generation that had to blunder about in the crises that broke out in the Revolution of 1789 in France. In his scoundrels and ne'er-do-wells, there are echoes of Voltaire, Condorcet, and Diderot; the unspeakably vile cleverness of his Jews has no more of the Talmud in it than of the spirit of Moses Hess, the somewhat later predecessor of the socialists. Conspiracy was not alien to Hebel. Of course, the secret society of this man, whose simple but formless life is opaque to the outside gaze, was not political in nature. On the contrary, his "protean" nature, his love of the mountains, his entire nature mysticism with its boyish fascination with secret scripts and its altar in the mountains, with him as the High Priest, the "Pseudo King Peter I of Assmannshausen"—all that reminds us of the frivolous activities of prerevolutionary Rosicrucians. The fact that Hebel was able to say and think great or important things only incidentally—though this was a strength of his stories—also led to vacillation and weakness in his life. Even his contributions to the calendar of the *Rheinischer Hausfreund* arose under an external compulsion about which he constantly grumbled. But that did not prevent him from preserving a sense of proportion as to what was great and what was small. If he was never able to speak of one without at the same time including the other in a highly complex and imbricated manner, his realism was always powerful enough to preserve him from that mystical glorification of the small and the petty which sometimes became a weakness in Stifter.[2] He not only loved Jean Paul, whose writing is related to his, but also Goethe.[3] Schiller, on the other hand, he could not read. This meek and pious author of dialect poems and catechisms can still show modern schoolteachers his cloven hoof in "Andreas Hofer," with which the *Schatzkästlein* of 1827 concludes. In this story he gives a stern, even sarcastic account of the Tirolese uprising. When confronted with Goethe's lack of patriotism, the German literary historian cannot but react with something of the embarrassment he feels after a lost world war. In truth, however, both writers are only expressing the same unwavering respect for actual power relationships, and it may be added that, when confronted with these, naïveté on moral issues is the least permissible attitude of all. According to this basic principle, Hebel duly recorded daily life in town and village. In his business transactions, only cash payment is allowed. He declines to honor the check of irony, but his

humor collects huge sums in pennies. He is exemplary in his storytelling as a whole, as well as inexhaustible in every detail. One of his stories opens with the words, "It is well known that once upon a time an old mayor of Wasselnheim complained to his wife that his French would bring him to an early grave." This expression "well known" is enough to fill in the sterile gulf that separates history from private life in the mind of every philistine. To say nothing of that twenty-line historical excursus in "Unverhofftes Wiedersehen" [Unexpected Reunion] which contains the whole of Hebel in a nutshell. Hebel's artistry is as nondescript as emperors and victories appear to be in those twenty lines of world history. It is all difficult to evaluate, right down to the level of linguistic detail, for the use of dialect seems to swathe its power in a veil of mystery rather than provide a source of energy. The minute scale of his work is the guarantee of his survival in even the most alien environment. A bishop's crozier that is handed down in a family from one generation to the next may one day be thrown away because it has become as great an embarrassment as a Jacobin's *bonnet rouge*. But no one will throw away that inconspicuous brooch on which a crozier is crossed with a *bonnet rouge*.

Written in 1926; published in *Die literarische Welt,* 1926. Translated by Rodney Livingstone.

Notes

1. Johann Peter Hebel (1760–1826) was a journalist and author; he was much esteemed for the use of dialect in his writings, a practice that had fallen prey to eighteenth-century enlightened universalism. As editor and chief writer of the *Badischer Landkalendar,* an annual publication not unlike the American *Old Farmer's Almanac,* Hebel produced an enormous volume of prose and poetry. A typical calendar would include a cosmology embellished with anecdotes and stories, practical advice for the homeowner and farmer, reports on crime and catastrophe, short biographies, riddles, and, finally, political observations on the year just past. Hebel's narrative persona, the "Rhenish Family-Friend," narrates and comments; Sterne-like ironic interjections are not infrequent.—*Trans.*
2. Adalbert Stifter (1805–1868), Austrian writer whose short prose and novels are characterized by an unusually graceful style and a reverence for natural process.—*Trans.*
3. Jean Paul Richter (1763–1825) is remembered for a series of wildly extravagant novels that are indebted to Sterne. He, like Goethe, was one of Benjamin's favorite authors; Schiller, on the other hand, plays virtually no role in Benjamin's canon.—*Trans.*

A Glimpse into the World of Children's Books

A soft green glow in the evening red.
—C. F. Heinle

In one of Andersen's tales, there is a picture-book that cost "half a kingdom." In it everything was alive. "The birds sang, and people came out of the book and spoke." But when the princess turned the page, "they leaped back in again so that there should be no disorder." Pretty and unfocused, like so much that Andersen wrote, this little invention misses the crucial point by a hair's breadth. The objects do not come to meet the picturing child from the pages of the book; instead, the gazing child enters into those pages, becoming suffused, like a cloud, with the riotous colors of the world of pictures. Sitting before his painted book, he makes the Taoist vision of perfection come true: he overcomes the illusory barrier of the book's surface and passes through colored textures and brightly painted partitions to enter a stage on which fairy tales spring to life. *Hoa,* the Chinese word for "painting," is much like *kua,* meaning "attach": you attach five colors to the objects. In German, the word used is *anlegen:* you "apply" colors. In such an open, color-bedecked world where everything shifts at every step, the child is allowed to join in the game. Draped with colors of every hue that he has picked up from reading and observing, the child stands in the center of a masquerade and joins in, while reading—for the words have all come to the masked ball, are joining in the fun and are whirling around together, like tinkling snowflakes. "'Prince' is a word with a star tied to it," said a boy of seven. When children think up stories, they are like theater-producers who refuse to be bound by "sense." This is easily proved. If you give children four or five specific words and ask them to make a short sentence on the spot, the most amazing prose comes to light: thus, not a glimpse into but a guide to children's books. At a stroke, the words throw

on their costumes and in the twinkling of an eye they are caught up in a battle, love scenes, or a brawl. This is how children write their stories, but also how they read them. And there are rare, impassioned ABC-books that play a similar sort of game in pictures. Under Plate A, for example, you will find a higgledy-piggledy still-life that seems very mysterious until you realize what is happening and what Apple, ABC-book, Ape, Airplane, Anchor, Ark, Arm, Armadillo, Aster, and Ax are all doing in the same place. Children know such pictures like their own pockets; they have searched through them in the same way and turned them inside out, without forgetting the smallest thread or piece of cloth. And if, in the colored engraving, children's imaginations can fall into a reverie, the black-and-white woodcut or the plain prosaic illustration draws them out of themselves. Just as they will write about the pictures with words, so, too, will they "write" them in a more literal sense: they will scribble on them. Unlike the colored pictures, the surface of the black-and-white illustration seems to be incomplete and hence in need of additions. So children imaginatively complete the illustrations. At the same time as they learn language from them, they also learn writing: hieroglyphics. It is in this spirit that the first words learned are supplemented with line drawings of the objects they refer to: "egg," "hat." The genuine worth of such straightforward picture-books is far removed from the rationalist crudeness that caused them to be recommended in the first place.— "The way the child makes itself a little home," explores its picture landscape with its eyes and finger, can be seen in this paradigmatic nursery rhyme from an old picture-book, *Steckenpferd und Puppe* [Stick-Horse and Doll], by J. P. Wich (Nördlingen, 1843):

> In front of the little town, there sits a little dwarf,
> Behind the little dwarf, there stands a little mountain,
> From the little mountain, there flows a little stream,
> On the little stream, there floats a little roof,
> Beneath the little roof, there stands a little room,
> Inside the little room, there sits a little boy,
> Behind the little boy, there stands a little bench,
> On the little bench, there rests a little chest,
> In the little chest, there stands a little box,
> In the little box, there lies a little nest,
> In front of the little nest, there stands a little cat,
> That's a lovely little place, I'll make a note of that.

In a less systematic, more whimsical and boisterous way, children play with puzzle-pictures in which they set out in pursuit of the "thief," the "lazy pupil," or the "hidden teacher." Though such pictures may seem related to those drawings full of contradictions and impossibilities which nowadays are used for tests, these are likewise really only a masquerade: exuberant, impromptu games in which people walk upside down, stick their arms and

legs between tree branches, and use a house roof as a coat. These carnivals overflow even into the more serious space of ABC-books and reading primers. In the first half of the last century, [Paul] Renner in Nuremberg published a set of twenty-four sheets in which the letters were introduced in disguise, as it were. *F* appears as a Franciscan, *C* as a Clerk, *P* as a Porter. The game was so popular that variations on these old motifs have survived to this day. Last, the rebus rings in the Ash Wednesday of this carnival of words and letters. It is the unmasking: from the midst of the resplendent procession, the motto—the gaunt figure of Reason—gazes out at the children. The rebus (a word that, curiously, was formerly traced back to *rêver* instead of to *res*) has the most distinguished origins: it descends directly from the hieroglyphics of the Renaissance, and one of its most precious books, the *Hypnerotomachia Poliphili,* may be described as its letters patent. It was perhaps never so widely known in Germany as in France, where around 1840 there was a fashion for charming picture collections in which the text was printed in the form of picture writing. Even so, German children, too, had delightful "educational" rebus books. By the end of the eighteenth century at the latest, we see the publication of *Sittensprüche des Buchs Jesus Sirach für Kinder und junge Leute aus allen Ständen mit Bildern welche die vornehmsten Wörter ausdrücken* [Moral Sayings from the Book of Ecclesiasticus for Children and Young People of All Classes, with Pictures that Express the Most Important Words]. The text is delicately engraved in copper, and wherever possible all the nouns are represented by small, beautifully painted illustrative or allegorical pictures. As late as 1842, [Benedictus Gotthelf] Teubner published a *Kleine Bibel für Kinder* [Little Bible for Children], with 460 illustrations. And in children's books, even children's hands were catered to just as much as their minds or their imaginations. There are the well-known pull-out books (which have degenerated the most and seem to be the most short-lived as a genre, just as the books themselves never last for long). A delightful example was the *Livre jou-jou,* which was published by Janet in Paris, presumably in the 1840s. It is the story of a Persian prince. All the incidents of his adventures are illustrated, and each joyful episode where he is rescued can be made to appear with the wave of a magic wand, by moving the strip at the side of the page. Similar to these are the books in which the doors and curtains in the pictures can be opened to reveal pictures behind them. And finally, just as a novel has been written about the doll you can dress up (*Isabellens Verwandlungen oder das Mädchen in sechs Gestalten: Ein Unterhaltendes Buch für Mädchen mit sieben kolorierten beweglichen Kupfern* [Isabella's Transformations, or The Girl with Six Outfits: An Entertaining Book for Girls, with Seven Colored Pictures that Move]; published in Vienna), so, too, you now find in books those beautiful games in which little cardboard figures can be attached by means of invisible slits in the board and can be

Figure 1 Aesop's Fables, second edition. Published by Heinrich Friedrich Müller, Bookseller, Kohlmarkt 1218, Vienna, no date. Collection of Walter Benjamin.

rearranged at will. This means that you can change a landscape or a room according to the different situations that arise in the course of the story. For those few people who as children—or even as collectors—have had the great good fortune to come into possession of magic books or puzzle books, all of the foregoing will have paled in comparison. These magic books were ingeniously contrived volumes that displayed different series of pictures according to the way one flicked through the pages. The person in the know can go through such a book ten times, and will see the same picture on page after page, until his hand slips—and now it is as if the entire book were transformed, and completely different pictures make their appearance.

Figure 2 Moral sayings from the book by Jesus Sirach, Nuremberg. Collection of Walter Benjamin.

.Rübezahl.

Figure 3 The Book of Tales for Daughters and Sons of the Educated Classes,
by Johann Peter Lyser. With eight copperplate illustrations. Leipzig: Wigand'sche
Verlags-Expedition, 1834. Collection of Walter Benjamin.

Books such as these (like the quarto from the eighteenth century in the hands
of the present writer) seem to contain nothing but a flower vase, or again
a grinning devil, or some parrots, followed by all black or all white pages,
windmills, court jesters, or pierrots. Another one has a series of toys, sweets
for a well-behaved child, or, again, when you turn it round, a series of
punishments and frightening faces for the child who has been naughty.

The heyday of children's books, in the first half of the nineteenth century,
was not just the product of an educational philosophy (which was in some
respects superior to that of today), but also emerged simply as an aspect of
the bourgeois life of the day. In a word, it was created by the Biedermeier
period. Even the smallest towns contained publishers whose most ordinary
products were as elegant as the modest house furniture of the time, in the
drawers of which their books lay untouched for a century. This is why there
are children's books not just from Berlin, Leipzig, Nuremberg, and Vienna;
for the collector, works published in Meissen, Grimma, Gotha, Pirna,
Plauen, Magdeburg, and Neuhaldensleben have a much more promising
ring. Illustrators were at work in almost all of those towns, though the

Figure 4 The Magical Red Umbrella: A New Tale for Children. Neuruppin Printers, and Verlag von Gustav Kühn. Collection of Walter Benjamin.

majority have remained unknown. From time to time, however, one of them is rediscovered and receives a biographer. This was the case with Johann Peter Lyser, the painter, musician, and journalist. A. L. Grimm's *Fabelbuch* [Book of Fables] (Grimma, 1827), with Lyser's illustrations, the *Buch der Mährchen für Töchter und Söhne gebildeter Stände* [Book of Fairy Tales for Daughters and Sons of the Educated Classes] (Leipzig, 1834), with text and illustrations by Lyser, and *Linas Mährchenbuch* [Lina's Book of Fairy Tales] (Grimma, n.d.), with text by A. L. Grimm and illustrations by Lyser, contain his most beautiful work for children. The coloring of these lithographs pales beside the fiery coloring of the Biedermeier period, and matches better the haggard and often careworn figures, the shadowy landscape, and the fairy-tale atmosphere which is not without an ironic, satanic streak. The craftsmanship in these books was fully committed to the ordinary life of the petty bourgeoisie; it was not there to be enjoyed but was to be used like cooking recipes or proverbs. It represents a popular, even childlike variant of the dreams that assumed their most exaggerated forms in the works of the Romantics. This is why Jean Paul is their patron saint.[1] The central-German fairy-world of his stories has found expression in their pictures. No writing is closer to their unpretentiously colorful world than his. For his genius, like that of color itself, is based on fantasy, not creative power. When you look at colors, the intuitions of fantasy, in contrast to the creative imagination, manifest themselves as a primal phenomenon. All form, every outline that man perceives, corresponds to something in him that enables him to reproduce it. The body imitates itself in the form of dance, the hand imitates and appropriates it through drawing. But this ability finds its limits in the world of color. The human body cannot produce color. It does relates to it not creatively but receptively: through the shimmering colors of vision. (Anthropologically, too, sight is the watershed of the senses because it perceives color and form simultaneously. And so, on the one hand, the body is the organ of active relations: the perception of form and movement, hearing and voice. On the other hand, there are the passive relations: the perception of color belongs to the realms of smell and taste. Language itself synthesizes this group into a unity in words like "looking," "smelling," "tasting," which apply intransitively to objects and transitively to human beings.) In short, pure color is the medium of fantasy, a home among clouds for the spoiled child, not the strict canon of the constructive artist. Here is the link with its "sensuous, moral" effect which Goethe understood entirely in the spirit of the Romantics:

> In their illumination and their obscurity, the transparent colors are without limits, just as fire and water can be regarded as their zenith and nadir ... The relation of light to transparent color is, when you come to look into it deeply, infinitely fascinating, and when the colors flare up, merge into one another,

arise anew, and vanish, it is like taking breath in great pauses from one eternity to the next, from the greatest light down to the solitary and eternal silence in the deepest shades. The opaque colors, in contrast, are like flowers that do not dare to compete with the sky, yet are concerned with weakness (that is to say, white) on the one side, and with evil (that is to say, black) on the other side. It is these, however, that are able . . . to produce such pleasing variations and such natural effects that . . . ultimately the transparent colors end up as no more than spirits playing above them and serve only to enhance them.[2]

With these words, the "Supplement" to the *Theory of Color* does justice to the sensibilities of these worthy colorists and hence to the spirit of children's games themselves. Just think of the many games that are concerned with pure imaginative contemplation: soap bubbles, parlor games, the watery color of the magic lantern, watercoloring, decals. In all of these, the color seems to hover suspended above the objects. Their magic lies not in the colored object or in the mere dead color, but in the colored glow, the colored brilliance, the ray of colored light. At the end of its panorama, the glimpse into the world of children's books culminates in a rock covered with Biedermeier flowers. Leaning on a sky-blue goddess, the poet lies there with his melodious hands. What the Muse whispers to him, a winged child sitting next to him puts into a drawing. Scattered around are a harp and a lute. Dwarves fiddle and toot in the depths of the mountain, while in the sky the sun is setting. This is how Lyser once painted the landscape, and the eyes and cheeks of children poring over books are reflected in the glory of the sunset.

Written in 1926; published in *Die literarische Welt*, 1926. Translated by Rodney Livingstone.

Notes

1. Jean Paul Richter (1763–1825) is remembered for a series of wildly extravagant, highly imaginative novels that combine fantasy and realism; they are indebted to Sterne.—*Trans.*
2. Johann Wolfgang von Goethe, *Farbenlehre,* ed. Hans Wohlbold (Jena, 1928), pp. 440–442.—*Trans.*

One-Way Street

This street is named
Asja Lacis Street
after her who
as an engineer
cut it through the author

Filling Station

The construction of life is at present in the power far more of facts than of convictions, and of such facts as have scarcely ever become the basis of convictions. Under these circumstances, true literary activity cannot aspire to take place within a literary framework; this is, rather, the habitual expression of its sterility. Significant literary effectiveness can come into being only in a strict alternation between action and writing; it must nurture the inconspicuous forms that fit its influence in active communities better than does the pretentious, universal gesture of the book—in leaflets, brochures, articles, and placards. Only this prompt language shows itself actively equal to the moment. Opinions are to the vast apparatus of social existence what oil is to machines: one does not go up to a turbine and pour machine oil over it; one applies a little to hidden spindles and joints that one has to know.

Breakfast Room

A popular tradition warns against recounting dreams the next morning on an empty stomach. In this state, though awake, one remains under the spell of the dream. For washing brings only the surface of the body and the visible motor functions into the light, while in the deeper strata, even during the morning ablutions, the grey penumbra of dream persists and, indeed, in the solitude of the first waking hour, consolidates itself. He who shuns contact with the day, whether for fear of his fellow men or for the sake of inward composure, is unwilling to eat and disdains his breakfast. He thus avoids a

rupture between the nocturnal and the daytime worlds—a precaution justified only by the combustion of dream in a concentrated morning's work, if not in prayer; otherwise this avoidance can be a source of confusion between vital rhythms. In this condition, the narration of dreams can bring calamity, because a person still half in league with the dream world betrays it in his words and must incur its revenge. To express this in more modern terms: he betrays himself. He has outgrown the protection of dreaming naïveté, and in laying hands on his dream visages without thinking, he surrenders himself. For only from the far bank, from broad daylight, may dream be addressed from the superior vantage of memory. This further side of dream is attainable only through a cleansing analogous to washing, yet totally different. By way of the stomach. The fasting man tells his dream as if he were talking in his sleep.

Number 113

The hours that hold the figure and the form
Have run their course within the house of dream.

Cellar

We have long forgotten the ritual by which the house of our life was erected. But when it is under assault and enemy bombs are already taking their toll, what enervated, perverse antiquities do they not lay bare in the foundations! What things were interred and sacrificed amid magic incantations, what horrible cabinet of curiosities lies there below, where the deepest shafts are reserved for what is most commonplace? In a night of despair, I dreamed I was with my best friend from my schooldays (whom I had not seen for decades and had scarcely ever thought of at that time), tempestuously renewing our friendship and brotherhood. But when I awoke, it became clear that what despair had brought to light like a detonation was the corpse of that boy, who had been immured as a warning: that whoever one day lives here may in no respect resemble him.

Vestibule

A visit to Goethe's house. I cannot recall having seen rooms in the dream. It was a perspective of whitewashed corridors like those in a school. Two elderly English lady visitors and a curator are the dream's extras. The curator requests us to sign the visitors' book lying open on a desk at the farthest end of a passage. On reaching it, I find as I turn the pages my name already entered in big, unruly, childish characters.

Dining Hall

In a dream I saw myself in Goethe's study. It bore no resemblance to the one in Weimar. Above all, it was very small and had only one window. The

side of the writing desk abutted on the wall opposite the window. Sitting and writing at it was the poet, in extreme old age. I was standing to one side when he broke off to give me a small vase, an urn from antiquity, as a present. I turned it between my hands. An immense heat filled the room. Goethe rose to his feet and accompanied me to an adjoining chamber, where a table was set for my relatives. It seemed prepared, however, for many more than their number. Doubtless there were places for my ancestors, too. At the end, on the right, I sat down beside Goethe. When the meal was over, he rose with difficulty, and by gesturing I sought leave to support him. Touching his elbow, I began to weep with emotion.

For Men

To convince is to conquer without conception.

Standard Clock

To great writers, finished works weigh lighter than those fragments on which they work throughout their lives. For only the more feeble and distracted take an inimitable pleasure in closure, feeling that their lives have thereby been given back to them. For the genius each caesura, and the heavy blows of fate, fall like gentle sleep itself into his workshop labor. Around it he draws a charmed circle of fragments. "Genius is application."

Come Back! All Is Forgiven!

Like someone performing the giant swing on the horizontal bar, each boy spins for himself the wheel of fortune from which, sooner or later, the momentous lot shall fall. For only that which we knew or practiced at fifteen will one day constitute our attraction. And one thing, therefore, can never be made good: having neglected to run away from one's parents. From forty-eight hours' exposure in those years, as if in a caustic solution, the crystal of life's happiness forms.

Manorially Furnished Ten-Room Apartment

The furniture style of the second half of the nineteenth century has received its only adequate description, and analysis, in a certain type of detective novel at the dynamic center of which stands the horror of apartments. The arrangement of the furniture is at the same time the site plan of deadly traps, and the suite of rooms prescribes the path of the fleeing victim. That this kind of detective novel begins with Poe—at a time when such accommodations hardly yet existed—is no counterargument. For without exception the

great writers perform their combinations in a world that comes after them, just as the Paris streets of Baudelaire's poems, as well as Dostoevsky's characters, existed only after 1900. The bourgeois interior of the 1860s to the 1890s—with its gigantic sideboards distended with carvings, the sunless corners where potted palms sit, the balcony embattled behind its balustrade, and the long corridors with their singing gas flames—fittingly houses only the corpse. "On this sofa the aunt cannot but be murdered." The soulless luxury of the furnishings becomes true comfort only in the presence of a dead body. Far more interesting than the Oriental landscapes in detective novels is that rank Orient inhabiting their interiors: the Persian carpet and the ottoman, the hanging lamp and the genuine dagger from the Caucasus. Behind the heavy, gathered Khilim tapestries, the master of the house has orgies with his share certificates, feels himself the eastern merchant, the indolent pasha in the caravanserai of otiose enchantment, until that dagger in its silver sling above the divan puts an end, one fine afternoon, to his siesta and himself. This character of the bourgeois apartment, tremulously awaiting the nameless murderer like a lascivious old lady her gallant, has been penetrated by a number of authors who, as writers of "detective stories"—and perhaps also because in their works part of the bourgeois pandemonium is exhibited—have been denied the reputation they deserve. The quality in question has been captured in isolated writings by Conan Doyle and in a major work by A. K. Green.[1] And with *The Phantom of the Opera,* one of the great novels about the nineteenth century, Gaston Leroux has brought the genre to its apotheosis.

Chinese Curios

These are days when no one should rely unduly on his "competence." Strength lies in improvisation. All the decisive blows are struck left-handed.

At the beginning of the long downhill lane that leads to the house of ———, whom I visited each evening, is a gate. After she moved, the opening of its archway henceforth stood before me like an ear that has lost the power of hearing.

A child in his nightshirt cannot be prevailed upon to greet an arriving visitor. Those present, invoking a higher moral standpoint, admonish him in vain to overcome his prudery. A few minutes later he reappears, now stark naked, before the visitor. In the meantime he has washed.

The power of a country road when one is walking along it is different from the power it has when one is flying over it by airplane. In the same way, the power of a text when it is read is different from the power it has when it

is copied out. The airplane passenger sees only how the road pushes through the landscape, how it unfolds according to the same laws as the terrain surrounding it. Only he who walks the road on foot learns of the power it commands, and of how, from the very scenery that for the flier is only the unfurled plain, it calls forth distances, belvederes, clearings, prospects at each of its turns like a commander deploying soldiers at a front. Only the copied text thus commands the soul of him who is occupied with it, whereas the mere reader never discovers the new aspects of his inner self that are opened by the text, that road cut through the interior jungle forever closing behind it: because the reader follows the movement of his mind in the free flight of daydreaming, whereas the copier submits it to command. The Chinese practice of copying books was thus an incomparable guarantee of literary culture, and the transcript a key to China's enigmas.

Gloves

In an aversion to animals, the predominant feeling is fear of being recognized by them through contact. The horror that stirs deep in man is an obscure awareness that something living within him is so akin to the animal that it might be recognized. All disgust is originally disgust at touching. Even when the feeling is mastered, it is only by a drastic gesture that overleaps its mark: the nauseating is violently engulfed, eaten, while the zone of finest epidermal contact remains taboo. Only in this way is the paradox of the moral demand to be met, exacting simultaneously the overcoming and the subtlest elaboration of man's sense of disgust. He may not deny his bestial relationship with the creature, the invocation of which revolts him: he must make himself its master.

Mexican Embassy

Je ne passe jamais devant un fétiche de bois, un Bouddha doré, une idole mexicaine sans me dire: c'est peut-être le vrai dieu. [I never pass by a wooden fetish, a gilded Buddha, a Mexican idol without reflecting: perhaps it is the true God.]
—Charles Baudelaire

I dreamed I was a member of an exploring party in Mexico. After crossing a high, primeval jungle, we came upon a system of above-ground caves in the mountains. Here, a religious order had survived from the time of the first missionaries till now, its monks continuing the work of conversion among the natives. In an immense central grotto with a gothically pointed roof, Mass was celebrated according to the most ancient rites. We joined the ceremony and witnessed its climax: toward a wooden bust of God the

Father, fixed high on a wall of the cave, a priest raised a Mexican fetish. At this, the divine head turned thrice in denial from right to left.

To the Public: Please Protect and Preserve These New Plantings

What is "solved"? Do not all the questions of our lives, as we live, remain behind us like foliage obstructing our view? To uproot this foliage, even to thin it out, does not occur to us. We stride on, leave it behind, and from a distance it is indeed open to view, but indistinct, shadowy, and all the more enigmatically entangled.

Commentary and translation stand in the same relation to the text as style and mimesis to nature: the same phenomenon considered from different aspects. On the tree of the sacred text, both are only the eternally rustling leaves; on that of the profane, the seasonally falling fruits.

He who loves is attached not only to the "faults" of the beloved, not only to the whims and weaknesses of a woman. Wrinkles in the face, moles, shabby clothes, and a lopsided walk bind him more lastingly and relentlessly than any beauty. This has long been known. And why? If the theory is correct that feeling is not located in the head, that we sentiently experience a window, a cloud, a tree not in our brains but rather in the place where we see it, then we are, in looking at our beloved, too, outside ourselves. But in a torment of tension and ravishment. Our feeling, dazzled, flutters like a flock of birds in the woman's radiance. And as birds seek refuge in the leafy recesses of a tree, feelings escape into the shaded wrinkles, the awkward movements and inconspicuous blemishes of the body we love, where they can lie low in safety. And no passer-by would guess that it is just here, in what is defective and censurable, that the fleeting darts of adoration nestle.

Construction Site

It is folly to brood pedantically over the production of objects—visual aids, toys, or books—that are supposed to be suitable for children. Since the Enlightenment, this has been one of the mustiest speculations of the pedagogues. Their infatuation with psychology keeps them from perceiving that the world is full of the most unrivaled objects for children's attention and use. And the most specific. For children are particularly fond of haunting any site where things are being visibly worked on. They are irresistibly drawn by the detritus generated by building, gardening, housework, tailoring, or carpentry. In waste products they recognize the face that the world of things turns directly and solely to them. In using these things, they do not so much imitate the works of adults as bring together, in the artifact

produced in play, materials of widely differing kinds in a new, intuitive relationship. Children thus produce their own small world of things within the greater one. The norms of this small world must be kept in mind if one wishes to create things specially for children, rather than let one's adult activity, through its requisites and instruments, find its own way to them.

Ministry of the Interior

The more antagonistic a person is toward the traditional order, the more inexorably he will subject his private life to the norms that he wishes to elevate as legislators of a future society. It is as if these laws, nowhere yet realized, placed him under obligation to enact them in advance, at least in the confines of his own existence. In contrast, the man who knows himself to be in accord with the most ancient heritage of his class or nation will sometimes bring his private life into ostentatious contrast to the maxims that he unrelentingly asserts in public, secretly approving his own behavior, without the slightest qualms, as the most conclusive proof of the unshakable authority of the principles he puts on display. Thus are distinguished the types of the anarcho-socialist and the conservative politician.

Flag . . .

How much more easily the leave-taker is loved! For the flame burns more purely for those vanishing in the distance, fueled by the fleeting scrap of material waving from the ship or railway window. Separation penetrates the disappearing person like a pigment and steeps him in gentle radiance.

. . . at Half-Mast

When a person very close to us is dying, there is (we dimly apprehend) something in the months to come that—much as we should have liked to share it with him—could happen only through his absence. We greet him, at the last, in a language that he already no longer understands.

Imperial Panorama

A Tour through the German Inflation[2]

I. In the stock of phraseology that lays bare the amalgam of stupidity and cowardice constituting the mode of life of the German bourgeois, the locution referring to impending catastrophe—"Things can't go on like this"—is particularly noteworthy. The helpless fixation on notions of security and property deriving from past decades keeps the average citizen from perceiving the quite remarkable stabilities of an entirely new kind that underlie the

present situation. Because the relative stabilization of the prewar years benefited him, he feels compelled to regard any state that dispossesses him as unstable. But stable conditions need by no means be pleasant conditions, and even before the war there were strata for whom stabilized conditions were stabilized wretchedness. To decline is no less stable, no more surprising, than to rise. Only a view that acknowledges downfall as the sole reason for the present situation can advance beyond enervating amazement at what is daily repeated, and perceive the phenomena of decline as stability itself and rescue alone as extraordinary, verging on the marvelous and incomprehensible. People in the national communities of Central Europe live like the inhabitants of an encircled town whose provisions and gunpowder are running out and for whom deliverance is, by human reasoning, scarcely to be expected—a situation in which surrender, perhaps unconditional, should be most seriously considered. But the silent, invisible power that Central Europe feels opposing it does not negotiate. Nothing, therefore, remains but to direct the gaze, in perpetual expectation of the final onslaught, on nothing except the extraordinary event in which alone salvation now lies. But this necessary state of intense and uncomplaining attention could, because we are in mysterious contact with the powers besieging us, really call forth a miracle. Conversely, the assumption that things cannot go on like this will one day confront the fact that for the suffering of individuals, as of communities, there is only one limit beyond which things cannot go: annihilation.

II. A curious paradox: people have only the narrowest private interest in mind when they act, yet they are at the same time more than ever determined in their behavior by the instincts of the mass. And mass instincts have become confused and estranged from life more than ever. Whereas the obscure impulse of the animal (as innumerable anecdotes relate) detects, as danger approaches, a way of escape that still seems invisible, this society, each of whose members cares only for his own abject well-being, falls victim—with animal insensibility but without the insensate intuition of animals—as a blind mass, to even the most obvious danger, and the diversity of individual goals is immaterial in face of the identity of the determining forces. Again and again it has been shown that society's attachment to its familiar and long-since-forfeited life is so rigid as to nullify the genuinely human application of intellect, forethought, even in dire peril. So that in this society the picture of imbecility is complete: uncertainty, indeed perversion, of vital instincts; and impotence, indeed decay, of the intellect. This is the condition of the entire German bourgeoisie.

III. All close relationships are lit up by an almost intolerable, piercing clarity in which they are scarcely able to survive. For on the one hand, money

stands ruinously at the center of every vital interest, but, on the other, this is the very barrier before which almost all relationships halt; so, more and more, in the natural as in the moral sphere, unreflecting trust, calm, and health are disappearing.

IV. Not without reason is it customary to speak of "naked" misery. What is most damaging in the display of it, a practice started under the dictates of necessity and making visible only a thousandth part of the hidden distress, is not the onlooker's pity or his equally terrible awareness of his own impunity, but his shame. It is impossible to remain in a large German city, where hunger forces the most wretched to live on the banknotes with which passers-by seek to cover an exposure that wounds them.

V. "Poverty disgraces no man." Well and good. But *they* disgrace the poor man. They do it, and then console him with the little adage. It is one of those that may once have been true but have long since degenerated. The case is no different with the brutal dictum, "If a man does not work, neither shall he eat." When there was work that fed a man, there was also poverty that did not disgrace him, if it arose from deformity or other misfortune. But this deprivation, into which millions are born and hundreds of thousands are dragged by impoverishment, does indeed bring disgrace. Filth and misery grow up around them like walls, the work of invisible hands. And just as a man can endure much in isolation but feels justifiable shame when his wife sees him bear it or suffers it herself, so he may tolerate much so long as he is alone, and everything so long as he conceals it. But no one may ever make peace with poverty when it falls like a gigantic shadow upon his countrymen and his house. Then he must be alert to every humiliation done to him, and so discipline himself that his suffering becomes no longer the downhill road of grief but the rising path of revolt. Yet there is no hope of this so long as each blackest, most terrible stroke of fate, daily and even hourly discussed by the press, set forth in all its illusory causes and effects, helps no one uncover the dark powers that hold his life in thrall.

VI. To the foreigner who is cursorily acquainted with the pattern of German life and who has even briefly traveled about the country, its inhabitants seem no less bizarre than an exotic race. A witty Frenchman has said: "A German seldom understands himself. If he has once understood himself, he will not say so. If he says so, he will not make himself understood." This comfortless distance was increased by the war, but not merely through the real and legendary atrocities that Germans are reported to have committed. Rather, what completes the isolation of Germany in the eyes of other Europeans— what really engenders the attitude that, in dealing with the Germans, they are dealing with Hottentots (as it has been aptly put)—is the violence,

incomprehensible to outsiders and wholly imperceptible to those imprisoned by it, with which circumstances, squalor, and stupidity here subjugate people entirely to collective forces, as the lives of savages alone are subjected to tribal laws. The most European of all accomplishments, that more or less discernible irony with which the life of the individual asserts the right to run its course independently of the community into which it is cast, has completely deserted the Germans.

VII. The freedom of conversation is being lost. If, earlier, it was a matter of course in conversation to take interest in one's interlocutor, now this is replaced by inquiry into the cost of his shoes or of his umbrella. Irresistibly intruding on any convivial exchange is the theme of the conditions of life, of money. What this theme involves is not so much the concerns and sorrows of individuals, in which they might be able to help one another, as the overall picture. It is as if one were trapped in a theater and had to follow the events on the stage whether one wanted to or not—had to make them again and again, willingly or unwillingly, the subject of one's thought and speech.

VIII. Anyone who does not simply refuse to perceive decline will hasten to claim a special justification for his own continued presence, his activity and involvement in this chaos. There are as many exceptions for one's own sphere of action, place of residence, and moment of time as there are insights into the general failure. A blind determination to save the prestige of personal existence—rather than, through an impartial disdain for its impotence and entanglement, at least to detach it from the background of universal delusion—is triumphing almost everywhere. That is why the air is so thick with life theories and world views, and why in this country they cut so presumptuous a figure, for almost always they finally serve to sanction some utterly trivial private situation. For just the same reason the air is teeming with phantoms, mirages of a glorious cultural future breaking upon us overnight in spite of all, for everyone is committed to the optical illusions of his isolated standpoint.

IX. The people cooped up in this country no longer discern the contours of human personality. Every free man appears to them as an eccentric. Let us imagine the peaks of the High Alps silhouetted not against the sky but against folds of dark drapery. The mighty forms would show up only dimly. In just this way a heavy curtain shuts off Germany's sky, and we no longer see the profiles of even the greatest men.

X. Warmth is ebbing from things. Objects of daily use gently but insistently repel us. Day by day, in overcoming the sum of secret resistances—not only the overt ones—that they put in our way, we have an immense labor to

perform. We must compensate for their coldness with our warmth if they are not to freeze us to death, and handle their spiny forms with infinite dexterity if we are not to bleed to death. From our fellow men we should expect no succor. Bus conductors, officials, workmen, salesmen—they all feel themselves to be the representatives of a refractory material world whose menace they take pains to demonstrate through their own surliness. And in the denaturing of things—a denaturing with which, emulating human decay, they punish humanity—the country itself conspires. It gnaws at us like the things, and the German spring that never comes is only one of countless related phenomena of decomposing German nature. Here one lives as if the weight of the column of air that everyone supports had suddenly, against all laws, become in these regions perceptible.

XI. Any human movement, whether it springs from an intellectual or even a natural impulse, is impeded in its unfolding by the boundless resistance of the outside world. A shortage of houses and the rising cost of travel are in the process of annihilating the elementary symbol of European freedom, which existed in certain forms even in the Middle Ages: freedom of domicile. And if medieval coercion bound men to natural associations, they are now chained together in unnatural community. Few things will further the ominous spread of the cult of rambling as much as the strangulation of the freedom of residence, and never has freedom of movement stood in greater disproportion to the abundance of means of travel.

XII. Just as all things, in an irreversible process of mingling and contamination, are losing their intrinsic character while ambiguity displaces authenticity, so is the city. Great cities—whose incomparably sustaining and reassuring power encloses those who work within them in an internal truce [*Burgfrieden*] and lifts from them, with the view of the horizon, awareness of the ever-vigilant elemental forces—are seen to be breached at all points by the invading countryside. Not by the landscape, but by what is bitterest in untrammeled nature: ploughed land, highways, night sky that the veil of vibrant redness no longer conceals. The insecurity of even the busy areas puts the city dweller in the opaque and truly dreadful situation in which he must assimilate, along with isolated monstrosities from the open country, the abortions of urban architectonics.

XIII. Noble indifference to the spheres of wealth and poverty has quite forsaken manufactured things. Each thing stamps its owner, leaving him only the choice of appearing a starveling or a racketeer. For although even true luxury can be permeated by intellect and conviviality and so forgotten, the luxury goods swaggering before us now parade such brazen solidity that all the mind's shafts break harmlessly on their surface.

XIV. The earliest customs of peoples seem to send us a warning that, in accepting what we receive so abundantly from nature, we should guard against a gesture of avarice. For we are unable to make Mother Earth any gift of our own. It is therefore fitting to show respect in taking, by returning a part of all we receive before laying hands on our share. This respect is expressed in the ancient custom of the libation. Indeed, it is perhaps this immemorial practice that has survived, transformed, in the prohibition on gathering forgotten ears of corn or fallen grapes, these reverting to the soil or to the ancestral dispensers of blessings. An Athenian custom forbade the picking up of crumbs at the table, since they belonged to the heroes.—If society has so denatured itself through necessity and greed that it can now receive the gifts of nature only rapaciously—that it snatches the fruit unripe from the trees in order to sell it most profitably, and is compelled to empty each dish in its determination to have enough—the earth will be impoverished and the land will yield bad harvests.

Underground Works

In a dream, I saw barren terrain. It was the marketplace at Weimar. Excavations were in progress. I, too, scraped about in the sand. Then the tip of a church steeple came to light. Delighted, I thought to myself: a Mexican shrine from the time of pre-animism, from the Anaquivitzli. I awoke laughing. (Ana = ἀνά; vi = vie; witz [joke] = Mexican church [!])

Coiffeur for Easily Embarrassed Ladies

Three thousand ladies and gentlemen from the Kurfürstendamm are to be arrested in their beds one morning without explanation and detained for twenty-four hours. At midnight a questionnaire on the death penalty is distributed to the cells—a questionnaire requiring its signatories to indicate which form of execution they would prefer, should the occasion arise. Those who hitherto had merely offered their unsolicited views "in all conscience" would have to complete this document "to the best of their knowledge." By first light—the hour that in olden times was held sacred but that in this country is dedicated to the executioner—the question of capital punishment would be resolved.

Caution: Steps

Work on good prose has three steps: a musical stage when it is composed, an architectonic one when it is built, and a textile one when it is woven.

Attested Auditor of Books

Just as this era is the antithesis of the Renaissance in general, it contrasts in particular with the situation in which the art of printing was discovered. For whether by coincidence or not, printing appeared in Germany at a time when the book in the most eminent sense of the word—the Book of Books—had, through Luther's translation, become the people's property. Now everything indicates that the book in this traditional form is nearing its end. Mallarmé, who in the crystalline structure of his manifestly traditionalist writing saw the true image of what was to come, was in the *Coup de dés* the first to incorporate the graphic tensions of the advertisement in the printed page. The typographic experiments later undertaken by the Dadaists stemmed, it is true, not from constructive principles but from the precise nervous reactions of these literati, and were therefore far less enduring than Mallarmé's, which grew out of the inner nature of his style. But for this very reason they show the contemporary relevance of what Mallarmé, monadically, in his hermetic room, had discovered through a preestablished harmony with all the decisive events of our times in economics, technology, and public life. Script—having found, in the book, a refuge in which it can lead an autonomous existence—is pitilessly dragged out into the street by advertisements and subjected to the brutal heteronomies of economic chaos. This is the hard schooling of its new form. If centuries ago it began gradually to lie down, passing from the upright inscription to the manuscript resting on sloping desks before finally taking itself to bed in the printed book, it now begins just as slowly to rise again from the ground. The newspaper is read more in the vertical than in the horizontal plane, while film and advertisement force the printed word entirely into the dictatorial perpendicular. And before a contemporary finds his way clear to opening a book, his eyes have been exposed to such a blizzard of changing, colorful, conflicting letters that the chances of his penetrating the archaic stillness of the book are slight. Locust swarms of print, which already eclipse the sun of what city dwellers take for intellect, will grow thicker with each succeeding year. Other demands of business life lead further. The card index marks the conquest of three-dimensional writing, and so presents an astonishing counterpoint to the three-dimensionality of script in its original form as rune or knot notation. (And today the book is already, as the present mode of scholarly production demonstrates, an outdated mediation between two different filing systems. For everything that matters is to be found in the card box of the researcher who wrote it, and the scholar studying it assimilates it into his own card index.) But it is quite beyond doubt that the development of writing will not indefinitely be bound by the claims to power of a chaotic academic and commercial activity; rather, quantity is approaching the moment of a qualitative leap when writing, advancing ever more deeply into the graphic regions of its new eccentric figurativeness, will suddenly take

possession of an adequate material content. In this picture-writing, poets, who will now as in earliest times be first and foremost experts in writing, will be able to participate only by mastering the fields in which (quite unobtrusively) it is being constructed: statistical and technical diagrams. With the founding of an international moving script, poets will renew their authority in the life of peoples, and find a role awaiting them in comparison to which all the innovative aspirations of rhetoric will reveal themselves as antiquated daydreams.

Teaching Aid

Principles of the Weighty Tome, or How to Write Fat Books

I. The whole composition must be permeated with a protracted and wordy exposition of the initial plan.

II. Terms are to be included for conceptions that, except in this definition, appear nowhere in the whole book.

III. Conceptual distinctions laboriously arrived at in the text are to be obliterated again in the relevant notes.

IV. For concepts treated only in their general significance, examples should be given; if, for example, machines are mentioned, all the different kinds of machines should be enumerated.

V. Everything that is known a priori about an object is to be consolidated by an abundance of examples.

VI. Relationships that could be represented graphically must be expounded in words. Instead of being represented in a genealogical tree, for example, all family relationships are to be enumerated and described.

VII. Numerous opponents who all share the same argument should each be refuted individually.

The typical work of modern scholarship is intended to be read like a catalogue. But when shall we actually write books like catalogues? If the deficient content were thus to determine the outward form, an excellent piece of writing would result, in which the value of opinions would be marked without their being thereby put on sale.

The typewriter will alienate the hand of the man of letters from the pen only when the precision of typographic forms has directly entered the conception of his books. One might suppose that new systems with more variable typefaces would then be needed. They will replace the pliancy of the hand with the innervation of commanding fingers.

A period that, constructed metrically, afterward has its rhythm upset at a single point yields the finest prose sentence imaginable. In this way a ray of

light falls through a chink in the wall of the alchemist's cell, to light up gleaming crystals, spheres, and triangles.

Germans, Drink German Beer!

The mob, impelled by a frenetic hatred of the life of the mind, has found a sure way to annihilate it in the counting of bodies. Given the slightest opportunity, they form ranks and advance into artillery barrages and department stores in marching order. No one sees further than the back before him, and each is proud to be thus exemplary for the eyes behind. Men have been adept at this for centuries in the field, but the parade-march of penury, standing in line, is the invention of women.

Post No Bills

The Writer's Technique in Thirteen Theses

I. Anyone intending to embark on a major work should be lenient with himself and, having completed a stint, deny himself nothing that will not prejudice the next.

II. Talk about what you have written, by all means, but do not read from it while the work is in progress. Every gratification procured in this way will slacken your tempo. If this regime is followed, the growing desire to communicate will become in the end a motor for completion.

III. In your working conditions, avoid everyday mediocrity. Semi-relaxation, to a background of insipid sounds, is degrading. On the other hand, accompaniment by an étude or a cacophony of voices can become as significant for work as the perceptible silence of the night. If the latter sharpens the inner ear, the former acts as touchstone for a diction ample enough to bury even the most wayward sounds.

IV. Avoid haphazard writing materials. A pedantic adherence to certain papers, pens, inks is beneficial. No luxury, but an abundance of these utensils is indispensable.

V. Let no thought pass incognito, and keep your notebook as strictly as the authorities keep their register of aliens.

VI. Keep your pen aloof from inspiration, which it will then attract with magnetic power. The more circumspectly you delay writing down an idea, the more maturely developed it will be on surrendering itself. Speech conquers thought, but writing commands it.

VII. Never stop writing because you have run out of ideas. Literary honor requires that one break off only at an appointed moment (a mealtime, a meeting) or at the end of the work.

VIII. Fill the lacunae in your inspiration by tidily copying out what you have already written. Intuition will awaken in the process.

IX. *Nulla dies sine linea*[3]—but there may well be weeks.

X. Consider no work perfect over which you have not once sat from evening to broad daylight.

XI. Do not write the conclusion of a work in your familiar study. You would not find the necessary courage there.

XII. Stages of composition: idea—style—writing. The value of the fair copy is that in producing it you confine attention to calligraphy. The idea kills inspiration; style fetters the idea; writing pays off style.

XIII. The work is the death mask of its conception.

Thirteen Theses against Snobs

(Snob in the private office of art criticism. On the left, a child's drawing; on the right, a fetish. Snob: "Picasso might as well pack it in!")

I. The artist makes a work.	The primitive man expresses himself in documents.
II. The artwork is only incidentally a document.	No document is, as such, a work of art.
III. The artwork is a masterpiece.	The document serves to instruct.
IV. With artworks, artists learn their craft.	With documents, a public is educated.
V. Artworks are remote from one another in their perfection.	All documents communicate through their subject matter.
VI. In the artwork, content and form are one: meaning [*Gehalt*].	In documents the subject matter is wholly dominant.
VII. Meaning is the outcome of experience.	Subject matter is the outcome of dreams.
VIII. In the artwork, subject matter is ballast jettisoned by contemplation.	The more one loses oneself in a document, the denser the subject matter grows.
IX. In the artwork, the formal law is central.	Forms are merely dispersed in documents.
X. The artwork is synthetic: an energy-center.	The fertility of the document demands: analysis.
XI. The artwork intensifies itself under the repeated gaze.	A document overpowers only through surprise.
XII. The masculinity of works lies in assault.	The document's innocence gives it cover.
XIII. The artist sets out to conquer meanings.	The primitive man barricades himself behind subject matter.

The Critic's Technique in Thirteen Theses

I. The critic is the strategist in the literary struggle.

II. He who cannot take sides must keep silent.

III. The critic has nothing in common with the interpreter of past cultural epochs.

IV. Criticism must speak the language of artists. For the concepts of the *cénacle* are slogans. And only in slogans is the battle-cry heard.

V. "Objectivity" must always be sacrificed to partisanship, if the cause fought for merits this.

VI. Criticism is a moral question. If Goethe misjudged Hölderlin and Kleist, Beethoven and Jean Paul,[4] his morality and not his artistic discernment was at fault.

VII. For the critic, his colleagues are the higher authority. Not the public. Still less, posterity.

VIII. Posterity forgets or acclaims. Only the critic judges in the presence of the author.

IX. Polemics mean to destroy a book using a few of its sentences. The less it has been studied, the better. Only he who can destroy can criticize.

X. Genuine polemics approach a book as lovingly as a cannibal spices a baby.

XI. Artistic enthusiasm is alien to the critic. In his hand, the artwork is the shining sword in the battle of minds.

XII. The art of the critic in a nutshell: to coin slogans without betraying ideas. The slogans of an inadequate criticism peddle ideas to fashion.

XIII. The public must always be proved wrong, yet always feel represented by the critic.

Number 13

Treize—j'eus un plaisir cruel de m'arrêter sur ce nombre. [Thirteen—stopping at this number, I felt a cruel pleasure.]
—Marcel Proust

Le reploiement vierge du livre, encore, prête à un sacrifice dont saigna la tranche rouge des anciens tomes; l'introduction d'une arme, ou coupe-papier, pour établir la prise de possession. [The tight-folded book, virginal still, awaiting the sacrifice that bloodied the red edges of earlier volumes; the insertion of a weapon, or paper-knife, to effect the taking of possession.]
—Stéphane Mallarmé

I. Books and harlots can be taken to bed.

II. Books and harlots interweave time. They command night as day, and day as night.

III. No one can tell from looking at books and harlots that minutes are precious to them. But closer acquaintance shows what a hurry they are in. As our interest becomes absorbed, they, too, are counting.

IV. Books and harlots have always been unhappily in love with each other.

V. Books and harlots: both have their type of man, who lives off them as well as harasses them. In the case of books, critics.

VI. Books and harlots in public establishments—for students.

VII. Books and harlots: seldom does one who has possessed them witness their end. They are apt to vanish before they expire.

VIII. Books and harlots are fond of recounting, mendaciously, how they became what they are. In reality, they did not often notice it themselves. For years one follows "the heart" wherever it leads, and one day a corpulent body stands soliciting on the spot where one had lingered merely to "study life."

IX. Books and harlots love to turn their backs when putting themselves on show.

X. Books and harlots have a large progeny.

XI. Books and harlots: "Old hypocrites—young whores." How many books that were once notorious now serve as instruction for youth!

XII. Books and harlots have their quarrels in public.

XIII. Books and harlots: footnotes in one are as banknotes in the stockings of the other.

Ordnance

I had arrived in Riga to visit a woman friend. Her house, the town, the language were unfamiliar to me. Nobody was expecting me; no one knew me. For two hours I walked the streets in solitude. Never again have I seen them so. From every gate a flame darted; each cornerstone sprayed sparks, and every streetcar came toward me like a fire engine. For she might have stepped out of the gateway, around the corner, been sitting in the streetcar. But of the two of us, I had to be, at any price, the first to see the other. For had she touched me with the match of her eyes, I would have gone up like a powder keg.

First Aid

A highly convoluted neighborhood, a network of streets that I had avoided for years, was disentangled at a single stroke when one day a person dear to me moved there. It was as if a searchlight set up at this person's window dissected the area with pencils of light.

Interior Decoration

The tractatus is an Arabic form. Its exterior is undifferentiated and unobtrusive, like the façades of Arabian buildings, whose articulation of begins only in the courtyard. So, too, the articulated structure of the tractatus is invisible from the outside, revealing itself only from within. If it is formed by chapters, they have not verbal headings but numbers. The surface of its deliberations is not enlivened with pictures, but covered with unbroken, proliferating arabesques. In the ornamental density of this presentation, the distinction between thematic and excursive expositions is abolished.

Stationers

Pharus map.[5]—I know someone who is absent-minded. Whereas the names of my suppliers, the location of my documents, the addresses of my friends and acquaintances, the hour of a rendezvous are at my fingertips, in this person political concepts, party slogans, declarations, and commands are firmly lodged. She lives in a city of watchwords and inhabits a neighborhood of conspiratorial and fraternal terms, where every alleyway shows its color and every word has a password for its echo.

List of wishes.—"Does not the reed the world / With sweetness fill? / May no less gracious word / Flow from my quill!"[6] This follows "Blessed Yearning" ["Selige Sehnsucht"] like a pearl that has rolled from a freshly opened oystershell.

Pocket diary.—Few things are more characteristic of the Nordic man than that, when in love, he must above all and at all costs be alone with himself—must first contemplate, enjoy his feeling in solitude—before going to the woman to declare it.

Paperweight.—Place de la Concorde: the Obelisk. What was carved in it four thousand years ago today stands at the center in the greatest of city squares. Had that been foretold to the Pharaoh, what a feeling of triumph it would given him! The foremost Western cultural empire would one day bear at its center the memorial of his rule. How does this apotheosis appear in reality? Not one among the tens of thousands who pass by pauses; not one among the tens of thousands who pause can read the inscription. In such a way does all fame redeem its pledges, and no oracle can match its guile. For the immortal stands like this obelisk, regulating the spiritual traffic that surges thunderously about him—and the inscription he bears helps no one.

Fancy Goods

The incomparable language of the death's-head: total expressionlessness—the black of the eye sockets—coupled with the most unbridled expression—the grinning rows of teeth.

Someone who, feeling abandoned, takes up a book, finds with a pang that the page he is about to turn is already cut, and that even here he is not needed.

Gifts must affect the receiver to the point of shock.

When a valued, cultured, and elegant friend sent me his new book and I was about to open it, I caught myself in the act of straightening my tie.

He who observes etiquette but objects to lying is like someone who dresses fashionably but wears no shirt.

If the smoke from the tip of my cigarette and the ink from the nib of my pen flowed with equal ease, I would be in the Arcadia of my writing.

To be happy is to be able to become aware of oneself without fright.

Enlargements

Child reading.—You are given a book from the school library. In the lower classes, books are simply handed out. Only now and again do you dare express a desire. Often, in envy, you see coveted books pass into other hands. At last, your wish was granted. For a week you were wholly given up to the soft drift of the text, which surrounded you as secretly, densely, and unceasingly as snow. You entered it with limitless trust. The peacefulness of the book that enticed you further and further! Its contents did not much matter. For you were reading at the time when you still made up stories in bed. The child seeks his way along the half-hidden paths. Reading, he covers his ears; the book is on a table that is far too high, and one hand is always on the page. To him, the hero's adventures can still be read in the swirling letters like figures and messages in drifting snowflakes. His breath is part of the air of the events narrated, and all the participants breathe it. He mingles with the characters far more closely than grown-ups do. He is unspeakably touched by the deeds, the words that are exchanged; and, when he gets up, he is covered over and over by the snow of his reading.

Belated child.—The clock over the school playground seems as if damaged on his account. The hands stand at "Tardy." And as he passes in the corridor, murmurs of secret consultation come from the classroom doors. The teachers and pupils behind them are friends. Or all is silent, as if they were waiting for someone. Inaudibly, he puts his hand to the doorhandle. The spot where he stands is steeped in sunlight. Violating the peaceful hour, he opens the door. The teacher's voice clatters like a mill wheel; he stands before the grinding stones. The voice clatters on without a break, but the mill workers now shake off their load to the newcomer. Ten, twenty heavy sacks fly toward him; these he must carry to the bench. Each thread of his jacket is flour-white. Like the tread of a wretched soul at midnight, his every step makes a clatter, and no one notices. Once arrived at his seat, he works quietly with the rest until the bell sounds. But it avails him nothing.

Pilfering child.—Through the chink of the scarcely open larder door, his hand advances like a lover through the night. Once at home in the darkness, it gropes toward sugar or almonds, raisins or preserves. And just as the lover embraces his girl before kissing her, the child's hand enjoys a tactile tryst with the comestibles before his mouth savors their sweetness. How flatteringly honey, heaps of currants, even rice yield to his hand! How passionate this meeting of two who have at last escaped the spoon! Grateful and tempestuous, like someone who has been abducted from the parental home, strawberry jam, unencumbered by bread rolls, abandons itself to his delectation and, as if under the open sky, even the butter responds tenderly to the boldness of this wooer who has penetrated her boudoir. His hand, the juvenile Don Juan, has soon invaded all the cells and spaces, leaving behind it running layers and streaming plenty: virginity renewing itself without complaint.

Child on the carousel.—The platform bearing the docile animals moves close to the ground. It is at the height which, in dreams, is best for flying. Music starts, and the child moves away from his mother with a jerk. At first he is afraid to leave her. But then he notices how brave he himself is. He is ensconced, like the just ruler, over a world that belongs to him. Tangential trees and natives line his way. Then, in an Orient, his mother reappears. Next, emerging from the jungle, comes a treetop, exactly as the child saw it thousands of years ago—just now on the carousel. His beast is devoted: like a mute Arion he rides his silent fish,[7] or a wooden Zeus-bull carries him off like an immaculate Europa. The eternal recurrence of all things has long become child's wisdom, and life a primeval frenzy of domination, with the booming orchestrion as the crown jewels at the center. As the music slows, space begins to stammer and the trees to come to their senses. The carousel

becomes uncertain ground. And his mother appears, the much-hammered stake about which the landing child winds the rope of his gaze.

Untidy child.—Each stone he finds, each flower he picks, and each butterfly he catches is already the start of a collection, and every single thing he owns makes up one great collection. In him this passion shows its true face, the stern Indian expression that lingers on, but with a dimmed and manic glow, in antiquarians, researchers, bibliomaniacs. Scarcely has he entered life than he is a hunter. He hunts the spirits whose trace he scents in things; between spirits and things, years pass in which his field of vision remains free of people. His life is like a dream: he knows nothing lasting; everything seemingly happens to him by chance. His nomad-years are hours in the forest of dream. To this forest he drags home his booty, to purify it, secure it, cast out its spell. His dresser drawers must become arsenal and zoo, crime museum and crypt. "To tidy up" would be to demolish an edifice full of prickly chestnuts that are spiky clubs, tinfoil that is hoarded silver, bricks that are coffins, cacti that are totem poles, and copper pennies that are shields. The child has long since helped at his mother's linen cupboard and his father's bookshelves, while in his own domain he is still a sporadic, warlike visitor.

Child hiding.—He already knows all the hiding places in the apartment, and returns to them as if to a house where everything is sure to be just as it was. His heart pounds; he holds his breath. Here he is enclosed in the material world. It becomes immensely distinct, speechlessly obtrusive. Only in such a way does a man who is being hanged become aware of the reality of rope and wood. Standing behind the doorway curtain, the child himself becomes something floating and white, a ghost. The dining table under which he is crouching turns him into the wooden idol in a temple whose four pillars are the carved legs. And behind a door, he himself *is* the door—wears it as his heavy mask, and like a shaman will bewitch all those who unsuspectingly enter. At all cost, he must avoid being found. When he makes faces, he is told that all the clock has to do is strike, and his face will stay like that forever. The element of truth in this, he finds out in his hiding place. Anyone who discovers him can petrify him as an idol under the table, weave him forever as a ghost into the curtain, banish him for life into the heavy door. And so, at the seeker's touch, he drives out with a loud cry the demon who has so transformed him; indeed, without waiting for the moment of discovery, he grabs the hunter with a shout of self-deliverance. That is why he does not tire of the struggle with the demon. In this struggle, the apartment is the arsenal of his masks. Yet once each year—in mysterious places, in their empty eye sockets, in their fixed mouths—presents lie.

Magical experience becomes science. As its engineer, the child disenchants the gloomy parental apartment and looks for Easter eggs.

Antiques

Medallion.—In everything that is with reason called beautiful, appearance has a paradoxical effect.

Prayer wheel.—Only images in the mind vitalize the will. The mere word, by contrast, at most inflames it, to leave it smouldering, blasted. There is no intact will without exact pictorial imagination. No imagination without innervation. Now breathing is the latter's most delicate regulator. The sound of formulas is a canon of such breathing. Hence the practice of yoga meditation, which breathes in accord with the holy syllables. Hence its omnipotence.

Antique spoon.—One thing is reserved to the greatest epic writers: the capacity to feed their heroes.

Old map.—In a love affair, most people seek an eternal homeland. Others, but very few, eternal voyaging. The latter are melancholics, who believe that contact with Mother Earth is to be shunned. They seek the person who will keep the homeland's sadness far away from them. To that person they remain faithful. The medieval complexion-books understood the yearning of this human type for long journeys.

Fan.—The following experience will be familiar: if one is in love, or just intensely preoccupied with another person, his portrait will appear in almost every book. Moreover, he appears as both protagonist and antagonist. In stories, novels, and novellas, he is encountered in endless metamorphoses. And from this it follows that the faculty of imagination is the gift of interpolating into the infinitely small, of inventing, for every intensity, an extensiveness to contain its new, compressed fullness—in short, of receiving each image as if it were that of the folded fan, which only in spreading draws breath and flourishes, in its new expanse, the beloved features within it.

Relief.—One is with the woman one loves, speaks with her. Then, weeks or months later, separated from her, one thinks again of what was talked of then. And now the motif seems banal, tawdry, shallow, and one realizes that it was she alone, bending low over it with love, who shaded and sheltered it before us, so that the thought was alive in all its folds and crevices like a

relief. Alone, as now, we see it lie flat, bereft of comfort and shadow, in the light of our knowledge.

Torso.—Only he who can view his own past as an abortion sprung from compulsion and need can use it to full advantage in every present. For what one has lived is at best comparable to a beautiful statue that has had all its limbs broken off in transit, and that now yields nothing but the precious block out of which the image of one's future must be hewn.

Watchmaker and Jeweler

He who, awake and dressed, perhaps while hiking, witnesses the sunrise, preserves all day before others the serenity of one invisibly crowned, and he who sees daybreak while working feels at midday as if he himself has placed this crown upon his head.

Like a clock of life on which the seconds race, the page number hangs over the characters in a novel. Where is the reader who has not once lifted to it a fleeting, fearful glance?

I dreamed that I was walking—a newly hatched private tutor—conversing collegially with Roethe, through the spacious rooms of a museum where he was the curator. While he talks in an adjoining room with an employee, I go up to a glass display case. In it, next to other, lesser objects, stands a metallic or enameled, dully shining, almost life-size bust of a woman, not unlike Leonardo's Flora in the Berlin Museum. The mouth of this golden head is open, and over the lower teeth jewelry, partly hanging from the mouth, is spread at measured intervals. I was in no doubt that this was a clock.—(Dream motifs: blushing for shame [*Scham-Roethe*]; the morning hour has gold in its mouth [*Morgenstunde hat gold im Munde*, "the early bird catches the worm"]; *"La tête, avec l'amas de sa crinière sombre / Et de ses bijoux précieux, / Sur la table de nuit, comme une renoncule, / Repose"* [The head, heaped with its dark mane / and its precious jewels, / on the night-table, like a ranunculus, / rests]—Baudelaire.)

Arc Lamp

The only way of knowing a person is to love that person without hope.

Loggia

Geranium.—Two people who are in love are attached above all else to their names.

Carthusian carnation.—To the lover, the loved one appears always as solitary.

Asphodel.—Behind someone who is loved, the abyss of sexuality closes like that of the family.

Cactus bloom.—The truly loving person delights in finding the beloved, arguing, in the wrong.

Forget-me-not.—Memory always sees the loved one smaller.

Foliage plant.—In the event an obstacle prevents union, the fantasy of a contented, shared old age is immediately at hand.

Lost-and-Found Office

Articles lost.—What makes the very first glimpse of a village, a town, in the landscape so incomparable and irretrievable is the rigorous connection between foreground and distance. Habit has not yet done its work. As soon as we begin to find our bearings, the landscape vanishes at a stroke, like the façade of a house as we enter it. It has not yet gained preponderance through a constant exploration that has become habit. Once we begin to find our way about, that earliest picture can never be restored.

Articles found.—The blue distance which never gives way to foreground or dissolves at our approach, which is not revealed spread-eagled and long-winded when reached but only looms more compact and threatening, is the painted distance of a backdrop. It is what gives stage sets their incomparable atmosphere.

Stand for Not More than Three Cabs

I stood for ten minutes waiting for an omnibus. "*L'Intran . . . Paris-Soir . . . La Liberté,*" a newspaper vendor called incessantly in an unvarying tone behind me. "*L'Intran . . . Paris-Soir . . . La Liberté*"—a three-cornered cell in a hard-labor prison. I saw before me how bleak the corners were.

I saw in a dream "a house of ill-repute." "A hotel in which an animal is spoiled. Practically everyone drinks only spoiled animal-water." I dreamed in these words, and at once woke with a start. Extremely tired, I had thrown myself on my bed in my clothes in the brightly lit room, and had immediately, for a few seconds, fallen asleep.

In tenement blocks, there is a music of such deathly sad wantonness that one cannot believe it is intended for the player: it is music for the furnished rooms, where on Sundays someone sits amid thoughts that are soon garnished with these notes, like a bowl of overripe fruit with withered leaves.

Monument to a Warrior

Karl Kraus.—Nothing more desolating than his acolytes, nothing more godforsaken than his adversaries. No name that would be more fittingly honored by silence. In ancient armor, wrathfully grinning, a Chinese idol, brandishing a drawn sword in each hand, he dances a war-dance before the burial vault of the German language. "Merely one of the epigones that live in the old house of language," he has become the sealer of its tomb. Keeping watch day and night, he endures. No post was ever more loyally held, and none was ever more hopelessly lost. Here stands one who, like a Danaïd, fetches water from the ocean of tears of his contemporaries, and from whose hands the rock which is to bury his enemies rolls like that of Sisyphus. What more helpless than his conversion? What more powerless than his humanity? What more hopeless than his battle with the press? What does he know of the powers that are his true allies? But what vision of the new seers bears comparison with the listening of this shaman, whose utterances even a dead language inspires? Who ever conjured up a spirit as Kraus did in "The Forsaken" ["Die Verlassenen"],[8] as if "Blessed Yearning" ["Selige Sehnsucht"] had never been composed? Helpless as only spirits' voices are when summoned up, a murmur from the chthonic depths of language is the source of his soothsaying. Every sound is incomparably genuine, but they all leave us bewildered, like messages from the beyond. Blind like the *manes,* language calls him to vengeance, as narrowminded as spirits that know only the voice of the blood, who care not what havoc they wreak in the realm of the living. But he cannot err. Their commands are infallible. Whoever runs into him is condemned already: in his mouth, the adversary's name itself becomes a judgment. When his lips part, the colorless flame of wit darts forth. And no one who walks the paths of life would come upon him. On an archaic field of honor, a gigantic battleground of bloody labor, he rages before a deserted sepulcher. The honors at his death will be immeasurable, and the last that are bestowed.

Fire Alarm

The notion of the class war can be misleading. It does not refer to a trial of strength to decide the question "Who shall win, who be defeated?" or to a struggle whose outcome is good for the victor and bad for the vanquished. To think in this way is to romanticize and obscure the facts. For

whether the bourgeoisie wins or loses the fight, it remains doomed by the inner contradictions that in the course of development will become deadly. The only question is whether its downfall will come through itself or through the proletariat. The continuance or the end of three thousand years of cultural development will be decided by the answer. History knows nothing of the evil infinity contained in the image of the two wrestlers locked in eternal combat. The true politician reckons only in dates. And if the abolition of the bourgeoisie is not completed by an almost calculable moment in economic and technical development (a moment signaled by inflation and poison-gas warfare), all is lost. Before the spark reaches the dynamite, the lighted fuse must be cut. The interventions, dangers, and tempi of politicians are technical—not chivalrous.

Travel Souvenirs

Atrani.[9]—The gently rising, curved baroque staircase leading to the church. The railing behind the church. The litanies of the old women at the "Ave Maria": preparing to die first-class. If you turn around, the church verges like God himself on the sea. Each morning the Christian era crumbles the rock, but between the walls below, the night falls always into the four old Roman quarters. Alleyways like air shafts. A well in the marketplace. In the late afternoon, women around it. Then, in solitude: archaic plashing.

Navy.—The beauty of the tall sailing ships is unique. Not only has their outline remained unchanged for centuries, but they appear in the most immutable landscape: at sea, silhouetted against the horizon.

Versailles façade.—It is as if this château had been forgotten where hundreds of years ago it was placed *Par Ordre du Roi* for only two hours as the movable scenery for a *féerie.*[10] Of its splendor it keeps none for itself, giving it undivided to that royal condition which it concludes. Before this backdrop, it becomes a stage on which the tragedy of absolute monarchy was performed like an allegorical ballet. Yet today it is only the wall in the shade of which one seeks to enjoy the prospect into blue distance created by Le Nôtre.[11]

Heidelberg Castle.—Ruins jutting into the sky can appear doubly beautiful on clear days when, in their windows or above their contours, the gaze meets passing clouds. Through the transient spectacle it opens in the sky, destruction reaffirms the eternity of these ruins.

Seville, Alcazar.—An architecture that follows fantasy's first impulse. It is undetected by practical considerations. These rooms provide only for dreams and festivities—their consummation. Here dance and silence become

the leitmotifs, since all human movement is absorbed by the soundless tumult of the ornament.

Marseilles cathedral.—On the sunniest, least frequented square stands the cathedral. This place is deserted, despite the fact that near its feet are La Joliette, the harbor, to the south, and a proletarian district to the north. As a reloading point for intangible, unfathomable goods, the bleak building stands between quay and warehouse. Nearly forty years were spent on it. But when all was complete, in 1893, place and time had conspired victoriously in this monument against its architects and sponsors, and the wealth of the clergy had given rise to a gigantic railway station that could never be opened to traffic. The façade gives an indication of the waiting rooms within, where passengers of the first to fourth classes (though before God they are all equal), wedged among their spiritual possessions as if between suitcases, sit reading hymnbooks that, with their concordances and cross-references, look very much like international timetables. Extracts from the railway traffic regulations in the form of pastoral letters hang on the walls, tariffs for the discount on special trips in Satan's luxury train are consulted, and cabinets where the long-distance traveler can discreetly wash are kept in readiness as confessionals. This is the Marseilles religion station. Sleeping cars to eternity depart from here at Mass times.

Freiburg minster.—The special sense of a town is formed in part for its inhabitants—and perhaps even in the memory of the traveler who has stayed there—by the timber and intervals with which its tower clocks begin to chime.

Moscow, Saint Basil's.—What the Byzantine Madonna carries on her arm is only a life-size wooden doll. Her expression of pain before a Christ whose childhood remains only suggested, represented, is more intense than any she could display with a realistic image of a boy.

Boscotrecase.[12]—The distinction of the forest of stone-pines: its roof is formed without interlacements.

Naples, Museo Nazionale.—Archaic statues offer in their smiles the consciousness of their bodies to the onlooker, as a child holds out to us freshly picked flowers untied and unarranged; later art laces its expressions more tightly, like the adult who binds the lasting bouquet with cut grasses.

Florence, Baptistery.—On the portal, the *Spes* [Hope] by Andrea de Pisano. Sitting, she helplessly extends her arms toward a fruit that remains beyond her reach. And yet she is winged. Nothing is more true.

Sky.—As I stepped from a house in a dream, the night sky met my eyes. It shed intense radiance. For in this plenitude of stars, the images of the constellations stood sensuously present. A Lion, a Maiden, a Scale and many others shone palely down, dense clusters of stars, upon the earth. No moon was to be seen.

Optician

In summer, fat people are conspicuous; in winter, thin.

In spring, attention is caught, in bright sunshine, by the young foliage; in cold rain, by the still-leafless branches.

After a convivial evening, someone remaining behind can see at a glance what it was like from the disposition of plates and cups, glasses and food.

First principle of wooing: to make oneself sevenfold; to place oneself sevenfold about the woman who is desired.

In the eyes we see people to the lees.

Toys

Cut-out models.—Booths have docked like rocking boats on both sides of the stone jetty on which the people jostle. There are sailing vessels with lofty masts hung with pennants, steamers with smoke rising from their funnels, barges that keep their cargoes long stowed. Among them are ships into which one vanishes; only men are admitted, but through hatchways you can see women's arms, veils, peacock feathers. Elsewhere exotic people stand on the deck, apparently trying to frighten the public away with eccentric music. But with what indifference is it received! You climb up hesitantly, with the broad rolling gait used on ships' gangways, and so long as you are aloft you realize that the whole is cut off from the shore. Those who reemerge from below, taciturn and benumbed, have seen, on red scales where dyed alcohol rises and falls, their own marriage come into being and cease to be; the yellow man who began wooing at the foot of this scale, at the top of it deserted his blue wife. In mirrors they have seen the floor melt away beneath their feet like water, and have stumbled into the open on rolling stairways. The fleet has brought unrest to the neighborhood: the women and girls on board have brazen airs, and everything edible has been taken aboard in the land of idle luxury. One is so totally cut off by the ocean that everything is encountered here as if all at once for the first and the last time. Sea lions, dwarfs, and dogs are preserved as if in an ark. Even the railway has been

brought in once and for all, and circulates endlessly through a tunnel. For a few days the neighborhood has become the port of a south-sea island, its inhabitants savages swooning in covetous wonderment before the things that Europe tosses at their feet.

Targets.—The landscapes of shooting-ranges in fairground booths ought to be described collectively as a corpus. There is, for example, a polar waste against which are set bundles of white clay pipes, the targets, radiating like spokes. Behind this, and before an unarticulated strip of woodland, two foresters are painted, while right at the front, like movable scenery, are two sirens with provocative breasts, painted in oil colors. Elsewhere pipes bristle from the hair of women who are seldom painted with skirts, usually in tights. Or they protrude from a fan the women spread in their hands. Moving pipes revolve slowly in the further regions of the clay-pigeon booths. Other stands present theatricals directed by the spectator with his rifle. If he hits the bull's-eye, the performance starts. On one occasion there were thirty-six such boxes, and above the stage of each was written what they held in store: *"Jeanne d'Arc en prison," "L'hospitalité," "Les rues de Paris."* On another booth: *"Exécution capitale."* In front of the closed gate a guillotine, a judge in a black robe, and a priest holding a crucifix. If the shot hits the mark, the gate opens and out comes a board on which the miscreant stands between two policemen. He places his neck automatically under the blade and is decapitated. In the same way: *"Les délices du mariage."* A penurious interior is revealed. The father is seen in the middle of the room; he is holding a child on his knee and, with his free hand, rocking a cradle containing another. *"L'Enfer":* when its gates part, a devil is seen tormenting a wretched soul. Next to him, another is dragging a priest toward a cauldron in which the damned must stew. *"Le bagne"* ["prison"]: a door with a jailer in front of it. When the target is hit, he pulls a bell-cord. The bell rings, the door opens. Two convicts are seen manhandling a big wheel. They seem to have to turn it. Yet another constellation: a fiddler with his dancing bear. When you shoot successfully, the bow moves. The bear beats a drum with his paw and lifts one leg. One thinks of the fairy tale of the brave little tailor, and could also imagine Sleeping Beauty awakened with a shot, Snow White freed of the apple by a shot, or Little Red Riding Hood released by a shot. The shot breaks in magically upon the existence of the puppets with that curative power that hews the heads from monsters and reveals them to be princesses. As is the case with the great door without an inscription: if you have hit the mark it opens, and before red plush curtains stands a Moor who seems to bow slightly. He holds a golden bowl before him. On it lie three pieces of fruit. The first opens; a tiny person stands inside it and bows. In the second, two equally diminutive puppets revolve in a dance. (The third did not open.) Below, in front of the table on

which the remaining scenery stands, a small horseman with the inscription: *"Route minée"* ["mined road"]. If you hit the bull's-eye, there is a bang and the rider somersaults with his horse, but stays—needless to say—in the saddle.

Stereoscope.—Riga. The daily market, a huddling city of low wooden booths, stretches along the jetty, a broad, dirty stone embankment without warehouse buildings, by the waters of the Dvina. Small steamers, often showing no more than their funnels above the quay wall, have put in at the blackish dwarftown. (The larger ships are moored downstream.) Grimy boards are the clay-gray foundation on which, glowing in the cold air, sparse colors melt. At some corners one can find all year round, alongside huts for fish, meat, boots, and clothes, petty-bourgeois women with the colored paper rods that penetrate as far as the West only at Christmastime. Like being scolded by the most-loved voice: such are these rods. For a few centimes, multicolored chastising switches. At the end of the jetty, fenced off and only thirty paces from the water, are the red-and-white mounds of the apple market. The apples on sale are packed in straw; those sold lie without straw in the housewives' baskets. A dark-red church rises beyond, outshone in the fresh November air by the cheeks of the apples.—Several shops for boat tackle in small houses near the jetty. Ropes are painted on them. Everywhere you see wares depicted on signboards or on house walls. One shop in the town has cases and belts larger than life on its bare brick walls. A low corner-house with a shop for corsets and millinery is decorated with ladies' faces complete with finery, and severe bodices painted on a yellow-ocher ground. Protruding from it at an angle is a lantern with similar pictures on its glass panes. The whole is like the façade of a fantasy brothel. Another house, likewise not far from the harbor, has sugar sacks and coal in gray-and-black relief on a gray wall. Somewhere else, shoes rain from horns of plenty. Ironmongery is painted in detail—hammers, cogs, pliers, and the tiniest screws on one board that looks like a page from an outmoded child's painting-book. The town is permeated with such pictures. Between them, however, rise tall, desolate, fortress-like buildings evoking all the terrors of czarism.

Not for sale.—A mechanical cabinet at the fair at Lucca. The exhibition is accommodated in a long, symmetrically divided tent. A few steps lead up to it. The signboard shows a table with a few motionless puppets. You enter the tent by the right-hand opening and leave it by the left. In the bright interior, two tables extend toward the back. They touch with their inner edge, so that only a narrow space is left in which to walk round. Both tables are low and glass-covered. On them stand the puppets (twenty to twenty-five centimeters high, on average), while in their lower concealed part the clock-work that drives them ticks audibly. A narrow raised board for children

runs along the sides of the tables. There are distorting mirrors on the walls.—Next to the entrance, princely personages are to be seen. Each of them makes a particular gesture: one a spacious, inviting movement with the right or left arm, another a swiveling of his glassy eyes; some roll their eyes and move their arms at the same time. Here stand Franz Joseph, Pius IX, enthroned and flanked by two cardinals, Queen Elena of Italy, the sultaness, Wilhelm I on horseback, a small Napoleon III, and an even smaller Victor Emmanuel as crown prince. Biblical figurines follow, then the Passion. Herod orders the slaughter of the infants with manifold movements of the head. He opens his mouth wide while nodding, extends and lets fall his arm. Two executioners stand before him, one free-wheeling with a cutting sword, a decapitated child under his arm; the other, on the point of stabbing, stands motionless but for his rolling eyes. And two mothers are there: one endlessly and gently shaking her head like a depressive, the other raising her arms slowly, beseechingly.—The nailing to the Cross. It lies on the ground. The hirelings hammer in the nails. Christ nods.—Christ crucified, slaked by the vinegar-soaked sponge, which a soldier offers him in slow jerks and then instantly withdraws. Each time, the Savior slightly raises his chin. From behind, an angel bends over the Cross with a chalice for blood, holds it in front of the body and then, as if it were filled, removes it.—The other table shows genre pictures. Gargantua with dumplings. A plateful in front of him, he shovels them into his mouth with both hands, alternately lifting his left arm and his right. Each hand holds a fork on which a dumpling is impaled.—An Alpine maiden spinning.—Two monkeys playing violins.—A magician has two barrel-like containers in front of him. The one on the right opens, and the top half of a lady's body emerges. The one on the left opens: from it rises half-length a man's body. Again the right-hand container opens and now a ram's skull appears with the lady's face between its horns. Then, on the left, a monkey presents itself instead of the man. Then it all starts again from the beginning.—Another magician: he has a table in front of him on which he holds beakers upside-down in each hand. Under them, as he alternately lifts one and then the other, appears now a loaf or an apple, now a flower or dice.—The magic well: a farm boy stands at a well, shaking his head. A girl draws water, and the unfaltering thick stream of glass runs from the well-mouth.—The enchanted lovers: a golden bush or a golden flame parts in two wings. Within are seen two puppets. They turn their faces toward each other and then away, as if looking at each other in confused astonishment.—Below each figure a small label. The whole dating back to 1862.

Polyclinic

The author lays the idea on the marble table of the café. Lengthy observation, for he makes use of the time before the arrival of his glass, the lens

through which he examines the patient. Then, deliberately, he unpacks his instruments: fountain pens, pencil, and pipe. The numerous clientele, arranged as in an amphitheater, make up his clinical audience. Coffee, carefully poured and consumed, puts the idea under chloroform. What this idea may be has no more connection with the matter at hand than the dream of an anaesthetized patient has with the surgical intervention. With the cautious lineaments of handwriting, the operator makes incisions, displaces internal accents, cauterizes proliferations of words, inserts a foreign term as a silver rib. At last, the whole is finely stitched together with punctuation, and he pays the waiter, his assistant, in cash.

This Space for Rent

Fools lament the decay of criticism. For its day is long past. Criticism is a matter of correct distancing. It was at home in a world where perspectives and prospects counted and where it was still possible to adopt a standpoint. Now things press too urgently on human society. The "unclouded," "innocent" eye has become a lie, perhaps the whole naive mode of expression sheer incompetence. Today the most real, mercantile gaze into the heart of things is the advertisement. It tears down the stage upon which contemplation moved, and all but hits us between the eyes with things as a car, growing to gigantic proportions, careens at us out of a film screen. And just as the film does not present furniture and façades in completed forms for critical inspection, their insistent, jerky nearness alone being sensational, the genuine advertisement hurls things at us with the tempo of a good film. Thereby "matter-of-factness" is finally dispatched, and in the face of the huge images spread across the walls of houses, where toothpaste and cosmetics lie handy for giants, sentimentality is restored to health and liberated in American style, just as people whom nothing moves or touches any longer are taught to cry again by films. For the man in the street, however, it is money that affects him in this way, brings him into perceived contact with things. And the paid reviewer, manipulating paintings in the dealer's exhibition room, knows more important if not better things about them than the art lover viewing them in the gallery window. The warmth of the subject is communicated to him, stirs sentient springs. What, in the end, makes advertisements so superior to criticism? Not what the moving red neon sign says—but the fiery pool reflecting it in the asphalt.

Office Equipment

The boss's room bristles with weapons. The apparent comfort that disarms those entering is in reality a hidden arsenal. A telephone on the desk shrills at every moment. It interrupts you at the most important point and gives

your opponent time to contrive an answer. Meanwhile, snatches of conversation show how many matters are dealt with here that are more important than the one under discussion. You say this to yourself, and slowly begin to retreat from your standpoint. You begin to wonder who it is they are talking about, and hear with fright that your interlocutor is leaving tomorrow for Brazil; soon you feel such solidarity with the firm that when he complains of a migraine on the telephone, you regret it as a disturbance of business (rather than welcoming it as an opportunity). Summoned or unsummoned, the secretary enters. She is very pretty. And whether her employer is either indifferent to her charms or has long clarified his position as her admirer, the newcomer will glance over at her more than once; and she knows how to turn this to advantage with her boss. His personnel are in motion, producing card-indexes in which the visitor knows himself to be entered under various rubrics. He starts to tire. The other, with the light behind him, reads this off the dazzlingly illuminated face with satisfaction. The armchair, too, does its work; you sit in it tilted as far back as at the dentist's, and so finally accept this discomfiting procedure as the legitimate state of affairs. This treatment, too, is followed sooner or later by a liquidation.

Mixed Cargo: Shipping and Packing

In the early morning I drove through Marseilles to the station, and as I passed familiar places on my way, and then new, unfamiliar ones or others that I remembered only vaguely, the city became a book in my hands, into which I hurriedly glanced a few last times before it passed from my sight for who knows how long into a warehouse crate.

Closed for Alterations

In a dream, I took my life with a gun. When it went off, I did not wake up but saw myself lying for a while as a corpse. Only then did I wake.

Augeas Self-Service Restaurant

This is the weightiest objection to the mode of life of the confirmed bachelor: he eats by himself. Taking food alone tends to make one hard and coarse. Those accustomed to it must lead a spartan life if they are not to go downhill. Hermits have observed, if for only this reason, a frugal diet. For it is only in company that eating is done justice; food must be divided and distributed if it is to be well received. No matter by whom: formerly, a beggar at the table enriched each banquet. The splitting up and giving are all-important, not sociable conversation. What is surprising, on the other

hand, is that without food conviviality grows precarious. Playing host levels differences, binds together. The count of Saint-Germain fasted before loaded tables, and by this alone dominated conversation. When all abstain, however, rivalries and conflict ensue.

Stamp Shop

To someone looking through piles of old letters, a stamp that has long been out of circulation on a torn envelope often says more than a reading of dozens of pages. Sometimes you come across stamps on postcards and are unsure whether you should detach them or keep the card as it is, like a page by an old master that has different but equally precious drawings on both sides. There are also, in the glass cases of cafés, letters with insufficient postage, pilloried before all eyes. Or have they been deported, and forced to wait in this case for years, languishing on a glass Salas y Gomez?[13] Letters that remain long unopened take on a brutal look; they are disinherited, and malignantly plot revenge for long days of suffering. Many of them later figure in the windows of stamp dealers, as entires branded over and over with postmarks.

As is known, there are collectors who concern themselves only with postmarked stamps, and it would not be difficult to believe them the only ones who have penetrated the secret. They confine themselves to the occult part of the stamp: the postmark. For the postmark is the night side of stamps. There are ceremonious ones that place a halo about the head of Queen Victoria, and prophetic ones that give Humbert[14] a martyr's crown. But no sadistic fantasy can equal the black practice that covers faces with weals, and cleaves the land of entire continents like an earthquake. And the perverse pleasure in contrasting this violated stamp-body with its white lace-trimmed tulle dress: the serrated border. The pursuer of postmarks must, like a detective, possess information on the most notorious post offices, like an archaeologist the art of reconstructing the torsos of the most foreign place-names, and like a cabbalist an inventory of dates for an entire century.

Stamps bristle with tiny numbers, minute letters, diminutive leaves and eyes. They are graphic cellular tissue. All this swarms about and, like lower animals, lives on even when mutilated. This is why such powerful pictures can be made of pieces of stamps stuck together. But in them, life always bears a hint of corruption to signify that it is composed of dead matter. Their portraits and obscene groups are littered with bones and riddled with worms.

Do the color sequences of the long sets perhaps refract the light of a strange sun? Did the postal ministries of the Vatican or Ecuador capture rays unknown to us? And why are we not shown the stamps of the superior planets? The thousand gradations of fire-red that are in circulation on Venus, and the four great gray shades of Mars, and the unnumbered stamps of Saturn?

On stamps, countries and oceans are merely the provinces and kings merely the hirelings of numbers that steep them in their colors at will. Stamp albums are magical reference books; the numbers of monarchs and palaces, of animals and allegories and states, are recorded in them. Postal traffic depends on their harmony as the motions of the planets depend on the harmony of the celestial numbers.

Old *groschen*-stamps showing only one or two large figures in an oval. They look like those first photos from which, in blacklacquered frames, relatives we never knew look down on us: figure-shaped great-aunts or forefathers. Thurn und Taxis, too, has the big figures on its stamps; there, they are like the bewitched numbers of taxi meters.[15] One would not be surprised, one evening, to see the light of a candle shining through them from behind. But then there are small stamps without perforations, without any indication of currency or country. In a tightly woven spider's web, they bear only a number. These things are perhaps truly without a fate.

Script on Turkish piaster-stamps is like the slanted, altogether too dandyish, too gleaming breast-pin in the tie of a sly, only half-Europeanized merchant from Constantinople. They number among the postal parvenus, the large, badly perforated, garish formats of Nicaragua or Colombia, which deck themselves out like banknotes.

Extra-postage stamps are the spirits among stamps. They are unaltering. The changes of monarchs and forms of government pass over them without trace, as if over phantoms.

The child looks toward far-off Liberia through an inverted opera-glass: there it lies behind its little strip of sea with its palms, just as the stamps show it. With Vasco da Gama, he sails around a triangle which is as isoscelean as hope and whose colors change with the weather. A travel brochure for the Cape of Good Hope. When he sees the swan on Australian stamps, it is always, even on the blue, green, and brown issues, the black swan that is found only in Australia and that here glides on the waters of a pool as on the most pacific ocean.

Stamps are the visiting-cards that the great states leave in a child's room.

Like Gulliver, the child travels among the lands and peoples of his postage stamps. The geography and history of the Lilliputians, the whole science of the little nation with all its figures and names, is instilled in him in sleep. He takes part in their transactions, attends their purple assemblies, watches the launching of their little ships, and celebrates with their crowned heads, enthroned behind hedges, jubilees.

There is, it is known, a stamp-language that is to flower-language what the Morse alphabet is to the written one. But how long will the flowers continue to bloom between the telegraph poles? Are not the great artistic stamps of the postwar years, with their full colors, already the autumnal asters and dahlias of this flora? Stephan, a German and not by chance a contemporary of Jean Paul, planted this seed in the summery middle of the nineteenth century. It will not survive the twentieth.

Si Parla Italiano

I sat at night in violent pain on a bench. Opposite me on another, two girls sat down. They seemed to want to discuss something in confidence and began to whisper. Nobody except me was nearby, and I would not have understood their Italian however loud it had been. But now I could not resist the feeling, in face of this unmotivated whispering in a language inaccessible to me, that a cool dressing was being applied to the painful place.

Technical Aid

Nothing is poorer than a truth expressed as it was thought. Committed to writing in such a case, it is not even a bad photograph. And the truth refuses (like a child or a woman who does not love us), facing the lens of writing while we crouch under the black cloth, to keep still and look amiable. Truth wants to be startled abruptly, at one stroke, from her self-immersion, whether by uproar, music, or cries for help. Who could count the alarm signals with which the inner world of the true writer is equipped? And to "write" is nothing other than to set them jangling. Then the sweet odalisque rises with a start, snatches whatever first comes to hand in the *mêlée* of her boudoir (our cranium), wraps it around her, and—almost unrecognizable— flees from us to other people. But how well-constituted she must be, how healthily built, to step in such a way among them, contorted, rattled, and yet victorious, captivating!

Hardware

Quotations in my work are like wayside robbers who leap out, armed, and relieve the idle stroller of his conviction.

The killing of a criminal can be moral—but never its legitimation.

The provider for all mankind is God, and the state his deputy.

The expressions of people moving about a picture gallery show ill-concealed disappointment that only pictures hang there.

Tax Advice

Beyond doubt: a secret connection exists between the measure of goods and the measure of life—which is to say, between money and time. The more trivial the content of a lifetime, the more fragmented, multifarious, and disparate are its moments, while the grand period characterizes a superior existence. Very aptly, Lichtenberg suggests that time whiled away should be seen as made smaller, rather than shorter, and he also observes: "A few dozen million minutes make up a life of forty-five years and a bit more."[16] When a currency in use is worth so little that a few million units of it are insignificant, life will have to be counted in seconds, rather than years, if it is to appear a respectable sum. And it will be frittered away like a bundle of banknotes: Austria cannot break the habit of thinking in florins.

Money and rain belong together. The weather itself is an index of the state of this world. Bliss is cloudless, knows no weather. There also comes a cloudless realm of perfect goods, on which no money falls.

A descriptive analysis of banknotes is needed. The unlimited satirical force of such a book would be equaled only by its objectivity. For nowhere more naively than in these documents does capitalism display itself in solemn earnest. The innocent cupids frolicking about numbers, the goddesses holding tablets of the law, the stalwart heroes sheathing their swords before monetary units, are a world of their own: ornamenting the façade of hell. If Lichtenberg had found paper money in circulation, the plan of this work would not have escaped him.

Legal Protection for the Needy

Publisher: My expectations have been most rudely disappointed. Your work makes no impression on the public; you do not have the slightest drawing

power. And I have spared no expense. I have incurred advertising costs.—
You know how highly I think of you, despite all this. But you cannot hold
it against me if even I now have to listen to my commercial conscience. If
there is anyone who does what he can for authors, I am he. But, after all,
I also have a wife and children to look after. I do not mean, of course, that
I hold you accountable for the losses of the past years. But a bitter feeling
of disappointment will remain. I regret that I am at present absolutely unable
to support you further.

Author: Sir, why did you become a publisher? We shall have the answer by
return mail. But permit me to say one thing in advance. I figure in your
records as number 27. You have published five of my books; in other words,
you have put your money five times on number 27. I am sorry that number
27 did not prove a winner. Incidentally, you took only coupled bets. Only
because I come next to your lucky number 28.—Now you know why you
became a publisher. You might just as well have entered an honest profes-
sion, like your esteemed father. But never a thought for the morrow—such
is youth. Continue to indulge your habits. But avoid posing as an honest
businessman. Don't feign innocence when you've gambled everything away;
don't talk about your eight-hour workday, or your nights, when you hardly
get any rest. "Truth and fidelity before all else, my child." And don't start
making scenes with your numbers! Otherwise you'll be thrown out.

Doctor's Night-Bell

Sexual fulfillment delivers the man from his secret, which does not consist
in sexuality but which in its fulfillment, and perhaps in it alone, is severed—
not solved. This secret is comparable to the fetters that bind him to life. The
woman cuts them, and the man is free to die because his life has lost its
secret. Thereby he is reborn, and as his beloved frees him from the mother's
spell, the woman literally detaches him from Mother Earth—a midwife who
cuts that umbilical cord which is woven of nature's mystery.

Madame Ariane: Second Courtyard on the Left

He who asks fortune-tellers the future unwittingly forfeits an inner intima-
tion of coming events that is a thousand times more exact than anything
they may say. He is impelled by inertia, rather than by curiosity, and nothing
is more unlike the submissive apathy with which he hears his fate revealed
than the alert dexterity with which the man of courage lays hands on the
future. For presence of mind is an extract of the future, and precise aware-
ness of the present moment is more decisive than foreknowledge of the most

distant events. Omens, presentiments, signals pass day and night through our organism like wave impulses. To interpret them or to use them: that is the question. The two are irreconcilable. Cowardice and apathy counsel the former, lucidity and freedom the latter. For before such prophecy or warning has been mediated by word or image, it has lost its vitality, the power to strike at our center and force us, we scarcely know how, to act accordingly. If we neglect to do so, and only then, the message is deciphered. We read it. But now it is too late. Hence, when you are taken unawares by an outbreak of fire or the news of a death, there is in the first mute shock a feeling of guilt, the indistinct reproach: Were you really unaware of this? Didn't the dead person's name, the last time you uttered it, sound differently in your mouth? Don't you see in the flames a sign from yesterday evening, in a language you only now understand? And if an object dear to you has been lost, wasn't there—hours, days before—an aura of mockery or mourning about it that gave the secret away? Like ultraviolet rays, memory shows to each man in the book of life a script that invisibly and prophetically glosses the text. But it is not with impunity that these intentions are exchanged, that unlived life is handed over to cards, spirits, stars, to be in an instant squandered, misused, and returned to us disfigured; we do not go unpunished for cheating the body of its power to meet the fates on its own ground and triumph. The moment is the Caudine Yoke beneath which fate must bow to the body. To turn the threatening future into a fulfilled "now," the only desirable telepathic miracle, is a work of bodily presence of mind. Primitive epochs, when such demeanor was part of man's daily husbandry, provided him with the most reliable instrument of divination: the naked body. Even the ancients knew of this true practice, and Scipio, stumbling as he set foot on Carthaginian soil, cried out, spreading his arms wide as he fell, the watchword of victory, "Teneo te, terra Africana!"[17] What would have become a portent of disaster he binds bodily to the moment, making himself the factotum of his body. In just such mastery, the ancient ascetic exercises of fasting, chastity, and vigil have for all time celebrated their greatest victories. Each morning the day lies like a fresh shirt on our bed; this incomparably fine, incomparably tightly woven fabric of pure prediction fits us perfectly. The happiness of the next twenty-four hours depends on our ability, on waking, to pick it up.

Costume Wardrobe

A bearer of news of death appears to himself as very important. His feeling—even against all reason—makes him a messenger from the realm of the dead. For the community of all the dead is so immense that even he who

only reports death is aware of it. *Ad plures ire* was the Latins' expression for dying.[18]

At Bellinzona I noticed three priests in the station's waiting room. They were sitting on a bench diagonally opposite mine. In rapt attention I observed the gestures of the one seated in the middle, who was distinguished from his brothers by a red skullcap. While he speaks to them, his hands are folded in his lap, and only now and then is one or the other very slightly raised and moved. I think to myself: his right hand must always know what the left is doing.

Is there anyone who has not once been stunned, emerging from the Métro into the open air, to step into brilliant sunlight? And yet the sun shone just as brightly a few minutes earlier, when he went down. So quickly has he forgotten the weather of the upper world. And as quickly the world in its turn will forget him. For who can say more of his own existence than that it has passed through the lives of two or three others as gently and closely as the weather?

Again and again, in Shakespeare, in Calderón, battles fill the last act, and kings, princes, attendants, and followers "enter, fleeing." The moment in which they become visible to spectators brings them to a standstill. The flight of the *dramatis personae* is arrested by the stage. Their entry into the visual field of nonparticipating and truly impartial persons allows the harassed to draw breath, bathes them in new air. The appearance on stage of those who enter "fleeing" takes from this its hidden meaning. Our reading of this formula is imbued with expectation of a place, a light, a footlight glare, in which our flight through life may be likewise sheltered in the presence of onlooking strangers.

Betting Office

Bourgeois existence is the regime of private affairs. The more important the nature and implications of a mode of behavior, the further removed it is from observation here. Political conviction, financial situation, religion—all these seek hideouts, and the family is the rotten, dismal edifice in whose closets and crannies the most ignominious instincts are deposited. Mundane life proclaims the total subjugation of eroticism to privacy. So wooing becomes a silent, deadly serious transaction between two persons alone, and this thoroughly private wooing, severed from all responsibility, is what is really new in "flirting." In contrast, the proletarian and the feudal type of man resemble each other in that, in wooing, it is much less the woman than their competitors that they overcome. In this, they respect the woman far

more deeply than in her freedom, being at her command without cross-examining her. The shift of erotic emphasis to the public sphere is both feudal and proletarian. To be seen with a woman on such-and-such an occasion can mean more than to sleep with her. Thus, in marriage, too, value does not lie in the sterile "harmony" of the partners: it is as the eccentric offshoot of their struggles and rivalries enacted elsewhere that, like the child, the spiritual force of marriage is manifest.

Stand-Up Beer Hall

Sailors seldom come ashore; service on the high seas is a holiday by comparison with the labor in harbors, where loading and unloading must often be done day and night. When a gang is then given a few hours' shore-leave, it is already dark. At best, the cathedral looms like a dark promontory on the way to the tavern. The ale-house is the key to every town; to know where German beer can be drunk is geography and ethnology enough. The German seamen's bar unrolls the nocturnal map of the city: to find the way from there to the brothel, to the other bars, is not difficult. Their names have criss-crossed the mealtime conversations for days. For when a harbor has been left behind, one sailor after another hoists like little pennants the nicknames of bars and dance-halls, beautiful women and national dishes, from the next harbor. But who knows whether he will go ashore this time? For this reason, no sooner is the ship declared and moored than tradesmen come aboard with souvenirs: chains and picture-postcards, oil-paintings, knives, and marble figurines. The city sights are not seen but bought. In the sailors' chests, the leather belt from Hong Kong is juxtaposed with a panorama of Palermo and a girl's photo from Stettin. And their real habitat is exactly the same. They know nothing of the hazy distances in which, for the bourgeois, foreign lands are enshrouded. What first asserts itself in every city is, first, service on board, and then German beer, English shaving-soap, and Dutch tobacco. Imbued to the marrow with the international norms of industry, they are not the dupes of palms and icebergs. The seaman is sated with proximity, and only the most exact nuances speak to him. He can distinguish countries better by the preparation of their fish than by their building-styles or landscapes. He is so much at home in detail that the ocean routes where he cuts close to other ships (greeting those of his own firm with howls from the ship's horn) become noisy thoroughfares where you have to give way to traffic. He lives on the open sea in a city where, on the Marseilles Cannebière, a Port Said bar stands diagonally opposite a Hamburg brothel, and the Neapolitan Castel dell'Ovo is to be found on Barcelona's Plaza Cataluña. For officers, their native town still holds pride of place. But for the ordinary sailor or the stoker, the people whose transported labor-power maintains contact with the commodities in the hull of the ship,

the interlaced harbors are no longer even a homeland, but a cradle. And listening to them, one realizes what mendacity resides in voyaging.

No Vagrants!

All religions have honored the beggar. For he proves that in a matter both as prosaic and holy, banal and regenerating, as the giving of alms, intellect and morality, consistency and principles are miserably inadequate.

We deplore the beggars in the South, forgetting that their persistence in front of our noses is as justified as a scholar's before a difficult text. No shadow of hesitation, no slightest wish or deliberation in our faces escapes their notice. The telepathy of the coachman who, by accosting us, makes known to us our previously unsuspected inclination to board his vehicle, and of the shopkeeper who extracts from his junk the single chain or cameo that could delight us, is of the same order.

To the Planetarium

If one had to expound the teachings of antiquity with utmost brevity while standing on one leg, as did Hillel that of the Jews, it could only be in this sentence: "They alone shall possess the earth who live from the powers of the cosmos." Nothing distinguishes the ancient from the modern man so much as the former's absorption in a cosmic experience scarcely known to later periods. Its waning is marked by the flowering of astronomy at the beginning of the modern age. Kepler, Copernicus, and Tycho Brahe were certainly not driven by scientific impulses alone. All the same, the exclusive emphasis on an optical connection to the universe, to which astronomy very quickly led, contained a portent of what was to come. The ancients' intercourse with the cosmos had been different: the ecstatic trance [*Rausch*]. For it is in this experience alone that we gain certain knowledge of what is nearest to us and what is remotest from us, and never of one without the other. This means, however, that man can be in ecstatic contact with the cosmos only communally. It is the dangerous error of modern men to regard this experience as unimportant and avoidable, and to consign it to the individual as the poetic rapture of starry nights. It is not; its hour strikes again and again, and then neither nations nor generations can escape it, as was made terribly clear by the last war, which was an attempt at new and unprecedented commingling with the cosmic powers. Human multitudes, gases, electrical forces were hurled into the open country, high-frequency currents coursed through the landscape, new constellations rose in the sky, aerial space and ocean depths thundered with propellers, and everywhere sacrificial shafts were dug in Mother Earth. This immense wooing of the

cosmos was enacted for the first time on a planetary scale—that is, in the spirit of technology. But because the lust for profit of the ruling class sought satisfaction through it, technology betrayed man and turned the bridal bed into a bloodbath. The mastery of nature (so the imperialists teach) is the purpose of all technology. But who would trust a cane wielder who proclaimed the mastery of children by adults to be the purpose of education? Is not education, above all, the indispensable ordering of the relationship between generations and therefore mastery (if we are to use this term) of that relationship and not of children? And likewise technology is the mastery of not nature but of the relation between nature and man. Men as a species completed their development thousands of years ago; but mankind as a species is just beginning his. In technology, a *physis* is being organized through which mankind's contact with the cosmos takes a new and different form from that which it had in nations and families. One need recall only the experience of velocities by virtue of which mankind is now preparing to embark on incalculable journeys into the interior of time, to encounter there rhythms from which the sick shall draw strength as they did earlier on high mountains or on the shores of southern seas. The "Lunaparks" are a prefiguration of sanatoria. The paroxysm of genuine cosmic experience is not tied to that tiny fragment of nature that we are accustomed to call "Nature." In the nights of annihilation of the last war, the frame of mankind was shaken by a feeling that resembled the bliss of the epileptic. And the revolts that followed it were the first attempt of mankind to bring the new body under its control. The power of the proletariat is the measure of its convalescence. If it is not gripped to the very marrow by the discipline of this power, no pacifist polemics will save it. Living substance conquers the frenzy of destruction only in the ecstasy of procreation.

Written 1923–1926; published in 1928. Translated by Edmund Jephcott.

Notes

1. Anna Katherine Green (1846–1935), American detective-story writer, born in Brooklyn, New York. Her thrillers are characterized by logical construction and a knowledge of criminal law. Her most famous book is *The Leavenworth Case* (1878).—*Trans.*
2. The "German inflation" began as early as 1914, when the imperial government took to financing its war effort with a series of financially disastrous measures. The economic situation was exacerbated in the early years of the Weimar Republic as the fledgling democracy confronted pressing social and political problems, the burden of reparations, and serious inflation. Most references to the inflation, however, intend the hyperinflation of late 1922 and 1923, when the German economy was decimated by one of the worst economic crises to

confront a modern industrial state. If we compare late 1913 (the last year before the war) with late 1923 using the wholesale price index as the basis for comparison, we find that one German mark in 1913 equaled 1,261 thousand million marks by December 1923.—*Trans.*

3. *Nulla dies sine linea:* "Not a day without a line" (i.e., "without writing a line"). Proverbial expression, from Pliny the Elder, *Natural History* XXXV, 36.— *Trans.*

4. Jean Paul Richter (1763–1825) wrote a series of wildly extravagant, highly imaginative novels that combine fantasy and realism.—*Trans.*

5. Pharus was the most popular brand of folding city maps in Germany during the 1920s.—*Trans.*

6. The quoted lines are from the poem "Tut ein Schilf sich doch hervor." This and "Selige Sehnsucht" are the last poems in Goethe's collection *West-Östlicher Divan* [West-Easterly Divan].—*Trans.*

7. Legendary Greek poet of the seventh century B.C.E. He was cast into the sea by envious sailors, but his lyric song charmed the dolphins, one of which bore him safely to land. The story is told by Herodotus and Plutarch.—*Trans.*

8. Kraus's poem appears in the collection *Worte in Versen* (1920).—*Trans.*

9. Atrani is an ancient village in southern Italy, near Naples on the Gulf of Salerno; today it is part of the town of Amalfi. Its church of San Salvatore de Bireto dates from the year 940.—*Trans.*

10. The presentation of a fairy story, usually outdoors, using elaborate staging and costumes. Popular in France and England in the seventeenth and eighteenth centuries.—*Trans.*

11. André Le Nôtre (1613–1700), French landscape architect. Created the gardens at Versailles and the Jardin des Tuileries, among many others.—*Trans.*

12. Boscotrecase is a commune in Napoli province, Campania, about twelve miles southeast of Naples.—*Trans.*

13. An uninhabited island in the Pacific, discovered in 1793 by the Spanish explorer Salas y Gomez. Benjamin no doubt knew the poem of the same name by Adelbert von Chamisso.—*Trans.*

14. Humbert I (1844–1900), conservative and pro-German king of Italy (1878–1900). Assassinated at Monza, near Milan.—*Trans.*

15. Thurn und Taxis: princely house in Germany that was granted the postal concession for the Holy Roman Empire. Synonymous with "mail service" in Europe.—*Trans.*

16. Georg Christoph Lichtenberg (1742–1799), satirist and experimental psychologist. Although Lichtenberg was a feared satirist in his time, he is remembered today as the first great German aphorist. More than 1,500 pages of notes were published posthumously; alongside jokes, linguistic paradoxes, puns, metaphors, and excerpts from other writers, they contain thousands of memorable aphorisms.—*Trans.*

17. Latin for "I hold you, African earth."—*Trans.*

18. Latin for "to go toward the many."—*Trans.*

A Note on the Texts

Many of the texts included in this first volume of Benjamin's selected writings remained unpublished during his lifetime; the textual status of these unpublished pieces varies widely. Some are highly polished essays produced first of all to clarify his own thinking, but also to be shared among a narrow circle of friends and partners in intellectual exchange ("Two Poems by Friedrich Hölderlin," "On Language as Such and on the Language of Man," "Stifter"), and some are the early precipitates of research projects completed later ("*Trauerspiel* and Tragedy," "On the Program of the Coming Philosophy"). But most of these unpublished texts are simply fragments, ranging between fascinating jottings and unfinished essays. The German edition of Benjamin's collected writings groups most of these latter texts in one volume (Volume 6: *Fragmente vermischten Inhalts, Autobiographische Schriften*). In the present volume, all texts are arranged chronologically and are accompanied by the following information: date of composition; place of publication or a note on the piece's unpublished status during Benjamin's lifetime; and the word "Fragment" if the text is designated as such in the German edition. All endnotes marked "Trans." were produced by the general editor in collaboration with the translators.

All translations are based on the text of the standard German edition: Walter Benjamin, *Gesammelte Schriften,* seven volumes (Frankfurt: Suhrkamp Verlag, 1972–1989), edited by Rolf Tiedemann and Hermann Schweppenhäuser. The editors of the present volume are indebted to Benjamin's German editors for the meticulous dating and preparation of his texts.

The editors would like to thank a number of friends and colleagues who have provided information and assistance at crucial stages of the project: Eduardo Cadava, Stanley Corngold, Michael Curschmann, Robert Gibbs, Barbara Hahn, Thomas Levin, Richard Martin, and Christian Wildberg. Very special thanks are due our colleagues at Harvard University Press. The idea for an expanded edition of Benjamin's writings came from Lindsay Waters, and without his now patient, now insistent godfathering, the edition would certainly never have been completed. And Maria Ascher, through her consistently insightful and meticulous editing of the final manuscript, improved not just the prose but the conception and apparatus of this first volume of the edition.

Chronology, 1892–1926

1892

Walter Benedix Schönflies Benjamin was born on July 15, 1892, into an upper-middle-class Jewish family in Berlin. His father, Emil Benjamin, was a prosperous businessman, born in 1866 to a well-established family of merchants in the Rhineland. His mother, née Paula Schönflies, likewise came from a financially secure bourgeois background. The Benjamin family later had a daughter, Dora, who died in 1946 in Zurich, and another son, Georg, who became a doctor, joined the Communist party, and died in a Nazi concentration camp.

The founding of the Second Empire in Germany in 1871, the astonishing economic boom of the empire's first twenty years, and the resulting rise of Berlin to its position as hub of a major economic power had brought considerable wealth to Benjamin's grandparents on both sides. Moreover, the liberal reform of the first years of the empire had opened the doors of the better schools to Jewish citizens, who would now be able to play a role in the cultural life of the nation commensurate with their achievements in the mercantile sphere. To Benjamin's parents, the idea that their first-born might be destined for eminence in the world of letters would have appeared natural, since his forebears could already pride themselves on a connection to one writer of note: Benjamin's maternal grandmother, Brunella Meyer, then still living, was descended from the van Geldern family and was thus related to the great nineteenth-century poet and essayist Heinrich Heine.

Berlin at the turn of the century displayed the marks of the rapid emergence of urban capitalism and especially new technologies in a way rivaled by few European capitals: the city had undergone the transformation from seat of quasi-feudal power to modern metropolis faster than had any of its sister cities. Benjamin's collections of reminiscences and reflections on his early years, "Berlin Childhood around 1900" and "Berlin Chronicle," take up the varied themes of confusion, mystery, and deception that dominated the world seen through the troubled eyes of an inquisitive child. In his maturity, Benjamin looked back on childhood as he had experienced it in the elegant old western residential district of the city, home of the "last true élite of bourgeois Berlin," where "the class that had pronounced him one of its number

resided in a posture compounded of self-satisfaction and resentment that turned it into something of a ghetto held on lease. In any case, he was confined to this affluent quarter without knowing of any other. The poor? For rich children of his generation, they lived at the back of beyond."[1]

His education began with private instruction in the company of a select group of children from his own class. "And that it was high on the social scale," he recalls, "I can infer from the names of the two from the little circle that remain in my memory: Ilse Ullstein and Luise von Landau" ("Chronicle," 44). Cut off from any larger perspective on the realities of other social strata, his existence was dominated by intense and overwhelming expressions of the social phenomena that he would later subject to philosophical and historical analysis. For Benjamin, the spectacle of everyday things beckoned with the promise of a meaning that always hovered just beyond his reach. "He who has once begun to open the fan of memory never comes to the end of its segments," he says of his speculative return to this past; "no image satisfies him, for he has seen that it can be unfolded, and only in its folds does the truth reside" ("Chronicle," 6). His memoir preserves the intensity of his efforts to comprehend the arcane banalities of luxury and social ritual from which human content had withered away, and the secretive distinctions among different levels within the family. Thus, for example, he describes how the sound his mother's knife made on the rolls she buttered for his father's lunch "became indissoluble from the image of my father's power and grandeur" ("Chronicle," 37). This allegorical understanding of social reality is characteristic: "The economic basis on which the finances of my parents rested was surrounded, long past my childhood and adolescence, by deepest secrecy. Probably not only for me, the eldest child, but also for my mother" ("Chronicle," 36). The meaning of everything he encountered was bound up, like the mysteries of his father's authority, with its concealment. Benjamin's early awareness of the disproportion between apparently natural significance and a hidden, coded meaning made him a precocious reader of social texts; he became keenly aware of "the carpet beating that was the language of the nether world, of servant girls, the real grown-ups—a language that sometimes took its time, languid and muted under the gray sky, breaking at others into an inexplicable gallop, as if the servants were pursued by phantoms" ("Chronicle," 44). Yet much else seemed to elude the child of privilege. The sphere of his parents' sexuality was present only as the strange scents and silks of his mother's bedroom, while the existence of other classes with other forms of life appeared solely in the spectacle of beggars and whores in the street. "But is not this, too, the city—the strip of light under the bedroom door on evenings when we were 'entertaining'? Did not Berlin itself find its way into the expectant childhood night . . . ?" ("Chronicle," 43).

His father's prosperity had begun with his work as an auctioneer and partner in an art dealership. His success as a dealer, and later as an entrepreneur in various speculative ventures (including a music hall known as the "Ice Palace"), depended on his gift for sundering all immediate human entanglements in order to call forth another dimension—one nourished by dreams, where these objects disclosed their value for purchase. When the child who grew up surrounded by these values did indeed become a writer, this divinatory relationship with things would shape his language. And the many-layered life of the city would furnish his subject. What makes Benjamin important to us now as a writer is precisely what made it impossible

for him to write a novel. Nowhere does he find the human substance out of which he might have created "characters"; he finds only the spectral absences to be traced in ruined settings and disastrous histories. The ability to find those traces equips Benjamin for the dazzling analyses of the things that constitute a past that had so far been denied a voice, from the little commentary "Dreamkitsch" *(Traumkitsch)* he wrote in 1926, to his great unfinished project on the Paris arcades.

1902–1905

A regular acquaintance with the larger institutions of contemporary society began after Easter, 1902, when his parents sent him to the Kaiser Friedrich Schule, one of Berlin's better secondary schools. "Berlin Chronicle" portrays the contempt he felt for the collective regimen. He writes of the "terror and the pall" of the punishments meted out to younger pupils ("Chronicle," 49) and of the horror of physical absorption into the routine expression of animal energy among his fellow students: "These staircases I have always hated: hated when forced to climb them in the midst of the herd, a forest of calves and feet before me, defenselessly exposed to the bad odors emanating from all the bodies pressing so closely against mine" ("Chronicle," 52). Here, too, exposure to rituals and symbols left him baffled and stranded on the margins. On the occasion of a sports competition his "bewilderment was uninterrupted" ("Chronicle," 50).

Gershom Scholem offers a very different picture of the school and its atmosphere, based on conversations with several of Benjamin's fellow pupils: they contradict Benjamin's account of oppressive militaristic authority. Scholem reports that the school was "a decidedly progressive institution," that the curriculum to which Benjamin was exposed may by no means have been so deadening, and that the director of the school, Professor Zernickel, was an educational reformer.[2] Benjamin's recollections are undoubtedly colored by later, more politically informed perceptions of the educational system. "Only today, it seems to me," he notes in 1932, "am I able to appreciate how much hatefulness and humiliation lay in the obligation to raise my cap to teachers" ("Chronicle," 49).

1905–1907

After three years of school in Berlin, Benjamin's parents sent him to the Landerziehungsheim Haubinda, a country boarding school in Thuringia. They acted in the conviction that life in this rural setting would improve his health, and no doubt they also felt that at age thirteen he should become more independent of his home and family. Haubinda was a distinctly progressive institution, founded in 1901 by Hermann Lietz but directed since 1904 by Paulus Geheeb and Gustav Wyneken. Wyneken's program of school reform became the first major intellectual influence on Benjamin, and his ideas on the role of youth in national and cultural affairs left a lifelong imprint on Benjamin's thinking.

Wyneken (who was born in 1875) differed markedly in his approach as a teacher from the traditional, distant authority of the schoolmaster: he based his pedagogy on a solidarity of youth. Within this environment, in which Benjamin experienced

education for the first time as an exchange of ideas, his own idealism could flourish. Wyneken taught at Haubinda only for the first year of Benjamin's stay; in 1906 he was dismissed, whereupon he founded an alternative institution, the Free School Community (Freie Schulgemeinde) at Wickersdorf, where he could develop his doctrine of youth in a still more radical direction. Wyneken's ideas, though widely influential, represented only one among a number of models for a new culture of youth in Germany; these models, to which we now refer collectively as the Youth Movement, ran the gamut from tame and pragmatic revisions in pedagogy, through the nature worship of young people tramping across the countryside (the *Wandervögel*), to the virulent nationalism and anti-Semitism of the radical Right. Wyneken maintained some degree of autonomy from these other elements and focused his ultimately rather banal and confused theories on the spiritual and intellectual independence of youth. Although Benjamin's notes and diaries from his stay at Haubinda have not survived, it can be inferred from his university writings, produced under the influence of Wyneken, that his allegiance to this dominating figure permitted him for the first time to distance himself from the authority of his family and from bourgeois models of existence in general.

1907–1909

Returning to Berlin to continue his education at the Kaiser Friedrich *Gymnasium,* Benjamin displayed the confidence and independence of mind he had brought back from Haubinda. Scholem writes: "Benjamin's schoolmates included, among others, Ernst Schoen, Alfred Cohn, Herbert Blumenthal (who later changed his name to Belmore), Franz Sachs, Fritz Strauss, Alfred Steinfeld, and Willy Wolfradt (later a writer on art). These students formed a circle that met regularly to read and discuss works of literature. Fritz Strauss told me that this group regarded Benjamin as its leader and that his intellectual superiority was evident to all" (Scholem, 4). Franz Sachs reports that these meetings continued from 1908 to the outbreak of the First World War. The group read plays, with the members taking different roles, choosing predominantly works by modern authors—Strindberg, Ibsen, Wedekind, and the German naturalists—which were denied them in the strictly traditional literary curriculum of their school.[3]

1910–1911

Benjamin's first ventures into writing for a larger audience begin at this time with his contributions to the student journal *Der Anfang* (Beginning) founded in 1908 by a disciple of Wyneken's calling himself Georg Barbizon (Georg Gretor). Until 1911, *Der Anfang* circulated in 150 copies duplicated on a hectograph, but after that time it was printed and more widely distributed. Benjamin, writing under the pseudonym "Ardor," contributed pieces that testify to his fervent embrace of Wyneken's ideal of a spiritually and ethically imbued Youth Movement.

In the first stages of his correspondence with his schoolfriend Herbert Belmore (then Blumenthal), which began in the summer of 1910 during a trip to Switzerland and continued until 1917, he reports on his efforts to read widely in the philosophy of language, which he found very tough going. The same letter of 1910 also reveals

Benjamin's characteristic and lifelong skepticism toward nature: "When I see the mountains from this perspective, I sometimes ask myself why all this culture exists at all. Yet we forget to take into account the extent to which it is precisely culture (and even superculture) that enables us to enjoy nature" (Letters, 8). In 1911 he reads Nietzsche, comments at some length on Tolstoy's *Anna Karenina*, and complains about the excessive emphasis on facts in Jacob Burckhardt's *Civilization of the Renaissance in Italy*. He also mentions having read a more recent book, Jakob Wassermann's *Caspar Hauser*, a novel about a man with a murky identity and no ability to use language; Wasserman's novel figured in the contemporary debates over the ability of Jews to participate in German literary culture.

1912

Benjamin's final high school examinations, which he passed in March, show him to have been a brilliant student with clear literary and philosophical proclivities—and some residual weakness in mathematics. Following an extended trip to Italy, his first taste of real freedom from the supervision of family and teachers, Benjamin, at the age of twenty, entered the Albert Ludwigs University in Freiburg im Breisgau, declaring his intention to study philosophy. A letter to Belmore dated March 14 makes it clear that he had arrived with a determination not to be impressed by this new institution or by his elevated academic status. "It is a fact that I am able to think independently about scholarly matters only about one tenth as often as in Berlin" (Letters, 15). He also adopted a new pseudonym, "Eckart, Phil.," under which he published a brief essay, "Educational Reform: A Cultural Movement" in *Student und Schulreform,* an anthology published (with a circulation of ten thousand) by the Free Students' Association (Freie Studentenschaft) in Freiburg.

In August he vacationed in Stolpmünde (now Ustka, Poland) with a fellow student from Freiburg, Franz Sachs, reporting to Belmore that what he calls his "A.N.G." *(Allgemeine normale Geistigkeit),* his normally functioning intellect, had recovered from exposure to the first semester at university. He praises Heinrich Wölfflin's *Classical Art,* the letters of Ninon de Lenclos, and Wilhelm Dilthey. During this visit he discussed Zionism with a young companion, Kurt Tuchler, to whom he had been introduced by Sachs. A correspondence over the next two years with Ludwig Strauß shows Benjamin's first extended confrontation with the question of Judaism and Jewishness. These letters attempt to justify an internally contradictory set of ideas: Benjamin argued that the commitment to Wyneken's principles and followers provided a deeper expression of his identity as a Jew than he could find among German Zionists. He describes the latter as entirely deficient in any developed Jewish consciousness: *Halbmenschen* ("half-persons"), "they make propaganda for Palestine, and then get drunk like Germans."[4] (*GS,* II, 838). At the end of August, when the summer semester in Freiburg was over, Benjamin returned to Berlin and enrolled at the Friedrich Wilhelm University during the winter session for the second semester of his philosophical studies.

1913

Although Benjamin sampled a broad range of philosophers, art historians, and literary scholars, the dominant impression from his study in Berlin was made early,

in the first of his five semesters there, when he attended lectures by the great social and economic philosopher Georg Simmel. Few teachers would have as lasting an influence on the leftist political and social theory produced by Benjamin's generation: besides Benjamin, Simmel numbered Ernst Bloch, Georg Lukács, and Ludwig Marcuse among his students.

The return to Berlin also meant renewed emphasis on his ties to *Der Anfang* and the group attached to Wyneken within the youth movement there. "On the school question I say only this: I have no definite ideas of my own," he had written to Ludwig Strauß in the fall of 1912, "but am a strict and fanatical disciple of G. Wyneken" (*GS*, II, 896). Benjamin became known in Berlin as an advocate not merely of educational reform but of a radical transformation of all German culture by means of a resurgent spirituality. His brief essay "'Experience'" of 1913 reflects the hope that his generation was capable of preparing a break with older instrumental conceptions of spirit and culture. This meant that "politics in the deepest sense is the choice of the lesser evil. Never the idea, only the party, can find expression there" (*GS*, II, 842). These ideas are contradicted, though, in the practical measures Benjamin undertook to spread Wyneken's doctrine: among other activities, he sought and won the presidency of the Free Students' Association, that part of the student body not affiliated with the fraternities.

In the summer semester of 1913, Benjamin again took up his studies in Freiburg; he had been unable to win reelection to the presidency of the Free Students' Association and had returned south, where prospects for Wyneken-inspired reform seemed brighter. In Freiburg, he attended lectures by the prominent neo-Kantian Heinrich Rickert. Martin Heidegger—three years older than Benjamin—was also one of Rickert's students. The influence of Rickert's lectures on logic, ethics, and aesthetics persisted: as late as 1940 Benjamin wrote to Theodor Adorno that "I, of course, am a student of Rickert, just as you are a student of [Hans] Cornelius" (Letters, 635). During this second stay in Freiburg, Benjamin came to know Fritz Heinle, a younger student and aspiring poet. Benjamin soon became a champion of Heinle's verse. Though few people then or since have shared his judgment of Heinle as a writer, the friendship was to be a decisive element in Benjamin's early experience. Benjamin began immediately to send Heinle's poems to *Der Anfang*, where Barbizon rejected them (see Letters, 53–54). Later he even takes up Heinle's interests against Wyneken's express wishes (Letters, 45).

At the end of April he wrote the first of several expansive letters to Carla Seligson, who would become Herbert Belmore's wife in 1917, the year in which the friendship between Belmore and Benjamin came to an end. She was a medical student in Berlin and an active member of the Free Students' Association. This correspondence documents the developing tensions within the Wyneken-inspired youth movement. Benjamin's first letter mentions intensive reading of Gottfried Keller on the epigram, Kierkegaard's *Either/Or*, and Kant's *Grounding for the Metaphysics of Morals*.

The next letter to her describes his first visit to Paris, undertaken in May. He writes that he has few specific recollections of the time in the city, but rather the sense of having lived those days with an intensity such as one knows only as a child. Benjamin describes his discovery of a connection with the city that will figure so prominently in his life, initially as a field for study and later, during his exile, as a home. "I have become almost more at home in the Louvre and on the Grand Boulevard than I am in the Kaiser Friedrich Museum or on the streets of Berlin"

(Letters, 27). Back in Freiburg, his efforts on behalf of the movement had limited success, though he writes that he remains confident about the future. The organization is still fragile; he only has one dependable colleague (Heinle); and "my work here is simply more impersonal, more abstract than in Berlin, where I knew more—and younger—people" (Letters, 28). He also feels that his allegiance to Wyneken's authority isolates him from people with academic philosophical competence: "Yesterday, for the first time since I've been a student, I found myself in a small group of professional philosophers. I had been invited to a reception at the home of a university teacher *(Privatdozent)*. It was a grotesque spectacle, from both an internal and an external perspective. I provide the internal perspective: of course, I am acutely aware that I am not a card-carrying member of the union, because, although I do indeed philosophize a lot, I do so in a totally different manner: my thinking always has Wyneken, my first teacher, as its starting point and always returns to him. Even when it comes to abstract questions, I intuitively see the answer prefigured in him. And when I philosophize, it is with friends, dilettantes. Thus, I am totally forlorn among these people, who speak with somewhat more circumspection (perhaps?) and more knowledge, for they have already completed their studies" (Letters, 29).

In July, Benjamin undertook a four-day walking tour in the Swiss Jura during which he made his first acquaintance with "rational solitude," spending the time "completely alone with my exhausted body" (Letters, 39–40). In addition to works of philosophy relating to his studies (Kant, Husserl, and Rickert), his reading included Heinrich Mann, Saint Bonaventure, Guy de Maupassant, and Hermann Hesse (Letters, 43, 46). On a brief visit to nearby Basel, he was able to see the originals of pictures that would have their full effect on his thinking years later, notably in the study of the German baroque *Trauerspiel,* which accords a prominent place to the theory of allegory. "Spent Wednesday in Basel. I saw the originals of the most famous Dürer prints: *Knight, Death, and the Devil; Melancholia; Saint Jerome;* and many more. They happened to be on exhibit. Only now do I have a notion of Dürer's power; of all the prints, *Melancholia* is inexpressibly profound and eloquent" (Letters, 42).

Shortly before the end of his time in Freiburg, he gives an indication of the way this child of Berlin had lived in daily proximity to the Black Forest landscapes: "Yesterday we climbed around in the woods from 10:00 to 12:30 and talked about original sin—we came up with some important ideas—and about dread. I was of the opinion that a dread of nature is the test of a genuine feeling for nature. A person who can feel no dread in the face of nature will have no idea of how to begin to treat nature" (Letters, 48).

After a brief visit to San Martin di Castrozza in Italy, Benjamin returned to Berlin and the center of activities of the Free Students' Association. Debates among the different tendencies and factions were intense and complex. The common ideological tenet that brought together the disparate elements in the movement was the members' desire to distance themselves from the conservatism of the traditional university fraternities, as well as from the atavism of the *Wandervögel* and their often anti-Semitic views. But within the organization, there were different views on the importance of social action and on the possibility of contributing to the progress of socialism in national politics. Benjamin opposed both these tendencies on the grounds that neither could ever sustain the ideality of pure spirit which he set beyond the concrete social realm. He had broached this in a sort of preparatory declaration

to Carla Seligson before his return. In the course of a long letter to her, he observes, "I believe it is true that only the person who has made the idea his own ('which' idea is irrelevant) can be solitary; I believe that such a person must be solitary. I believe that only in community and, indeed, in the most intimate community of believers can a person be truly solitary: a solitude in which the 'I' rises up against the idea in order to come to itself" (Letters, 50). Even the later concession (in "Berlin Chronicle") that such a politics of spirit was fundamentally hopeless includes an insistence on its "heroism": "There is no doubt that the city of Berlin was never again to impinge so forcefully on my existence as it did in that epoch when we believed we could leave it untouched, only improving its schools, only breaking the inhumanity of their inmates' parents, only making a place in it for the words of Hölderlin or George. It was a final, heroic attempt to change the attitudes of people without changing their circumstances. We did not know that it was bound to fail" ("Chronicle," 18).

1914

The vividness of Benjamin's experience of Berlin owed a great deal to the city's cafés. In "Berlin Chronicle," Benjamin names a number of their habitués, all of them important players in the drama of German modernism: the expressionist poet Else Lasker-Schüler, Wieland Herzfelde, later Dadaist and avant-garde publisher, and Franz Pfemfert, editor of the Expressionist journal *Die Aktion*, which advocated the integration of revolutionary ideals and advanced art. Benjamin's increasing presence in the cafés reflects his search for an alternative intellectual and cultural abode: as he will say to Herbert Belmore at the beginning of July, "The university simply is not the place to study" (Letters, 72). Meanwhile, tensions in Berlin's student circles continued to deepen from the beginning of 1914, as the participants diverged in their views. In March a sharp split developed between Georg Barbizon on one side and a group led by Heinle and Simon Guttmann on the other. Benjamin at first attempted to mediate, but on April 11 he announced in an open letter to Wyneken that he could no longer work with *Der Anfang* because of his break with its editor, Barbizon. He begins by declaring he has turned to Wyneken, "since there remains in the entire circle of the movement in Berlin no one at all whose person still upholds the purity of the words one addresses to him" (*GS*, VII, 543).

Benjamin could afford to withdraw from *Der Anfang* without jeopardizing his ability to influence events within the movement, because he had successfully sought election as president of the Berlin Free Students' Association at the end of the winter semester. In June he attended a conference of the Free Students at Weimar, presenting a paper on the new conception of the university. According to his report in a letter to Ernst Schoen, his presentation failed to achieve the desired effect because he badly miscalculated the audience's receptivity to his ideas (Letters, 69). A letter to Schoen in May indicates he had already begun to write the essay "The Metaphysics of Youth," a crystallization of his early thinking marked by an oracular tone and a self-conscious profundity.

Also in May, after publishing a piece, "The Religious Position of the New Youth," comparing this youth to "the first Christians," he wrote to Belmore that he had

begun to study Fichte's essay on the plan to establish a university in Berlin. Although he reads Fichte in 1914 hoping to find weapons for the struggles within the council of the Free Students' Association (Letters, 65), this philosopher will soon play an important role in Benjamin's dissertation. The same letter describes an intimate relationship with Grete Radt as "the only creative thing in this unbelievably disrupted period of activity. At the moment, she is the only person who sees and comprehends me in my totality. If I were not conscious of this, I could hardly bear the ineffectuality of these days" (Letters, 66). Ironically, it is also at this time that he begins to mention the presence of Dora Pollak (née Kellner) and her husband, Max, at the meetings. Grete would become Benjamin's fiancée, Dora his wife.

A personal acquaintance now began with Martin Buber and Ludwig Klages. Buber he had come to know at the university in Berlin; Klages he had invited to speak before the Free Students' Association and had visited in Munich in June. In July he spent some days in the Bavarian Alps with Grete Radt and her brother. Upon their return to Berlin, Benjamin and Grete Radt announced their wedding plans. In a conversation with Gershom Scholem fifty years after the fact, Radt asserted that this engagement was at least in part the result of a misunderstanding. "Toward the end of that month his father had sent him a telegram with the terse warning 'Sapienti sat'[5] . . . presumably to induce him to leave the country for some neutral territory such as Switzerland. But Benjamin misinterpreted the message and replied by formally announcing that he was engaged to Grete Radt" (Scholem, 12).

The approaching war now began to determine events, altering forever not only Benjamin's personal relationships but his thinking as well. According to Scholem, Benjamin had attempted to enlist immediately upon the outbreak of war in August, though not out of any real eagerness to serve. Expecting he would otherwise be conscripted, he and his friends had hoped that simultaneous enlistment might enable them to remain together. He was rejected. On August 8, after the German invasion of Belgium, Fritz Heinle and his friend Rika Seligson (Carla's sister) committed suicide together; although some interpreted this as the last act of a doomed love, Benjamin and their other close friends saw it as the most somber of war protests. The couple had chosen the rooms rented by the student groups for their meetings as the site for their suicide, and Heinle sent off an overnight letter to Benjamin to tell him where he would find their bodies. The immediate effect on Benjamin was several months of depression, and withdrawal from most of his former friends. But the shock of this loss never wholly left him: well into the 1930s, he continued to integrate images of Heinle's death into his work. The meeting room reappears, for example, in "Berlin Chronicle" as the locus for the shattering of the last illusions of Benjamin's youth. This old district, he writes, "where we chanced then to open our Meeting House, is for me the strictest pictorial expression of the point in history occupied by this last true élite of bourgeois Berlin. It was as close to the abyss of the Great War as the Meeting House was to the steep slope down to the Landwehr Canal; it was as sharply divided from proletarian youth as the houses of this *rentiers'* quarter were from those of Moabit; and the houses were the last of their line, just as the occupants of those apartments were the last who could appease the clamoring shades of the dispossessed with philanthropic ceremonies" ("Chronicle," 18). The double suicide put a stop to any desire to fight, even alongside his friends. "At the next regular call-up of his age group, which must have taken place in September or

October of 1914, Benjamin presented himself (having rehearsed beforehand) as a palsy victim. He consequently was granted a year's deferment" (Scholem, 12).

1915

In a pronouncement on the meaning of the war for the idea of youth, an essay entitled "Youth and War," Wyneken had in late 1914 joined the wave of enthusiasm that justified the catastrophe as a mystical renewal of the times. Benjamin, in a letter of March 1915, answers Wyneken's declaration by announcing an unequivocal break with his former mentor. Neither in this letter nor elsewhere does Benjamin acknowledge that Wyneken's advocacy of the war might be a direct outgrowth of his earlier teachings; he asserts instead that Wyneken has abandoned his own ideals, quoting extensively from the master's writings. "*Theoria* within you has been blinded" (Letters, 76).

In July, Benjamin began what would prove to be a lifelong friendship with Gershom Scholem, then a student of mathematics who would become a religious scholar and rediscoverer of the Kabbalah. Benjamin initiated an exchange on a variety of subjects: Zionism, the Kabbalah, philosophy, politics, and literature. He spoke at length about his interest in the works of Friedrich Hölderlin, the great German poet of the early nineteenth century. Initiating a practice that was to continue throughout his life, he sent Scholem a typescript copy of his essay "Two Poems by Friedrich Hölderlin." In the years between 1916 and 1923, the majority of Benjamin's writings were composed primarily for himself and a small circle of close friends and allies: Scholem, Ernst Schoen, Werner Kraft, and Alfred Cohn. The Hölderlin essay combines an interpretation of the task of poetry with a "plastic" construction of the relations between space and time. The essay is clearly a product of youth: it strongly echoes the cultic view of the poet as heroic representative of a higher dispensation of truth—a view that was typical of Stefan George and his followers. Nevertheless, the piece represents Benjamin's remarkable debut as a philosophical literary critic; he would comment in a letter of 1930 that he had been "unable to build on the magnificent foundations" laid down in the Hölderlin essay. In 1914 he also produced "The Life of Students," a meditation on the role of youth in national cultural life. The essay begins with a formulation of Benjamin's philosophy of history that will have lasting force in his subsequent thought.

After obtaining yet another military deferment by staying up all night in Scholem's company and consuming large amounts of coffee, Benjamin left Berlin to continue his studies at the Ludwig Maximilian University in Munich, where Grete was also enrolled. Scholem describes Benjamin's appearance at that time as follows: "No one would have called Benjamin handsome, but there was something impressive about him, with his unusually clear, high forehead. Over his forehead he had rather full, dark brown hair, which was slightly wavy and hard to manage . . . Benjamin had a beautiful voice, melodious and easily remembered. . . . He was of medium height, very slender then and for some years to come, dressed with studied unobtrusiveness, and was usually bent forward. I don't think I ever saw him walk erect with his head held high" (Scholem, 8). Of his style and temperament, Scholem observes: "From the first, Benjamin's markedly courteous manner created a natural sense of distance

and seemed to exact reciprocal behavior. This was especially difficult in my case . . . He was probably the only person toward whom I was almost invariably polite" (9).

In Munich at the end of the year he wrote to Scholem: "I intend to interrupt my stay here only briefly and to devote a solid stretch of time to my work . . . Here— away from my hometown—I have finally found the place I needed" (Letters, 78). By "my work," Benjamin meant less his studies—Munich's professors were a disappointment to him—than his emerging career as a writer. A letter from the period of his studies in Berlin (to Ernst Schoen, October 25, 1914) characteristically condemns "the swamp . . . that the university is today" and complains that "this university is capable even of poisoning our turn to the spirit" (Letters, 74).

1916

The relationship with Dora Pollak, with whom he had gone to visit Belmore in Geneva early in 1915, now displaced that with Grete Radt. Dora had separated from her husband and was soon to be divorced; Benjamin visited her frequently at the villa the Pollaks owned in Seeshaupt. In June, Benjamin invited Scholem to visit him and Dora: "Dora was a decidedly beautiful, elegant woman; she had dark blonde hair and was somewhat taller than Benjamin. Her attitude toward me was amicable and sympathetic from the start. She participated in most of our conversations with much verve and obvious empathy. . . . The two of them openly displayed their affection for each other and treated me as a kind of co-conspirator, although not a word was said about the circumstances that had arisen in their lives. Benjamin's engagement ring, however, had disappeared from his hand" (Scholem, 27).

His university studies in the summer semester included work with Walter Lehmann on the pre-Columbian culture of Mexico, and on the religion of the Mayans and Aztecs. In Berlin, Benjamin made the acquaintance of the great lyric poet Rainer Maria Rilke. Scholem notes that "he was full of admiration . . . for Rilke's politeness—he whose Mandarin courtesy constituted the utmost that I could imagine" (33). He also met Erich Gutkind, whose mystical work *Siderische Geburt* (Siderian Birth) impressed him, and the scholar Max Pulver, who drew his attention to the importance of Franz von Baader, a contemporary of the Romantics who was steeped in the traditions of Christian and Jewish mysticism.

Zionism and Judaism in general were a frequent topic of conversation between Benjamin and Scholem; yet Benjamin firmly rejected an invitation from Martin Buber, the religious philosopher and proponent of cultural Zionism, to contribute to *Der Jude,* a journal devoted to Jewish and Zionist topics. He was working intensively, beginning in 1915, to develop his theory of language, basing his ideas on a complex interweaving of motifs derived from his reading of German Romanticism and his discussions with Scholem on Jewish mysticism. This theory is fully expressed in the posthumously published essay of 1916, "On Language as Such and on the Language of Man," which treats language not primarily as a phenomenon of actual speech but as an idea to be deduced theologically. This language theory, in its *political* bearing, is at the basis of Benjamin's decision to decline Buber's invitation: "My concept of objective and, at the same time, highly political style and writing is this: to awaken interest in what was denied to the word; only where this sphere of speechlessness reveals itself in unutterably pure power can the magic spark

leap between the word and the motivating deed, where the unity of these two equally real entities resides" (Letters, 80).

1917

The military's draft review of December 28, 1916, had found Benjamin fit for light field duties, but he avoided service once again through an attack of sciatica; according to Scholem, Dora Pollak had been able to induce the attack using hypnosis, to which she claimed Benjamin was susceptible. On April 17, Benjamin and Dora were married. To mark the occasion, Scholem gave Benjamin a copy of Paul Scheerbart's *Lesabendio*, a utopian novel with a fantastic setting that would make a profound impression on him. The couple moved to a clinic in Dachau where Benjamin's sciatica could receive treatment by a specialist.

Still unsure of a profession, Benjamin began in 1916 and 1917 to weigh the possibility of a career in academics. He first considered writing a dissertation on Kant and the problem of history, but soon settled on a related topic: the philosophical foundation of the early Romantic theory of criticism. Benjamin's tendency to think literary and philosophical problems together is shown by the reading and writing that accompanied the early work on the dissertation topic in 1917. In January he reads Dostoevsky's *The Idiot*, on which he writes a short essay during the summer; he presses forward on a major translation of Baudelaire's poems, begun in late 1914 or early 1915; in May he mentions studying Baader and Franz Joseph Molitor, author of a nineteenth-century work on the Kabbalah; and in the fall he turns to the consideration of Kant that results in the essay "On the Program of the Coming Philosophy." By June he is able to describe his doctoral project as a well-defined topic (Letters, 137–138).

The decision to pursue a doctorate in philosophy sharpened Benjamin's sense of distance from the earlier pattern of relationships that had shaped his involvement with the youth movement. When he visited Belmore and Carla Seligson in Zurich once again in July, their differences produced a final break. "This was partly because of tensions between Dora and Carla," according to Scholem, "but primarily because Benjamin laid claim to unconditional intellectual leadership, to which Blumenthal [Belmore] henceforth would have to subject himself. Blumenthal refused, and this meant the end of a friendship of long standing. A despotic trait in Benjamin was evidenced here, which according to the accounts of a number of his acquaintances from the Youth Movement erupted not infrequently in those years, sharply contrasting with his usual civil conduct" (Scholem, 41–42). When Benjamin refers to this break in a letter to Schoen (July 30, 1917), he identifies it as a necessary step in achieving liberation from old entanglements and full clarity about his past.

In the early fall, Benjamin and Dora spent several weeks at St. Moritz. In September he had still not made up his mind where he would study, though he had resolved not to risk returning to Germany so long as his draft status remained a problem. By October he had decided on Bern. His letters attest to a keen awareness of contemporary movements in painting, something reflected in critical fragments such as "Painting, or Signs and Marks." A brief letter to Scholem in December confirms that he had overcome a period in which "demonic and ghostly influences" had grown ascendant; he was capable of facing "raw anarchy, the lawlessness of

suffering" (Letters, 91). Now he tells Scholem: "I have entered a new phase of my life because what detached me with astronomical speed from everybody and pushed even my most intimate relationships, except for my marriage, into the background, now emerges unexpectedly someplace else and binds me" (Letters, 102). Remarkably enough, Benjamin's letters and the accounts we have from his friends focus exclusively on personal issues such as these. There is rarely mention of the war, and no direct consideration of it or of his attitude toward it. It is as if Benjamin's injunction against political activity at the time also precluded cognizance of the most difficult events of the day.

1918

Initially Benjamin had some difficulty assimilating his plans to the situation he found at the university in Bern. "I have attended [Anna Tumarkin's], Häberlin's and Herbertz's lectures," he wrote to Schoen, "and, as I might have predicted, find your silence about them totally justified. I am staking all my hopes on my own work" (Letters, 115). Nevertheless, he managed to establish good relations with Richard Herbertz, who agreed to supervise a doctoral dissertation in philosophy. It would be difficult to discern any particular influence of Herbertz on Benjamin's thinking; Herbertz, to his credit, recognized a significant talent in his new doctoral candidate and treated Benjamin like a younger colleague. "His utterly unenvious admiration for Benjamin's genius, which was in such contrast to his own then still rather philistine mind, bespoke a great nobility of spirit" (Scholem, 58).

In February Benjamin and Dora, in advanced pregnancy, visited Locarno, where they happened to see Else Lasker-Schüler. They returned to Bern in March, and on April 11 Benjamin's only child, Stefan Rafael, was born. By May he had received Herbertz's approval for the precise topic of his dissertation, the foundation of German Romantic criticism in Kant and Fichte. This work, he writes to Ernst Schoen, should give him a newfound "internal anonymity." He expresses both determination to bring the project to completion, and some anxiety at the prospect as well: "I do want to get my doctorate, and if this should not happen, or not happen yet, it can only be an expression of my deepest inhibitions" (Letters, 125).

The dissertation, published in 1920 as *The Concept of Criticism in German Romanticism*, shows many signs of the tension that arose between the necessity of producing an academically acceptable text and Benjamin's desire to explore more esoteric concerns. "Even though I would never have taken it on without external inducement, my work on the dissertation is not wasted time. What I have been learning from it—that is, insight into the relationship of a truth to history—will of course hardly be at all explicit in the dissertation, but I hope it will be discerned by astute readers" (Letters, 135–136). A certain idea of art was at issue here. "Only since Romanticism has the following view become predominant: that a *work* of art in and of itself, and without reference to theory or morality, can be understood in contemplation alone, and that the person contemplating it can do it justice. The relative autonomy of the *work* of art vis-à-vis art, or better, its exclusively transcendental dependence on art, has become the prerequisite of Romantic art criticism" (Letters, 119).

Scholem came to visit on May 4 and stayed in Switzerland until August 1919,

permitting a period of sustained dialogue. From June until the end of summer, the Benjamins stayed in the village of Muri, a short distance outside Bern. Scholem took a room there too, and the two men invented the fantasy University of Muri as a running joke between them, granting one another official positions and discussing regulations and curriculum. During this period, too, Benjamin's letters first mention the collection of children's' books which would become an unusual and significant element of his library (Letters, 132).

1919

Early in 1919 Benjamin came to know Hugo Ball and his wife, Emmy Hennings, who lived close by in Bern. Ball had been one of the original group of Zurich Dadaists who had established the Cabaret Voltaire, while Hennings's poetry had contributed to the "second wave" of Expressionism after 1910. The still underacknowledged presence of Dadaism in Benjamin's work dates from this period. In Switzerland, Ball had contributed to the *Freie Zeitung,* a journal representing the views of German pacifists, and in March or April he introduced Benjamin to another contributor, Ernst Bloch, who was living in Interlaken. Scholem recalls: "Benjamin evidently was greatly impressed by Bloch's personality, although as yet he was unacquainted with his philosophical writings. He did not read the first edition of *The Spirit of Utopia,* which had appeared in 1918 and which Bloch undoubtedly told him about, until the fall of 1919. . . . Benjamin described to me Bloch's impressive appearance and told me that Bloch was now working on his magnum opus, *System of Theoretical Messianism;* he grew wide-eyed when he mentioned this" (Scholem, 79). This was the first in a series of intermittent but intense and mutually profitable encounters between the two writers.

In February Scholem had introduced the Benjamins to Else Burchardt, who would later become Scholem's first wife. A less harmonious situation resulted when Wolf Heinle, the younger brother of Benjamin's late friend, Fritz Heinle—and like him an aspiring poet—came to stay with them in March. He suffered from a nervous disorder whose symptoms included deep melancholy. After a few weeks some incident precipitated his sudden departure for Germany. A letter to Schoen mentions Heinle's chilling aura of self-destructiveness (Letters, 141). Despite this rift, Benjamin remained loyal to Heinle, doing what he could for him until his death in 1923.

By the beginning of April Benjamin had completed a rough draft of the dissertation. He felt that the required academic form of argument had kept him from achieving a full penetration of German Romanticism to its core; allowing for the limitations of form, however, he pronounced himself satisfied with the result (Letters, 139–140). With the formal completion of his studies, Benjamin's future became all the more uncertain; it is at this time that he first entertains the notion of leaving Europe for Palestine, perhaps "a necessity I will have to face" (Letters, 140). On June 27 he was awarded his doctorate *summa cum laude.* For some weeks he endeavored to keep this news from his parents in order to extend their financial support. He went so far as to ask Scholem to lie to his own mother about it (Letters, 143). In July he went to Iseltwald in the hope of renewing work on the translations of Baudelaire, together with his wide readings in French literature. His parents, having learned of the completion of his degree despite his best efforts, appeared

unannounced in Iseltwald; the days that followed produced a temporary crisis in their already strained relationship.

No after-effect of his academic labors, or the difficulties with his parents, or the worries about the illness of his wife and son at this time were able to keep Benjamin from significant new writing—though he does complain to Scholem about how little he has achieved that summer (Letters, 152). After a visit to Ticino in the fall, the family retreated in November to a sanatorium in Breitenstein, Austria, owned by Dora's aunt. From there Benjamin wrote, "I hope to be able to publish an essay I wrote in Lugano, 'Fate and Character.' I consider it to be one of my best essays. I also wrote the prolegomena to my new review of *Lesabendio* and a review of Gide's *Strait Is the Gate* there" (Letters, 154).

1920

At Breitenstein he continued work on a review of Bloch's *Spirit of Utopia,* with the intention of veiling his mixed estimate of the book in esoteric language. In order to give himself some grounding in the theory of Expressionism for the review, he read Wassily Kandinsky's "Concerning the Spiritual in Art," which impressed him as much as the author's paintings had previously (Letters, 229). The possibility of an extended stay in Vienna proved unappealing, since a visit there to stay with Dora's parents in February was marred by persistent family tensions, and the library resources fell short of what he required. He did, however, have an opportunity to hear a reading by Karl Kraus, whose work had interested him for some time. The question of pursuing an academic career, and therefore of undertaking a *Habilitation,* the "second dissertation" required of all German professors, remained open: "The decision, at least the provisional one, depends not only (even if to a significant extent) on the question of money but also on how the work on my *Habilitation* shapes up. All that exists of the dissertation is my intention to work on a particular topic—that is, a research project that falls within the sphere of the larger question of the relationship between word and concept (language and logos)" (Letters, 156). Much of the frenzied travel that marks the years 1920–1924 was undertaken in pursuit of an established position at the universities in Bern, Heidelberg, and finally Frankfurt.

The Benjamins returned to Berlin in March, staying at first with his parents. The level of discord soon forced them to accept an offer from Erich Gutkind to move to his house at Grünau-Falkenberg, a short distance outside Berlin. Here the couple made their first faltering attempts to support themselves financially. Dora found a job translating from English in a telegraph office, while Benjamin earned a little money by writing an occasional graphological analysis. He also began for the first time to study Hebrew, with Gutkind, Scholem's former pupil, as his teacher. In September the effort to achieve independence was given up again, and Benjamin and his wife moved back to his parents' house.

Benjamin had read Georges Sorel's *Reflections on Violence* while in Switzerland. Now, in Berlin, he began work on the political issues raised by that book, which crystallized toward the end of the year in the essay "Critique of Violence." He gave up any further plans to learn Hebrew, in order to concentrate once more on the question of his *Habilitation.* On reading Heidegger's *Habilitation* dissertation on

Duns Scotus, he expressed astonishment that one could get by on the basis of "mere diligence and a command of scholastic Latin"; he regarded the work, despite all its philosophical trappings, as little more than a piece of good translation. The resentment of Heidegger's position that would continue until the end is already evident here: "The author's contemptible groveling at Rickert's and Husserl's feet does not make reading it more pleasant" (Letters, 168). From his first encounter with the academic world, Benjamin had foreseen that the individualist tendencies of his own thought would work against his establishment within the realm of institutionalized philosophy. Though he had managed successfully to overcome this obstacle in his doctoral work, the same situation vis-à-vis the profession as such now set his intellectual independence against his hopes for economic independence. The eventual failure of his attempts to pursue an academic career follows from that contradiction with almost mathematical necessity.

In December Benjamin mentions his work on a philosophical critique of Scheerbart's *Lesabendio* that will provide a developed position on politics (Letters, 168–169). Neither this text nor the review of Bloch have been found. Prompted to turn once more to issues in the philosophy of language, he revived his contacts with Ernst Lewy, the Berlin professor whose lectures had impressed him in 1914. Having struggled with these issues in the context of his German versions of Baudelaire, he begins work on a preface to his collection, dealing "theoretically . . . with the task of the translator" (*GS*, IV, part 2, 889). This central essay was completed toward the end of the following year.

1921

The essays on Scheerbart and Bloch, and "Critique of Violence," which he completed in January, all turned on contemporary political questions. Taken together, they indicate that Benjamin was drawing closer to integrating the idea of pure language into politics. In this new spirit, he responded with enthusiasm to a book by Erich Unger, *Politics and Metaphysics,* calling it "the most significant piece of writing on politics in our time" (Letters, 172). Through Unger, he renewed his acquaintance with a group of Jewish intellectuals centered around the murky figure of Oskar Goldberg. Although he writes positively about Unger and about another member of the group, David Baumgardt, his response to Goldberg, expounder of an archaic magic doctrine embedded in the Hebrew Bible, is rather different: "To be sure, I know very little about him, but his impure aura repelled me emphatically every time I was forced to see him, to the extent that I was unable to shake hands with him" (Letters, 173).

Work on "The Task of the Translator" continued into the spring, while negotiations progressed on the publication of his translations of Baudelaire. In March he visited an exhibition of paintings by August Macke, who had been killed on the Western Front in 1914. The "short essay" he says he wrote on these pictures (Letters, 178) has not survived. He also mentions a painting by Chagall, *Sabbath,* which he liked but which lacked perfection for him: "I am coming more and more to the realization that I can depend sight unseen, as it were, only on the painting of Klee, Macke, and maybe Kandinsky. Everything else has pitfalls that require you to be on guard. Naturally, there are also weak pictures by those three—but I see that they

are weak" (Letters, 178). Sometime in the spring, Benjamin bought a small Klee drawing entitled *Angelus Novus,* which was to become his best-known possession and, many years later, the inspiration for one of his best-known pieces of writing: the meditation on the angel of history in "On the Concept of History" (1940). In June he traveled with Dora to the sanatorium at Breitenstein, where she was diagnosed with a serious pulmonary problem. In July he went to Heidelberg for a visit that lasted until the middle of August. He heard lectures by Friedrich Gundolf, who had introduced the aesthetic doctrines of the George school into the academy, and Karl Jaspers. Of Gundolf—whom he would criticize sharply in the magisterial essay "Goethe's Elective Affinities," which he began at this time—Benjamin observed that "he appeared to me to be terribly feeble and harmless in terms of the personal impression he makes, quite different from the impression he makes in his books." Toward the end of November, when work had progressed on the Goethe project, he wrote: "Meanwhile I have been feeling pretty good. The only thing is that I will not have any peace until I finish my essay on *Elective Affinities.* The legally binding condemnation and execution of Friedrich Gundolf will take place in this essay" (Letters, 196). He thought Jaspers feeble and harmless in his thinking, "but as a person obviously very remarkable and almost likable" (Letters, 182). He left Heidelberg convinced that he had created a place for himself and his *Habilitation;* in his absence, however, the philosophical faculty elected to support a different candidate: Karl Mannheim.

In August he wrote to Scholem that the publisher Richard Weissbach, who had also agreed to publish the Baudelaire translations, had offered to bring out a new journal which would be edited by Benjamin and which Benjamin proposed to call *Angelus Novus.* Ultimately, nothing was to come of the idea beyond the essay "Announcement of the Journal *Angelus Novus,*" Benjamin's articulation of the ideal function of such a journal. He says there that "the vocation of a journal is to proclaim the spirit of its age"; for Benjamin, this proclamation was to take the form of literary and philosophical criticism. The prospect of bringing out an independent journal seems to have caught Benjamin's imagination and stirred his enthusiasm more than any enterprise since the days of the youth movement and his work on *Der Anfang.* Even after it had become apparent that his plans would lead to nothing concrete, the intellectual exhilaration of the idea seems to have lingered. At the end of the year, Benjamin writes: "I am feeling fine in every respect. I do not know, of course, if I have good reasons for doing so. But in contrast to my usual mood, when all is said and done I am confident about the future. Not because *Angelus* will appear—this is unlikely. I am ashamed to admit it, but I cannot deny that I read the final proofs of my prospectus in Heidelberg" (Letters, 203–204). In the fall, Dora joined him in Berlin after an operation that apparently had little effect on her condition.

Throughout the year, Benjamin pushed steadily toward completion of the essay on Goethe. "Goethe's Elective Affinities" is in many ways the crown of his early work. It contains not only a penetrating critique of Goethe's dark novel, but also Benjamin's most thoroughgoing attempt to systematize his theory of criticism: he himself thought of it as "an exemplary piece of criticism" (Letters, 194). Benjamin's essentially dualistic argument demonstrates how profoundly the element of myth woven into the lives of the characters, into the setting and atmosphere of the novel,

militates against any clarity of self-determination and freedom. Benjamin delivers not only a rebuke to the cult of Goethe as mythic poet-hero propagated by the circle around Stefan George, but also a decisive blow to the status accorded the symbol in German tradition after Goethe. Benjamin fills the space vacated by the symbol with an invocation of the "debased" and "lesser" trope of allegory, which will remain at the center of his critical enterprise beginning with his study of the German mourning play, his next major work, right through the writings on Baudelaire and the Parisian arcades that occupied him in his last years.

The essay is informed by painful life experiences. Early in 1921, the marriage between Benjamin and Dora collapsed. Ernst Schoen had come to visit them during the winter, whereupon Dora fell passionately in love with him. The state of the marriage made it natural for Dora to be open about this with Benjamin. Following a pattern similar to Goethe's plot, Benjamin himself then fell in love with the sculptress Jula Cohn, sister of Benjamin's schoolfriend Alfred Cohn, who came to visit them in April. Benjamin and Dora had known her from the days of the student movement, but they had not seen one another for five years. The visit to Heidelberg in July and August during which Benjamin heard Gundolf lecture was undertaken not solely out of academic interest: he was able to spend time with Jula, a member of Gundolf's circle. "Both of them," according to Scholem, "were convinced that they had now experienced the love of their lives." But the conviction did not last, and the relationship ended indecisively. "The process that began at this time lasted for two years, and during that period Walter and Dora resumed their marital relationship from time to time, until from 1923 on they lived together only as friends, primarily for the sake of Stefan . . . but presumably out of financial considerations as well" (Scholem, 94). Scholem's portrait shows them both very considerate of each other during this upheaval: "It was as though each was afraid of hurting the other person, as though the demon that occasionally possessed Walter and manifested itself in despotic behavior and claims had completely left him under these somewhat fantastic conditions" (94–95). The record of their divorce proceedings, concluded on March 27, 1930, confirms that, on the question of money at least, Benjamin's more normal disposition had been restored with some vehemence. But later in the stormy decade to follow, their friendship would reassert itself.

1922

In the early 1920s Benjamin was especially close to the conservative intellectual Florens Christian Rang. "In Rang," Scholem writes, "Benjamin saw a personification of the true German spirit; he represented in an outstanding and noble way those qualities which were antithetical to Benjamin's. This polarity was probably the basis of the attraction between the two men" (Scholem, 115–116). The planned journal had played a key role in their intellectual interchange; Benjamin envisioned Rang's essay on Goethe's poem "Selige Sehnsucht" ("Blessed Longing") as a central feature of an early issue. In October, Benjamin indicates to Rang that he has finally lost patience with the delays caused by the publisher's financial difficulties, and has had to give up hope of seeing the journal in print: "Maybe I will be able to see the *Angelus* flying toward the earth at some future time. For the moment, however, a journal of my own would be possible only as a private and, so to speak, anonymous

enterprise, and in that case I would gladly and willingly follow your lead" (Letters, 203). Benjamin's correspondence with Rang, which covers issues in cultural politics, drama, literary criticism, and religion, is fully comparable in its range and depth, if not its size, to that with Scholem and later with Adorno. Rang's death in 1923 would be a heavy blow for Benjamin.

Benjamin's commitment to an academic career is now strong enough to cause him to look for a new field of study and a new academic institution: "Although Heidelberg is no longer at the forefront of these considerations," he wrote to Rang, "I will be going there anyway at the beginning of November just to make sure. . . . If—as almost seems to be the case—my chances might be improved by working outside the area of pure philosophy, I would also consider submitting a *Habilitation* dissertation in the field of postmedieval German literature" (Letters, 203). The urgency that persists despite his reluctance has a most predictable source. His parents were growing ever more impatient with him. "The more obstinate my parents prove to be, the more I am forced to consider acquiring this certificate of public recognition, which will bring them into line" (203). His father tried to force him take a job in a bank, and only the intervention of his father-in-law postponed a complete break between them. In response to this pressure, Benjamin attempted to persuade his father to give him enough money to start a business that would sell used books, "For I am determined to put an end to my dependence on my parents no matter what. Because of their pronounced pettiness and need for control, it has turned into a torture devouring all the energy I have to work and all my joy in life" (Letters, 201–202). Having confirmed his low expectations regarding his chances in Heidelberg, he went on to Frankfurt in December to see how things stood there.

1923

Benjamin was plagued by deep depression in the early months of 1923. In January, he traveled to Breitenstein again, where he wrote: "I have nothing good to report about myself." The *Habilitation* seemed to be the only way out of his dependency on his parents, and he says, "My fondest wish . . . is still to be able to give up the apartment at my parents' house" (Letters, 205–206). Despite some support from Gottfried Salomon, a member of the sociology faculty, in whose seminar that summer he would meet the young Theodor Wiesengrund-Adorno, the visit to Frankfurt still had not brought that wish any closer to fulfillment. Moreover the death of Wolf Heinle on February 1 brought back a mood akin to what he felt after Fritz Heinle's suicide. It is here that a new note enters Benjamin's essays and letters. The young Weimar Republic was experiencing profound difficulties in a period of astonishingly rapid inflation. In response to an invitation from Florens Christian Rang to contribute to a project, Benjamin replied: "I will gladly contribute whatever is in my power and whatever can be reconciled with my guilty reticence in the face of the destiny that is now, overwhelmingly and perniciously, making itself felt. Of course, these last days of traveling through Germany have again brought me to the brink of despair and let me peer into the abyss" (Letters, 207).

Following the intense, if still wholly theoretical, involvement with political issues that produced "Critique of Violence" and the review essays on Scheerbart and Bloch, Benjamin now turned for the first time to writing about concrete sociopolitical issues.

The earliest drafts of "Imperial Panorama," the section of *One-Way Street* that contains its central political meditation (it bears the subtitle "Journey through the German Inflation"), date from this period.

In October, Weissbach finally published Benjamin's translations of the "Tableaux Parisiens" from *Les fleurs du mal,* together with the essay "The Task of the Translator"; Benjamin had begun to fear that the book would "appear according to a transcendental time scheme." Despite his own hope that the volume would establish him as an intellectual presence in Germany, the translations disappeared virtually without a trace; there were two reviews, and one of them, in the *Frankfurter Zeitung,* was devastating. This came as an especially hard blow, since one of the editors at the journal was Siegfried Kracauer, with whom Benjamin had initiated a friendship earlier in the year. Following hard upon the neglect of the Baudelaire translations, with their theoretical foreword, the publisher Paul Cassirer rejected his essay on *Elective Affinities* (Letters, 208), for which he had already paid Benjamin an advance. As this year wore on, the hopelessness of all his earlier projects weighed on him ever more darkly. Of his *Habilitation* he writes at the end of September: "I still do not know if I can do it. At all events, I am determined to complete a manuscript. Better to be chased off in disgrace than to retreat."

By the end of 1923 Benjamin had in fact defined his topic—the historical significance of the German Baroque *Trauerspiel,* or "mourning play"—and collected the majority of his materials. "But on the other hand, the manifestations of decline have a paralyzing effect. What is certain is that this vigorous attempt to build a bridge for my escape from Germany will be my last attempt, and that, if it fails, I will have to try to achieve my redemption by swimming—by somehow making a success of it abroad—for neither Dora nor I can endure this slow erosion of all our vitality and worldly goods much longer." Sometimes it seemed to him that they had all been overtaken by the "night when no one can have any effect" (Letters, 209).

Two weeks earlier, Gershom Scholem had left Germany for Palestine; Benjamin had given him, significantly, not a mystical text but an untitled scroll which he labeled "A Descriptive Analysis of the German Decline"—the earliest draft of "Imperial Panorama," Benjamin's first foray into contemporary politics. As Scholem remembers, "It was hard for me to understand what could keep a man who had written this in Germany" (Scholem, 117–118). In November, in the wake of the assassination of the prominent industrialist and cabinet minister Walther Rathenau, and with renewed awareness of the situation confronting a Jew in Germany, Benjamin raised the question of emigration in a letter to Rang, acknowledging "neither the practical possibility nor the theoretical necessity" of going to Palestine, although Dora, who had just lost her job at the telegraph office, was thinking about emigrating to America (Letters, 216).

Only at the end of the year did Benjamin's prospects improve. Rang had passed on a copy of the Goethe essay to the Austrian poet and dramatist Hugo von Hofmannsthal, who collaborated with Richard Strauss to produce a series of operatic masterworks. Hofmannsthal hailed the essay as a work of genius and immediately accepted it for publication in his journal *Neue Deutsche Beiträge,* where it appeared in two parts in the issues of April 1924 and January 1925. The support and recognition of his talent that Hofmannsthal provided remained vital to Benjamin for many years. Every such friendship developed for Benjamin as the point at which

a particular facet of his complex intellectual world could meet its appropriate interlocutor. That complexity limited the scope of the correspondence between him and any one person, even where Benjamin's response records an extraordinary depth of understanding. The particular confirmation Benjamin found in Hofmannsthal as a reader of his work corresponds exactly to those qualities that distinguished Hofmannsthal as a writer. In January 1924 Benjamin wrote to his "new patron": "It is very important to me that you clearly underscore the conviction guiding me in my literary endeavors and that, if I understand you correctly, you share this conviction. That is to say, the conviction that every truth has its home, its ancestral palace, in language; and that this palace is constructed out of the oldest logoi" (Letters, 228).

1924

Support from this influential quarter restored Benjamin's confidence on a wide front, including his hopes for the *Habilitation*. And since international confidence in the German mark had also improved with the passing of the previous year's economic crisis, he was able in the spring to leave Germany and an atmosphere which had become oppressive, and move to Italy. He settled down in Capri, where he was able to live cheaply and comfortably for almost six months, working at his *Habilitation* project on the German tragic drama. In the early weeks of his stay, he had the company of the Gutkinds, a couple to whom he had become close in Berlin; at the end of summer, Ernst Bloch and his wife would join him on the island. In June he wrote to Scholem: "In the course of time, especially since the Gutkinds left, I have gotten to know one person after the other in the Scheffel Café Hidigeigei . . . In most cases, with little profit; there are hardly any noteworthy people here. A Bolshevist Latvian woman from Riga who performs in the theater and directs, a Christian, is the most noteworthy" (Letters, 242). This was Asja Lacis.

By September, he had revealed to Scholem how intensely concerned he had become with the question of Communism; his approach to the Left was typically guided in part by a text, Lukács's *History and Class Consciousness,* and partly by a person who was an object of desire: Lacis. "I believe I have written you that much of what I have arrived at thus far in thinking about this subject was greeted with very surprising interest by those with whom I discussed it—among these individuals was a wonderful Communist who has been working for the party since the Duma revolt" (Letters, 248). These references to Lacis appear all the more significant because he does not give her name or mention the nature of the relationship that had developed between them. Though he describes his visits to the Italian mainland, he does not mention that he traveled with her as her companion, nor does he state explicitly that she was his collaborator on the vivid account of his impressions entitled "Naples"—the first of many such city images—even though he mentions that it "will be published in Latvian and perhaps in German" (Letters, 253). There is even a noticeable distance in the way he reports receiving the news—"now slowly getting through to me" (Letters, 252)—of Rang's death on October 10. The center of gravity in Benjamin's life had simply been displaced.

Upon his return to Germany, Benjamin claims that "people in Berlin are agreed that there is a conspicuous change in me" (Letters, 257). In an important communication to Scholem, Benjamin formulates this change as provocatively as possible:

"I hope some day the Communist signals will come through to you more clearly than they did from Capri. At first, they were indications of a change that awakened in me the will not to mask the actual and political elements of my ideas in the Old Franconian way I did before, but also to develop them by experimenting and taking extreme measures. This of course means the literary exegesis of German literature will now take a back seat" (257–258). He notes his own "surprise" and indicates his regret that he can neither produce "a coherent written statement about these matters" nor "speak in person," since, "regarding this particular subject, I do not have any other means of expressing myself" (258). If this letter attempts to portray Benjamin's politics in 1924 as unambiguously leftist, other evidence points to ongoing political ferment and open-endedness. Concurrently with his first, tentative reading of Marx, Benjamin subscribed on Capri to *Action Française,* the organ of French reactionary monarchism; and alongside his growing attachment to Lacis stood his continued loyalty to everything the archconservative Rang had stood for: he pronounced himself indebted to him "for whatever essential elements of German culture I have internalized" (Letters, 252).

Back in Berlin in November, Benjamin reentered the literary marketplace with a vengeance. He completed two review essays on collecting children's books, apparently concluded an arrangement to work for a new publishing house (which went bankrupt before bringing out its first work), and began work on a number of new essays. And all of this was only the prelude to his breakthrough in 1925 as one of the most visible cultural critics in Germany.

1925

The early months of 1925 were devoted to finishing his *Habilitation* dissertation on the German Baroque *Trauerspiel,* or play of mourning. On February 19 he wrote to Scholem that "in spite of everything, the part of the thesis I plan to submit now exists in rough draft" (Letters, 260). The "everything" refers to an "internal resistance" about which Scholem had voiced concern—namely, Benjamin's ineradicable misgivings about the academic career to which this work would open the way. The letter gives evidence of all the disparate forces, internal and external, that were gathered to a head at this moment in Benjamin's career. "To be sure," he observes, "I have lost all sense of proportion in the course of working on this project," the introduction to which he calls "pure chutzpah" (261). He wants, he says, to "work in a polar climate," as a relief from "the all-too-temperate climate of my Baroque project." This severity would take him back to Romanticism and on to "political things." Whatever else, "this project marks the end for me—I would not have it be the beginning for any money in the world" (261).

His uncertainties regarding the project itself were coupled to a growing anxiety at the prospect of a permanent teaching position. In February, Benjamin visited the University of Frankfurt in order to come to an agreement regarding the submission of his work to the professor for literary history, Franz Schulz. Schulz in fact read *Origin of the German Trauerspiel* in the spring; his reading convinced him that Benjamin would be suited to any department other than his own, and he recommended that Benjamin submit the dissertation to the professor for aesthetics, Hans Cornelius. Benjamin's estimate in February that the situation in Frankfurt was "not

unfavorable" was based in large part on a reading of Schulz; after Schulz rejected the text, he earned a scathing reappraisal in a letter of April 6 as a cowardly pseudo-intellectual, and then in late May his "unreliability" (266) appeared as a factor threatening what slender chances remained for the *Habilitation*.

In May, growing misgivings about developments at the university prompted Benjamin to declare that his first choice would be to live off his various projects in the world of publishing, but the fragility of this source led him to contemplate an even more tenuous hope: "If I have no luck there, I will probably hasten my involvement in Marxist politics and join the party—with a view of getting to Moscow in the foreseeable future, at least on a temporary basis" (Letters, 268). The idea of experiment was uppermost: "To begin with, of course, the primary thing to happen will be a mighty conflict among powers (my individual powers). That must be a factor, along with my study of Hebrew. Also, I do not foresee making a fundamental decision, but instead must begin by experimenting with one thing or the other. I can attain a view of the totality of my horizon, more or less clearly divined, only in these two experiences" (276).

Benjamin submitted his formal request for *Habilitation* in May. Cornelius, however, pronounced himself unable to comprehend either Benjamin's project as a whole or its execution, and passed it along to two colleagues, who were likewise "incapable of understanding it."[6] One of the two negative responses came from Max Horkheimer, later to become Benjamin's associate at the Institute for Social Research. Benjamin's request was denied in July, and in August he agreed to withdraw his application. And thus ended his protracted effort to make a place for himself in the academy. "All in all I am glad. The Old Franconian stage route following the stations of the local university is not my way" (Letters, 276). *Origin of the German Trauerspiel*, one of the most original and influential literary studies of the century, was simply not in step with the German university system of the 1920s. It appeared only in 1928, in an edition published by Rowohlt; this edition, however, had an immediate and highly favorable impact on literary circles in France as well as in Germany.

Also in 1925, Benjamin brought a second major project to a provisional conclusion. As early as 1924 he had told Scholem of his plans to collect his aphorisms, dream protocols, and other short texts, such as "Imperial Panorama," in book form; he planned to call the work *Plaquette for Friends*. On September 18, 1926, he reported to Scholem that he had completed the collection, which he had now given the title under which it would be published, *One-Way Street (Einbahnstraße)*. It finally appeared with Rowohlt in 1928. If the book on *Trauerspiel* is the transitional work between Benjamin's early, metaphysically oriented work and the mature philosophy of history and theory of nature, *One-Way Street* marks the inception of Benjamin's career as a contemporary cultural critic and social theorist.

The finality with which Benjamin's academic aspirations had been denied seems to have spurred him to new efforts in Berlin. In the early months of 1925, he secured a place as a regular contributor to the *Frankfurter Zeitung*; he signed a contract with Ernst Rowohlt, who agreed to publish not only the *Trauerspiel* book and *One-Way Street*, but the Goethe essay as well; and he became a principal contributor to its important new literary house journal, *Die literarische Welt*. The major source of immediate help in his professional life at this time came from Hugo von Hofmannsthal, who got him a well-paid contract to translate "Anabasis," a long poem

by St. John Perse. The task had previously been intended for Rainer Maria Rilke, but Rilke was already in failing health and elected to write only the introduction. Benjamin also accepted a commission from the small, prestigious publishing house Die Schmiede to translate a portion of Proust's *A la recherche du temps perdu*—the fourth volume, *Sodome et Gomorrhe*.

The newfound financial security that came with so much activity produced a typical reaction: Benjamin left Berlin in August on an extended journey which took him first to Spain and Italy and finally to Riga, site of Asja Lacis' theater. Benjamin's surprise visit to Lacis was an unmitigated failure; she was deeply involved in her own work and had no desire to take up again with a "holiday lover." At the end of the year, Benjamin returned to Berlin.

1926

Despite his new situation—firm connections to leading publications and an established reputation as an author—Benjamin, in the early months of 1926, was plagued with old uncertainties. His letters show him reading a "sinful quantity of things" (Letters, 288), including Trotsky, Bachofen, Klages, and astonishing numbers of French newspapers; but for the first time since 1917, he was without a major project (aside from the Proust translation, which he had undertaken more out of financial than intellectual necessity). His familiarity with the French situation led him to suggest that he might "weave this threadbare fact into a solid context." He showed an unusual degree of interest in family affairs, answering Scholem's inquiries about the Jewish education of his son, Stefan.

Whether he was working on it or avoiding it, the Proust translation was never far from his mind. "You might not get far when you read my Proust translation," he writes to Scholem. "Some unusual things would have to happen for it to become readable. The thing is immensely difficult, and there are many reasons why I can devote very little time to it" (Letters, 289). To Hofmannsthal, he remarked on his problems with Proust; he had the idea of publishing his thoughts in an article entitled "En traduisant Marcel Proust." The translation of Proust was to be produced in collaboration with his friend Franz Hessel. By August, he and Hessel had completed the first volume of their translation; ultimately, they would complete three volumes and part of a fourth. *A l'ombre des jeunes filles en fleurs* was published by Die Schmiede in 1927, and *Le côté de Guermantes* by Piper Verlag in 1930. Benjamin's completed translation of *Sodome et Gomorrhe* was never published, and the manuscript has never been found; Hessel and Benjamin broke off before completing *La Prisonnière*.

In the spring, Hessel invited Benjamin to stay with him and his wife at Fontenay in order to speed progress on the project. Benjamin once more took the opportunity to leave Berlin, but preferred "to sample the pleasures of living in a hotel for once" (Letters, 293), as he wrote to Jula Cohn (now Jula Radt, since she had married Fritz Radt in 1925), who was also residing in Paris. Benjamin established himself in Paris at the Hotel du Midi on March 21. The letter he wrote to Jula Radt on his arrival in Paris mentions the now well-known sculpture of Benjamin which she had evidently completed earlier in the year. A later letter to her (April 8) details the difficulties caused by Frau Hessel's unreciprocated flirting with him, and describes

the chic social circles to which he has been introduced. Of Ernst Bloch, whose "problematic company" he kept at this time in Paris, he wrote to Jula: "Bloch is an extraordinary individual, and I revere him as the greatest connoisseur of my writings" (299).

Benjamin started work on several smaller projects in the late spring: "Most worth mentioning is the ten-line foreword to the *Trauerspiel* book, which I wrote as a dig at the University of Frankfurt and which I consider one of my most successful pieces" (Letters, 293). This foreword, a mordant retelling of the ending of "Sleeping Beauty," was not included in the published form of the book. Among the other projects was a commission to write three hundred lines on Goethe for the new *Soviet Encyclopedia*. "The divine impudence inherent in the acceptance of such a commission appealed to me," he writes, "and I think I will manage to concoct something appropriate" (294). Benjamin's strangely awkward approach to Communism— sometimes ironic, sometimes pained, sometimes almost flirtatious—emerges in pronounced fashion at the end of May, when he issues to Scholem something like a political credo. He writes on May 29 that his thought "seems to be giving signs of attempting to leave the purely theoretical sphere." This, he declares, can only mean an option within "religious or political observance" (300). He stresses that any political or religious action must be colored by the same experimental quality that characterizes his thought, noting the "indispensable prerequisite that every observation of action proceed ruthlessly and with radical intent"; "my stance would be to behave always radically and never consistently when it comes to the most important things." He is explicit, though, regarding his commitment to engagement: "Anyone of our generation who feels and understands the historical moment in which he exists in this world, not as mere words, but as a battle, cannot renounce the study and the practice of the mechanism through which things (and conditions) and the masses interact" (Letters, 300). The vacuity of Communist "goals" therefore "does not diminish the value of Communist action one iota, because it is the corrective for its goals and because there are no meaningfully political goals" (301).

In July, Benjamin's father died. In September he traveled in the south of France in the company of Jula Cohn, where he read Sterne's *Tristram Shandy*. He returned to Berlin in October, intending, as he wrote to Hofmannsthal, to stay until Christmas. When he heard in November, however, that Asja Lacis had suffered a nervous breakdown in Moscow, he rushed to her side. He arrived in Moscow on December 6, and would remain until February 1, 1927.

Notes

1. Walter Benjamin, "Berlin Chronicle," trans. Edmund Jephcott, in *Reflections*, ed. Peter Demetz (New York: Schocken, 1978), pp. 18, 10–11. Subsequent references to this work will appear in the text as "Chronicle."
2. Gershom Scholem, *Walter Benjamin: The Story of a Friendship* (Philadelphia: Jewish Publication Society of America, 1981), p. 4. Subsequent references to this work will appear in the text as Scholem.
3. *The Correspondence of Walter Benjamin,* trans. Manfred R. Jacobson and Evelyn M. Jacobson (Chicago: University of Chicago Press, 1994), p. 13. Subsequent references to this work will appear in the text as Letters.

4. Walter Benjamin, *Gesammelte Schriften* (Frankfurt: Suhrkamp Verlag, 1972–1989), vol. 2, p. 838. Trans. Marcus Bullock. Subsequent references to the *Gesammelte Schriften* will appear in the text as *GS*.

5. Latin phrase meaning "enough for him who knows" (i.e., the insider needs no further explanation).

6. Burkhard Lindner, ed., "Habilitationsakte Benjamins," *Lili* 14, nos. 53–54 (1984): 155.

Index